TWENTIETH-CENTURY

ART OF LATIN AMERICA

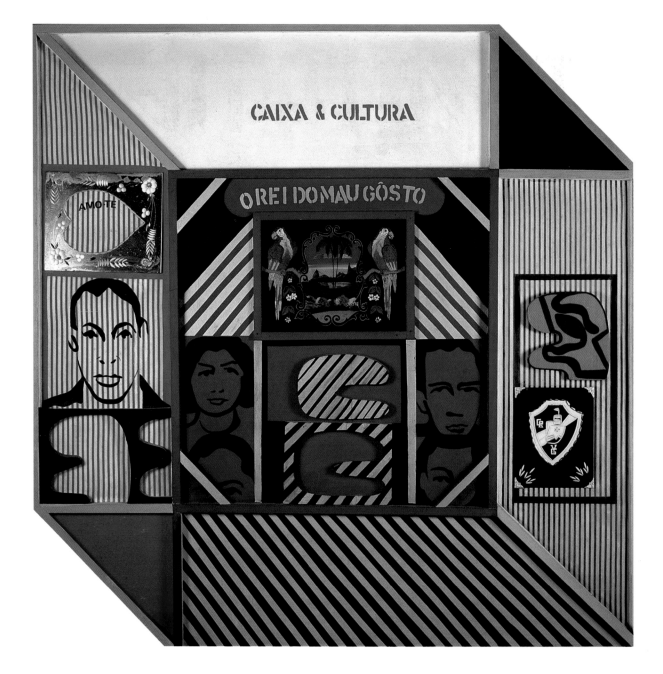

TWENTIETH-CENTURY ART OF LATIN AMERICA

JACQUELINE BARNITZ

UNIVERSITY OF TEXAS PRESS
Austin

Publication of this book was supported by grants from the Favrot Fund, Daniel D. Boeckman Investments, and an anonymous donor.

First edition, 2001

∞ The paper used in this book meets the minimum requirements of ANSI / NISO Z39.48-1992 (R1997) (Permanence of Paper).

Designed by Ellen McKie

LIBRARY OF CONGRESS
CATALOGING-IN-PUBLICATION DATA

Barnitz, Jacqueline.
 Twentieth-century art of Latin America / Jacqueline Barnitz.
 p. cm.
 Includes bibliographical references and index.
 ISBN 0-292-70857-2 (hardcover : alk. paper) —
ISBN 0-292-70858-0 (paperback : alk. paper)
 1. Art, Latin America. 2. Art, Modern—20th century—Latin America. I. Title.
 N6502.5 .B36 2001
 709'.8'0904—dc21

 99-050871

FRONTISPIECE: Rubens Gerchman, *O rei do mau gosto*. Courtesy Evandro Carneiro, Rio de Janeiro. Photo: Vicente de Mello.

TO MY TEACHERS

AND MY STUDENTS

CONTENTS

COLOR PLATES

Latin America does not have a survey of its modern art like those that exist for the art of Europe and the United States. Although several books have contributed greatly to an understanding of Latin American modern art, none fills the need for a structured, sequential discussion of this art in its diverse contexts and interrelationships. Recent multiauthored exhibition catalogs and general surveys offer helpful information and insights, but these are often fragmentary and do not provide the broader historical context that helps to explain the art as a whole.[1] The tendency to stereotype and exoticize this art as a whole has cast a negative shadow on the notion of a survey such as this. Although I am fully aware of the inherent danger posed by one individual's interpretations of the art of so many different times and places, for the purpose of studying and teaching such a subject, the same coherence that has been afforded the study of European and United States art by individual authors for decades seems equally justified for the study of the modern art of Latin America. The fact that it has become increasingly difficult to stylistically classify the art from the 1970s on, not only in Latin America but in most countries of the Western world, does not imply the absence of identifiable trends and patterns in the art of Latin America from earlier years. It is the purpose of this book to identify these patterns in their appropriate contexts.

As is the case for surveys of modern European art, this study centers around the major movements and artists who have contributed innovative forms and new directions to the art of their country. The material included is necessarily selective and therefore leaves out many groups as well as deserving individuals that are not very well known abroad. Without this selectivity, however, this book would have resulted in an unwieldy listing of names, and it seemed more appropriate to discuss fewer examples in greater depth.

It is my hope that the artists I have excluded will not take my omission as a dismissal of their work or its artistic value. In many cases, it is *because* of their originality (as exceptions to the rule) in not conforming to a given tendency that they do not have a place in my discussion. I am aware that any form of selectivity results in a partial truth. The selection is therefore predicated on how representative the groups and artists are of their time and place as well as on the need for clarity in presenting such a broad subject. In addition to artists, several countries have been excluded: the Central American ones, Puerto Rico, the Dominican Republic, and Paraguay. This inverse choice was dictated by the fact that before the 1970s, the art of these countries offered no new paradigms and, in some cases, followed the Mexican model. A significant portion of this book is devoted to this earlier period in order to establish the setting for some of the movements and artists that followed.

Because of its long history of colonization by the Spaniards, British, French, and North Americans and its proximity to the United States, Latin America has remained a volatile subject and its art has not benefited from the type of unbiased treatment other areas have received. For one, it has been subjected to the vicissitudes of fashions and political as well as economic factors outside Latin America, rather than to a serious dedication to its history. Second, writings on Latin American art have tended either to favor romantic perceptions of what it should be or to uphold an image of Latin America as a victim of oppression and predatory powers. While both views have some validity, in themselves they are exclusionary, leaving out a whole range of art forms that do not conform to them. The temptation—for outsiders especially—to invent Latin America, rather than to look at what is actually there, is always great.

For this reason I have attempted to be as straightforward as possible about presenting this subject and considering the major contacts between Latin America, Europe, and the United States—contacts that have too often been downplayed for

fear of making Latin American art seem derivative of other art. But this fear is unjustified. It is no more derivative than the art of other areas in the Western world. But far from being merely a factual exposé of the art itself, this study also addresses questions of cultural and social context and takes into account some of the revisionist positions in recent literature because of the insights they contribute.

I have basically followed a stylistic system of classification for the period prior to 1970. But this system breaks down after that time as art increasingly crossed stylistic boundaries. Therefore, the later period is treated primarily in terms of theme and medium. Each period is first identified by the patterns common to several artists, then developed in terms of individual artists. In cases where a single artist established a new direction with widespread ramifications, more space is devoted, such as the case of the Uruguayan Joaquín Torres-García, who is the subject of a whole chapter.

The material presented here is based on research conducted over a period of some forty years. It includes a study of writings and statements by Latin American critics, historians, and artists who have furnished valuable keys to the interpretation of their works or ideas. It is also indebted to the scholarly work of a few pioneering individuals, in and outside Latin America, who have contributed greatly to this field over the years.[2]

Intellectual currents, as well as social and historical events contemporary with the art, serve as a framework throughout most of this book. For instance, José Vasconcelos left his mark on the early phase of the Mexican mural program, and José Carlos Mariátegui left his on a generation of Peruvian artists in the 1930s. The art-critical community in individual countries has, to a great extent, affected the direction of each country's art. Before World War II, writers tended to situate their country's art

within a national discourse. This practice still exists in some countries. It is also common for novelists and poets, rather than art critics, to write about art, and they often provide literary equivalents rather than critical or art-historical analyses of the art. After the war, the need to accommodate new forms of art, especially abstraction, led a handful of influential critics—such as the Argentines Marta Traba and Jorge Romero Brest; the Brazilians Ronaldo Brito, Ferreira Gullar, and Aracy Amaral; and scores of others—to embrace new critical approaches to art based on a blend of social history, French art-critical methods, and, more rarely, formalist criticism. But the latter—a system generated in the United States by critics such as Clement Greenberg—proved inappropriate. Its exclusion of content (as irrelevant) from a reading of the art poses a problem, since content was rarely absent from Latin American art and was usually integral to its meaning, no matter how abstract. However, with the displacement in the 1970s of formalist criticism in the United States by postmodern and feminist debates, both of which opened the way for more flexible and inclusive systems of critical inquiry, content was back in favor. As indicated by the numerous exhibitions of modern Latin American art that took place in the United States, England, and other Western countries after 1980, a broader public was now better prepared to appreciate it.[3]

The recent art of Latin America has come to be relatively well known, but that of the earlier period is less so, and a considerable portion of this book is devoted to the latter. This study covers the major movements, groups, and artists in Mexico, Cuba, Haiti, and most of South America, including Brazil, from the turn of the twentieth century to the 1980s and begins with an overview of the nineteenth century. In the following chapters, each country is discussed in terms of its most significant and influential contributions and the conditions that fostered them.

The material is divided into two parts: before and after World War II. The first

period ends with social and *indigenista* art,[4] surrealism, and the utopian idealism of Torres-García's constructive universalism. The second begins with the spread of abstraction and the resulting need for artists to redefine their cultural identities within the new modes. The two sections are further subdivided chronologically by decade or, in the case of the 1930s and 1940s, by two decades. This method has made it possible to identify corresponding historical events and ideological currents that affected artists at given times and places, and has also helped to dispel stereotypes based solely on thematic tendencies.

The use of specific terminology like *indigenismo* and *modernismo* is explained within the appropriate chapters. However, some amplification is useful here for terms such as *modernism* and *contemporary.* Earlier in the twentieth century, *modernism* referred to the art of the impressionists through that of the cubists, futurists, and expressionists. In recent years it has come to include most nonrepresentational art up to the late 1960s. Here I use it specifically to refer to avant-garde art of the 1920s (Brazilians defined their avant-garde movement as *modernista*). When I use *modernism* in its broader sense to include art through the 1960s, I specify so. In order to avoid confusion between *modernism* as avant-garde and *modernismo* as the equivalent of symbolism as well as the name of the literary movement led by the Nicaraguan poet Rubén Darío and of a widespread form of painting in Latin America based on Spanish models, I use the Spanish term for the earlier art (which included symbolism, art nouveau, impressionism, and postimpressionism) and the English one for the avant-garde styles of the 1920s.[5] The term *contemporary* here is not synonymous with *modernism.* It refers to art or an event occurring contemporaneously with something else. It is used to designate an occurrence simultaneous with the art under consideration, or to refer to an ever-fugitive present.

The system I present here is by no means the only possible model for structuring nine decades of Latin American art, but it is the one that has worked best for me in the classroom. With that challenge in mind, I have designed this book to be accessible to a general educated public as well; it presupposes no special knowledge of art history or its terminology on the part of the reader.

The initial idea for this project began in the early 1960s in New York City, where I was living at the time. There I met numerous artists from Latin American countries, especially Argentines. Thus I was introduced to this big subject not by way of Mexico, as is more often the case, but by way of Argentina. On my first trip to Buenos Aires in 1962, I found a dynamic world of art and art critics. Among the latter was Rafael Squirru, founder and director of the Museo de Arte Moderno, whose ingenuous enthusiasm was contagious and did a lot to inspire me to look further. By the time I was reviewing for *Arts Magazine* in the mid-1960s, I had decided to devote my efforts to modern Latin American art in general.

Between my first trip to Mexico in 1969 and the early 1990s, I traveled to South America and Mexico on numerous occasions. My initial research trips through South America took place in 1973 and 1974. I am grateful to the Samuel H. Kress Foundation for providing funds to make the first trip possible. A second Kress Fellowship in 1980 allowed me to spend three months in Argentina and Uruguay to do research on the Argentine avant-garde of the 1920s. I am grateful to the Louccheim Stol Foundation for a stipend in 1978 that made it possible for me to devote my summer to research. My thanks also go to the Mellon Foundation for summer grants in 1987 and 1992, and to the University of Texas for several University Research Institute grants received since 1987. One of these, for the 1989–1990 academic year, made it possible for me to take a leave of absence from teaching. I am also grateful for a Foxworth Fellowship, received the same year, which enabled me to travel to Paris for a month to interview Paris-based Latin American artists and to study the archives of the Maison de l'Amérique Latine and issues of the *Revue de l'Amérique Latine* for information on the 1920s.

Over the years, many individuals have given me moral support and valuable suggestions for this project in ways they may not be aware of. Among them are my colleagues Terence Grieder, for whom nothing is impossible, and Naomi Lindstrom, whose interests in Latin American literature parallel mine in art. Numerous individuals in South American and Mexican museums and art galleries have been generous with their help over the years. These include Natalio Povarché, Enrique Scheinsohn, Ruth Benzacar, Axel Stein, Tahia Rivero Ponte, Ivanova Decán, Justo Camilo Sierra, Galería Garcés Velásquez, and a new generation of individuals too numerous to mention. In New York, I was able to spend many hours in the library of the Museum of Modern Art at a time when I could benefit from the expertise of James Findlay, Latin American art librarian, who contributed greatly to supplementing the museum's library holdings in significant ways.

I am indebted to several generous people who allowed me to stay in their homes or helped me in innumerable other ways during my stays in their country: Ana Mercedes Hoyos in Bogotá, Jorge and Marietta Korgi in Cali, Patricia Dinsmore, among others, in Buenos Aires. Santiago and Juan Cárdenas were generous with their time in Bogotá, as was Miguel González in Cali at different times. The many artists whom I have known personally over the years have been generous with their time and the information they have shared with me. Among critics and art historians, my meetings with Raquel Tibol and Teresa del Conde in Mexico, Aracy Amaral in São Paulo and New York, and the late Marta Traba—whose writings are invaluable sources of information—in Colombia and the United States were also personally illuminating. I have benefited also through my personal associations with Stanton Catlin, Damián Bayón, and Leopoldo Castedo.

I have received considerable assistance from a younger generation of scholars, especially Justo Pastor Mellado, Pedro Querejazú, Paulo Herkenhoff, María José Herrera, Trinidad Pérez, Natalia Majluf,

Florencia Bazzano Nelson, Nancy Deffebach, and Marguerite Mayhall, all of whom have gone out of their way to help find sources for illustrations; and Maricela Kauffmann, Christina Harrison, and Rachel Pooley, whose resourcefulness helped with some of the more tedious tasks for this book. The staff of the Jack S. Blanton Museum of Art (formerly the Archer M. Huntington Art Gallery) at the University of Texas have been generous in making available the museum's human and bibliographic resources. The museum's curator of Latin American art, Mari Carmen Ramírez, has been most willing to exchange information, books, and catalogs. I owe some of the photographs in this book to the museum's former staff photographer, George Holmes, and the museum's director, Jessie Otto Hite, who endorsed my use of George's services and the museum's resources. For some of the photographs, I also owe thanks to Ron Jameson of the University of Texas photographic staff. Many collectors and artists too numerous to name have also generously contributed to this project by providing me with illustrations of works.

I also wish to thank the initial readers of my manuscript for their helpful suggestions, Ramón Favela for his encouragement and support of my ideas, and Ronald Christ for his painstaking reading of my draft manuscript plus many helpful comments and editorial suggestions. Finally, I am extremely grateful to Nancy Warrington for her patient editing and to Mandy Woods, Carolyn Cates Wylie, and Ellen McKie for their invaluable assistance in pulling it all together, Nancy Bryan, Neva Smith, and Peter Morris for their part, and of course Theresa May.

TWENTIETH-CENTURY

ART OF LATIN AMERICA

The twentieth-century art of Latin America is art in the Western tradition. Its history is inseparable from the rest of the Western world's, and artists have responded to this condition as active participants. Latin America shares with other Western countries the contrasts between industrialized urban centers, where the wealth is concentrated, and rural areas, where poverty and regional folk customs coexist. But the disjunctions between these two poles are far more extreme in Latin America, where vast populations have remained marginalized from the urban mainstream and from the national economy to a far greater extent than in other areas of the Western world. Underprivileged groups defined as minorities in the United States constitute the vast majority in Latin America. An awareness of these conditions has preoccupied artists for most of the twentieth century, and although this preoccupation is not always obvious, many artists have expressed their concerns in various ways through their art.

That the Hispano-American countries differ from Portuguese-speaking Brazil or from French-speaking Haiti is a given. But the Spanish-speaking countries themselves are unified only by their language. Consequently, any attempt to find common characteristics among artists from these different countries is as futile as trying to find them in the art of artists from European countries. Yet one naturally looks for something unique that distinguishes this art as a whole from the art of other places. Differences do exist, not as a single continental identity but as a mosaic of distinct identities. These identities have been shaped by two main factors: the visual sources artists have come into contact with and the specific local circumstances that affect the artist's vision and perception of the world outside. Geography alone plays a part. Because of their location in the Northern Hemisphere, Mexico and the Caribbean countries are nearer the major North American and European art centers, which has resulted in more direct contact

with these other centers over the years. But unless there is considerable exchange and travel, as there was in the 1960s, some parts of South America remain physically quite isolated. This fact affects an artist's perception of the world, and it impelled Joaquín Torres-García to reverse the map of the Western Hemisphere in one of his drawings so that the tip of South America is at the top.

With the introduction into Latin America of European avant-garde styles like postimpressionism, cubism, and German expressionism, which displaced nineteenth-century academicism and documentary art, new issues of artistic identity began to surface. Although some artists incorporated these new avant-garde modes into their work as welcome alternatives to the academy and as statements about urban progress and modernity, they also sought ways to translate the new modes into something locally relevant that would affirm this identity by incorporating allusions to their own cultures into their work. Ultimately it is within the context of the new modes, whether from a nationalistic or cosmopolitan perspective, that artists redefined their cultural identities in the 1920s. During that decade, writers and artists established the directions that furnished frames of reference and a language for later art and literature, particularly in Mexico, Brazil, Argentina, Chile, and—in literature—Cuba. The direction taken by artists in the first half of the twentieth century had strong roots in the nineteenth-century history of their countries as emerging republics.

The postindependence years after the 1820s primarily set the pattern.[1] Neoclassicism replaced eighteenth-century colonial baroque in painting, sculpture, and architecture in most Latin American countries. European artists traveled to Latin America, and Latin American artists, to Europe. But only Mexico and Brazil had academies by the early nineteenth century, Mexico since 1785 and Brazil since 1826. Argentina had to wait until the turn of the twentieth century to

INTRODUCTION

AND AN

OVERVIEW

OF THE

NINETEENTH

CENTURY

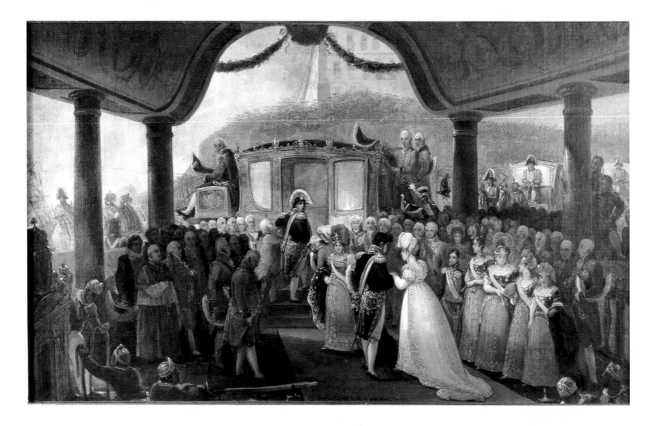

have one and Peru until 1919. The San Carlos Academy in Mexico City (1785), the first to be founded in the Western Hemisphere, was almost forty years old by the time Mexico gained its independence. In the 1790s, the Spanish artists Manuel Tolsá, a sculptor, and Rafael Jimeno y Planes, a painter, went to Mexico to run the academy. Thus, Spanish culture remained a strong, and not always welcome, presence in Mexico before the Mexican Revolution of 1910.

In Brazil, Dom João VI, the first Portuguese monarch to settle in Rio as an exile from the 1808 Napoleonic invasion of Portugal, invited the French Lebreton Artistic Mission to come in 1816 to establish the Royal Academy in Rio and to teach there. The mission, headed by Joaquin Lebreton, included, among others, the painters Jean Baptiste Debret and Nicolas Antoine Taunay, as well as the architect Auguste Henri Victor Grandjean de Montigny. The Brazilian monarchs were enthusiastic patrons of the arts, and French culture continued to play a strong part in the art of the first decades of the twentieth century in Brazil.

Artists from countries without official academies trained either in Europe or in the studios of French and Italian artists living in Latin American countries, as was the case in Argentina. Some of these artists took up genre (*costumbrismo*) to record local customs instead of painting mythological or historical scenes typical of the academies. But in many countries no significant public existed for anything other than commissioned portraits. Until the early twentieth century, collectors continued to look to Europe for their art, and artists from Latin America often exhibited in Paris before they did at home.

Throughout the nineteenth century, artists celebrated the new republics with independence themes, documentary paintings, genre, landscape, and panoramic views of battles. The academic style furnished a suitable means for artists to represent historical episodes and the heroes who fought for the new republics. But the popularity of neoclassicism all over Latin America had more to do with its identity with the French Revolution and Napoleon, through

Jacques Louis David's paintings of these subjects, than with the academy. As a replacement for Spanish baroque, artists in Latin America found in neoclassicism a desirable model for depicting their own revolutions of 1810 to 1821.

Between 1821 and 1835, historical episodes of Latin American independence were common, especially in Mexico, Brazil, and, to a lesser degree, Venezuela. The *Solemn and Peaceful Entrance of the Trigarantine Army* (into Mexico, 1823), by an anonymous Mexican painter, commemorated the victorious entrance of the soon-to-be-crowned emperor Agustín de Iturbide, even though his rule did not last long. Although Brazil remained under a monarchy until 1889, its ruling monarch, Dom Pedro I, had declared Brazil's independence from Portugal in 1822 in a bloodless coup. Debret's *Desembarque da princesa real Leopoldina [Landing of Dona Leopoldina]* (1816) represents the ceremonious arrival in Rio of the consort of Dom Pedro I (FIG. o.1). In Venezuela, Juan Lovera painted two works in 1835 commemorating an uprising, a council meeting, and the signing of documents proclaiming Venezuelan independence in 1810 and 1811. Although this type of painting developed independently in different countries, it shared similar characteristics everywhere—the horizontal alignment of figures against an architectural background of arched portals—with David's neoclassical paintings, especially the *Coronation of Josephine* (sometimes known as the *Consecration of Napoleon,* 1806).

In countries without academies, independence themes sometimes revealed a popular strain or some carryover from colonial painting. An anonymous Colombian painting, *Policarpa Salavarrieta al patíbulo [La Pola Goes to the Gallows]* (1823), shows the heroine Policarpa Salavarrieta being led to her death by a military official and a priest (FIG. o.2). The Peruvian José Gil de Castro (El Mulato Gil) painted a prodigious number of portraits of heroes of independence,

including the liberators Simón Bolívar and General José de San Martín in Napoleonic poses. Gil de Castro's minute handling of the gold braiding of their uniforms (he had been a uniform designer for the Peruvian military forces in the wars of independence) recalls the detailed work on brocades typical of the colonial schools of Cuzco where he may have trained.

Portraiture remained the most lucrative art form throughout the nineteenth century. Carlos Pellegrini, a French engineer and painter who settled in Buenos Aires in 1828, painted some eight hundred watercolor portraits in a seven-year span as well as scenes of local dances. His portraits included a drawing of the tyrant Juan Manuel Rosas, a rancher and owner of a meatpacking company. Rosas ruled the nation with an iron hand from 1828 to 1852. At the time, Argentina was politically divided between the *unitarios,* or "Blues," who favored Buenos Aires as the center of government, and the *federalistas,* or "Reds," who favored a federation with equal power given to the country at large, including its population of illiterate gauchos.[2] Rosas was a *federalista,* and during his administration, gauchos were popularized in painting invariably wearing some red article of clothing to show their allegiance to Rosas's party. Carlos Morel, an Argentine, and Raymond

FIGURE o.2

Anonymous, *Policarpa Salavarrieta al patíbulo [La Pola Goes to the Gallows],* 1823, oil on wood panel, 76.25 × 95.25 cm. / 30 × 37½ in. Courtesy Museo Nacional de Colombia, Bogotá.

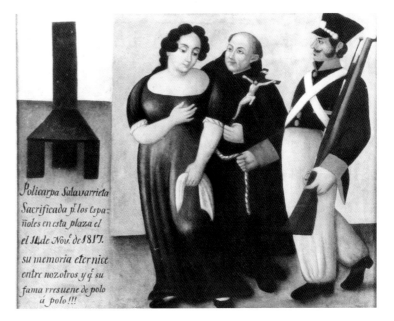

Quinsac Monvoisin, a Frenchman, both painted gauchos in the 1830s and 1840s.

After Rosas's downfall, artists continued to depict these heroes of the Argentine and Uruguayan pampa, but now as symbols of a new-found freedom. The second half of the century marked a time of relative peace and prosperity in those two countries, and the gaucho was often shown standing heroically and fearlessly against an open sky, as in the paintings of the Brazilian-born Juan León Pallière (such as *Gaucho pialando [Gaucho Lassoing on Foot]*, c. 1860; FIG. 0.3) and the Uruguayan Juan Manuel Blanes. José

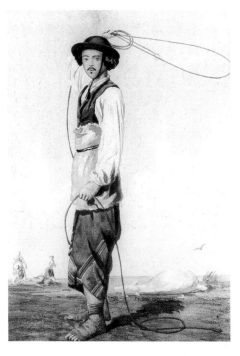

FIGURE 0.3
Juan León Pallière, *Gaucho pialando [Gaucho Lassoing on Foot]*, c. 1860, watercolor on paper, 34 × 24.5 cm. / 13⅜ × 9⅝ in. Courtesy Fondo Nacional de las Artes, Buenos Aires. Photo: Mosquera.

FIGURE 0.4
Prilidiano Pueyrredón, *Un alto en el campo [Rest in the Country]*, 1861, oil on canvas, 75.5 × 166.5 cm. / 29¾ × 65½ in. Courtesy Fondo Nacional de las Artes, Buenos Aires. Photo: Mosquera.

Hernández provided the literary equivalent of these paintings with his epic poem *Martín Fierro* of the 1870s based on popular gaucho ballads. The gauchos in the paintings of the Argentine Prilidiano Pueyrredón were more domesticated. As a well-to-do landowner, Pueyrredón painted his own farmhands shown at their daily tasks in a serene landscape or departing for the city, as in *Un alto en el campo [Rest in the Country]* (originally titled *La paz en el rancho [Peace on the Ranch]*, 1861; FIG. 0.4).

During the first half of the nineteenth century, many foreign artists and explorers from France, Italy, England, Germany, and the United States traveled to Latin America. Explorers recorded the landscape, archaeology, flora, and fauna, and artists were drawn to the romance of the New World's customs and awesome landscape. Alexander von Humboldt, a painter as well as a naturalist, did landscapes in Ecuador. Frederic Edwin Church based some of his most extraordinary sunset and volcano paintings on sketches he made during his visits to Ecuador. The Bavarian Johann Moritz Rugendas traveled extensively in Latin America, spending some twelve years in Chile. Besides scenes of Chilean country life and portraits, he painted urban and rural scenes in Brazil, Mexico, Peru, and Argentina. His paintings included awe-inspiring, wind-swept volcanic craters

and dangerous Andean mountain passes as records of his own adventurous travels.

Another adventurous artist, Frederick Catherwood, an English painter, traveled through the Yucatán and Central America with his friend John L. Stephens. Catherwood's drawings and watercolors of Maya archaeological sites were subsequently published in the 1840s in *Incidents of Travel in the Yucatan,* a book on which he and Stephens collaborated (FIG. 0.5). Artists' books recording local customs, types, and scenes from different locations were common among traveling as well as local artists in the first half of the nineteenth century. Debret, Rugendas, Pallière, and Morel, among others, had all published such books in Europe and Argentina.

From the midcentury on, landscape painting became a major form of expression among local and foreign artists. The Danish artist Fritz Melbye and Camille Pissarro (better known as a French impressionist) from the Danish protectorate island of St. Thomas in the West Indies spent three years together in Venezuela producing light-drenched drawings and paintings of the landscape and of local customs around Caracas and the nearby Caribbean coast. The tropical luminosity in Pissarro's and Melbye's landscapes anticipated Armando Reverón's predominantly white coastal landscapes of the 1920s and 1930s. The fugitive effects of natural phenomena such as wind and changing light were later explored in another way by Venezuela's kinetic artists, especially Jesús Rafael Soto and Alejandro Otero.

Landscape painting in Mexico can be traced to the 1830s romantic views of the Mexican countryside by the English artist John Egerton as well as by Rugendas. Panoramic views of the Valley of Mexico were later taken up by the Mexican José María Velasco, a contemporary of Paul Cézanne. From the 1860s to his death in 1912, Velasco translated the landscapes of the Roman *campagna* by his Italian teacher Eugenio Landesio into a Mexican idiom. In his numerous breathtaking

vistas of the Mexican valley, Velasco recorded the history of Mexico from its timeless volcanic topography, visible in the background, and its flora to the city in the middle distance with modern smoking factory stacks and colonial churches (*El valle de México desde el cerro de Tepeyac [The Valley of Mexico from the Hill of Tepeyac],* 1905; FIG. 0.6).[3]

In the second half of the nineteenth century, national heroes and battles became the subjects of action-packed historical paintings in several countries but especially in Argentina, Brazil, Mexico, Uruguay, and Venezuela. For instance, Blanes painted not only gauchos; he was commissioned by his government to paint mural-sized oils of Uruguayan history. One of these, *Los treinta y tres orientales [The Thirty-three*

FIGURE 0.5

Frederick Catherwood, *Views of Ancient Monuments of Central America, Chiapas, Yucatan (Well at Bolonchén),* 1843, chromo lithograph, 37 × 25.5 cm. / 14½ × 10 in. Courtesy Yale University Art Gallery, Gift of Henry Schnackenberg. Photo: Regina Monfort.

FIGURE 0.6
José María Velasco, *El valle de México desde el cerro de Tepeyac [The Valley of Mexico from the Hill of Tepeyac]*, 1905, oil on canvas, 74.5 × 105 cm. / 29⅓ × 41⅜ in. Courtesy Instituto Nacional de Bellas Artes y Literatura and the Museo Nacional de Arte, Mexico City. Photo: Crispin Vázquez, courtesy Jack S. Blanton Museum of Art (formerly the Archer M. Huntington Art Gallery), The University of Texas at Austin. Reproduction authorized by the Instituto Nacional de Bellas Artes y Literatura, Mexico City.

Orientals] (1870s), represents an oath taken by thirty-three patriots who helped found the Uruguayan republic in 1830 (Uruguayans were referred to as *orientales* because Uruguay was east of Argentina). The Venezuelans Martín Tovar y Tovar and Arturo Michelena both painted episodes of their country's history. In the 1880s, Tovar y Tovar did a series of panels for the domed ceiling of the Salón Elíptico in the Capitolio, Caracas's municipal building, representing the Battle of Carabobo, one of Venezuela's independence campaigns. For this assignment, he relied on drawings of the location where the battles had taken place. Michelena painted *Miranda en la carraca [Miranda in Jail]* (1896), a large canvas representing the early Venezuelan independence hero who was jailed and later sent off to Spain to die by his rival Simón Bolívar (FIG. 0.7). Nearly a century later, in the 1980s, the Venezuelan painter Carlos Zerpa appropriated Michelena's painting of Miranda in a large work commemorating the history of modern Western painting.

Indians were the subjects of popular as well as mainstream art. They were represented in a romanticized form of history painting as noble savages, often naked. The Indian as subject in Mexico goes back to *casta* (cast) paintings in which Indians and blacks were depicted in a type of visual census. Beginning in the eighteenth century, local parishes commissioned artists to record mixed-race unions and the resulting offspring in small *casta* paintings; the figures usually appeared in household settings with their children, each identified by their specific ethnic category. The child of a Spaniard and an Indian woman is a mestizo, of a Spaniard and a black woman (rarely the reverse), a mulatto. In turn, the offspring of the second generation of mixed breeds led to a further breakdown of ethnic classification. Although the original function of this custom ended in the nineteenth century, artists continued to paint such interracial family groups as a form of popular painting.

Indians were also the subjects of mainstream academic painting, especially in Mexico, where they were represented with classical European features as heroes or as the stoic victims of Spaniards. In José Obregón's *El descubrimiento del pulque* [*The Discovery of Pulque*] (1869; FIG. 0.8),

a young, light-skinned Indian woman presents the pulque (a national drink made from the maguey cactus) to the Indian ruler seated on a very neoclassical throne with pre-Hispanic motifs. In Leandro Izaguirre's painting *El suplicio de Cuauhtémoc* [*The Torture of Cuauhtémoc*]

FIGURE 0.7

Arturo Michelena, *Miranda en la carraca* [*Miranda in Jail*], 1896, oil on canvas, 196.25 × 245.75 cm. / 77¼ × 96¾ in. Reubicación Museo de Bellas Artes, Caracas. Courtesy Fundación Galería de Arte Nacional. Photo: Centro de Información y Documentación Nacional de las Artes Plásticas (CINAP).

FIGURE 0.8

José Obregón, *El descubrimiento del pulque* [*The Discovery of Pulque*], 1869, oil on canvas, 189 × 230 cm. / 74⅜ × 90½ in. Courtesy of the Consejo Nacional para la Cultura y las Artes, Instituto Nacional de Bellas Artes y Literatura and the Museo Nacional de Arte, Mexico City. Photo: Archivo Fotográfico IIE/ UNAM, Mexico City.

(1892), the last Aztec ruler, Cuauhtémoc, suffers torture by fire under the Spanish Inquisition for having defied and resisted the conquerors, unlike his more credulous predecessor, Moctezuma, who mistook Hernán Cortés for the god Quetzalcoatl returned according to prophesy. The mural painter David Alfaro Siqueiros later chose Cuauhtémoc as his favorite hero symbolizing the rebirth of the Mexican race out of the ashes of the conquest.

Representations of Indians took on distinct characteristics in different countries. In *Indio de la Cordillera [Inhabitant of the Cordillera]* (1855; FIG. 0.9), the Peruvian painter Francisco Laso represented an Indian as a single figure with idealized European features dressed in black and holding a Mochica portrait jar. The pre-Hispanic Mochica people had lived on the northern Peruvian coast and were known for their ceramic vessels shaped as portraits of rulers. This type of frontal representation of a single Indian man or woman persisted in Peru well into the twentieth century in the work of Camilo Blas and José Sabogal. In a different vein, the Brazilian Rodolfo Amoedo painted *Marabá* (as half-breeds of Indian and European origin were known; 1886; FIG. 0.10) as a naked young woman seated on the ground against a dark background of trees in a sort of equation between the natural landscape and the figure's primeval earthiness. Amoedo had trained at the Royal Academy in Rio, then moved to Paris, where he first exhibited *Marabá* (nudes were not considered acceptable in Latin America until well into the twentieth century).

Mexico's long tradition of popular art ranged from the semiacademic style of the *poblano* (from Puebla) artist José

FIGURE 0.9
Francisco Laso, *Indio de la Cordillera [Inhabitant of the Cordillera]*, 1855, oil on canvas, 135 × 86 cm. / 53¼ × 33⅞ in. Municipalidad de Lima, Lima. Photo: Daniel Giannoni.

FIGURE 0.10
Rodolfo Amoedo, *Marabá*, 1886, oil on canvas, 120.75 × 171.5 cm. / 47½ × 67½ in. Courtesy Museu Nacional de Belas Artes, Rio de Janeiro. Photo by Raul Lima.

Agustín Arrieta, to the naïve portrait style of Hermenegildo Bustos, José María Estrada, and numerous others, to the small anonymous paintings on tin known as ex-votos. The latter were designed as offerings to thank a saint, Christ, or the Virgin for some miraculous cure or salvation from disaster. Later, these nineteenth-century votive paintings became important creative sources for Frida Kahlo, who owned some. Arrieta, a student of the Puebla Academy, blended a slightly stilted photographic style with the baroque lighting of Dutch and Spanish seventeenth-century still-life painting. He rendered the textures of pots, glass jars, and fruits with loving care in his own tempting still lifes. He also painted market scenes and popular types socializing in *pulquerías* (saloons specializing in pulque).

Popular modes of expression in late-nineteenth-century Mexico included caricature and prints. Known for his humorous *calaveras* (skulls and skeletons), José Guadalupe Posada was one of many printmakers to illustrate news events for the penny newspapers sold on street corners in Mexico City. During his years in Antonio Vanegas Arroyo's printing shop in Mexico City, where he worked from the 1890s until his death in 1913, he satirized political and sensational events in the manner of today's tabloids. As witness to the early years of the Mexican Revolution, he created the first representations by an artist of the agrarian leader Emiliano Zapata based on a photograph (*Pormenores del entierro de Emiliano Zapata [Details of the Burial of Emiliano Zapata];* FIG. 0.11).[4] Later, his prints of Zapata were models for Diego Rivera's and José Clemente Orozco's paintings of this revolutionary figure.

For artists whose careers straddled both centuries, a question of classification arises as to which century they should belong. Artists classified here as twentieth-century artists are near contemporaries of some who are accepted as nineteenth-century artists. The Argentine painters Reinaldo Giudici, Carlos Sivori,

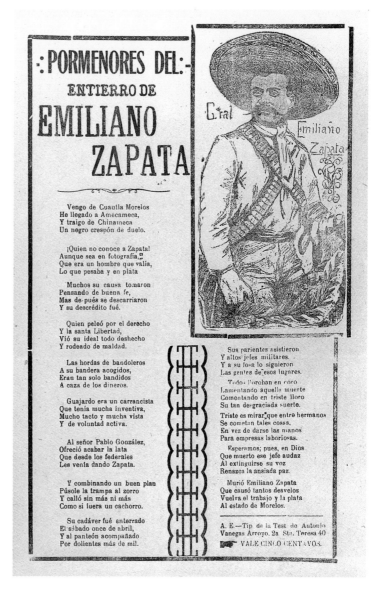

and Ernesto De la Cárcova, who died respectively in 1921, 1918, and 1927, are nevertheless considered nineteenth-century artists. Although the Mexicans Julio Ruelas and Saturnino Herrán died before them—Ruelas in 1907, Herrán in 1918—the latter are treated as twentieth-century artists because their styles no longer fitted the patterns of the nineteenth. Sivori's representation of the nude in *Le lever de la bonne [The Arising of the Maid],* shown in the Paris Salon of 1887, was in the realist style of Gustave Courbet and has the same buxom shapeliness as Amoedo's *Marabá* (1886). Both Giudici and De la Cárcova painted scenes of the working classes that showed more kinship with nineteenth-century

FIGURE 0.11

José Guadalupe Posada, *Pormenores del entierro de Emiliano Zapata [Details of the Burial of Emiliano Zapata],* **1910–1913, zinc etching broadside, reprinted in 1919 from a Posada plate. 29.5 × 19.7 cm. / 11⅝ × 7¾ in. Courtesy Art Collection Harry Ransom Humanities Research Center, The University of Texas at Austin.**

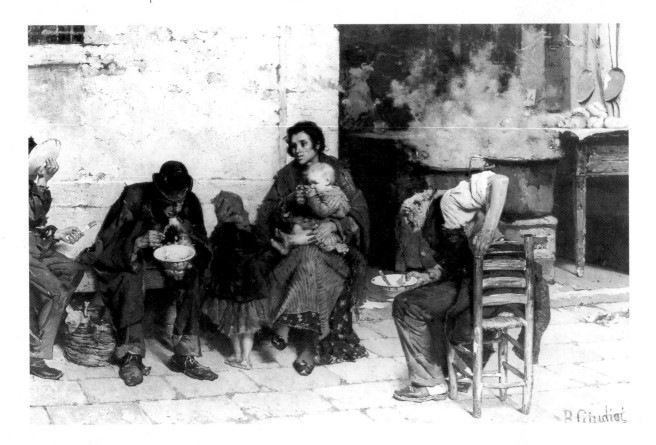

FIGURE O.I2

Reinaldo Giudici, *La sopa de los pobres [The Soup of the Poor]*, 1884, oil on canvas, 174 × 228 cm. / 68½ × 89¾ in. Courtesy Museo Nacional de Bellas Artes, Buenos Aires. Photo: Mosquera.

romantic representations of poverty, illness, and death than with twentieth-century social realism. Even though Giudici's *La sopa de los pobres [The Soup of the Poor]* (FIG. O.I2), which was awarded a prize in Berlin in 1884, anticipates the early-twentieth-century style related to Spanish painters like Joaquín Sorolla, Joaquín Mir, Santiago Rusiñol, and Hermenegildo Anglada-Camarasa, it nonetheless retains the romantic character and distancing of nineteenth-century painting. De la Cárcova's painting *Sin pan y sin trabajo [Without Bread and Without Work]* (1896), showing an unemployed worker seated at a barren kitchen table with his wife and baby as he looks out a window to a distant factory, reflects the economic problems and plight of the workers in Argentina in the 1890s and has remained a staple of late-nineteenth-century Argentine painting, just as Michelena's *Miranda* has of Venezuelan painting.

The choice of which artists to include in the twentieth century is not always clear-cut. In Europe, symbolism and impressionism belong to the nineteenth century, whereas in Latin America, they are a part of a twentieth-century revolution against the academy known as *modernismo*. A few artists such as the Brazilian Eliceu Visconti (1867–1944) belong as much to the twentieth century as to the nineteenth. Visconti spanned a range of modes from symbolism to art nouveau design to impressionism. But, as stated earlier, some hard choices had to be made for the sake of intelligibility. Thus, although Visconti is mentioned, it is only briefly. The artists included in the twentieth-century section not only represent some of the new modes and movements, they established directions in their art that were unequivocally innovative.

PART 1

By the turn of the twentieth century, many artists in Latin America had rejected academic art and embraced bolder forms of expression that synthesized elements of symbolism, art nouveau, impressionism, and postimpressionism. Most prevalent among the new tendencies was *modernismo,* a name borrowed from literature to define a type of art that was widely practiced in Hispano-America (excluding Brazil) in the first three decades of the century. A blend of symbolist and postimpressionist tendencies, *modernismo* was kin to turn-of-the-century Spanish painting like that of Hermenegildo Anglada-Camarasa, Joaquín Mir, Isidro Nonell, Joaquín Sorolla, and Ignacio Zuloaga, among others. Originally, *modernismo* referred to the literary movement initiated by the Nicaraguan poet Rubén Darío that had its artistic equivalent in symbolism. In Brazil, where the French rather than the Spanish influence had prevailed throughout the nineteenth and early twentieth centuries, European terminology like *impressionism, art nouveau,* and *symbolism* remained in use when parallel phenomena developed in art. The term *impressionism* was also commonly used in Spanish-American countries to describe paintings in which light and loose brushwork played central roles.

Modernismo did not develop in a vacuum. It corresponded to a time of rapid urban growth. In Mexico City, São Paulo, and Buenos Aires, newly built national theaters designed by Italian architects became the centers of heightened cultural activity. In Mexico City, construction of the Teatro Nacional (now the Palacio Nacional de Bellas Artes), designed by Adamo Boari, was begun in 1904 under the government of Porfirio Díaz.[2] In Buenos Aires, the development of the elegant Avenida de Mayo and the construction of the Teatro Colón, designed by Victor Meano and Francisco Tamburini and inaugurated in 1908, helped make Buenos Aires a fashionable and international cultural center in the Southern Cone. In São Paulo, the Teatro

Modernismo AND
THE BREAK WITH
ACADEMIC ART,
1890–1934[1]

ONE

Municipal, designed by Domiziano Rossi and inaugurated in 1913, was to become infamous in the 1920s for its daring avant-garde performances, poetry readings, and art exhibitions.

The identification of *modernismo* in art with Rubén Darío's Hispano-American literary movement had a historical and philosophical basis. Darío, who had lectured in Central America, South America, and Spain and had spent several years in Argentina, felt frustrated by the "restrictions of a language which as yet had no names for his experiences" as a Latin American. At issue was American Spanish versus Castilian. As a solution, he advocated an injection of French and Italian sources into the Spanish language to pump fresh blood into Latin American literature, thus diluting the Spanish influence and making it more cosmopolitan.[3] He advocated a synthesis of these literary sources to meet the modern needs of Latin Americans within their own frame of reference.

The new art was the visual equivalent of Darío's literary movement. One of *modernismo*'s contributions to painting was to make artists aware of their need for an art that expressed their own culture and experiences as Latin Americans. They began to take a closer look at their own daily lives, the things that surrounded them, the local people, landscapes, and contemporary life, in more personal and subjective ways than the previous generation had. They examined their immediate surroundings at close range instead of from a distance. They became the painters of modern life, not as viewed through European academic eyes but through the lens of their own lived experience. In paintings of landscapes or figure compositions, this experience also led to a radically different treatment of pictorial space within a continuing naturalistic idiom. Artists eliminated deep space and brought the background close to the surface of the canvas, so the subjects seemed to challenge viewers, sometimes through daring eye contact.

In Mexico and Peru, Spain had remained a strong cultural force through the nineteenth century. By the turn of the twentieth, this kinship with Spain was strengthened, as it was in other countries, by the apparent need to create a foil against U.S. incursions.[4] Spanish painting was seen in numerous exhibitions from the turn of the century on; however, it was not unequivocally well received. In 1910, when Mexican President Porfirio Díaz sponsored a centennial exhibition to commemorate the anniversary of Mexican independence from Spain—which, ironically, was shown in a centrally located building constructed especially for the purpose in Mexico City and featured work by the Spaniards Zuloaga, Sorolla, Eduardo Chicharro, Ramón Casas, Darío de Regoyos, Anglada-Camarasa, and Julio Romero de Torres, among others—some Mexican artists objected. A few days after the opening of the exhibition, the much angered painter Gerardo Murillo (better known by his pseudonym "Dr. Atl," meaning "water" in Nahuatl) hastily put together a smaller counterexhibition of work by contemporary Mexicans at the San Carlos Academy.[5] Centennial exhibitions of Spanish art elsewhere were received with less controversy. In Buenos Aires, the centennial was given special prominence in a glass-and-iron building that had been brought over piece by piece from Paris, where it had served as the Argentine pavilion in the 1889 Universal Exposition. In Santiago (Chile), it was commemorated in an international exhibition of fine and industrial art objects and designs that included Chilean artists as well as Spaniards.[6]

Although artists adopted some of the recent European models in art, the unorthodoxies present in the art of Latin America have never been fully explained except as chronological disjunctions. One explanation could be that Latin American artists who went abroad saw several styles or types of art all at once rather than as they had developed sequentially over a period of several decades in Europe. As a result, they often synthesized

these multiple styles in their work rather than follow the specific characteristics of a single style. They understood what they saw not so much as new formal problems but as new means through which to redefine their own cultures.

The sequence of these modes as they developed in European art was often inverted in Latin America. For instance, symbolism and art nouveau, which first appeared in Europe between the late 1880s and the turn of the century some twenty years after impressionism, preceded impressionism in Latin America. The reason symbolism and art nouveau came to the New World near the same time as they appeared in Europe is that they did so through literary sources, journal illustrations, and industrial design, whereas impressionism and postimpressionism had to await exposure in gallery exhibitions. Consequently they were known and adopted later.[7]

SYMBOLISM

By the turn of the twentieth century, art nouveau and symbolism were well established in the New World, especially in Brazil and Mexico. Not only was art nouveau prevalent in magazine illustration and design in the first two decades of the century, it was also present in architecture, notably in São Paulo, Buenos Aires, and Mexico—in their national theaters for instance. In painting and illustration, symbolism was often an aggregate of art nouveau. Art nouveau was characterized by its graceful curvilinear compositions incorporating plant forms and can generally be found in industrial design, whereas symbolism comprised decadent, morbid, or sacred and profane subject matter, with an emphasis on eroticism and death, sadism and satanism. The latter characteristics may account for the infrequent adoption of European symbolism in many Latin American countries, where the Catholic Church had remained a dominant force. When artists embraced symbolism, it

was more often in its allegorical form as Greek mythological and Old Testament themes. In the second decade of the century, these subjects were evident in illustrations by the Brazilian artist Emiliano di Cavalcanti, better known for his collaboration with the Brazilian vanguard of the 1920s. Di Cavalcanti had especially admired Aubrey Beardsley's pen-and-ink drawings for Oscar Wilde's *Salome* and in 1921 had himself illustrated a translation of Wilde's *Ballad of the Hanged One* in a Beardsley-like style.

Although Beardsley's style was known elsewhere, especially in Mexico and Brazil, symbolism as a form was not as widespread in painting and sculpture as it was in journal illustration, at least in its more blatant forms. Outside of Brazil and Mexico, artists who took up symbolism tended to avoid its more profane aspects until considerably later, when they sometimes incorporated it into their art as a way to satirize the clergy. In Argentina and Uruguay, symbolism was cloaked in religious metaphors and moon imagery—the latter for its bewitching qualities—rather than simultaneously morbid subject matter.[8] When symbolism occurred in Andean countries like Ecuador, Peru, or Bolivia, it tended to reflect a continuing preoccupation with biblical subjects that were the legacy of colonial and nineteenth-century art rather than the more typical decadent ones. Not until the 1940s and after did artists sometimes incorporate allusions to the sacred and profane in those countries, for instance, in the paintings of the Bolivian Arturo Borda discussed in a later chapter. In Colombia, where the church was especially powerful, artists responded to symbolist trends in ambiguous ways with themes of chastity and the human body. Chastity as a subject was initially treated in Colombia by Jorge Isaacs in his nineteenth-century romantic novel *María;* and the human body played a central role in the work of later twentieth-century Colombian artists. Although there was no major symbolist group in Colombia,

individual artists manifested aspects of it in their work, as Marco Tobón Mejía (1876–1933) did in his small bronze reliefs of academic nudes created from 1910 to 1930. In France, Mejía had befriended Auguste Rodin, whose work includes female nudes in seductive poses, sometimes with their genitals in full view. In European symbolist art, the female was often treated as a seductress and a threat to males, as is visible in paintings by Edvard Munch or drawings by Beardsley. Mejía's representations of the female body fall into this category, although without the monumentality of Rodin's work. All of Mejía's works were very small, such as his bronze relief of Salome kissing the mouth of the decapitated St. John the Baptist. Another small, enigmatic relief, *Vampiresa [Female Vampire]* (c. 1910), measuring no more than about five by three inches, shows a delicately curved body of a crouching female nude whose outstretched arms and batlike wings are nailed in place like a crucified Christ (FIG. 1.1).[9]

FIGURE 1.1
Marco Tobón Mejía, *Vampiresa [Female Vampire]*, c. 1910, bronze, 12 × 8.5 cm. / 4¾ × 3⅜ in. Courtesy Museo Nacional de Colombia, Bogotá.

Symbolism, in its more literal form, did not in itself contribute to the establishment of a country's artistic identity and culture, as other forms of *modernismo* did. But it did play a major role in liberating literature and art from their traditional nineteenth-century modes, and it paved the way for further innovations. Literary groups sprang up in most of the major capitals, along with journals championing *modernismo* and, by extension, symbolism, and artists joined their circles by contributing caricatures and vignettes to the journals.

In Mexico at the turn of the century, symbolism meant the rejection of the bourgeois values associated with the presidency of Porfirio Díaz and his positivist entourage. Literary journals were rallying points for artists as well as writers, many of whom took up a Bohemian lifestyle in emulation of Charles Baudelaire and Edgar Allan Poe.[10] Several artists, including Angel Zárraga, Germán Gedovious, Saturnino Herrán, and Roberto Montenegro, experimented with symbolism for a time. Even José Clemente Orozco manifested symbolist characteristics in his early portrayal of women. However, none was as true to the symbolist line as Julio Ruelas (1870–1907). Even though Ruelas spent relatively little time in his country, he played an important role among *modernista* intellectuals in Mexico. He had apparently already become familiar with symbolism through illustrated European journals before he left Mexico. In Europe, he traveled to Holland, Belgium, and France and studied at the Karlsruhe Academy of Art in Germany between 1892 and 1895. After a seven-year stay in Mexico from 1897 to 1904, he returned to Paris, where he died at the age of thirty-seven from health problems precipitated by excesses and dissipation.[11]

Orozco later described Ruelas as "a painter of cadavers, satyrs, drowned men, and spectral lovers returning from a suicide's grave."[12] Ruelas's themes revolved around death, lust, and Greek mythology. In *El ahorcado [The Hanged One]* (1890), a skeleton holding a scythe with a decapitated male head hanging from it places a noose around another man's neck (FIG. 1.2). According to Teresa del Conde's interpretation, the two victims are portraits: the decapitated head, of a writer friend of Ruelas's, and the one about to be hanged, of his brother. A barely visible figure of Ruelas in a corner in the background implies that he will be the next victim. Unlike José Guadalupe Posada's extroverted and satirical *calaveras* of the same years, Ruelas's skeleton conveys a

PLATE 1.1

Julio Ruelas, *Entrada de don Jesús Luján a la "Revista Moderna"* [*The Initiation of Don Jesús Luján into the "Revista Moderna"*], 1904, oil on canvas, 30 × 50½ cm. / 11¾ × 19⅞ in. Collection Manuel Arango, Mexico City. Archivo Fotográfico del IIE/UNAM.

sacrilegious and awesome fatalism typical of late-nineteenth-century death imagery liberated from earlier romantic connotations.[13]

In Mexico, Ruelas was affiliated as an illustrator with the *Revista Moderna* (1898–1911), whose benefactor Jesús Luján had saved the journal in 1902 from economic failure.[14] Other artists collaborating with this journal included Leandro Izaguirre, painter of *El suplicio de Cuauhtémoc [The Torture of Cuauhtémoc]* (1892), and Germán Gedovious, a deaf-mute artist known for *Desnuda [Nude]*, a luscious turn-of-the-century painting of a reclining woman. Ruelas paid homage to Luján in a small work, *Entrada de don Jesús Luján a la "Revista Moderna" [The Initiation of Don Jesús Luján into the "Revista Moderna"]* (1904), painted just prior to Ruelas's return to Europe (PL. 1.1). Teresa del Conde's detailed reading of this work identifies the subject as a Moreau-like allegory of the journal's benefactor and his colleagues in which they all appear as fantastic mythological creatures: the writer Jesús Valenzuela, as a centaur, greets Don Jesús Luján, who is attired in seventeenth-century costume and mounted on a splendid white unicorn; Jesús Contreras, a sculptor, is shown as an eagle with its right wing broken off, in allusion to the artist's amputated right arm; the writer and

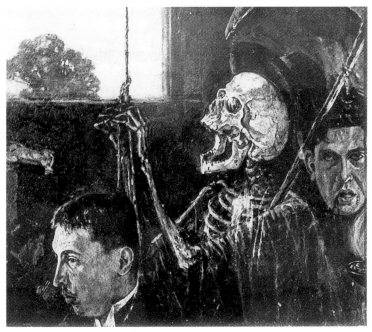

critic José Juan Tablada is a bird with colorful plumage, in a reference to his role as a spokesman and critic; the writer Jesús Urueta is transformed into a serpent with dragonfly wings coiled around the base of a leafless tree whose limbs are caught in a loose net; two other writers playing musical instruments share the body of the same quadruped, alluding to their homosexuality; Izaguirre appears as a satyr seated in the tree, and Ruelas, predictably, as a dead satyr hanging from one of its branches.[15]

FIGURE 1.2

Julio Ruelas, *El ahorcado [The Hanged One]*, 1890, oil on cardboard, 12.5 × 15 cm. / 5 × 6 in. Collection Lic. Severino Ruelas Crespo. Photo: From Teresa del Conde, *Julio Ruelas* (pl. 2.). Reproduction authorized by Teresa del Conde.

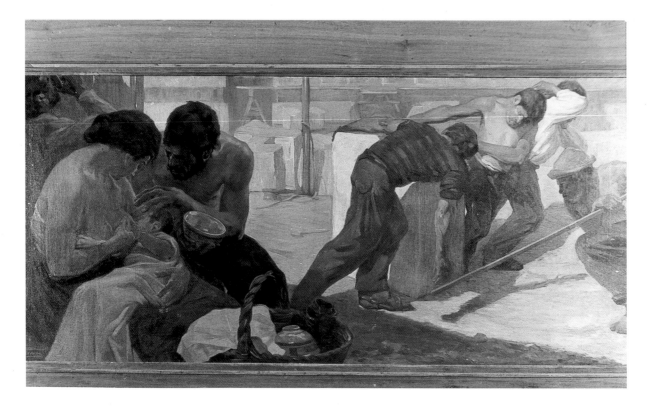

FIGURE 1.3
Saturnino Herrán, *El trabajo [Work]*, 1908, oil on canvas, 93.5 × 213 cm. / 36⅞ × 83⅞ in. Casa de la Cultura de Aguascalientes. Photo: Archivo Fotográfico of the IIE/UNAM. Courtesy of Instituto Cultural de Aguascalientes.

Elements of symbolism were often integrated into *modernista* painting along with reminders of its Spanish sources from Zuloaga, Sorolla, Romero de Torres, Anglada-Camarasa, and others. Among Mexicans to take up this type of painting were Saturnino Herrán, Jorge Enciso, Fernando Leal, and Diego Rivera, in the work the latter did in Spain between 1907 and 1913. Saturnino Herrán (1887–1918), as the major Mexican exponent of this form, represented regional Mexican types, including Indians and mestizos. According to Orozco, Herrán painted "the Creoles he knew at first hand instead of Manolas à la Zuloaga" (a reference to Zuloaga's paintings of courtesans from Madrid) at a time when Mexicans were taking "stock of the country they lived in" for the first time.[16] Herrán never went to Europe. He studied at the San Carlos Academy in Mexico City with Izaguirre, Gedovious, and the Spaniard Antonio Fabres.[17] *El trabajo [Work]* (1908), an early painting by Herrán, is in a naturalistic style that manifested little of the *modernista* characteristics of his later work (FIG. 1.3). Although this painting is unusual in its

early representation of men physically laboring and seems like a precedent for the worker theme taken up later by the mural painters, Herrán's worker has more affinities with nineteenth-century allegories of seasonal labor than with twentieth-century versions (he used the work theme again in 1910 in an allegorical series). In *El trabajo,* the focus is on the family the worker supports and protects, in an allusion to the life cycle, more than on the grueling conditions of labor.

By early in the second decade, Herrán's subjects included popular dances, local customs, regional types, old blind people, and, from 1914 to his death four years later, Indians in a distinctly *modernista* style. In his paintings of local types, such as *El rebozo [The Shawl]* (1916), he makes ample use of Mexican subjects with symbolist overtones (FIG. 1.4). In this painting, a naked woman, seated on a spread of embroidered fabrics with Mexican designs and holding her rebozo, temptingly offers fruit to the viewer, who is thus drawn into the scene. She holds an apple in front of one of her breasts, for which it substitutes. A sombrero on the ground next to

her implies the presence of a male. The Sagrario Metropolitano, adjacent to the cathedral in Mexico City's *zócalo* (main square), is visible in the background. The symbolism in this painting is evident in the juxtaposition of the sacred (the church) with the profane (the temptress with the man's hat). All the elements of the composition are tightly interwoven in a shallow space characteristic of Spanish painting of that period, but the painting's references are Mexican.[18]

In *La ofrenda [The Offering]* (1913), commemorating the Day of the Dead, Herrán explored folk customs. A family shown in a close-up view solemnly rides on Lake Xochimilco in a barge filled with *zempoalxochil,* the yellow flower that is taken to the graves as an offering on the Day of the Dead (PL. 1.2). The figures, seen from above, are compressed within a shallow pictorial space; some are cropped by the canvas's edge, and the horizon is near the top of the picture. *La ofrenda* symbolizes the cycle of life from youth to old age and, ultimately, death by the presence of three generations—children, parents, and grandparents on their way to visit deceased relatives.

In 1914, Herrán was commissioned to paint a frieze for the interior of the National Theater in Mexico City (now the Palacio Nacional de Bellas Artes). This work, planned as a sequence of three oil paintings on canvas to be titled *Nuestros dioses [Our Gods],* was to consist of life-sized figures. But the work remained unfinished due to the artist's early death. The left-hand panel is the only one to have been finished as a painting; the other two exist today only in the form of drawings. In its finished state, the work was to consist of two horizontal paintings, each representing a procession, converging on a third central, vertical painting, *Coatlicue transformada [Coatlicue Transformed]* (1918). On the left, Indians are shown kneeling and chanting in a trancelike state as they carry offerings of fruit to their deity. In the drawing of the Spanish counterpart, the conquerors and friars bear offerings and carry an image of the Virgin on a bier

in a procession toward their Lord. The two processions lead to the large central image showing the awesome figure of Coatlicue (Lady of the Serpent Skirt)—which is based on the massive sculpture of this deity found beneath the *zócalo* in the late eighteenth century—merged with the crucified Christ, in an allusion to Mexico's cultural and religious synthesis (FIG. 1.5).

Instead of re-creating a Mexican past as a historical event, as did Obregón or Izaguirre, Herrán invoked an archaeological past as a symbol of Mexican identity. But in his work, this identity consists of the fusion of the Indian and the Spanish legacies. Although based on academic studies of classical nudes, Herrán's depiction of Indians is also the result of renewed interest in Mexican pre-Hispanic art prompted by the discovery early in the century of a great number of pre-Columbian artifacts and by recent archaeological excavations, particularly at Teotihuacán just north of Mexico City. Herrán was among several artists who, along with the painter Francisco Goítia, illustrated these found objects. Herrán

FIGURE 1.4
Saturnino Herrán, *El rebozo [The Shawl],* 1916, oil on canvas, 120 × 112 cm. / 47½ × 44⅞ in. Museo Nacional de Arte (INBA, Mexico City). Photo: Archivo Fotográfico of the IIE/ UNAM. Reproduction authorized by the Instituto Nacional de Bellas Artes y Literatura, Mexico City.

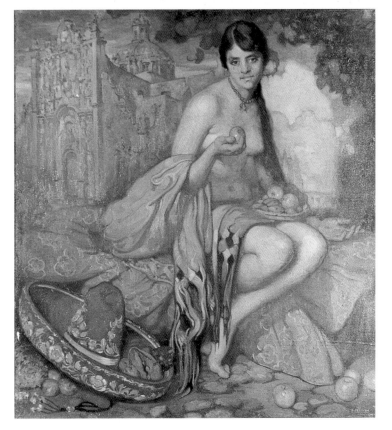

had also worked for the Archaeological Inspection Department in 1910 recording the newly discovered objects, and he had used some of his drawings as a basis for *Nuestros dioses.*

Like Mexico, Ecuador was the site of new archaeological investigations at about the same time. Not only did the Ecuadorian painter Camilo Egas (1899–1962) depict Indians in the 1920s, he also collected pre-Columbian art. Nonetheless, Egas, who turned to social themes and surrealism in the 1930s, had also lived in Italy and Spain. In the

latter country, he had seen the work of Zuloaga and Sorolla and had met Anglada-Camarasa. Shortly after his return to Ecuador in the early 1920s, he was commissioned by the Ecuadorian historian and archaeologist Jacinto Jijón y Caamaño to do a series of oil paintings on the theme of Indians for the second-floor landing of his Americanist library (now the Museo Jijón y Caamaño de Arqueología y Arte Colonial) in Quito. Jijón y Caamaño also owned a collection of pre-Columbian pottery, and Egas, who collected Ecuadorian folk art as well as pottery, used some of these objects as models for accessories in his paintings.[19]

Between 1922 and 1923, Egas painted fourteen horizontal panels—whose width was almost four times their height—of scenes depicting the daily life of Indians from before the conquest to the present (1920s). Indians are shown participating in ancient religious and agricultural rituals, at wakes or dances, in processions, as well as at various contemporary occupations such as in *Camino al mercado [Going to Market]* or *Fiesta indígena [Indian Festival]* (1922; PL. 1.3). Egas's use of classical poses is similar to Herrán's, but Egas leaves more space around his figures. Although he was later known as an *indigenista* painter, his incorporation of archaeological artifacts in some of his works and the poses of his figures in this series correspond to a *modernista* vision. In *Fiesta indígena,* a group of women carry flowers in a ritual-like procession against a mountainous landscape as a background foil.

Like Egas, the Peruvian José Sabogal and the Bolivian Cecilio Guzmán de Rojas are considered *indigenistas* whose major production belongs to the 1930s. But their early paintings more properly belong to *modernismo.* Sabogal's *El alcalde indio de Chincheros: Varayoc [The Indian Mayor of Chincheros: Varayoc]* (1925) is an example of *modernismo* rather than of *indigenismo* (PL. 1.4). Nonetheless, Sabogal is discussed more fully in another chapter. In the 1920s, Guzmán de Rojas

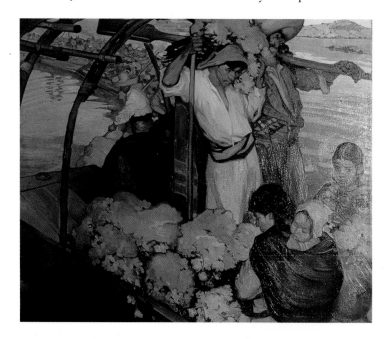

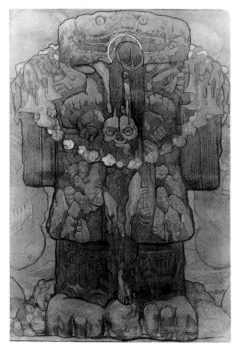

FIGURE 1.5
Saturnino Herrán, *Coatlicue transformada [Coatlicue Transformed]*, from *Nuestros Dioses [Our Gods]* series, 1918, crayon and watercolor on paper, 39.4 × 31.5 cm. / 15⅝ × 12⅜ in. Museo Nacional de Arte (INBA, Mexico City). Photo: Archivo Fotográfico of the IIE/UNAM. Reproduction authorized by the Instituto Nacional de Bellas Artes y Literatura, Mexico City.

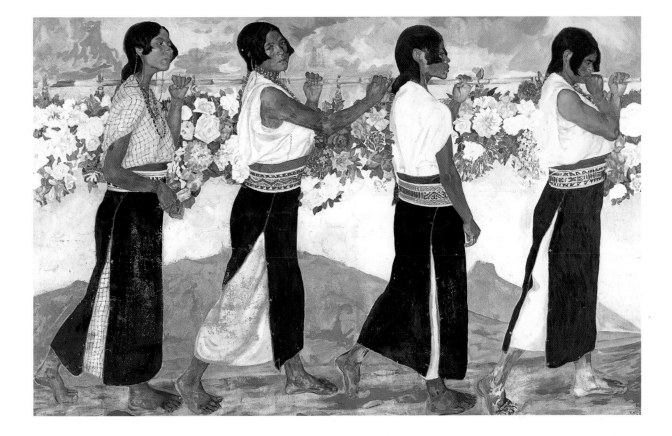

(1900–1950) painted scenes with Indians filled with symbolist allusions to Bolivia's ancient heritage rather than with references to the Indians' contemporary existence. In his work of the 1920s, it is the imprint of his teacher—the Spanish symbolist Julio Romero de Torres, with whom he had studied in Madrid—that is most evident, especially in Guzmán de Rojas's portraits of women.

His paintings of Indians of this period, like those of Herrán and Egas, represent them dressed or naked in classical poses and in local settings. In *Triunfo de la naturaleza [The Triumph of Nature]* (1928), painted in Spain just before his return to La Paz, Guzmán de Rojas depicted an Indian couple propped up against an ancient stone tomb bearing a half-hidden frontal image of the god Viracocha holding staffs (FIG. 1.6). This image of the deity was based on the low relief carving on the frieze of the monolithic Gate of the Sun in Tiahuanaco near La Paz. The arabesque patterns formed by the sleeping nude female and the standing nude male bending over her, or "sensuous

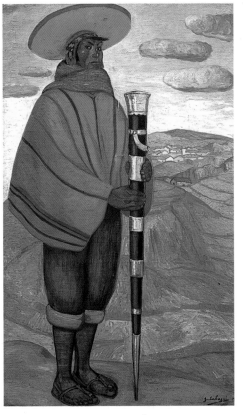

PLATE 1.3
Camilo Egas, *Fiesta indígena [Indian Festival]*, 1922, oil on canvas, 97 × 155 cm. / 38⅛ × 61 in. **Courtesy Museo Nacional del Banco Central del Ecuador, Quito. Photo: Judy de Bustamante.**

PLATE 1.4
José Sabogal, *El alcalde indio de Chincheros: Varayoc [The Indian Mayor of Chincheros: Varayoc]*, 1925, oil on canvas, 170 × 105 cm. / 67 × 41½ in. **Municipalidad de Lima. Photo: Daniel Giannoni.**

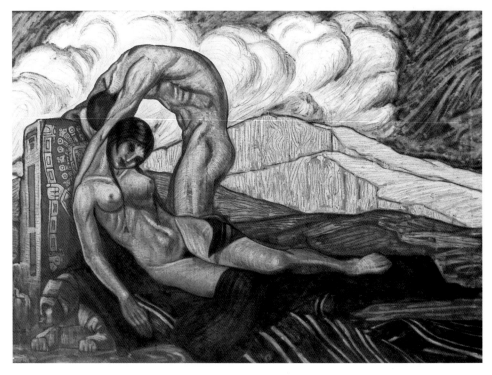

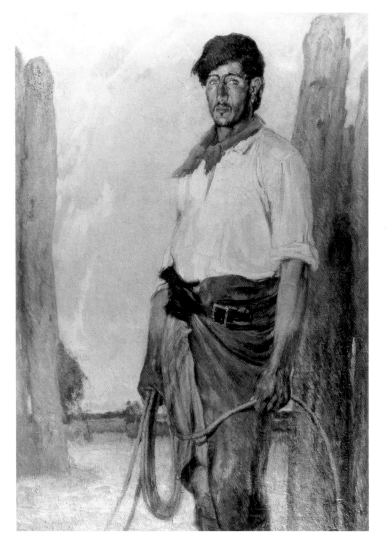

rhythms" as Guzmán de Rojas liked to call this type of flowing composition,[20] blend with a landscape of Bolivian mountains and swirling clouds that echo the contours of the two figures. The key to this painting lies in the tomb's symbolism: the couple, as the descendants of the defeated pre-Columbian civilization (Viracocha), are awakening from a long sleep and a remote past to foster the race like a new Adam and Eve. Their fusion with the landscape also makes them a part of nature and, by extension, of the land itself.[21] Although the woman's features look as Spanish as they do Indian, the artist had painted an allegory of the Indian race with which he felt intellectually—if not physically—bound.

In Argentina, Cesáreo Bernaldo de Quirós (1881–1968) took up the representation of gauchos in a manner analogous to the treatment of Indians by Herrán, Egas, Sabogal, and Guzmán de Rojas. Socially, the gaucho enjoyed a better status than the Indian and sometimes even owned a bit of land. He was, nonetheless, often poor, and his racial mixture—a blend of Indian, Spanish, and sometimes black blood—and his proverbial illiteracy made him into a potential outcast. In the Río de la Plata region

(which includes Argentina and Uruguay on either side of the River Plate), the gaucho as a type came to represent the counterpart (although not completely indigenous) of the Andean and Mexican Indian, and Cesáreo Bernaldo de Quirós made this figure a major subject of his art in the 1920s. Before World War I, he had spent many years in Florence, Rome, Mallorca, and Sardinia, and he returned to live in Italy after the war. His acquaintance with the work of Sorolla, Anglada-Camarasa, and other Spaniards, seen during his travels, is evident in his own style of painting. But during the years he spent in Argentina, he explored his own culture by living among gauchos for several months in the province of Entre Ríos (between the Paraná and the Uruguay Rivers in northeast Argentina) to observe and record their daily activities. While there, he did a series of drawings in which these figures dominate the pictorial space like photographic close-ups. Already then, gauchos, whose history was barely two centuries old, were a waning group, and Bernaldo de Quirós wanted to capture aspects of this rural Argentine tradition before it died out completely. His drawings and sketches were the basis for a series of paintings finished in 1927. In this series, Bernaldo de Quirós represented his subjects as individual portraits at their daily tasks, alone near their shacks, relaxing with their families, as healers, butchers, minstrels, hunters, or lassoers at rest rather than in action (*El pialador [The Lassoer]*; FIG. 1.7). The artist emphasized their rough and sunburnt features but also gave them dignity. He depicted them as he imagined them to have been in the 1850s and 1860s in the time of Pallière or Blanes. But in contrast to their more generic, romanticized, and sometimes documentary nineteenth-century counterparts, Bernaldo de Quirós's paintings manifested a shallow pictorial space, swirling colorful impastos, and an emphasis on the close-up view of his subjects.[22]

IMPRESSIONISM

In cases in which both impressionism and postimpressionism appeared as major ingredients in a work, critics applied the European term *impressionism* sometimes to postimpressionist as well as impressionist works. As a term, *postimpressionism* was not used in Latin America. But *impressionism* became a catchall term used to define any brightly colored impastoed painting, usually of a landscape with or without figures, in which light and color played an important part. Impressionists from Latin American countries, like their early French counterparts, generally worked outdoors. But instead of focusing only on the fleeting atmospheric effects typical of the French impressionists, many Latin American impressionists sought to retain the solidity and tonal qualities of naturalism as well.

Some variant of impressionism existed in Ecuador, Peru, Chile, Uruguay, and Brazil. Impressionism was introduced in Ecuador by the French-born painter Paul Alfred Bar, who had gone to Ecuador in 1912 and taught landscape painting at the Quito School of Fine Arts in the years 1910–1929. In Peru, besides Carlos Baca-Flor (1867–1941), who spent the greater part of his life outside Peru and was as well known abroad as he was in his own country, very few artists took up this mode. Baca-Flor was born in Chile and trained at the Academy of Fine Arts in Santiago and at the Julian Academy in Paris. Between 1908 and 1929, he made a small fortune painting portraits in Paris and New York, including several versions of the banker J. P. Morgan. In Chile, where a strong Francophile current ran, impressionist landscape painting was widely practiced. The Chilean impressionists, who included Alfredo Valenzuela Puelma, Alberto Valenzuela Llanos, and Juan Francisco González, combined French characteristics with Spanish ones in their landscapes and figure compositions.[23] The first two—both Paris-trained—put a romantic stamp on scenes of parks, trees, and the distant mountains

of the Chilean countryside. González concentrated on close-ups of flowers in luminous, Monet-like colors. On the other hand, the Uruguayan painter Pedro Blanes-Viale (1879–1926) adopted Spanish luminism, a type of impressionism characterized by brilliant effects of sunlight that was developed at the turn of the century in Spain, where Blanes-Viale lived for many years.[24] *Palma de Mallorca,* an undated early-century painting, is typical of the sun-drenched landscapes he painted in Mallorca as well as in Uruguay. The Brazilian impressionists, like Eliceu Visconti (1867–1944), tended to follow the French model. This phase of Visconti's work, mainly in the 1920s and 1930s, comprised Paris scenes and sun-dappled garden settings in Rio de Janeiro in which he included members of his family.

Mexicans, Argentines, and Venezuelans were among the most original Latin American impressionists. Impressionism's rapid rise in popularity in Mexico was due as much to the emergence of open-air schools during the years of the Mexican Revolution as to the presence of European models. In 1913, shortly after his return from Europe, Alfredo Ramos Martínez (1875–1946), known for his paintings of delicately colored figure compositions in oil and pastel, founded the Barbizon School of Santa Anita, named for its location in Santa Anita just outside of Mexico City (Barbizon was a reminder of the site near Paris made famous by its landscape painters). Santa Anita was the first of several such schools to open within a short span of time. Not only did Santa Anita provide a setting for *plein-air* painting (the French term for open-air or outdoor painting), it also functioned as an alternative to the San Carlos Academy, which had been the site of a student strike in 1911 to protest its antiquated methods.[25]

More than a refreshing break from the academy, Mexican impressionism became a means for artists to focus on their own native culture and popular roots.[26] Of the many open-air schools that followed the example of Santa Anita, few survived. Those that did, lasted until well into the 1930s but in a new form. After 1927 they were turned into urban centers known as People's Painting Centers, where aspiring artists, including children, from all classes of society could work free of

PLATE 1.5
Joaquín Clausell, *Ixtacalco,* n.d., oil on canvas, 123 × 155 cm. / 48½ × 61 in. Museo Nacional de Arte, Mexico City. Archivos Fotográficos del Centro Nacional de Investigación, Documentación e Información de Artes Plásticas (CENIDIAP), Mexico City.

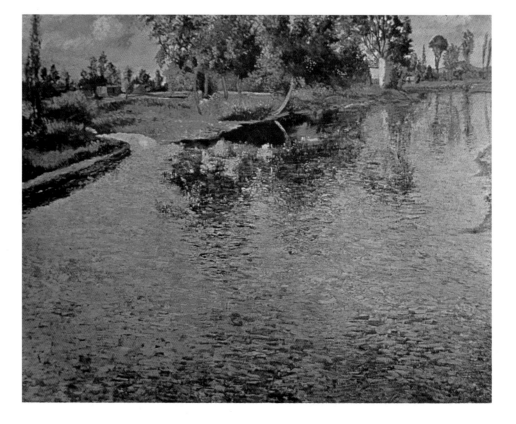

charge. A major objective of these centers was to awaken in the students an awareness of Mexico's artistic resources.

The interest in making local culture accessible and intelligible to a broader segment of society, as well as in liberating art from academic restraints, had existed since the early 1920s under the administration of Alvaro Obregón. The painter Adolfo Best-Maugard had developed a theory for teaching art in his book *Método de dibujo* (1923), translated as *A Method of Design* the following year. The theory was based on the notion that an infinite number of design variations could be obtained by combining seven basic universal signs also found in pre-Columbian art.[27] Dr. Atl (Gerardo Murillo, 1875–1964) was a great advocate both of impressionism and of Mexico's popular culture.[28] In 1921, he organized an exhibition of popular art for which he wrote a two-volume study, *Las artes populares en México*. Because of the interconnections between impressionism and mass education in Mexico through the open-air schools, impressionism had more populist connotations there than elsewhere, and most artists adopted this mode for depicting their own landscape and customs.

The two artists who made the most original contributions to Mexican impressionism were Joaquín Clausell and Dr. Atl (the latter in a less orthodox way). Both artists were avid walkers and lovers of nature and together took long walks through the countryside to sketch and paint. Instead of the vast panoramas in Velasco's paintings, Clausell and Atl chose bold perspectives that gave the viewer the sense of being inside the landscape. Clausell (1866–1935), a criminal lawyer and polemicist who had received his law degree in 1896, traveled to Europe between 1892 and 1893 during the Porfiriato.[29] Dr. Atl had encouraged him to paint, and today Clausell is better known as a painter than a lawyer. According to Orozco, Dr. Atl came back from his first trip to Europe in 1904 with "the rainbow of the impressionists in his hands and . . . all the

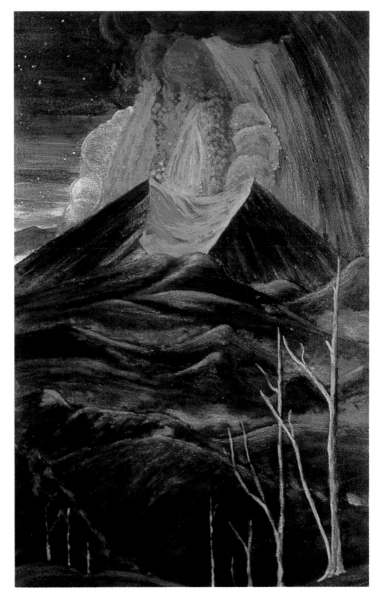

audacities of the Parisian School," and he conveyed his enthusiasm to his Mexican colleagues with flamboyance.[30]

None of Clausell's paintings are dated, but most of his better-known works were done after 1904. Although Clausell's style bears some resemblance to that of Monet, whom he may have met in Europe, he used complementary colors and, according to Dr. Atl, was concerned with the "vibrations of light"; typically Clausell never completely relinquished the solidity of form. As is evident in some of the titles of his works—*Santa Anita, Ixtacalco* (PL. 1.5), *Texcoco, Tlalpan*—he sought to record specific locations as much as momentary atmospheric effects. His subjects included seascapes, close-ups of waves

PLATE 1.6

Gerardo Murillo (Dr. Atl), *El Volcán Paricutín en erupción [The Paricutín Volcano Erupting]*, **1943, oil on canvas, 127 × 78.5 cm. / 50 × 31 in. Colección Seguros Comercial América, S.A. de C.V. Courtesy Fomento Cultural Banamex, A.C. Reproduction authorized by the Instituto Nacional de Bellas Artes y Literatura.**

and rocks, beaches, rivers, canals, mountains, volcanoes, parks, and trees in the surroundings of Mexico City, in the state of Michoacán, and on the Pacific coast. Clausell's notoriously stormy life (as a lawyer he often took up unpopular causes) came to an end in 1935 when he accidentally tripped over some rocks where he had been painting and died of the resulting injuries.

Dr. Atl, who was an early proponent of a mural movement in Mexico, is more difficult to classify. The body of his work cannot be confined to a mere two decades nor to a given style.[31] He invariably incorporated into his work changes that were constantly occurring in the arts, and he remained active until his death in 1964. His numerous interests also made him the epitome of the Renaissance man. He was a vulcanologist, essayist, journalist, poet, and orator as well as a painter. In 1906, he invented a type of crayon known as Atl colors made of pigments, resin, and wax that could be used over watercolor or oil to heighten their intensity.[32] Besides impressionism, Atl had been taken with the murals of the Italian Renaissance as well as futurism in Italy. During his second trip to Europe, from 1911 to 1914, he studied vulcanology in Rome and also became enamored with Italian futurism, a style that was not especially popular in the art of Latin Americans. Atl and Siqueiros (the latter discovered it a few years later), were the only ones in the 1920s and 1930s to apply its dynamic qualities quite literally to their work. In Italy, futurism had developed in 1911 at a time of high industrialization and urban expansion. It opposed the romantic aspects of symbolism (for instance, the moon was equivalent to a street lamp, with none of its earlier mystique). Futurist art was also characterized by a focus on energetic movement rather than on the figure or object itself. Both Atl and Siqueiros sought to represent motion and dramatic action in their work by applying these characteristics to landscape and figures.

Throughout his life, Atl applied these elements in drawings and paintings of landscapes and volcanoes he did from life, sometimes under perilous conditions. In 1917, he had climbed Popocatepetl to paint it in an active state (he was to paint the same volcano seen from the window of an airplane in the 1950s). By the 1930s, he was combining elements of futurism, expressionism, and curvilinear perspective (a system that took into consideration the curvature of the earth) into his landscapes.[33] In the 1940s, some years after *modernismo* had waned, he began a new series of paintings of volcanoes in a dynamic form of expressionism. When the Paricutín volcano first emerged in a farmer's field in the state of Michoacán in 1943, Atl risked camping on its rising and smoldering banks to study, draw, and paint it in its various stages of activity (*El Volcán Paricutín en erupción [The Paricutín Volcano Erupting]*; PL. 1.6).[34]

In Argentina and Uruguay, impressionism took a more traditional direction than it did in Mexico. Argentina's and Uruguay's history was much more recent than Mexico's, and *platense* artists applied impressionism as well as more synthetic forms of *modernismo* to themes developed in nineteenth-century landscapes and scenes of rural life. Ranches, open plains, and grazing cattle formed the very basis of their culture.[35] On the other hand, after the turn of the century, artists looked at these subjects through different lenses, those of impressionism and *modernismo*. The Argentine art historian and painter Romualdo Brughetti stated that "*modernismo* and impressionism, at this level, allied themselves in the need to create an art that transfigured reality through their legitimate values."[36] Artists looked to France and Germany as well as Spain for impressionist models, often fusing them into an idiosyncratic form that can be considered the visual equivalent of Argentine and Uruguayan symbolism in literature (Leopoldo Lugones, for instance).

Argentines had ample opportunities to become acquainted with impressionist

art. Paintings by Monet, Renoir, Bonnard, Vuillard, and Albert Marquet were shown in Buenos Aires in an *International Art Exhibition* in 1910—in the same year and in the same glass-and-iron pavilion as the centenary exhibition of Spanish art.[37] The work of Maurice Denis and of the Spaniards Anglada-Camarasa and Nonell was also exhibited in Buenos Aires galleries; in addition, most artists traveled to Europe.[38] Although *impressionism* became a catchall term by the 1920s, it best applies to the work of Faustino Brughetti (Romualdo's father), Martín Malharro, Fernando Fader, and Guillermo Butler.

Faustino Brughetti and Malharro are credited with being the first Argentine impressionists. Malharro (1865–1911) belonged to the same generation as Ernesto de la Cárcova, Eduardo Sivori, and Angel della Valle, but his first exhibition in Buenos Aires in 1902 revealed a new direction in Argentine art. His compositional simplifications and bold use of complementary colors differed dramatically from what his contemporaries were doing.

During a trip to Tierra del Fuego (at the tip of South America) in 1891, Malharro had first become captivated by the island's atmospheric luminosity. After an initial period of study in Buenos Aires, he spent seven years (from 1895 to 1902) in France painting Monet-like landscapes and haystacks. But his adoption of the bold brushwork and tonal opacities of the Spanish artists soon placed him in a distinct category. In *En plena naturaleza [The Fullness of Nature]* (1901), a landscape painted in Auvers (France) and exhibited in Buenos Aires in 1902, he made use of complementaries, not as small adjoining brush strokes but as two separate zones in the manner of postimpressionism. The foreground consists of a band of modulated yellow, and the background, of blue clouds and distant hills. However, the absence of oppressive subject matter and anguished brushwork removes him from a postimpressionist classification.

Although Malharro painted some of his best-known work in France, it had much in common with Argentine literary *modernismo*. His interest in effects of light was not confined to sunlight, but extended to night scenes and moonlight. His paintings revealed the presence of a symbolist current typical of Argentine literature. In *Nocturno [Nocturne]* (1902), a playful moon hides behind trees and clouds, outlining their edges with its sulphuric light. Moon and night imagery was a dominant subject in both art and literature in the Río de la Plata through the 1930s. In literature, besides being a major theme in the work of the symbolist poet Leopoldo Lugones, it was the subject of some of Jorge Luis Borges's poems of the 1920s, as well as for other writers.[39] This subject is also present in the work of two Uruguayan painters, Pedro Figari and José Cuneo. It is a ubiquitous presence in Figari's patio and pampa scenes and in Cuneo's fractured expressionist ranch scenes of the 1930s, in which enormous moons threaten to engulf the landscape. Malharro painted this theme more than once. In a later version of the same subject done later in the same year, *Nocturno* (1902), a rural house framed by a dark blue sky and trees in warm shades of green is bathed in pale yellow-green moonlight (PL. 1.7).

Malharro's pioneering role in Argentine art was not recognized until many years later. During the years 1910–1929, his reputation was eclipsed by that of his better-known colleague Fernando Fader. As the son of a German immigrant, Fader (1882–1935) chose to go to Germany in 1900 rather than France, and he studied painting with Heinrich von Zügel at the Royal Institute of Arts and Sciences in Munich.[40] Fader's German production was in the free style of the Berlin secession painters Max Lieberman and Max Slevogt rather than that of the impressionists. An early example is *La comida de los cerdos [Feeding the Pigs]* (1904), for which Fader received an award in a Munich exhibition. He returned to Argentina the same year. His impressionist

PLATE 1.7
Martín Malharro,
Nocturno [Nocturne],
1902, oil on canvas, 38.5 ×
55 cm. / 15¼ × 21⅝ in.
Courtesy Museo
Nacional de Bellas Artes,
Buenos Aires.

PLATE 1.8
Fernando Fader, *Los
mantones de Manila
[Shawls from Manila]*,
c. 1911, oil on canvas,
116 × 140 cm. / 45¾ × 55
in. Courtesy Museo
Nacional de Bellas Artes,
Buenos Aires.

phase began shortly after the 1910 *International Art Exhibition* in Buenos Aires and quite possibly as a result of it.

Fader was among the first Argentine artists to form an artists' collective in Buenos Aires. In 1907 he cofounded the Nexus group with the painter Pio Collivadino. This group initially helped to establish a sense of community among artists, who more often worked in isolation, not only in Argentina but in other Latin American countries as well. Malharro had initially been a member of the group but soon left because of differences and rivalries.[41] Although most of the Nexus affiliates—who exhibited twice as a group, in 1907 and 1908, before disbanding—considered themselves impressionists, only Fader practiced impressionism in its more orthodox sense. The other artists in the group followed a more naturalistic direction in their work.[42]

Despite the brevity of Fader's group affiliation, he enjoyed considerable success as an individual in the years following the disbanding of the Nexus group. During his Buenos Aires period, from 1905 to 1916, he painted interior scenes with figures as well as landscapes. In *Los mantones de Manila [Shawls from Manila]* (c. 1911; PL. 1.8), which earned him first prize in the *Third National Salon* of 1914 in Buenos Aires, four women, one of whom is naked, examine the flowery shawls. The manner in which the women's figures, hair, and background fuse and flow into the overall design and patterns of the shawls indicates Fader's familiarity with the work of Zuloaga, Nonell, and especially Vuillard. In comparison with Saturnino Herrán's near contemporary *El Rebozo,* in which the shawl was Mexican, Fader perhaps typically depicted imported shawls.[43]

Fader's commercial success and the advantages of the cultural ambience of Buenos Aires did not keep him from moving in 1916 to a quieter and more serene location on a farm in Ischilin near Córdoba in the interior of Argentina. There he began one of the most produc-

tive periods of his career as an impressionist. He worked out-of-doors and focused on effects of changing light at different hours of the day and in different seasons. In 1917 he painted a series of eight versions of his own farmhouse ranging from dawn to dusk, all titled *La vida de un día [The Life of a Day]* and identified individually by the specific time, such as *La mañanita [The Morning]* (FIG. 1.8). But unlike Monet's haystacks and Rouen Cathedral facades, Fader's views functioned as a collective portrait of the farm itself in different color combinations, in addition to recording fleeting atmospheric effects playing on its surface. Over the years, his colors became increasingly clear and luminous, but he never abandoned the subject's palpable solidity.

Fader's frequent inclusion of peasants in his landscapes reveals an interest in the life of the local populations in scenes of rural life in which the implied poverty and sadness of the subjects exists as an undercurrent downplayed by attractive color combinations and bold brushwork. In *La mazamorra* (1927; FIG. 1.9), a farmhand sits beneath a tree eating a lunch of *mazamorra,* a thin corn soup traditionally consumed by the poor, while his wife, who is not eating, sits by with an expression of profound resignation and melancholy watching the soup pot steaming over an improvised fire. The scene is bathed in warm luminous shades of pink, red, lavender, purple, and blue. Fader painted such subjects more by default than because of a commitment to social causes. He viewed farmhands as part of the landscape rather than as individuals whose lives deserved to be explored for their own sake.

For Guillermo Butler (1880–1961), the landscapes themselves were the central subject. Butler, a Dominican priest, sought to make art into a religious experience by infusing his landscapes with mystical serenity. In Paris, where he lived between 1911 and 1915, he had joined

FIGURE 1.8

Fernando Fader, *La mañanita [The Morning]*, from *La Vida de un Día [The Life of a Day]* series, 1917, oil on canvas, 100 × 80 cm. / 39½ × 31½ in. Courtesy Museo Municipal de Bellas Artes "Juan B. Castagnino," Rosario. Photo: Ron Jameson, from slide by the author.

FIGURE 1.9

Fernando Fader, *La mazamorra*, 1927, oil on canvas, 100 × 120 cm. / 39½ × 47¼ in. Courtesy Museo Nacional de Bellas Artes, Buenos Aires. Photo: Mosquera.

Maurice Denis's Association des Artistes Chrétiens, and in 1936 he founded his own version of it, the Sociedad de Artistas Cristianos, in Buenos Aires.[44] He conveyed the idea of nature as a religious experience in his tranquil landscapes and reductively simple church facades painted in delicate atmospheric colors undisturbed by sharp contrasts. For a while, he practiced a form of pointillism with cool, analogous colors similar to those of Maurice Denis to obtain what became his trademark, a sense of balance and silence.

In Argentina, impressionist landscape focused on rural tranquillity in a manner that evoked such scenes in nineteenth-century painting. In Venezuela, impressionism became a means to convey tropical luminosity. Impressionism was known early in the century in Venezuela through book and journal illustrations, but a number of Venezuelan artists also had direct contact with French impressionism. Many had traveled to Paris from the mid-nineteenth century on, and although these artists had gone to Paris to study with academic painters, while there, many of them were drawn to impressionism. The nineteenth-century painters

Rojas and Michelena came close to impressionism toward the end of their lives. The first Venezuelan to become an impressionist was Emilio Boggio (1857–1920), who went to France in 1905 and, like Michelena and Rojas, studied at the Julian Academy with Jean Paul Laurens. But Boggio also associated with Zuloaga and Sorolla, who were living in Paris at the time. He painted figures and landscapes of Paris and Auvers-sur-Oise that also synthesized French impressionist light and color with the solidity of the Spanish painters.

But though Boggio's art made an impact on Venezuelan painting because of its color and luminosity, his was not the only source of impressionism in his country. When he returned briefly to Venezuela in 1918, he associated with other artists who became major exponents of impressionism there and whose sources preceded Boggio's return. A student rebellion against the Academy of Fine Arts in Caracas and a strike in 1912 to denounce the academy's policies had paralleled the strike against the Mexican academy. In Venezuela, it led to artistic reforms at the academy that included the adoption of impressionism and plein-air painting.[45] It also motivated students and writers to take things into their own hands. Several of them banded together to form the Círculo de Bellas Artes, a dissident group under the leadership of the polemical writer and journalist Leoncio Martínez. During the four years of the Círculo's existence, its members organized lectures, literary meetings, and collective exhibitions, and they held annual salons that included awards to make up for the academy's failings. Although by 1916 the Círculo gradually disbanded for lack of sustained leadership, the way was paved for a major change in the Venezuelan art scene.

Some of the Círculo's members had included the painters Manuel Cabré and Antonio Edmundo Monsanto, known for their light-drenched landscapes and views of Monte Avila near Caracas,[46] and, after 1915, Rafael Monasterios and Armando Reverón, both of whom had just returned from Spain. These artists were the first in the twentieth century to focus on the landscape of their own country. They were especially taken with its tropical luminosity, which had been explored in the nineteenth century by Fritz Melbye and Camille Pissarro. Their interest in an impressionist treatment of light was also fueled by the 1916 arrival from Europe of two war exiles: Samys Mützner, a Rumanian impressionist, and Nicolas Ferdinandov, a Russian stage designer and exponent of art nouveau known for his predilection for blue. Both those artists painted coastal scenes of La Guaira near Caracas and Isla Margarita just off the coast, where Mützner settled until his return to Europe in 1919.

The Venezuelans formed a close bond with the two artists, Monsanto (1890–1947) with Mützner, Monasterios and Reverón with Ferdinandov, and Cabré with both. The Venezuelans all sought atmospheric effects in their landscapes, and Cabré made Monte Avila his main subject, as Mont Sainte Victoire in Provence had been for Cézanne. Of the four Venezuelans, Monasterios and Reverón—who had known each other in Spain—were the most daring in their treatment of light and color. Monasterios (1884–1961) painted still lifes as well as landscapes. In *Bodegón [Still Life]* (1930; PL. 1.9), he fused the structure of Cézanne with the colors of Renoir. He had noted that light absorbs color, and by the 1930s, some of his paintings were all but drained of color.

The absence of color had already characterized Armando Reverón's brand of impressionism a decade earlier. Reverón (1889–1954) studied at the Academy of Fine Arts in Caracas and, between 1911 and 1913, at the School of Arts and Crafts and Fine Arts in Barcelona and the San Fernando Academy in Madrid, where Monasterios was his fellow student. After a brief stay in Venezuela in 1912, Reverón returned to Spain until 1915. He met

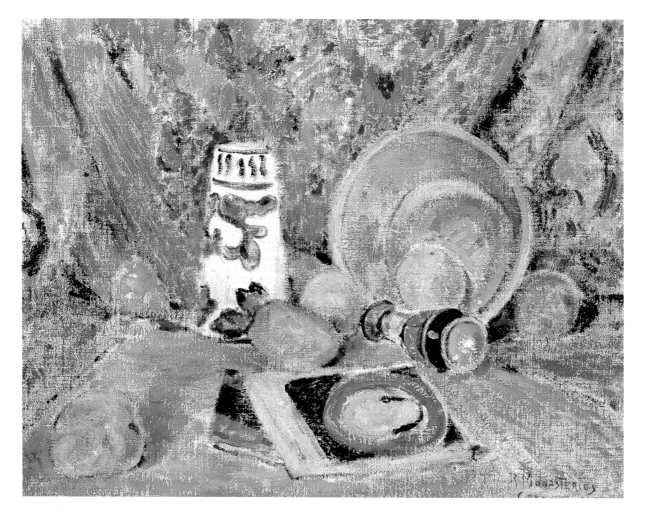

PLATE I.9
Rafael Monasterios,
Bodegón [Still Life], 1930,
oil on canvas, 53.3 × 69.6
cm. / 21 × 27⅜ in.
Courtesy Dr. José Jaime
Araujo Paul, Caracas.
Photo: Miguel Angel
Clemente.

PLATE I.10
Armando Reverón, *La
cueva [The Cave]*, 1919, oil
on canvas, 153.7 × 161.25
cm. / 39¾ × 61³⁄₁₆ in.
Former Collection
Alfredo Boulton,
Caracas. Photo: Ron
Jameson, from Alfredo
Boulton, *La obra de
Armando Reverón* (pl. 5).

Zuloaga during a visit to Paris and associated with *modernista* painters in Spain. He had also been drawn to the work of Diego Velázquez and Francisco Goya. In 1915, an exhibition of over six hundred works by Goya at the Palacio del Retiro in Madrid made a lasting impression on Reverón. The impact of Goya's dressed and naked *majas* is evident in Reverón's *La cueva [The Cave]* (1919; PL. 1.10), in which two reclining half-naked women with veiled eyes blend into an overall vaporous blue shadow. Although his use of blue in the work of this period can be traced to his association with Ferdinandov, Reverón's *La cueva* synthesizes different modes into a symbolist representation of women, in this case, two prostitutes awaiting their customers. The painting's title is in itself suggestive, implying that these women, as potential sources of pleasure, are also threats to a male, since they might engulf him.

Reverón turned to impressionism after meeting Boggio, Mützner, and especially Ferdinandov in 1916. During the following five years he adopted Ferdinandov's blue tonalities in several paintings; however, over time he gradually eliminated blue and most other bright colors from his palette, and by the mid-1920s his paintings were virtually bled of all color. He began using a predominance of white after moving to the coastal town of Macuto near Caracas in 1921. Macuto, now known as a sprawling resort, was a quiet little town in the 1920s. There Reverón built his own home out of palm thatch and wooden posts, with rough canvas curtains at the windows, and lived there for the rest of his life with his companion and model, Juanita Motta.[47]

Reverón's move to Macuto was seen by some critics as an escape from an overindustrialized urban environment to a more primitive way of life. The late Argentine critic Marta Traba noted that this move coincided with the development of the oil industry in Venezuela.[48] In Europe it was the postimpressionists,

not the impressionists, who were alienated and who turned against over-industrialization. Reverón's life had some of the legendary aspects of Van Gogh's and Gauguin's lives. He became a recluse and later suffered mental breakdowns on several occasions, attributed by some to complications after a bout with typhoid at the age of twelve, and by others to his complex relationship with a negligent mother. Nonetheless, as an artist, his concerns with atmospheric effects and luminosity were those of the impressionists.[49]

Reverón's years in Macuto belong to his mature period. Of the three periods identified in his work—the blue before 1921, the white from about 1925 to 1934, and the sepia one from about 1936 to 1949—his most original work belongs to the white period. Some of these paintings have the vaporous haze of Monet's late work, particularly Monet's *Houses of Parliament* series (London). But for Reverón, the phenomenon of light was also a direct response to his immediate experience in a tropical setting. By the mid-1920s, the subjects of his paintings emerge as barely revealed visions in a haze of blinding white light painted with broad brush strokes on unprimed canvas. His subjects included reclining figures and coastal land and seascapes. In the

FIGURE 1.10
Armando Reverón, *El playón [Landscape,* or *The Little Beach]*, 1929, oil and tempera on canvas, 91 × 106 cm. / 35¾ × 41¾ in. Collection Eduardo López de Ceballos, Caracas. Photo: Ron Jameson, from Alfredo Boulton, *La obra de Armando Reverón* (pl. 18), courtesy Sylvia Boulton.

FIGURE 1.11
Armando Reverón,
Autorretrato con muñecas
[Self-Portrait with Dolls],
c. 1949, charcoal, chalk,
crayon, and pastel on
paper on cardboard,
64.66 × 83.5 cm. / 25½ ×
32⅞ in. Courtesy
Fundación Galería de
Arte Nacional, Caracas.
Photo: CINAP.

landscapes, trees, mountains, and beaches can be detected as pale bluish or beige shapes in an otherwise white painting. The natural tone of the canvas, visible between the brush strokes, is integral to the composition. In *El playón [Landscape,* also known as *The Little Beach]* (1929; FIG. 1.10), the barest touches of ocher, lavender, and pale blue with broad sweeps of white define trees, a beach, the sea, and a distant coastline. In *Marina [Marine]* (1931), a distant coastal landscape can be identified through white haze that is similar to one Fritz Melbye had painted in the nineteenth century. Reverón's exploitation of the bare canvas as background and use of painted white areas also bring to mind Pissarro's technique of allowing the white paper to convey effects of brilliant light in his drawings and watercolors. In spite of Reverón's elimination of all he considered unessential and his overall white surfaces, his paintings have structure and remain surprisingly solid.

Reverón's way of approaching his painting was as unusual as the finished work. The act of painting itself became a performance resembling a ritual dance that combined penitent and erotic gesturing as part of the process. He worked bare from the waist up, tightly cinching his waist and plugging his ears with cotton in order to shut out all distractions. He then attacked the canvas with lunges, grunts, and what he perceived as a necessary rhythm.[50] Unlike Jackson Pollock, who poured and dripped color onto a canvas laid out on the floor as an extension of his actions, Reverón's motions were not intended as gestures or as expressions of the individual. Rather, they evoked a trancelike state that led, through a ritualistic dance sometimes resembling a bullfight, to a finished painting as the product of this concentrated ritual.

Reverón's subjects also included indoor scenes. He depicted his thatch home looking from the inside out with the same predominance of white as in his landscapes to convey the impact of blinding light experienced as one goes from the dark interior to the sunny exterior. In many compositions he also included figures, some of which were painted from live models, others from the life-sized rag dolls he had made. These eerie, lifelike dolls with real hair and glass eyes that Reverón treated like members of his family are now part of the museum display. They can be found standing, seated, or reclining with their offspring on couches throughout the complex. Dolls appear in one of Reverón's later works, *Autorretrato con muñecas [Self-Portrait with Dolls]* (c. 1949; FIG. 1.11), one of several such works in which he is a part of the family group. Regardless of the psychological complexities of Reverón's character, the dolls, like the rest of his household in Macuto, should be seen as a significant part of his artistic production.

Reverón exhibited little during his lifetime. His first and only individual exhibition took place in Caracas in 1933, and a short time later, he exhibited in Paris. It took another generation of artists such as Jacobo Borges and Alejandro Otero to appreciate the value of Reverón's contribution to Venezuelan art.

POSTIMPRESSIONISM

As is evident in the work of Fader and Reverón, impressionism became a source for idiosyncratic mutations in Latin America. On the other hand, postimpressionism, because of its broader definition independent of any single style, was widespread. Some of postimpressionism's characteristics were implicit in *modernismo* and some symbolist art, but it also existed on its own, even though it did not have a name in Latin America at the time it was occurring. The popularity of postimpressionism can be attributed to its synthetic adaptability that could even accommodate elements of expressionism as well as Gauguin's flat design. Many postimpressionists admired Cézanne and Van Gogh as well as Gauguin for their use of color or brushwork. Two major exponents of postimpressionism were the Colombian Andrés de Santa María and the Uruguayan Pedro Figari.

Santa María (1860–1945), like Reverón, had been something of an anomaly in his country during his lifetime. But rather than being alienated like Reverón, Santa María was misunderstood by his compatriots, and his art was not appreciated until after his death. Until the late 1950s, Colombian art consisted primarily of various forms of naturalism and Mexican-inspired social realism. Santa María's work presented too much of a departure from these traditions to be appreciated at the time. Perhaps for this reason, he spent only thirteen years of his eighty-five-year life in Colombia. He was taken to Europe at the age of two and lived first in England, then France. Following the pattern of other artists from Latin American countries, he studied at the Fine Arts Academy in Paris and participated in several Salon des Artistes Français exhibitions. He also met Zuloaga and Rusiñol in Paris, and later studied with Rusiñol in Spain. Consequently, his formation incorporated both the French and Spanish schools.

As both sculptor and painter, he worked in Colombia on two occasions, from 1893 to 1897 and from 1904 to 1911. During his second stay in Bogotá, he taught art, directed the School of Fine Arts, and established a School of Decorative Arts and Industries as an annex for ceramic and silver work, bronze casting, and wood and stone carving.[51] But in spite of his efforts, he found a hostile environment in his country, and when he exhibited in Bogotá in 1911, his work was ill received. He returned to Europe the same year, settling in Brussels until his death.

Santa María's early career straddled both the nineteenth and the twentieth centuries. In the 1890s he painted genre scenes that reveal an interest in capturing fleeting effects of light and shimmering water, but there was more of Jean-François Millet and early Sorolla in his work than of the impressionists. In *Las segadoras [Gleaners]* (1895), he makes a clear reference to Millet's *The Gleaners,* but in Santa María's version, the gleaners are three Colombian women shown in the highland Colombian savannah wearing traditional costumes and the bowler hats typically worn by Andean Indian women. Santa María went through a short-lived impressionist phase from about 1904 to the middle of the following decade when he worked in Colombia and Macuto (where Reverón was to live a few years later).

Santa María's postimpressionist phase began in the 1920s, but instead of embracing Van Gogh's or Gauguin's undulating designs, he adopted the expressionist distortions of his contemporaries Oskar Kokoshka and Chaim Soutine tempered by the naturalism of Spanish painting. The sense of discomfort generated by Santa María's paintings comes not from the distortions, which in his work are limited to figural elongations, but to his perverse color combinations. In *Anunciación [Annunciation]* (1922; PL. 1.11), all of the traditional iconography for this subject is present: the Virgin's book, lilies, and the dove of the Holy Spirit. But the Virgin

and the archangel appear as contemporary aristocratic types dressed in black against a vivid red background. This color inversion gives the painting a profane symbolist twist more appropriate for a satanic ritual.[52] Santa María's taste for contradiction is also evident in *Bodegón con figura [Still Life with Figure]* (1934; PL. 1.12), in which a woman, clearly recognizable as the same individual as the Virgin in *Anunciación,* stands behind a gargantuan spread of fish, cheeses, fruits, ham, and an earthen jug of wine—all of which takes up the whole foreground of the picture. The arrangement of figure and table is a take on Henri Matisse's *Harmony in Red* of 1909. But in contrast to Matisse's appealing colors, Santa María used color in the manner of the German expressionists to jolt the viewer's sensibilities. His banquet consists of thick layers of dark reds, ochers, and prunes that emphasize a repulsive, rather than an appetizing, side of this culinary overload. The unappealing mass of food is also at odds with the gracious, aristocratic female figure. Except in his early works, Santa María's subjects were not identifiably Colombian but were international. Perhaps for this reason neither his status as a Colombian citizen nor his importance as an innovative painter was acknowledged until the 1960s. Only then did a change in critical attitudes in Colombia bring a new awareness of Santa María as Colombia's first modernist.[53]

Conversely, the Uruguayan Pedro Figari (1861–1938), a contemporary of Santa María's, preferred the decorative arabesques and appealing color of Vuillard and Bonnard. Figari also made Uruguay's and Argentina's landscape, creoles, and blacks his main subjects, imbuing them with poetic qualities.[54] Born to an Italian immigrant father and an Uruguayan mother, Figari was strongly motivated by the youth of his country (founded just thirty-one years before his birth) to contribute to its cultural development and to the formulation of an appropriate artistic expression. As a

lawyer, an educator, a journalist, a parliamentarian, a philosopher, and a writer as well as a painter (another Renaissance man like Dr. Atl), he had actively participated in the country's political and legal arena before the turn of the century.[55]

Figari expressed his commitment to his culture in his abundant writings, and he believed that art should be an expression of this culture. He set down his ideas in a three-volume book, *Arte, estética, ideal* (1912), illustrating his peculiar position as a progressive intellectual whose theories incorporated elements of positivism, Darwinism, Marxism, and the ideas of the French philosopher Henry Bergson. The latter had been especially influential on late-nineteenth- and early-twentieth-century European artists.[56]

In 1910, Figari had developed a method of industrial design and art education based on the notion that "either a country industrializes itself or others would industrialize it."[57] He sought to establish a program of mass education in the industrial arts for the purpose of awakening a "national soul" and producing "worker/artists."[58] In a parallel with the Mexicans, Figari believed that a method of design could be developed based on "our flora, our fauna, our virgin archaeology," in light of the "anguished exhaustion experienced by the peoples of the old world."[59] He truly believed in the possibility of a cultural renewal through art and industry independent of Europe. But his plans for educational reform in Uruguay were thwarted by bureaucracy and rivalry. Nevertheless, his pioneering work in the art education of his country did not go unnoticed by his Mexican colleagues. In appreciation, the Mexican artists Julio Castellanos and Manuel Rodríguez Lozano, who were visiting Buenos Aires when Figari lived there in the early 1920s, presented him with a signed copy of Adolfo Best-Maugard's book *A Method of Design.*[60]

Although Figari had painted in his spare time for many years, he began to devote full time to his art after his move to Buenos Aires in 1921. He had studied

PLATE 1.11
Andrés de Santa María,
Anunciación [Annuncia-
tion], 1922, oil on canvas,
132 × 173 cm. / 52 × 68⅛ in.
Courtesy Museo Nacional
de Colombia, Bogotá.

PLATE 1.12
Andrés de Santa María,
Bodegón con figura [Still
Life with Figure], 1934, oil
on canvas, 60½ × 63½ in.
Courtesy Museo Nacional
de Colombia, Bogotá.

FIGURE 1.12
Pedro Figari, *Baile criollo [Creole Dance]*, c. 1925, oil on cardboard, 52.1 × 81.3 cm. / 20½ × 32 in. The Museum of Modern Art, New York. Gift of the Honorable and Mrs. Robert Woods Bliss. Photograph © 1997 The Museum of Modern Art, New York.

briefly in Montevideo with Godofredo Somavilla and possibly earlier in Venice in 1886 during his first trip to Europe. His early paintings have some of the characteristics of Spanish *modernismo,* but by 1919 the impact of the intimists Bonnard and Vuillard had taken over. His friend and fellow painter Milo Beretta, with whom he had gone on painting trips in Montevideo, owned works by Van Gogh, Bonnard, and Vuillard that he had brought back from Europe. Like Vuillard, Figari painted on cardboard and adopted Van Gogh's and Anglada-Camarasa's sinuous brushwork.[61] But Figari, unlike the Europeans, gave up using models in favor of memory, or what the Argentine writer Victoria Ocampo referred to as his "far away and long ago" with brushes (an allusion to the title of a book on the customs of La Plata by the nineteenth-century Argentine-English naturalist Guillermo Henrique Hudson).[62] Figari eschewed scenes of contemporary life in favor of evocations of earlier events, particularly those of colonial salons and nineteenth-century life in the Río de la Plata region.

In his paintings and drawings, Figari sought to capture and record a vanishing *platense* history by creating his own vision of a genesis of the pampa. His sequence ranged from primeval scenes of naked Indians looking over an endless plain in peaceful coexistence with grazing cattle through Argentine and Uruguayan nineteenth-century traditions and folklore. Although Figari used sketches as a basis for his paintings, the fact that he painted from imagination allowed him to eliminate what he considered unessential elements, including shadows, a feature that resulted in a timeless quality in many of his paintings. His richly painted skies suspended over ranches or patios seldom betray the time of day or night except for the frequent presence of the moon hovering near the edge of a tree, near a cloud, or above a patio as in *Baile criollo [Creole Dance]* (c. 1925; FIG. 1.12). A sense of timelessness was a characteristic in some postimpressionist painting, particularly that of Cézanne, whose notion of time represented a Bergsonian synthesis of many moments. But Cézanne's paintings

were identifiably day scenes, whereas Figari's were ambiguous. A night moon might appear in what otherwise looks like a day scene.

Many of Figari's themes were the same ones Carlos Pellegrini had painted almost a century earlier. They included nineteenth-century upper-class salons, popular dances, and *tertulias* (conversation gatherings). But unlike Pellegrini's detailed scenes, Figari preferred the blurred effects of a dreamed reality filtered through his imagination or memory. He also injected an element of caricature in his work. In his paintings of eighteenth- and nineteenth-century salons, he satirized the pretentiousness of his subjects in this manner. These figures converse or dance in rooms hung with ornate crystal chandeliers and the inevitable portrait of some forebear on a wall. In some paintings, he alluded to a specific historical moment, as is the case in the undated *Media caña federal* (the *media caña* is a creole dance), which shows a ball during the time of Juan Manuel Rosas and his Federalist Party. The event takes place in a red room in which all the ladies are also dressed in red.

In Argentina, Figari also began painting scenes of *estancias* (Argentine ranches) and the pampa with grazing cattle. He had formed a close friendship with the writer and *estanciero* Ricardo Güiraldes, author of the novel *Don Segundo Sombra* (1926) about an old gaucho and Argentine ranch life. Figari's association with Güiraldes led to a productive exchange. Figari inspired Güiraldes as he wrote the novel, and in turn, Figari's visits to Güiraldes's *estancia* outside Buenos Aires prompted him to paint some of his most memorable ranch scenes. *Fiesta en la estancia [Fiesta at the Ranch],* an undated painting of his Buenos Aires period, depicts a group of women in crinolines and men dancing in front of an *estancia* under a moonlit sky.

Figari painted numerous scenes of creole and black dances. The creole dances represented gauchos and their ladies dressed in nineteenth-century crinolines dancing to popular rhythms in pink- or white-walled patios or under the

FIGURE 1.13

Pedro Figari, *Pericón bajo los naranjeros [Pericón beneath the Orange Trees]* (titled *Pericón Creole Dance,* no. 30 in Marianne Manley, *Intimate Recollections of the Rio de la Plata: Pedro Figari*), n.d., oil on cardboard, 70 × 100 cm. / 27½ × 39¼ in. Museo Nacional de Bellas Artes, Buenos Aires. Photo: Ron Jameson, from Marianne Manley, *Intimate Recollections of the Rio de la Plata: Pedro Figari* (p. 6). Courtesy Museo de Artes Plásticas, Montevideo.

PLATE 1.13
Pedro Figari, *Candombe*, 1924, oil on cardboard, 60 × 80 cm. / 23⅝ × 31½ in. Collection Leonardo Grozoysky, Buenos Aires. Courtesy Leonardo Grozoysky.

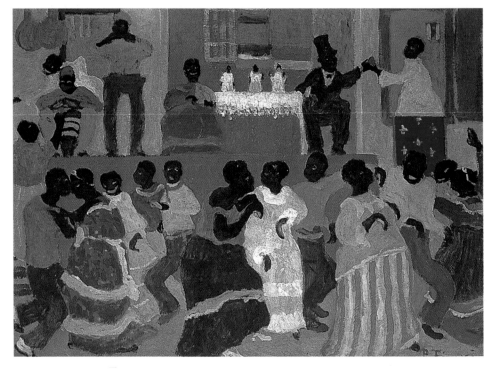

trees. Scenes of rural dances, such as *Pericón bajo los naranjeros [Pericón beneath the Orange Trees]* of the 1920s (FIG. 1.13), are like creole counterparts of French scenes such as Auguste Renoir's *Dancing at the Moulin de la Galette* or Georges Seurat's *Sunday Afternoon at the Isle of the Grande Jatte.* But Figari used color more expressively and emulated the sinuous brush strokes of Van Gogh. He also assigned specific meanings to color, as he did with red in paintings with references to Rosas's times. While these are post-impressionist characteristics, some of his scenes—though not all—are filled with the joyful exuberance of the impressionists rather than the anguish and sense of alienation often present in Van Gogh's art. Figari translated local scenes as well as the endlessly flat and uneventful pampa landscape into memorable effects of earth and sky.[63] When he exhibited some of his paintings at the Drouet Gallery in Paris in the early 1930s, Vuillard and Bonnard, who were among the visitors to the exhibition, commented that Figari was lucky to have found such "lovely, fresh and poetic" things to paint, and that they too would have liked to paint them.[64] But for Figari these subjects were as commonplace as Vuillard's and Bonnard's interiors and gardens were to them.

Figari's representations of Uruguayan and Argentine blacks at leisure in their own homes; visiting one another; attending wakes, weddings, and funerals; or dancing the *candombe* (an Afro-Uruguayan dance) were more controversial. Although black culture was the rage in Paris and New York during the 1920s, Figari was the first artist in the Southern Cone, where racism was rampant, to represent blacks as independent citizens instead of as subordinates of white masters.[65] Many of his paintings showed blacks dancing *candombe,* a profane blend of a European quadrille and an African (Bantu) rhythm (not to be confused with the Brazilian *candomblé,* which is a religious ritual combining elements from African and Catholic religions and practiced widely in the northeast and other coastal regions of Brazil). The *candombe* was danced by Uruguayan and sometimes Argentine blacks on special occasions such as carnival, Christmas, Easter, the Day of Kings, and other Catholic holidays. Since the custom of dancing the *candombe* had all but died out by the time Figari took up the subject in his paintings, he based his

representations of it on written and verbal accounts. He had also studied the ways of blacks as a youth when he visited a rooming house in a black community in Montevideo and sketched its inhabitants from life.

In Figari's *candombe* scenes, the dancers are shown wearing the clothes they inherited from their white masters, for whom they had worked as domestics. The women usually wore flowery crinolines, and some of the men, crepe-hung top hats and tuxedos.[66] Except for the undated *Candombe federal,* whose title specifically refers to the time of Rosas's administration in Argentina, most of the paintings of this subject had the same title. In *Candombe* of 1924, a "king" and "queen," traditionally elected for the day, preside over the dance from their respective positions on either side of an altar with three cult figures on it set up in a room (PL. 1.13). The cult figures have the double attributes of African deities and Catholic saints. On the left, a drummer plays a *tamboril* (a type of bongo drum), and a master of ceremonies on a stage next to him directs the dance that takes place in the foreground.[67]

Figari chose blacks as subjects less for their exotic appeal than for their embodiment of his radical theories about Western society. In the process, he unwittingly stereotyped his subjects in a manner that would be seen as racist by today's standards. In a parallel with Gauguin, who found in Tahitians a return to innocence, Figari saw in blacks an example of all the qualities missing in contemporary white civilization. Because, according to him, they had spiritual integrity without hypocrisy and were unburdened by Christian morality, they were better adjusted to normal human experience than were overcivilized whites, since blacks followed their instincts.[68] At the time, his beliefs were the commonplace ones of many artists who sought in non-Western cultures ways to reinvigorate their own art. Figari's familiarity in the early 1920s with French art and literature on black culture undoubtedly played a role. Taken in the context of his time, his introduction of blacks and popular creole types as the subjects of his paintings was, to a conservative Argentine and Uruguayan public, both daring and provocative.

Figari belongs to the *modernista* generation of Herrán, Egas, and Bernaldo de Quirós, all of whom introduced local and rural types from the lower or marginalized classes in a new anti-academic style. These artists painted a class of society never before represented with such boldness and candor in a South American country. They had replaced the safe and distant visions of nineteenth-century Eurocentric painting with images of a reality that had been there all along but that they were now presenting from an uncomfortably close point of view. The *modernistas* had discovered their own popular traditions and landscape, and they presented them in a new vernacular form based on a clever synthesis of Spanish, French, and Italian tendencies that paralleled Rubén Darío's *modernismo.* These artists' manner of representing their subjects was also contemporary with Rivera's depictions of Mexican Indians of the 1920s. But Rivera was a member of a new avant-garde generation whose style derived from cubism. It was left to this new generation to establish the linguistic and visual codes that were to be the basis of later art. But the *modernistas* paved the way.

TWO

THE AVANT-GARDE
OF THE 1920S

COSMOPOLITAN OR
NATIONAL IDENTITY?

The avant-garde in Latin America was a postwar phenomenon that flowered in the early 1920s.[1] Rather than a belated version of earlier European art, as has often been assumed, the Latin American avant-garde was a continuation of tendencies that had, to a great extent, been interrupted in Europe by the First World War. It synthesized cubist and futurist elements along with their postwar distillations. In Latin America, the avant-garde overlapped chronologically with *modernismo,* but in countries where it occurred, it also displaced the latter. Writers viewed *modernismo* as romantic and *pasadista* (retrograde) in opposition to *futurista* (futurist)—the latter, a term that embodied the notion of a new urban dynamism.[2]

In both literature and art, the avant-garde took two directions: an ideological one that focused on issues of national identity, as did the art of Mexico, and an aesthetic and cosmopolitan one with an international orientation, as in Argentina and—to a lesser degree—Brazil. Regardless of the direction, by the late 1920s, the avant-garde in all these countries served as a means for artists and writers to build a new cultural identity that corresponded to a dynamic modern age.[3] To express this new identity, writers looked to futurism, and artists, to cubism and expressionism (more infrequently to futurism) for their formal models.

An avant-garde movement in art, however, did not occur in the same way everywhere. In the Andean countries (Colombia, Ecuador, Peru, and Bolivia), where, in the 1920s, urban life did not play as great a role in defining national identities for intellectuals as it did in Mexico and especially in Argentina and Brazil, the avant-garde trend was a rural one. As a result, it did not occur during the urban avant-garde period of the 1920s but surfaced in the 1930s and 1940s as the *indigenista* (nativist) movement.[4] In Cuba and Chile, an avant-garde did occur, but it was mainly in literature. Although artists there introduced in their work some formal novelties derived from postimpressionism, these novelties did not rival the writ-

ers' in daring. The Cuban avant-garde was officially launched in Havana by a group of intellectuals who founded the Grupo de Avance and a related periodical, *Revista de Avance* (1927–1930). The journal's founders, who included Jorge Mañach and Alejo Carpentier, rebelled against the "mental inertia and the moral baseness of their country"[5] and stood for "movement, change, advance."[6] Three painters affiliated with the journal, Víctor Manuel, Antonio Gattorno, and Eduardo Abela, led the Havana artistic avant-garde, known there as the "*vanguardia*." They all had studied in France as well as at the Academy of San Alejandro in Havana. In 1927, when Manuel and Gattorno exhibited their European works individually at the Asociación de Pintores y Escultores, the changes signaled by the *Revista de Avance* poets were manifested in the artists' work as an adoption of postimpressionism rather than of the more radical elements of cubism. Abela expressed dynamic movement in his illustrations for the *Revista de Avance* but not in his painting until much later.[7]

In Chile, likewise, there was no counterpart among artists for the avant-garde poet Vicente Huidobro. The latter was known in Paris for his affiliation with the French writer Pierre Reverdy and his collaboration on the journal *Nord-Sud,* and for his claim to the term *creacionismo* (creationism), a poetic form that focused on creative inventiveness in poetry.[8] Many Chilean artists had traveled to Paris and knew the work of Fernand Léger, Jacques Lipchitz, Louis Marcoussis, and Pablo Picasso. But they, too, adopted postimpressionism rather than cubism as their model. In 1923, Luis Vargas Rosas (1897–1976) founded in Santiago the Grupo Montparnasse, an artists' collective named for the famous artists' community in Paris. Other members of the group were Henriette Petit (1894–1983) and Camilo Mori (1896–1974), both great admirers of Cézanne.[9] They were later joined by the Paris-trained Chileans Jean Emar, Julio and Manuel Ortiz de Zárate, and José Perotti, who were referred to in the press as the "heroic precursors of the new sensibility."[10] In 1928, Chile's Francophile government encouraged artists to study in France by awarding them travel stipends. It should be noted that what these artists saw in Paris galleries in the 1920s was not the cubist and futurist avant-garde of earlier years, but more often was postimpressionist, late fauvist, expressionist, and some constructivist art.

In contrast, Mexican, Brazilian, and Argentine artists as well as writers did introduce formal innovations into their work. Many of the artists from these three countries had traveled to Europe earlier than some of their colleagues elsewhere and were familiar with the more radical forms of cubism and futurism. In Mexico, the avant-garde came at the end of the Agrarian Revolution (1910–1920), and its art found an ideological voice in the mural movement. In literature it was represented by two major groups: Los Contemporáneos (1928–1931) and the Estridentistas (1923–1927), each with their own journal. The poets Xavier Villaurrutia, Carlos Gorostiza, and Carlos Pellicer, who headed the first group and published the journal *Los Contemporáneos,* took a cosmopolitan and aesthetic position. The other, more aggressive Estridentistas, led by Manuel Maples Arce and Germán List Arzubide, issued manifestos with a distinctly dadaist/futurist orientation and were represented by several journals, including *Horizonte.* Numerous artists were affiliated with these groups. Rufino Tamayo, who, unlike his muralist colleagues, believed that art had an aesthetic, not an ideological, function, was active with Los Contemporáneos. The mural painters Jean Charlot and Ramón Alva de la Canal, both of whom were committed to a more activist position in their art, did futurist or cubist illustrations for *Horizonte, El Universal Ilustrado,* and other Estridentista journals as well as for books of poems by Estridentista poets.

THE MEXICAN MURAL MOVEMENT

The Mexican artistic avant-garde was the only one in Latin America to receive government support. As a result, the art of the mural painters also became a tool of the new postrevolutionary government's ambitious educational program. The artists faced two major challenges: that of introducing a new public monumental art requiring special technical skills, and that of creating an effective visual language for propaganda purposes.[11] In its early phase, the mural movement, which began under the postrevolutionary government of Alvaro Obregón (1920–1924) and his minister of education José Vasconcelos, reflected the new administration's populist objectives. Besides Alva de la Canal and Charlot, the painters included Fernando Leal, Xavier Guerrero, Roberto Montenegro, and Dr. Atl as well as Diego Rivera, David Alfaro Siqueiros, and José Clemente Orozco.

Rivera (1887–1957) had gone to Europe in 1907 on a stipend from the gover-

FIGURE 2.1

Diego Rivera, *Paisaje zapatista [Zapatista Landscape]*, 1915, oil on canvas, 143.25 × 122.75 cm. / 56⅜ × 48⅜ in. Museo Nacional de Arte, Mexico City. Archivo Fotográfico IIE/UNAM, Mexico City. Reproduction authorized by the Instituto Nacional de Bellas Artes y Literatura, Mexico City.

nor of Veracruz. Aside from a brief return trip to Mexico in 1910, he spent the years of the Mexican Revolution and World War I in Spain and France. He turned to cubism in 1913 after moving to Paris. One of his cubist paintings, *Paisaje zapatista [Zapatista Landscape]* (1915; FIG. 2.1), reflects his concern, even at a distance, for events occurring in Mexico. The painting's fragmented image contains an inventory of Mexican revolutionary symbols: a sombrero, a rifle, a cartridge belt, a serape, and the volcanic Mexican landscape celebrated earlier by one of Rivera's former teachers, José María Velasco.[12] After 1918, Rivera turned to Cézanne and Gauguin as models, to the first, for the structure of his compositions, to the second, for his colorful treatment of Tahitians, which Rivera could apply to his own depictions of Indians. Although he abandoned the fragmentations of cubism, he continued to use the cubist grid as an underlying structure. In 1921, after touring Italy to see Italian Renaissance and Byzantine murals, he returned to Mexico at the request of José Vasconcelos.

Siqueiros (1896–1974) had actively participated in Mexico's conflicts by joining the revolutionary forces of Manuel D. Diéguez against General Victoriano Huerta in 1915. Between 1919 and 1921, Siqueiros traveled to Europe as military attaché to the Mexican Consulate and during that time met Rivera in Paris. He too visited Spain and Italy, where he studied fifteenth-century Italian Renaissance murals. But he was especially taken with European modernism, and futurism in particular, incorporating its basic premises into his art and writings. As a theorist, he first formulated his ideas in Barcelona in the single issue of *Vida Americana* (1921), which he also edited.[13] This issue included Siqueiros's "Three Appeals for a Modern Direction to the New Generation of American Painters and Sculptors," dedicated to a "North, Central, and South American Vanguard," and "Mexican Cinematography." Both tracts had a distinctly futurist tone to

them.[14] In "Three Appeals," he denounced Spanish symbolism and called not only for a new dynamic art but also for the incorporation of modern techniques in art. He exhorted artists to "live our marvelous dynamic age! Let us love the modern machine which provokes unexpected plastic emotions, the contemporary aspects of our daily lives, the life of our cities under construction."[15] He later incorporated futurist devices such as film and photographic projections into his mural techniques. But instead of the fascist platform identified with Italian futurism, Siqueiros adopted a socialist one. On the other hand, he also defied the academic style favored by the Soviet government in the 1920s and 1930s, subscribing instead to an original use of modernist forms and techniques.

Orozco (1883–1949) had remained in Mexico during most of the revolution. He had joined Dr. Atl in Orizaba in 1915, contributing caricatures to Atl's pro–Venustiano Carranza journal *La Vanguardia*. Besides illustrations for that and other journals, Orozco did drawings and paintings of prostitutes and coy schoolgirls, which he first exhibited in Mexico City in 1916. The theme of the prostitute later served as a metaphor for social evils. Orozco did not go to Europe until 1932, but he was well aware of cubism and Italian Renaissance art from watching Rivera and other artists paint their first murals, as well as from reproductions and plaster replicas of works by Michelangelo and classical and Hellenistic sculpture displayed in the patio of San Carlos Academy.[16] Between 1917 and 1919, he visited the United States, including New York, where he had access to avant-garde art in the galleries.

Between 1921 and 1924, all three artists painted their first murals in the Colegio de San Idelfonso in Mexico City, an eighteenth-century building known then as the Escuela Nacional Preparatoria. Rivera painted murals in the school's Anfiteatro Bolívar, Orozco in the patio, and Siqueiros in a stairwell. But far from following a political agenda, their first murals were allegorical and reflected José Vasconcelos's Hellenic-universalist philosophy and objectives for a "publicly visible art program as a complement to his new centralized national education policy."[17] The government's main goal was didactic: to educate a broad and largely illiterate population.

In the absence of a political agenda in these early years, the three artists initially based their murals on traditional Christian and Hellenistic models and used materials—fresco and encaustic—that were durable and permanent. Rivera painted his first mural, *La Creación [The Creation]* (1922–1923; PL. 2.1), in the Anfiteatro Bolívar with encaustic (pigments mixed with hot wax) applied with a blowtorch, then heightened with gold leaf (he used fresco in his subsequent murals). *La Creación* is a symmetrical composition around a central recessed area. A blue semicircle studded with gold stars at the mural's apex evokes the Byzantine mosaics in Ravenna's San Apollinare in Classe as well as Giotto's ceiling frescoes in Padua's Arena Chapel. In Rivera's painting, the blue semicircle symbolizes Primal Energy. Hands issuing from the semicircle point in three directions, to a male figure in the central recess and, on either side of a triangular design, to the seated naked figures of Woman to the left and Man to the right.

On the back wall of the central vaulted recess, the male figure appears to grow out of a leafy pyramidal background surrounded by symbols of the four evangelists—a lion, a man, an eagle, and an ox. The figure with outstretched arms is based on Byzantine versions of the crucified Christ and Christ Pantocrator all in one. The dark-skinned woman (the Indian) and the light-skinned man (the European), one on either side, look up at personifications of the arts: Woman looks at Comedy, Song, Music, Dance, and the theological virtues surmounted by Wisdom; Man, at Tragedy, Tradition, Erotic Poetry, Knowledge, Fable, and the cardinal virtues surmounted by Science.

PLATE 2.1

Diego Rivera, *La Creación [The Creation]*, 1922–1923, encaustic and gold leaf, 7.08 × 12.19 m./ 23¼ × 40 ft. Anfiteatro Bolívar, Colegio de San Idelfonso, Mexico City. Photo: Archivos Fotográficos del CENIDIAP. Reproduction authorized by the Instituto Nacional de Bellas Artes y Literatura.

FIGURE 2.2

José Clemente Orozco, *Maternidad [Maternity]*, 1923–1924, fresco, Colegio de San Idelfonso, Mexico City. Photo: Archivo Fotográfico IIE/UNAM, Mexico City. Reproduction authorized by the Instituto Nacional de Bellas Artes y Literatura, Mexico City.

But instead of giving his allegorical figures classical features, Rivera converted them into Mexican types from the different regions of the country, particularly the southern states.[18] The presence of a snake near Man identifies him and Woman as Adam and Eve. Despite the biblical references, this mural has none of the traditional implications of sin and expulsion from Paradise. Rather, its focus is on the central figure, who is not Christ as redeemer but Emergent Man, the new cosmic man based on Vasconcelos's Pythagorean mysticism as expressed in his 1918 book, *El monismo estético* (in 1925

he also wrote *La raza cósmica,* about a strong fifth race that would result from a synthesis of the other four races found in Latin America).[19] The allegories in this mural appear to have a redemptive function in this cosmic rebirth of a race.

Orozco's early frescos on the first floor of the Preparatoria's patio (1923–1924) originally included the Botticelli-like *Primavera [Spring],* with dancing nude figures, *Maternidad [Maternity],* and *La lucha del hombre con la naturaleza [Man Strangling Gorilla].* The latter was reminiscent of classical representations of the labors of Hercules. But with the exception of *Maternidad* (1923–1924; FIG. 2.2)—of a nude mother and child perversely resembling a Renaissance Virgin and Child surrounded by floating figures—which is still in existence, Orozco later replaced these early frescos.

Siqueiros's Preparatoria encaustic and fresco mural *Los elementos [The Elements]* (1923; FIG. 2.3), subtitled *The Spirit of the Occident Descending on the Americas* by Charlot,[20] represents a monumental winged female surrounded by shells like those on the reliefs of the Temple of Quetzalcoatl in Teotihuacán near Mexico City. Siqueiros's elongated figure of St. Christopher, painted on a side wall, has no apparent connection to the main panel. These were to be Siqueiros's only

fresco murals. In subsequent ones, he used cement and industrial paints applied with a spray gun.

After 1924, all three painters turned to more contemporary subjects of populist and revolutionary orientation. This change was signaled in Siqueiros's 1923 manifesto published in *El Machete,* the organ of the newly formed Syndicate of Technical Workers, Painters, and Sculptors.[21] Besides Siqueiros, Rivera, Orozco, and five other artists signed it. The manifesto denounced "bourgeois individualism" and repudiated "so-called easel painting and . . . all art of ultra intellectual circles for being aristocratic, and [it exalted] the manifestations of a monumental art for its public usefulness. We proclaim that all aesthetic manifestation devoid of, or contrary to, popular sentiment is bourgeois." In a time of transition between the old and the new order, the "creators of beauty" must ensure that "their work present a clear aspect of ideological propaganda."[22]

When Siqueiros painted *Entierro de un obrero [Burial of a Worker]* (1924; FIG. 2.4) on a side wall beneath *Los elementos,* he became the first of the three painters to take a militant position. *Entierro de un obrero* addresses social injustice and sacrifice: Three solemn figures with faces resembling Aztec masks are shown carrying a blue coffin, presumably of a worker. In 1924 when news reached Siqueiros of the assassination of the liberal governor of Yucatán Felipe Carrillo Puerto, he dedicated the painting to him and paid him further tribute by adding a hammer and sickle on the coffin.

Siqueiros's work at the Preparatoria remained unfinished, however. In 1924, the Obregón administration came to an end and, with it, Vasconcelos's term in office. The incoming president, Plutarco Elías Calles (1924–1934), dismissed all the painters, thus stalling the mural movement as conceived by Vasconcelos. In 1926, Orozco was rehired by the Calles government to finish the patio murals at the Preparatoria. But after completing these in 1927, he painted no

more murals in Mexico for the next seven years. Rivera, on the other hand, continued to work on frescos at the Ministry of Education begun under Obregón's administration, and he received other major commissions during the Calles years that kept him busy in Mexico through the 1920s.

Calles was especially anxious to see the Mexican Revolution—and, by extension, his administration—represented in a favorable light. Rivera satisfied that objective; Orozco did not. Orozco's somber and pessimistic scenes of the revolution betrayed his disappointment over its outcome, which he perceived as a failure.[23] In 1926 he replaced most of his earlier frescos on the Preparatoria's first floor with scenes related to contemporary or recent events, done in a style that had undergone a change and betrayed Orozco's new understanding of cubism, which he translated into bold, simplified

FIGURE 2.3
David Alfaro Siqueiros, *Los elementos [The Elementos],* 1923, encaustic and fresco, Colegio de San Idelfonso, Mexico City. Photo: Archivos Fotográficos del Centro Nacional de Investigación, Documentación e Información de Artes Plásticas (CENIDIAP), Mexico City. Courtesy of Sociedad Mexicana de Autores de las Artes Plásticas (SOMAAP), Mexico City. © David Alfaro Siqueiros / SOMAAP, México, 1998.

FIGURE 2.4

David Alfaro Siqueiros, *Entierro de un obrero [Burial of a Worker]*, 1924, fresco, Colegio de San Idelfonso, Mexico City. Photo: Archivos Fotográficos del CENIDIAP, Mexico City. Courtesy of SOMAAP, Mexico City. © David Alfaro Siqueiros/SOMAAP, México, 1998.

forms. In *La huelga [The Strike]* (FIG. 2.5), three men stand loosely holding a red cloth in front of a narrow blind door from which a disembodied head mysteriously emerges. The head is the only remaining portion of the earlier mural *Cristo destruye su cruz [The New Redemption]*, in which an angry and disappointed Christ has returned to destroy his cross. In 1926, the Mexican clergy had launched a strike against governmental oppression, which resulted in a government crackdown. Orozco's *La huelga* can be interpreted as a timely—if enigmatic—reminder of this episode in Mexican history. As a consequence of this event, no public masses were conducted for three years and angry believers known as Cristeros terrorized people in the countryside.[24]

In 1924, Orozco had satirized religion, the law, and social injustices in the caricature style of his journal illustrations in a cycle of frescos on the patio's second floor. But *Cristo destruye su cruz*—now *La huelga*—was Orozco's earliest reference to Christ as a revolutionary activist. Among his other murals of 1926 are *La trinchera [The Trench]* on the ground floor and *La despedida de la madre [Farewell to the Mother]* and *La clase obrera [The Working Class]* on the third. These panels, like those Rivera painted in the Agricultural School in Chapingo during the same years, are among the first to refer directly to the Mexican Revolution and to the worker. In *La trinchera* (FIG. 2.6), the bodies of two dead figures, one crossed over the other in the form of an ✕, and a third one kneeling and shielding his face, all set against a red background, express defeat. The tragic, larger-than-life figures in the third-floor panels *La despedida de la*

FIGURE 2.5

José Clemente Orozco, *La huelga [The Strike]*, 1926, fresco, Colegio de San Idelfonso, Mexico City. Photo: Archivo Fotográfico IIE/UNAM, Mexico City. Reproduction authorized by the Instituto Nacional de Bellas Artes y Literatura, Mexico City.

FIGURE 2.6

José Clemente Orozco, *La trinchera [The Trench]*, 1926, fresco, Colegio de San Idelfonso, Mexico City. Photo: Archivo Fotográfico IIE/ UNAM, Mexico City. Reproduction authorized by the Instituto Nacional de Bellas Artes y Literatura, Mexico City.

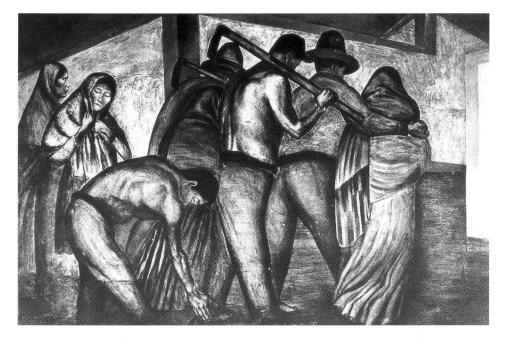

FIGURE 2.7

José Clemente Orozco, *La clase obrera [The Working Class]*, 1926, fresco, Colegio de San Idelfonso, Mexico City. Photo: Archivo Fotográfico IIE/UNAM, Mexico City. Reproduction authorized by the Instituto Nacional de Bellas Artes y Literatura, Mexico City.

madre and *La clase obrera* (FIG. 2.7) also convey doom and hopelessness.

La clase obrera is also Orozco's first mural on the worker theme. Unlike Saturnino Herrán's 1908 allegorical painting *El trabajo* (see FIG. 1.3), in which the focus is on the cycles in the worker's life, Orozco's painting directly addresses social injustice and the anonymity of an exploited class. Nonetheless, beneath his indictments and apparent cynicism lies an incipient faith in the redemptive potential of industriousness, a theme Orozco

elaborated in later murals. At the end of 1927, he left Mexico for the United States.

Between 1923 and 1929, Rivera also took up the worker and other themes in murals for the chapel of the Universidad Autónoma de Chapingo, an agricultural school, and for the Ministry of Education in Mexico City. However, he presented these subjects in a more hopeful light than Orozco had. Rivera's optimistic depictions and exotic color in these two mural cycles accorded with the nationalistic objectives of the Calles government.

PLATE 2.2
Diego Rivera, *La sangre de los mártires [Blood of the Revolutionary Martyrs Fertilizing the Earth]*, 1926–1927, fresco, 2.44 × 4.91 m / 8 × 16 ft. Chapel of the Universidad Autónoma de Chapingo, Chapingo, Mexico. Photo: Archivos Fotográficos del CENIDIAP. Reproduction authorized by the Instituto Nacional de Bellas Artes y Literatura.

In Chapingo, Rivera took advantage of the chapel's lateral northwest and southeast walls (the latter pierced by round windows), the vaulted ceiling, and the arched end wall to present a sequence of scenes leading from struggle to the fruitful outcome of the revolution. These scenes were artfully located to correspond to a traditional Christian iconographical program.

Social Revolution on the northwest side walls leads from struggle, uprising, and death to ultimate triumph (resurrection), and Natural Evolution on the southeast ones evolves from the sacrificial *La sangre de los mártires [Blood of the Revolutionary Martyrs Fertilizing the Earth]* in the narthex through scenes of germination to abundance. Social Revolution is dominated by workers, miners, and peasants who take control; Natural Evolution, by voluptuous female nudes symbolizing germination, production, and agricultural bounty. In *La sangre de los mártires* (1926–1927; PL. 2.2), the cutaway scene of the buried bodies of Emiliano Zapata and Otilio Montaño in their coffins, visible beneath the new vegetation that grows as a result of their sacrifice, is based on the biblical story of the barren tree that returned to life with Christ's sacrifice. The notion of death and rebirth was also present in the pre-Hispanic annual corn cycle culminating in the harvest, which was especially relevant for a school of agriculture. In these murals, Rivera addressed the con-

cepts of work as a source of production and revolution as the catalyst to this process.

The Revolution and Evolution scenes converge at the arched apse with *La tierra liberada por las fuerzas naturales controladas por el hombre [Liberated Earth with Natural Forces Controlled by Man]* (FIG. 2.8), a scene dominated at the top by a monumental reclining nude who holds a budding plant in her right hand and points upward with her left at the exact center of the composition. She is surrounded by nude male and female figures who control and utilize natural elements such as water, wind, and fire. This panel's strategic location at the apse end of the chapel emphasizes the idea that humankind, not supernatural forces, controls nature. In the pendentives of the vaulted ceiling, male figures (obviously inspired by Michelangelo's Ignudi in the Sistine Chapel) with agricultural attributes lead the eye to the vaulted bays near and above the apse end. Sharply foreshortened male figures occupy the center of the vaults. In one bay, two men discover a red star; in another, they hold a hammer and sickle. The overall theme of death and regeneration in these scenes also recalls Giotto's Arena Chapel. But here this regeneration takes place through revolution, industriousness, and the new order signaled by the hammer and sickle and the red star.[25]

Rivera's murals in the Ministry of Education cover three floors of two adjacent patios, the Court of Labor, the Court of Fiestas, and a stairwell. The main themes portrayed on the first floor are the crafts, industries, and folklore of Mexico. Mining, farming, and the making of pottery are represented on the east wall of the Court of Labor. *Entrada a la mina [Entering the Mine]* and *Saliendo de la mina [Leaving the Mine]* show exploited miners who are carefully monitored as they enter and leave the mine. In *Saliendo de la mina* (1924; FIG. 2.9), a Christ-like miner with outstretched arms is being frisked as he emerges from the pit. In a number of these panels, Rivera adapted

Mexican imagery to Renaissance models. In *El abrazo [The Embrace]* (1924; FIG. 2.10), the figures of an embracing farmer and a worker are obviously patterned after those of Joachim and Anna (the Virgin Mary's parents) in Giotto's panel *Meeting at the Golden Gate* in Padua's Arena Chapel, but Rivera substituted Mexican hats for the halos. Some of the background landscape scenes flanking and surmounting doors also reveal Rivera's acquaintance with Simone Martini's murals in the Palazzo Pubblico in Siena.

In the Court of Fiestas, Rivera also celebrated Mexico's resources. The first floor is devoted to Mexican folklore and popular religious and secular festivals such as the corn harvest, local produce markets, May Day celebrations, and regional dances. The festivals include scenes of the Day of the Dead in urban and rural locations. In *Día de los Muertos en la ciudad [Day of the Dead in the City]* (1923–1924; FIG. 2.11), Rivera identified with the celebrants by including himself and his wife, Lupe Marín, in the crowd.

On the third floor of the Court of Fiestas, the *corridos* (ballads) of the Agrarian Revolution take up the west and north walls. Rivera unified and linked these scenes by painting a continuous festoon above them containing the verses they illustrate. Some of the *corrido* scenes on the north wall satirize the ruling classes and the social disparities between rich and poor. For example, in *Banquete de Wall Street [Wall Street Banquet]* (1928; FIG. 2.12), he included J. D. Rockefeller, Henry Ford, and J. P. Morgan among the diners. In contrast, the nearby *El sueño [Sleep—Night of the Poor]* shows a group of Mexicans sleeping in the street huddled together for warmth and comfort.

In 1929, Rivera began work on two major fresco commissions, one in the loggia of the Palacio de Cortés in Cuernavaca, which he finished before going to the United States in 1930, the other in the stairwell of the Palacio Nacional in Mexico City, finished in 1935 after his return. Both depict Mexican

history. The Cuernavaca murals, which were commissioned by Dwight W. Morrow, the new U.S. ambassador sent to Mexico to improve diplomatic relations between the two countries, cover three walls of the open second-floor loggia of the Palacio de Cortés. The subject is the history of the state of Morelos and its capital, Cuernavaca (the name is a corruption of the Nahuatl word *cuauhnahuac*, meaning "place of the trees"), from the conquest in 1521 to the agrarian revolt. Its leader Emiliano Zapata, who was from Morelos, is shown on the south wall with his Ucello-like white steed.[26] Rivera introduced the ideas of time and space in this mural by depicting scenes that had occurred in the surrounding countryside in the exact location where the palace stands. In *Construyendo el Palacio de Cortés [Building the Palace of Cortés]* (1929; FIG. 2.13), Indians under the stern guidance of the Spanish conquerors are shown build-

FIGURE 2.8
Diego Rivera, *La tierra liberada por las fuerzas naturales controladas por el hombre [Liberated Earth with Natural Forces Controlled by Man]*, 1926–1927, fresco, Chapel of the Agricultural School at the Universidad Autónoma de Chapingo, Chapingo, Mexico. Photo: Archivo Fotográfico IIE/UNAM, Mexico City. Reproduction authorized by the Instituto Nacional de Bellas Artes y Literatura, Mexico City.

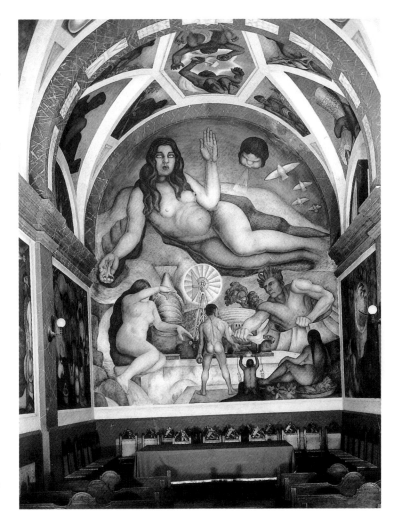

FIGURE 2.9

Diego Rivera, *Saliendo de la mina [Leaving the Mine]*, 1924, fresco, First Floor, Court of Labor, Ministry of Public Education, Mexico City. Photo: Archivos Fotográficos del CENIDIAP, Mexico City. Reproduction authorized by the Instituto Nacional de Bellas Artes y Literatura, Mexico City.

FIGURE 2.10

Diego Rivera, *El abrazo [The Embrace]*, 1924, fresco mixed with nopal juice, First Floor, Court of Labor, Ministry of Public Education, Mexico City. Photo: Archivos Fotográficos del CENIDIAP, Mexico City. Reproduction authorized by the Instituto Nacional de Bellas Artes y Literatura, Mexico City.

FIGURE 2.11

Diego Rivera, *Día de los Muertos en la ciudad [Day of the Dead in the City]*, 1923–1924, fresco, First Floor, Court of Festivals, Ministry of Public Education, Mexico City. Photo: Archivos Fotográficos del CENIDIAP, Mexico City. Reproduction authorized by the Instituto Nacional de Bellas Artes y Literatura, Mexico City.

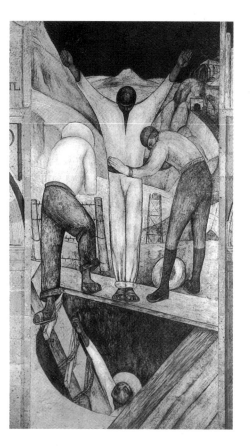
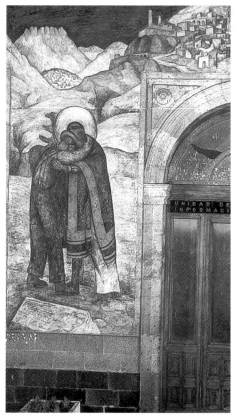
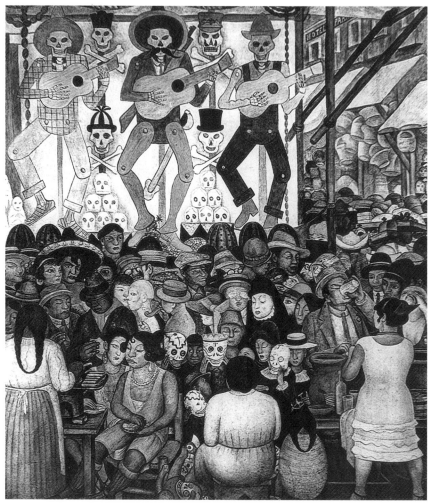

ing the Cortés palace from the ruins of their earlier temples. In *Cortés y los encomenderos [The New Religion],* the natives are being converted to Christianity and branded like cattle.

The stairwell murals in the National Palace in Mexico City were commissioned in 1929 by the interim President Emilio Portes Gil (who served between two Calles periods). Here Rivera developed the history narrative on an unprecedented scale in a sequence of scenes extending from the conquest to the beginning of the presidency of Lázaro Cárdenas in 1935. The packed narrative unfolds over the expanse of five arched spaces flanked on the right by a scene of the pre-Hispanic world beneath a setting sun, and on the left, by the world of the future with Karl Marx standing beneath a rising sun. The central portion (FIG. 2.14) reads vertically from the conquest to the Mexican Revolution. It begins at the bottom with the battle between Cortés's armies and the Aztecs, which is separated from the colonial and later periods by the Mexican symbol—the eagle sitting on a cactus—with the Aztec war symbol in its beak instead of the traditional serpent. Above, Miguel Hidalgo appears among the nineteenth-century heroes of Mexican independence. To his right (the viewer's left) are Porfirio Díaz and his ministers. The mural culminates at the top with Emiliano Zapata, Pancho Villa, and other revolutionary figures. Read horizontally from the center out to left and right, colonial and nineteenth-century episodes unfold on either side, including *Conquista y colonización [Spanish Conquest and Colonization], Imperialismo norteamericano [United States Invasion (1847)],* and *La reforma de 1857 y Juárez [Reform and the Era of Benito Juárez]* to the right, and colonial scenes of the Inquisition, *La dictadura porfiriana [The Porfirian Era (1876–1910)],* and *Imperialismo francés [French Intervention and the Empire under Maximilian]* to the left. Rivera's underlying use of the cubist grid enabled him to preserve astounding unity in a very complex and detailed scene.

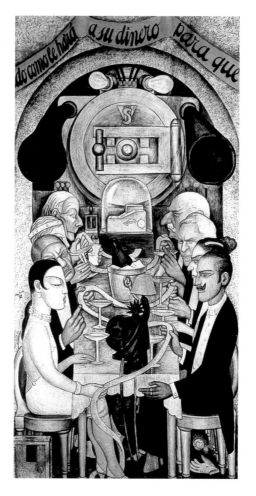

FIGURE 2.12

Diego Rivera, *Banquete de Wall Street [Wall Street Banquet],* from the *Corrido Revolucionario [Revolutionary Ballad]* series, 1928, fresco, Third Floor, Court of Festivals, Ministry of Public Education, Mexico City. Photo: Archivos Fotográficos del CENIDIAP, Mexico City. Reproduction authorized by the Instituto Nacional de Bellas Artes y Literatura, Mexico City.

The impact of Rivera's stay in the United States is evident in a comparison between the two side walls. The organic and colorful style of *La leyenda de Quetzalcóatl [The Legend of Quetzalcoatl]* (1929; FIG. 2.15) on the north wall, showing Quetzalcoatl (feathered serpent) as the Toltec ruler and deity, is absent in the utopian Karl Marx panel *El México de hoy y de mañana [Mexico Today and Tomorrow]* (1935; FIG. 2.16). Instead, Rivera crowded the figures of the latter mural into a regimented and geometric composition. His blatant indictment of capitalism (and the clergy) in this panel can also be attributed in part to his experiences in the United States, among which was the 1933 destruction of his Rockefeller Center murals because he had included a portrait of Lenin. But his fascination with the industrialized world of the United States is also evident in the cold, gray steel pipes that frame and divide the scenes in *El México de hoy y de mañana.*

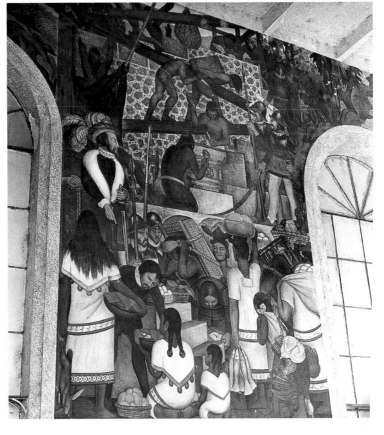

FIGURE 2.13

Diego Rivera, *Construyendo el Palacio de Cortés [Building the Palace of Cortés],* from *La Historia de Cuernavaca y Morelos [The History of Cuernavaca and Morelos]* series, 1929, fresco, Second Floor Loggia, Palace of Cortés, Cuernavaca, Mexico. Photo: Archivo Fotográfico IIE/UNAM, Mexico City. Reproduction authorized by the Instituto Nacional de Bellas Artes y Literatura, Mexico City.

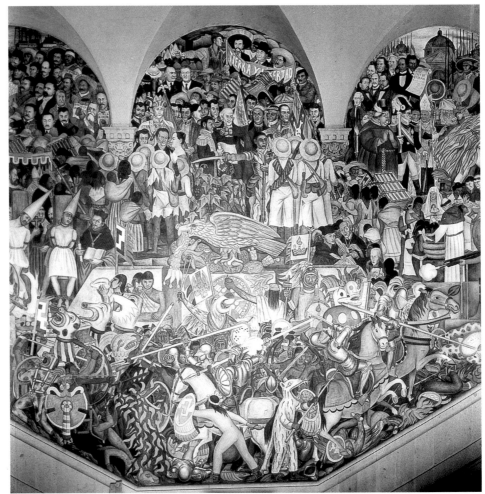

FIGURE 2.14

Diego Rivera, *Historia de México de la conquista hacia el futuro [History of Mexico from the Conquest to the Future],* 1929–1935, five bays and two end panels in the stairwell, general view fresco, west wall, Palacio Nacional, Mexico City. Photo: Archivo Fotográfico IIE/UNAM, Collection Luis Márquez Romay, Mexico City. Reproduction authorized by the Instituto Nacional de Bellas Artes y Literatura, Mexico City.

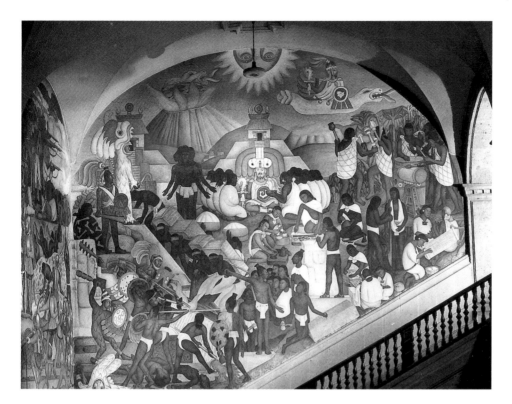

FIGURE 2.15
Diego Rivera, *La leyenda de Quetzalcóatl [The Legend of Quetzalcoatl]*, 1929, fresco, north wall, Palacio Nacional, Mexico City. Photo: Archivo Fotográfico IIE/UNAM, Collection Luis Márquez Romay, Mexico City. Reproduction authorized by the Instituto Nacional de Bellas Artes y Literatura, Mexico City.

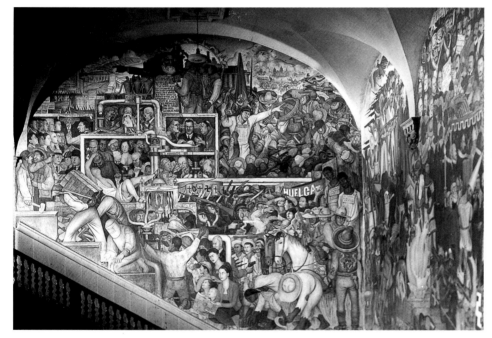

FIGURE 2.16
Diego Rivera, *El México de hoy y de mañana [Mexico Today and Tomorrow]*, 1935, fresco, south wall, Palacio Nacional, Mexico City. Photo: Archivo Fotográfico IIE/UNAM, Collection Luis Márquez Romay, Mexico City. Reproduction authorized by the Instituto Nacional de Bellas Artes y Literatura, Mexico City.

Rufino Tamayo (1898–1991), who in a later phase painted murals as well, rejected the narrative and ideological content of his muralist colleagues. Rather than describe his culture descriptively, he wanted to express it by formal means. Although he did not go to Europe until 1949, he was well acquainted with modernism through his affiliation with Los Contemporáneos and his first stay in New York from 1926 to 1928. His central subject was the human figure, but instead of the larger-than-life heroes that dominated the art of the muralists, Tamayo's humans were ordinary generic types not always based on live models. Instead, he sought sources in pre-Hispanic and Mexican folk art, which he translated into cubist-based compositions in which color orchestrations played an important part. His first awareness of pre-Hispanic art came in 1921 when Vasconcelos had

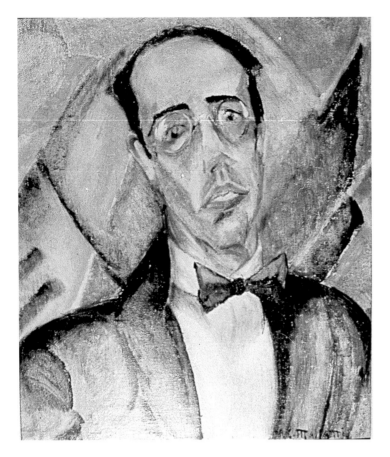

FIGURE 2.17

Anita Malfatti, *Mario de Andrade,* 1922, oil on canvas, 51 × 41 cm. / 20 × 16⅛ in. Mario de Andrade Archives, IEB of the Universidad de São Paulo, Arquivo Marta Rossetti Batista.

appointed him to head the Department of Ethnographic Drawing at the National Museum of Archaeology in Mexico City. Later, he also collected pre-Columbian and popular art. However, it was not until the 1940s, when interest in ideologically based art declined abroad, that Tamayo's reputation came to equal that of his colleagues in Mexico.

BRAZILIAN MODERNISM

In Brazil and Argentina, where the majority of artists were more interested in introducing new forms of art than in espousing ideologies, they also retained more visible ties with Europe than did their Mexican counterparts in the 1920s. In Brazil, modernism was introduced in art in 1913 with an exhibition in São Paulo of work by the Lithuanian-born painter Lasar Segall, a resident of Germany at the time and a former member of Der Blaue Reiter (The Blue Rider, a group of German expressionist painters

who exhibited together between 1912 and 1914). Segall's São Paulo exhibition received moderate attention, but when the young Brazilian Anita Malfatti (1896–1964) showed expressionist paintings in São Paulo just four years later in 1917, they caused considerable controversy. She had first exhibited in São Paulo in 1914. At that time, her work was looked upon indulgently as that of a promising art student. But the brightly colored expressionist paintings she showed in the 1917 exhibition proved to be too daring for some viewers. The São Paulo critic Monteiro Lobato attacked them in the press in an article entitled "Paranoia ou mistificação" (Paranoia or deception), published in the influential daily newspaper *O Estado de São Paulo,* in which he compared the apparent distortions in her paintings to those of the insane.[27] Potential buyers withdrew their requests, and Malfatti, discouraged by the virulence of the article, turned to a more traditional form of painting in the years that followed.

During her early years, Malfatti had direct contact with European modernism. She had lived in Germany from 1911 to 1914, studying in Berlin with Lowis Corinth. An exhibition of French impressionism and postimpressionism that she saw in South Germany impelled her to use bright colors. During the war years between 1915 and 1916, she lived in the United States. In New York City, she met the war exiles Juan Gris, Jean Crotti, and Marcel Duchamp and attended the Art Students League. But finding the League too conservative for her taste, she left for Monhegan (Maine) to work with Homer Boss, a former student of Robert Henri's. Boss encouraged her to be daring and to use high-keyed color.[28]

The paintings Malfatti showed in the 1917 exhibition—*Rochedos, Monhegan Island [Rocks, Monhegan Island], O homem amarelo [The Yellow Man], Nu cubista [Cubist Nude], O japonês [The Japanese Man], A estudante russa [The Russian Student], O homem de sete cors [The Man of Seven Colors],* and *A bôba [The Fool]* (PL. 2.3)—

were done during her years in the United States. She had dared to use pure color, including the primaries, and had painted blue and green shadows on her subjects' faces. If these works offended Monteiro Lobato, they also appealed to the avant-garde poets Mario de Andrade and Oswald de Andrade (unrelated to each other), who were to be major figures in the Brazilian avant-garde movement. Mario, a musicologist and an art critic as well as a poet, became her most support-ive friend and ally, wrote favorably about her work, and began collecting it. *Mario de Andrade* (1922; FIG. 2.17), a brightly colored painting by Malfatti, commemo-rates this association. Malfatti has since been recognized as a pioneer of Brazilian modernism.

In the 1920s, São Paulo was the major center of avant-garde activities. The Bra-zilian avant-garde was officially inaugu-rated at the Municipal Theater in Febru-ary 1922 with the Semana de Arte Moderna (Modern Art Week). This event, co-organized by Oswald de Andrade, Mario de Andrade, the Rio de Janeiro painter Emiliano di Cavalcanti, and sev-eral other writers, consisted of a week-long series of dance performances, music festivals, poetry readings, and an art exhibition. The week was strategically planned to coincide with Carnival and the centennial celebrations of Brazil's declaration of independence from Portu-gal (1822) and, by implication, symbol-ized the Semana's independence from past artistic conventions. The poetry readings and dance performances had all the scandalous character of European dadaist and futurist performances.

Although the art exhibition was some-what less daring than the poetry readings and performances, it nonetheless repre-sented a noticeable departure from ear-lier symbolist and postimpressionist art. Besides Anita Malfatti, other participants included the painters Zina Aita, John Graz, Antonio Gomide, di Cavalcanti, and Vicente do Rêgo Monteiro (from the northeastern city of Recife), and the São Paulo sculptor Vitor Brecheret.[29] The exhibition presented an eclectic ensemble of work that ranged from art-nouveau design patterns to expressionist and cubist-derived art.[30] Although none of this art had a specifically Brazilian stamp, it paved the way for an art that did.

The first artist to explore Brazilian themes within a cubist context was the painter Tarsila do Amaral (1887–1974)— known by her first name. Tarsila, who came from a family of coffee plantation owners, had first studied art in São Paulo with the impressionist painter Pedro Aleijandrino and in Paris at the Julian Academy in 1921. She did not take up cubism in Europe at the time but was first indoctrinated into modernism in São Paulo. Shortly after her return from Europe in 1922—too late to participate in the Semana de Arte Moderna—she met Anita Malfatti, Oswald de Andrade, Mario de Andrade, and the writer/painter Menotti del Picchia in São Paulo.[31] The group began socializing in one another's studios and in the home of the socialite and world traveler Dona Olivia

PLATE 2.3
Anita Malfatti, *A bôba [The Fool]*, 1915–1916, oil on canvas, 61 × 50 cm. / 24 × 19¾ in. Museu de Arte Contemporânea da Universidade de São Paulo. Courtesy Museu de Arte Contemporânea da Universidade de São Paulo.

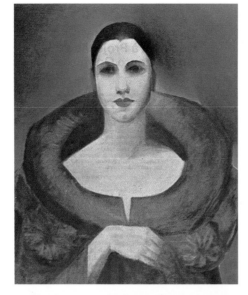

PLATE 2.4
Tarsila do Amaral,
*Manteau rouge [Red
Coat]*, 1923, oil on canvas,
73 × 60 cm. / 28¾ × 23⅝
in. Museu Nacional de
Belas Artes, Rio de
Janeiro. Courtesy Museu
Nacional de Belas Artes,
Rio de Janeiro.

PLATE 2.5
Tarsila do Amaral,
Caipirinha [Little Hick],
1923, oil on canvas, 60 × 81
cm. / 23⅝ × 32⅞ in.
Private collection, São
Paulo. Courtesy Museu
de Arte Contemporânea
da Universidade de São
Paulo. Photo: Gerson
Zanini.

art had the most visible impact on her painting of 1923 and 1924. In 1923, she painted two works that captured her double identity: *Manteau rouge [Red Coat]* (PL. 2.4), a self-portrait as a sophisticated Paris urbanite, and *Caipirinha [Little Country Girl,* or *Little Hick]* (PL. 2.5), a Léger-like cubist scene representing a generic figure of a woman carrying a pitchfork in a landscape with a house and a tree. The French title of the first betrays Tarsila's self-identification with Paris. She wears an elegant red coat designed by the fashionable Parisian couturier Paul Poiret. The second painting, which is not a self-portrait, is an expression of her attachment to her rural Brazilian roots as a girl on the farm. The painting's title was taken from a poem by Oswald de Andrade, "Atelier," dedicated to Tarsila, in which he affectionately refers to her as a "Caipirinha dressed by Poiret."[34]

A major source of inspiration for Tarsila in 1924 and 1925 was Blaise Cendrars, who visited Brazil for the first time in 1924 and was known for poems about railroad crossings and the sounds of city life.[35] During those years, Tarsila painted urban themes celebrating the city of São Paulo, its house facades, railroad stations and crossings. All of her scenes had a quality of studied naïveté. In 1924, she painted *E.F.C.B. (Estrada de Ferro Central do Brasil)* (PL. 2.6), the name of the new rail line linking Rio to São Paulo, in Cendrars's honor on the occasion of a lecture he gave in São Paulo that year.

With Cendrars's encouragement, Tarsila also began painting regional themes that included figures of mulattos and blacks. In 1924, together with Oswald, Blaise Cendrars, and Dona Olivia de Penteado, she visited Rio during Carnival as well as the state of Minas Gerais, known for its eighteenth-century pilgrimage churches. The numerous drawings she made on this trip were the basis for many of her paintings of the following year. Her colors also intensified as a result of this experience. In Minas Gerais, she had found the "colors I loved as a child," which she had been told were

Guedes de Penteado, who owned works by Juan Gris, Fernand Léger, Robert Delaunay, Constantin Brancusi, and others. Tarsila first adopted cubism in 1923 after she returned to Paris to study with Albert Gleizes, André Lhote, and briefly with Fernand Léger. She and Oswald also began a relationship that lasted through the 1920s (they were married from 1926 to 1930) and led to a short-lived but productive collaboration.[32]

In Paris, Tarsila and Oswald formed friendships with Fernand Léger as well as with the Swiss-French poet Blaise Cendrars. Tarsila thought of cubism as a means rather than an end in itself and referred to this phase in her work as her "military service," something every artist should go through.[33] Lhote's and Léger's

ugly and *caipira* (hick-like or in bad taste), "the purest blue, violet rose, bright yellow, a singing green."[36] These colors became her trademark in what came to be known as her Pau Brasil phase of 1924.

That year she illustrated Oswald's book of poems *Pau Brasil,* named for the brazilwood exported to Europe in colonial times and from which the country took its name (PL. 2.7). In the book's manifesto, Oswald referred to Brazilian poetry as "poetry for export" (like the brazilwood) in a reversal of the more common notion that Brazil imported its culture.[37] The book's cover represents the yellow, green, and blue Brazilian flag, but the book's title, *Pau Brasil,* substitutes for the flag's positivist logo *ordem e progreso.* Positivism was a rational philosophy imported from Europe in the nineteenth century, while *pau brasil* focused on the authentic and the native. According to Oswald's *Pau Brasil* manifesto, Brazilians enjoyed a dual heritage, the jungle and the school. He defended "native authenticity [as the means] to redress the balance of academic influence" and reacted "against the indigestibility of knowledge" because Brazil was "wild, naïve, picturesque and tender."[38] Accordingly, Tarsila's illustrations for *Pau Brasil* are simple, childlike notations.

In 1924, Tarsila also began painting scenes of Brazilian folk culture, depicting fairs, fruit markets, and *favelas* (shantytowns). At the same time, she accepted Brazil's cultural affiliations with Paris. In *Carnaval en Madureira [Carnival in Madureira]* (1924; PL. 2.8), an Eiffel Tower stands in the midst of a tropical landscape populated by Afro-Brazilians. The Eiffel Tower, which was inspired by a Delaunay painting of the Eiffel Tower in Tarsila's collection at the time,[39] celebrates the proximity of the two worlds—the Parisian and the Brazilian—made possible through transatlantic travel and wireless telegraphy. In *Morro da favela [Shantytown Hill]* (1924; PL. 2.9), however, she focused on Brazil's rural life by emphasizing the folkloric charm of the hill with no hint of the squalid conditions of its inhabitants. In a 1933 painting, *O morro [The Hill]* (PL. 2.10), Cândido Portinari was to offer a very different version. The figures in Tarsila's painting are not particularized but generic and integral to the landscape. Her interpretation is that of the late cubists like Gleizes and Léger.

After the mid-1920s, Tarsila stopped painting urban scenes entirely and focused on local ones. Many of the new paintings, especially from 1928 to 1930,

PLATE 2.6
Tarsila do Amaral, *E.F.C.B. (Estrada de Ferro Central do Brasil) [E.F.C.B. (Central Railway of Brazil)]*, 1924, oil on canvas, 142 × 127 cm. / 55⅞ × 50 in. Courtesy Museu de Arte Contemporânea da Universidade de São Paulo. Photo: Gerson Zanini.

PLATE 2.7
Oswald de Andrade, cover for book of poetry *Pau Brasil [Brazilwood]*. Courtesy Archives of the Instituto de Estudos Brasileiros da Universidade de São Paulo. Photo: Author.

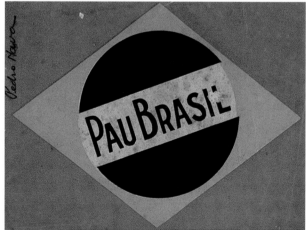

also manifest an oneiric quality bordering on fantasy. They include strangely distorted figures, amorphous animals, and vegetation with unexplained scale discrepancies that seem to overtake the surrounding landscape. These distortions are not those of cubism but of surrealism. Tarsila was aware of surrealist biomorphism, such as in the work of Joan Miró. By 1926 she and Oswald had met the surrealists in Paris, including the poet Benjamin Péret, who visited Brazil in 1929.[40]

Two of Tarsila's paintings of this period, *Abaporú* (1928) and *Antropofagia [Anthropophagy]* (1929), depict elongated figures with large feet and tiny heads. Although these figures are neither specific nor naturalistic, the titles and the figures' context indicate that they are Indian. In January 1928, Tarsila had given *Abaporú* (PL. 2.11) as an untitled painting to Oswald for his birthday. The main subject is a long rubbery figure sitting next to a cactus sprouting what Tarsila described as an "absurd flower."[41] Oswald, in collaboration with the poet Raúl Bopp, randomly selected the title *Abaporú,* meaning "man eats," from a Tupí-Guaraní dictionary.[42] The Tupí-Guaraní were a tribe of Indians who were said to practice cannibalism. For Oswald, cannibalism, which implied the absorption of the "sacred enemy" in order to appropriate his best qualities, was a metaphor for the Brazilians' ability to digest European culture and transform it into something original.

PLATE 2.8

Tarsila do Amaral, *Carnaval en Madureira [Carnival in Madureira],* 1924, oil on canvas, 76 × 63 cm. / 28⅛ × 24⅛ in. Private collection, São Paulo. Courtesy Museu de Arte Contemporânea da Universidade de São Paulo. Photo: Gerson Zanini.

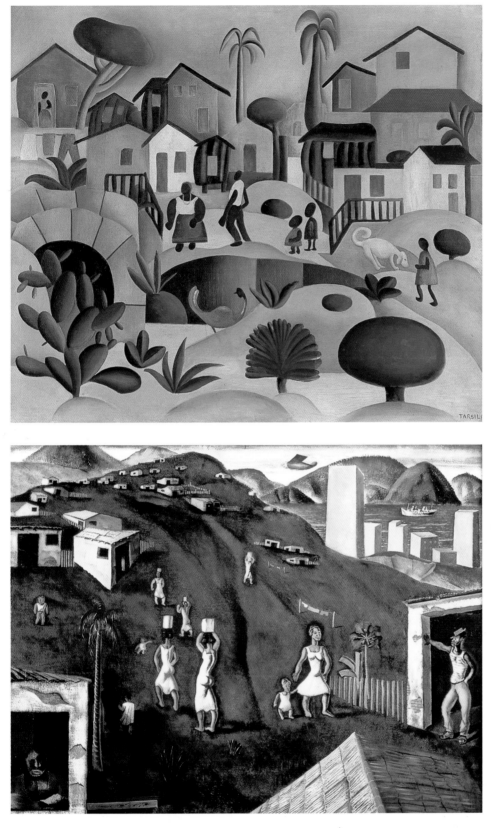

PLATE 2.9

Tarsila do Amaral, *Morro da favela [Shantytown Hill]*, 1924, oil on canvas, 64 × 75.5 cm. / 25¼ × 29⅞ in. Collection João Estefano, São Paulo. Courtesy Museu de Arte Contemporânea da Universidade de São Paulo.

PLATE 2.10

Cândido Portinari, *O morro [The Hill]*, 1933, oil on canvas, 114 × 146 cm. / 44⅞ × 57½ in. Courtesy Projeto Portinari, Rio de Janeiro. Photo: Peter Schneider.

To further develop these ideas, Oswald, with the collaboration of the poets Antonio de Alcântara Machado and Raúl Bopp, founded an Anthropophagite Club and the *Revista de Antropofagia,* an ephemeral journal that lasted only a few months (1928–1929). Nevertheless, its role in helping to define a Brazilian identity was far-reaching. Oswald formulated—or constructed—this identity in an "Anthropophagite Manifesto" published in the journal's first issue.[43] He

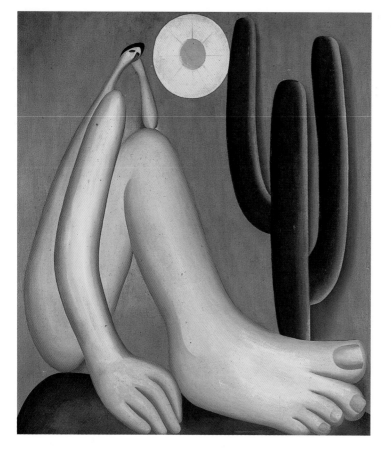

PLATE 2.11

Tarsila do Amaral,
Abaporú, **1928, oil on**
canvas, 86.5 × 75.5 cm. /
34 × 29¾ in. Collection
Dr. Eduardo and María
Teresa Constantini,
Buenos Aires. Photo:
Author's photo archives.

characterized Brazil as a society entirely guided by instinct, in which "science was transformed into magic." He denounced the "canned conscience" and "antagonical sublimations" brought in caravels (the tall ships used by the Portuguese colonizers) and celebrated "the pre-logical mentality" that already existed in Brazil. In a reference to Freud's essay "Totem and Taboo," he declared that in Brazil taboo was permanently transformed into totem, that is, the forbidden became the accepted rule. Brazilians "already had surrealist language."[44]

The notion of a Brazilian as a creature born of the jungle whose mentality and actions are entirely guided by instinct, pleasure, and fear was implicit in Mario de Andrade's 1928 novel *Macunaima* about a generic black protagonist known as "a hero without a character." In Tarsila's *Abaporú,* the large foot, firmly planted on the ground, stands for the figure's firm roots in the Brazilian soil, and the tiny head minimizes the role of intellect and logic. Regardless of whether Tarsila had thought of this figure in such specific

terms when she painted it, it well illustrates the ideas set down in the "Anthropophagite Manifesto."

Other paintings of this period include *A lúa [The Moon]* (1928) and *Composição [Composition]* (or *Figura só [Figure Alone];* 1930), both of which convey distance and isolation. In the latter, a tall, vase-shaped figure with endlessly floating hair stands in a desolate landscape quite different from the buoyantly exotic scenes of Tarsila's earlier years. In 1930, Tarsila's marriage to Oswald came to an end, and with it, their collaboration. Nonetheless, as a team they left a legacy whose impact on Brazilian art and literature continues to be felt.

Although Malfatti bore the cross of novelty by introducing modernism in Brazil, it was Tarsila who translated modernism into a Brazilian idiom.[45] Emiliano di Cavalcanti and Lasar Segall both turned to popular Brazilian subjects in the mid-1920s after Tarsila had done so. Di Cavalcanti's earlier work showed the impact of Picasso's classical phase of the early 1920s, and Segall's, of German expressionism. Di Cavalcanti (1897–1976) turned to brightly colored scenes of Brazilian types, many of whom are women of varying skin tones. In *Samba* (1928; PL. 2.12), a group of shantytown hill people, two of whom are seminaked women, move to the rhythm of the dance. Lasar Segall (1891–1957), who had returned to Brazil from Germany in 1923 and become a Brazilian citizen the following year, adapted his cubo-expressionist style to Brazilian themes after the mid-1920s.[46] In *Bananal [Banana Plantation],* also known as *The Last Slave* (1927; PL. 2.13), the head of a slave appears against a thick screen of blue, green, and yellow banana leaves. Although this work conveys anguish and confinement, Segall also made reference to Brazilian nationality by using the colors of the Brazilian flag in the painting (like Oswald's *Pau Brasil* cover). Thus the painting can be interpreted ambiguously as both a symbol of Brazilian identity and an indictment of colonialism.

Nationalism in its more stringent sense was not a strong force in the Brazilian avant-garde before the mid-1920s, but after 1925, it was evident in both literature and art. Two groups embodied the nationalist position. One of the literary groups to surface in São Paulo, the Verdeamarelo (Green Yellow), so named for two of the flag's colors, was founded in 1925 by conservative São Paulo poets in opposition to what they perceived as the cosmopolitanism of poets like Oswald de Andrade and Mario de Andrade. The Verdeamarelo poets thought of themselves as the nationalist answer to the other avant-garde groups.[47]

Shortly after the formation of Verdeamarelo, a regionalist form of nationalism was established in the northeastern city of Recife. The anthropologist Gilberto Freyre and a group of poets who also objected to the internationalism of the São Paulo poets organized a regionalist congress. In a lecture given in 1926, Freyre proposed a form of modernism that incorporated local traditions in specific, rather than generic, ways.[48] His idea of a modernist form of regionalism can be seen on the cover design of *Lendas, Crenças e Talismãs dos Indios do Amazonas* (Legends, beliefs, and talismans of Indians of the Amazon; 1923), a book by Vicente do Rêgo Monteiro about the native cultures of northeastern Brazil. Here the artist, whose paintings had a strong cubist base, turned the cubist grid into a pattern of primitive symbols taken from Amazonian pottery designs.[49]

The Brazilian avant-garde came to an end with the election of Getulio Vargas in 1930.[50] The crash of 1929 and the depres-

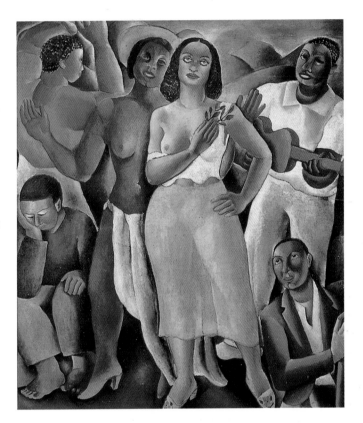

PLATE 2.12
Emiliano di Cavalcanti, *Samba*, 1928, oil on canvas, 177.75 × 156.5 cm. / 70 × 61⅝ in. Collection Jean Boghici, Rio de Janeiro. Photo: Ron Jameson, from Clarival do Prado Valladares, *Di Cavalcanti* (pl. 1).

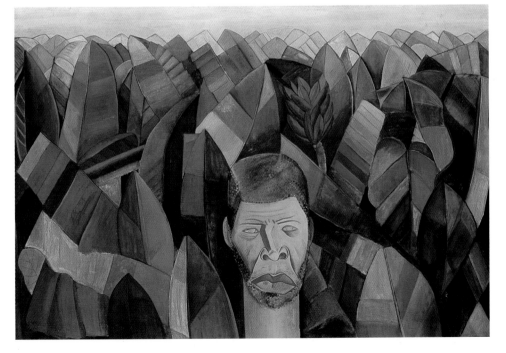

PLATE 2.13
Lasar Segall, *Bananal [Banana Plantation]*, 1927, oil on canvas, 85 × 124 cm. / 33½ × 48¾ in. Courtesy Pinacoteca do Estado de São Paulo.

sion that followed in the United States affected Brazil's economy as well as that of other countries. The Paulista coffee industry was severely weakened, and São Paulo lost its lead as a cultural center to its rival city Rio de Janeiro. The São Paulo avant-garde artists went underground. Some of them founded two private clubs in 1933, the Sociedad Pro Arte Moderna [SPAM] and the Clube dos Artistas Modernos [CAM], where they continued to meet, exhibit, and hold lectures and Carnival balls. By the early 1930s, a new generation of artists came into prominence that included the Rio-based painters Alberto Da Veiga Guignard and Cândido Portinari, but neither of them participated in the clubs' activities.

THE ARGENTINE AVANT-GARDE

In Argentina, the avant-garde was launched in 1924 with the founding in Buenos Aires of the cosmopolitan journal *Martín Fierro* and with a controversial exhibition of cubist paintings by Emilio Pettoruti (1892–1970) later the same year. Neither Pettoruti nor his other avant-garde colleagues—the painter Xul Solar and the sculptor Pablo Curatella-Manes—would have found any support for their work in an artistically conservative country like Argentina without the backing of the *Martín Fierro* writers, who included Oliverio Girondo, Eduardo González Lanuza, Leopoldo Marechal, Ricardo Güiraldes, and later, Jorge Luis Borges.

In a manifesto ("Manifiesto de *Martín Fierro*") formulated by Girondo and published in *Martín Fierro*'s first issue, the *martínfierristas* declared that "we are in the presence of a NEW SENSIBILITY and of a NEW COMPREHENSION" and "new means and forms of expression" (caps in original). Without renouncing its past, *Martín Fierro* consulted "the barometer [and] the calendar, before going out into the street to experience it with its nerves and with its mentality of today."[51]

Pettoruti, Xul Solar, and Curatella-Manes provided the visual counterpart of the literary avant-garde. Pettoruti and Xul Solar, who had returned together from Europe in July 1924, shortly after the journal's founding, joined the writers through the intermediary of their friend the architect and *Martín Fierro* art critic Alberto Prebisch. Prebisch was famous for his support of avant-garde art and for regularly bashing the staid annual National Salons in Buenos Aires.

An exhibition of the work of Pettoruti inaugurated at the Witcomb Gallery in October 1924 created such a scandal that his work had to be placed under glass to protect it from vandalism until well into the 1940s. But when Xul Solar (Alejandro Oscar Agustín Schulz Solari, 1887–1963) exhibited "strange," unclassifiable watercolors in the *Primer Salón Libre* (*First Free Salon*) in the same gallery shortly after Pettoruti, his work invited more curiosity than shock. A month later, when Curatella-Manes (1891–1962) showed cubist sculpture at the Witcomb, he, too, met with considerable scorn. But unlike Pettoruti, who knew how to field—and capitalize on—the jeering and criticism launched at his work, Curatella-Manes, less self-assured, chose to remain in Paris, where he accepted and held the post of Argentine cultural attaché until the late 1940s.

Curatella-Manes and Pettoruti, both from the town of La Plata some sixty kilometers southeast of Buenos Aires, first met in Florence, where they had both gone respectively in 1911 and 1913 in search of the great art of the past. They also inadvertently stumbled on the futurists. But only Pettoruti experimented with futurism at the time. His early experience in Italy was tumultuous. He had felt considerable "spiritual turmoil" on seeing the *First Florence Futurist Exhibition* at the Gonelli Gallery and Bookshop. A few days later, he was equally stunned by the "bestial violence" displayed by the public at the First Futurist Poetry Reading in the Teatro Verde in Florence. Unaware at the time that this behavior was

characteristic of Italian futurist events, he objected to the deafening noise that prevented him from hearing the poetry. Nonetheless, there he met the futurists, including the group's founder, Filippo Tommaso Marinetti, and soon adopted elements of both futurism and cubism in his own painting.[52] He learned about cubism in Florence through journal and book illustrations and through his association with the painters Carlo Carrá and Ardengo Soffici, both of whom had been to France.[53]

But Pettoruti's color had little of the opaqueness of the cubists. Rather, it shared some of the translucence of Gino Severini's and Giacomo Ballá's color, especially the latter's *Iridescent Compenetration* series of 1912 to 1914, which Pettoruti saw in Ballá's Rome studio in 1915. His futurist-derived obsession with sunlight—he sought to "trap" and solidify it in paint—led in the 1940s to the *Soles Argentinos,* a series of still-life compositions in which light pours onto objects from an open window. In 1915 he had systematically studied light intensity on geometric solids of different colors.[54]

In *La pensierosa [The Pensive One]* of 1921, he turned the flat planes of the figure of a young woman with a hat into a symphony of translucent lavender, red, tan, and violet overlapping planes. His concern with light is especially evident in the blue-green tonalities of *Gruta azul de Capri [Blue Grotto of Capri]* (1918; PL. 2.14), an oval painting with an abstract pattern in which he sought to translate into visual terms the strange luminosity of the sea's reflections in the grotto he had seen on a visit to Capri. Light permeates the whole painting.

In 1917 Pettoruti also took up the theme of city streets viewed from windows as in *Mi ventana en Florencia [My Window in Florence]* (1917; FIG. 2.18), a collage, and *Calle de Milán [Outskirts of Milán]* (1919), an oil painting. In the first, he included a small postcard of the Florence Cathedral as a homage to the city's artistic legacy, and a strip of newspaper

PLATE 2.14
Emilio Pettoruti, *Gruta azul de Capri [Blue Grotto of Capri],* 1918, oil on canvas, 87 × 63 cm. / 34¼ × 24¾ in. Private collection, Buenos Aires. Photo: Author's archives.

from the Argentine daily *La Nación* as a reminder of his home country (like the cubists, he incorporated bits of newsprint, magazine titles, and headlines into collages). In the second, he emphasized verticality by tilting the street to increase its visibility and fusing the cobblestones on the ground with a tall palm tree in a composition twice as high as it is wide.

After his return to Buenos Aires, Pettoruti developed the theme of musicians begun in Italy and a series of harlequins whose facial features resemble those in Fortunato Depero's futurist theater designs. In Pettoruti's as well as Depero's work, the faces are schematic and geometric. Although Pettoruti's subjects have no national identity in themselves, in *El quinteto [The Quintet]* (1927; PL. 2.15) he introduced an identifiably Argentine element: the tango, which Argentines claim as a national dance. The musicians in this work inevitably call to mind Picasso's two versions of the *Three Musicians* (1921). But *El quinteto* differs from Picasso's works in both color and content. Pettoruti's musicians here are neither harlequins nor monks but members of a contemporary tango band. One of the musicians plays a *bandoneón,* a small accordion-like instrument used in Argentine tango ensembles. The tango is said to have originated in the Buenos Aires slums in the late nineteenth century. By the 1920s, it was popularized as a ballroom dance. Pettoruti's representa-

tion of this subject was contemporary with some of the *martínfierrista* writers' interest in the tango. Several of them, including Jorge Luis Borges, wrote about it.[55]

Curatella-Manes's absence from Buenos Aires kept him from participating in the journal's activities. Nevertheless, on the occasion of his 1924 exhibition, Prebisch defended his art in a double-page spread published in *Martín Fierro*.[56] Eleven years earlier, in 1913, Curatella-Manes had escaped the futurist fervor by moving from Italy to Paris. There he took a more conservative direction studying with Antoine Bourdelle. But he also admired Juan Gris and felt some kinship

FIGURE 2.18

Emilio Pettoruti, *Mi ventana en Florencia [My Window in Florence]*, 1917, oil and collage, 46 × 36 cm. / 18⅛ × 14⅛ in. Private collection, Buenos Aires.

PLATE 2.15

Emilio Pettoruti, *El quinteto [The Quintet]*, 1927, oil on plywood, 149.8 × 131.5 cm. / 55 × 51¾ in. Private collection, Buenos Aires. Photo: Courtesy owner.

with the sculptors Jacques Lipchitz and Alexander Archipenko, whose impact can be detected in Curatella-Manes's cubist sculpture of 1921 and after. Like Pettoruti, he took up the subject of musicians, but Curatella-Manes's musicians had no specific nationality. His small bronze figure of *El guitarrista [The Guitarist]* (1921; FIG. 2.19) consists of a buildup of convex/concave planes as substitutes for the color planes of cubist painting. The counterpoise of these planes is also intended to convey the rhythm of the music. In *Los acróbatas [Acrobats]* (1923; FIG. 2.20), Curatella-Manes, like his colleagues, also explored the notion of verticality in defiance of gravity. One of the two figures in this piece balances precariously on the other's head.

After 1925, Curatella-Manes changed from solid cubist figures to open abstract forms through which he explored movement rather than the objects themselves. Both *Rugby* (1925; FIG. 2.21) and *Baile [Dance]* (1926) consist of thick, continuous plaster bands (later they were cast in bronze) that project into the surrounding space to convey dynamic movement. The open organic configurations of these works find a parallel in Lipchitz's near contemporary *Transparents* series. The latter are also open works whose components function as a sort of sculptural drawing in space. Curatella-Manes's works, which have since been cast in bronze, nonetheless retain some semblance of human figures in motion, even though this feature is not immediately apparent. *Rugby* and *Baile* were not shown in Buenos Aires until much later. Only his cubist sculpture was shown in the 1920s.

Ultimately, Xul Solar's work may have contributed more than anyone else's to establishing an original Argentine avantgarde mode. But at first, his work did not have as big an impact on the public as that of his cubist colleagues. Xul Solar's watercolors of puppets, floating disembodied faces, ancient goddesses, landscapes, birds, snakes, and masks, sometimes consisting of colored bands interspersed with letters and numbers in alchemical

FIGURE 2.19
Pablo Curatella-Manes (Argentinean, 1891–1962), *El guitarrista [The Guitarist]*, 1921, bronze with black patina, 34.3 × 22.5 × 18.4 cm. / 13½ × 8⅞ × 7¼ in. Jack S. Blanton Museum of Art (formerly Archer M. Huntington Art Gallery), The University of Texas at Austin. Archer M. Huntington Museum Fund, 1982. Photo: George Holmes, 1982.1249.

FIGURE 2.20
Pablo Curatella-Manes, *Los acróbatas [Acrobats]*, 1923, bronze cast, 43 × 21 × 13 cm. / 17 × 8¼ × 5⅛ in. Courtesy John Axelrod, Boston. Photo: H. O. Casenave.

FIGURE 2.21
Pablo Curatella-Manes,
Rugby, 1925, plaster, 112 ×
88.5 × 70.5 cm. / 44⅛ ×
34⅞ × 27¾ in. Museo
Nacional de Bellas Artes,
Buenos Aires. Reproduc-
tion authorized by Jorge
Antonio Pablo Curatella.

symbioses, were small and far too enig-
matic to classify. His *martínfierrista* friends
solved the problem of incomprehension
by ignoring these works and treating Xul
Solar as a literary colleague instead of as a
painter, since he also wrote. One aspect
that set Xul Solar apart from his fellow
artists was his mysticism. Throughout his
life he studied various esoteric systems
that included theosophy, the Cabala,
sinology, astrology, and pre-Columbian
mythology.[57]

In 1912 he had set out on a ship bound
for Hong Kong, but for reasons that
remain unclear, he disembarked in Lon-
don, subsequently traveling to France,
Germany, and Italy.[58] He took up medita-
tion after meeting the English mystic
Alistair Crowley and, by the 1920s, based
his paintings on visions obtained in this
manner.[59] Unlike the surrealists, who
claimed to base their art on subconscious
imagery induced by self-hypnosis, Xul

Solar's experience with meditation re-
sulted in a mystical exaltation more like
that of the symbolists.[60] *Entierro [Burial]*
(PL. 2.16), painted in Paris in 1914, has
some affinities with the wash drawings of
the Dutch symbolist Jan Tooroop. But
Xul Solar's figures of angels accompany-
ing the deceased seem dematerialized,
and the scene takes place in a cosmic
realm that anticipates Xul Solar's later
work.

During his 1916–1921 stay in Italy,
where he met Pettoruti, Xul Solar came
into contact with futurism and began
incorporating cubist and futurist space
and all the spectrum colors in his work.
The simplified anthropomorphic tree
shapes, snakes, bird, sun, and moon in an
abstract space in *Troncos [Tree Trunks]*
(1919; PL. 2.17) lend themselves to a
dual interpretation. The presence of the
spectrum colors and the compression of
time and space into a simultaneous
present are futurist features. On the
other hand, from a metaphysical point of
view, the simultaneous existence of three
stages of development, the vegetable to
the animal to the human one played out
by the walking trees, is also theosophical.
The appearance and subsequent fall of
man is implied in the animated gestures
of the trees that evoke an expulsion from
paradise; they also imply a transition
from a lunar (on the right) to a solar
phase (on the left). These characteristics
conform to a theosophical notion of
transformation through several cosmic
stages of development. Xul Solar's rejec-
tion of naturalism and dislike of material-
ism also led him to reject oil in favor of
watercolor and tempera. The small scale
of his work was determined in part by his
liking for medieval manuscripts, which
he apparently saw when visiting Italian
monasteries. He felt an affinity with the
religious function of manuscripts and an
aversion for Northern Flemish Renais-
sance paintings, which he perceived as
too materialistic because of their focus on
the natural world of objects.

Between 1921 and 1924, Xul Solar
spent time in Munich, where he saw the

work of Paul Klee and Wassily Kandinsky, with whom he shared many affinities, including an interest in theosophy. During his years in Germany, he also came into contact with the work of George Grosz and the Russian constructivists. Although his fanciful compositions of floating masks and puppets of this period are of Italian origin and may be traceable to some of Depero's theater puppet designs, Xul Solar's German production comprised more complex fusions of occult systems including alchemy. For instance, *Pareja [Couple]* (1923; PL. 2.18) depicts an androgynous head with a male and a female half accompanied by the number *2* and the letter *B*. This combination symbolizes the alchemical fusion of the male and female principles that is to lead to a perfected state. In *Jefa* (1923), the bewhiskered female chief or priestess of the title alludes to the feline cult of the

PLATE 2.16

Xul Solar, *Entierro [Burial]*, 1914, watercolor on paper, 27 × 36 cm. / 10⅝ × 14⅛ in. Collection Dr. Eduardo and María Teresa Constantini, Buenos Aires. Photo: H. O. Casenave.

PLATE 2.17

Xul Solar, *Troncos [Tree Trunks]*, 1919, watercolor on paper, 31.7 × 46.8 cm. / 12¾ × 18½ in. Collection Dr. Eduardo and María Teresa Constantini, Buenos Aires. Photo: H. O. Casenave.

PLATE 2.18
Xul Solar, *Pareja [Couple]*, 1923, watercolor on paper, 25.9 × 32 cm. / 10⅝ × 12⅞ in. Collection Dr. Eduardo and María Teresa Constantini, Buenos Aires. Photo: H. O. Casenave.

Egyptian goddess Isis, and by implication, to death and rebirth through association with the death and resurrection of Osiris.

Some of Xul Solar's paintings represent purification rituals. In *Burial* (1914, see PL. 2.16), the deceased is carried in a procession to a distant kilnlike cave in which the purification will take place in preparation for the next stage of development. In a later painting, *Nana Watzin* (sometimes spelled *Nanawatsin;* 1923; PL. 2.19), the purification occurs on an altar. Nana Watzin is the ancient scabby Mexican god who threw himself into the fire (purification) to rise and become the sun. The name Tlazolteotl written on the altar in the painting reinforces this idea. Tlazolteotl was the ancient Mexican mother goddess who devoured filth (cleansing) and had the power to forgive humans their sins. Besides purification as

the central theme of the painting, additional words and names scattered throughout *Nana Watzin* are an indication of Xul Solar's increasing interest in linguistic games no longer restricted to occasional floating letters. The cryptic words written in Spanish, Portuguese, and Nahuatl in this painting are from Neocriollo (Neocreole), one of two languages Xul Solar had invented. Neocriollo was made up of words from languages spoken in the geographic area occupied by Latin America.[61] In Buenos Aires, he shared his linguistic interests with Jorge Luis Borges.

Borges and his artist sister Norah spent the war years in Switzerland. Right after the war they moved to Spain, where Borges became a central figure in the Spanish *ultraísta* literary avant-garde movement. (Ultraism was a distillation of cubist, expressionist, and futurist ideas.

Writers often combined Apollinaire's calligrammes with Marinetti's "parole in libertá," or floating words.) Norah Borges illustrated for ultraist journals and exhibited her paintings in Spain. After the Borgeses' return to Argentina in 1921, Norah illustrated for the Argentine avant-garde journals *Martín Fierro* and *Proa*. In Buenos Aires, Borges introduced a modified version of *ultraísmo* to the literary avant-garde, which formed the basis of *martínfierrista* ideas. *Ultra* means "beyond," hence *ultraísmo* introduced the notion of surpassing nature and gravity by liberating poetry from the fetters of romanticism and tradition. Pettoruti's and Xul Solar's paintings and Curatella-Manes's sculpture represented the visual counterparts of *ultraísmo* by surpassing, or going beyond, naturalism and—sometimes—gravity.

As a result, the *martínfierristas* were especially supportive of these artists' work, but particularly of Pettoruti's and Curatella-Manes's. Xul Solar praised Pettoruti's art in an article published in *Martín Fierro* in 1924 in which he conferred transcendental (going beyond) properties on Pettoruti's paintings to

justify their deviation from convention.[62] In Prebisch's article in *Martín Fierro* on Curatella-Manes's cubist sculpture, the author also referred to his sculpture in constructivist terms as "architectonic," rather than in the earlier language of cubism. In 1924, other journalists often confused terms like *cubismo* and *futurismo,* and referred to Pettoruti's work interchangeably as *cubista* and *futurista,* meaning something ultramodern or incomprehensible. They had seen neither cubist nor futurist art but had long known the language of futurism through Marinetti's poetry and manifestos.

Xul Solar's paintings were more difficult to classify. On the occasion of his 1924 exhibition, only one critic, Alfredo Chiabra Acosta (known by the pseudonym Atalaya, meaning "watchtower"), mentioned him in the leftist journal *La Protesta,* singling out his work as "a most curious and unusual contribution" to an otherwise "mediocre" exhibition.[63] Both Borges and Girondo acquired small works by Xul, often as gifts from the painter. But when he exhibited with a group in 1926, his work proved too enigmatic even for the *martínfierrista* writers,

PLATE 2.19
Xul Solar, *Nana Watzin*, 1923, china ink and watercolor on paper mounted on cardboard, 25.9 × 31.5 cm. / 10⅛ × 12⅜ in. Galería Vermeer, Buenos Aires. Photo: José Cristelli, courtesy Galería Vermeer.

who barely mentioned him in their journal, citing problems of classification in art. Xul Solar thought of himself as a synthesizer who incorporated "all schools" in his work, including surrealism.[64]

Both the Argentine and, to a lesser extent, the Brazilian avant-garde were centered on urban imagery. In Brazil this type of imagery was restricted to the first half of the 1920s. Ultimately, though, it did not play a part in the national image constructed by the Brazilian avant-garde artists and writers. However, in Argentina it continued to be a major component of the art of the whole decade as Argentines identified the avant-garde with the city. Pettoruti and Xul Solar both included urban references in their work. In *The Quintet* (see PL. 2.15), Pettoruti situated the group in an urban setting, as implied by the tall building visible in the background. Several of Xul Solar's paintings of the late 1920s and after have the port or city of Buenos Aires as their subject. Buenos Aires was also the subject of literary works, including a book of poems by Borges, *Fervor de Buenos Aires* (1925), and a novel by Leopoldo Marechal, *Adán Buenosayres* (begun in 1929), satirizing *martínfierrista* characters, their intellectual games, and their common urban experiences.

Linguistic games were a major component of *martínfierrista* activities. In 1928, Borges published *El idioma de los argentinos* (The language of the Argentines), a book that Xul Solar illustrated. It addressed the modifications that occur in the meaning of words according to the location of one's experiences. Xul's vignettes for this

JORGE LUIS BORGES

es el de *audaz*. Sabe que los fracasos perseverantes de la expresión, siempre que blasonen misterio, siempre que finja un método su locura, pueden componer nombradía. Ejemplo: Góngora. Ejemplo: todo escritor de nuestro tiempo, en alguna página.

FIGURE 2.22
Xul Solar, vignette for Jorge Luis Borges's *El idioma de los argentinos*. Photo: Author.

FIGURE 2.23
Xul Solar, *Otro drago, [The Other Dragon]*, 1927, watercolor, 23 × 31 cm. / 9 × 12¼ in. Collection Carol Blum Mackauf, New York. Photo: Ron Jameson, from Xul Solar, *Xul Solar* (no. 28).

book include floating masklike heads, some of which are lined up so as to resemble a sky dragon, with a tongue issuing from each mouth like a Mexican pre-Hispanic speech scroll (FIG. 2.22). These images correspond in their meaning to Xul Solar's contemporary paintings. In *Otro drago [The Other Dragon]* (1927; FIG. 2.23), the double images of a sea dragon and a sky dragon float as mirror images in a cosmic space interspersed with a sun, a moon, and stars. Both dragons are studded—often humorously—with toy boats, keys, fishes, and little stick figures holding the flags of different American nations. Two Xs (for Xul) substitute for the sky dragon's teeth, and a forked tongue issues from its mouth like a speech scroll. *Otro drago* is one of several paintings Xul did between 1925 and 1927 in which flags appear. The focus on language, different nations, and tongues in these paintings and in Xul Solar's contributions to Borges's book was a mark of the affinity between the writer and the painter. Their shared interests led to a mutually fruitful association that was to last for the following two decades. The impact of this association can be detected in some of Borges's later short stories.

Although the avant-garde in Argentina remained politically conservative and cosmopolitan through the 1920s, it was not for lack of nationalist and socially engaged artists. As was the case elsewhere, writers and artists had formed themselves into separate competing groups. One group, which included the *Martín Fierro* and *Proa* writers, was known as the Florida group, named after a fashionable street lined with elegant shops and art galleries in downtown Buenos Aires. Another, a politicized group centered around leftist journals such as *La Protesta* and *Extrema Izquierda,* was known as the Boedo group, named for a street in a working-class neighborhood on the north side of Buenos Aires. But though the two camps engaged in fierce literary battles in their publications, they often attended one another's banquets.[65] Among the Boedo artists was Benito

Quinquela Martín (1890–1977), who, like Pettoruti, was of Italian descent. Quinquela belonged to an artists' collective known as Pintores de la Boca (Painters of La Boca), a reference to the mouth (of the Río de la Plata) or the port of Buenos Aires and, by extension, to a poor, largely Italian section attached to it. His subjects reflected his own humble background, and they included port scenes and dockworkers painted in a heavily impastoed but naturalistic style. Both the Florida and the Boedo affiliates claimed to embody the essence of Argentine identity as well as an avant-garde position, the first, through a defense of progressive forms in art and poetry, the second, of progressive politics. But in the end, the *martinfierrista* camp gained the upper hand in securing its position as Argentina's first avant-garde in the 1920s.

The Argentine avant-garde, like its Brazilian counterpart, did not survive the political upheavals that ended the decade. General José Uriburu established a military dictatorship in 1930—the same year Vargas took office in Brazil—bringing to an end the liberal presidencies of the 1920s in Argentina. Most avant-garde journals had ceased publication by 1930. *Martín Fierro*'s last issue came out in 1927. In a parallel with the Brazilians, artists took the initiative by founding their own meeting places.[66] Pettoruti, who assumed the post of director of the Museo Municipal de Arte of La Plata in 1930, described the impact of these changes on his own life:

Without museums where I could take refuge and be alone with great works of art; without artists of my direction and style against whom to pit myself in order to find, through confrontation, the impulse that leads farther; without spirits accustomed to first-hand knowledge of the new expressive currents [in art to help] sharpen the blade of creative lucidity; without dealers or buyers, my life as an artist was very difficult and very lonely.[67]

In the following decade, an Italianate form of neoromanticism, and social and rural scenes painted in a naturalistic style, replaced the more audacious cubist tendencies of the 1920s, and Xul Solar was virtually forgotten among artists until the late 1950s.

SUMMARY

Although artists from Mexico, Brazil, and Argentina had initially looked to similar European models for their art, they distilled these sources in very distinct ways. The Mexicans opted for a form of figuration with a powerful cubist or futurist base in public murals directed to a largely illiterate population. They turned what had been an elitist avant-garde art into a populist form and defined their Mexican identity through themes of the revolution, their colonial history, and their ancient past. On the other hand, Argentine and Brazilian artists painted for a small but growing elite that had previously looked to Europe for its art but was gradually developing an interest in its own artists. In Argentina, a country whose history was little more than two centuries old, artists sought an identity through their European legacy and through recent traditions like the tango, with little reference to a specific moment in time. Rather, they tended to avoid reference to their immediate surroundings and to escape from the mundane into an immaterial world of ideas, or else chose subjects that were not fixed in time. This identity found a metaphysical dimension in the work of Borges and Xul Solar.

In Brazil, where the aboriginal Indian legacy embodied in Amazonian Indian pottery was not eradicated and Afro-Brazilian culture remained a strong component, a local form of primitive exoticism focusing on rural life dominated avant-garde imagery by 1925 after an early brush with urban themes. Argentines welcomed their European legacy as the legitimate one, whereas Brazilians in the end rejected theirs.[68]

The contrast between the Argentines' and Brazilians' self-image was confirmed in 1926 in their response to Marinetti when he visited both countries. In São Paulo, Brazilians arrogantly informed their visitor that Brazil did not need futurism because "we are the country of the future." When Marinetti attempted to lecture at the Teatro Cassino Antártica there, young intellectuals pelted him with vegetables, rotten eggs, and other missiles (as had audiences in Milan and Florence before World War I).[69] A poem commemorating the event was circulated as further warning:

Ay Marinetti
if I were you
I would lecture
from atop a bamboo[70]

On the other hand, when Marinetti arrived in Buenos Aires from Brazil, he was received with decorum and his words were taken seriously by the *martínfieristas,* Pettoruti, and other artists, even by those who opposed his ideas.[71]

But in spite of the apparent impact of futurism in Latin America, most artists were not prepared to follow its doctrines. Unlike the European futurists, they did not wish to overthrow traditions they were in the very process of defining in the 1920s. For this reason, artists adopted cubism more readily than futurism. Cubism allowed them to examine their own culture in a new way while providing them with a means to construct a national image within the framework of modernism.

The 1930s and 1940s were marked by the coexistence of three major art currents: constructivism, surrealism, and social and nativist art. Constructivism emerged primarily in Uruguay and Argentina; surrealism, in the work of individuals from several countries rather than as a widespread movement. But some variant of social and nativist painting existed in most countries as general concerns for the conditions of workers, peasants, and a disenfranchised Indian population gained urgency after 1930. In countries like Mexico and Peru, the Indian as subject also came to represent a powerful symbol of cultural identity.

Social painting was not a uniform style but a complex phenomenon that differed from country to country according to whether the subject was the white immigrant worker in Argentina, the mestizo miner in Peru and Bolivia, the black laborer and farmer in Brazil, or the rural Indian in Mexico and the Andean countries. In the latter countries, the term *indigenismo* (nativism) is applied to representations of Indians.[1] Two major problems confronted artists: first, that of establishing an ideological position that would appropriately address their particular concern, and second, how to test the limits of tolerance shown by their government for an art of social protest when the government itself felt targeted.

During the 1930s and 1940s, there was considerable tension in some countries between right-wing governments and a growing Communist Party that had established itself in many parts of Latin America by the early 1920s. In 1929, the Communist Party sponsored labor-related meetings that a number of artists attended.[2] These events helped to draw attention to the problem of the worker in Latin America, a subject invariably considered within a Marxist frame of reference. However, promoting Marxism as the underlying tenet of Communism was a European-generated solution. While it was applicable to the conditions of workers that were universal concerns, it did not adequately address the very different

SOCIAL, IDEOLOGICAL, AND NATIVIST ART

THE 1930S, 1940S, AND AFTER

THREE

conditions of the Indian population in Latin America. Indians belonged to a segment of the population that had not been integrated into most countries' national, social, or political discourse. In Bolivia, for instance, Indians did not even gain citizenship status until the 1930s, and when they did, it was to be exploited as nationals.

Workers and Indians were the main subjects in the art of the 1930s and 1940s in most Latin American countries and, in Mexico, since the 1920s (nineteenth-century depictions of Indians in Mexico were romanticized visions of a lost legacy rather than realistic portrayals of the contemporary Indian). Murals had been a major means of diffusion for these subjects in Mexico, but other countries did not have significant mural movements. Although murals were painted by individuals in most Latin American countries, social and indigenous art produced in them was more often in the form of easel painting. In Brazil, mural painting was largely confined to the work of Cândido Portinari in the 1940s. In Argentina, Bolivia, Peru, and Ecuador, artists filled a limited number of mural commissions during the 1940s, and a mural movement occurred in Bolivia after the 1952 revolution that brought in the liberal administration of Víctor Paz Estenssoro.[3] But the movement did not survive after Paz Estenssoro was ousted in 1964 after a second term in office (1952–1956 and 1960–1964), and many murals were subsequently destroyed.

Novels and essays initially brought attention to the problems of contemporary Indians, but interest in Indian culture in Mexico and the Andean countries was also prompted early in the century by archaeological investigations that drew attention to the great legacies of the past. Consequently, *indigenismo* was an ambiguous tendency. On the one hand, it was directed to the contemporary plight of Indians that writers had helped to identify, and on the other, to a sense of national pride in an ancient legacy that helped define cultural identities for artists (the latter tendency has been referred to as *indianismo* by some writers) as well as for the general public.

MEXICO

In Mexico, the Indian presence was acknowledged earlier than it was elsewhere. But to be Mexican meant to be mestizo rather than Indian.[4] However, in the period following the Mexican Revolution, Mexico's social problems were considered in European terms as ones of class struggle rather than of race. When the artists developed a political agenda after the mid-1920s, it was borrowed from Marxism.

FIGURE 3.1
José Clemente Orozco, *La mesa de la fraternidad* [*Table of Universal Brotherhood*], 1930, fresco, The New School for Social Research, New York. Photograph courtesy of The New School for Social Research.

During the era of influence of Elías Plutarco Calles (1924–1934), artists were also expected to accommodate Calles's own nationalist objectives and to represent his administration (1924–1928) in a favorable light. For a while, Rivera fulfilled these expectations in his murals for the Ministry of Education in Mexico City and the Palace of Cortés in Cuernavaca. But it became increasingly difficult for the mural painters to work freely in Mexico under Calles, and by the early 1930s, Orozco, Siqueiros, and Rivera had all gone to the United States. There, all three took up more universal themes that focused on the worker rather than the Indian. In late 1927, Orozco went to New York, where he became affiliated with a group led by Eva Sikelianos, widow of the Greek tragic poet Angelos Sikelianos, and Alma Reed, a romantic admirer of Mexican and Greek culture who helped to promote Orozco's work there.[5]

In 1930 Orozco painted two mural projects, *Prometheus,* in the dining hall at Pomona College in Claremont, California, and *La mesa de la fraternidad [Table of Universal Brotherhood]* (FIG. 3.1), in the dining room of the newly finished New School for Social Research in New York. The subject of the New School murals (1930–1931) was revolution and the struggle for social justice and independence in Mexico, Russia, and India. Each panel is dominated by its heroic leader (Felipe Carrillo-Puerto, Vladimir Lenin, and Mahatma Gandhi respectively). The end wall from which the mural takes its name represents a gathering of many races seated at a table. This scene, which includes portraits of some of Orozco's New York acquaintances, reflects the utopian concerns for world peace for which they stood.

La familia universal [The Hearth] (1930; FIG. 3.2), on the wall facing *La mesa de la fraternidad,* represents a worker being greeted by his family upon his return from a day's labor at a factory—visible outside the window. The optimistic tone of this mural, painted at the height of the depression, was characteristic of many of Orozco's and Rivera's worker images created during their stays in the United States. In *La familia universal,* Orozco's worker has a job, the security of a roof over his head, and food on the table.

In his mural cycle *Epic of American Civilization* (1932–1934), painted in the Baker Library at Dartmouth College in New Hampshire, Orozco interpreted the universal genesis theme with New World figures from pre-Columbian and post-conquest to modern times. In these panels, he equated the sacrificial banishment of the Mexican God Quetzalcoatl, who angrily departs promising to return, with

FIGURE 3.2
José Clemente Orozco, *La familia universal [The Hearth],* 1930, fresco, The New School for Social Research, New York. Photograph courtesy of The New School for Social Research.

FIGURE 3.3
José Clemente Orozco,
Mexican, 1883–1949,
*Trabajador industrial
[Modern Industrial Man],*
detail from *The Epic of
American Civilization:
Ideal Modern Culture* II
(Panel 23), 1932–1934,
fresco, P.934.13.23.
Commissioned by the
Trustees of Dartmouth
College, Hanover, New
Hampshire. Photo
courtesy Hood Museum
of Art, Dartmouth
College.

a Byzantine-inspired image of Christ who has returned and, in an act of defiance against the apparent uselessness of his sacrifice, destroys his own cross (the theme Orozco had first approached ten years earlier). Nonetheless, here in *Trabajador industrial [Modern Industrial Man]* (FIG. 3.3) the cycle also culminates on an optimistic note with Orozco's inclusion of construction workers above and next to the library's bookshelves. Workers are shown coaxing and setting steel girders into place in one scene. In another, a worker rests and reads a book after a day's work.

Orozco's faith in education—or rather in knowledge in the sense of enlightenment—both as the means to redemption for all humankind and as the final reward for the industrious worker, can be seen again in his frescoes in Guadalajara, painted after his return to Mexico in 1934. In the University of Guadalajara murals (1936), work and productivity have a redemptive function. In the background murals of the university auditorium stage, Orozco mocks the military leaders as deceptive forces who misguide the people. But in the auditorium's dome he celebrates true learning in *Hombre creador [Man in His Four Aspects]* (FIG. 3.4) embodied in the worker, teacher, scientist, and rebel. Orozco personally identified with the worker, which is a self-portrait.

Rivera's interpretation of the worker theme incorporated the machine as a necessary component of his productivity. In his U.S. murals in San Francisco (1931), Detroit (1932), and New York (1933), Rivera treated the worker theme from a Marxist point of view. The Na-

tional Palace murals in Mexico City, which he had left unfinished until his return to Mexico in 1934, directly reflect his experience in the industrialized world. The paintings he did in the United States between 1930 and 1934 and in Mexico after his return there celebrate industry and the structure and cold beauty of the machine. In *El México de hoy y de mañana* (see FIG. 2.16), painted in 1935 on the south wall at the National Palace in Mexico City facing the 1929 panel representing the pre-Hispanic world, Karl Marx is shown holding a scroll defining the classless society and points the way to a future utopia as workers agitate. The type of compartmentalization evident in this mural is also apparent in *Construcción de un fresco [The Making of a Fresco]* (1931) in the San Francisco Art Institute and in *Detroit: El hombre y la máquina [Detroit Industry]* (1932) at the Institute of Fine Arts in Detroit.

Far from the rural culture Rivera had painted in Mexico, the U.S. factory worker for him was the center of constructive activity. Rivera viewed the machine as a symbol of progress and a source of employment for workers during the depression.[6] According to Bertram Wolfe, Rivera was in love "with American industrial buildings, machine design and engineering," which he saw as "the greatest expression of the plastic genius of this New World."[7] In *Construcción de un fresco,* the monumental figure of a worker/engineer, wearing a small badge of the Communist Party, controls the levers in a composition divided into scenes by illusionistically painted scaffolding showing the different aspects of the building of a city.

The machine and the worker are the principal subjects in *Detroit: El hombre y la*

máquina. This cycle of twenty-seven panels in the Italian Renaissance–style court of the Institute of Fine Arts in Detroit celebrates not only the assembly of the motor and chassis of an automobile at Edsel Ford's River Rouge Plant, but also the transportation industries and medical science in general. Ironically, in these murals Rivera paid homage to Ford as the benevolent employer of numerous workers during a time of widespread unemployment by including Ford's portrait as the donor in the manner of Renaissance paintings. On both the north and south wall panels, respectively *The Making of a Motor* and *The Making of a Chassis* (PL. 3.1), the workers form an integral part of the murals' rhythm in two main tripartite compositions. On the north wall, their movements and poses synchronize with the undulating lines of conveyor belts against a background of blast furnaces, and on the south wall, with conveyor belts leading through the different stages of the making of the chassis.[8]

The theme of the worker at the controls appeared again in Rivera's ill-fated Rockefeller Center mural *El hombre contralor del universo [Man at the Crossroads]* (1933) in New York, originally located near the main entrance of the newly completed building and later destroyed, as is well-known, because of Rivera's inclusion of a portrait of Lenin.[9] He painted an almost identical version of this mural at the Instituto Nacional de Bellas Artes (PL. 3.2) after his return to Mexico City in 1934. The worker controlling the levers of a machine is the central figure in a composition consisting of two inter-crossed central diagonal wings, one containing planetary formations, the other, bacteria. In both versions of this mural, Rivera contrasted the capitalist world on the left with the communist one on the right in a way that clearly favored the latter, where the workers are the main subject.[10]

In Mexico between 1942 and 1952, Rivera returned to the Indian theme in a new cycle of murals in the patio of Mexico City's National Palace. These Indians were not the contemporary ones he had represented in the Ministry of Education panels nor in his numerous easel paintings, but Indians of past history in idealized reconstructions of pre-Hispanic scenes from the different regions of Mexico.

In the 1930s, Siqueiros painted Indians and workers in more confrontational ways than either Orozco or Rivera. In 1932, following a jail sentence and a period under house arrest in Taxco, he went to Los Angeles as a political exile from Mexico. While there he painted two outdoor murals, *América tropical [Tropical America]* at the Plaza Art Center and *Mitin obrero [Street Meeting]* at the Chouinard Art School. In the first, he represented a Mexican Indian as a victim of racism and injustice, and in the second, as a worker agitating for his rights. In *América tropical* (FIG. 3.5), Siqueiros denounced the mass deportations of Mexican nationals and the "wretched conditions of Mexican migratory workers" by painting as a central figure an Indian crucified beneath the eagle of U.S. coins. He used subdued colors instead of the bright exotic ones expected of a Mexican artist and promised by the mural's title. The mural led to considerable criticism and resulted in

FIGURE 3.4
José Clemente Orozco, *Hombre creador [Man in His Four Aspects]*, 1936, fresco, cupola of the auditorium at the University of Guadalajara, Mexico. Photo: Juan Víctor Arauz, from the author's archives.

Siqueiros's own deportation from the United States.[11]

In both *América tropical* and *Mitin obrero,* Siqueiros had also explored dynamic theories of space, compression, and motion as well as other innovative mural techniques, such as the airbrush as a solution for the fast-drying cement base he had used in his exterior murals in Los Angeles. In two large easel paintings done in Mexico, *Madre campesina [Peasant Mother]* (1929) and *Madre proletaria [Proletarian Mother]* (1930), Siqueiros brutally compressed the figures of the mothers and their babies within the pictures' space to convey the oppressive conditions of poverty, not to mention his own memory of confinement while in jail. He began formulating his ideas about new techniques as a result of his conversations in Taxco with the Russian filmmaker Sergei Eisenstein during the latter's stay

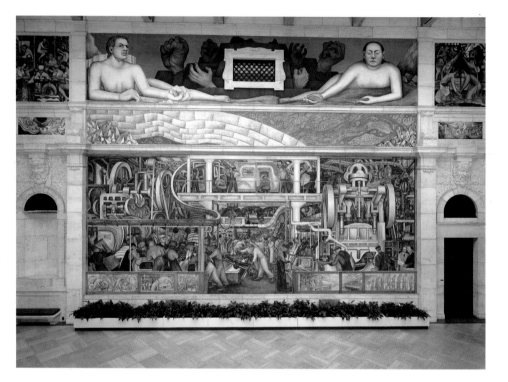

PLATE 3.1
Diego Rivera, *Detroit: El hombre y la máquina [Detroit Industry (The Making of a Chassis)],* 1932, fresco, south wall, 5.40 × 13.72 m./17¾ × 45 ft. Courtesy Detroit Institute of Arts. Founders Society Purchase, Edsel B. Ford Fund and Gift of Edsel B. Ford.

PLATE 3.2
Diego Rivera, *El hombre contralor del universo [Man at the Crossroads],* 1934, fresco, 4.85 × 11.45 m./16 × 37½ ft. Instituto Nacional de Bellas Artes, Mexico City. Reproduction authorized by the Instituto Nacional de Bellas Artes y Literatura. Photo: Archivos Fotográficos del CENIDIAP.

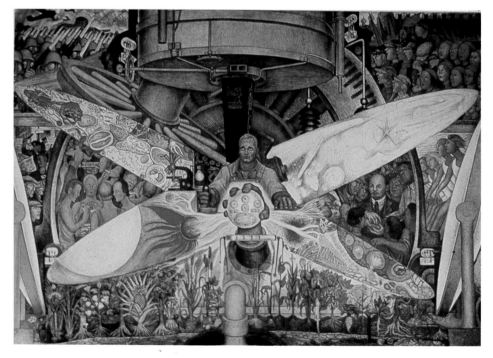

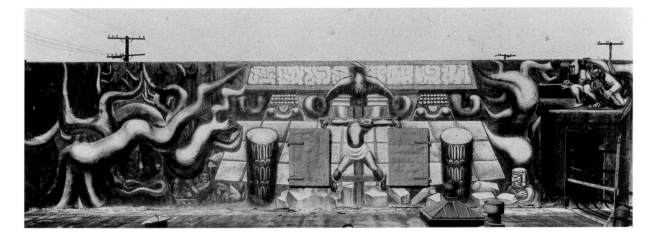

in Mexico. Siqueiros's association with Eisenstein led to later experiments with dynamic space and multiple points of view, or what he called "polyangular perspective," geared to the moving spectator. These effects were obtained by directly projecting photographic and film images onto the walls so they could also be enlarged or rectified on irregular surfaces such as corners and ceilings and seen from the spectator's various viewing angles. This technique also eliminated the need for the traditional systems of transferring scale drawings onto a wall. Siqueiros utilized these methods throughout the 1930s, first in Argentina, then again in the United States and Mexico.[12]

In addition to techniques borrowed from industry, such as pyroxylin paints applied with a spray gun and photomontage, Siqueiros incorporated into his paintings and murals images based on well-known documentary photographs taken from newspapers and magazines. His subjects included victims of war in anti-Fascist contexts. Before leaving for Spain to join the Republican army during the Spanish civil war, he painted *El eco del llanto [Echo of a Scream]* (1937; FIG. 3.6), in which he took the image of a wailing baby abandoned along the railroad tracks from a newspaper photograph. He used an enlarged version of the baby's head, obtained with the help of a camera projection, to express the baby's scream.

Siqueiros's mural *Retrato de la burguesía [Portrait of the Bourgeoisie]* (1939; FIG. 3.7) at the Mexican Electricians Union in

Mexico City (originally titled *Retrato del fascismo [Portrait of Fascism]*)—a team-painted mural—was the first in which he made full use of multiple perspectives. Within the limited space of a small stairwell, he created the appearance of a continuously flowing surface, designed to be seen from numerous points of view (those of the workers going up and down the stairs for instance), by dissolving corners and extending the existing architectural features into illusionistically painted ones.

On the right wall, an armed revolutionary worker, rifle in hand pointed toward the viewer, symbolizes the socialist struggle against imperialism. Both capitalism and fascism are cast as the enemies of the people; the latter is represented by a parrotlike dummy addressing the people from a podium. Soldiers and civilians wearing gas masks are a reminder of war (in this case, primarily the Spanish civil war that had just ended). The image of a black man hanging from the neck of a metal eagle, shown on the back wall as an indictment of racism in the United States, is based on a news photograph of a lynching. The "infernal machine" in the center, taken from a photo of a turbine mold, pours forth gold coins as a reference to capitalist greed. In the lower portion of the mural, workers' heads are detectable within the tentacles of an octopus. They are the victims of greed. On the ceiling, illusionistically painted giant derricks jut up into a blue

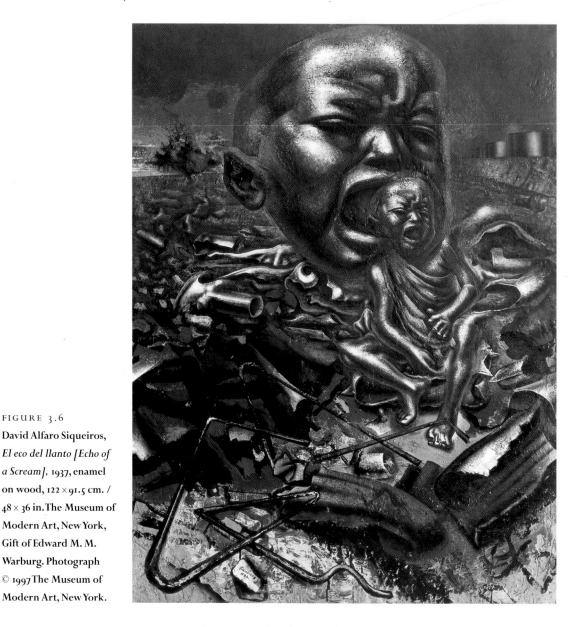

FIGURE 3.6
David Alfaro Siqueiros, *El eco del llanto [Echo of a Scream]*, 1937, enamel on wood, 122 × 91.5 cm. / 48 × 36 in. The Museum of Modern Art, New York, Gift of Edward M. M. Warburg. Photograph © 1997 The Museum of Modern Art, New York.

FIGURE 3.7
David Alfaro Siqueiros, *Retrato de la burguesía [Portrait of the Bourgeoisie]*, 1939, pyroxylin on cement, 114.8 sq. m. / 328 sq. ft. Mexican Electricians Union, Mexico City. Photo: Archivos Fotográficos del CENIDIAP. Courtesy SOMAAP, Mexico City. © David Alfaro Siqueiros/SOMAAP, México, 1998.

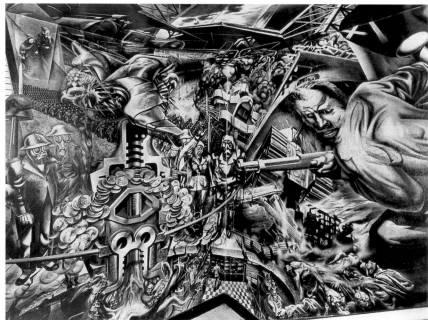

sky and point toward a radiant sun in a burst reminiscent of seventeenth- and eighteenth-century baroque church ceilings. In addition to its militant message, this mural also pays homage to modern industry in both its technique and theme. Siqueiros used multiple points of view and perspective illusionism again in the murals he painted in the Escuela México in Chillán, Chile, where he went into exile in 1941 following the assassination of Trotsky in Mexico,[13] as well as in his unfinished 1949 murals in San Miguel de Allende.

ARGENTINA

In 1933, in the course of a trip through South America, Siqueiros spent time in Argentina and, with the assistance of the Argentine painters Antonio Berni, Lino Eneas Spilimbergo, and others, painted *Ejercicio plástico [Plastic Exercise]* in the vaulted space of a bar in the country home of Natalio Botana, owner of the newspaper *Crítica,* as a demonstration of his use of industrial materials. He had hoped to launch a mural movement in Argentina as he had elsewhere, but he met with little success. Antonio Berni, Argentina's major social painter of the 1930s, quarreled with Siqueiros over this issue, defending large-scale easel paintings as a practical and effective alternative to public murals. Argentina was (and is) a conservative country, and public murals were not an option. In the 1930s, Argentina was run by a sequence of reactionary presidents beginning with General José F. Uriburu, and from 1943 to 1955, by Juan Domingo Perón, who looked to fascism as a model for his policies. For artists with leftist views such as Berni, these were difficult years. In 1943, Berni founded the Taller de Arte Mural (Mural Art Workshop) in collaboration with Juan Carlos Castagnino, Lino Eneas Spilimbergo, and several others, but his efforts resulted in a very limited number of privately commissioned portable murals.[14]

FIGURE 3.8
Antonio Berni, *Manifestación [Manifestation]*, 1934, tempera on burlap, 180 × 250 cm. / 39⅛ × 98⅜ in. Collection Dr. Eduardo and María Teresa Constantini, Buenos Aires. Photo: H. O. Casenave.

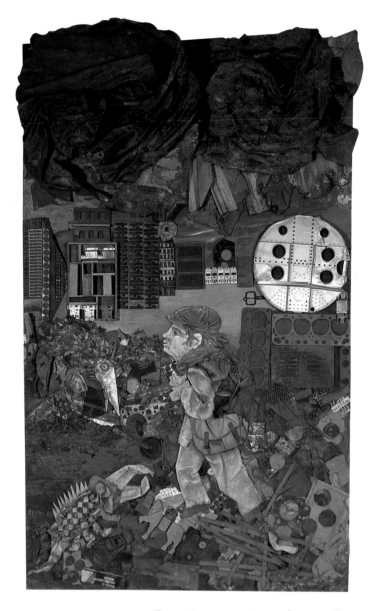

PLATE 3.3

Antonio Berni, *Juanito Laguna va a la ciudad [Juanito Laguna Goes to the City]*, 1963, mixed-media collage, 2 × 3 m./ 6½ × 10 ft. Collection Jorge and Marion Helft, Buenos Aires. Photo: H. O. Casenave.

lation, were Berni's main subjects.[15] He based the characters in two 1934 paintings, *Desocupados [Unemployed]* and *Manifestación [Manifestation],* on photographs he collected from the news media or took himself in order to document as graphically as possible the abysmal conditions of his subjects.

In *Desocupados,* sleeping men ranging in age from their teens to their sixties, sprawled or seated on the ground, convey a sense of total dejection and despair. The life-size scale of the figures and the sharp tonal contrasts add to the picture's impact. The crowd of rough-skinned men and women confronting the viewer in *Manifestación* (FIG. 3.8) is equally disturbing. A sign in the background reading "pan y trabajo" (bread and work) plays on the title of Ernesto de la Cárcova's less aggressive 1896 painting of an unemployed worker with his family, *Sin pan y sin trabajo [Without Bread and Without Work].* Neither *Desocupados* nor *Manifestación* was exhibited on a regular basis in Argentina until after 1964 (the first was shown there only twice before that).

Long after social painting was displaced by other currents, Berni continued to address issues of poverty, but in a form that blended with current tendencies. By the 1960s, he made his characters the subjects of assemblages by incorporating discarded objects and detritus. These were the same materials used by some of his younger colleagues, but Berni's continuing commitment to social causes in the 1960s and 1970s distanced him from other artists whose work was neither ideological nor narrative. To make his point about social inequities, Berni invented two characters, Juanito Laguna, a slum boy, and Ramona Montiel, a courtesan, whose daily experiences became the basis for narrative sequences that unfolded over a series of works. In these mural-sized paintings, Berni conveyed something of the slum environment by incorporating materials collected from urban refuse such as discarded bottle tops, broom parts, corrugated metal, cardboard, and rags.

Berni (1905–1981) was the son of an Italian immigrant father from the interior town of Rosario. He went to Europe in the 1920s with a fellowship from his hometown and became familiar with the collage techniques of the surrealists. His work of the late 1920s and early 1930s also has similarities with Giorgio de Chirico's metaphysical paintings, which he had seen in a Paris exhibition in 1928. However, in 1934, he began depicting proletarian and peasant themes in a sharp-focus realist style on canvases measuring some seven-by-ten feet as substitutes for murals. The Argentine proletariat, made up of low-paid factory or dock workers and peasants from a largely white European immigrant popu-

Juanito Laguna is shown in a variety of activities ranging from the commonplace to the far-fetched. He is shown taking lunch to his factory-worker father, helping his mother in domestic chores, flying a kite, or making his way through the rubble of his slum environment to go off to the city dressed in his Sunday best, such as in *Juanito Laguna va a la ciudad [Juanito Laguna Goes to the City]* (1963; PL. 3.3); or he exists in a fantasy world watching unlikely spaceships with cosmonauts glide by overhead, or in juxtaposition with advertisements for commodities (expensive automobiles for instance) that he would never own.[16]

BRAZIL

Despite some social and political parallels between Argentina and Brazil in the 1930s, conditions in Brazil were distinct. President Getulio Vargas's populist, nationalist government did not initially seem threatening. But when his term came to an end in 1937, he secured dictatorial power by dissolving the constitution (he remained in power until 1945 and returned again for another term as president from 1950 to 1954). Although the Brazilian government was less repressive than that of Argentina, Vargas nonetheless established a rigid system of censorship and promoted nationalist propaganda.[17] With few exceptions during those years, artists tended to focus on Brazilian themes in nonpolitical ways. Yet there existed a large underclass of poor European immigrants, mulattos, and the black descendants of plantation slaves who were either unemployed or worked as laborers and farmers without reaping the benefits of Brazil's industrial expansion.

Cândido Portinari as well as di Cavalcanti and Segall painted mulattos and blacks. But in contrast to di Cavalcanti's and Segall's passive figures, Portinari's rural laborers were actively working. He could also better identify with them: Tarsila do Amaral's family had *owned*

coffee plantations, but Portinari's family had *worked* on them. Like Berni, Portinari (1903–1961) was the son of poor Italian immigrants, and his family had settled in Brodosqui near São Paulo.

After a period of study in Rio and a two-year stay in Europe, he turned to social themes in the 1930s at about the same time Berni did. Although Portinari's early social phase consisted mainly of easel paintings, during the 1940s, he undertook several mural cycles. These appeared not to reflect a political agenda as much as to function as components of building programs and, more covertly, as propaganda for Brazil's resources. The country's agricultural resources especially were the subject of two of Portinari's mural cycles. His first major commission was for frescoes in the interior lobby of the newly completed Ministry of Education in Rio de Janeiro (1936–1943) and blue-and-white tile murals on the exterior wall near the entrance.[18] The interior murals focused on Brazil's agricultural and mineral riches, a subject with parallels in some of Rivera's work of the 1940s.[19] Portinari's murals include scenes of the cultivation and harvesting of cotton, tobacco, rubber, sugar, brazilwood, and coffee as well as scenes of a cattle farm and of iron production. Far from suggesting social protest, his murals seemed to place the government in a good light.

But in spite of the optimism implied by the subject of national wealth, these murals could as readily be interpreted as an indictment of the exploitation of a labor force that will not reap the benefits of this production. Ambiguity in his portrayal of workers and marginalized classes is evident in numerous paintings of the 1930s as well as in some of his murals.

By the end of the 1930s, Portinari was well known in the United States. His work was exhibited there and he was awarded Honorable Mention for his painting *Café [Coffee]* at the *Third Carnegie International* in Pittsburgh in 1935. Relations between the United States and Brazil were especially cordial from the

late 1930s through the 1940s, in part because of Roosevelt's Good Neighbor Policy and the importance given to Panamericanism during the war years.[20] In 1939, Portinari contributed murals to the Brazilian Pavilion at the World's Fair in New York. A year later, he began the murals at the Hispanic Foundation of the Library of Congress in Washington, D.C. These frescoes, finished in 1941, centered on themes of mutual interest to both countries: the discovery of the New World, the religious conversion of Indians, the settling of the land, and the discovery of gold.[21] In a discussion of this mural, the art historian Annateresa Fabris pointed out that, far from catering to official taste, Portinari had included a

black man in the discovery scene, thus making him an active participant, along with the Europeans, in the initial settling of the new land instead of a slave in a colonial system.[22] However, it should be noted that in his preparatory sketch for this panel, none of the subjects were black, leading one to conclude that his decision to introduce a black man at the helm was made in the process of painting.

Blacks and mulattos had been central themes in Portinari's easel work of the 1930s. Afro-Brazilians were a controversial issue in Brazil, where segregation remains an unspoken reality and social and economic inequities continue unresolved. Unlike Tarsila do Amaral's and, less blatantly, Segall's and di Cavalcanti's

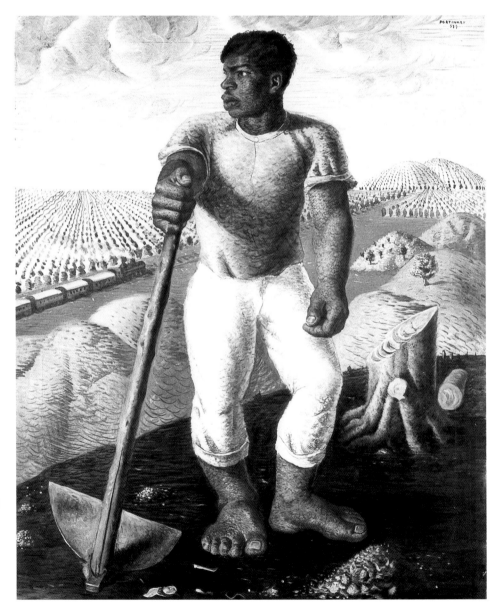

FIGURE 3.9
Cândido Portinari, *O lavrador de café* [*The Coffee Plantation Laborer*], 1939, oil on canvas, 100 × 81 cm. / 39⅜ × 31⅞ in. Museu de Arte de São Paulo. Courtesy Projeto Portinari, Rio de Janeiro. Photo: Peter Schneider.

FIGURE 3.10
Cândido Portinari,
*Enterro na rede [Burial
in a Hammock]*, 1944, oil
on canvas, 180 × 220 cm. /
70⅞ × 86⅝ in. Museu de
Arte de São Paulo.
Courtesy Projeto
Portinari, Rio de Janeiro.
Photo: Peter Schneider.

more exotic representations of Brazilian blacks, Portinari's are the unembellished, industrious laborers or the dispossessed inhabitants of barren lands. He portrayed laborers as strong, stoic, heroic figures rather than as helpless victims. In *O lavrador de café [The Coffee Plantation Laborer]* (1939; FIG. 3.9), a young male laborer stands resolutely in the foreground as if he owned the land he worked on.

Like his Mexican counterparts, Portinari made use of distortion and spatial compression to give the figures solidity and mass. In *Café* (1935; PL. 3.4), the focus is on the picking, bagging, and transportation of coffee beans as a collective task in which people of all racial mixtures participate. The figures, whose large hands and feet are an indication of their industriousness and hard work, and the background trees are packed into the space of the painting.

Portinari's painting of the 1940s, like that of many other artists, was indebted to Picasso's *Guernica* more than to the Mexican models because of Picasso's forceful expressiveness and absence of narrative. The impact of *Guernica* is especially visible in the *Retirantes* ("refugees" from the arid lands in northeastern Brazil known as the *sertão*) series of 1944.[23] In accordance with this new model, Portinari eliminated racial specificity from these paintings. Instead, the figures are generic types fleeing inhospitable conditions in the northeast to seek work further south, a flight that usually resulted in low-paying factory jobs. The weak among them often died on the way. Portinari's refugees embodied the universal condition of human misery rather than racial problems, yet at the same time, they were the victims of a specifically Brazilian phenomenon—drought in the *sertão*. The subjects are ragged humans carrying their worldly belongings in a bag, scrawny children with swollen bellies, and mourners at funerals for those who did not survive the journey. In *Enterro na rede [Burial in a Hammock]* (1944; FIG. 3.10), the deceased is carried in the hammock that served as a bed during life and has become the coffin in death. The foreground is dominated by the back view of a kneeling, wailing woman.

PLATE 3.4
Cândido Portinari, *Café
[Coffee]*, 1935, oil on
canvas, 131 × 195.3 cm. /
51½ × 76⅞ in. Museu
Nacional de Belas Artes,
Rio de Janeiro. Courtesy
Projeto Portinari, Rio de
Janeiro. Photo: Peter
Schneider.

THE ANDEAN COUNTRIES

In the Andean countries, the main subjects of *indigenismo* in art[24] were the mestizo miners who labored and lived in squalid conditions, and the native rural population. In Bolivia, besides miners, landscape was also an integral subject of nativist painting. These subjects had a precedent in indigenist literature. Writers such as the Bolivian Alcides Arguedas, the Peruvians José Carlos Mariátegui and Ventura García Calderón, and the Ecuadorian Jorge Icaza had addressed issues of exploitation and land. Alcides Arguedas had been a pioneer in raising the issue of the abuse of Indians in the twentieth century in his novel *Raza de bronce* (1919). Others such as Mariátegui and Icaza addressed problems of the Indian and land allotment in novels or political essays. Artists, however, confronted these problems less overtly.

During the 1930s and 1940s, both Peru and Bolivia fluctuated between left- and right-wing governments, which resulted in unpredictable conditions. Some of these governments favored the cause of workers and Indians, while others favored tin barons and U.S. interests at the expense of the exploited working classes. A strong German presence in Ecuador,

Peru, and Bolivia also competed with the United States for control. Diplomatic relations with the Axis were not severed in those countries until about 1942, three years after the outbreak of the war in Europe. The majority of artists and writers, however, were leftists and were hostile to both the Axis and the United States.

In Ecuador, where Indians had been singularly absent from nineteenth-century mainstream art, by the 1930s and 1940s they were represented with far more daring than was the case in other Andean countries. Camilo Egas was the first to introduce this subject in Ecuadorian art in the 1920s, albeit in its more exotic aspects, but he became a pioneer indigenist in the early 1930s. *Indigenismo* was not officially launched as a movement there, however, until 1939, when three writers—Jorge Reyes, José Alfredo Llerena, and Alfredo Chávez—founded the Salón de Mayo del Sindicato de Escritores y Artistas Ecuatorianos (May Salon of the Syndicate of Ecuadorian Writers and Artists), and an initial art exhibition was held the same year.[25] Many Ecuadorians had direct contact with Mexicans. Siqueiros had traveled through Ecuador and lectured there in 1933 and 1935, and again in 1943 in transit to Mexico from his Chilean exile (he

stopped in other countries as well), and Egas had also met Orozco in New York in 1930.

After the 1930s, Egas spent relatively little time in Ecuador and took up other subjects in addition to Indians. In 1927, he had moved to New York, though he still made frequent trips back to Ecuador. From 1935 to his death in 1962, he taught in and directed the art department at the New School for Social Research, and in the early 1930s, he painted a mural there, as had Orozco and Thomas Hart Benton. Egas's mural *Festival indio ecuatoriano [Ecuadorian Indian Festival]* (1932) represented an All Saints Day festival among the Quechua Indians. But far from showing a joyous folk scene, Egas incorporated an indictment of the oppression of Indians by introducing a disembodied hand in the lower left side that he described as the "hand of Spain" placed over a Quechua Indian's mouth to silence him.[26] In the 1930s, Egas also painted scenes of workers as well as barren surrealist landscapes. His somber, sometimes erotic landscapes have common characteristics with the art of the European war exiles Kurt Seligmann and Stanley William Hayter and of U.S. artists O. Louis

Guglielmi, Ralston Crawford, Chaim Gross, and Moses Soyer; and his worker subjects, with that of Orozco.[27]

Egas's compatriot Eduardo Kingman (1913–1998) collaborated with him on *La cosecha [The Harvest],* a mural for the Ecuadorian Pavilion at the 1939 New York World's Fair that celebrated productivity in accordance with the optimistic image projected by the fair and the mood of the time.[28] Kingman's easel paintings of the 1940s and later included worker and Indian themes in a style indebted to Siqueiros and Orozco. Kingman's life-sized painting *Los guandos [The Hauliers]* (1941; PL. 3.5) makes one of the most powerful statements by an Andean artist in its unequivocal indictment of exploitation. The composition is divided diagonally into two zones, the upper right sector dominated by an intimidating foreman on horseback who wields a whip, and the lower left one showing a procession of Indians bowed under the excessive weight of their load and brutally compressed into the space of the picture. The Guandos are the Indians who haul huge blocks of ice packed and tied with ropes down the slopes of the Chimborazo volcano to sell at the weekly

PLATE 3.5
Eduardo Kingman, *Los guandos [The Hauliers],* 1941, oil on canvas, 150 × 200 cm. / 59 × 78¾ in. Courtesy Casa de la Cultura Ecuatoriana Benjamín Carrión, Quito. Photo: Christoph Hirtz.

market.[29] Although Kingman painted numerous other scenes of Indians, none surpassed this one for its degree of pathos and dramatic impact.

In 1940, Kingman founded the Caspicara Gallery in Quito, which soon became a meeting place for artists with similar interests. In 1942, Oswaldo Guayasamín (1919–1999), a mestizo and the oldest in a family of ten children, had his first solo exhibition there. He began painting Indians as well as portraits of non-Indians while he was still in his teens. By 1938, he had adopted the dramatic indigenist style of Egas and Kingman. Guayasamín had attended the Quito School of Fine Arts, whose institutionalized academicism was regarded as antiquated by the indigenists. His 1942 exhibition provoked a scandal, because the indigenist style and content of his work was interpreted by the school's officials as a gesture of rebellion against their academic standards and earlier support of his work.[30] Nonetheless, in the following years, Guayasamín was to enjoy considerable success at home and abroad and gained a reputation as Ecuador's official painter.

The social and leftist content of his work did not deter capitalist patrons like Nelson Rockefeller from acquiring five of his paintings during a visit to Ecuador. As a result of this contact, in 1942 Guayasamín was invited by the state department to visit the United States and exhibit at the Pan American Union in Washington, D.C. In 1957, he showed again in Washington. The same year, he was awarded the prize as Best Latin American Painter at the *Fourth São Paulo Biennial.* Like his fellow Ecuadorians, Guayasamín had direct contact with the Mexicans. He befriended Siqueiros and in 1943, on his way back to Ecuador from the United States, stopped in Mexico and worked with Orozco on the latter's murals of the Apocalypse in the Templo de Jesús in Mexico City.

Guayasamín's early paintings combine the tortured and somber style of Orozco and Siqueiros as well as hints of Picasso's blue period. In two early works, *El paro [The Strike]* (1938) and *La procesión [The*

FIGURE 3.11

Oswaldo Guayasamín, *El paro [The Strike],* 1938, oil on canvas, 200 × 250 cm. / 78¾ × 98½ in. Fundación Guayasamín, Quito. Photo courtesy Fundación Guayasamín, Quito.

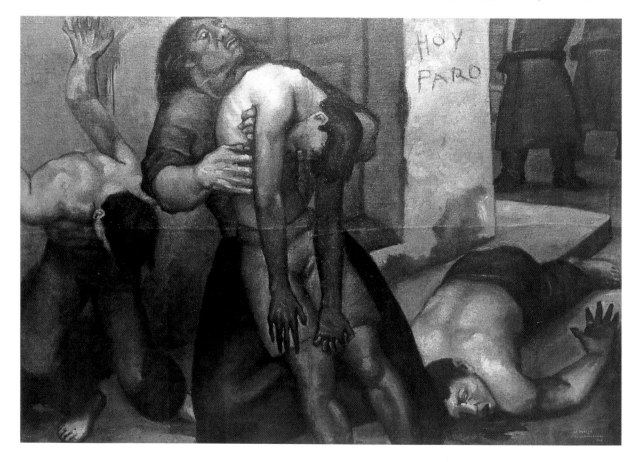

FIGURE 3.12
Francisco Goítia (1882–
1960), *Tata Jesucristo
[Daddy Jesus]*, 1926–1927,
oil on canvas, 85.5 × 106
cm. / 33½ × 41¼ in. Col.
Museo Nacional de Arte,
Mexico City. Photo:
Archivos Fotográficos
del CENIDIAP. Courtesy
Consejo Nacional para la
Cultura y las artes,
Instituto Nacional de
Bellas Artes y Literatura,
and Museo Nacional
de Arte.

Procession] (1942), he focused on tragic moments in the lives of workers and Indians. In *El paro,* the figures are not identifiably Indian, but in *La procesión* they are. The impact of Guayasamín's paintings comes from what they imply rather than from obvious narrative. In *El paro* (FIG. 3.11), a frightened woman amid dead and prostrate bodies struggles to hold one of them up. The words *hoy paro* (today I strike) scribbled on a house wall and the cropped figures wearing boots, visible in the background, tell of the aftermath of a brutal shooting by the police into a group of strikers. In *La procesión* (PL. 3.6), grieving Indian peasant women, one of whom shields a lit candle with a gnarled hand, advance toward the viewer in a funeral scene. The identity of the deceased is not revealed. Is it a relative, some victim of violence or illness, an enactment of a Good Friday procession, or a mourning scene on the Day of the Dead? The nearest stylistic parallel to this work is the Mexican Francisco Goítia's 1926–1927 painting *Tata Jesucristo [Daddy Jesus]* (FIG. 3.12), in which two women grieve by the eerie light of a lone candle on the Day of the Dead.

By the mid-1940s, Guayasamín no longer painted naturalistically. Instead, he incorporated geometric elements in a late-cubist manner with flatter areas of red, tan, yellow, creamy white, and black, something like the colors used by Siqueiros and Tamayo. Guayasamín's appointment in the 1940s as Ecuadorian cultural attaché to several South American countries gave him the opportunity to observe the squalid conditions of blacks, Indians, and mestizos in Peru, Chile, Bolivia, and Argentina.[31] This experience resulted in a series of paintings collectively titled *Huacayñán,* the Quechua name for *Camino del Llanto [Road of Tears],* which he did over a period of several years. In these works, he sought to convey the oppressive conditions of people metaphorically rather than in the more literal manner of his earlier indigenist style. In *Flagelamiento II. Tema indio [Flagellation II. Indian Theme]* (1948; PL. 3.7), he drew a parallel between the Indian and the martyrdom of Christ. A kneeling, lacerated black male figure with outstretched arms, set against a background of red flames, is flanked by

two mourning women. The Indian appears to embody several stages of the Via Crucis: the flagellation, crucifixion, and lamentation. In another work from this series, *La corrida. Tema mestizo [The Bullfight. Mestizo Theme]* (1947), a bull—reminiscent of Tamayo's paintings of animals of the early 1940s—is being killed, not by a matador but by loosely draped figures (mestizos), as a white victim (the European race) lies dead beneath the bull. The bull, of course, is a symbol of Spain, but it also represents what survived in the New World. The painting implies the emergence and dominance of the mestizo as the new race resulting from the conflict between the Spanish and the Indian legacies. In a later work, *El toro y el cóndor (The Bull and the Condor]* (1957; PL. 3.8), Guayasamín more blatantly represented this conflict. The subject is taken from a popular Andean ritual in which a condor is caught, starved for three days, then sewn to a bull, culminating in a bloody conflict between the angry bull and the hungry

PLATE 3.6

Oswaldo Guayasamín, *La procesión [The Procession]*, 1942, oil on canvas, 80 × 101 cm. / 31½ × 39¾ in. Courtesy Casa de la Cultura Ecuatoriana Benjamín Carrión, Quito. Photo: Christoph Hirtz.

PLATE 3.7

Oswaldo Guayasamín, *Flagelamiento II. Tema indio [Flagellation II. Indian Theme]*, from the *Huacayñán [Camino del Llanto, or Road of Tears]* series, 1948, oil on canvas, 97 × 138 cm. / 38⅛ × 54⅛ in. Collection Maruja Monteverde, Quito. Photo courtesy Fundación Guayasamín, Quito.

condor. In the 1950s and 1960s, Guaya-samín continued to focus on the victimized members of society in *La Edad de la Ira [The Age of Wrath],* a series comprising some 250 paintings. In these works, he explored the expressive potential of faces and hands in various gestures of prayer, anguish, rage, and supplication.[32]

Indigenismo in Peru and Bolivia was, on the whole, less confrontational than it was in Ecuador. In both countries, artists tended to represent ancestral and allegorical visions of Indians, local festivals, and landscape rather than contemporary issues. Most of the work was in the form of easel painting, although some murals were painted in both countries between the 1930s and the 1970s, and especially after 1950. Many of the murals were allegorical, but a limited number of artists also took up challenging subjects that addressed social injustices. Among the most daring of the mural painters were the Peruvian Juan Manuel Ugarte-Elespuru (b. 1911), who had studied fresco in Buenos Aires with Alfredo Guido, and the self-taught Bolivian painter Miguel Alandía Pantoja (1914–1975). Both artists depicted scenes that exposed the oppressive conditions of miners: Ugarte-Elespuru in his mural at the Universidad Nacional de Ingeniería (Lima) in 1944, and Alandía Pantoja in his painting for the Union of Mines in the mining town of Catavi, Bolivia, in 1946–1947, in which he also attacked capitalist dictatorship.[33]

Despite some similarities, there were also profound differences between the Peruvians' and Bolivians' approaches to their subjects in easel painting and murals. In both countries, artists tended to idealize Indians as symbols of national identity. In Bolivia, this idealization sometimes disguised indictments of social injustices, whereas in Peru, in spite of activists like Mariátegui, more often than not Indians were thought of in abstract terms as part of a dual Peruvian legacy: the European and the Indian.[34]

Augusto Leguía, who was president of Peru from 1908 to 1912 and again from 1919 to 1930, appeared to defend the cause of Indians, paying them lip service by proclaiming them full citizens of the republic, but he did little to change their living standards.[35] The presence of a powerful landowning class and the social impact of foreign interests led to the founding in the 1920s of the APRA party (Alianza Popular Revolucionaria Americana [Popular Revolutionary American Alliance]) by Haya de la Torre. Although patterned after the Mexican and Russian models, APRA consisted of a modified form of socialism that rejected Lenin's dictatorship of the proletariat. *APRismo* stood for social reform and nationalization of land and industry as well as for the uniting of Indoamerica (as Haya de la Torre referred to Latin America) against U.S. imperialism.[36] However, Haya de la

PLATE 3.8
Oswaldo Guayasamín, *El toro y el cóndor [The Bull and the Condor],* 1957, oil on canvas, 190 × 133 cm. / 74¼ × 52⅜ in. Private collection, Andorra, Ecuador. Photo courtesy Fundación Guayasamín, Quito.

FIGURE 3.13
José Sabogal, *Indio
[Indian]*, 1926, woodcut
for cover of *Amauta* 9
(September 1926), Lima,
Peru. Photo: Author.

Torre's program did not solve the more immediate problem of the Indians, which was one of land allotment more than of nationalization. In an attempt to find a solution to this problem, José Carlos Mariátegui had advocated a modified form of Marxism based on the Inca *ayllu* (commune) system of government rather than a European system, that is, on a system that came closer to addressing the Indian problem. But his efforts were aborted by his early death in 1930. Nevertheless, his founding of the journal *Amauta* (meaning "wise man" or "teacher" in Quechua) (FIG. 3.13) in 1926 as a platform for his theories contributed significantly to drawing attention to the problems of the Indian population, if not to solving them.

Mariátegui also proposed an art for Peru that would be relevant to the Indian problem. In a series of debates published in *Amauta* in 1929 under the title "El problema indígena," he called for an art that would focus on the conditions and life of the Indian.[37] He considered *indigenismo,* at least in its literary form, as an antidote to the nostalgic idealization of "literary colonialism," in a reference to earlier Indianist representations. *Indigenismo,* he maintained, has roots that are "alive in the present" and takes its inspiration from the protest of 3 million men (the Indian population).[38]

Mariátegui also felt that art should address issues of Peruvian identity, but this led to a disjunction in concepts of what constituted this identity. Until the mid-1940s, Peruvians perceived themselves as Indian and European, without acknowledging the existence of the mestizo. This dichotomy was evident in the work of José Sabogal (1888–1956), who addressed issues of identity rather than contemporary problems. As one of the first artists to do murals in modern Peru, Sabogal took up the theme of Peruvian identity in three panels on the subject of Garcilaso de la Vega painted in the Tourist Hotel in Cuzco in 1945. In one of the panels, he presented the sixteenth-century writer Garcilaso de la Vega (known as Garcilaso "El Inca" because he embodied the Spanish and Indian duality) with a divided face, half Indian, half Spanish, and half male, half female. Mariátegui too had considered Garcilaso de la Vega to be historically "the first Peruvian."[39] Sabogal, a great admirer and friend of Mariátegui's, was responsible for the woodcut of the Indian head on the cover of the first issue of *Amauta* in 1926 (see FIG. 3.13).

Sabogal's own Spanish heritage made it difficult for him to identify with Indian problems (a situation that also existed among some indigenist writers who were not themselves Indian), although he upheld their value and dignity and especially admired the local Indian crafts. He once declared, "I am not an indigenist,"[40] even though he helped to form a whole generation of indigenist artists at the National School of Fine Arts. Although

his own representations of Indians had some of the formal simplifications of *indigenismo,* they did not have the compressions and distortions present in the work of the Mexicans and some Ecuadorians. Sabogal's Indians, dressed in their traditional costumes, were more typical of the folkloric aspects of *modernismo* than of *indigenismo.*

Between late 1922 and early 1923, Sabogal had traveled to Mexico, where he met Rivera, Manuel Rodríguez Lozano, and Abraham Angel, and saw early work by Siqueiros, Amado de la Cueva, and Roberto Montenegro in Guadalajara. But he did not find a model for a social agenda during that trip, as has been supposed, because Mexican artists had not yet formulated one of their own.[41] Rather, Sabogal was as indebted to Spanish, Italian, and Argentine sources as he was to Mexican ones. Between 1908 and 1913, he had traveled to Europe, and from 1913 to 1918 to Argentina, where he came into contact with Spilimbergo.[42]

Sabogal's interest in Peruvian Indians dates from his visits after 1918 to highland towns around and near Lake Titicaca when he was living in Cuzco.[43] He depicted Indians at their daily activities and at folk festivals in *altiplano* (highland) settings. Some of his paintings of Indian women recall the poses in Gauguin's representations of Tahitian women as well as full-length colonial portraits of Inca rulers and princesses. Some of Sabogal's figures are shown carrying pottery or baskets on their heads, such as in *Victoria Regis* (1938; PL. 3.9). By the 1940s, his interest in Indians came to focus increasingly on their crafts, and he wrote abundantly about Peruvian incised gourds, pottery making, and textiles.[44]

Still, as the central force behind a group of indigenist artists who studied at the National School of Fine Arts under his direction between 1932 and 1943, Sabogal was, theoretically at least, very influential. His followers included Enrique Camino Brent, Julia Codesido, and Camilo Blas, and there were numerous other indigenists who worked inde-

pendently. The majority of Sabogal's followers limited their subjects to rural scenes and festivals. Although Camino Brent (1909–1960) had scandalized the public in Lima in 1936 when he showed a painting satirizing the clergy, his scenes of Indians were less daring and did not address social problems. His interest, like Sabogal's, was archaeological rather than social. He too had visited highland Peruvian towns and was especially drawn to the Indians' crafts and popular art. He subsequently taught courses in ceramics at the National School of Fine Arts.

Julia Codesido (1892–1979) applied the simplifications of modernism to her paintings of Andean Indian themes such as dances with a focus on aesthetic values rather than ideological ones.[45] Camilo Blas (Alonso Sánchez Urteaga; 1903–1985) chose as his subjects highland landscapes, native types, and processions. Although his *Pescadora mochica [Moche Fishmonger],* painted in the 1940s and depicting a contemporary Indian woman with a basket on her head crossing a desolate coastal landscape, is reminiscent of Sabogal's *Victoria Regis* in her pose, the reference in Blas's painting is to her past legacy as a descendant of the north-coast Mochica people rather than to a present condition.

Other Peruvian *indigenistas* of the same period include Jorge Vinatea Reinoso and Mario Urteaga. Vinatea Reinoso (1900–1931), who died young, expressed his liking for the art of ancient as well as contemporary Indians in his oil painting *Balseros en Titicaca [Straw Boats on Lake Titicaca]* (1920s; PL. 3.10), in which *balsa* boats form an ascending pattern of repeated shapes over the blue background of the water. This painting's rhythmic and geometric designs also evoke Tiahuanaco textile patterns.

Mario Urteaga (1875–1957), Camilo Blas's uncle, was largely self-taught, admired academic art, and had diligently read Leonardo da Vinci's *Treatise on Painting.* This aspect set him apart from most indigenists, yet he conferred a quiet

PLATE 3.9
José Sabogal, *Victoria Regis*, 1938, oil on canvas, 154 × 99 cm. / 60⅝ × 39 in. Private collection, Lima. Photo courtesy Daniel Giannoni.

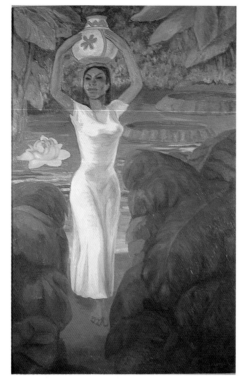

PLATE 3.10
Jorge Vinatea Reinoso, *Balseros en Titicaca [Straw Boats on Lake Titicaca]*, 1920s, oil on burlap, 95 × 74 cm. / 37⅜ × 29⅛ in. Private collection, Lima. Photo courtesy Daniel Giannoni.

dignity on his Indian subjects and personalized them more than did any other painter of his generation. Urteaga never traveled out of Peru, but he knew the territory around his native Cajamarca in the Peruvian highlands very well. Between 1910 and 1915, he ran a photographic studio in his hometown. After he gave up photography to devote himself entirely to painting, he continued to use photographs as a basis for his work. He also used the non-Indian members of his own family as models. As a result, the Indians he painted had none of the exaggerated exoticism visible in the work of some of his colleagues. Rather, Urteaga gave his Indian subjects aristocratic features and formulated an image of the Indian as one of humility and modesty as well as dignity. He painted Indians in betrothal scenes, in religious processions, at funerals, or at their daily tasks such as making sun-dried adobe bricks with which to build their houses. In *Entierro de un hombre ilustre [Burial of an Illustrious Man]* (1936; FIG. 3.14), Urteaga also re-created a historic event. According to his testimony, the deceased was a Cuzqueño Indian survivor of the War of the Pacific (fought between 1879 and 1883 by Peru, Bolivia, and Chile over territorial rights).[46] The scene takes place in front of a row of single-story houses typical of highland towns.

In Bolivia, where Indians had been reduced to serfdom since colonial times, the first general awareness of their conditions came in the 1930s, prompted in part by Alcides Arguedas's writings. Their great number also forced the government to take some action. But when the Bolivian government made an effort to integrate them into the Bolivian social body and grant them citizen status, it was not for disinterested reasons, although at first this move was seen as a twentieth-century solution to a serious economic and racial problem.[47] It was to the government's advantage to acknowledge Indians as citizens for the purpose of recruiting them during the disastrous Gran Chaco War (1932–1935) between

Paraguay and Bolivia over border issues. The Indians' forced participation in this war as nationals was merely another form of exploitation. Thousands of them died at the front during the campaign.[48]

To compensate for these and other inequities, a few individuals in both Bolivia and Peru took advantage of short-lived liberal governments to establish self-sustaining rural schools for the purpose of educating Indians, teaching them useful trades, and helping them to preserve and incorporate their local traditions into the schools' daily activities. Although these rural schools sound like twentieth-century counterparts of colonial Jesuit missions, their purpose was not to convert and control the Indians but to teach them to be self-sufficient in a society that had long robbed them of their ability to function independently. These schools were based on a communal system, something like that advocated by Mariátegui. A cluster of these schools

emerged on both the Peruvian and Bolivian sides of Lake Titicaca in the early 1930s.

The rural commune of Warisata on the Bolivian side between La Paz and Lake Titicaca was one of these.[49] The school's purpose as a consciousness-raising educational center was enhanced by the inclusion of murals and wood reliefs by several artists who depicted the activities the school encouraged and taught. Manolo Fuentes Lira, a Peruvian sculptor and one of the school's teachers, carved low-relief panels representing indigenous musical instruments of Inca and colonial origin on the entrance portal of the Warisata Theater in 1941.

In 1934, the Bolivian painter and printmaker Alejandro Mario Yllanes (1913–1960)[50] had painted murals in tempera on the plaster walls along the Warisata school's open arcade. The murals, which remained unfinished, depicted the commune's daily activities, with an emphasis on self-sustaining productivity. They included scenes of ferrymen trans-

FIGURE 3.14
Mario Urteaga, *Entierro de un hombre ilustre [Burial of an Illustrious Man],* **1936, oil on canvas, 58.5 × 82.5 cm. / 23 × 32½ in. The Museum of Modern Art, New York, Inter-American Fund. Photograph © 1997 The Museum of Modern Art, New York.**

porting goods in *balsa* boats on Lake Titicaca and of Indians working with leather, plowing and sowing the land, or enjoying a picnic. Yllanes's Indians were the central actors on their own land, in control of their lives. These murals, along with many of the communes, including Warisata, were subsequently destroyed by later administrations.[51] Yllanes was one of few Bolivian artists to take a militant position in easel paintings as well, some of which contained scathing indictments of the government's treatment of peasants and Indians, thinly disguised as colorful scenes of folk festivals. As a result, it became impossible for him to remain in his country, and he went into exile.[52]

In the 1930s and 1940s, when intercontinental travel usually occurred by sea, Bolivia's situation as a landlocked country resulted in limited exchange with the international art centers, though artists were by no means closed off from the outside world, as has sometimes been proposed.[53] Foreign artists went to Bolivia in the 1930s; contacts existed between Mexico, Bolivia, Peru, Ecuador, and Argentina; and Bolivian artists did travel abroad.[54] Cecilio Guzmán de Rojas, the "father of *indigenismo*" in Bolivia, had spent many years in Europe before 1928, and David Crespo Gastelú, a painter, caricaturist, and cofounder of Bolivian *indigenismo* known for his leftist views, had lived and worked in Argentina in the mid-1940s before returning to Bolivia in 1946. An unusual number of Bolivian artists also went to the United States. Roberto Guardia Berdecio worked in Siqueiros's 1936 New York Experimental Workshop and also lived in Mexico for several years. The painter Jorge de la Reza studied at Yale in New Haven. Armando Pacheco Pereyra, a painter and caricaturist, studied at the Art Students League in New York in the mid-1940s with Yasuo Kuniyoshi, Vaclav Vytlacil, and Morris Kantor, and some of his work also shows the impact of Siqueiros.[55] But even painters like Arturo Borda, whose only trip abroad was a brief

visit to Argentina in 1919, had ample access to documentary photographs, prints, and information from abroad.

Guzmán de Rojas (1900–1950) taught for several years at the National Academy of Fine Arts (founded in La Paz in 1926) and was as influential a teacher in his country as Sabogal was in Peru. Guzmán de Rojas called for a national art that drew on the country's Indian population and culture.[56] His paintings of Aymara Indians represented the Bolivian counterpart of paintings of Quechua Indians in the coastal countries. His Indians were shown in frontal, formal poses wearing the native dress of people of rank, not the contemporary clothing worn by the majority of Indians. Aymara Indians were the main subjects of works by many of Guzmán de Rojas's and Crespo Gastelú's colleagues and followers also. For Crespo Gastelú (1901–1947), who had studied fresco in the 1940s at the Ernesto de la Cárcova Higher School of Fine Arts in Buenos Aires with a grant from the Bolivian government,[57] Aymara Indians embodied the very soul of highland Indian culture. *Ritmo aymara [Aymara Rhythm]* (1946; PL. 3.11), a gouache study for a mural done in Buenos Aires, shows Bolivian musicians and their instruments in a dynamic arrangement of alternating curves that evoke the rhythms of the music. Guzmán de Rojas had recommended the use of curvilinear designs, or "voluptuous rhythms," to his fellow indigenist artists, and Crespo Gastelú was among those to take up this system.

One of Guzmán de Rojas's students was the sculptor Marina Núñez del Prado (1910–1995), known for her sculptures of miners, dancers, and Indian mother figures. Her terra-cotta *Cabeza de indio [Head of an Indian]* (c. 1935; PL. 3.12) shows the proud head of an Aymara. Núñez del Prado sculpted another very similar head in wood during her stay in the United States between 1941 and 1948. Her work is very much in the Bolivian tradition of the 1940s, but it also shows

affinities with William Zorach's rounded forms of the same period. Núñez del Prado also acknowledged the impact of Alexander Archipenko and Henry Moore in the development of her later style. When abstraction displaced *indigenismo* in Bolivia in the 1950s, she began a series of bronze casts and stone carvings in which she sought to convey the movement of condors in flight in abstract terms rather than portray the condors themselves as physical entities.

A constant in the art of many Bolivians was the presence of landscape. Salazar Mostajo referred to this aspect of Bolivian *indigenismo* as the "cult of the mountain." He noted that "there is a natural sense of completion between the human figure and the Andean landscape," due in part to its significance in the survival of the Indian.[58] Landscape forms an integral part of Guzmán de Rojas's and Arturo Borda's paintings. The assigning of nurturing, protective attributes to landscapes and mountains goes back to pre-Hispanic times. The ancient Aymara worshiped mountain peaks as their tribal ancestors. Landscape also had mythical, allegorical, and ancestral meanings in Bolivia, especially in the 1940s when it also became a part of miners' mythological vocabulary in carnival festivals.

In addition, the altiplano landscape was generally considered feminine, a perspective shared by both Guzmán de Rojas and Arturo Borda. They equated landscape—and by extension, nature—with the female nude, an association also made by some surrealists.[59] The mountain peak is present in many paintings by Arturo Borda (1883–1953), a self-taught artist from La Paz.[60] Because of the Bosch-like incongruities in Borda's paintings, it is difficult to classify him merely as an indigenist. His work contains surrealist and symbolist elements as well as indigenist ones. Borda's taste for the sacred and profane may have derived from his earlier association with Bolivian *modernista* poets,[61] as well as from prints and photographs he used as sources for some of his paintings, which included nineteenth-century prints by European artists. His use of such prints follows a Bolivian custom that has its source in the colonial practice of basing the background landscapes in religious paintings on prints imported from Antwerp.[62] But Borda also used his own drawings made during his walks in the countryside. Such drawings probably served as a basis for *La pascana [The Halt]* (1943–1950), in which Indians and their llamas pause to rest on a mountain plateau. The Indians and llamas

FIGURE 3.15
Arturo Borda,
Pachamama [Mother Earth], **1944, oil on cardboard, 77 × 109 cm. / 30¼ × 42⅞ in. Private collection, La Paz. Photo: Archivo Fotográfico del Archivo de La Paz; rephotographed by Pedro Querejazú.**

PLATE 3.11
David Crespo Gastelú, *Ritmo aymara [Aymara Rhythm]*, 1946, gouache (tempera?) on paper, 16.5 × 16.5 cm. (paper, 24.5 × 17.5 cm.)/6½ × 6½ in. (paper, 9⅝ × 6⅞ in.), preparatory sketch for a mural in Buenos Aires. Private collection, La Paz. Courtesy Ligia Siles, representative for the estate of David Crespo Gastelú. Photo: Pedro Querejazú.

seem inseparable from the mountainous landscape that envelops them.

Borda's incorporation of Bolivian myths and mountain metaphors in his work can also be traced to colonial and pre-Hispanic sources. He painted several landscapes of Illimani, a mountain peak near La Paz that was sacred to the ancients. In *Pachamama [Mother Earth]* (1944; FIG. 3.15), he equated the mountain with the Andean earth mother, whose milk-filled breasts were believed to ensure a successful harvest. Borda's naturalistic, pyramidal mountain reveals itself as a veiled woman reminiscent of the anonymous colonial painting of the Virgin of Potosí, whose mantle doubles as a mountain. But Borda's woman is comfortingly fleshy. Although Borda painted many Indian themes, some of his works are of non-Indian female nudes playfully romp-

ing in Andean landscapes. These works blend surrealist touches with Bosch's hell scenes that take inspiration from medieval heaven and hell imagery. In *El despertar de la Naturaleza [Nature Awakening]* (1943–1950), a nude with a biblical potential for evil stretches enticingly before a roaring, wild mythical animal in a jungle landscape with a mountain in the background.

Borda's vivid imagination, nourished by psychological quirks, was expressed in his numerous essays, plays, and statements on art written over a period of several years and posthumously compiled into a three-volume work titled *El loco* (The madman; 1966).[63] His allegorical painting *Crítica de los ismos y triunfo del arte clásico [Criticism of the Isms and Triumph of Classical Art]* (1948; PL. 3.13) is based on his satirical play *El triunfo del arte* (The triumph of art). The painting, also filled with Bosch-like details, is divided diagonally into two zones: the ideal realm symbolizing eternal beauty, embodied in the Parthenon, a bust of Homer, the Venus of Milo, and Illimani in the upper right; and a hellish one populated by mythical animals, humanoid monsters, and lustful degenerates in the lower left, alluding to the follies of modern art. The ground dissolves into a female figure in an obscene position. Although this interpretation finds echoes in Borda's play, Salazar Mostajo has suggested that this painting is an allegory, not of art, but of "past humiliations and shame" suffered by "the country known as Bolivia," thus placing Borda's work within a nationalist discourse. He also detected in most of Borda's allegorical paintings a struggle between past and present.[64]

Borda, like many of his colleagues, painted scenes of Indians with no apparent social implications. But the highland landscape in Bolivian *indigenismo* serves as a powerful substitute for what is left unsaid. It is the land that nurtured the Indian. It is also a timeless presence that provided a sense of permanence to Bolivians in quest of an identity through links with an ancient past. Some artists used

the term *andinismo* for their art to indicate that their cultural identity resided as much in the telluric qualities of the Andean landscape as it did in the image of the Indian.[65] Nonetheless, Bolivian representations of Indians as a whole are more allegorical than reflective of contemporary realities.

SUMMARY

Far from representing a unified mode, *indigenismo* manifested considerable thematic and stylistic diversity from region to region. Although initially *indigenismo* was intended as an expression of social protest against the current conditions of Indians, in most countries it served more as a means to construct national identities. The image of a proud Indian dressed in native costume served this purpose in all the Andean countries. Except for a

PLATE 3.12

Marina Núñez del Prado, *Cabeza de indio [Head of an Indian]*, **c. 1935, terracotta, 26.5 cm. high / 10⅜ in. high. Courtesy Casa Museo Núñez del Prado, La Paz. Photo: Pedro Querejazú.**

PLATE 3.13

Arturo Borda, *Crítica de los ismos y triunfo del arte clásico [Criticism of the Isms and Triumph of Classical Art]*, **1948, oil on cardboard, 119 × 142 cm. / 46⅞ × 55⅞ in. Courtesy Museos Municipales, La Paz. Photo: Pedro Querejazú.**

few artists such as Guayasamín, many painters working before the 1950s came from the upper classes and were often not Indian themselves. In Peru, artists tended to view their subjects from a Eurocentric point of view while at the same time appropriating ancient Indian culture as part of their Peruvian legacy.

In most countries with large Indian populations, attempts to homogenize this population, whose original territorial boundaries were not those of a nation's geographic borders, continued to be a problem, and many issues of social injustice remained unresolved. In the 1940s, Ecuadorian artists were the most vociferous in addressing these problems; Peruvian artists, the least. Even Rivera's work of the 1940s idealized and embellished the pre-Hispanic Indian legacy instead of addressing the inequities of the present, as he had done in earlier paintings. This idealization of the indigenous past must be seen as a widespread phenomenon that was implicit also in the work of the surrealists and the Uruguayan constructivists. It was the expression of a whole period rather than a characteristic of a particular style and was at its peak during the war years. Among the three Mexican mural painters—Orozco, Rivera, Siqueiros—only Siqueiros maintained his rebellious spirit and ideological position throughout his life. Orozco had painted a powerful image of Indian women in 1947, but others were more ambiguous in their representations of Indians. By the mid-1940s, this theme came to be fused with a myth about origins and historical legacy.

Indigenismo is not synonymous with social painting; rather, it is an offshoot of a broader tendency in Latin America during the 1930s and 1940s to examine a segment of society that had previously not been adequately represented in art. The problem of the worker was generally one of poverty, exploitation, and unemployment in urban settings rather than one of land allotment in rural settings. Social painting itself showed numerous variations in style as well as subject matter throughout two decades (in Mexico it began in the 1920s). It is, however, possible to identify a general chronological sequence in which worker themes were more prevalent in the 1930s, and miner and Indian ones, in the 1940s. The predominance of Indian themes as constructs of national identity in the 1940s also served to assuage many New World artists' sense of cultural orphanhood during World War II, when Europe had become inaccessible. In the absence of new influences from Europe, a new sense of continental solidarity could be established based on the Indian legacy. But during these years the focus was on the race itself rather than on the archaeological past, as had been the case in the first decades of the century.

By the 1950s, social and nativist art was displaced in many countries by the incursions of abstraction. The surrealist and constructivist currents that coexisted with social art in the 1930s and 1940s contributed in different ways to these changes.

When André Breton went to Mexico in 1938, he pronounced it "the surrealist country par excellence." He was, of course, projecting a Eurocentric vision on a culture that seemed to fulfill his dreams of the marvelous and the exotic.[1] The Mexican art historian Ida Rodríguez-Prampolini, in an attempt to differentiate between the Mexican surrealist phenomenon and its European counterpart, referred to it as "fantastic" rather than surrealist: "Mexican fantasy," she wrote, "is childlike (*infantil*), whereas the fantasy of [European] surrealism is sophisticated. Perhaps because the Mexican lives this fantasy, [s/he] conceals it."[2] In Latin American countries in general, artists and poets themselves have referred to their lives as surreal because of the frequent occurrence of unexpected events.

But the fact is that in art there was no overall surrealist movement there. In several countries since the late 1960s, a neosurrealist tendency has existed that overlapped with the earlier generation, and many acknowledged surrealists, such as Leonora Carrington and María de los Remedios Varo y Uranga in Mexico, produced some of their key works in the 1950s and after.[3] In the earlier period from the 1930s through the 1950s, when artists had direct contact with European surrealism, this mode was taken up by individuals rather than groups or was brought over by European exiles, many of whom settled in Mexico. Otherwise, surrealism was mainly confined to literature. When it was present in art, it differed considerably from its European counterparts (and not necessarily for its alleged fantasy), as it did from one country to another. Its local variants were determined less by Breton than by a preexisting aesthetic with sources in the avant-garde of the 1920s. In some cases, it was also a component of social realism (in the work of Egas and Portinari, for instance).

Although surrealism in its more orthodox forms was not a strong presence in the art of Latin America, some writers had defined their idea of it as early as the

SURREALISM, WARTIME, AND NEW WORLD IMAGERY, 1928–1964

FOUR

1920s. In Argentina as in Spain, the term *superrealism* rather than *surrealism* was originally used to denote a world beyond the real. The Spanish poet Guillermo de Torre, who had been a contributor to Argentine avant-garde journals in the 1920s, opposed Breton's automatist, Freudian surrealism because of its rejection of the process of intellectual reasoning. "Superrealism," he wrote, consisted rather of "an absolute abandon on the part of the poet to an almost religious state of inspiration," which was not the same as the surrender to one's instincts.[4] In art, the Argentine Xul Solar came the closest to fulfilling de Torre's definition of surrealism.

In Brazil on the other hand, Oswald de Andrade, in a telling contrast to de Torre's defense of intellectual reasoning and control, had rejected "the concept of logic" in his "Anthropophagite Manifesto" of 1928 and sought to project an image of Brazilians as embodying uncensored license unfettered by feelings of guilt. But in spite of the surrealist elements in Oswald de Andrade's writings and in Tarsila do Amaral's paintings of 1928, no surrealist movement developed in Brazil.[5]

In its early stages, surrealism in Latin America, like *modernismo* and *indigenismo,* was confined to literature. The writings of André Breton and Benjamin Péret were well known in most countries. In Argentina, the poet Aldo Pellegrini, who, like Breton, was also a former medical student, founded the surrealist journal *Qué* in Buenos Aires in 1928. Although it closed in 1930 with the change of government, Pellegrini later founded other journals with a surrealist agenda that included *Ciclo* (1948–1949) and *A Partir de 0* (1952–1956).

In Peru and Chile, as in Argentina, it was the writers who first took up the banner of surrealism, but they were also active in art circles. In 1938 a group of Chilean poets—Braulio Arenas, Teófilo Cid, Jorge Cáceres, and Enrique Gómez-Correa—staged a poetry reading in Santiago and founded the surrealist journal *Mandrágora*.[6] Works by Joan Miró and Jean Arp had been reproduced in the Santiago art journal *Pro* in 1934,[7] and the following year, a surrealist exhibition that included work by Chileans strongly influenced by Miró took place in Santiago and Lima. In 1941, the Chilean poets organized a second surrealist exhibition of work by Chilean artists. In 1948, the *First International Surrealist Exhibition* took place in Santiago; it featured work by European surrealists Victor Brauner, Jack Hérold, and René Magritte—all of whom were already well known through book illustrations—as well as pre-Hispanic and popular art objects.

In Peru, the poet and painter César Moro, who had spent many years in Paris, was already a key figure in surrealist circles prior to his move to Mexico in 1939.[8] In 1935, with the help of a few other artists, Moro organized the first surrealist exhibition in Lima. The participants included the same three Chileans— María Valencia, Jaime Dvor, and Carlos Sotomayor—who had exhibited in Santiago that year. Out of the fifty-two works in the Lima exhibition, thirty-eight were by Moro.[9] But except for Moro, who was remembered for his writings rather than for his paintings, the other artists have since been forgotten. The Chilean painter Roberto Matta was not affiliated with these groups. He was abroad at the time and made his reputation as a member of the European surrealist community.

The type and variations of surrealism in Latin America after 1930 corresponded to Breton's second manifesto of 1929 in which he expanded on the definition of surrealism by emphasizing its political role (an aspect the European surrealists never resolved) and the value of incorporating occult systems (alchemy, magic, cabalism) and science into surrealist language. One or the other of these themes can be found in most of the work of artists in Latin American countries. For some artists, surrealism was a way of expressing political or social preoccupa-

tions. For others, particularly exiles, it provided a space and psychological freedom to explore issues of personal or cultural identity, race, or gender.

In accordance with Guillermo de Torre's definition of superrealism, if not directly related to it, Argentine artists were not particularly self-revelatory in their application of surrealist elements. What was thought of as surrealist in Argentine art of the 1930s had more kinship with metaphysical and neoromantic painting than with Breton's stream-of-consciousness automatism. In 1939 a handful of artists in Buenos Aires proclaiming themselves surrealists formed the Grupo Orión,[10] although few among them truly manifested the characteristics of surrealism in their work. For a short-lived period, Xul Solar and Antonio Berni exhibited as surrealists, but both soon moved in other directions. Only two other artists working in the 1930s and 1940s, Juan Batlle-Planas and Raquel Forner, may with some reservations be cast in that category. Juan Batlle-Planas (1911–1966) took up mystical themes, and Raquel Forner (1902–1988), wartime or apocalyptic imagery. Both artists were of Spanish descent. Batlle-Planas was born in Catalonia and was taken to Argentina at the age of two. Forner was born in Argentina of a Spanish father and a mother of Spanish origin, and had lived in Spain as a child. Batlle-Planas had practiced a form of automatism in the early 1930s in a series of free-form pencil and pen-and-ink drawings. Although elements of this practice were present in delineations of figures in his work of the mid-1930s, he later abandoned these free-form associations.

In 1936 Batlle-Planas painted a series of temperas titled *Radiografías paranoicas [Paranoid X Rays]*, consisting of flat, spectral figures in ambiguous spatial relationships. Because they can be seen through, the figures suggest X-ray views but also photographic positive/negative contrasts. This type of image can be found in early Spanish surrealism. Batlle-Planas's title evidently derived from Dalí's "paranoia-

critical" method, and the paintings recall some of Dalí's flat images of the 1920s.[11] In *Radiografía paranoica [Paranoid X Ray]* (FIG. 4.1), Batlle-Planas's figures represent the invisible or hidden side of the human being. The presence of a palette in the lower right metaphorically alludes to the artist in general rather than in personal terms, although this painting also refers to the artist and his family.

After 1940, Batlle-Planas began a Tibetan series. He had been interested in Zen Buddhism since the age of seventeen, but he also had more recent sources for his mystical leanings. In 1940 Xul Solar exhibited at Amigos del Arte.[12] Although Batlle-Planas's style was markedly different from Xul Solar's, he chose as subjects the same cosmic themes—mystics, hermits, spiritual messengers, Tibetans, and judges (of souls)—as Xul Solar did. In *El Tibet [Tibet]* (1942; PL. 4.1), a standing

FIGURE 4.1
Juan Batlle-Planas, *Radiografía paranoica [Paranoid X Ray]*, **1936, tempera on paper, 35 × 25 cm. / 13¾ × 9⅞ in. Collection Eduardo and María Teresa Constantini, Buenos Aires. Photo courtesy Ruth Benzacar Gallery.**

shaggy figure in a hermit's garb, with no facial features and with wing-like antennae in lieu of ears, points to a stone at his feet. A group of small figures in the background mill around another large (philosopher's) stone. They exist in an endless, barren landscape and a timeless world. Batlle-Planas later stated that "what I paint are neither dreams nor fantasies. They are concrete forms of the feelings of my soul that take the shape of dreams."[13] One critic pointed out that the stone here represents the soul, and that the word *Lama* in the title of other works by Batlle-Planas of the same years was an anagram for the Spanish word *alma* (soul).[14]

Batlle-Planas also expressed an interest in the 1941 discoveries of orgonomy by the German biopsychiatrist Wilhelm Reich. Reich's theories, centered around cosmic particles that could be concentrated in an "orgone box" as a source for cancer therapy and cosmic energy, were very much in the news in the 1940s.[15] The bluish-gray tones in Batlle-Planas's paintings may correspond to the bluish light produced by a concentration of cosmic particles trapped in a box. Batlle-Planas had also studied psychoanalysis, but instead of drawing on it as a self-expressive source for his art, he used it as a means to evoke responses in others. His paintings remained the conscious product of an escape mechanism that led him into a cosmic, not a psychological, realm.

Forner had been active since the 1920s, first as an expressionist, then—following her return to Buenos Aires from Europe in 1932—as a surrealist.[16] Her surrealist period was confined to the 1940s, mostly during the Perón years, and focused on somber-colored, apocalyptic events in the news such as wartime imagery and global misery. Forner, like other women surrealists, included self-portraits in her work. But rather than using them as personal statements, as did the Mexican women, her female subjects played the role of victims of war and "mankind's" follies. At the time, neither she nor any of her biographers made any reference to the blatantly visible role women played in her paintings. Instead, they interpreted her scenes in general terms as expressions of suffering humanity.[17] Her self-portraits were not indicators of personal experiences but indictments of gender and social and political oppression. Thus, she made herself into a representative for humanity. In some cases, she did so by borrowing from traditional Christian iconography, painting herself in the role of a Christian martyr or as a female Christ helplessly witnessing a scene of destruction.

In *El drama [The Drama]* (1942; FIG. 4.2), one of a series by that name, women look up to the sky as distant parachutists are about to land (the use of parachute troops to invade enemy territory was a

FIGURE 4.2
Raquel Forner, *El drama
[The Drama]*, 1942, oil on
canvas, 125 × 178.5 cm. /
49½ × 70¼ in. Courtesy
Museo Nacional de
Bellas Artes, Buenos
Aires. Photo: Mosquera.

common tactic during World War II).
Another woman protects a child who
holds a dead bird. Behind them, a skel-
eton stands next to a seven-headed de-
mon, probably a reference to the apoca-
lyptic demon described in the Gospel of
John. A classical torso and severed head,
visible in the lower left background,
emphasize the idea of the destruction of
civilization.[18] At the bottom center, a
torn self-portrait, a cracked globe, and a
severed hand bearing the stigmata of
Christ's crucifixion allude to the destruc-
tion and sacrifice of war. The dark,
stormy, El Greco–like sky in the back-
ground recalls the skies in traditional
crucifixion scenes. Although Forner's
victims are invariably female, her dedica-
tion to exploring global issues and de-
nouncing war, hunger, and victimization
places her in a category separate from
that of other women. Hers are neither
the personalized statements of many
women artists, such as Frida Kahlo,
Leonora Carrington, and Remedios Varo,
nor exclusively the social and political
statements of male artists such as Camilo
Egas, Juan O'Gorman, Siqueiros, and
Orozco. Forner stood somewhere in the
middle.

The surrealists in Mexico had more
direct contact with artists from the out-
side world than did those in other Latin
American countries during the 1940s. In
Mexico, Octavio Paz was a major expo-
nent of surrealist poetry. In art, surreal-
ism was officially introduced there in
1940 when the *International Surrealist
Exhibition,* organized jointly by André
Breton, César Moro, and the Austrian-
born émigré painter Wolfgang Paalen,
took place at the Galería de Arte
Mexicano in Mexico City. The exhibition
was divided geographically into a Euro-
pean and a Mexican section. At their own
request, Diego Rivera and Frida Kahlo
were included in the European section
with Remedios Varo, Wolfgang Paalen,
and Alice Rahon (the latter three moved
to Mexico as war exiles). Other Euro-
pean participants were Hans Bellmer,
Victor Brauner, Max Ernst, René
Magritte, Yves Tanguy, Alberto Giaco-
metti, Meret Oppenheim, Pablo Picasso,
and Wassily Kandinsky. Agustín Lazo,
Guillermo Meza, Roberto Montenegro,
and Antonio Ruiz were in the Mexican
section. Paalen and Breton, both of
whom collected pre-Columbian and
Oceanic art, included ceremonial masks
from Mexico, Oceania, and New Guinea

as well as drawings by the insane in the exhibition. A photograph by Manuel Alvarez-Bravo figured on the catalog's cover.[19] Besides acting as host country to a major surrealist exhibition in 1940, Mexico was a lure to artists from abroad. In 1941, Roberto Matta, then living in New York, traveled to Mexico with Robert Motherwell as the guests of Wolfgang Paalen, who had moved to Mexico in 1939. Frida Kahlo and Diego Rivera had made many friends in the United States during their stays there, and in 1938, Kahlo exhibited at the Julian Levy Gallery in New York. Tamayo also traveled back and forth between the two countries.

But despite regular contact, certain characteristics existed among Mexican artists, either in style or subject, that were peculiar to them and not necessarily classifiable as surrealist. For instance, the portrait had a long tradition in popular painting in Mexico, and from the 1920s on, these came to include self-portraits. Far from being the exclusive province of Frida Kahlo and other women, self-portraits were also done by Mexican men, many of whom were included in the 1940 surrealist exhibition. Federico Cantú, Julio Castellanos, Guillermo Meza, Roberto Montenegro, and Juan O'Gorman had all painted self-portraits more or less in a surrealist context be-

tween the late 1930s and 1950. These portraits either expressed a search for self-identity or were plays on reality versus mirror image. In Meza's *Autorretrato [Self-Portrait]* (1940), his head, with a section of it removed to reveal a bit of hairy growth, emerges threateningly out of a barren landscape. In Castellanos's *Autorretrato [Self-Portrait]* (1947), the reflection of his face appears in a circular mirror on an easel in lieu of a painting, as an obvious allusion to Parmigianino's 1524 *Self-Portrait in a Convex Mirror.* In Juan O'Gorman's *Autorretrato [Self-Portrait]* (1950; FIG. 4.3), he appears in multiple roles as architect, sportsman, and painter at his easel painting himself dressed in a shirt that does not match the one reflected in his mirror. His painting is autobiographical without being personal. All of the roles in which he represented himself are of his public, not his private, persona. This painting is also a play on the relationship of the artist and the viewer to the picture.

Some of the imagery in these artists' work was based on folk legends instead of psychic phenomena. For instance, *Los Robachicos [The Angel Kidnappers]* (1943; FIG. 4.4) by Julio Castellanos represents a Mexican myth—used to explain the high rate of infant mortality in Mexico—about angels stealing babies from their cribs at night while the parents sleep.

Antonio Ruiz (1897–1964), a contemporary of Siqueiros and Tamayo, also combined reality with allegory or myth. His subjects ranged from references to past history to witty scenes of contemporary events. In spite of the naïve appearance of his small-scale paintings, Ruiz had lived in Paris and was entirely familiar with French surrealism. But his miniaturist style and meticulous technique, revealing his liking for Flemish fourteenth- and fifteenth-century painting, are the exact opposite of surrealist automatism, not to mention of the large-scale public murals by his colleagues. Yet his themes intrigued the surrealists enough for them to want to include two of his paintings in the 1940 exhibition.

FIGURE 4.3
Juan O'Gorman, *Autorretrato [Self-Portrait]*, 1950, tempera on masonite, 68 × 52 cm. / 26¾ × 20½ in. Museo de Arte Moderno, INBA, Mexico City. Photo: Archivos Fotográficos del CENIDIAP, Mexico City.

FIGURE 4.4
Julio Castellanos, *Los Robachicos [The Angel Kidnappers]*, 1943, oil on canvas, 57.5 × 95 cm. / 22⅝ × 37⅜ in. The Museum of Modern Art, New York, Inter-American Fund. Photograph © 1997 The Museum of Modern Art, New York.

Ruiz's *Sueño de Malinche [Dream of Malinche]* (1939; FIG. 4.5) shows that, despite her negative image as a traitor to the Mexican race, Malinche is also considered the mother of the race. As such, she is the Mexican counterpart of Garcilaso de la Vega as father of the Peruvian race. In Ruiz's painting, Malinche's monumental sleeping figure lies on a bed under a blanket. The shape of her body beneath the cover doubles as a hill surmounted by a colonial church. A Mexican colonial town is cradled in a space on the hill's slope. The equation of Malinche's female form with the earth makes her both an earth mother and the generatrix of the colonial town. The painting's ambiguous relationships between interior and exterior space, in which the background functions as the sky in a landscape as well as wallpaper partially torn away to reveal a brick wall, indicate Ruiz's familiarity with Magritte.

The liberating potential of surrealism served the cause of women in multiple ways. It became a form of magic through which they could transform and control the universe, and it provided a means for self-scrutiny. It also placed the woman in the double role of becoming both the painter and the painted, in contrast to her traditional role as the object of someone else's gaze. Of the three principal women surrealist painters (Kahlo, Carrington,

Remedios Varo) in Mexico, Frida Kahlo (1910–1954) was the most ruthless and straightforward in her objectification of personal, often painful, experiences in her paintings. For her, painting became a form of exorcism. Although her works were not unequivocally surrealist, her diary contained pages of obsessive, stream-of-consciousness drawings that indicated her familiarity with European surrealism. She did not always accept this classification, because she claimed she did not paint her dreams but "my own reality." She liked to say she did not know she was a surrealist until Breton "told me I was."[20]

FIGURE 4.5
Antonio Ruiz, *Sueño de Malinche [Dream of Malinche]*, 1939, oil on wood, 29.5 × 46 cm. / 11⅝ × 18⅛ in. Courtesy Galería de Arte Mexicano (GAM), Mexico City. Coll. Mariana Pérez Amor.

Her career as an artist ran parallel to her life as a frequently bedridden invalid. Her almost fatal accident at the age of fifteen, when the bus she was riding collided with a trolley, resulted in some thirty-five hospital stays and operations throughout her life. Those experiences, besides her inability to bear children and her often difficult relationship with Rivera, have led writers to make impassioned interpretations of her paintings that tend to obscure the importance of Kahlo's sources in pre-Columbian imagery and colonial Christian symbolism. She and Rivera collected popular and folk, as well as pre-Columbian, art. Her collection included *retablos,* also known as ex-votos, the small paintings, usually on tin, offering thanks to a saint or, more often, to the Virgin for the fulfillment of a wish or the escape from some misfortune in which both the event and the holy being is represented.[21]

Kahlo's focus on herself as subject originated with her experience as a convalescent when she had no other models. In her self-portraits, she often incorpo-

rated pre-Columbian objects or ornaments for their particular meaning or symbolism as well as their mythological references. A recurring theme was her ruined reproductive system, for which she compensated by representing herself as a functioning part of a life cycle. In *Raíces [Roots]* (1943), vines grow out of an open cavity in her chest as she reclines on the metaphorically barren soil of the *pedregal* (lava flow in southern Mexico City). Thus she becomes an integral part of the natural environment to which she also contributes. She becomes a part of a cosmic family in *El abrazo de amor del universo, la tierra (México), Diego, yo y el señor Xolotl [The Love Embrace of the Universe, the Earth (Mexico), Diego, Me and Señor Xolotl]* (1949; PL. 4.2), a dual night-and-day scene about an all-embracing universe. A pale-faced personification of the universe cradles a dark-faced one of the earth, who in turn holds Frida, who holds a large baby with Rivera's face on her lap.

Kahlo's 1939 painting *Las dos Fridas [The Two Fridas]* (FIG. 4.6) was a response to her divorce from Rivera, whom she remarried the following year. According to Hayden Herrera, Kahlo described the two images in this painting as the Frida in the Tehuana dress whom Rivera loved and the Frida in a Victorian dress whom he no longer loved.[22] The two Fridas' exposed hearts are linked by a vein, the end of which the Victorian Frida severs with surgical scissors. Heart imagery has a long-standing history in Mexico dating from pre-Hispanic times and continues to figure in contemporary painting. Even though Kahlo resisted the classification, the double image in this painting is a surrealist device, as were some other aspects of her paintings.[23] However, on the whole, her imagery was too objective to fit comfortably into a surrealist classification.

María Izquierdo's life (1902–1955) was less flamboyant than Kahlo's but no less eventful. Raised by her grandparents and an aunt in a strict Catholic environment, Izquierdo was married off at the age of

PLATE 4.2
Frida Kahlo, *El abrazo de amor del universo, la tierra (México), Diego, yo y el señor Xolotl [The Love Embrace of the Universe, the Earth (Mexico), Diego, Me and Señor Xolotl],* **1949, oil on canvas, 70 × 60 cm. / 27½ × 23¾ in. Collection Estate of Jacques and Natasha Gelman, Mexico City. Reproduction authorized by the Instituto Nacional de Bellas Artes y Literatura and the Banco de México. Photo: Courtesy Robert Littman, Mexico City.**

FIGURE 4.6
Frida Kahlo, *Las dos
Fridas [The Two Fridas]*,
1939, oil on canvas, 173.75 ×
173 cm. / 68⅜ × 68⅛ in.
Museo de Arte Moderno,
INBA, Mexico City. Photo:
Ron Jameson, from
author's slide archives.
Reproduction authorized
by the Instituto Nacional
de Bellas Artes y
Literatura and the Banco
de México.

PLATE 4.3
María Izquierdo (1902–
1955), *El alhajero [The
Jewelry Box or Adorn-
ments]*, 1942, oil on
canvas, 70 × 100 cm. /
27½ × 39⅝ in. Collection
Banco Nacional de
México, S.A., Mexico City.
Courtesy Aurora Posadas
Izquierdo. Photo:
Mexican Fine Arts Center
Museum, Chicago.

fourteen to a much older man with
whom she had three children. She es-
caped her captivity when she moved to
Mexico City to study painting. In 1928,
she formed an association with Rufino
Tamayo that was mutually enriching and
lasted until 1933. Subsequently, she estab-
lished a place for herself within the Mexi-
can tradition as a painter of circus scenes,
still lifes, altars, and portraits of women.
Rivera had encouraged her as a painter
and helped to arrange her first exhibition
in 1929. However, this did not prevent
Izquierdo from being foiled by the male-
dominated art establishment when the
opportunity to paint a mural came and
was abruptly rescinded.[24]

Until after the mid-1940s, Izquierdo's
work was tied more to the Mexican
popular tradition in painting than to
surrealism. Her 1948 painting *Sueño y
premonición [Dream and Premonition],* with
its ominous symbols, decapitated self-

portrait head, tangled hair around denuded tree branches, and diminishing figures escaping into the distance, is an exception. She had not been included in the *International Exhibition of Surrealism* in 1940 (possibly for factional, rather than for aesthetic, reasons) and associated little with the surrealists. Many of her paintings owe a debt to popular art as much as to surrealism, especially her altar scenes. The majority of her paintings are of women from a variety of social backgrounds—poor peasant women as well as those from the elite class. Like Kahlo, she painted some self-portraits but with fewer identifiably personal references. Many of them emphasized traditional women's roles. She represented herself both alone and in family groups with her nieces, for instance. In *El alhajero [The Jewelry Box* or *Adornments]* (1942; PL. 4.3), she also satirized the role women were expected to play. Her presence is implied in this painting by the still-life objects that function as fetishes. They include personal symbols of feminine attire—a fan, a high-heeled shoe, a jewelry box, a dress with black lace borders and decorations that she is shown wearing in other paintings as well, gloves hung over the back of a chair, an umbrella—all of which are set in a shallow compressed space. Her emphasis on the objects that make a female pleasing to a male may be seen as a parody on male surrealist representations of the female either as object or as furniture.

But in spite of recent feminist interpretations of Kahlo's and Izquierdo's work, neither artist had set out to do feminist art. Rather, they were responding to their particular experiences as women. In contrast, the exiles Remedios Varo and Leonora Carrington deliberately approached the subject of female identity, the first, through autobiographical depictions of women with her own face, the second, by means of broader mythological references. Nevertheless, the four women (Mexicans and exiles) shared the common experience of living,

or having lived, in the shadow of a dominant male partner: Kahlo with Rivera, Izquierdo with Tamayo (in 1944 she married the less visible Chilean painter Raúl Uribe), Remedios Varo with Benjamin Péret, and Carrington with Max Ernst before 1940. But there the similarities end. The Mexican women imbued their autobiographical allusions with Mexican lore in styles derived from popular art, whereas the European exiles sought their sources in medieval alchemy, sorcery, magic, witchcraft, oriental philosophy, and mythology in ways that derived from European surrealism and borrowed from medieval miniaturist painting. Both Carrington and Remedios Varo had been affiliated with the surrealist movement since the 1930s, but they did not develop their mature styles and pictorial vocabulary until after their move to Mexico, where they found the independence and freedom through which they could flourish. The major part of their production dates from the 1950s, that is, at a temporal and geographic distance from their original surrealist sources.

Although both artists were also interested in Mexican lore, neither incorporated Mexican themes into her art (though Carrington had done so once in a mural).[25] In Europe, Carrington and Remedios Varo had both experimented with automatism and collage, and Remedios Varo continued to incorporate automatist techniques in her otherwise meticulously painted pictures. The women had met briefly in France but became close friends only after their arrival in Mexico, where they visited each other on a regular basis and shared an interest in the arcane. In their paintings, they transformed traditional female occupations like sewing, weaving, cooking, feeding, and nurturing into magic acts that gave them the power to control their own surroundings. Both adopted a painstaking, detailed style to depict the female experience in magical and alchemical terms: Remedios Varo in a personal way, Carrington in a more generalized one.

Born in Spain, María de los Remedios Varo y Uranga (1908–1964) was sent to a convent school by her devout mother. Art for her became a means of escape. After a period of study at the San Fernando Academy, she joined the Spanish surrealists and met the French poet Benjamin Péret, who was in Spain during the Spanish civil war. She first went with him to Paris and then, with the outbreak of World War II, to Marseilles, joining the other surrealists there. In 1941, Remedios Varo and Péret moved to Mexico circuitously by way of Africa and New York.[26] In Mexico, Remedios Varo did not begin painting on a regular basis until after her divorce from Péret in 1947. The majority of her paintings were done during the last decade of her life.

Remedios Varo's heroine invariably had her own features and enacted roles or conditions of particular relevance to her. She often represented herself as a vagabond in a quest for self-definition, as a prisoner escaping from confinement, or as a nurturer in a cosmic realm (she never had children of her own). In Europe she had made some *corps exquis* (exquisite corpses) with other surrealists.

Exquisite corpses were drawings or photographic collages made by three or more artists, which inevitably resulted in incongruous and unexpected juxtapositions. Although she painted with the meticulousness of medieval miniaturists, she continued to use the automatist techniques of surrealism, such as blotting the wet paint to obtain vaporous effects, in her works. Inanimate objects are set in motion by supernatural or cosmic forces. Frail young women (and a few men) make discoveries, escape, or search for a holy grail.

Remedios Varo's paintings lent themselves to psychological as well as mystical interpretations. In *Exploración de las fuentes del río Orinoco [Exploration of the Source of the Orinoco River]* (a river that runs through Venezuela north of the Amazon) of 1959,[27] the female subject rides in a boat that is an extension of her clothing and is propelled by a rudder and an unlikely mechanism with wings attached to the back of her hat. She glides along the river through a forest in a double quest for the holy grail and a psychological search for the self. She discovers the source in a small glass of endlessly run-

FIGURE 4.7

Remedios Varo, *Bordando el manto terrestre [Embroidering the Terrestrial Mantle]*, 1961, oil on masonite, 123 × 100 cm. / 48⅜ × 39⅜ in. Collection Walter Gruen, Mexico City. Photo courtesy Walter Gruen.

PLATE 4.4
Remedios Varo, *La huida*
[The Escape], 1962, oil on
masonite, 123 × 100 cm. /
48⅜ × 39⅜ in. Museo de
Arte Moderno, INBA,
Mexico City. © 1998
Artists Rights Society
(ARS), New York / VEGAP
Madrid. Photo: Archivos
Fotográficos del
CENIDIAP.

ning water (the fountain of life) on an altarlike table set inside a niche in a tree.

Remedios Varo took up the theme of escape in a triptych. The central panel, *Bordando el manto terrestre [Embroidering the Terrestrial Mantle]* (1961; FIG. 4.7) represents a group of young women—all of whom have her own features and are dressed in the gray robes of the convent—sitting in a medieval tower embroidering an endless piece of fabric that rolls out through a slot in the tower wall to become the earth's surface. Inside the tower, a hooded mother superior stands in the center stirring a substance in an alchemical vessel that generates the threads. Behind her, another hooded woman plays the flute. One of the convent girls has planned her own escape and glances furtively around. A detail hidden in the folds of the earth's mantle, so

minute it easily escapes detection, reveals a couple, upside down, sliding down the fold. Embroidering has become a magic act that transforms a wish into a reality. In the triptych's right-hand panel, *La huida [The Escape]* (1962; PL. 4.4), the convent girl rides off with her lover in an oval vessel over a golden cloud. The predominance of gold and gray in these paintings may allude to the two metals, gold and mercury, used in alchemical distillations.

Leonora Carrington's paintings of the 1950s and after were less personal than Remedios Varo's. Although females were the central players in Carrington's work also, they were not usually self-portraits. Her story was also one of escape, but in her case, from an upper-class English background and an overbearing father. Carrington (b. 1917) found her chance when she met Max Ernst in London in 1937 and went to live with him in France. After Ernst was interned as a German subject in a French camp during the early months of the Second World War, they lost touch with each other. Carrington went to Spain, where she suffered a nervous breakdown, recovered, went to Portugal, and ultimately escaped the ongoing yoke of her English family by going to Mexico, where she spent many years and continues to maintain residence. In 1946, she married Emeric Weisz, a Hungarian photographer, and in the ensuing years had two sons and embarked on her most productive period as a painter.

Carrington's paintings were not quests for personal identity but protests against, or satires of, a patriarchal system. She was a writer as well as a painter, and the themes of her short stories can sometimes be identified in her paintings. In 1937, while still in France, she painted *Autorretrato [Self-Portrait]* (FIG. 4.8) in a rare attempt at self-portrayal. She appears in riding habit seated in a room with a female hyena in front of her and a wooden, levitating rocking horse behind her. A white horse is also visible outside an open window, galloping off into the

distance. All of these characters were in the short stories she had written and first published in France in 1939.[28] Through a series of borrowed identities conflating the mother goddess and characters from the Greek underworld with Celtic mythology, the white horse embraces them all and becomes a symbol of freedom. This painting draws on two of her short stories. One of them involves a rocking horse as a symbol of games forbidden to girls by a stern father. The other is about a reluctant debutante who finds a hyena to dress up and replace her at her coming-out ball.

In her later paintings she took up more esoteric subjects derived from ancient magic and alchemy. Several of her works of the 1950s depict the female as a powerful priestess presiding over a transformation ritual. In *Adieu Amenhotep* of 1955 (FIG. 4.9), four veiled priestesses perform a delicate surgical operation on the levitating body of an embalmed figure (Amenhotep, also known as Akhenaton), whose open wound resembles a lotus, while a group of black-clad men wearing priests' hats sit uncomprehendingly in the spectators' box in the background. Compasses along the box indicate that some magic transformation is under way.

Amenhotep was the first monotheistic pharaoh, and Carrington considered monotheism to be the origin of a patriarchal society. As the title suggests, the priestesses are doing away with a patriarchal image through some intricate surgery. Some years later, after feminist theory provided a language for Carrington's ideas, she stated that "a woman should not have to demand Rights. The Rights were there from the beginning, they must be Taken Back Again, including the Mysteries which

FIGURE 4.8

Leonora Carrington, *Autorretrato [Self-Portrait]*, **1937, oil on canvas, 63 × 70 cm. / 24¾ × 27½ in. Private collection, New York. © 1998 Leonora Carrington/Artists Rights Society (ARS), New York. Photo courtesy Brewster Gallery, New York.**

FIGURE 4.9

Leonora Carrington, *Adieu Amenhotep*, **1955, oil on canvas, 35 × 45 cm. / 13¾ × 17¾ in. Collection Galería de Arte Mexicano, Mexico City. © 1998 Leonora Carrington/Artists Rights Society (ARS), New York. Photo courtesy GAM.**

FIGURE 4.10
Wolfgang Paalen, *Fata Alaska*, 1937, oil on canvas, 91.5 × 59.5 cm. / 36 × 23½ in. Collection Galería de Arte Mexicano, Mexico City. Photo courtesy GAM.

FIGURE 4.11
Wolfgang Paalen, *Combat of Saturnine Princes II*, 1938, fumage and oil on canvas, 100.5 × 72.5 cm. / 39½ × 28½ in. Collection Gordon Onslow Ford, Inverness, California. Photo: Ron Jameson, from Gustav Regler, *Wolfgang Paalen* (p. 33).

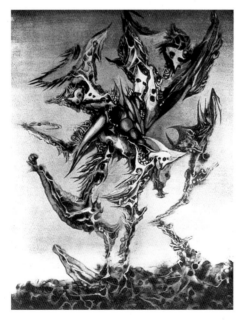

were ours and which were violated, stolen or destroyed" (caps in original).[29]

The exiled male surrealists experienced a similar sense of displacement as the women, but they tended to identify with more universal themes that included scientific or mystical notions of space. Wolfgang Paalen and Roberto Matta were among these. In 1939, Paalen (1907–1959) had moved to Mexico from France by way of New York. That same year, he also traveled to Canada and Alaska with Alice Rahon, to whom he was married, and the photographer Eva Sulzer, fulfilling a long-standing wish to see Northwest coastal Indian art. He had painted *Fata Alaska* (FIG. 4.10) in France in 1937 prior to his trip. The painting's title plays on Breton's book *Fata Morgana* and consequently implies a mirage.[30] Paalen's interest in ethnography dates from the time he lived in France and is apparent in the totemic shapes in *Fata Alaska*. Icy columns rise through a cloud-like surface like a mirage and culminate in elongated primitive male and female figures that recall Giacometti's totemic sculptures.

These columns also resemble Ernst's totemic images, which he obtained through a technique known as *frottage* (a rubbing made by placing paper or canvas over a textured surface such as floorboards, resulting in unexpected effects). Paalen invented an automatist system of his own, which he called *fumage* (smoke), in which he passed a lit candle over a painted surface in order to create random smoke marks. He used this technique in 1938 in several paintings, including *Combat of Saturnine Princes II* (FIG. 4.11), one of several works by that title. Here the resulting image is one of unidentifiable creatures rearing threateningly through the air. Paalen also applied this technique in a series titled *Fumages*, which he continued to produce in Mexico. In *Fumage* (1944), a work painted on Mexican bark paper, he exploited the paper's rough texture to enhance the chance effects.

In Mexico, Paalen played a central role in surrealist art circles by founding the

magazine *Dyn* (1942–1944). The last of its six numbers was a double issue entirely devoted to Amerindian art.[31] *Dyn* was widely distributed, including as far as New York, where it was read by the budding abstract expressionists as well as the surrealists. But in spite of *Dyn*'s strong affiliations with surrealism, in 1942, Paalen disassociated himself from the latter in a statement titled "Farewell au Surréalisme," published in *Dyn*'s first issue. He objected to surrealism's—or rather, Breton's—restrictive and dogmatic position and opposed the inclusion of myth and mystical applications of science.[32] He eliminated descriptive imagery and metaphysical associations from his own work but without abandoning automatist processes. He was especially interested in scientific notions of energy and motion based on quantum physics and on wave theory, and he made the latter the subject of his later wave paintings.[33] In the last years of his life, which ended in suicide, Paalen's work moved in a direction parallel to that of the New York abstract expressionists rather than one consistent with contemporary Mexican currents.

Besides Kahlo, Carrington, and Paalen, Breton also acknowledged Rufino Tamayo (1899–1991) among the surrealists. He perceived in Tamayo's work a "world full of vibrations, in which man has remained in direct contact with the forces of nature." Tamayo was not adverse to this view and also agreed with Breton's more general assessment of Mexico as a surrealist country.[34] However, his coloristic compositions of figures and animals inspired by pre-Columbian and folk art have more in common with Willem de Kooning or Jean Dubuffet than with the surrealists. Yet the savagery and the cosmic character of his imagery of the 1940s place him in the orbit of his surrealist contemporaries. The New York art dealer Julian Levy, whose gallery was a major outlet for surrealist art, showed Tamayo's work in 1937, a year before Kahlo had her first exhibition there.

Tamayo's many still lifes with watermelons, among other subjects, were seen by some in autobiographical terms as evoking his childhood experience selling fruit at his aunt's market in Mexico City, where he had moved from his native Oaxaca. But most of Tamayo's work was less autobiographical than it was indebted to sources drawn from his native culture. His interest in pre-Columbian art dates from his work as a draftsman in the ethnographic division of the Museum of Anthropology in 1921. Pre-Columbian and folk art contributed considerably to shaping Tamayo's art, just as African art had to Picasso's work. But unlike the Europeans, Tamayo found in pre-Columbian art an expression of his own heritage. Although he had sometimes used models in his early paintings, the elementary style evident in his later representations of humans and animals derives from pre-Columbian ceramics, especially from western Mexico. He was also well acquainted with the integrated shallow space and simplifications of cubism.

FIGURE 4.12

Rufino Tamayo, *Animales [Animals]*, 1941, oil on canvas, 76.5 × 101.5 cm. / 30⅛ × 40 in. The Museum of Modern Art, New York, Inter-American Fund. Photograph © 1997 The Museum of Modern Art, New York.

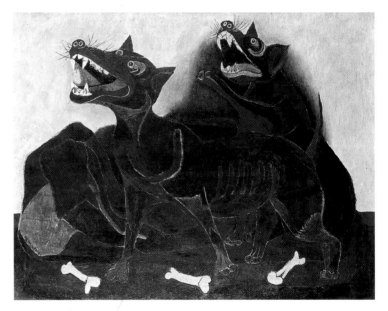

Tamayo had lived in New York from 1926 to 1928 and, intermittently, from 1936 to 1949. During the early 1940s, he began a series of animals apparently inspired by Picasso's *Guernica* but also by the pre-Columbian ceramic dogs from the western Mexican states. Among these paintings is *Animales [Animals]* (1941;

PLATE 4.5
Rufino Tamayo, *Bailarina en la noche [Dancer in the Night]*, 1946, oil on canvas, 70 × 50 cm. / 27½ × 19¾ in. Courtesy Fundación Museo de Bellas Artes, Caracas.

FIG. 4.12), in which fierce, sharp-toothed black dogs with scrawny anatomies bark into the air as they stand by the bones left over from their savage meal. Tamayo stated that rather than "paint cannons and things of that sort" as a response to the war, he used dogs as metaphors for "the horror of the moment" and "to represent anger."[35]

Ordinary humans standing, sitting, sleeping, playing musical instruments, singing, or contemplating the cosmos were a constant subject in Tamayo's work. After the mid-1940s, these humans were no longer bound by gravity. They either jumped into the cosmos, reached for a tangible moon, or simply contemplated the heavens, represented by a network of interlinked stars. In *Bailarina en la noche [Dancer in the Night]* (1946; PL. 4.5), the dark silhouette of a woman rises into a

space occupied by a large crescent moon and stars. This painting was related to Tamayo's *Constelaciones [Constellations]* series begun in 1946 and was probably inspired by an exhibition in New York in the early 1940s of Miró's *Constellations.* But for Tamayo, the human figure remained an integral part of his cosmic universe: "Space acquired a new meaning for me," he said, "man was no longer confronting his earthly world only, but also infinity."[36] Breton referred to these works as a "world where, as Tamayo shows, man's nerves are stretched to breaking point and so lend a marvelous resonance to the strings of the constellations."[37]

Tamayo never succumbed to illusionistic space in his painting. For the Chilean-born Roberto Matta (b. 1912), on the other hand, space—in its pictorial and cosmic sense—was his main subject. Like Paalen, Matta was interested in scientific phenomena, especially notions of time, space, and motion (the fourth dimension) and non-Euclidean geometry. He may have been inspired initially by an exhibition of mathematical objects shown at the Poincaré Institute in Paris in 1937. But Matta blended science with myth and magic and ultimately created a space of the mind as well as of the cosmos.

In 1933, as a young architecture student, he had moved from Chile to Paris to work in Le Corbusier's studio.[38] But after meeting and associating with the surrealists, he abandoned architecture. In 1938, he published his own theories in an essay titled "Mathématique sensible: Architecture du temps" in the surrealist journal *Minotaure,* defining his idea of what a living space should be like. In his later paintings, he translated that living space into an intangible cosmic one. He began exploring automatist techniques by pouring, wiping, and sponging thin glazes of color to reveal underlying layers, then adding others. In New York, where he lived from 1939 to 1948, he made use of these techniques in most of his paintings.

Although Matta used organic shapes similar to Yves Tanguy's, his were intangible and translucent. He obtained trans-

lucent effects not just with thin glazes, but by eliminating cast shadows. His early New York paintings, under the blanket title of *Psychological Morphologies,* or *Inscapes,* had the appearance of undersea life, like those of Tanguy and Mark Rothko of the same years. In *Prescience* (1939; FIG. 4.13) from this group, mineral and biological shapes appear to float upward in a watery substance.[39] The biomorphic shapes in Matta's *Psychological Morphologies* were influential for other New York artists, especially Arshile Gorky, with whom he formed a close friendship, but Gorky retained the material qualities of the natural world in his work.

After Matta's return from a trip to Mexico in 1941, his work gradually changed. Instead of the amorphous world of the *Psychological Morphologies,* his new work consisted of webs of fine lines, vortexes, and floating and orbiting stone-like objects in a dark, dimensionless space of mineral colors interspersed with sudden shafts of sulphuric yellow light. *The Onyx of Electra* (1944) consists of a maze with multiple perspectives. The painting's title plays on the word *electronics,* but the name Electra and the maze also refer to the labyrinth of the Minotaur, a favorite surrealist theme.[40] Matta's formal inclusion of a complex system of lines in this painting is traceable to his association in New York with Marcel Duchamp. Duchamp's contribution to the 1942 surrealist exhibition *First Papers of Surrealism* at the Reid Mansion in New York was a maze of twine strung from one side of the exhibition room to the other. The introduction of linear elements in Matta's work at this time also derived from his study of contour maps.[41]

Lines, whirlpools, spatial ambiguities, and male and female genitalia are present in *Le vertige d'Eros [The Vertigo of Eros]* (1944; FIG. 4.14). The French title again plays on the words' sounds, which can be understood as "le vert tige des roses" (the green stem of the roses), in a probable

FIGURE 4.13
Roberto Matta, *Prescience,* 1939, oil on canvas, 92 × 132 cm. / 36¼ × 52 in. Wadsworth Atheneum, Hartford, Conn., The Ella Gallup Sumner and Mary Gallup Sumner Collection Fund. Photo courtesy Wadsworth Atheneum.

reference to Duchamp's alter-ego character, Rrose Selavy. William Rubin has explained this painting in psychoanalytic terms, noting that *Le vertige d'Eros* "relates to a passage in which Freud located all consciousness as falling between Eros and the death wish—the life force and its antithesis." His description of this work as "an inscrutable morphology of shapes suggesting liquid fire, roots, and sexual parts" sums up its visual contents.[42]

After the mid-1940s, Matta's paintings became more aggressive. At times, they revealed violent encounters between human-insect-machine hybrids suggesting torture rituals. *Etre avec [Being With]* (1946; PL. 4.6) also marked a time when Matta experienced what he called a "horrible crisis of society" that compelled him to look outside of himself into the world at large: "My vision of myself was becoming blind for not [being] one with the people about me, and I sought to create a new morphology of others within my own field of consciousness."[43] Some works of this period were believed to refer to wartime atrocities and gas chambers. But in *Etre avec*, the victims of violence are also identifiably female, indicating the presence of sadomasochistic rituals that were as personal as they were political.[44]

By the time Matta left New York in 1948, abstract expressionism had taken over. Even though his work had contributed to its development, he was not willing to go the route of total abstraction. By the 1950s, he incorporated forms and colors suggesting vegetation and landscape into some of his paintings; in others, colors suggesting complex mechanical and electronic paraphernalia. On a personal level, when Matta left New York, he had also outlived his welcome.[45] He returned to Europe, where he divided his time between France and Italy, but he

FIGURE 4.14
Roberto Matta, *Le vertige d'Eros [The Vertigo of Eros]*, 1944, oil on canvas, 195.5 × 252 cm. / 77 × 99 in. The Museum of Modern Art, New York. Given anonymously. Photograph © 1997 The Museum of Modern Art, New York.

PLATE 4.6
Roberto Matta, *Etre avec [Being With]*, 1946, oil on canvas, 2.22 × 4.55 m./7¼ × 15 ft. Private collection, Paris. Photo: Fotografie Gnani, from Francesco Arcangeli, *Matta, mostra antologica* (pl. 5).

also maintained contact with Chile, especially during the administration of Salvador Allende, whose socialist program he supported.

In the 1940s, both Matta and Wifredo Lam sought to transcend the physical and the literal in their art, Matta, by creating a universal cosmic realm of intangible space, and Lam, by exploiting the power of Caribbean lore and religion as a means of communication. Lam chose myth and magic as vehicles for his ideas instead of themes reflecting a scientific and technological world, such as those found in the work of Matta and Paalen. Lam applied his art to the representation of a Third World culture through his synthesis of Caribbean anthropomorphic beings with tropical plant life. Wifredo Lam (1902–1980), who was born in Sagua la Grande, Cuba, returned to the Caribbean in 1941 after a long sojourn in Europe and spent the better part of a decade there. Like Matta, he was an international figure in the world of surrealism, but his circumstances differed greatly from Matta's. Lam's father was a Chinese merchant and his mother, a *mulata*. For most of his life he straddled two worlds, the European and the Caribbean.

In 1924, Lam had gone to Spain to study art. With the outbreak of the Spanish civil war, he joined the Republican army, then escaped to Paris where he met the surrealists and Picasso, with whom he formed a mutually productive friendship. He returned to Cuba by way of Martinique and the Dominican Republic. In

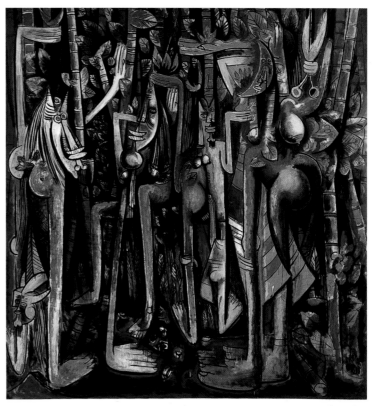

1941, Lam boarded a ship from Marseilles with Breton, Masson, the French anthropologist Claude Lévi-Strauss, and the Russian writer Victor Serge and his son Vlady (now a well-known artist in Mexico) as fellow passengers. He was detained in Martinique (West Indies) for several months and stopped in the Dominican Republic—then a bastion of surrealist literary activity—before arriving in Cuba in 1942.

In Martinique, Lam had met the poet Aimé Césaire, whose long poem *Cahier d'un retour au pays natal* Lam illustrated in

PLATE 4.7
Wifredo Lam, *La jungla [The Jungle]*, 1943, gouache on paper mounted on canvas, 239.5 × 229.75 cm. / 94¼ × 90½ in. The Museum of Modern Art, New York, Inter-American Fund, 1945. Photograph © 1997 The Museum of Modern Art, New York.

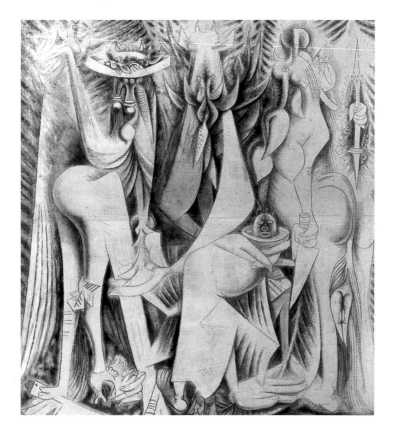

FIGURE 4.15
Wifredo Lam, *Le présent éternel [The Eternal Present]*, 1944, mixed media on jute, 216 × 197 cm. / 85 × 77½ in. Courtesy Museum of Art, Rhode Island School of Design, Nancy Sayles Day Fund.

a 1942 edition. As a key force in promoting black pride in his country, Césaire had coined the term *negritude,* which was to provide a model for Lam's painting in Cuba.[46] The decade Lam spent in Cuba was to be his most productive and original. He elaborated a form of surrealism that escaped the conflicts between the worlds of the unconscious and the political that European surrealists faced. He succeeded in fusing Freudian concepts with an art of social protest. For Lam, surrealism was not an end in itself but "the last liberating commotion of man. It nourishes itself on the concept of liberty which in turn nourishes creativity."[47] His was surrealism with a cause.

The world he found in his country disturbed him greatly, especially the deplorable conditions of Cuban blacks. He objected to "the picturesque frivolity" that Cuba represented. Like Siqueiros in 1932, Lam defied foreign expectations of exoticism and chose instead to "express the spirit of the negroes."[48] One of the strategies he adopted was to use the language of Santería, the Cuban popular religion that fuses Christianity with Afri-

can religion of Yoruba origin.[49] Lam had some knowledge of African art and Santería. He had studied African art in Paris with Michel Leiris and had learned about Santería from his godmother, Mantonica Wilson, who had been an initiate. The recurring symbols such as birds and horse faces, tails, and hoofs in many of his paintings come from several sources besides Picasso and have different meanings. For instance, Lam recalled a childhood experience when he watched a sorcerer's hut burn down and the rising smoke take the form of a horse.[50] In Haitian voodoo, *être à cheval* (to ride a horse) refers to the spirit or deity riding the possessed individual, who thus becomes its vehicle and intercessor. For Picasso, a horse was the victim of violence; for Lam, it could symbolize possession as well as corruption. Ultimately these themes had the authentication of their African origins in Lam's work.

Some of these symbols can be found in *La jungla [The Jungle]* (1943; PL. 4.7), one of the first works in which Lam used Santería as a means of protest. Alain Jouffroy referred to *La jungla* as "the first revolutionary statement in a plastic art of a Third World [country]."[51] According to Lam, this painting was also "intended to communicate a psychic state."[52] Its title alludes not only to this state but also to Afro-Cuban religion. *La jungla* in the title does not refer to a jungle (in Cuba there are only hills, forest, and open country) but to a sacred space, which practitioners of Santería call the jungle, for the worship of Afro-Cuban deities.[53]

Lam did not use symbols of Santería in specific ways but placed them in new revolutionary contexts. The human and vegetable hybrids in *La jungla* appear against a background of a sugar plantation, a symbol of servitude—the sacred space usurped. The picture is dominated by four main vertical axes resembling poles with hybrid female attributes, and detailed with ripening fruit, masklike horse faces, lunar crescents, and scissors—all set against a screen of thick

foliage.[54] Lam referred to the four creatures as monsters, with "the one on the right proffering its rump, as obscene as a whore." Lam sought to convey the situation of blacks as "they were then. I have used poetry to show the reality of acceptance and protest," he said.[55]

Prostitution was rampant in Cuba in the 1940s (it remains a problem today). In *La jungla,* Lam used a *mulata* prostitute as a metaphor for Cuba's degradation. The prostitute theme occurs again in *Le présent éternel [The Eternal Present]* (1945; FIG. 4.15), in which a female figure on the left wears a hat decorated with fruit from which dangles an ear of corn—a popular symbol for money. She wears a single shoe and holds a knife between the toes of the other foot. Lam described her as "a stupid whore" who, "in her heterogeneity," evokes "cross-breeding and the degradation of the race." The figure on the right also has a knife but makes no use of it. According to Max Pol Fouchet, Lam "suggests the indecision of the mulato, who does not know where to go or what to do."[56] In the center, a large hand holds a dish with the sacred Elegua, god of the crossroads and intercessor between gods and mortals, to whom offerings of food are made. He is represented here by a small horned head. Another ear of corn is shown issuing from a vulva in the upper center where a deity or spirit would be expected instead. The figures stand against a foil of palm fronds (in Santería, certain divinities are believed to reside in palm fronds). In this picture, Lam alluded to what he perceived as the choice faced by Cuban blacks between their African roots, represented by the thunderbolt in the upper right-hand corner—symbol of Shangô, the God of Thunder—and Westernization through the lure of money.

As an individual as well as an artist, Lam fulfilled Breton's dream of "the marvelous and the primitive" fused with a healthy dose of "the most skillful disciplines of European art."[57] Lam willingly accepted Breton's assessment. He described himself as fifty percent "Cartesian" and fifty percent "savage."[58] But it was during his years in Cuba that he found the vocabulary that gave his work its special stamp. Although he lived abroad most of his life (he returned to Europe in 1952), in a parallel with Matta, Lam made numerous trips back to his homeland. In 1967 he organized a *Salón de Mayo* exhibition in Havana (patterned after the Paris *Salon de Mai*) as a gesture of support for Fidel Castro. Lam's own contribution to the exhibition was to paint one section of a spiral-shaped collective mural dedicated to the Cuban revolution. This work subsequently became a model for the Chilean mural brigades during Salvador Allende's administration from 1969 to 1973.

The Caribbean inspired numerous surrealists, especially between 1943 and 1948. Lam's compatriot Mario Carreño (b. 1913), who, like him, spent many years abroad and moved to Chile in the early 1950s, was one of them. Carreño's paintings of Afro-Cuban themes, however, were less representative of surrealism as an expressive mode than they were of subjects favored by surrealists. His brightly—almost garishly—colored d o painting *Baile afrocubano [Afro-Cuban Dance]* (1943; PL. 4.8) conveys an idea of Cuban culture that exudes savage eroticism. It shows a fierce masked male (Africa) dancing with a muscular white female in a violent confrontation. The male removes the female's white clothing, leaving her seminaked as they dance against a foil of dense vegetation.[59] Carreño's tightly packed, staccato composition was meant to evoke the compelling rhythm of the African drums.[60] Like Lam, Carreño, who was not black himself, made the interracial aspects of his culture the subject of this painting. But he made the African into a dominant, almost threatening, presence and the white female, subordinate. Carreño also played on the surrealist taste for violence with a synthesis of classicism and surrealist distortion. His swirling colors in this painting have some similarities to those

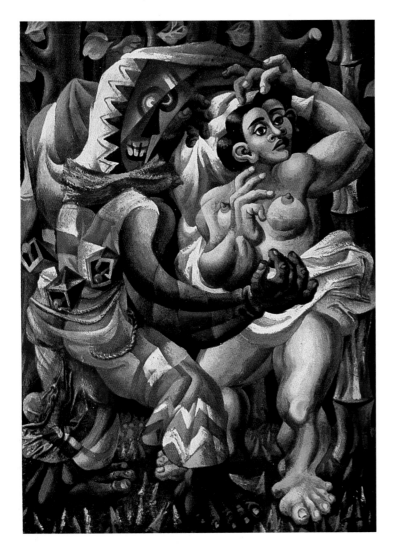

used by the French surrealist André
Masson in *Antilles,* painted the same year
in the United States. In the 1940s, the
Afro-Caribbean cultures epitomized, for
the surrealists, the liberation of the un-
conscious spirit and, for the many tour-
ists who vacationed there, the accessibil-
ity of forbidden fruit. Carreño's imagery
was ambiguous and took a descriptive
direction; Lam's versions expressed
unequivocal distaste for tourist frivolity.

In late 1945, Lam traveled with Breton
to Haiti, where the two attended a voo-
doo ceremony. Although Breton was not
comfortable in the presence of the real
thing, he was enchanted when he saw
Haitian painting for the first time at the
Centre d'Art in Port-au-Prince. He was
particularly taken with the work of Hec-
tor Hyppolite (1894–1948) and bought

five of his paintings; Lam bought two.
Hyppolite had become a legend. He
claimed to have been the son of a voodoo
priest, but he was illegitimate and his
father was unknown. He was believed by
some to be a voodoo priest himself and
reportedly did not marry because he
claimed to be married to Sirène, Goddess
of the Sea.[61] The foreign critics who have
written about Haitian art have focused on
its naïve and magical qualities, and
Breton included Hyppolite in *Surrealism
and Painting.* But Haitians knew little
about surrealism at the time. Rather than
being surrealist, Haitian painting was the
discovery of the surrealists.

What has come to be known as the
Haitian Renaissance began when Dewitt
Peters, a teacher and artist from the
United States who was disqualified from
military service during World War II and
sent to Haiti to teach English under
Roosevelt's Good Neighbor policy, dis-
covered Hyppolite and other local artists.
No galleries or museums existed there at
the time. In 1944, Peters founded the
Centre d'Art in Port-au-Prince, where
free materials were distributed to anyone
wishing to paint, and the work produced
was regularly exhibited. Peters's own
chauffeur, Rigaud Benoit, and gardener,
Castera Bazile, were among the artists to
work at the center.

Prior to Peters's arrival, art in Haiti
already had a complex history dating
back to the eighteenth century.[62] What
Peters provided was a center where
artists could work free of charge.
Hyppolite himself did not have brushes.
He painted with chicken feathers and
with his fingers, usually on several works
at once, applying one color at a time. He
drew and painted on cardboard that he
prepared by flattening packing boxes.[63]

Hyppolite was the first to introduce
voodoo subjects in his painting. When
Peters first saw Hyppolite's colorful bird
and flower designs painted on the exte-
rior doors of a bar, with a sign reading
"Ici la Renaissance," while driving
through the coastal village of Mont Rouis
in 1943, he was enchanted. The following

year, with the help of the Haitian writer Philippe Thoby-Marcelin, Peters returned to find Hyppolite and to persuade him to go with him to Port-au-Prince.[64] Although the subjects of the door paintings were not identifiably voodoo, flowers did in fact represent attributes of certain deities that would have been understood by Haitians.[65] But as he became aware of the commercial value of such subjects as voodoo deities, especially Sirène and Erzulie, goddesses of the sea, Hyppolite began painting these and other voodoo deities.

One of Hyppolite's paintings that had so intrigued Breton was *Ogoun Ferraille* (1944; FIG. 4.16), which he bought. The title and subject of this painting is the voodoo warrior god and healer Ogoun, whose attribute is a thunderbolt and whose Christian counterpart is St. James. In this painting, Ogoun appears as a healer in a room with a table surrounded by emblems of magic: a saber, a machete, a gourd, bottles, a snake, candles, and playing cards. The playing cards in particular reminded Breton of the juggler in the tarot deck, but it is unlikely that Hyppolite himself had made that association.[66]

In the following four decades, other Haitians took up voodoo subjects in addition to colorful landscapes, exotic markets, and scenes of daily life. In the 1960s, André Pierre represented deities with their divine attributes dressed in elaborate costumes shown presiding over ceremonies surrounding the vevers (designs of cornmeal and palm oil made on the ground, usually at the base of a tree or a pole, to invoke a specific loa or deity), or making offerings to the gods and goddesses of the sea. In *L'offrande remise aux esprits de mer: Cérémonie Agoué [Offerings Given to the Spirits of the Sea: Ceremony for Agoué]* (1969; PL. 4.9), Agoué, god of the sea, stands behind a boat holding a fish. The vevers are in the middle foreground.

FIGURE 4.16
Hector Hyppolite, *Ogoun Ferraille*, 1944, oil. Collection Elisa Breton, Paris. Photo: Ron Jameson, from André Breton, *Surrealism and Painting* (p. 311). Reproduction authorized by Elisa Breton.

PLATE 4.9
André Pierre, *L'offrande remise aux esprits de mer: Cérémonie Agoué [Offerings Given to the Spirits of the Sea: Ceremony for Agoué]*, 1969, oil on canvas, 61 × 91.5 cm. / 24 × 36 in. Collection Count G. N. da Vinci, Rome. Courtesy Ruth Reed, Gallery "Arc-en-Ciel," Long Valley, N.J.

The whole scene is masked in Christian symbolism.

In spite of Breton's inclusion of Hyppolite among the surrealists, his work—and that of other Haitians—was the product of his daily reality and religion, not of chance or dream symbolism. But to foreign art collectors and visitors to Haiti, Haitian art seemed to fulfill the surrealist promise of the marvelous.

SUMMARY

Aside from Matta's work, Latin American surrealism did not always correspond to Breton's definitions of it. During the war years, the European surrealists saw in the New World the embodiment of their dream, a mythical and untamable primordial place. The exotic world they thought they had found was primarily located in Mexico and the Caribbean as well as in the western United States. But for most artists from Latin America, surrealism was not so much about dream or magic as about paradox. Some surrealists reflected the somber anguish of wartime in their art, as was the case with Forner; others blended surrealist objects or desolate landscapes with social painting, as was the case for Egas and Portinari. Where mysticism provided a theme, as it did for Batlle-Planas, it was intellectualized and other-oriented rather than personally revealing or Freudian. On the other hand, for individuals who had traditionally been treated as second-class citizens, notably women and blacks, surrealism in Latin America provided the language of revolt and liberation.

Since the 1940s, a notable number of artists in South American countries have taken up some variation of geometric art. This phenomenon may seem at odds with the narrative and expressive tendencies expected of them by foreigners, but the special appeal of geometry as both subject and form came to fulfill two basic and seemingly antithetical objectives: it promoted a sense of being modern at a time of growing urbanization and industrialization, and it provided a link with the pre-Hispanic cultures, particularly of the Andean regions, where art was often based on geometric patterns.[1] By 1944, Uruguayan and Argentine artists began forming groups in Buenos Aires to promote geometric abstraction.[2] In the following years, artists in other countries also took up some aspect of it.

The interest in geometry as the underlying component of a broad spectrum of art forms can be traced, at least in part, to the Uruguayan painter and theorist Joaquín Torres-García (1874–1949), who introduced modernism to Uruguay in 1934. His style, consisting of a grid with pictographs, has left its signature on the art of younger generations both within and outside Uruguay.[3] Although his influence on geometric art in other countries was considerable—an influence that had a strong revival in the 1980s— he was far from the only source for some of its postwar manifestations. Nonetheless, the impact he made on artists with whom he was in direct contact in the 1930s and 1940s cannot be denied, and through his numerous writings, it continued to be felt long after his death.[4] One reason he appealed to many younger artists was that he represented a welcome alternative to the Mexican mural painters and the Andean indigenists (not to mention Picasso) because of his rejection of naturalism, narrative, and ideological content.

Following his return to his native Montevideo in 1934 after a forty-three-year absence, Torres-García became a central force in the Uruguayan art world. He had synthesized the experience of his

TORRES-GARCÍA'S CONSTRUCTIVE UNIVERSALISM AND THE ABSTRACT LEGACY

FIVE

European years into the style he called "constructive universalism," and he set out to teach his aesthetic theories to his followers. Initially, he owed a great deal to European modernism. His family had taken him at the age of seventeen to Spain, where he studied and taught art in and near Barcelona. There he learned the crafts as well as painting and sculpture. He designed stained-glass windows, including some for Antonio Gaudí's Sagrada Familia in Barcelona and for the cathedral in Palma de Mallorca (1904), made wooden toys, and painted murals. He was especially drawn to classical antiquity and its later manifestations because of classicism's timeless qualities. For a while, his own work showed similarities with Puvis de Chavannes's. This was evident to some extent in his mural cycle painted between 1911 and 1916 at the Saló de Sant Jordi in the Palacio de la Diputació (Salon of Saint George in the Government Palace) in Barcelona. These murals remained unfinished, however, due to a change in the administration.[5]

In 1917, Torres-García's interest shifted from classical antiquity to modern urban imagery. In Barcelona he had met a fellow Uruguayan, the modernist painter Rafael Barradas, who invented *vibracionismo* (vibrationism), a personal variant of futurism. Together the two artists took walks through the city to discover its dynamic life. Torres-García adopted the cubist grid as a basis for drawings and paintings of city streets and café scenes. His urban phase culminated with a two-year stay between 1920 and 1922 in New York City, where he focused entirely on views of city life from different vantage points. However, he soon tired of the city's mechanistic features and yearned once again for the classical humanist values that had formed the basis of his earlier legacy. He returned to Europe, first to Italy, then to the south of France, and in 1926 settled in Paris until 1932.[6] Those last six years proved to be the most crucial in the formation of his art and theories.

His meeting in Paris with the neo-plasticists Theo Van Doesburg in 1928 and Piet Mondrian in 1929 led him to adopt the grid in its more rigorous, geometric sense as a means to preserve the two-dimensionality of a picture. This new use of the grid was to form the basis of his constructive universalism. He created allover patterns by dividing the picture surface into horizontal and vertical formations based on golden section proportions.[7] Adopting Mondrian's off-center composition, Torres-García added a dynamic element to his grid compositions with a system of increasing and decreasing proportions in pinwheel configurations.

Like the neoplasticists, he believed in a universal art not bound by local traditions. But while Van Doesburg and Mondrian meant by that an art with no nationality and no concrete past, Torres-García, who also rejected the narrow frame of nationalism, in no way rejected the past. For him, the link with history was a major component of constructive universalism. He proposed an art that was at once as modern as Fernand Léger's, Amédée Ozenfant's, and Robert Delaunay's, and as eternal as the temples and monuments of antiquity. What Van Doesburg saw in an Egyptian pyramid was a model of "measure, direction and number."[8] What Torres-García saw in it was a structure "ruled by laws" that were "the center of innumerable cosmic relationships" and a depository of lost hermetic knowledge.[9]

His Paris colleagues criticized him for combining the "pure" qualities of the grid with pictographs. But he defended his use of both (the grid as the constructive, the pictographs as the universal) by maintaining that the images were part of the overall structure—just as they had been for ancient Egyptians and Indo-Americans—instead of two separate elements. In some of his paintings, the grid and symbols had different and unique functions; in others, the two were intertwined, as in *Estructura animista [Intersected Animist Form]* (1933; FIG. 5.1), in

which a figure drawn with a continuous line defines both the subject and the grid.

During his Paris years, Torres-García developed an interest in many cultures, including African and Oceanic, but especially the pre-Columbian one. The accessibility of this art in Paris museums and through exhibitions[10] was a factor leading to his belief that a grand American art should develop out of a fusion of its ancient art with modernism. His interest in ethnography was contemporary with that of the surrealists. Like them, he generally found in non-Western art a refreshing vitality, and he especially liked this art for its mythical and magical properties. However, he opposed some surrealists' emphasis on chance effects and on the irrational at the expense of reason. For Torres-García, reason and measure were essential components in all art. To counteract the onslaught of surrealism in Paris, he gathered an international group of geometric abstract artists around him and cofounded the group and the journal *Cercle et Carré* (Circle and Square) together with the Belgian critic Michel Seuphor. Among the Cercle et Carré group's activities were exhibitions that included work by some of the major Paris-based geometric abstractionists of the time.[11]

During those years, Torres-García's interest in esoteric systems of thought was sparked by his association with the Spanish painter Luis Fernández. During walks together in Paris, Fernández had drawn his attention to the occult, cabalistic, and alchemical symbolism in the exterior sculpture programs of churches. Fernández, who was a Freemason, also took Torres-García to a meeting at a Masonic lodge, which the latter attended as an observer. Torres-García seems to have felt more kinship with Freemasonry, whose sources can be found in the Middle East and Egypt, than with Mondrian's theosophical beliefs that incorporated Eastern mysticism. Although Torres-García never subscribed to any single belief system and did not rule out some Far Eastern ideas—visible in

his use of the yin/yang in some of his paintings—a great number of the symbols he used were of geometric architectural construction (sacred architecture) that corresponded to the Masonic belief in God as the Great Architect of the Universe.[12] Masonic symbols, such as temples, hammers, knives (the stonemasons' tools), stars, triangles, hands, etc., are present in many of his works.

By 1929, Torres-García's inventory of symbols also included objects from contemporary daily life such as milk cans, trains, café paraphernalia (favored by the cubists), as well as architectural elements from antiquity. By 1930, he had evolved his characteristic vocabulary of pictographs. In *Composición [Composition]* (1931; FIG. 5.2), a hierarchy of universal symbols fills the compartments: at the bottom, masks, a temple, a clock, a lad-

FIGURE 5.1

Joaquín Torres-García, *Estructura animista [Intersected Animist Form]*, 1933, tempera on board, 105 × 75 cm. / 41⅜ × 29 in. Private collection, Houston. Courtesy Cecilia de Torres. Photo: D. James Dee.

der; in the middle, a fish, a hand, a medieval tower, a man with a triangle above him; at the top, scales, a five-pointed star, a serpent, and a sun. The sun alludes to Egyptian and Inca sun worship as well as to the sun of the Uruguayan flag.[13] The triangle and man symbols represent composites of the three elements Torres-García considered essential to unity and balance in the human being: the material (in the lower section), symbolized by a fish; the emotional (in the middle), by a heart; and the idea (in the upper section), by a triangle. The triangle also embodies unity and represents the sum of all three elements. According to Torres-García, the three had equal value, and a balance of these was ideal.

In most of his paintings, Torres-García used muted earth tones and emphasized the hand-made, as opposed to the machine-made, appearance of the work by allowing brush strokes to be visible within the constraints of the grid. He also integrated words, letters, and numbers,

such as significant dates and acronyms (the date of his birth or arrival in some country, his signature as the acronym JTG), into the composition that blended the Phoenician with the Latin alphabets. The words sometimes function as autobiographical records, for instance, the name of a particular street or statement of his artistic beliefs spelled out. *Arte constructivo [Constructive Art]* (1943) incorporates the word *planismo* and the letters *AAC. Planismo* refers to the planar dimension he believed was a necessary condition of painting, and the letters stand for Asociación de Arte Constructivo, the name of the group he founded in Montevideo in 1935.

The contrast between the Paris art world from which he had come and Montevideo in 1934 propelled Torres-García to take on a missionary's task. In Uruguay he found a country "without a tradition" of its own, without museums or art centers for exhibitions; consequently, these had to be created. It was important, he felt, to do something original, "something of ours." In the absence of local models, "we must bow to the major elements of nature, since we don't have a grand landscape either. For this reason, we should make grander work, since the elements must be more universal."[14] Within this system, all references to the local and the immediate were automatically eliminated from his vocabulary. He set out to introduce modernism into Uruguay and—he hoped—to other South American countries by giving lectures, arranging exhibitions, publishing statements and manifestos, books and articles, and through radio speaking engagements. By the time of his death in 1949, his influence reached Argentina, Chile, and Brazil.

Torres-García sought to remedy the isolation created by Uruguay's geographic position far from the major art centers. He announced the creation of a School of the South, referring here to his form of painting rather than to the workshop he was to found in 1943. In a lecture given in 1935, he had stated, "A great School of

Art ought to arise here in our country. . . . I have said School of the South; because in reality, our North is the South. There should be no North for us, except in opposition to our South. That is why we now turn the map upside down."[15] Thus Torres-García instilled in his audience a strong sense of cultural (as opposed to national) identity, and set a precedent by drawing attention to artistic activities in the Southern Hemisphere. This system was to draw on Latin America's past Indian legacy and completely sidestep all reference to the colonial one as though there had been nothing between the pre-Hispanic and the modern period. It was to be a decolonized art.

He soon gathered around him a circle of experienced artists who welcomed his support of abstraction in a country with few opportunities and outlets. He also attracted a group of very young, inexperienced artists who had never been out of Uruguay and who looked to him as a guru. In 1935 he founded the Asociación de Arte Constructivo (AAC) to meet the need for a center where these artists could gather and exhibit. Among the first of the young artists to join the group were Julio Alpuy and Torres-García's own sons, Augusto and Horacio. But in 1940, after only five years, the AAC was discontinued for lack of financial support. In its place, Torres-García established in 1943 the Taller Torres-García (TTG) as an arts and crafts workshop. After his death, the TTG continued to function until 1962 under the direction of his followers.[16]

Torres-García was the first known Latin American artist to successfully establish a school of arts and crafts. In Uruguay, his compatriot Pedro Figari had tried to establish one earlier but had failed for lack of administrative support. The TTG attracted many new artists, including Francisco Matto, Gonzalo Fonseca, José Gurvich, and Manuel Pailós, as well as some from the earlier group. The Taller's main purpose was to broaden the definition of art by including ceramics, stained glass, wrought iron, textiles, jewelry, inlaid and incised wood furniture, and murals as well as painting, sculpture, and printmaking in its agenda. Central to its premises was Torres-García's antihierarchical belief that "'art' as an illusion separate from life must disappear." Painting, sculpture, and architecture are all branches of the same tree. There are "no superior or minor arts."[17] He wished to revive the idea of a workshop collective as it had existed in gothic guilds (stonemasons, glassmakers, etc.) and among ancient Indo-American cultures such as the Chimu people of the Peruvian north coast. He aspired to a revival of the practice of producing functional art objects in a twentieth-century context but in a way different from the European Bauhaus.

In 1935, he began a serious quest for an art based on pre-Columbian models as he initiated studies for *Monumento cósmico [Cosmic Monument]* (FIG. 5.3), begun the following year and finished in 1938. This large pink granite monument, located in the Parque Rodó in Montevideo, was inspired by the Sun Gate at Tiahuanaco, Bolivia, which Torres-García had not seen in Bolivia but knew through reproductions as well as from a plaster copy in the Trocadero in Paris. But unlike the monolithic Sun Gate, *Monumento cósmico,* with its projecting granite frame, was made of separate, carefully fitted rectangular blocks to create a flat surface with clean, modern lines, covered with incised designs. The monument is surmounted by a cube, a sphere, and a pyramid because these solids represent the most timeless and stable of geometric volumes. For that reason, Torres-García and his students all used them repeatedly in their work. At the center of the monument's base is a semicircular fountain (the fountain of life). A slab on the ground nearby has incised on it the cardinal points reversed, so "SUR" (south) appears at the top and "N(ORTE)" (north) at the bottom.

This phase of Torres-García's work culminated in 1939 with a pamphlet titled *Metafísica de la prehistoria indoamericana,*

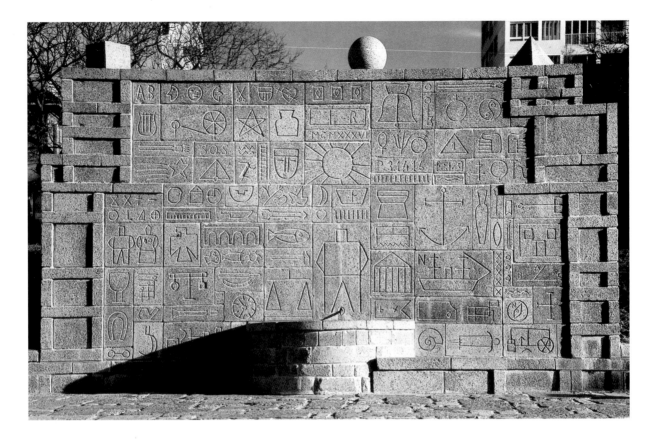

FIGURE 5.3
Joaquín Torres-García,
*Monumento cósmico
[Cosmic Monument]*, 1938,
pink granite, Parque José
Enrique Rodó,
Montevideo. Courtesy
Cecilia de Torres. Photo:
Alfredo Testoni.

published by the AAC as part of its program of studies in pre-Columbian art. This study of Indo-American cultures was anthropological rather than art historical, but its purpose was to find correspondences between the pre-Columbian abstract tradition and modern art.[18] By the 1940s, Torres-García turned his back on Europe and sought to establish an art for North and South America based on a universal abstract rule that was relevant to the present as well as a shared historical past. This past was increasingly sought in the ancient art of the Andes, which Torres-García perceived as the basis for a new "virgin and powerful art . . . far from the Babel of Europe."[19] His interest in Indo-American art was in part motivated by the geometric patterns in the textile and pottery designs of ancient American cultures that were compatible with modernism. Although Torres-García did not personally visit Andean sites, Fonseca, Alpuy, and Horacio and Augusto Torres had gone to see ancient Peruvian and Bolivian centers in the mid-1940s.

Torres-García's greater focus on a pre-Columbian legacy during the early 1940s prompted him to paint *Arte constructivo [Constructive Art]* (1942; FIG. 5.4), one of a series in which he substituted minimal shading and vigorous brushwork for pictographs. The textured grid without the symbols created the appearance of an Inca wall. But far from a literal representation of Inca masonry, this work emphasizes a two-dimensional abstract surface.

Torres-García's idea of what was modern derived primarily from the use of geometry and not from modern industry, and that is what he taught his followers. Thus his teachings opposed those practiced at the Bauhaus and at Black Mountain College in North Carolina, where industrial design was part of the program. Torres-García's rejection of industrial and mechanical systems of production was based on his conviction that "art and progress don't go together." Industry, he felt, was an aberration of human development rather than part of its evolution, and therefore antithetical to art.[20] Only those elements that had survived through time and occurred universally,

such as geometry and proportion, were valid as means of linking past and present. In his work as well as in that of his students, there was an emphasis on the appearance of age, never on newness. Thus all possible association with the industrial object was eliminated.

This rejection of modern industrialism accounts in part for the weathered appearance that is characteristic of Torres-García's and the TTG artists' work. But there were also more basic reasons for the aged appearance. The TTG and its artists operated with minimal resources and needed to be frugal. They also wished to preserve their sense of independence by using only locally available and recycled materials. For instance, when they lacked the funds for commercial canvas, they used burlap or cardboard. For sculpture or reliefs, they used wood rescued from packing crates. Their economic limitations sometimes led to great resourcefulness. In the 1950s, Alpuy used the bones he had saved from a stew pot to make a bone-inlaid table and a frame. Fonseca inlaid a box with glass and lead salvaged from flattened, empty paint tubes. Fine stones, bricks, and iron were plentiful in Uruguay, and the artists used them for sculpture, murals, and architectural projects.[21]

The major part of the Taller's production in ceramics, wrought iron, stained glass, jewelry, textiles, and mosaic murals dates from the 1950s. At first, the TTG did not have the available equipment to produce the objects they designed. Since they did not have clay, a wheel, or a kiln, the earliest ceramics to come out of the Taller were unglazed, store-bought pots that the members decorated by hand. By the late 1940s, they had acquired clay and a kiln, but not a wheel, because the ancient artisans had not used one. Instead, they adopted the slab method, which consisted of rolling out the clay, cutting it, and using molds, then burnishing the finished pot as the Nasca potters in Peru had done prior to firing. Similarly, the Taller's textile production consisted of hand-embroidered designs until the

1950s, when a member of the workshop acquired a loom and was able to translate drawings and paintings by the TTG members into woven tapestries.

A major ambition of the workshop artists was to design and execute architectural projects from start to finish, including the interior design. This they would do with the collaboration of architects. Both Torres-García and Horacio Torres built their own houses in Montevideo, the former in 1948, the latter in 1960. These buildings were entirely made out of local bricks and furnished with Taller-made tables, cupboards, wrought-iron gates, ceramic ware, and textile wall hangings. In the early 1950s, several artists collaborated with architects in the decoration of their homes and gardens. Francisco Matto contributed a stone sculpture and Julio Alpuy, a mosaic mural made of local cut stones (1951; FIG. 5.5), to the architect Ernesto Leborgne's garden in Montevideo.

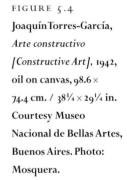

FIGURE 5.4
Joaquín Torres-García, *Arte constructivo [Constructive Art]*, 1942, oil on canvas, 98.6 × 74.4 cm. / 38¾ × 29¼ in. Courtesy Museo Nacional de Bellas Artes, Buenos Aires. Photo: Mosquera.

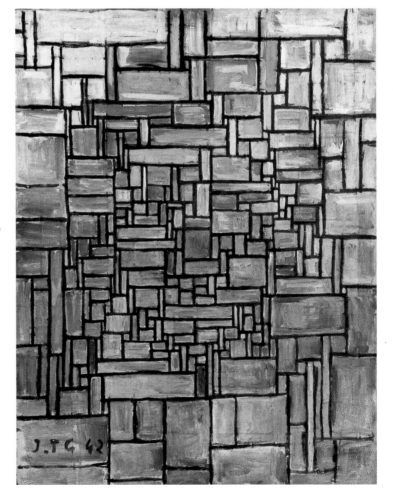

Murals represented a major component of the workshop artists' idea of the integration of art and architecture. Torres-García owned a copy of the Mexican mural manifesto formulated by Siqueiros in 1923. Although he had left Barcelona by the time Siqueiros was there, one of Torres-García's works had been reproduced in Siqueiros's single copy of *Vida Americana* in 1921. Torres-García was also familiar with Siqueiros's "Three Appeals of Timely Orientation to Painters and Sculptors of the New American Generation."[22] But though both artists shared in a desire to launch a new art form relevant for the New World, Torres-García disagreed with the Mexicans' ideological premise, maintaining that a mural had to form an integral part of an architectural setting, which only geometry and constructivism could provide.[23]

In 1944, Torres-García and his followers collaborated on a cycle of twenty-seven panels painted with commercial enamels directly on the wall in the Martirené wing of the Colonia Saint-Bois, a sanatorium for the treatment of tuberculosis on the outskirts of Montevideo. Torres-García contributed seven panels, two of which, *Constructivo con hombre universal [Construction with Universal Man]* and *Pacha Mama [Mother Earth]* (FIG. 5.6), illustrate the range of his repertoire of symbols. Both were later destroyed in a fire.[24] The first panel included modern urban imagery along with the usual sun, fish, snail, and man symbols; the second was an off-white monochromatic mural with the Andean mother goddess as a semicircular stela-like head at the bottom surrounded by diagrammatic designs based on those of some Central and South American Indian cultures.[25] The Martirené mural project contrasts dramatically with the descriptive representations of Indians by Peruvian and Bolivian indigenists. Instead of naturalistically painted contemporary Indians, Torres-García and his constructivist followers borrowed the formal characteristics from the Indian past.

Yet in spite of Torres-García's differences with the Mexicans, there is a striking correspondence between his work and Rivera's Detroit murals of 1932 (see PL. 3.1). The two main panels in Rivera's murals are also based on an underlying grid structure that serves to anchor the

FIGURE 5.5
Julio Alpuy, mural for Architect Ernesto Leborgne's garden, Montevideo, 1951, stone mosaic. Courtesy Cecilia de Torres. Photo: Alfredo Testoni.

FIGURE 5.6
Joaquín Torres-García, *Pacha Mama [Mother Earth]* (destroyed), 1944, commercial enamel mural, Martirené Pavilion, Saint Bois Hospital, Montevideo. Courtesy Cecilia de Torres. Photo: Alfredo Testoni.

composition. Also significant is that Orozco used the theme of universalism and depended on a geometric system of subdivisions (in Orozco's case, dynamic symmetry)[26] to unify the compositions in his 1930 New School for Social Research murals. On the other hand, the Taller murals differed in major ways from all the others. These murals signaled a second phase of mural painting in Latin America, based not on narrative but on architectural and environmental considerations in line with the ideas of Fernand Léger rather than with the ideologically based ones of the Mexicans. A later example of this category of wall decoration can be seen in the abstract geometric patterns of the murals at Ciudad Universitaria (University City) in Caracas, Venezuela, built in the early 1950s and discussed in Chapter 7.

THE ARGENTINE CONCRETE ARTISTS

Torres-García's leadership of Uruguayan modernism received wide diffusion through two journals he published: *Círculo y Cuadrado* (named after the earlier *Cercle et Carré;* 1936–1943) and *Removedor* (Paint remover; 1945–1951).[27] By 1944, he had won recognition from artists in neighboring countries as well as from officials at the Museum of Modern Art in New York.[28] His legacy was especially far-reaching in Argentina and Uruguay, where contact with other artists was direct. He had lectured in Argentina on several occasions since the 1930s. In 1935, two Uruguayan abstract artists, Carmelo Arden Quin and Rhod Rothfuss, traveled to Buenos Aires. In 1941, the Argentine painter Tomás Maldonado, a leader of early Argentine geometric abstraction, met Torres-García first in Montevideo, then in Buenos Aires, and Torres-García's writings, including his monumental *Universalismo constructivo* published in Buenos Aires in 1944, were known. That same year, Arden Quin, Rhod Rothfuss, and the Hungarian-born

Argentine sculptor Gyula Kosice published the first and only issue of *Arturo,* a journal featuring poems and articles on constructivist art, to which Torres-García contributed. In 1945, these same artists formed a group in Buenos Aires called Arte Concreto Invención. Other splinter groups formed under different names. One of these was the Asociación Arte Concreto-Invención (not to be confused with the first group), led by Tomás Maldonado (b. 1922). This second association, whose members included Manuel Espinosa, Lidy Prati, Ennio Iommi, Alfredo Hlito, and Raúl Lozza and his brothers, exhibited together in 1946. The same year, Kosice, Quin, and Rothfuss, with the addition of the painter and sculptor Martín Blasko, formed the Grupo Madí and exhibited internationally several times in subsequent years.[29]

The term *concrete* rather than *abstract* was applied to the work of artists in all these groups, including Grupo Madí, to indicate that nothing was abstracted. Their work had no prior association with nature nor any metaphysical significance; rather, it stood for nothing but itself. Theo Van Doesburg was the first to use this term, but concrete art as a new form originated with the Swiss artist Max Bill.[30] The Argentine concrete artists also emphasized "invention" as further indication that their geometric compositions were the result of an intellectual and premeditated process, not an intuitive one. Although Torres-García was the initial source for geometric abstraction in Argentina, he never rejected intuition nor the Platonic view that geometry held the key to a higher order.

The Argentine concrete artists were a postwar phenomenon, and by 1946, they had rejected Torres-García's definition of geometry. Their emphasis was on the mathematical, scientific, and mechanical appearance of a work in flat, high-keyed colors that obliterated any hint of the handmade object. They concurred in proposing an art that was antiromantic, rational, geometric, and, in a further

break with Torres-García, lacking the
mark of the individual artist's hand, an
element that was always a strong compo-
nent in Torres-García's paintings.[31]

Philosophically, the Argentine concrete
artists felt a stronger kinship with Max
Bill than with Torres-García. According
to Lawrence Alloway, Bill bridged "the
platonic and the existential phases of
Abstract art . . . [while he] retained a
high sense of order."[32] Argentine concrete
art was contemporary with the acceler-
ated industrialization and urban popula-
tion growth of the postwar period in that
country. The Argentine scholar Nelly
Perazzo has noted that while in the
United States abstract expressionism
(more or less contemporary with Argen-
tine concrete art) reflected an existential
sense of the world, in Argentina, geomet-
ric art profited "from the atmosphere of
reconstruction of a new world upon the
preceding chaos."[33]

Although the concrete artists shared
with Torres-García, as with the European
neoplasticists, the notion of the work of
art as integral to the total environment
and not a separate object, they went a

step further by promoting the destruction
of the conventional picture format in
favor of the broken or irregular frame.
The idea for an irregular frame originated
in 1944 with a statement in *Arturo* by
Rhod Rothfuss summing up modernist
precedents and explaining that the tradi-
tional window-frame effect "disappears
only when the frame is rigorously struc-
tured according to the painting's compo-
sition."[34] The broken frame liberated the
work from its representational function
by emphasizing its role as an object in its
own right that could function as part of a
whole environment instead of as a sepa-
rate element framing a naturalistically
painted scene. Tomás Maldonado was an
adherent of this idea, as is evident in his
painting *Arte concreto [Concrete Art]* of
1946.[35] The polished enamel painting
Pintura No. 72 [Painting No. 72] (1945;
FIG. 5.7) by Raúl Lozza (b. 1911) also
exemplified Rothfuss's broken-frame
theory. Many other artists, including
Martín Blaszko, Manuel Espinosa, and
Lidy Prati, took up this practice. Paintings
could be hung in clusters, as they were at
the 1948 *Réalités Nouvelles* exhibition in
Paris, so that the wall functioned both as a
support and as part of an environment.
The concept of the broken frame also
applied to sculpture by liberating it from
its function as a closed volume. For ex-
ample, the free-standing, angular cast
aluminum *Concrete Sculpture* (1945) by
Claudio Girola (b. 1923) is open in the
center to reveal and incorporate the space
behind it. Other artists used acrylic, iron,
wood, and aluminum for constructions
that defined, rather than occupied, space.
Gyula Kosice (b. 1924) first used
fluorescent lights to form a geometric
pattern in the 1940s. In the late fifties, he
introduced Plexiglas, aluminum, and
water to create motorized, hydraulic
sculptures. The inclusion of water as an
element of instability, coupled with the
shifting effects of light resulting from
rising air bubbles trapped within the
Plexiglas containers, produced a sense of
perpetual motion. This phase in Kosice's
work more appropriately belongs to the

optical and kinetic phenomenological world of the 1960s and 1970s rather than to the stable geometric art of the immediate postwar period. Nevertheless, it had its source in concrete art.

THE URUGUAYAN LEGACY

Torres-García's legacy among his Uruguayan followers took a different turn. Due to his hold on his students, his death had ambiguous consequences among Uruguayans. On the one hand, it was a great loss for those who depended on his guidance. On the other, it was a liberation that allowed artists to seek new directions. The sculptors Fonseca and Matto, and the painters Alpuy and Augusto and Horacio Torres were among those to benefit from this new-found freedom. The common thread that linked them as they developed in individual directions was, to use Mari Carmen Ramírez's words, that they liberated "the pictographic symbol from the grid structure" in their work.[36]

Alpuy and Fonseca chose to travel and to discover for themselves the world they had only heard about through Torres-García. In 1950, they went together to Greece, Jordan, and other Middle Eastern countries. Alpuy (b. 1919) then went on to Ravenna, Italy, to see Byzantine art. The stone mosaic mural he did in Leborgne's garden in 1951 (see FIG. 5.5) was inspired by the Byzantine mosaics he had seen in Ravenna. Fonseca (1922–1997) participated in an archaeological project in Jordan and visited North Africa. As a result, he began incorporating ideas derived from North African tribal art into wood constructions for their formal, as well as magical, properties. For instance, he suspended fetishlike objects over wood surfaces, as in *Parafernalia órfica [Orphic Paraphernalia]* (1962; FIG. 5.8), or set them in niches.

When Fonseca took up stone carving, he transferred some of these elements to the new medium. Fonseca's assimilation of African as well as other Middle Eastern and pre-Columbian cultures led him, after the late 1960s, to create three-dimensional works made of concrete, limestone, or granite that evoked ancient ceremonial sites. In the 1960s, he began making small stone objects in New York and larger pieces in Pietra Santa, Italy, where he spent summers in close proximity to the quarries. In *Graneros III [Granaries III]* (1971–1975; FIG. 5.9), he finished the exposed part of the sculpture to a high degree of polish, but allowed the back side to remain in a rough, unfinished state. The purpose was to emphasize the idea of time passing from the primordial state of the original stone to the one in which humans had intervened. This work's polished, carved-out levels connected by steps and depressions remind one of Inca sites and monuments, especially the monolithic Intiwatana (Sun Stone) at Machu Picchu and the dressed-stone structures of Ollantaytambo in the Peruvian highlands. A circular depression on the top surface contains real grain, an

FIGURE 5.8
Gonzalo Fonseca, *Parafernalia órfica [Orphic Paraphernalia]*, 1962, wood and string, 301.8 × 153.4 cm. / 121½ × 61¼ in. On loan to Jack S. Blanton Museum of Art (formerly Archer M. Huntington Art Gallery), The University of Texas at Austin. Courtesy estate of Gonzalo Fonseca, Michael F. Johnston, executor. Photo: George Holmes.

allusion to the granary's sacred function as a central storage bank, and also to "seeds of knowledge."[37] The addition of separate, movable parts, such as a classical foot and a head, incorporates the idea of the European past as part of the human legacy.

Fonseca and Alpuy both lived in New York in the 1960s, and Horacio Torres moved there in the 1970s and remained until his death in 1976. All these artists shared a common disregard for the contemporary fashions that surrounded them in New York. Although their work differed considerably from artist to artist, they all concurred in their rejection of the language of advertising and mass media, and they invested their own work with a timeless sense that preserved the fundamental ideas of Torres-García's teachings. Alpuy strayed the least from Torres-García's ideas. He discarded the grid as an obvious structural component in his paintings that represented naked figures in some primordial paradise, but he nonetheless respected the two-dimensionality of the picture by avoiding all naturalistic sense of distance.

By the 1960s, Augusto and Horacio Torres had also reintroduced elements of naturalism into their painting. Horacio (1924–1976) began painting female nudes in a Titianesque manner during his years in New York. In comparison with Philip Perlstein, whose paintings represent unembellished nudes in contemporary settings, Horacio's sensual nudes in classical poses do not reveal a specific time or place. The only element in his pictures besides the figure is the drapery, as can be seen in *Desnuda en pañerías blancas sobre fondo azul [Torso on White Draperies against Blue Background]* (1974; PL. 5.1). His way of setting the figure off-center and cropping it helps to preserve a sense of anonymity, and his inclusion of masses of drapery also contributes to maintaining the painting's abstract qualities. Although these figurative works would seem like a radical departure from Torres-García's teachings, they do not contradict the theories he expressed in his late writings. In *La recuperación del objeto* of 1948, Torres-García proposed a return to the object, but not to naturalism.[38] Horacio resolved this challenge by substituting color for the grid. In spite of his choice to use shading on flesh, he avoided illusionistic pictorial space as well as any clue that would have fixed the figure in time. The human figure as subject—both female and male—was fairly common in New York in the 1970s, including in Perlstein's paintings, and figural compositions revealed their debt to abstraction,

as in this case for Horacio Torres. But figures in the work by U.S. artists were usually shown in familiar, contemporary settings that fixed them unequivocally in the present. None of them expressed the timeless and sensual attributes of Horacio Torres's figures.

Torres-García's legacy was not limited to his immediate followers nor to the years immediately following his death. A great number of Argentine artists sooner or later rediscovered his theories either directly through his writings or because of their acquaintance with one of the original followers. Marcelo Bonevardi, César Paternosto, and Miguel Angel Ríos, among others, followed Torres-García's teachings in individual ways. Paternosto and Ríos, both of whom were minimalists in the 1960s and 1970s, took up Indo-American themes in the 1980s as a result of their renewed awareness of Torres-García's legacy. For Bonevardi (1924–

1995), the impact was more direct. In the 1950s, he had moved to New York, where he met Fonseca. After an initial period of interest in the work of Joseph Cornell, Bonevardi looked to Fonseca's wood constructions as a source (see FIG. 5.8). But instead of wood panels, Bonevardi developed a form of constructivism consisting of shaped canvas and polished, carved wood constructions. For a short time, the two artists' work looked similar. Like Fonseca, Bonevardi preserved the flatness of the surface. But color played a more important role in Bonevardi's work than it did in Fonseca's. By the late 1960s, the latter devoted his time primarily to sculpture. Bonevardi evolved a type of painting that defied the traditional rectangular format of the picture in favor of irregular shapes. He assembled his paintings and constructions from several components stretched on frames of different sizes and thicknesses that

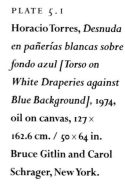

PLATE 5.1

Horacio Torres, *Desnuda en pañerías blancas sobre fondo azul [Torso on White Draperies against Blue Background]*, 1974, oil on canvas, 127 × 162.6 cm. / 50 × 64 in. Bruce Gitlin and Carol Schrager, New York.

FIGURE 5.10
Marcelo Bonevardi
(Argentinean, 1929–
1994), *Cámara privada
[Private Chamber]*, 1966,
mixed media on
stretched canvas with
carved wood object,
99.1 × 140.0 cm. / 39 × 55⅛
in. Jack S. Blanton
Museum of Art (formerly
Archer M. Huntington
Art Gallery), The
University of Texas at
Austin. Gift of John and
Barbara Duncan, 1971.
Photo: George Holmes,
G1971.3.7.

allowed for recesses to accommodate polished geometric solids or totemic objects carved in wood. *Cámara privada [Private Chamber]* (1966; FIG. 5.10) is essentially a rectangle with a carved totemic figure embedded in one of two niches formed by the irregularly stretched canvas components. The viewer is given a voyeuristic sense that there is another world beyond the visible one, a sort of inaccessible inner sanctum. In some of his works, Bonevardi drew lines that suggest perspective projections as found in Italian Renaissance architectural studies (like Fonseca, he was trained as an architect). But at no time do these lines convey pictorial depth. Bonevardi's surfaces remain two-dimensional and have the quality of ancient walls. Although Bonevardi drew from a set of references similar to Fonseca's, Bonevardi's paintings have an elegant finish that sets them apart from the rough-textured, hand-made appearance typical of the Taller artists. Bonevardi combined the universal constructivist aspects of Torres-García

with the shaped canvas whose sources can be traced to Argentine concrete art.

Torres-García's abstract theories were rediscovered in the 1980s by artists from several countries who found in these theories a justification for their own inclinations. For artists working in the 1960s and 1970s, these concepts suggested ways to incorporate myth and ancestral references into informalist abstraction. In the 1980s, it was the grid's structural variations and apparent compatibility with the architectonic qualities of Indo-American art that appealed to artists. On a broader level, Torres-García furnished a Latin American model for artists of very diverse tendencies. Even artists whose work differed formally from his, such as the Bolivian María Luisa Pacheco and the Ecuadorian Enrique Tábara, could state emphatically that Torres-García's ideas provided them with the means to reconcile abstraction with a sense of their own cultural legacy.

PART II

After World War II, a rapid change from social figuration and Torres-García's utopian constructivism to informalist abstraction occurred in the art of most Latin American countries. The founding of new galleries and museums of modern art from the late 1940s on, and of the São Paulo Biennial exhibitions in Brazil in 1951, played a key role in this change. Abstraction was seen in most Latin American countries on a regular basis for the first time, and artists, in turn, were receiving unprecedented exposure through exhibitions both at home and abroad. But the new presence of artists from Latin American countries in international art circuits was not an unmixed blessing. Too often this new exposure led to paternalistic evaluations of their art by foreign critics who either accused them of being "derivative" if they chose to be abstract or "behind the times" if they did not. As a result, this new global visibility put artists under pressure to conform to international standards and, consequently, led to renewed questions of cultural identity.

The Mexican mural painters, the Andean indigenists, and Torres-García had helped in different ways to define Latin American or regional identities before World War II. But abstraction in itself had no identity, and artists who adopted it had to reinvent one within this new framework.[1] While geometric and informalist abstraction coexisted, the latter was the more prevalent during the 1950s and 1960s. *Informalismo* (informalism), as this type of abstraction was known in Latin America, took two main directions: one that depended on surface elaboration and texture, the other, on gestural brush strokes. The first was indebted to Spain, the latter to both France and Spain.[2]

Some form of abstraction was practiced by individual artists in many countries from the late 1940s on, including Cuba. Its spread throughout Central and South America was encouraged and promoted by increased industrial and corporate patronage (IBM, Esso, etc.) as well as

NEW MUSEUMS, THE
SÃO PAULO BIENNIAL,
AND ABSTRACT ART

SIX

by the establishment of new museums and galleries. Museums of modern art were founded in São Paulo in 1948, in Rio de Janeiro in 1949, in Mexico City in 1953, in Buenos Aires in 1956,[3] and in Bogotá in 1962. Although Caracas did not have contemporary art museums until later, two galleries, the Galería de Arte Contemporáneo and Estudio Actual, performed the function of promoting contemporary abstraction there from the 1950s on. In Santiago, Chile, a Museo de Arte Contemporáneo had existed since 1946, and the first Latin American graphics biennial was established in Santiago in 1963.

The São Paulo Biennial, inaugurated in 1951, played an especially crucial role in the dissemination of abstraction by bringing together for the first time in Latin America the art of Europeans and North Americans as well as Latin Americans. The biennial's director, Lourival Gomes Machado, aimed to place "modern art in Brazil not in a mere comparative position, but in live contact with the art of the rest of the world" and to make of the São Paulo Biennial a strong rival of the Venice Biennial, if not "the world's art center."[4] Other biennials followed, including the Kaiser Industries American Biennial in Córdoba, Argentina (1962–1966), and the Coltejer Biennial in Medellín, Colombia (1968–1972, briefly revived in 1981). In addition, national and international award exhibitions were organized at the Instituto Torcuato di Tella in Buenos Aires. The latter was founded in 1958 to promote research in the humanities and the sciences, and in 1960, it added a Department of Visual Arts.

Many of these institutions were headed by influential and charismatic leaders who took upon themselves the task of launching the newest trends in art and discouraging the "aesthetic of poverty" that had prevailed before the war, which they perceived as a blight on Latin America's cultural image.[5] Four of these leaders—Jorge Romero Brest, Rafael Squirru, Marta Traba, and Clara Diament Sujo—were Argentines. In 1963, Romero

Brest, an art critic and former director of the Museo National de Bellas Artes in Buenos Aires, took over the direction of the di Tella's new visual arts section until its demise in 1970. Squirru, the creator of Buenos Aires's Museo de Arte Moderno, was also the museum's first director. In 1963, critic and novelist Traba, as the first director of the Museo de Arte Moderno of Bogotá, where she had lived since the 1950s, was instrumental in redefining the character of Colombian art, for which she was both praised and criticized. In Caracas, Clara Diament Sujo directed the Estudio Actual Gallery, where contemporary artists were shown without the stigma of national identities.[6]

MEXICO

In Mexico City, Miguel Salas Anzures, as head of the Visual Arts Department of the Instituto Nacional de Bellas Artes (INBA) from 1957 to 1961 and contributor to the founding of the Museo de Arte Moderno, promoted international exhibitions as well as the work of a younger generation of Mexican artists. What he and these other leaders all had in common was their defense of internationalism and of the most avant-garde art Latin America had to offer.

But no modern art museums or biennials existed in most Andean and Central American countries until the late 1960s, so older existing institutions had to serve as the venues for the new art. Artists who took up the banner of abstraction in these countries often found a hostile audience, and the more ambitious among them moved abroad for varying periods of time.[7] Although some critics and artists in Mexico and the Andean countries defended their right to embrace contemporary modes of expression, others saw this change as a betrayal of their cultural identity and the result of a conspiracy originating mainly in First World art centers to discredit ideological art in favor of internationalization because of its

safe, apolitical stand.[8] In Mexico, the response to the incursions made by international art proved especially challenging. When Miguel Salas Anzures brought foreign exhibitions to the INBA, he was accused of "contaminating national art" with them. Although he also encouraged younger Mexican artists like José Luis Cuevas, Manuel Felguérez, and others who supported him, he was eventually forced to resign from his post.[9]

Despite the pressure he experienced, Anzures had a loyal following among older as well as younger artists who opposed the government's institutionalization of the local in Mexican art. Among these were Rufino Tamayo, Mathias Goeritz, and the Mexican-based Guatemalan Carlos Mérida, all of whom had chosen a formalist rather than an ideological direction some years earlier. Tamayo had made his reputation abroad and was not given full recognition in Mexico until a major retrospective of his work was held at the INBA in 1948. By the 1950s, he had become a role model for the younger generation.[10] The German-born sculptor and architect Mathias Goeritz (discussed in the next chapter) also aligned himself with the younger artists, including Cuevas,[11] and nurtured a new generation of abstract and constructivist sculptors in Mexico.

Although Tamayo was never completely abstract, since he continued to use the human figure, he was still looked upon favorably by young abstractionists. Pedro Coronel was an obvious heir to Tamayo's style, and even Francisco Toledo, who painted figures and animals in strange symbioses (like Tamayo, he was of Zapotec origin and from the state of Oaxaca), adopted some of Tamayo's surface qualities. But abstraction in Mexico also grew out of surrealism, French or Spanish informalism, or some aspect of constructivism. Among the Mexicans to take up this type of abstraction were Manuel Felguérez, Vlady, Luis López Loza, Lilia Carrillo, Gunther Gerzso, and Vicente Rojo.

Some of these artists continued to incorporate Mexican cultural references of a nonpolitical nature in their work, as Tamayo did, but Felguérez and sometimes Rojo opted instead for a more general repertoire of reductive geometric shapes.[12] Both artists also had direct European contacts. Felguérez (b. 1928) had been to Europe and had studied in Paris with Ossip Zadkine during two stays there between 1948 and 1955. Although Zadkine's influence eventually was minimized in Felguérez's work, these trips placed Felguérez in direct contact with international postwar modernism, and he subsequently defended an artist's right to follow any chosen direction without the weight of localisms. But there was no public for his art in Mexico until the late 1950s when a rising middle class his own age developed an interest in the new abstract modes.[13]

By the late 1950s, murals in the narrative style of Rivera were discredited by younger artists, but the practice of doing murals continued in a new aesthetic form with a decorative function. Felguérez executed several murals throughout the 1960s as assemblages of stone, wood, cement, scrap iron, shells, and welded steel. His 1961 panel at the Cine Diana in Mexico City incorporated what Octavio Paz described as "levers, screws, wheels, winches, axles, pulleys and washers"[14] into a huge relief. In the late 1960s, Felguérez turned to geometric abstraction, partially as a result of his collaborations with architects. The semaphoric signs in his first geometric abstractions had similarities with those of Rojo. Both used arrows, triangles, and other highway signs. Some of Felguérez's semaphore series took the form of installations that incorporated painting and sculpture as interrelated units. They consisted of a painting in enamel on canvas and a separate, free-standing, polychromed metal sculpture whose geometric patterns repeated those of the painting.

Defying Mexico's folkloric tradition, Felguérez took advantage of the technology available to artists in the developed

FIGURE 6.1

Manuel Felguérez, *Sin título [Untitled]*, from *"El Espacio Múltiple" (Multiple Space) Paintings and Sculpture: Manuel Felguérez* exhibition, Carpenter Center for the Visual Arts, Harvard University, 1976, based on computer-generated designs, oil on canvas, 45.75 × 35.5 cm. / 18 × 14 in. Courtesy Manuel Felguérez, Mexico City.

countries. In 1976 he worked on a computer-generated project at Harvard University in Cambridge, Massachusetts.[15] Through a process of codification, selection, or rejection based on his original mathematical model of a drawing, Felguérez could reprocess and multiply his selections as many times as he wished, then translate the resulting "idea forms," as he called them, into paintings or sculptures based on variations of the original drawing (see *Sin título [Untitled]*; FIG. 6.1). The mechanical aspects of this series reflected a tendency among a handful of Latin American artists to dismiss the

pressures to represent their culture in some way by exploring options offered by industrialized countries that were either not available or prohibitively expensive in their own country.

Vicente Rojo (b. 1932) chose instead to explore the painter's options rather than those offered by technology. He had moved to Mexico from his native Barcelona in 1949 and made his reputation as a layout and typographical artist for the National Autonomous University Press in Mexico City.[16] His experience as a graphic artist and book designer may have contributed to the geometric direction his painting took. Like Felguérez, he began with a loose form of impastoed abstraction related to Spanish informalism. But from the early 1960s on, he embarked on a series of semaphoric images comprising triangles, hexagons, circles, squares, and trapezoids, as in *Recuerdo No. 1403 [Remembrance No. 1403]* (1976; FIG. 6.2). In the *Señales [Signs]* series, painted between 1965 and 1970, he began scraping off the earlier layers of impasto to reveal residual brush strokes, drips, scratches, and graffiti in the remaining stains. Among these is *Señal antigua en forma de letra [Ancient Sign in the Form of a Letter]* of 1969 from the *Señales* series (PL. 6.1). The frontality of the

FIGURE 6.1

Manuel Felguérez, *Sin título [Untitled]*, from *"El Espacio Múltiple" (Multiple Space) Paintings and Sculpture: Manuel Felguérez* exhibition, Carpenter Center for the Visual Arts, Harvard University, 1976, based on computer-generated designs, oil on canvas, 45.75 × 35.5 cm. / 18 × 14 in. Courtesy Manuel Felguérez, Mexico City.

PLATE 6.1

Vicente Rojo, *Señal antigua en forma de letra [Ancient Sign in the Form of a Letter]*, 1969, oil on canvas, 100 × 140 cm. / 39⅜ × 55⅛ in. Photo courtesy Vicente Rojo.

FIGURE 6.2
Vicente Rojo (Mexican,
b. 1932), *Recuerdo No.
1403 [Remembrance No.
1403]*, 1976, oil on canvas,
140 × 140 cm. / 55⅛ ×
55⅛ in. Jack S. Blanton
Museum of Art (formerly
Archer M. Huntington
Art Gallery), The
University of Texas at
Austin. Archer M.
Huntington Museum
Fund, 1976. Photo:
George Holmes,
P1976.19.1.

PLATE 6.2
Vicente Rojo Almaraz,
*México bajo la lluvia 146
[Mexico under the Rain
146]*, 1983, acrylic on
canvas, 140 × 140 cm. /
55⅛ × 55⅛ in. Private
collection, U.S.A. Photo
courtesy Vicente Rojo
Almaraz.

image, the impenetrability of the surface, and the illusion of brushwork share common ground with Antoni Tàpies's surface qualities as well as with Jasper Johns's visible brush strokes, but without their materiality. The brush strokes in Rojo's work were now illusory. But also, unlike either Johns or Tàpies, Rojo developed a palette of rich and resonant colors that gave his work immense sensual appeal. His contradictory tendency toward an appealing treatment of color and surface on the one hand, and the simultaneous denial of these on the other, led to the formulation of a vocabulary of tightly woven patterns that permitted him to reconcile both aspects.

According to his own testimony, Rojo had felt uncomfortable when he saw an illustrated book about his work, published in 1970. As a result, he embarked on a series of *Negaciones [Negations]* that denied "my own self" and "depersonalized" the previous work.[17] Through the 1970s, he covered square canvases with a grid either composed of patterns of small raised squares within a square formation, allowing for a narrow border between the internal square and the picture's boundaries, or inscribed with small squares contained within the T shape where this letter functioned as a limiting geometric agent, as in *Señal antigua.* Contrary to expectations, this series did not result in impersonal, mechanized images, but in richly colored and worked surfaces with endless variations consisting of gridlike patterns of small stars, circles, semicircles, triangles, or crosses, and the whole in turn was limited by its outer geometric boundaries. The resulting grids are reminiscent of the glazed-tile patterns on the exterior of colonial churches in Puebla such as San Francisco Acatepec. In a reference to the *Recuerdos,* the critic Raquel Tibol suggested that the apparent erasure of visible subject matter in these paintings was directly related to Rojo's childhood as a "republican child in the Spanish Civil War" and was a way of

obliterating a painful memory (he was four years old when the civil war broke out and nine when it ended).[18]

By the 1980s, Rojo had developed a series begun twenty years earlier titled *México bajo la lluvia [Mexico under the Rain]* consisting of diagonal patterns of narrow strips of canvas (the rain) collaged onto the surface (he subsequently obtained similar textured effects with paint), using colors inspired by Mexican folk art. The practice of borrowing colors from folk art was not unique to Rojo. Other Mexican artists, such as Jesús (Chucho) Reyes Ferreira and architects like Luis Barragán, also incorporated them in nonreferential ways. As in his earlier work, Rojo created unlimited variations from repetition, in this case of diagonal patterns. In some of the "rain" paintings, the diagonals resulted in a relatively tranquil design, in others, in a dynamic or undulating one, as in *México bajo la lluvia 146 [Mexico under the Rain 146]* (1983; PL. 6.2).

BRAZIL

Rojo's preference for the textured surface, shared with the Argentine painter José Antonio Fernández-Muro and the Ecuadorians Aníbal Villacís and Enrique Tábara, had roots in Spanish informalism. However, this type of abstraction was infrequent in Brazil, where a more gestural form of painting related to French informalism was more prevalent. One of the artists to practice such abstraction was the Japanese-born Brazilian Manabu Mabe, who adopted a form of gestural painting related to French *tachisme* (a term taken from the French word *tache* for "spot," hence, "spotting"). Although his type of gestural painting would seem to be related to Jackson Pollock's manner of pouring and flicking paint, Mabe's paintings are the result not of body action but of a form of wrist action like that used in Japanese calligraphy. Mabe's type of brushwork also resulted in an elegant lyricism more often avoided by U.S.

abstractionists. But for Mabe, "beautiful things are the purpose of my life."[19]

Mabe (b. 1924) was brought to Brazil at the age of ten. As a youth in Brazil, he worked on coffee plantations (just as Portinari did) and painted when rain made it impossible to work outside. In São Paulo, he found a large Nippo-Brazilian community whose artist members encouraged him to paint. Today he is a successful painter living in a Japanese-style house with a garden landscaped in the Japanese tradition. In an acknowledgment of his double identity, Mabe says: "My decades in Brazil have made me a strange Brazilian who also happens to speak Japanese."[20] In spite of his association with other artists, especially the Nippo-Brazilian painters of the São Paulo–based Seibi group, he is largely self-taught, and his life and art developed "under nature's guidance." From the late 1950s on, his themes were determined by things from the natural world, closer to the tradition of Japanese landscape painting than to Western abstract concepts. He stated that since he was "created in contact with nature, with plants, trees and fishes," he developed "a melancholy, romantic spirit." But in spite of the hard life he had lived in his youth, "I did not suffer any negative influence. That is why my art is joyous, with clear colors."[21]

In both the early representational and the later abstract works, landscape and natural phenomena figure as Mabe's main themes. *Paisagem—Leblon [Landscape—Leblon]* (1953; FIG. 6.3), an early work named after one of Rio de Janeiro's beaches, is based on a shallow cubist space. When Mabe began painting abstractly, he first used broad strokes like those of the French abstractionist Pierre Soulages, but he soon began to vary his brush strokes. Although there is no mention of the French artist Georges Mathieu as an influence in Mabe's art, the two artists met during Mathieu's visit to Brazil. In 1959, Mathieu had lectured in São Paulo and painted pictures as public demonstrations at the São Paulo and Rio Museums of Modern Art.[22] His abstrac-

tions were supposed to represent the action of battles, which he enacted by dressing up in the appropriate costumes and lunging at his canvas, as if in a fencing duel, thus producing a type of action painting. The visible result of the "battle" was invariably an abstraction with frenzied brush strokes. Whether or not there was a connection, Mabe's own brushwork gained a new fluidity, albeit of a more tranquil nature, from then on, as can be seen in *Sonho de meiodia [Midday Dream]* of 1969 (PL. 6.3). His reputation in the international arena was also sealed in 1959 after winning the "Best National Painter" award at the *Fifth São Paulo Biennial.*

Mabe's approach to painting during the 1960s and 1970s was systematic without being premeditated. He usually began by covering several canvases with a solid color, then turning them to the wall to dry. When he later selected one to work on, he allowed himself to be guided by the mood evoked by the color, often a bright red, green, or blue. He then brushed on colors in broad areas while leaving the background visible around a central abstract shape. Sometimes he worked on the floor by rolling the paint-laden brush handle across an area of the canvas, then setting his canvas upright for the finishing touches. These consisted of gradually reducing the size of the strokes,

FIGURE 6.3
Manabu Mabe,
*Paisagem—Leblon
[Landscape—Leblon],*
1953, oil on canvas, 73 ×
92 cm. / 28¾ × 36¼ in.
Courtesy Manabu Mabe,
São Paulo.

PLATE 6.3
Manabu Mabe, *Sonho de meiodia [Midday Dream]*, 1969, oil on canvas, 200 × 240 cm. / 78¾ × 94½ in. Private collection, São Paulo. Photo courtesy Manabu Mabe.

then ending with networks of fine filaments and tendrils that resemble insect antennae or flower pistils. A painting is finished, he said, "when the brushstroke is spent."[23]

ARGENTINA

In Argentina, several artists went through an abstract phase before turning to other modes.[24] The period between the end of the Perón administration in 1955 and the rise of the military regime in 1966 was a time of frenzied artistic activity in Buenos Aires. During these years, abstraction spread rapidly as a major tendency. But in Argentina, abstraction had a precedent in the concrete movement of the 1940s. What marked the later forms was the looser brushwork as a break from

concrete art's hard-edged linearity. In the 1950s and 1960s, many abstractionists maintained a blend of French abstract colorism and the surface textures of Spanish matter painting. Both José Antonio Fernández-Muro and Sarah Grilo took up informalism after a period of geometric art.

Born in Madrid and living in Buenos Aires since 1938, Fernández-Muro (b. 1922), together with Grilo, Miguel Ocampo, and several others, gained international visibility when they exhibited in 1952 and 1953 with the Grupo de Artistas Modernos, respectively in Rio de Janeiro's Museu de Arte Moderna and at the Stedelijk in Amsterdam. In 1955, when they exhibited with the Asociación Arte Nuevo in Buenos Aires,[25] their work still showed ties with concrete art. But

soon after, a loosening up of their work was evident, and each developed in an individual direction. By the late 1950s, Fernández-Muro sought an "alternative to gestural abstraction on the one hand and to hard-edged geometry on the other"[26] by using a system of pointillism obtained mechanically by applying the paint over a screenlike stencil to arrive at an impenetrable surface.

In New York, where he and Grilo lived from 1962 to 1969, Fernández-Muro began incorporating metal foil rubbings of industrial products, such as embossed lettering taken from commercial plaques on buildings and utility-hole covers, which he made surreptitiously at night in the streets of New York by rubbing foil over them, later transposing them to his paintings. Although his incorporation of such commonplace things into paintings was contemporary with pop art, he did not make pop art of them but used them as geometric substitutes that he enhanced with silver paint in combination with rich, muted colors. Thus, he also satirized the industrial object by raising it to the level of an aesthetic one, often with intended humor.

Two paintings, *Bandera secreta [Secret Banner]* and *Al gran pueblo argentino [To the*

Great Argentine Nation], both done in 1964, represent flags—an indication of Fernández-Muro's familiarity with Jasper Johns's flag paintings. In *Al gran pueblo argentino* (FIG. 6.4), the sun of the Argentine flag is replaced by an embossed impression of a utility-hole cover, and its top and bottom bands, by repeated sections of embossed lettering. The title plus the word *salud,* or "greetings," spelled out in the painting are taken from the words in the Argentine national anthem "Al gran pueblo argentino, salud." Lawrence Alloway noted that "the idea of using a country's flag in a determinedly non-expressive way, like [Jasper] Johns, is inconceivable in South America."[27] Fernández-Muro's apparently sacrilegious representation of the Argentine flag might lead to the conclusion that it was in some way meant to be political. But Fernández-Muro's brand of humor is more in the spirit of Picasso's, which has the makings of a private joke rather than that of a serious ideological statement. Fernández-Muro's painting is a satire, not necessarily of the Argentine flag, but of the mythical power of flags in general.

Fernández-Muro's 1963 painting *Disparo en la espalda [Shot in the Back]*

(PL. 6.4), likewise, can be compared to Johns's targets. It consists of a bright red disk (the target) enclosed in a square seemingly supported by a vertical band of the same color on a gray background. In Fernández-Muro's work, the target refers to a specific event, the assassination of the civil rights leader Medgar Evers in Mississippi, revealed by the blurry graffiti across the work's surface. In a more general way, the reference was also to the series of assassinations that occurred in the United States in the early 1960s, for instance, that of John F. Kennedy. But rather than a direct response to the events themselves, Fernández-Muro's works are a response to the media coverage of them.[28] The distancing implicit in his paintings also confirms that his work had no resemblance to the emotionally charged paintings of the abstract expressionists, but rather was the product of a media-saturated decade.

Sarah Grilo (b. 1920) also relied on contemporary referents in her abstractions of the 1960s but within a broader context and in a style that ultimately differed from Fernández-Muro's. In *Pintura [Painting]* (1958; PL. 6.5) and *Rojo y naranja [Red and Orange]* (1960), Grilo focused exclusively on the formal components. But in the paintings she did in New York, such as *X en la calle 13 [X on 13th Street]* (1963; FIG. 6.5), she introduced numbers and letters as symbols floating inside multiple layers of thin glazes of color. The letters had no specific meaning in her work. She used them because "they appear all around us."[29] Nonetheless, compared to her work of the 1950s, *X en la calle 13* goes beyond its formal components by making reference to the outside world as an urban space bursting with scrambled information. What her work has in common with Fernández-Muro's is its apparent absence of emotional involvement. Both Grilo and Fernández-Muro used the figure of an X repeatedly in their work, as did some of their contemporary Spanish abstractionists. It was not necessarily a conscious choice, but it usually acted to preserve the two-dimensional surface by denying entry into the picture's space.

ECUADOR

For artists from the Andean countries, where nativist themes painted representationally had predominated well into the 1950s, abstraction was imported. In some cases, it was introduced by nationals who returned to their countries after studying abroad. The type of abstraction that developed in Peru can be traced to several sources, including Spain and France. In Ecuador and Bolivia, it more closely followed the Spanish model. In 1951, General Francisco Franco of Spain had initiated a new open-door policy in an effort to improve his international image, and Latin American artists were encouraged to go to Spain to study and to exhibit.[30] The majority of artists to take up this option were from the Andean countries, especially Ecuador and Bolivia. When they went, many of them already had some training from their own countries.

From the turn of the century on, Ecuadorians had been in contact with

FIGURE 6.5

Sarah Grilo (Argentinean, b. 1920), *X en la calle 13 [X on 13th Street]*, c. 1964, mixed media on canvas, 101.8 × 102 cm. / 40 × 40⅛ in. Jack S. Blanton Museum of Art (formerly Archer M. Huntington Art Gallery), The University of Texas at Austin. Gift of Jordan Metzger, 1975. Photo: George Holmes, G1975.35.1.

PLATE 6.5
Sarah Grilo, *Pintura
[Painting]*, 1958, oil on
canvas, 94 × 94.5 cm. /
37 × 37¼ in. Museo
Nacional de Bellas Artes,
Buenos Aires. Courtesy
Sarah Grilo. Photo
courtesy Museo Nacional
de Bellas Artes, Buenos
Aires.

artists from Italy and France as well as Spain. Painters from these countries had emigrated to Ecuador at different times and taught there. Between 1939 and 1941, a generation of war exiles moved there and trained some of the younger Ecuadorian artists. Enrique Tábara and Estuardo Maldonado studied in the coastal city of Guayaquil with the German painter Hans Michaelson; Osvaldo Viteri (and more informally Aníbal Villacís) studied in Quito with the Dutch artist Jan Schreuder, who had gone to Quito as a cartographer for Shell Oil in 1939 and remained there until 1962.[31] At first, abstraction in Ecuador seemed alien to that culture. When the Ecuadorians adopted this form, they did so for two major reasons: they wished to follow the new abstract modes and they wanted to overthrow *guayasaminismo*—a reference to Oswaldo Guayasamín's domination of the local art establishment in Ecuador, which paralleled Rivera's dominance of

the Mexican art establishment before his death in 1957.[32] In 1967, young Ecuadorian artists, including Villacís and Tábara, founded the Grupo VAN in Quito to defend abstraction and artistic freedom. The group's name referred both to the avant-garde and to the verb form *se van* (Spanish for "they are going," in the sense of moving forward).[33]

These young artists soon found ways to tap their rich heritage as a means to translate abstraction into something personally and culturally relevant. Unlike artists from the more Europeanized metropolises, such as Buenos Aires or São Paulo, Ecuadorians lived in close proximity to their pre-Columbian and colonial legacies and their local folk traditions. Many of them owned collections of pre-Columbian, colonial, or folk art. Villacis's collection of colonial art includes fragments of gilded columns, moldings, furniture with wrought-iron fixtures,

FIGURE 6.6
Aníbal Villacís, *Filigranas
[Filigree]*, 1962, mixed
media, 76 × 101.5 cm. /
30 × 40 in. Courtesy Art
Museum of the Americas,
OAS, Washington, D.C.

and polychromed saints, and his pre-Columbian one comprises pottery from the Inca period.[34] From his living-room window, Villacís commands a breathtaking view of Quito overlooking the historic spot where the last Inca emperor, Atahuallpa, once enjoyed his baths. Today a reservoir occupies the spot.

As a youth, Villacís (b. 1927), who was from the highland town of Ambato, had attempted to decorate the whitewashed walls in his neighborhood, but he was soon intercepted by the local police. He later restricted himself to a more modest form of expression by teaching crafts in elementary schools. He was essentially self-taught and began his adult career by copying Spanish bullfight posters announcing forthcoming competitions. In 1953, with a grant from his local government, he traveled first to Paris and then to Madrid, where he settled until 1955. The thickly worked incised surfaces of his paintings of the 1960s and 1970s show affinities with those of Antoni Tàpies, Modest Cuixart, and other Spanish artists working in the 1950s.[35]

When, on the occasion of an exhibition of his work at the Pan American

Union in Washington, D.C., in the early 1960s, Villacís took the opportunity to look at abstract expressionist painting at the Museum of Modern Art in New York, he referred to it as "the best painting in the world."[36] He especially admired Jackson Pollock, although his own work most resembles the tightly packed allover compositions of Richard Poussette-Dart. After his return to Quito, where he then lived, Villacís experimented with allover patterns in paintings of a series he called *Filigranas [Filigree]* because of the silver and gold powders he used to build up the surfaces. Patterns suggestive of pre-Hispanic designs began appearing in some of them, as in *Filigranas* of 1962 (FIG. 6.6). Unlike Pollock and Poussette-Dart, Villacís never resorted to accidental effects in his paintings but kept to a deliberate crafting of the surface. After building up the surface with sand, metal, or marble powders, he incised them with arabesque designs, dashes, floral motifs, crosses, chevrons, bars, and dots. He then covered the resulting relief design with several layers of thin, modulated tones of clay, black, coffee, green, gray, or white. By wiping and rubbing each layer of color as he went along, he ob-

tained a dull polish like the burnished finish on pre-Columbian ceramic pots. This laborious process also had precedents in the technique of *estofado* used in colonial art to color wood carvings of saints. This process consisted of first applying a coat of silver or gold leaf over a base coat of plaster, then a layer of color, and finally, of scratching away parts of the color to expose the gold or silver to give the appearance of brocade.[37] Thus Villacís, more than his other colleagues, acknowledged Ecuador's colonial legacy.

Even so, the majority of Villacís's paintings were inspired by Ecuador's ancient traditions. In the 1960s and 1970s, he worked on a series of *Precolombinos [Pre-Columbians]*[38] with a variety of designs possibly derived from aboriginal Ecuadorian ceramic roller stamps as well as excised pots and gourds.[39] Among these works is *Precolombino [Pre-Columbian]* (1976; FIG. 6.7), whose incised design

includes among its symbols arrows and fangs suggesting feline attributes. In *Precolombino,* Villacís used marble powder for surface texture (he stopped using gold and silver powder because he found the resulting paintings too decorative). Villacís's approach to modern abstraction was to incorporate into it the tactile qualities of pre-Columbian art by applying some of the designs, colors, and techniques used by aboriginal people.

Enrique Tábara (b. 1930), who was from the port city of Guayaquil, shared Villacís's interest in the surface aspects of abstraction. But Tábara's paintings also incorporated elements of myth in addition to the tactile attributes of pre-Columbian art. His early works included literal representations of Indians and peasant children as well as exuberant tropical landscapes with anthropomorphic trees and roots in a late-surrealist style. He first experimented with

FIGURE 6.7
Aníbal Villacís,
Precolombino [Pre-Columbian], 1976, mixed media, 121 × 121 cm. / 47¼ × 47¼ in. Courtesy Art Museum of the Americas, OAS, Washington, D.C.

impastos and abstraction in 1953 under
the influence of Hans Michaelson and
Manuel Rendón, an older European-
trained abstract painter from Guayaquil.
After his move to Barcelona in 1955 on a
grant from the Ecuadorian government,
Tábara, like Villacís, was exposed to the
work of Cuixart and Tàpies, and he be-
friended the latter. During his nine-year
stay in Europe (Switzerland as well as
Spain), Tábara abandoned illusionistic
space for the elaborated surface patterns
of the matter painters and also took up
collage. He used canvas cutouts, sand,
and—according to the art historian
Damián Bayón—dried insects.⁴⁰ As a
child, Tábara had collected insects and
ancient pottery shards that he found
during family outings. He held on to the
shards as though they had some magic
property.

Tábara had considerable interest in
esoteric subjects and believed in interga-
lactic communication, popular myths,
and magic. His painting *Región de los shiris
[Region of the Shiris]* (the Shiris were a
fictitious tribe of Ecuadorian Indians) of
1967 (PL. 6.6) combines tactile qualities
with myth. His work of the 1960s had
much in common with that of Tàpies,
both in its surface treatment and in its
references to an ancient or mythical
culture (for Tàpies, it was the caves of
Altamira, which Tábara also knew). But
Tábara emphasized color as well. The
cream-colored surface over a green field
in *Región de los Shiris* has a luminosity
seldom seen in Spanish *informalismo*. The
painting's central area, covered with
cryptograms, evokes ancient petroglyphs
as well as a distant mythical past that
corresponds to the Ecuadorian abstrac-
tionists' "*precolombino*" phase of the 1960s.

After 1969, Tábara reintroduced into
his work organic shapes that did not
directly refer to the past but did answer
his desire to find a form that incorpo-

PLATE 6.7

Osvaldo Viteri, *América muchedumbre sedienta [America Thirsting Crowd]*, 1976, collage on wood, 122 × 122 cm. / 48 × 48 in. Courtesy Viteri Centro de Arte, Quito.

rated some living reference to the human body. However, in defiance of Guayasamín's use of hands and faces as expressive agents in the *Edad de la Ira [Age of Wrath]* series of the early 1960s, Tábara opted for the human foot because of its anonymity and minimal potential for emotional or dramatic expressiveness. He titled the resulting series *Patas-patas.* The doubling of the word, which coincidentally means "paws" in Spanish and "feet" in Quechua, creates a type of verbal *mestizaje* (the hybridization of Indian and European). *Construcción en azul y gris [Construction in Blue and Gray]* (1976) is a variation of the *Patas-patas* series. It consists of a compartmentalized structure containing petrified and ossified pediform objects, some of which overlap their assigned space. The gridlike structure in this work was prompted by Tábara's acquaintance with Torres-García's *Universalismo constructivo,* which for him, as for others, justified abstraction as a universal and timeless expression.

The grid also served as the basis for some of Estuardo Maldonado's encaustic paintings of the 1960s. Born in 1930 in the small highland town of Pintag, Maldonado, like Villacís, also painted a series of *Precolombinos* in the 1960s, of which *Composición No. 4 [Composition No. 4]* (1961; FIG. 6.8) is one. But instead of Villacís's arabesque designs, Maldonado's patterns consist of allover clusters of tightly woven cryptograms that include the letter *S,* an ancient symbol for life. However, Maldonado chose to free himself from his local environment. Rather than go to Spain, he went to Italy, where he could explore the aesthetic possibilities of industrial materials. There he began working with sheets of stainless steel and devised a process for coloring the metal. His experiments resulted in a series of modular structures known as *inoxcolor* (colored stainless steel).[41] Al-

though Maldonado chose to be part of an international community by using the type of industrial materials many Italian artists were working with at the time, he nonetheless continued to use the *S* as a symbol that could be adapted to geometric configurations. He also obtained textural variation by contrasting a mat with a polished metallic surface.

Conversely, Osvaldo Viteri (b. 1931), an architect and anthropologist by training, sought to revive his country's symbols of *mestizaje* in paintings and assemblages.[42] After a period of gestural abstraction and collage with no visible cultural identity, and following a trip to Spain in the 1960s, he began to use identifiably Ecuadorian referents like colonial liturgical vestments and folk dolls in his work. During his tenure as director of the Instituto Ecuatoriano de Folklore from 1966 to 1968, his attention was drawn to the possibilities of incorporating folk art into his paintings. He

began making assemblages with small folk dolls and gluing them in clusters on canvases with roughly painted backgrounds. In *América muchedumbre sedienta [America Thirsting Crowd]* (1976; PL. 6.7), the cloth dolls substitute for paint. The distribution of these dolls across the surface preserves the two-dimensionality of the work and at the same time provides an original solution for the expression of cultural identity. Viteri was in this sense an heir to *indigenismo,* applied in his case to an abstract idiom. Viteri's particular emphasis on the ongoing condition of hybridization in Ecuador, rather than on an ancient past, is unique.

PERU

The arrival of abstraction in Peru corresponded to a time of accelerated urbanization and industrialization in the early 1950s as well as to the emergence of new

FIGURE 6.8
Estuardo Maldonado,
*Composición No. 4
[Composition No. 4]* from
the *Precolombino [Pre-
Columbian]* series, 1961,
encaustic on wood, 90 ×
70 cm. / 35½ × 27⅝ in.
Private collection, Rome.
Courtesy Estuardo
Maldonado. Photo:
G. Como.

outlets for artists to show abroad. Many artists were still practicing some form of *indigenismo* when abstraction first made its appearance in the 1950s. The rapidity with which some of them changed from figuration to abstraction leads to the conclusion that they felt pressured to do so by the new opportunities for international exposure. The Peruvian artists' participation in the *Sixth São Paulo Biennial* in 1961 is a flagrant example of the rapid assimilation of international art into their work. All of the works in the biennial were painted the preceding year, between 1960 to 1961. Some of the works in the biennial had residual ancestral figures in them and evocative titles (*Pachacamac, Parakas, Auki V, Espíritus [Spirits]*), while others referred only to the works' formal components (*Composición [Composition], Pintura [Painting], Blanco y negro en contraste [Black and White in Contrast]*) with no visible cultural reference. The rapid shift from *indigenismo* to gestural abstraction is exemplified in the work of Sabino Springett, who had painted *Educación religiosa [Religious Education]*, a fresco in the indigenist mode, at the Ministry of Education in Lima in 1957, and by 1961 was painting abstractions with no extrapictorial meaning.

Only for artists like Fernando de Szyszlo (b. 1925), who had first gone through a late cubist stage, did abstraction represent a more natural transition. De Szyszlo was among the first Peruvians to explore this mode. But when he first showed abstract paintings in a 1951 exhibition at the Sociedad de Arquitectos in Lima, his work was denounced as "decadent," "un-Peruvian," and "immoral."[43] At the time there was considerable ferment in intellectual circles, and abstraction was at the center of a heated debate between its supporters and its detractors. It was not until the 1960s that de Szyszlo's work was appreciated in his country, even though he had already enjoyed considerable success abroad.

Unlike some of his compatriots, de Szyszlo had a broad international background and had studied and taught abroad. Born in Lima to a Polish father and a Peruvian mother, he had first studied art at the School of Fine Arts at the Universidad Católica of Lima with the Austrian-born painter Adolfo Winternitz, who had founded the department.[44] Between 1949 and 1955, de Szyszlo lived in Paris and Florence (instead of Spain), returning periodically to exhibit in Lima. Between 1956 and 1960, he held the post of cultural advisor in the Department of Visual Arts at the Pan American Union in Washington. He taught painting at Cornell University in Ithaca, New York (1962), at Yale University (1966), and at the University of Texas in Austin (1977) as a visiting professor. During those years, his work received wide international diffusion.

Although de Szyszlo's type of abstraction can be associated with French and U.S. models, he adopted a tonal rather than a coloristic approach in his use of thick paint. In Europe he had admired Paul Gauguin, Vincent Van Gogh, Pierre Soulages, and Hans Hartung among the moderns. But he had also copied old master paintings in museums and been drawn to the impastos and tonal qualities in Rembrandt's paintings. In *Inkarri* (1968; PL. 6.8), a thickly painted black oblong figure floats over a deep red field above an altarlike band identifiable as feline paws joined at the center. Feline attributes recur in many of his paintings. In ancient Peruvian and Bolivian art, felines appeared in pottery designs, textiles, stele, and temple facade reliefs and were believed to be endowed with supernatural powers.

The floating black oblong shape in *Inkarri* may bring to mind such configurations in works by Mark Rothko or Adolph Gottlieb. Like them, de Szyszlo preserved the two-dimensionality of the image through a balance of shape and color. But his use of tonal modulations and impastos gave his work a tactile, shadowy quality quite distinct from the flat colors of the U.S. artists. Furthermore, the meaning of

PLATE 6.8
Fernando de Szyszlo
(Peruvian, b. 1925),
Inkarri, 1968, acrylic on
wood, 150.5 × 150.5 cm. /
59¼ × 59¼ in. Jack S.
Blanton Museum of Art
(formerly Archer M.
Huntington Art Gallery),
The University of Texas
at Austin. Gift of John
and Barbara Duncan,
1971. Photo: George
Holmes, G1971.3.48.

his work lay in the symbolism and palpability of his color, which were more in line with Tamayo than either Rothko or Gottlieb. His modulated tones of rose, pink, ocher, red, plum, turquoise, and black are those of ancient textiles, not of the modern industrial world. Gilbert Chase aptly defined de Szyszlo's particular synthesis as "abstract nativism" for all these reasons. Designs from Chavín stele and ancient pottery, such as feathers, fangs, and rings, are visible in his work, but so are black suns. These elements were meant to express the somber mood of conquest and the defeated Inca civilization.

Like Villacís, de Szyszlo is a collector, but only of pre-Hispanic art. He owns Chavín, Chancay, and Mochica ceramic pottery and figurines and has visited Inca sites. But a greater source for him was the sixteenth-century Quechua elegy *Apu Inka Atahuallpaman* (first published in Spanish in 1942 and reprinted in several

later editions). Atahuallpa, the subject of the elegy, was the last Inca emperor. The central theme in this elegy is death, which also underlies most of de Szyszlo's paintings. He based much of his work on such literary descriptions as "the color of blood," which had "stopped flowing in your veins," the sun that "turns yellow, then darkens," and exclamations such as "what rainbow is this black rainbow that is rising."[45] He translated these phrases into visual equivalents to evoke the "contamination" of a culture by an enemy and the resulting demise of the Inca. The color black in his paintings refers to the darkening sun and the black rainbow, and red refers to blood. Black and red are the dominant colors in *Inkarri* (see PL. 6.8).[46] De Szyszlo's titles invariably contribute conceptually to the paintings' meaning. The Quechua title *Inkarri* alludes to the Incas as brave people and is also a refer-

ence to an Andean myth predicting the return of the Incas and the ultimate destruction of the Spaniards, a legend Szyszlo surely knew. In some cases, the titles refer to historical sites. For instance, *Cajamarca* (1959) was named after the northern Peruvian town where Atahuallpa was murdered by the Spaniards in a last confrontation before the fall of the Inca Empire.

COLOMBIA

Death is also an undercurrent in the work of the Colombian painter Alejandro Obregón (1920–1995). Like de Szyszlo, Obregón had an international background. Born in Barcelona to a Spanish mother and a Colombian diplomat father, he went to Colombia for the first time when he was in his teens and did not settle there permanently until he was in his thirties, after the mid-1950s, living first in Barranquilla, then in Cartagena on the Caribbean coast. His travels had taken him to England, France, and the United States. In 1939, he studied art briefly with Carl Zerbe at the Museum of Fine Arts School in Boston, Massachusetts, but in the end he was more self-taught than formally trained.

During *la violencia,* the bloody episode in Colombia's history that lasted from 1948 through the 1950s,[47] Obregón was among the many Colombian artists to flee the country. From 1949 to 1954, he lived in the south of France near Avignon, where he associated with the English artist Graham Sutherland and the Spanish painter Antonio Clavé. Ultimately, Obregón's major sources were from Spain. Some compositional similarities existed between his work and Clavé's, but Obregón was more daring, thus Picasso made a stronger impact on him than Clavé.

In the 1940s, even though Obregón taught painting at the School of Fine Arts in Bogotá, there was considerable controversy over his work because it was too advanced for a still-conservative art

community. But when he returned to Colombia in 1955, the reception to his work was much more positive. At that time, Marta Traba was living in Colombia and had launched a campaign to promote abstraction there. She found a ready model in Obregón, who soon gained a reputation as the "father of modern art" in his country, a title he maintained through the 1960s.

Although Obregón was considered an abstractionist, touches of naturalism, such as flowers or the vestige of a human figure, are often identifiable in his work. His work of the 1950s, like that of his Colombian contemporaries, had its roots in late cubism, especially that of Picasso's *Guernica*. The latter provided a relevant model for the expression of violence without narrative suitable for the post-*violencia* period, and Obregón made good use of these characteristics in his own work of the 1950s.[48] Death is the central theme in *El velorio [The Wake]* (1956; PL. 6.9), in which the body of a young man (sometimes identified as a student) is stretched out laterally on a tabletop surrounded by a glass, a bottle, foliage, and other identifiable objects. A rooster (the Caribbean *coq*) as a sacrificial symbol stands guard below. Red and analogous tones of hot pink or orange something like Tamayo's colors bathe the scene in an eerie glow. An undercurrent of Christian martyr imagery underlies this and other

PLATE 6.9
Alejandro Obregón, *El velorio [The Wake]*, 1956, oil on canvas, 140 × 175 cm. / 55 × 69 in. Courtesy Art Museum of the Americas, OAS, Washington, D.C.

Obregón paintings. In *El velorio,* a focus on bones, a broken leg, ribs, and marks on the corpse's face also hints at brutality.

Death is also the subject of a series Obregón did on *la violencia,* of which *Violencia: Detalle de un genocidio [Violence: Detail of a Genocide]* (1962; FIG. 6.9) is an example. Although *la violencia* was officially over at the time Obregón

painted this work, scattered killings continued to occur, and the episode was still in the news and was the subject of a book published in the early 1960s.[49] In Obregón's painting, the dead body of a pregnant woman merges with the ground in a white, tan, and gray haze. Although Obregón's painting appears to focus on formal rather than narrative elements, the scratches that appear all over the pregnant woman's body (as they had on the dead student's face in *El velorio*) not only convey brutality but refer to a particularly perverse practice by extremist terrorists during *la violencia:* that of attacking women as the perpetrators of the race.

Obregón's subjects also included landscapes with volcanoes, cattle drownings, bones, funerals, South American fauna, and Caribbean flora. In all of these subjects, death was implied or imminent, not as a past condition, as in some of de Szyszlo's paintings, but as a timeless or ever present one. Obregón's paintings of condors imply a vulnerable species that is also a symbol of Latin

FIGURE 6.9

Alejandro Obregón, *Violencia: Detalle de un genocidio [Violence: Detail of a Genocide],* 1962, oil on canvas, 157.5 × 190.5 cm. / 62 × 75 in. Collection Hernando Santos, Bogotá. Courtesy Estate of Hernando Santos. Photo: Ron Jameson, from *Alejandro Obregón* (fig. 8).

FIGURE 6.10

Alejandro Obregón, *El último cóndor [The Last Condor],* 1965, oil on canvas, 172.75 × 201.5 cm. / 68 × 79⅜ in. Courtesy Deere & Company Art Collection, Moline, Ill.

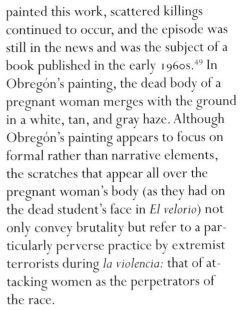

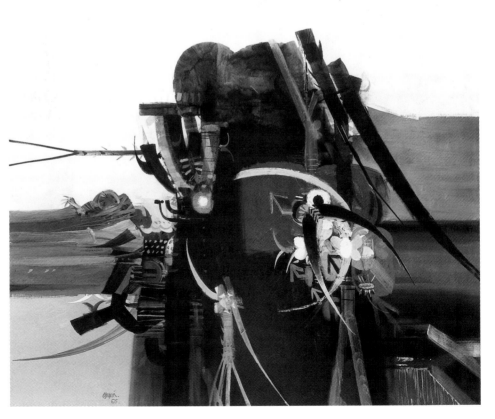

FIGURE 6.11

María Luisa Pacheco, *Tihuanacu*, 1956, oil on canvas, 67 × 97 cm. / 26⅜ × 38¼ in. Present location unknown. Courtesy María Eugenia Azcarrunz, Santa Cruz, Bolivia. Photo: Ron Jameson, from *María Luisa Pacheco* (unpublished).

America rather than of a specific country. *El último cóndor [The Last Condor]* (1965; FIG. 6.10) is a semiabstract painting whose violent shapes cluster at the intersection of a vertical and a horizontal axis. The central core of the painting is brownish black heightened with sudden color accents that can be identified as sharp threatening objects, feathers, feet, and a beak. The painting conveys the idea of an atomized bird. Many of Obregón's flora and fauna paintings are inspired by the Caribbean coast where he was living, but his subjects are also generic references to the fragility of life as a whole.

BOLIVIA

In contrast to de Szyszlo's and Obregón's abstractions, those of the Bolivian painter María Luisa Pacheco (1919–1982) are not about death, but evoke the timeless qualities of a primordial landscape. Her paintings conjure up images of mountain peaks or petrified ancestral idols. When she began painting in Bolivia, *indigenismo* still held sway. But the Tamayo-like figures she painted in the mid-1950s reflect a concern for formal and aesthetic problems rather than ideological ones. In the early 1950s, she had worked in La Paz as a

journalist illustrating for the newspaper *La Razón*. As one of the pioneers of 1950s modernism in her country, she also cofounded the avant-garde group 8 Pintores Contemporáneos (8 Contemporary Painters). But she left Bolivia in 1956 and, aside from brief return trips there, spent the rest of her life abroad.

Like Tábara and Villacís, in the early 1950s, Pacheco went to Spain with a fellowship to study in Madrid with Daniel Vázquez-Díaz, and there she saw the work of Rafael Canogar and Antoni Tàpies, among others. The dynamic shapes in her own paintings can be traced to Spanish painting. But like the Ecuadorians, Pacheco opted for clear, luminous color rather than the opaque earth tones of some of the Spaniards. The paintings she did following her return to La Paz in the mid-1950s conjure up anthropomorphic and geological formations. Residual figures seem to grow out of the highland landscape, as for instance in *Tihuanacu* (1956; FIG. 6.11). One may look to Arturo Borda and Cecilio Guzmán de Rojas for precedents in the correlation of figure with landscape, but Pacheco's *Tihuanacu* is also very much related to a form of Bolivian abstract nativism sometimes referred to as "ancestralism."[50]

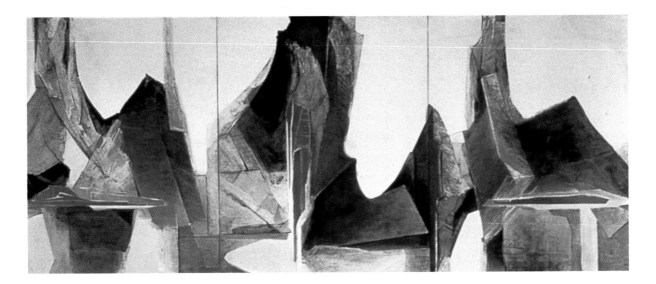

PLATE 6.10

María Luisa Pacheco
(Bolivian, 1919–1982),
Catavi, triptych, 1974,
mixed media on canvas,
147.3 × 366.8 cm. / 58 ×
144⅜ in. Jack S. Blanton
Museum of Art (formerly
Archer M. Huntington
Art Gallery), The
University of Texas at
Austin. Barbara Duncan
Fund, 1975. Photo:
George Holmes,
G1975.33.2.

After Pacheco moved to New York in 1956, her work became totally abstract. She was very much taken by the expressive power of the abstract expressionists, especially Pollock and de Kooning. Her New York environment, she felt, enabled her "to transform reality into abstract painting."[51] But in the end, her own work owed little to the abstract expressionists and much to the Spanish informalists, especially to her former teacher, Vázquez-Díaz. But it also tapped the Bolivian legacy of ancient textured surfaces. As a child in La Paz, Pacheco had taken long walks in the countryside with her father and had admired native Bolivian art, ceramic ware, ancient stone walls, and the range of colors in pre-Hispanic textiles.[52] She also credited Torres-García with having proposed ways to reconcile her past legacy with modern abstraction.[53]

In the 1960s, Pacheco began incorporating sand, corrugated cardboard, and thin layers of plywood into her paintings to give texture. She used a limited number of colors, sometimes reducing them to white or black and allowing the textures to provide the tonal modulations. Instead of raw primaries, typically she used the mellow and glowing shades of soft red, orange, tan, and blue that she had seen in Andean textiles. But within an abstract framework, she also applied the color principles of impressionism to enhance luminosity. She accomplished this by layering colors over their complement and allowing the underlying color to bleed through. Vázquez-Díaz had stressed the importance of luminosity as well as form in painting. For Pacheco, light was also a legacy of the thin atmosphere in the Bolivian highlands. In *Catavi* (1974; PL. 6.10), a triptych named after the mining town by the same name in Bolivia (the site of a miners' strike in the 1940s), she created a vibrant effect by layering reddish orange over blue in an approximation of those complementaries against a white background.

The originality and consistency of Pacheco's forms can be detected in a comparison between *Tihuanacu* and *Catavi*. Even though these paintings are separated by almost twenty years, the anthropomorphic shapes in the first and the abstract geological ones in the second are compositionally very similar. They both reinforce the notion of a ubiquitous ancestral presence as well as the dynamic form of Spanish abstraction.[54] Like many of her colleagues from Latin America, Pacheco remained unaffected by pop art and the mass media in New York. Instead, she developed her art around the notion of timelessness. Abstract expressionism appealed to her as an idea, if not as a visual model, because of its atemporality and mythical qualities, unlike later art

modes like pop whose central premise was its emphasis on the present and the specific.

Pacheco's success as an internationally known artist was to some extent helped by her residence in New York. But like many of her Andean colleagues, by the late 1970s, she was less visible on the international stage when other art forms took over the spotlight. Nonetheless, together with Marina Núñez del Prado, she has remained the major exponent of abstraction in Bolivia.

SUMMARY

During the 1960s and the first part of the 1970s, all of these artists, including the Ecuadorians, had been avidly sought after by dealers and collectors outside of their countries because they were seen as the true representatives of Latin American art. They seemed to fulfill a foreign public's wish for something distinctively Latin American—an expectation for cultural authenticity that artists elsewhere were never expected to satisfy. Many of these artists did fulfill this unspoken order, but not to placate the market. For them abstraction represented the means to express their cultural identity in a pressured and competitive world.

Modes of abstraction differed from country to country. These differences manifested themselves in the use and meaning of the materials themselves as well as in the artists' particular choices of references. The Ecuadorians tended to stress the tactile qualities of surface; the Peruvians, their historical legacy; and the Bolivians, the telluric nature of an anthropomorphic landscape and—in Pacheco's case—textures as well. In

Brazil and Argentina, where abstraction had existed earlier, it was sometimes applied to more timely and less culturally specific themes such as references to contemporary conditions or news events.

The many biennials and international exhibitions that took place in Latin America and abroad had contributed considerably to the visibility of art by Latin Americans in the 1960s. But by the 1970s, mounting economic problems forced most biennials and international exhibition programs to close, leaving the São Paulo Biennial as the main venue.[55] Communication between countries diminished in the 1970s for that reason as well as for political ones.

However, other more modest venues opened up for artists in several countries. During the 1970s, graphic art biennials took over the function of the earlier ones. Major biennials emerged in San Juan, Puerto Rico (1970), and in Cali, Colombia (1971), with a precedence in Santiago and Caracas.[56] These exhibitions also increased the visibility of Latin American graphic artists, gave the graphics medium an important boost, and helped to raise the status of drawing and printmaking to that of painting and sculpture. Because in the 1970s artists were more confined to their own countries than they had been in the 1960s, their art developed in directions that were less tied to the international art market, a beneficial condition that allowed them the freedom to develop independently. After 1968, many artists also turned to political subjects as they responded to events both inside and outside their countries.

SEVEN

FUNCTIONALISM, INTEGRATION OF THE ARTS, AND THE POST-WAR ARCHITECTURAL BOOM

Modernization in Latin American architecture began in the 1920s with the introduction of functionalism. It accelerated during and after World War II with new waves of building activity that culminated in the 1950s with the creation of Brasília, the new capital of Brazil. From the nineteenth century to the 1920s, French neoclassicism had dominated urban architecture in many countries. By the turn of the twentieth century, art nouveau and eclecticism also took hold, particularly in Brazil, Argentina, and—to a lesser extent—Mexico. In Andean countries and the Caribbean, where a strong Spanish influence had prevailed since colonial times, the Andalusian style of stuccoed arcades, iron balconies, and facades with shuttered windows persisted into the twentieth century. But by the mid-1920s, Le Corbusier's functionalist theories, as set forth in his book *Towards a New Architecture* (1923), came to be known in most countries. Contact with his ideas had been direct in Brazil, Uruguay, and Argentina, where he had traveled on several occasions between 1929 and 1936 to act as advisor for city planning and individual building projects. As a result, his style was adopted selectively from the late 1920s on.[1]

Le Corbusier's—and the German Bauhaus's—simple functional style was first evident in Mexico and Brazil. In Mexico from 1925 on, the architect José Villagrán García (1901–1979) led a group of younger architects in a campaign against the academic Frenchification that had occurred under Porfirio Díaz before the 1910 revolution. Juan O'Gorman (1905–1982) was the first among Villagrán García's followers to execute functional houses in Mexico City. In 1929, he designed housing projects for the working classes and a limited number of private homes. Among the latter were a studio for Diego Rivera (1930) in the Pedregal San Angel[2] and a nearby house for Frida Kahlo. Rivera's studio was a boxlike building with a painted concrete exterior, a roof divided into sloped sections to accommodate rows of skylight windows,

and a separate entrance defined by a curving exterior staircase. Compared with the Italianate art nouveau curves of Adamo Boari's near contemporary Palacio de Bellas Artes in Mexico City (begun in 1904 and finished in 1934),[3] O'Gorman's simple, functional houses defied all previous romantic tendencies in architecture. His functional phase would undergo a reversal in the 1950s when he sought a more culturally rooted outlet for his architectural and artistic fantasies.

The purist style of Le Corbusier and the Bauhaus was revolutionary when it was introduced in São Paulo in the mid-1920s by the Russian-born, Rome-trained émigré architect Gregori Warchavchik (1896–1940). His first modernist houses were contemporary with Tarsila do Amaral's and Oswald de Andrade's Anthropophagic movement. In 1925 Warchavchik issued a manifesto of functional architecture titled "Apropos of Modern Architecture"[4] patterned on Le Corbusier's ideas. In 1928, Warchavchik built a house for himself as a model on the Rua Santa Cruz (his houses were identified by the name of the street they were on). The house was a two-story concrete building with iron and glass windows[5] surrounded by a tropical garden designed by the architect's wife, Minna Warchavchik (FIG. 7.1). The garden design incorporating local vegetation was an early example of the integration of landscape with architecture for which Roberto Burle-Marx was later to become the major exponent in Brazil. Among the house's innovative features were the iron-framed windows that turned the corners. This feature represented a first attempt in Brazil to replace corner walls with angular windows made structurally possible by the use of metal frames for a light and airy effect. The large upper-story windows were shielded from the summer sun by canvas awnings. Inside, Warchavchik used daring color combinations on the walls such as white, black, gray, and silver.[6]

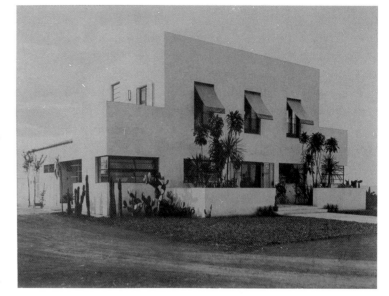

In 1930, Warchavchik completed a modernist house on the Rua Itapolis that was inaugurated with considerable fanfare. Its pantry, staircase, garage, and pale lilac–walled bedrooms blended into an ensemble that, according to Oswald de Andrade, inspired a sense of "pleasant repose."[7] But in Brazil, Warchavchik did not readily find the furnishings and workmanship to match his functionalist objectives. Consequently he set up a workshop to have the Bauhaus-like furniture built according to his specifications. For the interior design, he sought the collaboration of the modernist artists. Besides artwork by European artists such as Lipchitz and Brancusi from Brazilian collections,[8] he included paintings by Anita Malfatti, Tarsila do Amaral, and Lasar Segall, sculpture by Victor Brecheret, and a bedspread designed by Regina Graz Gomide in the master bedroom.[9] Warchavchik's incorporation of art into the architectural decor was undoubtedly patterned on Le Corbusier's Pavillon de l'Esprit Nouveau, exhibited in 1925 at the *Exposition Internationale des Arts Décoratifs* in Paris, in which sculpture by Lipchitz and paintings by Le Corbusier, Léger, and Ozenfant as well as a bedspread designed by Sonia Delaunay formed part of the ensemble.

But although Warchavchik's houses were initially designed to be both functional and inexpensive, the difficulty he

FIGURE 7.1

Gregori Warchavchik, Casa da rua Santa Cruz [Santa Cruz House], São Paulo, 1928, tropical garden by Minna Warchavchik. Courtesy Museu Lasar Segall, São Paulo.

had in getting appropriate materials and furnishings locally made them too exclusive to be cost-efficient. In the end, only an upper-middle-class clientele could afford them. His work, however, came to the attention of architects in Rio de Janeiro, especially Lucio Costa, who became a champion of modernism there.

Frank Lloyd Wright and Le Corbusier each visited Brazil between 1929 and 1931.[10] But although Wright's taste for integrating architecture with the environment was admired by Brazilian architects, his influence there was negligible, as it was elsewhere in Latin America. Le Corbusier's more socially directed solutions—at least theoretically—for low-cost housing and the adaptability of his designs to a tropical climate made his propositions far more appealing. Lucio Costa (1902–1998) and the younger architect Oscar Niemeyer (b. 1907) first met Le Corbusier in Rio during his visit there in 1929. With Le Corbusier as advisor, Costa, Niemeyer, and a group of associates designed the Ministério da Educação [Ministry of Education] in Rio de Janeiro (1937–1943; FIG. 7.2). The innovations proposed by Le Corbusier are clearly visible in this fifteen-story building. The use of *pilotis* (supporting pillars) created a floating structure that allowed for free pedestrian traffic on the ground floor as well as ventilation; and

brises-soleil (sun breakers), the adjustable louvers over recessed windows, provided shade and ventilation inside. The exterior walls of the ministry's ground-floor entrance are faced with *azulejos* (blue and white ceramic tiles) designed by Cândido Portinari, who also painted the mural cycle inside the building (see Chapter 3). The use of *azulejos,* a legacy of colonial architecture, was proposed by Le Corbusier as a providential solution for exterior wall treatment in a humid climate. Subsequently, all of these features, along with broad ramps and roof gardens, became standard in Brazilian residential and public-building design.

The prevalence of exuberant curves in architectural and landscape design was a peculiar feature of Brazilian design, especially in Rio. Some of this may have been dictated by Rio's topography, as the landscape itself is composed of curved bays punctuated by rounded hills. In building, curves were made possible by the use of reinforced concrete, which allowed for considerable formal freedom. But curved patterns can also be seen in the undulating stone mosaic pavement designs in Rio, Manaus, and other cities (a legacy of Portugal) as well, as in the garden and urban landscape designs by Roberto Burle-Marx and in residential building designs, for instance, the low-cost Pedregulho housing project of 1948–1950 in Rio de Janeiro by Affonso Eduardo Reidy.

With the rapid urban growth and industrialization that occurred in the 1940s, high-rise buildings in the International Style made incursions into the landscape in most cities of Latin America. Buildings in the manner of Walter Gropius, Ludwig Mies van der Rohe, and others who were affiliated with U.S. architectural schools emerged in Mexico City, Caracas, Bogotá, São Paulo, Buenos Aires, and, to a lesser extent, Lima and Santiago. Two examples are the twenty-two-story Ministry of Hydraulic Resources building (1950) in Mexico City and the Bank of Bogotá (1959). But the International Style was soon modified to

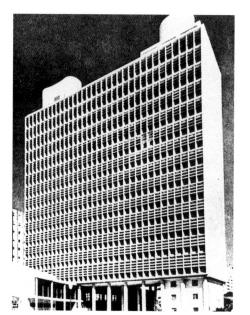

FIGURE 7.2
Le Corbusier, Lucio Costa, and Oscar Niemeyer, Ministério da Educação [Ministry of Education], Rio de Janeiro, 1937–1943. Photo: Author.

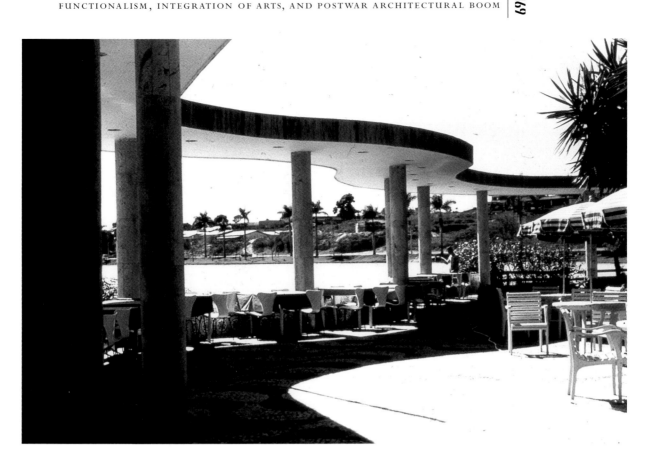

accommodate local conditions and available materials.

In most places, ferroconcrete was the preferred material in addition to the steel chassis and glass. Brick also remained a staple; in Uruguay, Colombia, and Ecuador, it was used in very original ways for residential buildings (the three Salmona Towers of the 1970s in Bogotá, for instance) as well as for private homes. Torres-García and countless other artists and architects in these countries chose brick for their own homes.[11] By the 1950s, building activity was at a peak. During that decade, architects indulged in considerable experimentation with varying and often very original results. A feature of this period was the integration of painting and sculpture into architectural design in the university cities of Mexico City and Caracas, and the civic center of Brasília.

In Brazil, it took the administrations of Juscelino Kubitschek—first as mayor of Belo Horizonte, then as governor of the state of Minas Gerais and, from 1956 to 1961, as president of Brazil—to implement extravagant building projects in

Pampulha, a suburb of Belo Horizonte in the state of Minas Gerais, and Brasília. Oscar Niemeyer was the principal architect for both. Pampulha was created in 1943 as a resort community along the shores of an artificial lake. It comprised a group of recreational buildings including a yacht club (originally several were planned); a casino, which now serves as a contemporary art museum; a restaurant; and a church located along the lakeshore.[12]

Niemeyer's use of reinforced concrete in most of the Pampulha buildings allowed him to exploit the sculptural potential of curved designs. The restaurant (FIG. 7.3), known as Baile (Dance), consists of an open colonnade sheltered by a concrete covering that undulates gracefully along the shoreline linking two enclosures: the dining and service areas on one end, and a small, ceramic, tile-faced circular enclosure sheltering a lily pond (from an inlet) on the other.[13]

The church, São Francisco de Assisi [Church of Saint Francis of Assisi], is a

FIGURE 7.3
Oscar Niemeyer,
Restaurant Baile,
Pampulha, Belo
Horizonte, Minas Gerais,
1942. Photo: Author.

FIGURE 7.4
Oscar Niemeyer, São
Francisco de Assisi
[Church of Saint Francis
of Assisi], exterior,
Pampulha, Belo
Horizonte, Mina Gerais,
1944. Photo: Author.

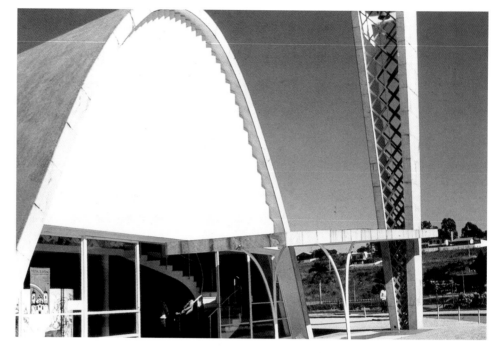

FIGURE 7.5
Oscar Niemeyer, São
Francisco de Assisi
[Church of Saint Francis
of Assisi], interior;
baptistery reliefs by
Alfredo Ceschiatti; tile
and fresco by Cândido
Portinari, Pampulha,
Belo Horizonte, 1944.
Photos: Author.

gleaming white structure when seen from across the lake. A single exterior vault in the front encloses a nave, and four vaults in the back define the other liturgical spaces, including the altar and vestry. A separate bell tower is linked to the entrance-way by a concrete slab (FIG. 7.4). The exterior back wall framed by the four vaults, entirely covered with a blue-and-white ceramic tile mural, and an interior fresco behind the altar—both by Portinari—represent episodes from the life of Saint Francis. But the church proved too controversial for the local bishop to consecrate. Its simple, functional appearance and the fact that Niemeyer was known to sympathize with the Communist Party may have contributed

to this decision. Furthermore, the opposing curves formed inside the church by the baptistery screen near the entrance and the pulpit toward the altar (FIG. 7.5)—repeated for symmetry on the opposite side by a staircase and second pulpit—combine to form configurations that were read as question marks, seen perhaps as questioning religion itself.[14]

VENEZUELA AND MEXICO

During the 1950s, Venezuela, Mexico, and Brazil dominated the field of architecture in Latin America. The building surge in Venezuela coincided with the oil boom and a military dictatorship that lasted until 1958. Although Caracas is not

on the coast (it is within a forty-five-minute drive from it at an elevation of 1,000 feet), its architecture has Caribbean features. One of these features is the use of color on buildings, as was customary on Caribbean colonial facades. Besides its distinctive decorative function, the color helped to diminish the glare of stark white stucco in the bright tropical light. Also, in the 1950s, color was a feature proposed for architecture by Fernand Léger, who contributed mosaic murals to Ciudad Universitaria (University City) in Caracas.

Major residential building programs were realized and the new Ciudad Universitaria (1953–1957) campus complex was built during the decade of the 1950s. The main architect for these projects was Carlos Raúl Villanueva (1900–1975), who had trained in Paris at the School of Fine Arts. Far from creating the airy effects of Oscar Niemeyer's concrete structures, Villanueva's buildings were massive and ponderous, as is evident in both the Ciudad Universitaria library (1953; FIG. 7.6) and the building enclosing the Olympic swimming pool (1957). The library is a ten-story red-and-white building whose entrance is surmounted by a heavy rectangular concrete slab. The prow-shaped Olympic pool structure comprises massive concrete ribs and ramps leading to entrances above ground level. Its cantilevered white and red exterior also defines the bleachers and dressing rooms inside.[15]

A little earlier in the same decade, Mexico City's Ciudad Universitaria (1950–1953) was also built. In both university cities, covered walks leading from one area or building to another and exterior mosaic murals and sculpture were integrated into the architectural program. In both campuses, a ten-story windowless block (except for the stair and elevator shafts), designed for temperature and light control, housed the central library. But in spite of these functional similarities, the complexes were vastly different. Abstract art dominated the Venezuelan project, while an attempt to integrate pre-Hispanic motifs in murals characterized the Mexican one.

In the main Caracas campus complex, Villanueva conceived of the integration of the arts as incorporating music symbolism besides that of painting and sculpture. Its core, designed in 1953, was divided into six general areas that he referred to in musical terminology as "movements." These were interconnected

FIGURE 7.6
Carlos Raúl Villanueva,
Biblioteca [Library],
Ciudad Universitaria,
Caracas, 1953. Photo:
Author.

by undulating covered walks and plazas that incorporate two auditoria, the fan-shaped structure of the Aula Magna (large assembly hall), and a smaller concert hall. Foreign as well as Venezuelan artists were asked to contribute murals and sculpture. The contributions include work by Antoine Pevsner, Jean Arp, Fernand Léger, Henri Laurens, and Victor Vasarely, among the Europeans; Alexander Calder from the United States; and the Venezuelans Mateo Manaure, Osvaldo Vigas, Francisco Narváez, Pascual Navarro, and Alejandro Otero.[16] In the Aula Magna, located in the "third movement," Calder stabiles suspended from the ceiling are engineered to function as acoustical devices to control and modify the sound. Music symbolism is also implicit in Laurens's bronze *Petit Amphion* (FIG. 7.7), which stands in the central plaza. As the name implies, this semiabstract work by the French sculptor refers to the mythical Greek poet and musician whose beautiful lyre playing coaxed the stones to form the walls of Thebes.

The covered walks lead from one patio to another, each enhanced by mosaic murals, sculpture, and plants to furnish intimate spaces where students can pause (in spite of the absence of seats), study out-of-doors, or find shelter from sun and rain. These pleasant spots provide a restful interlude in a city otherwise known for its endless, uncomfortable architectural spaces without the relief of resting places. A brightly colored abstract glass mosaic mural by Léger forms the background for Laurens's *Petit Amphion* (see FIG. 7.7), and a nearby freestanding aluminum screen by Vasarely (FIG. 7.8) reflects the changing daylight in shimmering geometric patterns on its movable vertical blades. The choice of geometric, optical, and kinetic forms for Ciudad Universitaria in Caracas was an obvious source for the Venezuelan kinetic art movement that occurred there from the mid-1950s on.

In contrast to Villanueva's choice of abstract art for the Caracas campus, the mosaic murals at Mexico City's Ciudad Universitaria were of pre-Hispanic and historical Mexican themes in the earlier mural tradition. When Ciudad Universitaria was first built in Mexico, the capitalist form of industrialization and internationalization endorsed by President Miguel Alemán (1946–1952)[17] was not unanimously welcome. As a result, *neotoltecism* (a term applied to the incorporation of subjects from Mexico's pre-Hispanic legacy into architectural decoration programs in the 1950s) may be seen as a form of resistance to this internationalization. On the other hand, Juan O'Gorman attributed the disjunction between the International Style of the architecture and the apparently anachronistic mural decoration of Ciudad Universitaria to the stylistic discrepancies and time lag in Mexico between painting and architecture.[18] Abstraction of any sort did not take root in Mexico until the late 1950s, almost thirty years after functional architecture made its first appearance.

The Ciudad Universitaria project in Mexico City was directed by the architect Carlos Lazo and planned by Enrique del Moral and Mario Pani.[19] Located in the Pedregal on the southern fringes of Mexico City, the campus occupies a space divided by Insurgentes Avenue along the city's north-south axis. The teaching and research institutes occupy the east side; the recreational facilities and Olympic Stadium, the west side, and these are accessible from the east by two underpasses to save pedestrians from having to cross Insurgentes Avenue. The dormitories, originally planned for an area further south on the west side, were never built.

The administration building, the central library, and the humanities tower form a unit on the east side that is considerably less intimate than the Caracas complex. Each of these buildings, linked by rectilinear covered walks, comprises a two- to three-story horizontal element and a ten- to twelve-story tower. The lower element of the administration building's facade is faced with an unusual

FIGURE 7.7
Carlos Raúl Villanueva, covered walk mosaic mural by Fernand Léger, and *Petit Amphion* (bronze sculpture) by Henri Laurens, 1953, Ciudad Universitaria, Caracas. Photo: Author.

FIGURE 7.8
Carlos Raúl Villanueva, open space; aluminum screen by Victor Vasarely, Ciudad Universitaria, Caracas, 1953. Photo: Author.

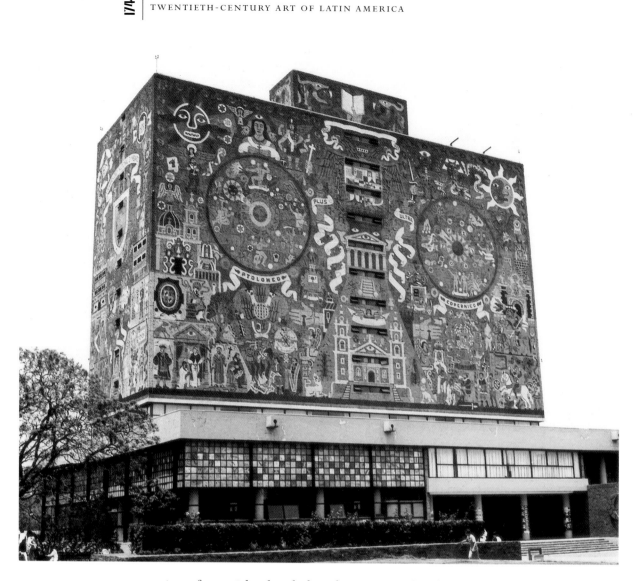

FIGURE 7.9
Juan O'Gorman, Gustavo
Saavedra, and Juan
Martínez de Velasco,
Biblioteca Central
[Central Library], Ciudad
Universitaria, Mexico
City, 1950–1951; exterior
stone mosaic murals by
Juan O'Gorman, 1957.
Photo: Archivo
Fotográfico IIE/UNAM.

variety of materials: glazed tiles, glass bricks, Carrara glass, concrete, onyx, and plastic. A concrete and stone mosaic relief by Siqueiros faces south and was designed to be seen from an automobile going by at sixty miles an hour.[20] The numerous auditoria and rooms on the ground floor of the humanities building on the north side of campus are accessible individually from an almost 1,000-foot-long ground-floor arcade. The building's tower houses the Departments of Philosophy, Law, Economics, and Art History—all considered part of the humanities in Mexico.[21] Two upper floors are occupied by the Instituto de Investigaciones Estéticas (IIE), an institution devoted to research in modern Mexican art.

The Olympic Stadium and the central library are among the most coherent examples of artistic integration. The stadium's sloped, stone-faced outer wall and Rivera's volcanic stone mosaic relief over the entrance evoke the shape and materials of Mexican pre-Hispanic architecture. The library is another of the better integrated examples. Its four sides are entirely covered with mosaic murals by Juan O'Gorman. Unlike the murals by Francisco Eppens and José Chávez Morado on the exterior end walls of the medical and biological science buildings, whose narrative subjects follow the traditional Mexican mural style, O'Gorman's library mural designs are carefully structured in geometric patterns to blend visually with the architecture, while at the same time their subject matter is Mexican (FIG. 7.9). Composed of stone tesserae from different parts of Mexico, the murals represent the history of Mexican culture from the pre-Hispanic and

colonial periods through the Revolution of 1910 and the modern epoch, with additional references to the Ptolemaic and Copernican planetary systems. In the same spirit of successful synthesis, O'Gorman designed stone reliefs to look like sculptured Aztec masks on the outer walls surrounding the library's garden courtyard.[22]

The neotoltec tendency of the 1950s is also apparent in the widespread use of stone and glass mosaics and stone or cement reliefs for the decoration of numerous other exterior facades and surfaces outside of Ciudad Universitaria. These materials were a practical solution for the treatment of a wall where fresco would have been impractical. Diego Rivera used stone mosaics on the exterior fountain of the Lerma Waterworks (1951) and glass mosaics on the marquee of Insurgentes Theater (1953), halfway between the center of town and Ciudad Universitaria. In the 1940s, Rivera had already initiated a form of neotoltecism with the building of his own museum, the Anahuacalli (1944–1964), to house his extensive pre-Hispanic collection. O'Gorman likewise executed mosaics for a hotel and government buildings.

But O'Gorman's most fanciful project of this period was the building and decoration of his own house, begun in 1951 and finished in 1958. The house was built on multilevel rocky terrain in San Jerónimo, not far from the university, and the initial idea for it owes something to Frank Lloyd Wright. O'Gorman had visited Wright's client, Edgar Kaufmann, at Falling Water in 1939. O'Gorman had greatly admired this well-known house, built over a waterfall in Bear Run, Pennsylvania.[23] The lot O'Gorman chose had a natural grotto whose interior walls he covered entirely with mosaics, and the space was then used as a living room. The rest of the complex was built around the grotto using a variety of local stones, and the units that made up the various living spaces and studio were likewise entirely decorated inside and out with mosaic designs and reliefs based on pre-

Hispanic and folk art. The patio walls were surmounted with fantastic native and mythic figures and animal symbols (PL. 7.1), some of which had protuberances and appendages like those on the Maya temple at Chichén Itzá known as the Iglesia (Church). Aside from displaying his interest in Mexican themes, O'Gorman's objective was also to integrate the house snugly into the surrounding landscape, as Wright had done in Bear Run. In 1969, however, O'Gorman sold the house hoping that the future owner would preserve his work. But this was not the case. Today, O'Gorman's house exists as documentation only.

Although O'Gorman's fantasy house marked a radical departure from the functionalism he had practiced in the 1930s, by the 1950s—and in keeping with the neotoltec revival—he felt that "the puritanism of our architecture today" represents "the exact antithesis of the plastic art of Mexico."[24] His "dream house" may also be seen in the context of his surrealist painting as an expression of his liking for the incongruous. However, it inevitably brings to mind two other examples: Ferdinand (Facteur) Cheval (the French postman) and his nineteenth-century "dream palace," and Simon Rodia and his contemporary (1950s) Watts Towers in Los Angeles, California. O'Gorman's living quarters and mosaic-covered studio a few steps from the main house also have something in common with the exuberant mosaic designs created for parks and churches by the Catalonian architect Antonio Gaudí, especially his turn-of-the-century mosaic decoration for buildings in Barcelona's Parque Güell. Gaudí's gingerbread style was popular in Mexico at the time, and Mexico's liberal building codes contributed to encouraging such projects there.

Another contributor to the integration of art and architecture in the 1950s was the German-born sculptor Mathias Goeritz (1915–1990), who arrived in Mexico in 1949 to teach at the University of Guadalajara, then moved to Mexico

PLATE 7.1
Juan O'Gorman,
residence, patio, San
Jerónimo, Mexico,
1951–1958, stone mosaics
by Juan O'Gorman.
Photo: Archivo
Fotográfico IIE/UNAM.

City. Goeritz had escaped the German Nazi regime by way of Spain and North Africa. In 1948 he had founded the School of Altamira (named after the prehistoric caves) in Santillana del Mar (Santander Province) in the north of Spain where a late-surrealist style prevailed that led ultimately to abstraction.[25]

Among the works Goeritz did in Mexico were El Eco, designed to function as a living art museum, and the *Cinco Torres [Five Towers, or Towers without Function]*, at the approach of Ciudad Satélite (Satellite City) near Mexico City. He considered himself a sculptor rather than an architect; nevertheless, he was commissioned to create an emotional building, a satire on Goeritz's definition of his

work as "emotional sculpture" (the architect Luis Barragán also used this term to describe his own work). El Eco's patron, Daniel Mont, asked Goeritz to build "something, anything" on a lot he had acquired. El Eco (1953) in Mexico City was originally destined to be an experimental museum where, for a small fee, the public could watch artists at work inside or dancers perform on the patio. But before the project was completed, Daniel Mont died suddenly. The participants lost interest, the museum was turned into a nightclub and—like O'Gorman's house—was eventually destroyed. But during its short life, it was a source of considerable interest.

The museum was accessible through a narrow hallway, and its patio, sheltered by a high exterior wall, contained a large abstract sculpture, *Serpiente [The Snake]* (FIG. 7.10), by Goeritz. His architectural plan for El Eco was conceived more by intuition than by conscious design.[26] The building was characterized by high exterior walls for privacy, the absence of ninety-degree angles, and the use of illusionistic perspective devices based on Italian baroque precedents that included a tilted floor to make a narrow corridor appear wider and longer and the use of color (black, white, gray, and yellow). The high walls and color as integral components were inspired by the work of the Mexican architect Luis Barragán, with whom Goeritz later collaborated on the Satellite Towers and who was an adviser for El Eco. Unfinished murals by Rufino Tamayo and Henry Moore were visible on the walls of the small museum space at the end of the corridor as one entered El Eco.[27] In the patio, Goeritz erected a slablike column as well as his angular iron sculpture *Serpiente*, which was to serve also as a backdrop for dance performances.

The *Cinco Torres [Five Towers]* (1958; FIG. 7.11) at Ciudad Satélite have been attributed variously to Goeritz and Barragán.[28] Regardless of which one was the principal designer, Goeritz claimed them as his. These white, yellow, and bright orange

FIGURE 7.10
Mathias Goeritz,
Serpiente [The Snake],
patio of El Eco (de-
stroyed), 1953, Mexico
City. Courtesy Museo de
Arte Moderno, Mexico
City. Photo: Armando
Salas Portugal.

FIGURE 7.11
Mathias Goeritz and Luis
Barragán, *Cinco Torres
[Five Towers]*, 1958,
entrance to Ciudad
Satélite, outskirts of
Mexico City. Photo:
Armando Salas Portugal,
author's archives.

concrete towers, measuring from 135 to 190 feet in height, stand as a landmark on the median strip of the highway leading to Ciudad Satélite. Although, like other work by Goeritz, the *Cinco Torres* seemingly anticipate minimal sculpture, they were inspired by Italian medieval towers in San Gimignano. Goeritz stated that "for the majority of people, the Towers meant only a big advertisement. For me—an absurd romantic living in a century without faith—they are, and have been, a Plastic Prayer."[29] Minimal art, on the other hand, addresses issues of scale shifts and perception with no romantic connotations. For Goeritz, the function of architecture or sculpture was as "an expression of man's spiritual condition at a particular time."[30] He defended "static values," like those implicit in Gothic cathedrals and Egyptian pyramids, at a time when many artists accepted "instability" as the reality of their age.[31] This particular aspect made Goeritz's work philosophically contradictory, especially since he influenced a whole generation of younger Mexican sculptors who did not share his mysticism. In the 1950s, Goeritz's work was also controversial in Mexico because he had broken through

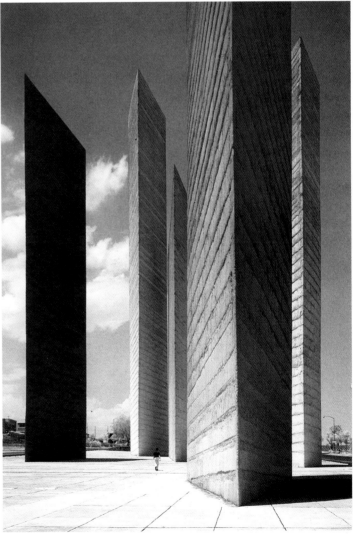

FIGURE 7.12
Fernando González
Gortázar, *La gran puerta
[The Great Portal]*, 1969,
Guadalajara, Mexico, 15
m. high/c. 44½ ft. high,
concrete painted yellow
and white. Photo
courtesy Fernando
González Gortázar.

the ideological barrier set by the mural
painters and—according to Rivera and
Siqueiros—had introduced "dangerous
foreign influences."[32]

By 1968, and partially as a result of
Goeritz's influence, a great number of
Mexican sculptors were creating com-
pletely abstract works. A telling example
of Goeritz's role in, and impact on, the
new Mexican sculpture was the *Ruta de la
amistad [Road of Friendship],* an ambitious
sculptural project that he directed in
conjunction with the 1968 Olympics held
in Mexico City. Large-scale concrete
works by artists from seventeen coun-
tries, many of them from Mexico, were
installed at intervals along the Periférico,
a highway that circumscribes the city and
passes by Ciudad Universitaria.

One of Goeritz's younger followers
was the Guadalajara-born architect and
sculptor Fernando González Gortázar
(b. 1943), a contemporary of the painters
José Luis Cuevas and Vicente Rojo and a

friend of the latter's. Although González
Gortázar studied architecture at the
University of Guadalajara some years
after Goeritz had left there, the latter's
impact was still apparent. González Gor-
tázar admired Goeritz's work, particu-
larly the *Cinco Torres* at Ciudad Satélite,
because of "their uselessness" and absence
of didactic function.[33] Like many of his
contemporaries, González Gortázar
sought a fusion between sculpture, archi-
tecture, and the environment, sometimes
as interchangeable components, but with
none of Goeritz's lofty ideals.

González Gortázar, however, was not a
minimalist either. His sculptural monu-
ments were designed to challenge not so
much accepted notions of scale as ac-
cepted notions of monumental sculpture
in Mexico, which was expected to be
naturalistic and heroic. Rather, his sculp-
ture was also designed to blend with the
surrounding landscape. One of his
projects was *La gran puerta [The Great
Portal]* (1969; FIG. 7.12), a yellow-and-
white concrete portal commissioned by

the Guadalajara government. The colors matched those of Los Arcos, a turn-of-the-century triple archway next to the Orozco museum at the other end of town. González Gortázar's portal, based entirely on geometric rectilinear planes, appears to satirize the cake-icing appearance of Los Arcos. *La gran puerta* was designed to function as both portal and playground, with ramps recalling the slanted planes and exaggerated perspectives in de Chirico paintings.[34] Its appearance changes, alternately revealing white or yellow surfaces, as one moves around it. The success of its intent is confirmed by the numerous children who enjoy running up and down the ramps.

In 1970, González Gortázar designed a fountain for a busy intersection of Guadalajara to replace an earlier one from the mid-1940s that had deteriorated. González Gortázar's new fountain inherited its name *La fuente de la hermana agua [The Fountain of the Sister Water]* (FIG. 7.13) from the earlier one, so named because of its tile-covered sides and biblical inscriptions. The new fountain was in no way biblical. Its huge, dark, rough concrete blocks of varying sizes measure over twenty feet at their highest and sprawl over a large stepped base. Water gushes out of vertical fissures and from the top of the blocks. Without the water, the appearance is of a natural, if awesome, ancient stone formation. Although at first this fountain invited considerable criticism and was sometimes jeeringly referred to as Hermana Drácula (Sister Dracula),[35] it has since become a familiar landmark in the city. When it is lighted at

FIGURE 7.13
Fernando González Gortázar, *La fuente de la hermana agua [The Fountain of the Sister Water]*, Guadalajara, Mexico, 1970, colored concrete blocks and water, 7.5 m. high/c. 21 ft. high. Photo courtesy Fernando González Gortázar.

night, it takes on a magical quality and its massiveness seems to dematerialize.

Two major figures among González Gortázar's older colleagues were the Mexico City architects Luis Barragán and the Spanish-born exile Félix Candela. The work of these two architects could not have been more opposed. Barragán, from an affluent Guadalajara family, sought to imbue his handsome and exclusive private homes and clubs with elements derived from Mexican sources. On the other hand, Candela, who served more often as an engineer (he considered himself a contractor) to other architects because of his ingenious technical solutions (he was known as the master of the slide rule), conceived of a type of economic, functional yet graceful architecture for public buildings, elementary schools, warehouses, markets, churches, and restaurants for "the people," whom he felt contemporary architects tended to forget.[36]

Luis Barragán (1902–1988) arrived at the style of "emotional" architecture for which he is known in the late 1950s. His fusion of "the spirit of modernism with the traditions of Mexican culture"[37] had as a source the Hispano-Moorish closed courts with high exterior walls, a feature

Goeritz borrowed in El Eco. In this vein, Barragán created intimate "enchanted" private spaces to which he added colors inspired by Mexican folk art and European and Mexican contemporary paintings. One of his sources for color was the Mexican painter Jesús (Chucho) Reyes Ferreira, whose brightly colored gouache paintings on China paper were based on Mexican folk art.[38] Barragán's customers came primarily from an affluent community for whom he designed houses in the Pedregal San Angel. One of his major achievements was the San Cristóbal horse ranch (1967–1968; PL. 7.2) in the state of Mexico, just outside of Mexico City, designed in collaboration with the architect Andrés Casillas de Alba. Thick courtyard walls, with openings scaled to accommodate horses, enclose a rectangular pool and wall with a built-in fountain. The design and the tall red, pink, and lavender walls impart a sense of tranquillity that Barragán likened to the feeling one gets in the open-air atriums and walled courtyards of seventeenth-century Mexican churches.[39]

Félix Candela (b. 1910), who went to Mexico in 1939 as a Spanish émigré, generally collaborated with other architects, including Enrique de la Mora and

PLATE 7.2
Luis Barragán, in collaboration with the architect Andrés Casillas de Alba, San Cristóbal horse ranch (Cuadra de San Cristóbal), 1967–1968, División Los Clubes, State of Mexico. Courtesy Alberto Moreno Guzmán.

Fernando López Carmona. He made his reputation with his designs for hyperbolic paraboloids (hypars), the thin concrete vaulted shells known for their unusual strength and flexibility. Instead of the more common longitudinal vault axes, Candela had worked out a system of diagonal directrixes that made it possible for the vaults to be both light and resistant. His vaults were not of precast concrete but of concrete mixed and poured on the spot over a temporary wooden support with wire mesh to hold the concrete in place. This system made his structures "cheap, useful, and well adapted to Mexican conditions." He also benefited from the use of a local, inexpensive, and excellent labor force.[40]

Candela's first vault was for the Pavilion for Cosmic Ray Research at Ciudad Universitaria, for which he was technical advisor to Jorge González Reyna. This small building, located near the schools of medicine, dentistry, and biology on the east side of campus, stands on the spot where the Mexican physicist Sandoval Vallarta first investigated cosmic rays. Its function called for a thin, translucent shell. For this purpose Candela devised a shell just five-eighths of an inch thick at its apex to cover the two small labs raised from the ground on arched supports and accessible by a cantilevered stairway.[41]

Other examples of Candela's use of the hypar include the Capilla Abierta (Open Chapel) in Cuernavaca and the restaurant Los Manantiales (The Source) on the shores of Lake Xochimilco. The Capilla Abierta (1958–1959), built on the outskirts of Cuernavaca in collaboration with Guillermo Rossell and Manuel de la Rosa, consists of a single vault sheltering a portion of a fan-shaped open theater. The vault rises to a height of some 72 feet at the crown, diminishes to a height of about 13 feet at its lowest point in the center of the chapel, and rises again toward the altar. The upward curve of the vault over the entrance seems to embrace the open-air theater and also functions as

an acoustical amplifier. The altar is silhouetted against the surrounding landscape visible through the chapel's glassed-in wall.[42]

The contemporary Los Manantiales (1957–1958), designed in collaboration with the architect Joaquín Alvarez Ordóñez, is an octagonal structure composed of four double-vaulted sections. It is set on a platform on the lake surrounded by lush vegetation, a canal, and flower-decorated gondolas visible through the restaurant's recessed windows.[43] Its light, undulating shape gives it the appearance of a water lily.

By inverting the vault, Candela devised an "umbrella" whose sections could be multiplied to any specifications for roofs of warehouses, markets, or churches. The umbrella is based on the same principle as a tree whose root spread determines its expanse above ground. A column joins the subterranean base to the slanting roof shell. This system was especially appropriate for the unstable foundations of Mexico City. The column supporting each section could also conceal a drainage pipe. The umbrella provided a practical solution for the roofing of large areas such as markets and warehouses.[44] An example is the warehouse of 1955 (FIG. 7.14). Open markets designed in this manner were also patterned after the tents, or *tianguis*,

FIGURE 7.14

Félix Candela, Almacén [warehouse with umbrella], Mexico City, 1955, poured concrete. Photo courtesy Félix Candela.

FIGURE 7.15

Félix Candela, La Virgen
Milagrosa [Church of the
Miraculous Virgin],
Mexico City, 1954–1955,
poured concrete. Photo
courtesy Félix Candela.

commonly used for Mexican street markets.[45] Although the numerous columns supporting the umbrellas give these markets and warehouses the appearance of the interior of a mosque, this effect is more coincidental than deliberate. They are based on a very different structural system and have none of the mosque's absolute symmetry. Each of the mushroom-shaped shell quadrants that rise from the central column are assembled so that one end is higher than the next to allow for natural light to penetrate, thus eliminating the need for artificial light during the day.[46]

Candela used a combination of vault and umbrella in La Virgen Milagrosa (Church of the Miraculous Virgin) in Mexico City (1954–1955; FIG. 7.15), a building designed entirely by him. The roof shell appears to undulate because of its double curves derived from this combination. The exterior bell tower likewise is composed of thin hypar sections warped at an angle, as are the interior

columns. The pointed Gothic windows and embrasures are echoed in the interior vaults, which form an organic unit with the columns. Although the warped shapes of the church's interior shell are also reminiscent of Antonio Gaudí's gothicizing elements in the Sagrada Familia in Barcelona, structurally there is no resemblance. Nor does Candela's work have any of Gaudí's romantic and mystic objectives. It has more in common with the work of the later Madrid-born architect Eduardo Torroja in its purely functional solutions.[47] Nonetheless, the interior of the Virgen Milagrosa invited rhapsodic utterances about the fact that only "an inch and a half separates you from divinity."[48]

In 1968, Candela engineered the design for the copper-domed Olympic Stadium in Mexico City. This oval structure depends on an intricate network of internal ribs and suspensions, recalling some of the work of the Italian architect Pier Luigi Nervi, to cover the vast expanse of its stadium, unencumbered by interior supports. The exterior approach is punctuated by seven tall, star-based concrete columns, *Ursa Mayor [The Big Dipper,* or *Constellations]* by Goeritz. The star-shaped bases of these yellow, pink, and red columns give them the appearance of fluted columns.

By the 1960s, new museum buildings of daring design had been completed to house institutions already in existence. Both the Museum of Anthropology and the Museum of Modern Art in Mexico City's Chapultepec Park were completed around 1964. The Museum of Anthropology, built by Pedro Ramírez Vázquez (b. 1919), houses Mexico's finest collection of pre-Hispanic art. The museum was built around a long, rectangular central court with an overhang supported by a single column that doubles as a fountain whose surface is covered with reliefs derived from pre-Columbian art. A curtain wall shields the sides of the main building while admitting daylight and air.

BRAZIL

The near contemporary museums in Brazil were also designed to utilize controlled natural light.[49] The Museu de Arte de São Paulo (MASP), finished in about 1970 and built to house the museum's permanent collection of modern European and Brazilian art as well as temporary exhibitions, was designed by Lina Bo Bardi (b. 1914).[50] Situated along the busy Avenida Paulista, it is daringly suspended by steel cables and wedged between heavy concrete supports that continue across the top, spanning the 246-foot length of the building. The glassed-in museum space and offices accessible from one end occupy the second floor, while the ground floor, which is entirely open to pedestrian traffic except for a staircase and an elevator, provides an open vista and a space for the display of sculpture.

The Museu de Arte Moderna in Rio, designed by Affonso Eduardo Reidy (1909–1964), was finished in 1964 to house the preexisting institution. Built on land reclaimed from Guanabara Bay that offers a spectacular view of Sugarloaf

Mountain, it is easily accessible from downtown Rio by a pedestrian overpass. Heavy, slanted concrete ribs support and encase the museum's two glassed-in floors, giving it a V-shaped profile. The surrounding gardens were designed by the painter and landscape architect Roberto Burle-Marx (1909–1994), who incorporated beds of stones and tropical vegetation into the setting.

Since the 1940s, Burle-Marx had also designed the complex of lawns, playing fields, and automobile parkway linking the financial center to the beach-front residential section known as Flamengo Park, as well as Rio's Botanical Gardens and scores of roof gardens for residential buildings and private residences. His private garden designs combining undulating gravel paths, pools, and lush tropical vegetation serve to bridge the scale between the natural landscape and the residence. With his fine sense of textural variety, he combined tropical flora with rocks, curved gravel beds, and a pond in the garden of the Hungria Machado residence in Rio (FIG. 7.16). He also contributed to the landscaping of Brasília.

FIGURE 7.16
Roberto Burle-Marx, Garden of the Hungria Machado Residence, Rio de Janeiro, c. 1954, Egyptian lotus, papyrus, nymphaea, shrubbery, pond, rocks, and gravel. Courtesy Roberto Burle-Marx Studios, Rio de Janeiro. Photo: Marcel Gautherot.

Brasília was the most audacious urban project of the twentieth century. Begun in 1956 during the administration of Juscelino Kubitschek (1956–1961), it was almost contemporary with Chandigarh, the new Punjabi capital designed in the early 1950s by Le Corbusier. Because of the vertiginous pace with which a whole city arose out of nothing, Brasília's "expenditure of space only possible in virgin territory"[51] seemed dehumanized and sterile at first. Located on a plateau some six hundred miles to the interior from the coast, it has no spectacular view, as does Rio, just a flat, endless horizon that made its gleaming white government buildings and concrete residential blocks seem all the eerier at first. Originally Brasília was built to accommodate a population of 500,000. The population dwindled in the early 1960s, but increased again in the mid-1960s and stands today at about 1,500,000. Brasília's aura of aerodynamic modernity attracted artists, theater and musical groups, and especially a young generation of settlers.[52]

Unlike either of the two previous capitals (Salvador and Rio), which were established as colonial settlements in the sixteenth century, Brasília's history is barely forty-five years old from its founding.[53] The idea for a capital in the interior of the country was not new. It was first conceived in the nineteenth century. But it took Kubitschek's zeal, postwar optimism, and ambition to implement it. By 1957, Brasília was already functioning, and—in the spirit of showmanship, ready or not—it was officially inaugurated in April 1960 with parades and thirty-eight tons of fireworks.[54] But Kubitschek's presidential successors Jânio Quadros (1961) and then João Goulart (1961–1964) were less enthusiastic. They considered the project extravagant and antisocial. Brasília was neglected for the following three years as government officials commuted back to their homes in Rio for weekends. Ironically, it was revived when the incoming military regime of Humberto Castelo Branco, which overthrew Goulart in 1964, saw the new capital as a symbol of nationalism and power.[55] For Kubitschek it represented the fulfillment of his dreams for "a new Brazil—dynamic, progressive and pioneering."[56] For Niemeyer, who went into exile during the military government, it was originally the fulfillment of a socialist utopian experiment.

Brasília's location in the interior state of Goiás was strategically designed to be equidistant from all other capitals in Latin America. With Oscar Niemeyer as its main architect, it was based on a standard cruciform plan conceived by Lucio Costa in the shape of an airplane held within the arms of an artificial lake (FIG. 7.17). But its fixed urban plan allowed for little organic variation and contradicted the nature of the average Brazilian, indisposed to accept such regimentation. It was certainly at odds with the shantytown system of building as needed from the inside out, and then not according to a preconceived plan. Brasília's zoning system separated industry, commerce, and cultural institutions from the government buildings located at the Praça dos Tres Poderes (Plaza of the Three Powers) at the east end. The government buildings (in the airplane's cockpit) and the ministries, cathedral, national theater, television tower, and some of the businesses are lined up along the Avenida dos Ministerios (Avenue of the Ministries) in the fuselage along the east-west axis. The *supercuadras* (residential blocks), each comprising local shops, schools, hospitals, and other services, formed the wings along the north-south axis.[57]

Freeways through the main axes are separated from the residential sections by cloverleaf turnoffs leading to internal streets designed for pedestrian circulation in the *supercuadras*. Schools, parks, and other neighborhood facilities are within walking distance of the residences. A central bus depot, located at the axial cross section of the city, is accessible through a system of over- and underpasses. But public transportation proved

FIGURE 7.17
Lucio Costa, plan of
Brasília, 1956–1960.
Courtesy of the late
Lucio Costa. Photo: Lucio
Costa archives.

inadequate and did not solve the many unanticipated traffic problems. Traffic lights, originally believed to be unnecessary, have since been put in.

The building materials were primarily of local origin, including reinforced concrete. Steel-frame construction was used sparingly in Brasília, for instance, in the Palace Hotel and the Ministries. The residential units in the *supercuadras* are built of concrete on supporting pillars to allow for free pedestrian traffic at street level. One of Niemeyer's first buildings was the small neighborhood chapel Nossa Senhora de Fátima, decorated on its curved exterior wall with blue and white tiles created by Portinari.

Some buildings were situated outside the main plan—including the Alvorada (Palace of the Dawn) presidential palace (FIG. 7.18), the 667-foot-long Brasília Palace Hotel, luxury houses and yacht clubs dotting the shores of the lake to the east, and the airport and university to the west—but the majority are within the plan. The civic center, Praça dos Tres

Poderes (Plaza of the Three Powers: legislative, judicial, and executive), was set within a triangular plan intersected on one side by the highway. At the plan's apex are the twenty-five-story twin towers of the Administration Building, connected on the eleventh to the thirteenth floors by a suspended passage (FIG. 7.19). The towers are offset by an adjacent low horizontal building housing the Senate and Chamber of Deputies; the Senate is surmounted by a dome, the Chamber of Deputies is defined by a contrasting bowl. The level on which stand the dome and bowl is accessible by exterior ramps as well as by ground-floor entrances and serves the double function of rooftop and pedestrian vista. A reflecting pool helps to bridge the scale between this building unit and the surrounding space.

Perpendicular to the administration towers are the horizontal buildings of the Planalto (plateau) executive power and the Supreme Court. The three-storied Planalto and Supreme Court buildings,

FIGURE 7.18
Oscar Niemeyer,
Alvorada [Palace of the
Dawn], presidential
palace, Brasília, 1959,
marble facing. Photo
courtesy Fundação Oscar
Niemeyer, Rio de Janeiro.

FIGURE 7.19
Oscar Niemeyer,
Administration Building,
Civic Center, 1957–1960,
Praça dos Tres Poderes
[Plaza of the Three
Powers] seen from the
Itamarati [Ministry of
Foreign Affairs];
landscaping by Roberto
Burle-Marx. Photo
courtesy Fundação Oscar
Niemeyer, Rio de Janeiro.

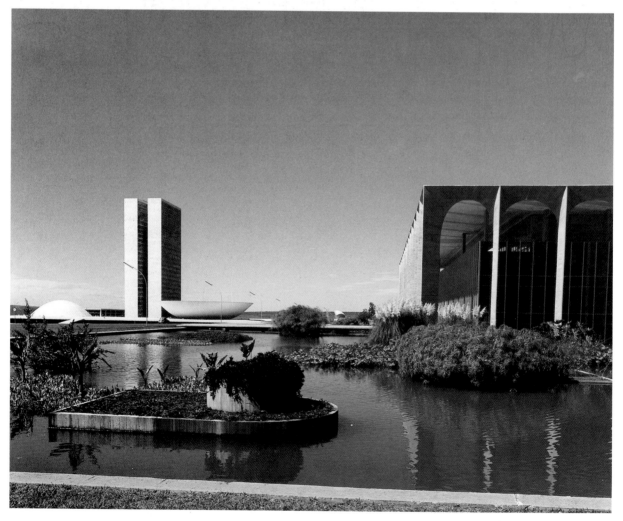

at opposite sides from each other on the triangular plan, are suspended above ground over an underground level, both of which are accessible by ramps. These two buildings are glass faced, recessed, and enclosed within a porch beneath a projecting roof supported by gracefully curved, gleaming white marble-faced columns. The columns for each of these buildings, including the Alvorada, are of distinctive designs. The column design of the Alvorada has since been popularized in Brazil as a commercial logo.[58] The resemblance between these buildings and Greek temples is not coincidental. Niemeyer, like Le Corbusier, admired Greek temple architecture, ironically for its human scale among other features. A walk across the plaza from one building to the other is equivalent to about ten average city blocks across a rough stone pavement. The bronze sculpture *Warriors* by Bruno Giorgi, situated between the Planalto and the Supreme Court, contributes little to bridging the enormous expanse between these buildings.

Although Niemeyer and Costa adopted many of Le Corbusier's ideas in the planning of Brasília, in its architecture Niemeyer departed from Le Corbusier, believing in "unlimited plastic freedom" such that everything did not have to be functional.[59] He once stated that "I have always considered architecture as a work of art, and only as such is it capable of subsisting."[60] Some of this license is apparent in the cathedral (1958; FIG. 7.20), a circular structure composed of sixteen ribs rising in the shape of an hourglass to form a symbolic crown along the Avenida dos Ministerios. Its foundation is set ten feet below ground level and ringed by private chapels accessible by ramps and stairs. Some of these chapels are decorated with flowers and cult symbols of *candomblé,* the Afro-Brazilian religion whose deities are thinly disguised as Catholic saints.[61] The circular plan and the altar set to one side instead of along an identifiable axis make the main axis where the congregation gathers difficult to situate. Because of the cathe-

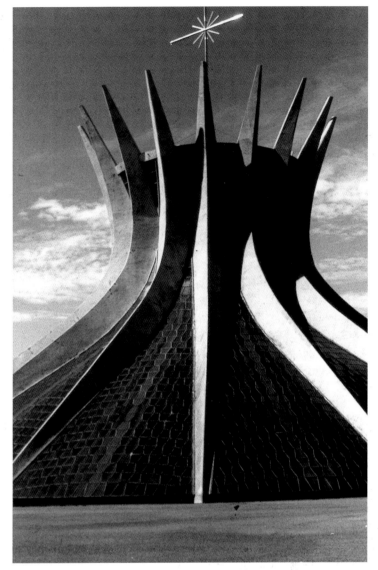

dral's peculiar plan, the curia, choir, and sisters' residences were built as separate units.[62]

A number of other buildings were completed in the late 1960s, including the Itamarati (Ministry of Foreign Affairs) on the Avenida dos Ministerios and the all-blue glassed-in church of Dom Bosco in a residential section. Major landscaping and roof gardens were designed by Roberto Burle-Marx, including the hanging gardens for the Itamarati. But only time can soften the visual shock of the vast spaces that are characteristic of Brasília. Much of Brasília's initial plan is gradually being obliterated by the inevitable onslaught of expansion and building. From a broader point of view, the creation of Brasília, along with the founding

FIGURE 7.20
Oscar Niemeyer,
Cathedral, Brasília, 1959.
Photo: Author.

of the São Paulo Biennial in the 1950s, initiated a vital period in Brazilian culture that gave Brazil international visibility.

SUMMARY

Although it would appear that modern architecture in itself does not have a nationality—its flowering in Latin America in the 1950s corresponded to a general period of internationalization in the arts—in retrospect, some local characteristics do exist. With the exception of Mexico in the 1950s, these are not due to the preservation and fusion of national legacies into contemporary design and architecture, but to the adaptation of modern architecture to local conditions. The choice of materials alone, concrete or local brick, has produced some daring modernistic styles with a distinctive regional look. In Venezuela, the use of color on concrete gave its buildings a Caribbean stamp, and in Uruguay, Colombia, and Ecuador, an imaginative use of local brick made possible the building of original home designs. In most of Latin America, the continued preference for high exterior walls around private residences follows a long tradition of monastic and fortress-like architecture of Hispano-Moorish derivation. The house with nothing but a green lawn separating it from the street would not be popular in Latin America.

Structural elements have also contributed to local idiosyncrasies. Supporting pillars, sun-breakers, recessed windows, roof gardens, ramps, and curved plans—originally chosen for practical as well as aesthetic reasons—have become a national trademark in Brazil. Some of these features in Mexico had different functional purposes and resulted in a completely distinct urban profile. Pillars as a basis for high-rise buildings in Mexico City had as their function the reinforcement of the foundations over the city's marshy soil, since these pillars could be driven down to bedrock.

The introduction of high-rise buildings in the International Style for office and residential purposes along with functional architecture gave many urban centers in Mexico, the Caribbean, and Central and South America an impressive air of modernity. The daring geometric volumes and sweeping lines provided by Le Corbusier's models as symbols of progress may be seen as substitutes for the machinolatry that accompanies the highly industrialized First World.[63] This architectural vision of modernity also reflects the industrial expansion that occurred everywhere in the Americas during and after World War II. But it still masks the pervasive poverty that exists among a vast percentage of the population in most countries—a paradox that continues to characterize the two faces of Latin America. It was left to artists to address some of these issues in their work in the 1960s and after.

It is commonly believed that geometric, optical, and kinetic art are mere clones of the School of Paris and not representative of Latin American art. But many artists consider these modes to be a true expression of their culture or, at least, of their artistic freedom. Before World War II, geometric art was associated primarily with the constructive universalism of Torres-García in the Southern Cone. But after the war, it took many different forms that reflected a concern with the new cosmic and technological age. In some cases, it also involved the active participation of the spectator.[1]

Some variation of geometric art was practiced from the 1950s on by Brazilians, Colombians, Argentines, and Venezuelans. Because of its idiosyncratic form, the Brazilian phenomenon is discussed in a separate chapter. Colombians practiced a form of constructivism parallel to minimal art, while Argentines and Venezuelans more often took up optical and kinetic art. In all of these countries, geometric and kinetic art served to address issues of visual perception and the art's function within a given place. Rather than conveying the timeless universe of Torres-García's constructivism, the new generation of artists reflected the unstable world of the postwar period. But far from emulating European models, the artists of Latin America were active members of, and contributors to, an international avant-garde, especially during the 1960s.

GEOMETRIC, OPTICAL, AND KINETIC ART FROM THE 1950S THROUGH THE 1970S

EIGHT

COLOMBIAN CONSTRUCTIVISM

After the mid-1950s, artists in Colombia made a leap from academic and social art influenced by the Mexicans to styles ranging from neofiguration to the total denial of the image through constructivist art. Colombian constructivism developed along very specific lines, and the artists shared common tendencies, primarily because of their contact with one another. Their work had as common factors

a monastic—sometimes hermetic—sobriety and an obsessive sense of order. These artists also tended to work with flat elements, either as painted planes or as sheets of plastic, metal, or wood that they bent into three-dimensional forms. Among the numerous Colombians to take up some aspect of geometric painting or sculpture were Edgar Negret, Eduardo Ramírez Villamizar, Carlos Rojas, and Omar Rayo. Except for Negret, who began as a sculptor, the others all began as painters before turning to sculpture, and Rayo continued as a painter and printmaker.

Although these Colombians remained close to their country throughout their mature careers, they were well acquainted with contemporary international currents. All of them had lived abroad for varying periods of time. Unlike their Argentine and Venezuelan colleagues, many of whom chose France as a base after the 1940s, the Colombians' strongest links were with the United States. With the exception of Rayo, however, they ultimately returned to the quieter confines of Bogotá to continue developing their art without the media saturation and distractions of Paris or New York. By the 1970s, most of them worked in Colombia.

Edgar Negret (b. 1920), who was from the colonial town of Popayán, set up his first studio in a section of San Francisco, Popayán's former Franciscan monastery, which is now a tourist hotel. In the 1940s, Negret's themes were traditional religious ones modeled in clay or carved in marble. His change to abstraction came as a result of his contact with the Spanish sculptor Jorge Oteiza, who visited Popayán in the 1940s and showed him reproductions of the work of Henry Moore and Julio González. Moore's organic sculpture and juxtapositions of volumes and spaces inspired Negret to carve a schematic *Cabeza del bautista [Head of the Baptist]* (1946) with the eye socket hollowed out. Moore's sculpture also awakened in Negret an impulse to look at pre-Columbian art (Moore himself was influenced by Maya art).

During most of the years of *la violencia* (1948–1958), Negret lived abroad. He went to New York in 1948 with Eduardo Ramírez Villamizar, studied sculpture at the New York Sculpture Center, and taught at the New School for Social Research.[2] Between 1950 and 1954, he traveled to France and Spain. In Paris, he visited the studios of Constantin Brancusi and Jean Tinguely, and at the Musée de l'Homme, he saw African fetishes, which

FIGURE 8.1
Edgar Negret, *Aparato mágico [Magic Gadget]*, 1954, polychromed wood and aluminum, 48.6 × 91.4 × 53.3 cm. / 19 × 35 × 20 in. Courtesy Art Museum of the Americas, OAS, Washington, D.C. Gift of U.S. International Petroleum Co., Ltd., 1964.

FIGURE 8.2

Edgar Negret (Colombian, b. 1920), *El puente [The Bridge]*, 1972, painted aluminum, 59.5 × 275.5 × 73.5 cm. / 23½ × 108½ × 29 in. Jack S. Blanton Museum of Art (formerly Archer M. Huntington Art Gallery), The University of Texas at Austin. Gift of Arlene Bobker, 1978. Photo: George Holmes, 1978.78.

he noted were "full of nails." In Barcelona and Mallorca, he had also admired the work of Gaudí as well as metal sculpture by contemporary Spanish artists.[3]

In New York, where he returned and lived from 1956 to 1963, he befriended the sculptor Louise Nevelson and the painter Jack Youngerman, whose paintings comprised flat, organic patterns. In addition, he saw Calder's metal sculpture and was exposed to the work of the abstract expressionist painters. Like the abstract expressionists, he developed a strong interest in northwest coast Indian art and traveled west with a UNESCO fellowship to see north- and southwest Indian art. His wall reliefs and freestanding metal and wood constructions of this period blend elements of the mythical world of Indian and African fetishes with those of the industrialized world. These works, with titles such as *Eclipse, Máscara [Mask], Señal [Signal],* and *Aparato mágico [Magic Gadget],* had strong evocative powers revealing his liking for myth in a parallel to Pollock's paintings of the 1940s. Negret's constructions of this period have parallels with the organic forms of some abstract painting and sculpture, such as that of Youngerman and Calder. There were also similarities in these artists' choice to work with flat elements. The cutout, curved shapes in *Aparato mágico* (1954; FIG. 8.1), a freestanding polychromed aluminum and wood sculpture, mimic natural organic forms. In many of his works, Negret used a selection of colors inspired by Indian art, such as brown, coral, turquoise,

yellow, red, black, and white. In *Aparato mágico,* red, white, and black prevail.

Negret was equally impressed by New York's subway and urban landscape, and his metal constructions increasingly reflected it. He began to simplify shapes and reduce the number of colors to just one or two, usually black and a soft red. When he worked with metal, he had to find ways to shape and assemble the pieces. Initially, Negret did not have soldering equipment, so he constructed his pieces with nuts and bolts. But after acquiring the desired equipment, he continued to use the fasteners nonfunctionally on his aluminum pieces because he found the appearance pleasing.

After his return to Colombia, he limited his colors to just one of three: black, white, or red. Not only were these the colors of industrial products, but the mat finish he gave them served to divert attention away from the seductive potential of surface embellishment and focus it on the form itself. In Bogotá, he created a great variety of configurations in sequences of two, three, or more overlapping units by bending sheet aluminum into big curves.[4] Each piece was shaped individually, not prefabricated.

Negret's themes of the 1960s ranged from the sacred and transcendental *(Templos [Temples]* and *Escaleras [Stairs]),* to urban construction *(Puentes [Bridges]* and *Edificios [Edifices]),* to space-age subjects *(Navegantes [Navigators]* and *Acoplamientos [Dockings]),* which he set accordingly in horizontal, tilted, or surging diagonal formations. He celebrated—and also parodied—the industrial world of ma-

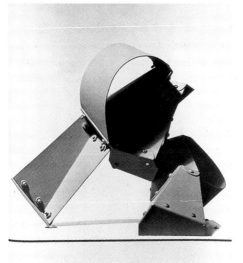

FIGURE 8.3

Edgar Negret, *Acopla-miento [Docking]*, 1975, painted aluminum. Collection Claude Le Maire, Bogotá. Courtesy Edgar Negret.

one of the first of the *Puente* series. Later examples of this theme include *El puente [The Bridge]* (1972; FIG. 8.2), consisting of three red elements joined to make a horizontal structure supported by four interlocking ribbonlike curves. Another type of structure is the larger eight-foot-long exterior sculpture *Dinamismo [Dynamism]* (c. 1974), located outside the entrance of the Banco Gánadero (Cattleman's Bank) in Bogotá. Seen from either end, this work and others like it give the viewer the impression of looking inside a curved, spiraling tunnel, thus giving the sculpture an entirely distinct appearance depending upon one's angle of vision.

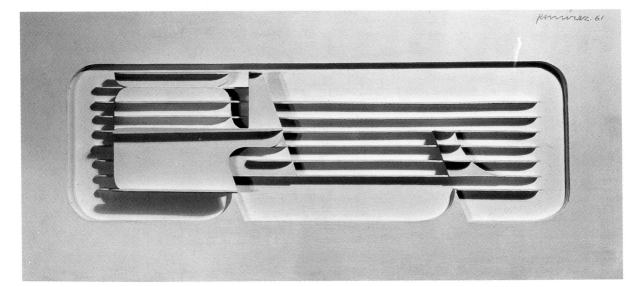

FIGURE 8.4

Eduardo Ramírez Villamizar, *Relieve horizontal blanco [Horizontal White Relief]*, 1961, synthetic polymer paint on cardboard, 28 × 62 × 4.5 cm. / 11 × 24⅜ × 1¾ in. The Museum of Modern Art, New York. Gift of Silvia Pizitz. Photograph © 2000 The Museum of Modern Art, New York.

chines by stripping the latter of their productive function.[5] The ambiguity of his constructions, wavering as they did between the mechanical and the organic, made them stand out from the more rigidly geometric work of his Colombian colleagues.

The idea for his *Puentes* dates to Negret's friendship in New York with Paul Foster, a playwright and founder of the Off-Off-Broadway La Mama Theater. Foster had dedicated his play *Hurrah for the Bridge* to Negret in gratitude for Negret's financial assistance in helping to establish the theater. Negret returned the compliment in 1968 with his sculpture *Homenaje a Paul Foster [Homage to Paul Foster]*, a complex red construction and

Except for *Gemini* and *Cape Kennedy* (1968–1970), whose titles refer to specific events, most of his space themes are identified by their generic titles, *Nave-gantes* or *Acoplamientos* (1975; FIG. 8.3). Some writers have noted that his *Nave-gantes* and *Acoplamientos* were "vehicles to escape from chaos."[6] In accordance with Negret's taste for ambiguities, these space-age works, especially those made up of only two units, also have an erotic component. The *Dockings,* or *Acoplamientos* (literally "couplings" in Spanish), suggest copulation as well as a rendezvous in space between two ships.[7]

Although these works are contemporary with minimal art in the United States, none of them, including large pieces like *Dinamismo*, perform the

minimalist function of modifying the viewer's perception of scale. Rather, the emphasis is on the sculpture's changing configurations as a spectator moves around it. Furthermore, Negret's constructions are on bases (primarily to raise them from the ground), something that minimalist sculptors eliminated.

The flat elements in Eduardo Ramírez Villamizar's sculpture developed out of geometric painting. Born in 1923, Ramírez Villamizar was the son of a goldsmith from Pamplona, Colombia, and was trained as an architect and decorator. Between 1950 and 1952, he visited France, Spain, and Italy, and in 1963, he moved to New York.[8] Although he began doing relief sculpture in Colombia in the 1950s, he made the final transition from painting to sculpture while in New York. It was but a short step from his oil paintings of shifting geometric planes and wood reliefs to three-dimensional constructions in wood or shaped from plastic or metal sheets.

During a transitional period in 1958, he made all-white wood reliefs. In *Relieve horizontal blanco [Horizontal White Relief]* (1961; FIG. 8.4), the shadows cast by layered horizontal planes provide the tonal contrasts he had obtained earlier with black or gray paint. During this period, he also took up pre-Columbian themes in abstract constructions, such as *Construcción precolombino [Pre-Columbian Construction]* (1958), or *El Dorado* (translated as *The Golden Mural;* 1958), a gold-leaf relief mural for the Bank of Bogotá. The title refers both to the mythical place (El Dorado or The Golden One) sought by the Spanish conquerors and to the bank's resources. These relief murals were based on smaller works, many of which, including *Relieve horizontal blanco*, functioned as scale models for the murals, but the larger scale of the murals gave them an added dynamism not visible in the smaller works.

From the mid-1960s to 1970, Ramírez Villamizar worked with sheets of translucent and opaque black, white, or red acrylic that he shaped into interpenetrat-

ing, angular configurations. Like Negret, Ramírez Villamizar sought reductive color in order to draw attention to the form itself, and he used the same three colors as Negret did.[9] By sanding white plastic and leaving the sheen on black plastic, he reduced the material and palpable qualities of the work to a minimum. *Convoluciones [Convolutions]* (FIG. 8.5) and *Construcción suspendida [Suspended Construction]* of 1968 both consist of a single continuous sheet of white plastic shaped into three-dimensional forms that look like folded paper.[10] The matte white makes this work translucent, almost immaterial.

From 1967 on, Ramírez Villamizar used iron, steel, aluminum, and concrete for large public commissions. These large-scale works also consist of flat elements shaped into rectangular limbs to form dynamic configurations. One of them, *De Colombia a John F. Kennedy [From Colombia to John F. Kennedy]* (1973; FIG. 8.6) is a black, sheet-iron construction made for the Kennedy Center in Washington, D.C. Dominated by powerful horizontals held in suspension by sharply tilted diagonal limbs, this construction also appears to be an integral part of the surrounding landscape that it frames.

The landscape-defining properties of some of Ramírez Villamizar's works are important components, as they are for other Colombians. Critics have seen this aspect of exterior sculpture in Colombia as an antidote to the "chaos of nature."

FIGURE 8.5
Eduardo Ramírez Villamizar, *Convoluciones [Convolutions]*, **1968, white plastic, 38 × 53.25 × 35.5 cm. / 15 × 21 × 14 in. Courtesy Eduardo Ramírez Villamizar. Photo: Ron Jameson,** from *Eduardo Ramírez Villamizar: Retrospective 1958–1972* **(unpublished).**

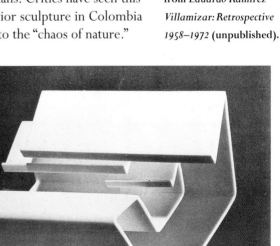

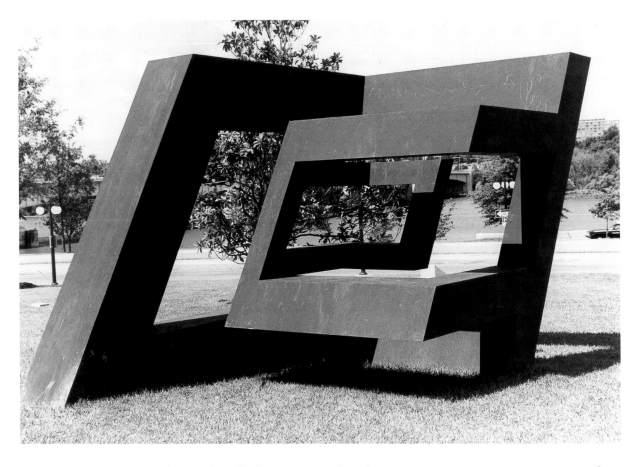

FIGURE 8.6
Eduardo Ramírez Villamizar, *De Colombia a John F. Kennedy [From Colombia to John F. Kennedy]*, **gardens of the Kennedy Center, Washington, D.C., 1973, sheet-iron construction painted black, constructed by Lippincott, Washington, D.C. Courtesy Eduardo Ramírez Villamizar.**

Galaor Carbonell, for instance, referred to Ramírez Villamizar's monumental exterior work in Pythagorean terms as "an architectonic portrait of God in the midst of the imperfection of the physical world,"[11] a concept Goeritz would have liked perhaps more than Ramírez Villamizar. On the other hand, Ramírez Villamizar's sculpture also shared affinities with minimalists such as Ronald Bladen and Tony Smith. Like them, he eliminated the base; created large-scale work, sometimes with unexpected scale shifts; and for exterior settings, made pieces whose dynamic projections activate the space around them while also controlling it.

Ramírez Villamizar also explored the idea of instability in some of his exterior pieces. *Cubo [Cube]* (1971) is a large red construction composed of a continuous rectilinear limb that bends its way at right angles to form the outer cube, which is precariously tilted on one of its edges. The energetically projecting limbs in *Construcción como nave espacial [Construction like a Space Ship]* (1976; FIG. 8.7) make this piece seem poised for takeoff. One of several works to address the theme of space travel, the latter also defies its earthbound nature by appearing weightless, a characteristic of many of his exterior works.

The impact made by Edgar Negret and Eduardo Ramírez Villamizar on Colombian art of the 1960s was enormous. Both artists trained or influenced a new generation of sculptors there. Two other artists to adopt a spartan geometry and exacting craftsmanship were Carlos Rojas, who had studied briefly with Negret, and the printmaker and painter Omar Rayo. Like Ramírez Villamizar, Rojas (1933–1997), from the town of Facatativá, Colombia, was a trained architect and had also studied applied design and mosaics during a two-year stay in Italy from 1958 to 1960. Following his return to Colombia, he taught drawing at the Universidad de los Andes in Bogotá. In the mid-1960s he visited Mexico and the United States, spending several months in Washington, D.C. His early

work on canvas reflected a response to U.S. art by drawing from the vocabulary of pop art (women's apparel, for instance) and using the borrowed subjects, such as a woman's corset, as cutouts collaged onto canvas. But by the mid-1960s, he had abandoned the pop vernacular for geometric abstraction. Again like Ramírez Villamizar, he went from a constructivist painting stage to painted reliefs and ultimately to metal sculpture, which he sometimes exhibited in combination with paintings. By 1966 his paintings and sculpture consisted of rectilinear, geometric planes based on a proportional system derived from the square and from dynamic symmetry.[12] For Rojas, geometry represented an antidote to disorder. He explained that "on the face of natural chaos, proper to the milieu in which I exist, I present a desire which eventually becomes a will and principle: conscious order and structure."[13]

After the mid-1960s, Rojas did a series of works consisting of paintings with horizontal or vertical bands of muted color on canvas, in combination with projecting, angular, iron-rod constructions. The iron rods' mechanical precision contrasted with the softer edges of the painted bands, which were imperceptibly curved. Rojas designed the irregular bands on the paintings to conform to the human eye's curved retina.[14] The paintings also evoke woven pre-Columbian textiles. As director of the Design Workshop of Artesanías de Colombia in the early 1970s, Rojas promoted folk as well as colonial art, even though his own work remained geometric.

In the 1970s, Rojas explored visual perception in several square black-and-white canvases under the generic titles *Objetos comunicantes [Communicating Objects]* from a series titled *Ingeniería de la Visión [Engineering of Vision]* and in another series, *Límites y Limitaciones [Limits and Limitations]*. *Objetos comunicantes* (the title puns Breton's 1932 book, *Les Vases Communicants*), from the *Ingeniería de la Visión* series, consists of three square

paintings tilted on their points, hung side by side in horizontal alignment so their corners touch. The black-and-white design that runs through the three acrylic paintings seems to continue conceptually and independently of its support beyond the paintings' boundaries. Taking the visual game a step further, Rojas displayed three similar acrylic paintings (1970; FIG. 8.8) on the floor under the same title to challenge the viewer's perception of the definition of painting and sculpture. On the floor, these pieces are no longer read as painting but as virtual sculpture, something like Carl Andre's flat, square floor pieces.

From the late 1960s on, Rojas had concentrated on three-dimensional rectilinear pieces based on a square module in aluminum or iron assembled with nuts and bolts (similar to Negret's constructions). One of them, *Ingeniería de la Visión [Engineering of Vision]*, also the title of the series it belongs to, is a large aluminum construction designed to be shown out-of-doors. It is a modular work that can be assembled in any number of configurations to accommodate the location. In 1969, this piece was shown snaking up the steps leading from downtown Bogotá to the Salmona residential towers (FIG. 8.9).

Some of his exterior works of the 1970s consist of black iron rods that appear to frame the surrounding space. Placed upright in a landscape setting, as is *Ara alta [High Altar]* (1974; FIG. 8.10) from the *Límites y Limitaciones* series, the rods function like a pencil line to delin-

FIGURE 8.7

Eduardo Ramírez Villamizar, *Construcción como nave espacial [Construction like a Space Ship]*, **1976, sheet iron, 55 × 113 × 156 cm. / 21⅞ × 44½ × 61⅜ in. Museo de Arte Moderno Jesús Soto, Ciudad Bolívar, Venezuela. Courtesy Eduardo Ramírez Villamizar.**

FIGURE 8.8
Carlos Rojas, *Objetos comunicantes [Communicating Objects],* from *Ingeniería de la Visión [Engineering of Vision]* series, 1970, acrylic on canvas, floor pieces of varying dimensions. Courtesy Rosse Mary Rojas G., Bogotá. Photo: Ron Jameson.

FIGURE 8.9
Carlos Rojas, *Instalación [Installation],* from *Ingeniería de la Visión [Engineering of Vision]* series, 1969, modular aluminum and iron, variable dimensions; shown on the stairs leading up to the Salmona Residential Towers, Bogotá. Courtesy Rosse Mary Rojas G., Bogotá. Photo: Sergio Trujillo.

eate and frame the background landscape. This near eight-foot-high work, in this case set in the savannah near Bogotá, also makes the landscape it defines appear two-dimensional by association.

For Omar Rayo (b. 1928), "discovering geometry is to reconcile oneself with life. Unhappiness is the product of chaos," he once said.[15] Although he was (and is) a painter, Rayo shared with the sculptors discussed above a preference for flat elements—in his case painted bands or ribbons—as the basis for his work as well as a taste for stark color contrasts like black and white. But Rayo's works are more hermetic than the others'. Rayo, who is from Roldanillo in the Cauca Valley, began his career in the 1940s as a surrealist painter, caricaturist, and illustrator for Bogotá journals. Following a trip through Latin America in the mid-1950s and a period of work in Colombia,[16] he spent a year working in a graphics workshop in Mexico City

(1959–1960). There he developed a technique for embossing intaglio prints to create images in relief by pressing cutouts into the wet paper without the need for ink. In the following years, he made a series of large prints, most of which were stark white except for an occasional touch of a single primary color.

The subjects of his prints in the 1960s were taken from a pop vocabulary of objects: scissors, a can opener, an umbrella, articles of clothing—such as shoes seen from above, gloves, or a man's jacket—or a table setting for two, and, occasionally, parts of the human anatomy rendered humorous by their starkness and geometric order. His printed images were invariably in horizontal, vertical, or diagonal formations. In *Only for Winter* (1965), a perfectly folded closed umbrella appears as a diagonal across the all-white background.

In *Water Please* (1965; FIG. 8.11), Rayo added a conceptual element by leaving

FIGURE 8.10
Carlos Rojas, *Ara alta [High Altar]*, from *Límites y Limitaciones [Limits and Limitations]* series, Bogotá, 1974, painted iron, 220 × 123.5 × 60 cm. / 86⅝ × 48⅜ × 23⅜ in. Courtesy Rosse Mary Rojas G., Bogotá. Photo: Sergio Trujillo.

something out (the water glasses, as the title indicates) of an otherwise impeccable table setting for two shown from a bird's-eye view. Rayo's sense of the absurd can be traced to his years as a caricaturist, but he was also aware of the puns, double takes, and scale shifts of pop, and his titles were often given in English. In the *Little Machine* (1963), an oversized safety pin is the lone subject of a white print, perhaps

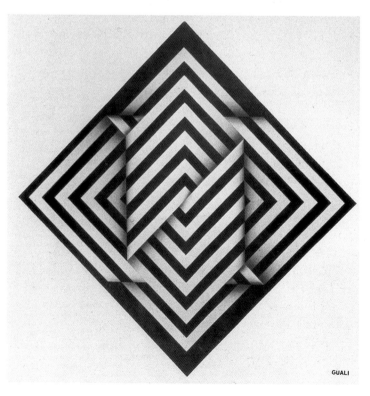

GUALI

to emphasize the underestimated role of this commodity. But far from representing pop objects, Rayo's white, geometric images are ghostly icons that parody objects of consumerism.

Rayo's oil paintings of the same period are abstract and based on a square module that also obeyed a strict geometric order. The paintings consist of black-and-white ribbonlike bands woven into knotted, folded, or intercrossed vertical/horizontal patterns. Some of them are black and white, others have an additional solid color. At times, Rayo used a spray gun to create trompe-l'oeil shading so the ribbons appear in relief. The fact that the paintings are not representational makes the shading perversely humorous.

Some of his titles derive from the names of angels, others from those of Indian tribes, as does *Guali* (1972; FIG. 8.12). Indian and pre-Columbian references in his titles have a visual as well as a conceptual basis. The striped black-and-white designs in many of these works are evocative of the geometric wall paintings in Tierra Dentro, a pre-Hispanic tomb carved directly into the rock near the archaeological site of San Agustín, southwest of Bogotá. The tomb walls are entirely covered with black-and-white, and some red, diamond-shaped designs and schematized masklike faces.

Besides their Indian references, the black-and-white bands in *Guali* form tightly woven knots, which for Rayo have a hermetic and cosmic significance. He even titled one of his works *Knots* (1969). He once explained that "in mythology, the gods kept light inside a knot which began to emit pulsations, energy, to breathe in its struggle to untie itself. From this knot emanated the infinite thread of time."[17] There is an element of paradox in Rayo's combination of hermetic geometry and mythical evocations, as implied in his statements and titles. He stated that he used ribbons for the first time "to tie the wings of an angel"[18] in an early example from the *Angel* series. Wings are implicit in *Winged Origami* (1970), a black-and-white intaglio resem-

bling a folded paper airplane whose title also refers to the Japanese art of paper folding.

The source of hermeticism in his work remains elusive. He claims to have exchanged "secrets and techniques" with the indigenous people in Brazil with whom he had lived briefly during his South American travels in the 1950s.[19] But Rayo's stark black-and-white ribbons also evoke the intricate planar geometry in Moorish designs that are especially prevalent in Colombian colonial church architecture and portal and ceiling decoration. He described white as representing the other side of black and "terrible in its purity, [with] its skin . . . of lime, like those white walls of Hispano-American religious art."[20]

Geometric tendencies in the art of Colombians in the 1960s and 1970s were not only present in abstract painting and sculpture but also in some representational art. For instance, Santiago Cárdenas's realistic paintings of objects and rooms are notable for their sparse geometric order. Likewise, Ana Mercedes Hoyos's 1970s paintings and drawings of doors and windows, which ranged from recognizable images to completely abstract designs, were based on such geometric shapes. Some of her windows were reduced to a schematic pattern of squares resembling Josef Albers's *Homage to the Square*. In the mid-1970s, Hoyos added a conceptual element to this subject in a series—designed to be displayed together—in which she systematically reduced the image from an identifiable painted window to a mere pencil notation as the only remaining indication of the original image. In the last of the series, the viewer is left to supply the missing information.[21]

During the 1960s and 1970s, Colombian artists had responded to U.S. pop and minimalist art, but they transformed these modes into distinctive forms that corresponded to their own reality. Pop objects lost their identity as consumer commodities, and minimalism was transformed into a means to control the environment and the forces of nature. The monastic sparseness present in the work of many Colombians belonged to a specific historical moment that spanned approximately fifteen years' time from the early 1960s to the mid-1970s. During those years, constructivist artists produced some of the most spartan art in Latin America, a phenomenon one is tempted to associate with the aftermath of *la violencia* and religious repression.[22] According to some art critics including Marta Traba, it was a characteristic specific to Colombian art. More likely it was the result of interaction between artists who knew one another and had similar constructivist sources.

OPTICAL AND KINETIC ART IN VENEZUELA AND ARGENTINA

In contrast, contemporary Venezuelan and Argentine artists were not always constructivists—although many of them admired the work of Piet Mondrian—nor was their work object oriented. Rather, they addressed phenomenological questions of perception by means of color and movement and, in a few cases, they produced an art that broke down the barriers between artist and audience and required the direct participation of the spectator. In comparison with Colombian constructivists who claimed thematic sources from a timeless past or a present space age, Venezuelan and Argentine optical and kinetic artists sought theirs primarily in the unstable technological world they were living in. Instead of representing vessels for escape through space travel, like Negret's *Navegantes* or Ramírez Villamizar's *Construcción como nave espacial* (see FIG. 8.7), the art of Venezuelan and Argentine artists addressed the intangible forces of the space age, cosmic energy, and the effects of these on the human psyche.

Optical art and kinetic art are not synonymous, although both can be

present in the same work. Optical art acts specifically on the retina but does not itself move physically. Kinetic art is not necessarily optical but always involves motion. The motion can be generated by motors, by natural phenomena like wind or water, or through the spectator's action. By the early 1960s, optical and kinetic art were firmly established in Western international art circles. In 1965, the Museum of Modern Art in New York officially endorsed optical art in *The Responsive Eye* exhibition, in which fifteen artists (some of them as members of groups) from Argentina, Venezuela, Brazil, and Puerto Rico participated.[23] Optical and kinetic art did not survive for long in the United States, where these modes were too quickly snapped up by the media and neutralized or reduced to window dressing for store windows. But in Europe and Latin America they found an unusual number of practitioners who continued to investigate their potential as catalysts to human responses well into the 1970s.

Because there was a tendency among critics, especially those from abroad, to identify optical and kinetic art with the artistic elitism of an industrialized First World, artists who practiced these forms were believed to support bourgeois values or a right-wing system. This was especially the case for Venezuela, which had been under a military government (1948–1958) when these art forms first appeared at Ciudad Universitaria. In addition, banks and big corporations were quick to endorse this art. But for the artists, this assumption was far from true. Some of them had lived abroad during the military government. In Venezuela there had not been an avant-garde in the 1920s aside from Armando Reverón, and optical and kinetic art represented the first radical break with academic and representational art.

Of the Argentine and Venezuelan groups, the latter tended to be more apolitical, while some of the Argentines applied their art to populist causes. The common denominator between the Ar-

gentine and Venezuelan kinetic artists was their use of modern industrial materials, particularly metal and Plexiglas. Although artists of both countries sought the active participation of the spectator in their art, the Venezuelans showed a greater interest in the possibilities of natural phenomena such as wind and changing light as activating agents for their art, whereas the Argentine artists specifically sought the active participation of the human presence, the spectator in an urban setting.

Although the inclusion of geometric and kinetic art in Caracas's Ciudad Universitaria provided an initial impetus for artists to take up these modes, not all the artists who had contributed to this project continued to work along those lines.[24] On the other hand, others who had not contributed took it up independently. Among the first Venezuelans to turn to optical and kinetic art were Alejandro Otero, who had contributed to Ciudad Universitaria; Jesús Rafael Soto, who had not; and, later, Carlos Cruz-Diez. Both Otero and Soto spent many years in Paris, Otero intermittently from the late 1940s on, Soto in the 1950s. Cruz-Diez moved there in 1960.

Alejandro Otero (1921–1997) was from a small town near Ciudad Bolívar in southeastern Venezuela. He first moved in the 1930s to Caracas, where he studied, and later taught, art and stained glass. In the 1940s, he painted landscapes in the luministic tradition of Armando Reverón. He had met Reverón shortly before the latter's death in 1954 and had studied with Antonio Monsanto in 1939.[25] Rafael Monasterios, like Reverón, conveyed intense luminosity in his landscapes and still lifes of the 1930s. Otero's white and bluish sun-drenched landscape *Vista del Avila [View of Avila]* (1943) is directly indebted to these painters. In a 1945 landscape, *Terraplén visto desde San José del Avila [Embankment Seen from San José del Avila]* (PL. 8.1), the luminosity takes on a yellow glow.

In 1946 during his first stay in Paris, Otero began painting coffee pots and

PLATE 8.1
Alejandro Otero, *Terraplén desde San José del Avila [Embankment Seen from San José del Avila]*, 1945, oil on cardboard, 40 × 42 cm. / 15¾ × 16½ in. Courtesy Patricia Phelps de Cisneros, Caracas.

PLATE 8.2
Alejandro Otero, *Líneas inclinadas [Slanted Lines]*, 1951, oil on canvas, 130 × 97 cm. / 51⅛ × 38⅛ in. Courtesy Patricia Phelps de Cisneros, Caracas.

pitchers based on Picasso's still-life compositions. Although a cubist structure replaced his more fluid landscape style, the warm browns, blues, reds, and white in these works were similar to those in his landscapes. He gradually eliminated three-dimensionality by emphasizing the patterns formed by the reflections themselves instead of the objects. In *El cántaro rojo [The Red Pitcher]* (1948), the object remained visible, but by 1951 Otero had completely eliminated it. *Líneas inclinadas [Slanted Lines]* (1951; PL. 8.2) consists of nothing more than five barely defined off-center color lines over a thickly painted white background.[26]

Otero first became interested in the possibilities of abstract space, light, and movement on encountering Mondrian's work,[27] especially *Broadway Boogie Woogie*, which he had seen during an earlier trip to New York. He also admired the effects Tinguely achieved in his work. But Mondrian's work inspired him in 1951 to do a series composed of brightly colored

PLATE 8.3
Alejandro Otero,
*Colorritmo 34 [Color-
rhythm 34]*, 1957–1958,
duco on board, 201 ×
40.7 cm. / 78¾ × 40⅞ in.
Courtesy Art Museum of
the Americas, OAS,
Washington, D.C.

strips of paper glued onto square sheets of colored paper in horizontal and vertical formations. However, instead of limiting himself to Mondrian's primary colors, Otero used a wide spectrum of colors in varying combinations.

These collages in turn led Otero to the *Colorritmos* [*Colorrhythms*], begun in 1955 (PL. 8.3). Painted with duco on vertical wood panels, they consisted of evenly spaced black vertical stripes on a white background, intercepted by bands of bright color. The interaction between the black and the slightly slanted color bands in the *Colorritmos* produced a dynamic optical surface resulting in a retinal perception of movement without actual motion.[28]

In 1967, Otero began exploring the potential of the forces of nature, such as wind and changing light, in exterior constructions. *Rotor* (also known as *Homage to the Turbine*) and *Vertical vibrante oro y plata [Gold and Silver Vertical Vibrant]*, both of 1968 and made of anodized aluminum, are activated by weather conditions. *Rotor,* a silvery gray vertical structure rising some sixteen feet from a pivotal base in front of the Galería de Arte Nacional in Caracas, rotates around its central axis as it is propelled by the wind. *Vertical vibrante oro y plata* (FIG. 8.13), which stands over sixty feet high and is now located at the approach to the city of Maracay, is a light, airy structure whose blades, set within individual iron frames, rotate, vibrate, and reflect the changing light of day. Both of these works paid homage to what Otero referred to as the "miraculous technological conquests" of our age, which he thought of in aesthetic terms. He saw in their dynamic quality and "precarious stability" a reflection of the "fragility of the world" since the atomic bomb.[29] He perceived scientific and technological advances as conflicting forces, potentially negative and positive at the same time, but chose to celebrate their constructive aspects as a postwar legacy. He felt that art had a responsibility equivalent to technology to communicate "hope." He also made clear that art

should not be subordinated to technology but should be of "parallel significance."[30]

Some of his exterior sculpture was immensely poetic, even romantic. In the late 1960s, he began a series of large cubic structures tilted to stand on one of their edges. For Otero, the cube, which was a favorite shape for constructivists and some minimalist artists, "had to be transparent" and sensitive to external elements.[31] Based on similar principles as *Vertical vibrante oro y plata,* the cubes comprised smaller individual cubic units, each with its own stainless steel blade set in motion by the wind like propellers. *Integral vibrante [Vibrant Integral]* (1968), commissioned by an industrial plant in Ciudad Guayana in southeast Venezuela, functions as an integral part of the landscape and is entirely activated by "sun, wind, rain." By placing these light cubic structures in the midst of nature, Otero removed them from their industrial context and made them into pure receptors of natural phenomena.

Many of these works were site-specific. Although Otero created numerous cubic constructions with propellers, some of his exterior works consisted not of cubes but of slanted walls composed of individual cubic spaces, as in *Ala solar [Solar Wing]* (1975), a gift from Venezuela to Colombia made especially for its site in Bogotá. Similarly, *Delta solar [Solar Delta]* (FIG. 8.14), another gift, this time from the Venezuelan government to the United States on the occasion of the bicentennial of U.S. independence, was installed in 1977 in front of the National Air and Space Museum in Washington, D.C., in the middle of a reflecting pool. This work, consisting of a single layer of square modules, forms a triangular wall set at an angle. *Delta solar* paid a dual homage to modern technology and to the Inca sun cult.[32]

There was something eminently cosmic—if not romantic—in Otero's blend of technology, lyricism, and "visual poetry" in his works for architectural projects as well. In a stained-glass window cycle he designed for the Capilla del Ancianato (Chapel of the Elders) in the town of Tanaguarena in Venezuela, he combined transcendental effects of color with movement. These windows, collectively titled *Zenith Color* (1974; PL. 8.4), consisted of spectrum-colored glass set in a narrow, cruciform opening in the chapel's dome and in the oculi (the small round windows) surrounding it. The deeply recessed windows and cruciform opening are barely visible inside the circular chapel, unless one stands directly beneath the dome. Instead, one sees spectacular displays of constantly shifting light and color reflections on the chapel walls.

Jesús Rafael Soto (b. 1923), from Ciudad Bolívar, began as a painter, like Otero. He moved to Caracas, then to Maracaibo, where he taught painting. He had admired Cézanne and Van Gogh for their vibrant use of color, but just as for Otero, Mondrian and Malevich came to attract him more. Settling in Paris in 1950, Soto began exploring ways of translating the virtual movement in Mondrian's work into three-dimensional form.[33] Aware of Mondrian's liking for jazz (he had seen Mondrian's *Broadway Boogie Woogie* in New York), and as a musician himself, Soto based some of his work on musical rhythms, particularly the patterns formed by Bach's musical variations and Schoenberg's twelve-tone system.[34] His early *Serials* and *Progressions* consisted of small

FIGURE 8.13
Alejandro Otero, *Vertical vibrante oro y plata [Gold and Silver Vertical Vibrant],* 1968, aluminum and iron, 24 m. high / 60 ft. high, approach to the city of Maracay, Venezuela. Courtesy Museo Alejandro Otero, Caracas. Photo: Ron Jameson, from José Balza, *Alejandro Otero* (p. 100).

FIGURE 8.14
Alejandro Otero, *Delta solar [Solar Delta]*, 1977, stainless steel, 10 × 16 m./ 32 × 49 ft. National Air and Space Museum, Washington, D.C. Gift from the Venezuelan government to the United States. Courtesy Museo Alejandro Otero, Caracas. Photo: Ron Jameson, from José Balza, *Alejandro Otero* (p. 155).

PLATE 8.4
Alejandro Otero, *Zenith Color,* Capilla del Ancianato (Chapel of the Elders), Fundación Anala y Armando Planchart, Tanaguarena, Venezuela, 1974, stained glass. Courtesy Museo Alejandro Otero.

rhythmically spaced dots or squares painted in geometric formations based on these systems.

Soto's three-dimensional kinetic works evolved from two different currents in his early work: the Vasarely-inspired striped paintings, and the layered Plexiglas works. In the first category are the optical compositions of 1950–1952, such as *Paralelas interferentes [Interfering Parallels]* (1952; FIG. 8.15), consisting of irregular black-and-white patterns, fractured at intervals as though by some invisible barrier. The paintings in the *Vibración [Vibration]* series are the direct descendants of these optical works. In *Relación, vibración [Relation, Vibration]* (1964; FIG. 8.16), the interaction between the sticks, suspended with invisible nylon threads from a ledge at the top, and the vertically ridged wood background creates an optical vibration. The sticks, which substitute for the painted

FIGURE 8.15
Jesús Rafael Soto, *Paralelas interferentes [Interfering Parallels]*, 1952, acrylic on wood, 120 × 120 cm. / 47¼ × 47¼ in. Courtesy Museo de Arte Moderno Jesús Soto, Ciudad Bolívar, Venezuela.

FIGURE 8.16
Jesús Rafael Soto, *Relación, vibración [Relation, Vibration]*, 1964, metal, wood, and acrylic, 108 × 106 × 10 cm. / 42½ × 41¾ × 4 in. Courtesy Museo de Arte Moderno Jesús Soto, Ciudad Bolívar, Venezuela. Photo copyright Henry E. Corradini.

FIGURE 8.17
Jesús Rafael Soto,
Escritura Hurtado
[Hurtado Scripture],
1975, paint, wire, wood,
and nylon cord, 102.8 ×
171.7 × 46 cm. / 40½ × 67⅞
× 18¼ in. Courtesy Art
Museum of the Americas,
OAS, Washington, D.C.

black bands, appear to dissolve before the background, and the viewer becomes aware of the motion rather than of an object.

A similar phenomenon occurs with the *Escrituras [Scriptures]* series begun in 1957 in which Soto suspended thin, tangled wire in front of vertically ridged gray or black horizontal backgrounds. The resulting effect on the viewer is the illusion that some phantom hand is writing in the air. Both *Pre-alfabético [Pre-Alphabetical]* (1957), a large mural in Caracas, and *Escritura Hurtado [Hurtado Scripture]* (1975; FIG. 8.17), a smaller but similar work, seem dematerialized as the viewer is distracted by the motion created by an almost invisible agent (the wire).

In the second category are the superimposed sheets of Plexiglas in which different curved patterns on each layer interact to form a moiré effect,[35] which led to the *Penetrables*. The latter are the large-scale environments that spectators could enter. Following the early Plexiglas works, Soto first investigated the possibility of optical phenomena in small three-dimensional works. An early example was

La cajita de Villanueva [The Little Villanueva Box] (1955; FIG. 8.18), a translucent box named after the architect Carlos Raúl Villanueva. This box, measuring approximately a foot square, consists of three layers—the two outer walls and an interior parallel one—of alternately smooth and ridged areas on Plexiglas panels. The incised patterns on these panels appear to shift according to the spectator's position. This work proposed the possibility for larger boxes and spaces, and led to the first of Soto's *Penetrables* in 1967.[36] Among them was *Penetrable de Pampatar [Pampatar Penetrable]* of 1971 (since destroyed), known by the name of its location in Venezuela (FIG. 8.19). These large works consist of accumulations of translucent nylon tubes suspended from a ceiling grid to form a forest through which the spectator could walk. The nylon tubes in the *Penetrables* substitute for the ridged surfaces of *La cajita de Villanueva*.

But the *Penetrables* had an additional function. They were to be sensorial in the sense that they invited a tactile, as well as a visual, response from the human participants.[37] A walk through the translucent nylon tubing could evoke a gentle

tropical rain. The sensorial potential of penetrables led Soto in 1969 to conceive of the idea for a city plaza that he called *Aquapenetrable,* which was to be set up in a tropical country. It was to be divided into three cubicles in which recirculated water substituted for the nylon tubing of the *Penetrables* and was to rain upon dressed or naked participants. He had planned an analogous project for cold countries in which warm steam substituted for water. According to the Paris-based journal *Robho,* the resulting experience was to be simultaneously "playful, sensorial and meditative."[38] Neither project was ever executed.

Between 1969 and 1974, Soto added color and sound to the penetrables. In *Saturación móvil [Mobile Saturation]* (1971), composed of clusters of yellow painted aluminum tubes suspended over floor lights, he explored the visual impact of

FIGURE 8.18
Jesús Rafael Soto, *La cajita de Villanueva [The Little Villanueva Box]*, 1955, Plexiglas and paint, 30.5 × 30.5 cm. / 12 × 12 in. Collection Pauline Villanueva, Caracas. Courtesy Pauline Villanueva. Photo: Robert E. Mates and Mary Dondlon.

FIGURE 8.19
Jesús Rafael Soto, *Penetrable de Pampatar [Pampatar Penetrable]* (no longer in existence), 1971, white nylon tubing, variable sizes. Former collection of Alfredo Boulton, Caracas. Photo: Ron Jameson, from Alfredo Boulton, *Soto* (p. 158).

intense yellow. *Penetrable sonoro [Sonorous Penetrable]* (1973–1974) provides yet a further dimension. Hanging aluminum tubes of different sizes were designed— as the title implies—to produce different sound pitches that resemble church bells.[39]

Carlos Cruz-Diez (b. 1923) was more pragmatic than either Otero or Soto in his exploration of the properties of color. He applied the color theories of nineteenth- and twentieth-century investigators such as Eugene Chevreul and Josef Albers to his art. His background, first as art director for an advertising agency (McCann Erickson), then in 1957 as teacher of graphic and industrial design, led Cruz-Diez to conclude that "the 'knowledge' of centuries prevents us from freeing ourselves from 'artistic color' or from its symbolic, esoteric or cultural notion." This notion led him to investigate the psychological and phenomenological impact of color on the spectator as an independent agent.[40]

In 1959 he began a series of *Fisicromías [Physichromies]*, consisting of closely spaced vertical plastic strips glued onto a wood, plastic, or metal surface at right angles. The thin color bands painted along these strips in *Fisicromía No. 394 [Physichromie No. 394]* (1968; PL. 8.5) are barely perceptible when one looks at the

work frontally, but they produce the appearance of floating, shifting geometric patterns as one moves laterally in front of the work.[41] Besides color theories, Cruz-Diez was also guided by phenomenological questions involving spectator response to new situations. In the 1960s, the writings of the French philosopher Maurice Merleau-Ponty were read by many Latin American artists concerned with visual phenomena and behavioral responses.[42] Cruz-Diez sought to involve spectators in his color environments with the objective of breaking down the programmed response to art that he perceived in the average viewer. Like Soto's penetrables, Cruz-Diez's spaces addressed some aspect of sensorial experience.[43]

Paris subway entrances were favorite display sites for artists seeking to make their art public. At the Odéon subway entrance, Cruz-Diez set up a labyrinth, *Chromosaturation* (1968), that consisted of three booths, each encased, respectively, in translucent red, green, or blue acetate on aluminum frames accessible from a black-lined side corridor. The black corridor was designed to clear the retina of previous programming so the eye could accommodate each new color as an independent and new experience. These "chromosaturation" chambers were also "intended to make evident the notion

PLATE 8.5
Carlos Cruz-Diez
(Venezuelan, b. 1923),
*Fisicromía No. 394
[Physichromie No. 394]*,
1968, wood, plastic, and
metal construction,
121.2 × 62.2 × 6.3 cm. /
47¾ × 24½ × 2½ in. Jack
S. Blanton Museum of
Art (formerly Archer M.
Huntington Art Gallery),
The University of Texas
at Austin. Gift of Irene
Shapiro, 1986. Photo:
George Holmes, 1986.333.

of autonomous color in space, . . . isolated and acting with full force upon the spectator."[44]

During the 1950s and 1960s, several Argentine artists also explored the phenomenon of human perception through color and motion. These included Luis Tomasello, César Paternosto, Gyula Kosice, Rogelio Polesello, and Julio Le Parc. Argentine optical and kinetic art developed from the same international sources as it did elsewhere, but for Argentines it had a precedent in their concrete art movement of the 1940s. What developed in the 1960s and 1970s, however, belonged theoretically and visually to a new generation whose central premise was instability and the dematerialized, illusory effects of color rather than the constructive geometry of concrete art. In Paris in 1957, Tomasello (b. 1915) had explored the potential of serial reliefs as well as optical instability, which he developed as a series of "chromoplastic atmospheres." In 1959, he began attaching small cubes or half cubes, painted on their undersides and tilted at various angles, onto a flat, white, wooden surface to form color reflections on the background. As with Cruz-Diez's *Fisicromías,* the resulting image depended on one's viewing angle.[45]

After 1958, Gyula Kosice (b. 1924), a cofounder of the Madí group, began producing "hydrokinetic" works by incorporating into his work water as an element of instability besides Plexiglas, metal, and lights.[46] *Columnas hidroluz [Hydrolight Columns]* (1965; FIG. 8.20) comprises hemispherical plastic containers in which water is recycled. The air bubbles trapped inside rise and catch the spotlight in a constant play of burbling motion. The kinetic properties in Kosice's works defy the laws of gravity and visually destabilize the viewer. Like some of his contemporaries, Kosice was also drawn to the subject of space travel. In 1971, he devised Plexiglas models for a self-sustaining cosmic city, *Ciudad hidroespacial [Hydrospatial City]* (1971),

FIGURE 8.20
Gyula Kosice, *Columnas hidroluz [Hydrolight Columns],* 1965, Plexiglas, water, and aluminum, 170 × 25 cm. / 67 × 9⅞ in. Courtesy Gyula Kosice, Buenos Aires.

which was more utopian and fanciful than scientific.

Rogelio Polesello (b. 1939) began as a printmaker and expressionist painter but turned against his own gestural abstraction in the early 1960s. Instead, he began making optical paintings and Plexiglas panels in which he embedded distorting lenses of different sizes to magnify and multiply images reflected in, or seen

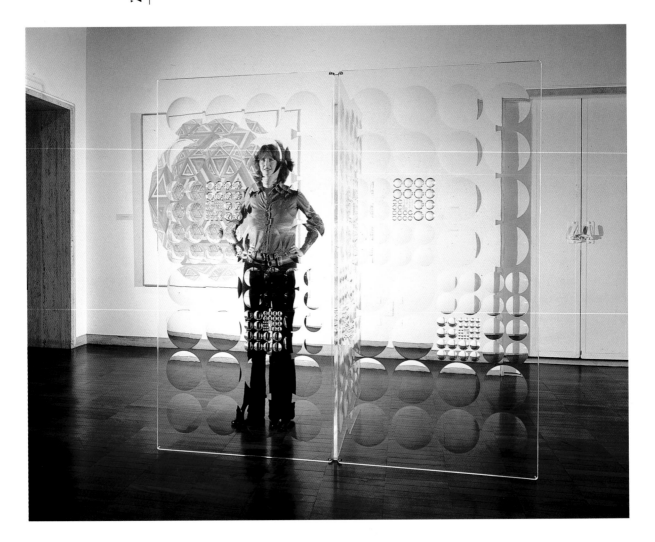

PLATE 8.6

Rogelio Polesello, *Lentes multiplicadoras de imágenes [Image Multiplying Lenses]*, also known as *Continuous Concave/Convex*, 1972, Plexiglas and magnifying lenses, in three parts, each 200 × 100 × 2 cm. / 78¾ × 39⅜ ×¾ in. Installation at Center for Inter-American Relations, New York, 1973. Courtesy Rogelio Polesello, Buenos Aires. Photo: Charles Uht.

through, them.[47] In *Lentes multiplicadoras de imágenes [Image-Multiplying Lenses]*, also known as *Continuous Concave/Convex*, (1972; PL. 8.6), lenses are embedded into large, translucent Plexiglas walls at right angles from each other so spectators can move around them and alternately become viewers and the viewed as their own image is multiplied. Besides the destabilizing effects of this environment, Polesello sought, by means of multiplication, to explode the notion of the unique art object.

These objectives also characterized the type of kinetic art taken up by several Paris-based Argentine artists, including Gregorio Vardanega, Marta Boto, Hugo Demarco, and Julio Le Parc. As the most visible and ideologically committed of the Argentine kineticists, Le Parc (b. 1928) cofounded the Groupe de Recherche d'Art Visuel (Visual Art Research

Group, or GRAV) in Paris in 1960 with five other artists: the Argentine Hugo García-Rossi, the Spaniard Francisco Sobrino, and the Frenchmen Yvaral (Jean Pierre Vasarely), François Morellet, and Joël Stein. Le Parc and Sobrino, both in Paris by 1958, visited Victor Vasarely's studio, finding there a model for an art form they could incorporate into their own agenda.

Le Parc began as a painter of optical canvases of large undulating bands in spectrum colors, but he subsequently rejected op art because of what he perceived to be the art media's too ready acceptance of this art as another commodity to be shown in art galleries.[48] Instead, he and his GRAV colleagues created environments with kinetic works to be manipulated by spectators. These artists based their program on the existential notion of individual will and responsibility for action, which they felt

could be stimulated by making their art an agent for such action. They also produced multiples, an idea that had widespread currency at the time. Polesello created the concept of multiples as a visual experience through his use of lenses; Le Parc did so by actually multiplying the object itself. The explanation for these multiples offered in the GRAV manifestos was that "the stable, unique, definitive, irreplaceable work goes counter to the evolution of our epoch." The GRAV artists believed in art as a collective endeavor stripped of individualism and free of all aesthetic, social, and economic pressures, an art to be activated by the spectator.[49]

The GRAV artists believed that art should be based on "scientific" investigation of the physical properties of vision and statistics and probabilities, as the means through which they could best achieve their political and philosophical goals.[50] Le Parc's political leanings, like those of other intellectuals in the 1960s, were toward the New Left, a postwar revisionist form of socialism that rejected Stalin and the constraints of traditional Marxism in favor of a more anarchistic and existential version.[51] As a group, the GRAV created labyrinths fashioned from impersonal, industrial materials such as aluminum, Plexiglas, mirrors, and lights. The labyrinths comprised flexible aluminum partitions or suspended plastic panels that swayed as spectators moved past or through them. Using the vocabulary of popular culture, the artists also created machines with levers and push buttons to be manipulated like pinball machines in a penny arcade as an art form accessible to a general public.

Even though these artists ideologically opposed art institutions, including galleries and especially museums, more often than not their labyrinths were exhibited in them. Between 1963 and 1965, they exhibited in France, Belgium, Argentina, Brazil, the United States, and Japan. One of their collective installations, shown at the 1963 Paris Biennial, was re-created in modified form at the Contemporaries Gallery in New York in 1965 under the name *Stop Art!,* in a take on op art. Spectators could walk through curtains of polished aluminum strips or mobile reflecting panels and manipulate levers and buttons in "game-rooms" whose signs exhorted them to "please touch"; or they could alter or modify their own reflections in an open cell with adjustable mirrors.[52] In this ensemble animated by light and movement, everything flashed, shivered, and jumped, and the spectator was in control of these actions.[53]

In 1966 the GRAV carried out a collective project titled *Une journée dans la rue [A Day in the Street]* as the fulfillment of the group's anti-institutional goals. Situations similar to those shown in galleries were set up at subway entrances in central Paris in order to reach a segment of the public that did not regularly go to art exhibitions. Most were middle-class people going to or coming from their work. One of the GRAV's stated objectives was to break the programmed habits of behavior in people, their "apathetic dependence" and passive acceptance of "what is imposed on [them] as art, but also [of] the whole system of living."[54] The situations the GRAV artists set up played on people's responses to unexpected conditions. Small whistles were distributed at one stop, surprise gifts at another. A cage made from a curtain of threads suspended from a grid into which spectators could enter was placed at a third (FIG. 8.21), and unstable floor slabs were presented at yet another subway entrance for the participants to walk over and test their balance. In addition, questionnaires (a favorite device of Le Parc's) were posted at the various locations for the public to voice opinions about the value and function of art galleries, museums, and other institutions in general, as well as of this particular event. According to the answers taken in percentages, art in the museums and galleries ranged from "interesting" to "necessary" to "incomprehensible," and reactions to this particular event varied from "justified" and "rel-

FIGURE 8.21

Julio Le Parc and Groupe de Recherche d'Art Visuel (GRAV), *Une journée dans la rue [A Day in the Street]*, Champs Elysées, corner of rue La Boétie, Paris, 1966, mixed media. Photo courtesy Julio Le Parc.

FIGURE 8.22

Julio Le Parc, *Anteojos para una visión distinta [Glasses for a Different Vision]*, 1965, exhibited at the Howard Wise Gallery, New York, in 1966. Photo courtesy Julio Le Parc.

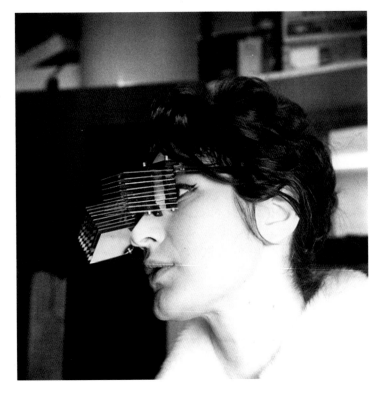

evant" to "experimental" and "amusing." Although participants had the option of calling it "stupid," none did.[55]

Prior to the 1968 student riots in Paris, all types of institutions, including theater, had come under fire from intellectuals.[56] The GRAV artists were both a product and the most vociferous critics of these institutions, which were also the main targets of their art. Politicized intellectuals in general, and Le Parc in particular, found a platform in the Paris-based activist journal *Robho,* which published political and anti-aesthetic statements by numerous Latin American artists between 1968 and 1972.[57] *Robho* featured a mix of essays on collective and anti-art projects, spectator-oriented art, and political demonstrations by militant intellectuals.

However, the GRAV artists' ideal of anonymity was difficult to maintain. In spite of Le Parc's populist and leftist inclinations, he exhibited as an individual

at the Howard Wise Gallery in New York in 1966 and had accepted the Grand International Prize the same year at the *Thirty-third Venice Biennial,* an event his GRAV colleagues attempted to justify by explaining that he had exhibited as a representative of the group. Nonetheless, as a result, Le Parc came under considerable criticism. The GRAV was dissolved in 1968 "for lack of coherence between the practice and the initial ideal of anonymity."[58]

Many of the works Le Parc exhibited in New York and Venice were similar to those he had included in the labyrinths, but they explored visual phenomena on a more intimate scale. In the Howard Wise exhibition, he included eyeglasses and mirrors fractured vertically or horizontally to distort vision and create individual environments based on the same principle as the aluminum curtains, as in *Anteojos para una visión distinta [Glasses for a Different Vision],* exhibited under the title *Anteojos para una visión fracturada [Glasses for Fractured Vision]* (1965; FIG. 8.22). Le Parc's interest in the alteration of vision through kinetic experience, like Polesello's, derived from contemporary notions of visual perception, and the distorting mirrors and lenses are peculiarly related to the distortions in some neofigurative painting discussed in Chapter 10.[59]

Perception and the dematerialization of the object were implicit in the work of less political Argentine optical and kinetic artists as well. In 1968, the Arte Generativo (Generative Art) group was formed in Buenos Aires by the painters Eduardo Mac Entyre and Miguel Angel Vidal, who were later joined by Ary Brizzi. The group's members did not directly address the spectator but sought to represent a cosmic idea of beauty in a technological age through the medium of paint on canvas. They wished to prove that they could produce "the most spiritual and most abstract [art] . . . that the human mind had as yet conceived."[60] Their paintings were characterized by geometric volumes seemingly composed of pure energy. The volumes are defined by a sequence of pencil-thin lines of intensely luminous color. The Generative artists obtained by means of paint the aesthetic and intangible qualities of light, energy, and cosmic force that Otero had obtained three-dimensionally.

The Generative group was more directly indebted to the Argentine concrete art of the 1940s than most of the other later groups. The term *generative* to define their art was proposed by the late Argentine painter and theorist Ignacio Pirovano, an admirer of George Vantongerloo and De Stijl, because a line or figure has "the capacity to engender" in its turn "a different or new geometric body."[61] But although they were heirs of Argentine concrete art, the Generative painters added a lyric and cosmic dimension to geometric art not present in the earlier form.

Vidal (b. 1928) and Brizzi (b. 1930) created volumes and energy fields with straight lines, Mac Entyre (b. 1929) with curved ones. With the aid of a compass, the latter produces dynamic configurations on a wood, canvas, or Plexiglas surface painted with a solid base of oil or acrylic. In *Pintura generativa [Generative Painting]* (1973–1974; PL. 8.7), painted in acrylic, the resulting volume appears to penetrate the surface of the flat background color through sheer energy. In all of Mac Entyre's paintings, the degree of the lines' density modifies optically the value of the adjacent color, making it appear lighter or darker, and also produces a brilliant, mandala-like internal luminosity at the point where the lines converge. The spherical or figure-eight patterns defined by the linear networks seem to spin in orbit. Mac Entyre's colors are not the primaries but sensuously beautiful, kaleidoscopic variations of the spectrum. The aesthetic appeal of Mac Entyre's, Vidal's, and Brizzi's depictions of non-Euclidean forms is characteristic of much Argentine geometric painting.[62]

PLATE 8.7

**Eduardo Mac Entyre,
*Pintura generativa
[Generative Painting]*,
1973–1974, acrylic on
canvas, 150 × 150 cm. /
59 × 59 in. Courtesy
Eduardo Mac Entyre,
Buenos Aires. Photo:
Estudio Caldarella.**

SUMMARY

The application of technology and industrial materials to art was specific to Argentine and Venezuelan artists. It was infrequently the case elsewhere. Colombians used industrial materials such as metal and plastic, but their art did not center on urban technology and industrialism as much as on controlling the environment. For the Venezuelans, these materials embodied industrial and technological advance.[63] For the Argentines, they provided the means to address issues of contemporary urban experience and media saturation as well as human behavior. For both Venezuelans and Argentines, technology and the notion of space were also converted into an aesthetic, near transcendental experience. These artists' choice of industrial materials also indicated an acquiescence to technological and industrial advance as the reality of the time as well as to a modern aesthetic. Although Brazilian artists also took up geometric art in the 1950s, they ultimately rejected First World industrial materials and adopted instead more humble, organic ones that better expressed their culture.

After 1950 a new surge of creativity was apparent in Brazil in art as well as in experimental theater, cinema, music, and poetry.[1] More than creative artists elsewhere, Brazilians tended to cross lines between the arts. Poets created visual poetry with the attributes of art objects, and artists made art out of letters and words. Performance found its way into art in distinctive ways, and music became a component of some environments and gallery installations or paralleled currents in the visual arts. In São Paulo, the new tendencies—stimulated by the *First São Paulo Biennial* in 1951—began with a concrete art movement along the lines of the one in postwar Argentina. But by the second half of the decade, several Rio artists dissented, broke away from the rigidities of concrete art, and in 1959, formed a neoconcrete group. Not only did these two currents—concrete and neoconcrete—dominate almost two decades of Brazilian art; they had an impact on artists not officially affiliated with either group but whose work followed parallel developments toward a gradual deformalization.

Concrete art in São Paulo had several sources. The *First Biennial* provided the occasion for contact between several Buenos Aires artists (Tomás Maldonado, Lidy Prati, and Ennio Iommi) and Brazilian artists (Alvir Mavignier, Alexander Wöllner, and Ivan Serpa, among others).[2] More important still was an exhibition of the work of Max Bill at the Museu de Arte de São Paulo in 1950, and the inclusion in the *First São Paulo Biennial* the following year of Bill's prize-winning stainless steel sculpture *Tripartite Unity* (1947–1948; FIG. 9.1). The latter was a continuous Möbius band that seemed to divide the space into three units.

The question of why Brazilians turned so eagerly to constructivist and concrete art models like Max Bill, when this art form was opposed to what was taking place in the United States and other major European centers at the time, was addressed by Ronaldo Brito and Mario Pedrosa. According to Brito, concrete

CONCRETE AND
NEOCONCRETE
ART AND THEIR
OFFSHOOTS IN THE
BRAZILIAN CONTEXT

NINE

FIGURE 9.1
Max Bill, *Tripartite
Unity*, 1947–1948, stainless
steel, 100 × 90 × 117 cm. /
39⅜ × 35½ × 46 in.
Courtesy Museu de Arte
Contemporânea da
Universidade de São
Paulo (USP), São Paulo.

art, by opposing "intuitive informalism," could claim exact scientific, mathematical precision that competed with other disciplines, such as architecture, design, and science, to create an autonomous art that could stand on its own. It attempted "to transform the social environment and to surmount underdevelopment" by attacking the "archaisms" of the traditional Brazilian power structures, and by extension, the academy.[3]

According to Mario Pedrosa, geometry introduced an order and clarity into Brazilian artisanry and design in general, which was seen as an improvement as well as a claim to modernity. The appropriation of Max Bill as a model (in Brazil) follows directly out of architecture (a phenomenon that did not occur in Mexico).[4] The most obvious parallel was the building of Brasília in the 1950s. Concrete art's focus was on craft and skill in opposition to process through what Pedrosa considered the "moral hedonism" of, say, Jackson Pollock's or the French painter Georges Mathieu's expressionism.[5]

The concern for and focus on craft as opposed to process must also be considered in terms of some of these artists' links to the newly founded school of design, the Hochschule für Gestaltung (1951), established by Max Bill in Ulm, Germany, just west of Munich. The school attracted numerous foreigners, among whom were Latin Americans. The Argentine artist Tomás Maldonado directed the school in 1954 after Max Bill resigned from the post, and the Brazilian artist Alvir Mavignier studied there.

Several of the São Paulo concrete artists were trained in architecture, industrial design, and the graphic arts as well as in painting. Alvir Mavignier, Antonio Maluf, Alexander Wöllner, and the Rio artist Ivan Serpa were among these. Maluf, a civil engineer and industrial designer, made the poster for the *First Biennial,* and Wöllner, an industrial designer, for the *Fourth* in 1957.[6]

Concrete art had a parallel in poetry. In 1952, three poets, Decio Pignatari, Haroldo de Campos, and his brother Augusto de Campos, founded the Noigandres concrete poetry group in São Paulo along with the journal *Noigandres.*[7] They sought to demystify language by producing a poetic form whose typographical pattern corresponded to, or in some way echoed, the meaning of the words, something like an ideogram or the mouse's tail in Lewis Carroll's *Alice in Wonderland.* Concrete poetry is non-syntactical and stripped of all romantic associations. The visual configuration formed by the words in a poem is integral to the poem's meaning. For instance, Augusto de Campo's poem "Ball of Yarn" is set on the page in the shape of a ball of yarn whose words *ovo* (egg) in the beginning and *morte* (death) at the end refer to a life cycle through a repetition of the vowel *o* and a play on soft to hard sounds, that is, from *v* (*ovo*) to *r* (*morte*). The visual component of concrete poetry had a wide-ranging impact on neoconcrete as

well as concrete art in São Paulo and Rio. Subsequently, poetry and art came to be virtually interchangeable. Some artists incorporated concrete poems in their work (Helio Oiticica, Rubens Gerchman), and the concrete poet Augusto de Campos created poetry that was exhibited as art.[8]

Following the *First Biennial,* two groups of artists were formed in 1952: in São Paulo, the Grupo Ruptura, whose members Hermelindo Fiaminghi, Waldemar Cordeiro, Judith Lauand, Luis Sacilotto, Nogueira Lima, and Lothar Charoux first exhibited together the same year and, along with Alvir Mavignier and Alexander Wöllner, took up concrete art; and in Rio, the Grupo Frente, whose members Lygia Clark, Ivan Serpa, Abraão Palatnik, Aloisio Carvão, Franz Weissmann, Amilcar de Castro, and Ligia Pape first exhibited as a group in 1953. Together with Helio Oiticica, the latter artists were to form the neoconcrete group after 1959.[9]

Although many artists followed the geometric dictates of concrete art well into the 1970s, others, including some poets, had become dissatisfied with its limitations. Fiaminghi, complaining of too much dogmatism, broke away from the concrete group;[10] likewise, the poet Ferreira Gullar broke with the concrete poets in 1957 and the painter Waldemar Cordeiro, with the Grupo Ruptura in São Paulo. The latter two aligned themselves with the neoconcrete group in Rio. Cordeiro, who sought a more "sensitive" geometry, one that allowed for some deviations from strict rules,[11] was the first to notice major differences between the São Paulo and Rio artists, "not only stylistically but in their whole way of thinking about art" and its relationship to the outside world.[12] These differences, already apparent in the *National Exhibition of Concrete Art* that took place in São Paulo in 1956 and in Rio in 1957, contributed to the creation of the neoconcrete group in 1959.

NEOCONCRETE ART

The deformalization of the rules of concrete art into neoconcrete art corresponded to the rise of informalist abstraction and gestural painting exemplified in Brazil by Manabu Mabe. But unlike the abstractionists, the neoconcrete artists completely rejected the notion of art as a commercial object in favor of an art to be experienced through the senses and that required the public's active participation—an art potentially accessible to a broader segment of society. At the time of the first neoconcrete exhibition at the Museu de Arte Moderna in Rio in 1959, the poet Ferreira Gullar formulated the group's objectives in a Neoconcrete Manifesto cosigned by Amilcar de Castro, Lygia Clark, Ligia Pape, and others.[13] Helio Oiticica, who joined the group shortly after, became one of neoconcrete art's major exponents.

Gullar provided an impetus for the new group with the publication in 1959 of his "Teoria do não-objeto" in the *Jornal do Brasil* (Rio) proposing the death of painting and of the art object as an independent entity. Instead, the nonobject would function as a mediator between the spectator and "sensorial and mental experiences."[14] Neoconcrete art, however, did not mean a total rejection of concrete art, which was in fact its basis, but a total reformulation of the function of art itself. Artists adapted concrete art's geometric shapes to neoconcrete purposes by transforming them into organic three-dimensional objects to be manipulated by spectators, or penetrable environments to be walked through and experienced sensorially.

The underlying philosophy was to alter the traditional relationship of spectator-to-object from a passive to an active one somewhat analogous to what the Argentine kineticist Julio Le Parc and the GRAV had proposed, but without the frenzy of an essentially destabilizing experience as an urban metaphor or the technological and industrial materials

used by the GRAV artists. Instead, the Brazilian counterpart was not urban in the strict sense of the word. It was in fact intended to counteract urban alienation and lead to a greater integration of meditative and sensorial experience by means of organic materials, as is evident in the work of Oiticica and Clark. According to the critic Ronaldo Brito, neoconcrete art produced a "very Brazilian paradox characteristic of underdevelopment: a constructivist vanguard that did not guide itself by any plan of social transformation and which functioned in an almost marginal manner." It existentialized and derationalized the geometric language.[15] Neoconcrete art abolished the distance between art and life and contributed more than any other movement to the politicization of art in Brazil, if not directly, then "by means of the mechanisms it activated, and by the effects of its nondogmatic and questioning practice." It has an ideological basis and is anarchistic in its rejection of established reality, a characteristic peculiar to Rio.[16] Mario Pedrosa noted that it was also the first Brazilian movement to defy predominant international currents.[17]

Of the major artists in the neoconcrete group (Amilcar de Castro, Ligia Pape, Lygia Clark, and Helio Oiticica), de Castro (b. 1920), a draftsman and former law student, maintained the closest adherence to the original premise of concrete art. Nonetheless, his flexible sheet-metal sculpture furnished a bridge between art as traditional object and its function as a vehicle for individual experience. But it was left to Lygia Clark to initiate the concept of such a construction not just as sculpture but as a "living organism" responsive to outside stimuli.

Both Ligia Pape (b. 1929) and Lygia Clark devised ways of turning their art into a direct experience for the spectator, Pape with her *Balé neoconcreto [Neoconcrete Ballet]* (1959), Clark with her hinged metal sculptures titled *Bichos [Animals]*, begun in 1959. Pape's *Balé neoconcreto* consisted of a group of painted, standing wooden blocks awaiting the spectator's intervention to create the choreography. In the same populist vein, her *Livro da Criação [Book of Creation]* (1959) comprised paper foldouts that could be opened like the pages of a book, taken out individually, and set up as three-dimensional constructions. Each page represents a phase in the Creation story. The *Sistema planetário [Planetary System]* page (FIG. 9.2) recalls *Hanging Construction* (1920) by the Russian constructivist Alexander Rodchenko. But far from the latter's industrial appearance, Pape's work is composed of flat, concentric,

FIGURE 9.2
Ligia Pape, *Sistema planetário [Planetary System],* **from** *O Livro da Criação [Book of Creation],* **1959, heavy paper, 30 × 30 cm. / 11¾ × 11¾ in. Ligia Pape, Rio de Janeiro. Courtesy Galeria Camargo Vilaça, São Paulo.**

circular paper cutouts that can be rotated around a central axis by a spectator. Other pages in the Creation sequence include the *Casa [House]* page, which opens up into a construction evoking shelter, and *Descoberta [Discovery]*, with a foldout of a wheel to allude to human resourcefulness.

The whole concept of this work exemplifies the major tenets of neoconcrete art: to communicate a complex idea on a level that "unifies the primitive with the social"[18] and addresses a broad audience, including a potentially illiterate one. As the spectator opens the book, he/she not only sees the story in narrative form but also becomes an active reader by participating in the unfolding process.[19] In neoconcrete art, function and content are more important than form, although the latter might also be present as an inducement. It is not always political, but it does have a populist base because of its easy legibility and its incorporation of the spectator as an essential component of the work. It engages the viewer directly through the senses, especially vision and touch. The materials used are usually simple, inexpensive, and easily available: paper, fabrics, rags, or natural substances like earth, stones, straw, shells, or sand. The purpose of the work is to stimulate creativity in the participant and eliminate the notion of the artist as sole creator.

Both Clark and Oiticica, who shared many of the same ideas, fulfilled these objectives and used these simple, natural materials in the 1960s, she in an intimate personal way, he in a more social and public one. Lygia Clark (1920–1988), from Belo Horizonte (Minas Gerais), moved to Rio in the 1940s and studied painting with Roberto Burle-Marx. This experience with the painter and landscape designer may have had some bearing on her later use of organic materials. In the early 1950s, she lived in Europe and, like her predecessor Tarsila do Amaral, studied with Fernand Léger in Paris, as well as with other mentors. At that time, she also developed an interest in psychology and that branch of cellular

biology known as endoplasty and applied both to her art.[20] Endoplasty refers to a network of membranes within a cell other than the cell's nucleus. She applied this concept to her early aluminum sculpture and conceived of each piece as a flexible network of interconnected planes analogous to the cellular membranes. The planes of her sculpture, like the endoplastic membranes, are organically connected, with one part affecting another.[21]

Before 1959, Clark was a concrete painter, although even then she thought of the drawn lines dividing one geometric shape from another as "organic." It was but a short step from these painted flat planes to the three-dimensional, hinged, articulated aluminum *bichos* (animals) (FIG. 9.3), because the hinges act as a "spinal cord" and the "parts are functionally related to each other, as if he were a living organism" (she referred to them as masculine). In turn, a new relationship is formed between spectator and "animal,"

FIGURE 9.3
Lygia Clark, *Pintura concreta [Concrete Painting]* and *Bicho [Animal]*, 1959–1963, industrial paint on celotex, wood, and nulac (60 × 60 cm. / 23⅛ × 23⅛ in.), and aluminum sculpture (varying dimensions). Courtesy Alvaro Clark, Rio de Janeiro. Photo: Vicente de Mello.

FIGURE 9.4
Lygia Clark, *Obra mole
[Grub]*, 1964, rubber,
142 × 43 cm. / 55⅞ × 17 in.
(variable according to
configuration). Museu de
Arte Moderna, Rio de
Janeiro, donated by the
artist. Courtesy Alvaro
Clark and Margareth de
Moraes. Photo: Vicente
de Mello.

possible because "the animal moves."[22]
There was no wrong or right side to the
bichos. They could be bent at will into any
number of different arrangements.

After 1964, Clark abandoned metal for
softer, more palpable materials—rubber,
fabrics, plastic bags, sand, stones, or
shells. Among the first of these was *Obra
mole [Grub]* (1964; FIG. 9.4), one of a
series of green rubber pieces cut spirally
out of a circle, so that it fell naturally into
undulating configurations that could be
manipulated or that depended on a host,
such as a tree trunk, for completion. The

Grubs were "animals without a spine."
Although these works might be com-
pared to Robert Morris's felt pieces of
the 1960s, the point of Clark's *Grubs* was
their dependence on another entity
rather than their existence as indepen-
dent objects. This idea led Clark in 1967
to make "vestiary" sculpture in the form
of clothing, tents, hoods, or gloves,
which required human participation to
give it meaning.

The focus on the role of the spectator
in Clark's work after 1966 took two
directions: the first consisted of "rela-
tional" objects for the spectator to hold,
in which the act of handling and the sense

of touching were central; the second, of clothing in which the wearer/spectator became the sculpture. In the first category, *Ar e pedra [Air and Stone]* (1966; FIG. 9.5), a bag filled with air and a large pebble embedded into it for the participant to hold and press with both hands, was designed to evoke erotic associations. This and other works of this period exemplified some of Gullar's statements in the 1959 Neoconcrete Manifesto: "We do not conceive of a work of art as a 'machine' or as an 'object,' but as a 'quasi-corpus' [quasi-body], that is to say, something which amounts to more than the sum of its constituent elements, but which can only be understood phenomenologically. We believe that a work of art represents more than the material from which it is made."[23] Both Clark's and Oiticica's work was nurtured on Gullar's (and Maurice Merleau-Ponty's) phenomenological theories, which addressed human response and the senses.

Merleau-Ponty rejected the Cartesian dualism of mind and body by stressing the importance of the body as a unified organism and of its role in perception. He denounced the notion of the superiority of purely visual perception in favor of polysensorial experience. Sensations were not in opposition to the intellect but part of a broader-based experience involving all the senses. His belief was at odds with Freud's concept of a preconditioned unconscious motivating human response and behavior. Rather, a perceptive reflex mechanism allowed for a reinvention of one's responses to more recent data.[24] These beliefs were central to Clark's and Oiticica's work of the 1960s.

In 1966, these two artists collaborated on *Diálogo de mãos [Dialogue of Hands]* (FIG. 9.6), an elastic Möbius loop to be worn by two people. This work depends entirely on the momentary experience of physical communication between the participants in a nonverbal dialogue. In Guy Brett's words, "The hands, their sensations and movements, become the sculpture, intensified by the band which

acts like a hinge," in this case, the hands of Clark and Oiticica joined by the loop in a well-known photograph. Brett defined Clark's and Oiticica's work as "a kind of kineticism of the body" specific to Brazil.[25] Although *Diálogo de mãos* is characteristically neoconcrete and ephemeral (it must be cut to be removed), its source in Max Bill's *Tripartite Unity* (see FIG. 9.1) and other loop sculptures of the late 1940s cannot be dismissed.

By 1967 Clark gave up the use of ob-

FIGURE 9.5
Lygia Clark, *Ar e pedra [Air and Stone]* (destroyed), 1966, inflated plastic bag and stone. Courtesy Alvaro Clark, Rio de Janeiro.

FIGURE 9.6
Lygia Clark and Helio Oiticica, *Diálogo de mãos [Dialogue of Hands]*, 1966, elastic Möbius band. Courtesy Projeto HO (Helio Oiticica Archives), Rio de Janeiro.

jects as intermediaries between the spectator and his/her sensations and instead produced sensorial masks for two or more people. These included magnetized cavernous enclosures that either attracted or repelled its two participants—gloves with two hands sewn together or overalls that look like space suits—and were designed to produce unexpected responses in the participants.[26] In her vestiary sculpture and performance phase, she considered "the body as house." In 1969, Clark explained that

in the sensorial phase of my work, which I named nostalgia of the body, the object was still an indispensable medium between sensation and the participant. Man found his own body through tactile sensations performed on objects external to himself.

Then, I incorporated the object by making it disappear. From then on, it is man who seizes his own eroticism. He himself becomes the object of his own sensation.[27]

Her works of this phase had two main objectives: to eliminate the artist as sole creator within a "disintegrating social organism," and to engage the spectator in the art experience "by attempting to release a general creativity without psychological or social limits. His creativity will express itself in what is lived."[28] Her belief in the human as a creative biological and psychological being and her rejection of the current social system also had elements of Oiticica's anarchism.

Between 1968 and 1971, Clark and several other Brazilian artists and intellectuals living in Paris at the time incorporated their human audience into collective situations involving clothing or containers as a means of expressing defiance of traditional art values and roles. Lygia Clark's *Parelha [Couple]* (1969) consisted of a complex of different fabrics and sacks sewn together to incorporate a seated woman and a standing man who pulled the whole structure—woman included—with him as he moved.[29]

Helio Oiticica's focus on the spectator as active participant had parallels in Brazilian theater and education, for instance, in Augusto Boal's experiments in populist theater and Paulo Freire's revolutionary educational methods developed to combat illiteracy in Brazil and other Third World countries.[30] But it also had its

roots in Ferreira Gullar's statements in the Neoconcrete Manifesto: "The notions of time, space, form, colour are so integrated . . . , that it is impossible to say art could be broken down into its constituent parts. Neoconcrete art affirms the absolute integration of those elements."[31] Oiticica (1937–1980) focused on three major premises: the fusion of art and audience, behavioral freedom, and total sensorial experience. Sometimes a work incorporates all three.

In spite of his own upper-middle-class background (he came from an intellectual family), Oiticica opposed bourgeois values and political oppression. He was the son of an entomologist, painter, and photographer, and the grandson of a well-known Rio anarchist. His work was colored by his own anarchistic tendencies on both a personal and a social level.[32] He had studied in 1954 with Ivan Serpa, whose painting Formas [Forms] (1951; PL. 9.1) was exhibited in the First São Paulo Biennial. Oiticica began his career as a concrete painter, but he joined the future neoconcrete artists after participating with them in the second exhibition of the Grupo Frente in 1955.

In 1957, Oiticica began a series of gouaches titled Metaesquema [Metascheme] comprising solid red or blue shifting rectangles distributed across the white surface of the paper in vertical and horizontal formations (like the Venezuelan geometric artists, he was an admirer of Mondrian). The blue and white Metaesquema (1958; PL. 9.2) is an example of this series. By 1959, in a parallel to Lygia Clark's artistic transformation from concrete to neoconcrete, he had converted the rectangles of his paintings into three-dimensional works. Variously titled Bilaterais [Bilaterals], Relevo espacial [Spatial Relief], and Núcleo [Nucleus], these works consisted of painted wooden panels suspended from the ceiling. The largest of these ensembles, Grande núcleo [Grand Nucleus] (1960–1963; PL. 9.3)—first shown in 1960, and again in 1964 and

PLATE 9.2
Helio Oiticica, Metaesquema [Metascheme], 1958, gouache on paper, 55 × 64 cm. / 21⅝ × 25⅛ in. Courtesy Projeto HO (Helio Oiticica Archives), Rio de Janeiro. Photo: Author.

PLATE 9.3
Helio Oiticica, Grande núcleo [Grand Nucleus], 1960–1963, oil on wood panels, varying dimensions. Whitechapel Installation, London, 1969. Courtesy Projeto HO (Helio Oiticica Archives), Rio de Janeiro. Photo: Helio Oiticica.

FIGURE 9.7
Helio Oiticica, *Tropicalia*,
1967, exhibited in the
*Nova Objetividade
Brasileira [New
Brazilian Objectivity]*
exhibition at the Museu
de Arte Moderna in Rio
de Janeiro in 1967.
Courtesy Projeto HO
(Helio Oiticica Ar-
chives), Rio de Janeiro.
Photo: Cesar Oiticica
Filho.

1969—was his first penetrable. He adopted the latter term in 1962 to describe any defined space through which spectators could walk. The effect on the spectator moving about in this room-sized space was like walking through a painting that ranged in shade from light to intense yellow bordering on orange. The experience was also more than visual. A bed of sand underfoot and the progressive color intensities affected one's perception of temperature as well as senses of vision and touch. Although Soto and Cruz-Diez had sought an analogous effect with their later penetrables, they did not achieve the total fusion and delicate orchestration of sensory experience that Oiticica did.

In 1963, possibly prompted by Ferreira Gullar's "Teoria do não-objeto" (Theory of the non-object), Oiticica began making the *bolides* (fireballs or flaming meteors). These consisted of containers such as glass jars filled with earth or pigments and gauze or wooden boxes with detachable compartments or drawers containing colored powders, mirrors, and photos for spectators to experience sensorially as they opened them and manipulated their contents. He chose the generic name *bolides* for the containers because they reminded him of the phenomenon of light consuming color, and he also thought of them as "energy centers."[33] For instance, *Poema caixa [Box Poem]* (1966) contains a clear plastic bag filled with light blue pigment. As the spectator pulls it out of the box, the words "through my blood, through my sweat, this love will live" appear written across it. One experiences simultaneously the tactile, the visual, and the act of reading. These containers or "trans-objects" were intended to give concrete body to color as an entity as well as to become the agents of multisensorial experience. The latter was enhanced by the works' im-

mense aesthetic appeal, an aspect more often avoided by contemporary U.S. artists at the time but one that was a common factor in Oiticica's and later Brazilian artists' art as part of a strategy of seduction.

The turning point in Oiticica's development as an artist occurred in 1964 (the year the military regime took over in Brazil) when a friend introduced him to Mangueira Hill, one of Rio's best-known and oldest slums. Following what Brett described as a "painful initiation," Oiticica broke through the social barriers, joined Mangueira's Samba School, and eventually acquired the rank of *pasista* (a leading dancer in a carnival samba procession) in the school. Believing that "intellectual differences are the cause of unhappiness," Oiticica, who befriended several of Mangueira's inhabitants, came to see these people from the point of view of an insider. His 1964 work was guided by his awareness of the meaning of samba as Mangueira's collective myth and of its role in establishing a relationship among its inhabitants as well as between them and the outer world.

He devised a type of cape, the *parangolé,* which, according to Guy Brett, is an untranslatable word conveying something like "agitation" or "the interior feelings and expressive panache of putting something on the body."[34] The *parangolés* were made of polyethylene, gauze, burlap, straw, silk, muslin, nylon net—materials of the type used by Mangueira inhabitants to divide communal spaces inside their shanties. The *parangolés* variously took the form of standards, banners, fabric body covers with hidden pockets containing pigments, as well as capes to be worn, moved, and danced in. Some of these *parangolés* were made for specific individuals and sported words or phrases relevant to their lives such as "I am possessed," "Of adversity we live," "We are hungry," or "I embody revolt" (PL. 9.4). Like Clark's *bichos,* the *parangolés* were reversible, had no wrong side, and could be worn in any direction. Their colors—salmon, green, pink, red, yellow, or pale blue—were often the identifying colors of particular samba schools. Mangueira's colors were pink and green.[35]

The friends Oiticica had made in Mangueira included outlaws and criminals sought by the police or already in jail. Far from seeing them as public enemies, he empathized with them. Their condition, he felt, was not a matter of law and order but a result of oppression. One of these figures was Cara di Cavalho (a nickname meaning "Horse face"), who was subsequently shot by death squads. Oiticica had found it difficult to reconcile the person he talked to as he would have to any one else with the public enemy wanted by authorities. Cara di Cavalho's violent end inspired Oiticica to make something of a martyr figure of him by dedicating three of his works to him. One of them consists of a red banner with the words "seja marginal seja herói" (be marginal be a hero); two others are box-poems. In *Box Bolide 21 [Box-Poem 21]* (1966–1967), the photographic image—taken from a newspaper—of Cara di Cavalho's dead Christ-like body, sprawled on the ground with outstretched arms, is revealed lying beneath shallow water as the spectator lifts out a second box filled with earth. The work-as-box in this case is a metaphor for burial.[36]

Although Oiticica was not yet known abroad in the 1960s, his reputation was established in Brazil when he showed *Tropicalia* (FIG. 9.7), a tentlike environment first shown in the 1967 *Nova Objetividade Brasileira (New Brazilian Objectivity)* exhibition at the Museu de Arte Moderna in Rio. *Tropicalia,* which consisted of two penetrable booths, was designed to evoke the materials of the *favela* (shantytown) without resorting to folklorism. The booths were made of wooden frames draped with colorful printed fabrics. The floor consisted of dirt, sand, and pebble pathways interspersed with tropical plants, hidden poems, and live macaws in a large cage.[37] The inscription "purity is a myth" appears above a partition. As par-

ticipants walked through the interior spaces, they encountered plastic bags filled with dirt or powdered pigment to be felt or looked at, then they were led through a dark, labyrinthine passage into a small space where a working television awaited them. There they fell into "a brutalist state" as they were devoured by the images on the TV.[38] This symbol of mass communication and modernity juxtaposed with the shantytown structure dramatized the paradox of existing social contradictions between the active and the passive, as well as alienation, as the images on the screen dazed and engulfed the viewer.[39]

As a reflection of a Third World aesthetic, *Tropicalia* became a model for Gilberto Gil's and Caetano Veloso's musical group Tropicalia, launched in 1968. Although these musicians were more overtly political than Oiticica, the title of Caetano Veloso's song "E proibido proibir" (It is forbidden to forbid) embodied many of Oiticica's anarchistic beliefs in addition to references to "censorship of the arts and the media" in Brazil at the time.[40]

In 1969, Oiticica exhibited at the Whitechapel Gallery in London. The "Whitechapel Experience," as he called it, incorporated most of his previous penetrable works into a total environment

under the general title *Eden,* because it contained "nuclei of leisure," and people could experience "sensorial" pleasure without guilt. A box *bolide* or *bolide* bed and nests, which were large-scale versions of the earlier *bolides,* beckoned participants to lie inside, experience privacy, and create what they wished out of the space. Participants could contemplate leisure in a *bolide* bed alone or with another person. *Tropicalia* was included and so were the *parangolés,* along with beds of sand and pigment-filled containers.

Eden was a celebration of the human body. At the time, body art was practiced in the United States as well. But there it tended to focus on the artist's own body, not the spectator's, and more often, it was not about pleasure. Vito Acconci's *Trademarks* (1970), in which the artist bit himself until he bled, then printed from the teeth marks, was considered in Brazilian terms to be a "denial of the body," not its celebration.[41] Oiticica also obliterated his role as artist-creator and instead established (or "proposed," as he preferred to say) a place where spectators could discover their own feelings, their own "interior cosmos," "sensory pleasures, or reverie."[42] The focus on the "sensorial perceptive field" and the defiance of "all political orthodoxies" present in Oiticica's work were to be influential on a later generation of Brazilians, especially the conceptual artist Cildo Meireles.[43]

In 1970, Oiticica moved to New York. During his years there, he developed several penetrable projects, most of which were never carried out and exist only as maquettes. The few environments he did produce in the United States were stripped of the exotic props of *Tropicalia* in order to discourage the possibility of having others co-opt his ideas for their superficial appeal. Instead of flowery fabrics and other tropical props, Oiticica used plain materials such as translucent plastic sheets to divide spaces. An example was *Rhodislandia* (1971), a large environment designed with the help of

PLATE 9.4
Helio Oiticica, *Parangolé* (Nildo de Mangueira wearing P 4 cape 1, "I embody revolt"), 1964, straw, stuffed burlap. Courtesy Projeto HO (Helio Oiticica Archives), Rio de Janeiro. Photo: César Oiticica Filho.

students at the University of Rhode Island in Kingston, Rhode Island. This work consisted of cubicles to be occupied by participants who were invited to use them as they wished. During the period of the exhibition, participants made something personal of their space by responses such as bringing in plants that made it look like an aquarium from the outside.[44]

Oiticica also designed circular or square penetrable structures comprising narrow passageways denuded of all props except for the sand or gravel on the floor and a few plants. These penetrables addressed behavioral—more than sensorial—questions treated in Merleau-Ponty's *Structure of Behavior*. They were intended for the participants' discovery and contemplation of themselves under different circumstances, alternately as observers then as actors as they moved through a narrow corridor. Two penetrables (never executed), *Autoperformance* and *Nada,* exemplify Oiticica's behavioral preoccupations of the early 1970s under the general title of *New Yorkaises. Auto-performance* (FIG. 9.8), also identified as *PN 15,* is a circular space designed so spectators first contemplate through a wire mesh enclosure other participants inside it. Then they were to proceed along a narrow passageway to a small central stage, with a wall on one side for slide or film projections and a space for electronic equipment, where these same spectators could become the performers, who in turn were to be observed by others. Thus participants alternated between a passive and an active role.

What characterized most of Oiticica's penetrables was the degree of behavioral choice they allowed. Where *Autoperformance* allowed for some freedom of choice, *Nada [Nothing],* also known as *PN 16,* did not. It was to be an all-black, square labyrinth divided into narrow passageways that led through three main spaces in which the word *nada* was to be contemplated by its participants. They were to follow a predetermined path through the three black rooms. In the first, powerful flood lights were designed to cast ominous shadows on the walls as the spectators filed through clicking their heels on the metallic floor as they walked

FIGURE 9.8

Helio Oiticica, *Autoperformance* (also *PN 15*), from the *New Yorkaises* series of subterranean Tropicalia projects, 1971, maquette for *PN 15,* cardboard and wire mesh. Courtesy Projeto HO (Helio Oiticica Archives), Rio de Janeiro. Photo: Author.

on to the second; in the last room, rows of microphones were to be set up diagonally across its length, and the participants were to be asked to speak about *nada*'s meaning by limiting the word to its dictionary definitions. Although this idea had some relationship to the antiromantic objectives of concrete poetry, it exceeded the latter in its restrictive options. In a final nihilistic act, the tapes were to be erased and reused, leaving no record of the experience. This penetrable was originally planned as part of a 1972 exhibition in São Paulo's Praça da Republica to commemorate the fiftieth anniversary of the Semana de Arte Moderna of 1922 that had taken place in the same location. Although it is tempting to give this project a political interpretation, its abrupt cancellation was apparently for financial, rather than political, reasons.[45]

The neoconcrete artists' belief in the creative potential of individuals from all walks of life led the Rio artist and critic Frederico Morais to organize a series of Creative Sundays in 1971 on the grounds of the Museu de Arte Moderna in Rio. Morais felt that a museum's role should extend beyond its traditional function of guarding and conserving works and should also include programs for public participation. To this end, he organized a series of activities that encouraged participants to create works out of materials distributed free of charge. These included salvaged refuse, scrap iron, string, paper, crayons, and fabrics. People could work individually or in groups. The purpose was not to make objects but to test their resourcefulness in devising situations whose "existence and development [depended] on the level of participation." The success of this venture can be measured by the attendance, often numbering from two to five thousand participants on a given Sunday.[46] In spite of the populist character of these events during a time of intense repression in Brazil, they were apparently not considered threatening to the government, since they were not overtly political.[47] Art thus

directed to the general public had as its objective to give people, more often docile and conditioned by the media, a sense of self-sufficiency and effectiveness in the control of their own lives.

OFFSHOOTS OF CONCRETE AND NEOCONCRETE ART

Both concrete and neoconcrete art made an impact on numerous other Brazilian artists not directly affiliated with either group. The Rio artist Rubens Gerchman (b. 1942) was one of them. His painting and sculpture based on populist themes and his political beliefs followed those of the neoconcrete artists, while his sculpture with letters was derived from concrete poetry. His work of the 1960s addressed issues of mass culture: the collective activities of Sunday crowds at football games or of people persecuted by the Rio police or isolated and alienated in an urban environment. He used faces taken from news photos, which he reproduced as multiple painted images in a comic-strip style. Instead of the well-known personalities represented by Andy Warhol (Marilyn Monroe, Jackie Kennedy, Elizabeth Taylor), Gerchman's images were of anonymous individuals or underworld characters with criminal records taken from the news media, people with drab lives suddenly caught in some newsworthy incident or listed among the disappeared.

Like Oiticica, Gerchman made boxes and containers in varying sizes destined to be opened by the spectator. Some of the boxes contained microcosmic "memories," others, a talisman or a poem.[48] Between 1966 and 1968, he produced a series of mixed media collages on wood, generically titled *Caixa de morar [Box to Live In]* in a reference to Le Corbusier's description of houses as "machines to live in." But these boxes are two-dimensional paintings whose cubic space is defined in illusionistic perspective by strips of wood within which faces, cutouts of wood escutcheons, mirrors,

and postcard views blended with painted abstract shapes, including stripes, occupy the separate compartments. Mario Pedrosa defined this series as representing "boxes of underdevelopment," examples of urban isolation and alienation.[49]

One work in this series, *O rei do mau gosto [The King of Bad Taste]* (PL. 9.5), was originally exhibited in the *Nova Objetividade Brasileira* exhibition of 1967 along with Oiticica's *Tropicalia. O rei do mau gosto* was inspired by Oswald de Andrade's 1934 play *O rei da vela* (The king of the candle), a satire on the bourgeoisie and industrial tycoons like the "match king" set in a grotesque tropical paradise.[50] In Gerchman's work, a postcard view of Rio's bay, with palm trees and the Sugarloaf in the background, framed on either side by images of parrots, dominates the center of the painting. Vasco da Gama's[51] escutcheon (symbolizing colonization), an overly decorated mirror, and anonymous faces appear in the other compartments. The words "box and culture" above refer to the crass taste of the newly rich. Although not the only source, this work contributed to the spread of kitsch in Brazilian painting after the mid-1960s. A form of pop art based on the comic strip had made incursions in Rio in the early 1960s. Although *O rei do mau gosto* would seem to fit the U.S. definition of pop, it typifies a Brazilian version that was more often about people and events in the news media than about consumer goods.

In his work of 1967 to 1973, Gerchman incorporated letters and words in paintings, photographs, and sculpture. The sculptural works included *Terra, Lute,* and *Sos,* all from 1967. *Terra [Earth]* consists of hollowed letters appropriately embedded in a red box of dirt. *Sos* (plural of *só,* or "alone") is thematically related to his *Boxes to Live In* in its reference to urban alienation. It has large, blocklike, black polished wood and Formica letters spread out along the floor like furniture. The large red letters spelling *Lute* ("struggle, fight"), exhibited in the Museu de Arte de São Paulo in 1974, have the

makings of a political imperative.

In New York, where Gerchman lived from 1968 to 1973, he produced several works with word combinations using English instead of Portuguese to accommodate his new audience, but without changing the populist nature of his intent. Artists shown in New York such as Bruce Naumann and Robert Indiana were also using letters at the time. But Gerchman's works in this category were clearly indebted to concrete poetry. *Skyeyeyellowline* (1970; FIG. 9.9), whose original title is in English, played visually with the letters *e* and *y* in quick succession. The letters, painted yellow with blue sides, and their relative location suspended from the ceiling and stretching across the floor illustrated the composite word's

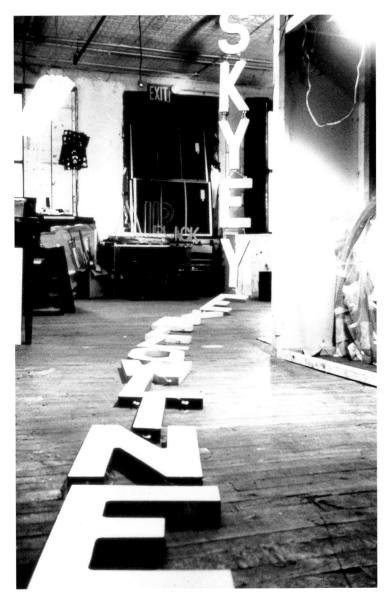

FIGURE 9.9
Rubens Gerchman, *Skyeyeyellowline,* 1970, wood and Formica letters painted yellow with blue sides. Courtesy Rubens Gerchman, Rio de Janeiro.

PLATE 9.5
Rubens Gerchman, *O rei do mau gosto [The King of Bad Taste]*, 1966, acrylic, decorated mirror, painted wood cutouts on wood, 200 × 200 cm. / 78¾ × 78¾ in. Courtesy Evandro Carneiro, Rio de Janeiro. Photo: Vicente de Mello.

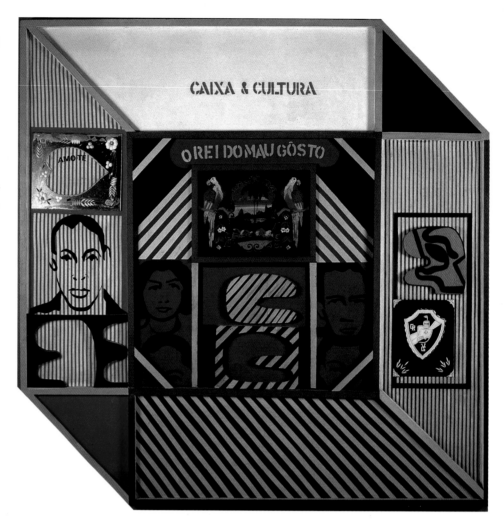

meaning. *Sky* hangs high with its blue side showing, *eye* is at eye level, *yellow* is the main color, and *line* refers to the portion that extends along the floor toward the viewer. Another of these works, titled *Spelling Book Project: House* (1972), painted in primary colors, consists of interlocking letters that can be assembled in various combinations like building blocks. The didactic character of this work is potentially—at least symbolically—directed to an illiterate or youthful audience, something like Ligia Pape's *Livro da Criação* (both Pape's and Gerchman's work was seen primarily in museum settings in Brazil), and is accessible to a general audience.

Between 1969 and 1971, some of Gerchman's work with letters also addressed issues of Latin America's relative geographic location in the Southern Hemisphere (a concern shared earlier by Torres-García and Oswald de Andrade,

both of whom Gerchman acknowledged as sources in his work). Others of his compatriots had similar preoccupations during the same years, including Oiticica and Meireles.[52] Two of Gerchman's works on this theme are plays on the letter *s*. In *Sinuous Snake* (1969), a steel letter is embedded in sand inside a rectangular box with the words *snake, sinuous,* and *sign* etched along the latter's surface, suggesting something both erotic and primitive. This letter recurs in *Americamerica (Homage to Oswald de Andrade)* (FIG. 9.10) of the same year, as words beginning with *s* are revealed by lifting a black cross (the Southern Cross) by its vertical arm out of a cruciform cradle in a box. The words *sand, sound, sun, soul, south,* and *salt* are printed along the arms of the depressed cross, and the combined name "Americamerica" is in the center. Gerchman cel-

ebrated the appealing connotations of the *s* as identified with the (S)outhern Hemisphere. The work's title also collapses the hierarchical connotations of North and South America (South America at the bottom) in the doubling and joining of the name "America."

Two other artists whose development paralleled the transition from concrete to neoconcrete art in a less socially oriented, but no less culturally significant, manner are Alfredo Volpi and Ione Saldanha. In the 1950s, both artists had depicted house facades in two-dimensional, frontal, geometric compositions that recalled similar scenes of São Paulo by Tarsila do Amaral. Volpi (1896–1988)—twenty-five years older than Saldanha—was born in Italy and taken to Brazil as an infant. His early work was naturalistic, but by the late 1940s he had focused on Brazilian themes in a stylized manner that betrayed his liking for popular art. From the 1950s on, his subjects included images of saints painted in a naïve style and house facades.

By 1957, facades were his main subject. He painted them in increasingly abstract configurations with fresh, sparkling colors. These facades consisted of windows, doors, pennants, flags, or masts arranged into colorful, rhythmic patterns

over flat surfaces, with the colors formally held in balance. Volpi was in direct contact with the concrete artists. In 1959, the painter Hermelindo Fiaminghi and the poet Decio Pignatari had shared his São Paulo studio for a while.[53] But instead of the hard-edged, mechanical appearance of concrete art, Volpi applied a free hand, allowing for irregularities of shape and color and visible brush strokes in order to assert the primacy of human agency. His colors were the festive folk colors of popular art prevalent in small coastal towns, especially in the northeast of Brazil.

PLATE 9.6

Alfredo Volpi, *Bandeirinhas verdes sobre rosa [Small Green Pennants on Pink]*, c. 1957, oil on canvas, 50 × 73 cm. / 19¾ × 28¾ in. Collection Adolfo Leirner, São Paulo. Courtesy Sociedade para Catalogação da Obra de Alfredo Volpi, São Paulo. Photo: João Musa, São Paulo.

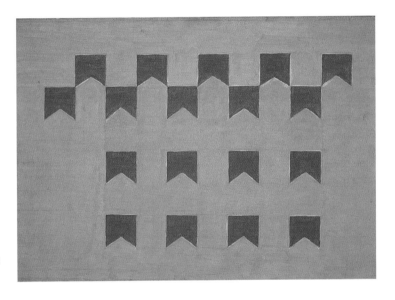

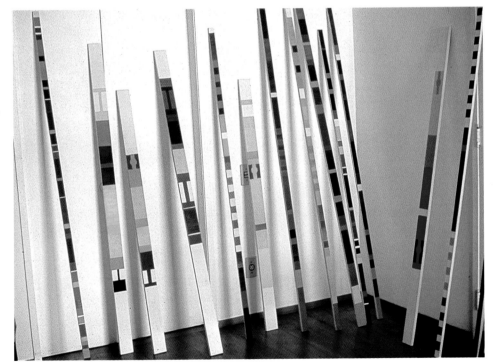

PLATE 9.7

Ione Saldanha, *Ripas [Slats]*, 1965–1969, acrylic on wooden slats, varying sizes, artist's studio, Rio de Janeiro. Courtesy Ione Saldanha. Photo: Author.

FIGURE 9.10
Rubens Gerchman,
*Americamerica (Homage
to Oswald de Andrade),*
1969, Formica, wood,
and sand, 63.5 × 63.5 ×
53.25 cm. / 25 × 25 × 21 in.
Courtesy Rubens
Gerchman, Rio de
Janeiro. The two photos
show the work open and
closed.

The pennants in his paintings are pat-
terned on the paper pennants—a familiar
sight in Brazil—displayed during tradi-
tional popular celebrations as well as on
the flags that decorated the facades of
colonial and imperial buildings. His
choice of these innately flat subjects freed
him to explore diverse color combina-
tions, sometimes with optical effects. In
*Bandeirinhas verdes sobre rosa [Small Green
Pennants on Pink]* (c. 1957; PL. 9.6), the
green and adjacent pink with the same
tonal value (a strategy often used by
Volpi) provoke afterimages. Most of his
works, including *Fachada azul con ban-
deiras [Blue Facade with Pennants]* (1959)
and *Bandeirinhas brancas [White Pennants]*
(1968), also emphasize the celebratory
nature of his themes, rather than their
geometric patterns.[54]

Ione Saldanha (b. 1921) shared with
Volpi and other artists an interest in
subjects and materials taken from familiar
Brazilian sources. Her work, like Volpi's,
evoked the festive appearance of Brazilian
popular culture through color and her
particular choice of natural materials.
Originally from a landowning family in
the southern state of Rio Grande do Sul,
she moved to Rio in the 1930s as a child.
In the late 1940s and early 1950s, after
first studying in Rio, she traveled to Italy
and France, where she especially admired
Henri Matisse's use of color.[55]

Saldanha's work evolved in the mid-
1950s from paintings of house facades to
simple patterns of horizontal stripes in
vertical formations. This phase of her
work corresponded to concrete art, but
she, too, avoided the mechanical aspects
of geometric painting by allowing the
brush strokes to show. By the 1960s, she
had substituted wooden slats and, later,
bamboo for canvas. In 1967 she began a
series of *Ripas [Slats]* (PL. 9.7), which she
painted with brightly colored, horizontal
bands and, in some cases, with irregular
emblemlike shapes across a white back-
ground to enhance luminosity.

The slats were invariably displayed in
artfully orchestrated accumulations
against a wall. Unlike the U.S. minimalist
John McCracken, whose large, industri-
ally made urethane foam and fiberglass
planks set against a wall were designed to
aggressively challenge the viewer's sense
of scale in a gallery space,[56] Saldanha's
aesthetically pleasing, narrow, decorative
slats pay homage to the vegetable nature
of wood and the festive colors associated
with Brazilian popular culture. Poten-
tially, her slats could also be manipulated
and shifted around by a spectator.

In 1968, she switched from *ripas* (slats)
to painted *bambus* (cut bamboos). Her
love of natural materials corresponded to
her attachment to the earth, because she
always wanted "to feel my feet in the
earth, to feel the earth, to hold some
earth in my hand, to sit under a tree
while at the same time placing my hand
against the tree to feel it palpitating."[57]

PLATE 9.8
Ione Saldanha, *Bambus [Bamboos],* 1969–1971, acrylic on hollowed, treated bamboo segments, varying sizes, artist's studio, Rio de Janeiro. Courtesy Ione Saldanha. Photo: Author.

PLATE 9.9
Rubem Valentim, *Pintura [Painting],* 1965, oil on canvas. Courtesy Lia Bicca de Alencastro, Rio de Janeiro.

PLATE 9.10
Rubem Valentim, *Totem,* c. 1974, painted wood. Courtesy Museu Nacional de Belas Artes, Rio de Janeiro. Photo: Vicente de Mello.

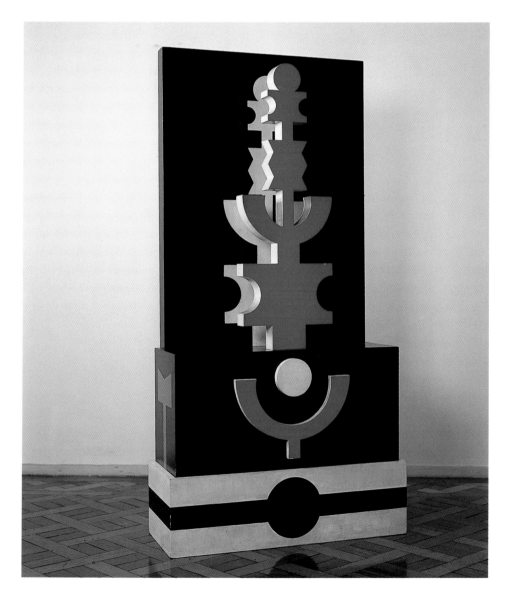

The organic nature of Saldanha's *Bambus [Bamboos]* is especially significant when compared with Max Bill's *Painting in the Form of a Column* (1947–1948), shown in São Paulo in 1950. Bill's man-made standing cylinder, measuring eleven and one-half feet in height, is meticulously painted on its entire surface with interweaving vertical and horizontal bands of bright color.[58] Saldanha avoided the industrial appearance of Bill's column by respecting the natural divisions of the bamboo segments, which led to considerable irregularities in the painted bands. Her transition from painting to three-dimensional organic objects (bamboo) parallels Lygia Clark's development from her structured paintings to the *Bichos*, grubs, and relational objects.

Saldanha's preparation of the *Bambus* (1969–1971; PL. 9.8) prior to the final painting is laborious, and the process of making art out of them is intrinsic to their meaning. She collects the bamboos in Rio's Botanical Gardens with official permission to prune the plants. She then hollows out the cut segments in her studio, sands them, then, after a drying period of several months, applies several coats of white paint as a primer before finally painting the bands in acrylic colors. At first she exhibited these bamboos suspended in clusters from the ceiling. But by 1969 she began leveling them at the base so they could be free-standing. *Doze bambus [Twelve Bamboos]*, for which she received an award at the 1969 São Paulo Biennial, stands like a brightly colored forest transferred to an interior setting and can also be walked through.

When in the early 1970s Saldanha ran out of bamboos, she found a substitute in the *bobinas* (empty electric cable spools). These came in a variety of sizes ranging from about forty inches to twelve feet in diameter. Over a base color she painted on both sides concentric designs radiating from the center in patterns evoking the large paper decorations used on Rio carnival floats. By exploiting the roughness and irregularities of the wood, she stripped the spools of their industrial function and returned them to their original vegetable nature as parts of a tree with a new life. In another parallel with Volpi, her *bobinas*, like the *bambus* and *ripas*, evoked popular Brazilian festivals.[59] Thus the *bobinas*, usually exhibited in clusters like the wheels of gigantic carts, were transformed from symbols of modern industry into ritualistic objects.

The emblemlike patterns on some of Saldanha's *ripas* and *bambus* and in Volpi's paintings find common ground in the work of the Bahia artist Rubem Valentim (1922–1991). But Valentim's paintings and serigraphs of geometric patterns are very consciously based on Afro-Brazilian symbols rather than on the more general ones of popular culture. He chose to create "an authentic Brazilian art language" through the incorporation of "profound mystical values of Afro-Brazilian culture, mestizo, animist, fetishist." Proud of his Afro-Brazilian heritage, he once stated that "I am from [Salvador] Bahia, I love Rio de Janeiro, I always had an eye and a part of my heart in the Brazilian northeast and I live in Brasília."[60] He had moved to Brasília in 1966 after a three-year stay in Rome, Italy.

Although he had associated with Theon Spanudis, a former member of the Rio concrete art group, as well as with the neoconcrete poet Ferreira Gullar, by his own statement, Valentim was never a concrete artist. His concerns were with "content, mystical impregnation, an awareness of the conscience of our cultural values, of our people, of our sense of being Brazilian." But he also believed in structure, and his work is generally considered in that light.[61] In the late 1950s, he incorporated totemic imagery in constructivist paintings, and by the mid-1960s, he had developed the structure/image synthesis that came to characterize his mature style.

Brought up in the Bahia tradition of *candomblé*, he sought to incorporate its symbols into geometric configurations. These included attributes of African gods

such as triangles, rectangles, circles, arrows, scepters, and hatchets, all of which he used in his abstractions. Valentim did not reject the mechanical symbols of modernity as did some of his colleagues. He combined logotypes (usually a print of a composite emblem) with signs whose underlying meaning is disguised by the work's mechanical appearance so as to avert all evocations of folklore. He shared this preoccupation with other Afro-Brazilian artists from Bahia who chose to "disarticulate the local artistic feudalism which explored folklore for its own interests" by opting for geometric abstraction.[62]

Valentim was well versed in ways to preserve the two-dimensional surface and abstract design. His paintings and serigraphs consist of solid-color (often red) backgrounds, over which he painted emblematic figures. Arrows, a double hatchet, and an altar can be identified in many of his paintings. In *Pintura [Painting]* (1965; PL. 9.9), a tempera on canvas, four totemic figures appear on either side of a central pole over a rectangular altar. Two arrows beneath the figures are the attributes of the hunter god Oxossi, and a double hatchet is an attribute of King Xangó, one of the major figures of the Afro-Brazilian pantheon. An altar and a double hatchet are also visible in the acrylic and ink painting *Emblema (Logotipo poético) [Emblem (Poetic Logotype)]* (1974) but in very schematic form, reduced to their simplest geometric components. Like Volpi, Valentim chose subjects taken from Brazilian lore that, by their nature, lent themselves to two-dimensional abstraction without sacrificing their intrinsic meaning. For Valentim in particular, the content of painting took precedence, no matter how reductive the form. By the 1970s, he also made wood reliefs and sculptures in altarlike compositions surmounted by cutout shapes

similar to those he had painted. *Totem* (c. 1974; PL. 9.10) is a three-dimensional version of his logotypes, but its identity as sculpture emphasizes its magical and religious symbolism.

SUMMARY

The constructivist basis of concrete and neoconcrete art was even evident in the work of Brazilian artists who worked outside the boundaries of abstraction. After 1959, Djanira da Mota e Silva (1914–1979), a Rio-based figurative painter of *candomblé* and other popular Brazilian scenes, used bright, flat colors in compositions reduced to carefully orchestrated geometric patterns.

The single thread running through the work of all these artists is their independence from contemporary international currents, even though they produced art within the framework of contemporary modes such as minimalism and body art. However, in their geometric art, the Brazilians did not sacrifice associative legibility. In body art, they did not focus on their own bodies but on those of the spectators, while the artists remained virtually out of sight. In Brazil, all these tendencies fell within the parameters of concrete and neoconcrete art. But it was neoconcrete art in particular that left its mark on Brazilian art of the following decades. In the 1950s and 1960s, whether art left the pedestal for the street or was based on a vocabulary of popularly recognizable signs, many Brazilian artists sought to reach a segment of the population traditionally excluded from art discourse by tapping familiar frames of reference or by including members of this population in the process.

TEN

NEOFIGURATION, REPRESENTATIONAL ART, POP, AND ENVIRONMENTS

THE 1960S AND 1970S

By the mid-1950s, geometric and informalist abstraction had gained acceptance in many Latin American countries. But abstraction failed to fulfill the needs of artists who wished for an expressive form of art that incorporated the human figure. However, they did not want to return to the social and political figuration of the 1930s and 1940s but sought instead to portray the contemporary condition of the urban dweller in a world no longer determined by cosmic order but by individual subjective experience. To fulfill this need, artists took up neofiguration, assemblage, and local variations of pop and environments, some of which also incorporated the spectator. Some type of figuration with varying degrees of expressive freedom emerged in the 1960s in several countries, especially in Mexico, Argentina, Venezuela, and Colombia. In the first three countries, this art was notable for its informal and free play of line or color derived from the vocabulary of abstraction with the added presence of images of anguished humans. In Colombia, figuration took a more academic direction and lasted through the 1970s.

NEOFIGURATION IN MEXICO

In Mexico, a young generation of neofigurative artists[1] rejected the mural painters as well as contemporary international circuits and looked instead to a past legacy of Mexican, Spanish, and Dutch graphic art and seventeenth-century painting for their sources. They found models in the work of Posada, Goya, Rembrandt, and Velázquez as well as in Picasso's blue period. But in Mexico they also relied on literature, contemporary mass media, and film for some of their themes.

Neofiguration, a term that took root in the early 1960s to describe an expressionist type of figuration (see notes 1 and 28), was first taken up by José Luis Cuevas (b. 1933) in the 1950s. Although there was a rising market for easel painting

when Cuevas began his career, the "Mexican school" of muralism was still firmly entrenched and did not loose its grip until after Rivera's death in 1957. Prior to the 1950s, Rufino Tamayo represented the only major alternative to the muralists, and he became a model for many younger figurative and abstract artists who saw in Tamayo's work a validation of their own break with Mexico's "institutionalized" art. But Cuevas found it difficult to relate to Tamayo's brand of modernism, which was based on cubist principles. In spite of his dislike for the muralists, he felt more kinship with Orozco's existential and iconoclastic interpretation of the human species than with Tamayo's approach to the figure as a mere symbol or sign.[2]

During a bout with rheumatic fever at the age of eleven, Cuevas began drawing and reading voraciously. His readings over the years included Fyodor Dostoyevsky, the French symbolists, and, later, existentialist writers like Albert Camus and Franz Kafka, whose ideas he expressed in his drawings. Although Cuevas had tried oil painting, he opted for ink drawing and watercolor on paper because they were more intimate and direct and—according to him—more "difficult," since they could not so readily be corrected as oil.[3] In 1953, at the age of twenty, Cuevas had his first exhibition at Alberto Gironella's ephemeral Galería Prisse, a cooperative that the latter ran in Mexico City with three other artists.[4] However, Cuevas's early international fame can be attributed more to the Cuban-born José Gómez-Sicre, who, as director of the Department of Visual Arts at the Pan American Union in Washington, D.C., invited him to exhibit there in 1954,[5] and to the Argentine-born critic Marta Traba, who considered Cuevas a major representative of the new Mexican generation.[6]

In 1956, Cuevas voiced his antinationalist position in a manifesto titled the "Cactus Curtain," in which he attacked the muralists. In it he stated that he sought "the broad highways leading out to the rest of the world, rather than narrow trails connecting one adobe village with another."[7] Unlike Rivera or Siqueiros, for whom the world consisted of heroes and villains, Cuevas and his contemporaries saw the human species as victims of intangible forces like war, violence, and spiritual isolation.

As a convalescent child, he had observed the sordid world of derelicts and prostitutes from his window. These social outcasts furnished many of the subjects that would absorb him as an adult. His numerous drawings of prostitutes often included self-portraits as a way of leveling himself with his subjects. Although his early drawings of prostitutes had their precedent in Orozco's,[8] unlike the latter's usually unflattering representations of women as symbols of evil and destructive forces, Cuevas's were more often sympathetic, even tender at times. In *Retrato de Mireya con autorretrato [Portrait of Mireya with Self-Portrait]* (1950) he represented himself in a tender moment with the woman who was his model and first lover. Years later, he paid homage to Picasso's prostitutes with a 1973 series of three pen, ink, and wash drawings—*Las verdaderas damas de Aviñón [The Real Ladies of Avignon]*, *Autorretrato con las señoritas de Aviñón [Self-Portrait with the Young Ladies of Avignon]*, and *Autorretrato con las modelos [Self-Portrait with Models]*—collectively titled *Homenaje a Picasso [Tribute to Picasso]* (FIG. 10.1). These works both satirized the cubist style of Picasso's 1907 painting *Demoiselles d'Avignon* and celebrated Picasso's earlier blue and pink periods, which had included his preparatory drawings for the *Demoiselles*.

Cuevas also represented insane people as well as performers and individuals in various stages of decomposition, many of them monstrously distorted and disproportionate. He practiced a form of distortion inspired, to some extent, by pre-Columbian and Paleolithic figurines. But his distortions were also an expression of a postwar international tendency visible in the work of Francis Bacon, Fernando

FIGURE 10.1

José Luis Cuevas, *Homenaje a Picasso [Tribute to Picasso] (Las verdaderas damas de Aviñón [The Real Ladies of Avignon], Autorretrato con las señoritas de Aviñón [Self-Portrait with the Young Ladies of Avignon], and Autorretrato con las modelos [Self-Portrait with Models])*, 1973, pen and ink and wash on paper, 75 × 90.25 cm. / 29½ × 35½ in.; 40.75 × 33 cm. / 16 × 13 in.; and 33 × 40.75 cm. / 13 × 16 in. respectively, shown together at the Art Museum of the Americas, OAS, Washington, D.C. Photo courtesy Art Museum of the Americas, OAS.

FIGURE 10.2

José Luis Cuevas, *Retrato del natural. Loco [Portrait from Life. Insane Person]*, 1954, pen and ink and wash on paper, 97 × 65 cm. / 38¼ × 25½ in. Collection Jan Neff, Pennsylvania. Photo: Ron Jameson, from José Luis Cuevas, *Cuevas por Cuevas*.

Botero, and many others. He also looked to 1930s horror movies (*Frankenstein, Dracula, The Freaks*) and Hollywood movie freaks such as Joseph "Buster" Keaton and Roscoe "Fatty" Arbuckle for his distortions.

Cuevas's early work of the 1950s was based on live models. Between 1953 and 1955, he did a series of drawings of inmates in an insane asylum, to which he gained access through his brother, a student in psychiatry.[9] Cuevas viewed the insane as caricatures of normal people: "In madmen, I encounter the personages I might know at any time in life," he said.[10] *Retrato del natural. Loco [Portrait from Life. Insane Person]* (1954; FIG. 10.2)

shows an asylum inmate with the vacant smile of someone lost in his own world, alienated by his insanity.

By the 1960s, Cuevas took as his models—and paid tribute to—the work of other artists as well as his favorite writers. Literature was one of his major sources. Baudelaire's nineteenth-century work *Les fleurs du mal* (The flowers of evil), in which a rotting carcass was considered as appropriate a subject as any, was a source of inspiration, not just to Cuevas but to other artists of the younger Mexican generation as well. Cuevas was especially drawn to the existential writers Dostoyevsky, Kafka, and Camus. Kafka was the subject of a series of pen-and-ink drawings Cuevas had done to illustrate his own 1959 book, *Mundo de Kafka y Cuevas [The World of Kafka and Cuevas].*[11] A drawing from this series titled *Retratos de Kafka y su padre [Portraits of Kafka and His Father]* (1957; FIG. 10.3) shows a group of heads isolated from one

another as an allusion to Kafka's estrangement from his father. Cuevas's inclusion of a self-portrait places him amid the victims of alienation but also refers to his own parallel experience with an authoritarian father.

Like Kahlo, he used themes peculiar to Mexico within an autobiographical context. He represented himself sick or dying as a result of his childhood illness, which had weakened his heart. In an early pencil drawing, *Autorretrato enfermo a los once años [Self-Portrait Sick at Age Eleven]* (1944; FIG. 10.4), he sits in a chair surrounded by doting women, his heart in a jar by his side. A portrait of himself crying hangs from his neck over his chest where his heart should be. The references in his work to his medical history, like Kahlo's, objectify (and theatricalize) his condition. Cuevas's allusion to the heart, like Kahlo's in *Las dos Fridas* (see FIG. 4.8), plays on its Mexican symbolism, beginning with the Aztec practice of

FIGURE 10.3

José Luis Cuevas, *Retratos de Kafka y su padre [Portraits of Kafka and His Father]*, 1957, pen and wash on blue paper, 51 × 66 cm. / 20 × 26 in. Formerly in the collection of the Philadelphia Museum of Art, Philadelphia. Courtesy Philadelphia Museum of Art. Photo: A. J. Wyatt, staff photographer.

sacrificing victims by extracting their hearts as offerings to the gods. But Cuevas was a victim of a medical condition, and Kahlo, of an emotional one as well.

By the 1960s, numerous other artists took up neofiguration in Mexico. In 1961, the Canadian-born painter Arnold Belkin (1930–1992) and the Mexican Francisco Icaza (b. 1930) founded the Nueva

FIGURE 10.4
José Luis Cuevas, *Autorretrato enfermo a los once años [Self-Portrait Sick at Age Eleven]*, 1944, pencil drawing, 32 × 23 cm. / 12½ × 9 in. Formerly in the collection of José Gómez-Sicre, Washington, D.C. Photo: Ron Jameson, from José Luis Cuevas, *Cuevas por Cuevas.*

FIGURE 10.5
Arnold Belkin, *Hiroshima Job*, 1961, acrylic on canvas, 161 × 205 cm. / 63⅜ × 80¾ in. Courtesy Muralista Patricia Quijano, Mexico City. Photo: Crispin Vázquez C.

Presencia group and a poster review by the same name, *Nueva Presencia*.[12] Other artists to join the group included the Mexican-based Colombian painter Leonel Góngora (1932–1999), the Mexican painter Francisco Corzas (1932–1986), the photographer Ignacio "Nacho" López (b. 1924), and several others.[13] These artists all shared Cuevas's anti-aesthetic position and, like him, rejected contemporary abstraction and painting based on a specific political agenda. But they also differed from Cuevas in their belief that an artist had a responsibility that went beyond mere observation. In their manifesto, published in the first of five issues of *Nueva Presencia* (1961–1963), they called for an "art which does not separate man as an individual from man as an integral part of society. No one, especially the artist, has the right to be indifferent to the social order." They took an anti-aesthetic position by denouncing bourgeois "good taste" and citing as their models Michelangelo, El Greco, Matthias Grünewald, Goya, and Orozco—all of whom "had terrible taste."[14]

A conjunction of events melded the ideas of the Nueva Presencia group. Its artists had direct contact with the U.S.

neofigurative artists Rico Lebrun and Leonard Baskin, both of whom had been included in Peter Selz's *New Images of Man* exhibition at the Museum of Modern Art (New York) in 1959.[15] Belkin reproduced drawings by Baskin and Lebrun in *Nueva Presencia*'s fourth issue in April 1962. The publication in 1960 of Selden Rodman's book *The Insiders,* which Belkin reviewed favorably in *Nueva Presencia*'s first issue, provided an added incentive. Rodman defined the "insider" as "an artist who feels drawn to values outside himself strongly enough to examine them in his work."[16] It was this sense of commitment and personal responsibility to society that differentiated the Nueva Presencia artists from Cuevas's clinical and impassive observation of the world around him, a disparity that ultimately ended the group's close association with Cuevas.

But their commitment was not to specific social issues like poverty or local politics; it was to a broader human condition based on an apocalyptic postwar awareness of the Holocaust, the atomic bomb, and Hiroshima. Although, like Cuevas, they represented spiritually isolated and alienated humans with varying degrees of expressive distortion, their purpose was didactic and intended for a general public. They represented generic scenes of the ravages of war and violence,

both direct and metaphoric. Belkin's acrylic painting *Hiroshima Job* (1961; FIG. 10.5) shows a crouched figure compressed in a claustrophobic space and is based on the biblical character Job, whose faith in God was tested by a series of calamities. Belkin's figure is a modern Job with little promise of redemption.

In 1961, Icaza began a series of paintings on the metamorphosis of birds and human/bird hybrids. Whether to interpret the metamorphosis as going from human into bird—the freeing of the spirit from the "dead weight of the body"—or from bird to human—the grounding of the spirit—is open to question.[17] In Icaza's watercolor and ink paintings *La peste [The Plague]* (1963; FIG. 10.6), from another series based on Albert Camus's novel by that title, rats are metaphors for the disease and the quarantine that isolated a city. A large rat is the sole subject of this painting.[18]

Góngora used a blend of colored inks, acrylic glazes, and wax to produce drawings featuring "naked, contorted bodies in neutral space" to express "interior torment."[19] His exclusive focus on the human body, however, may have been determined as much by his experience as a child growing up in Colombia during *la violencia* as by association with the Mexican artists.[20] Nonetheless, it was during his years in Mexico that he found a direc-

FIGURE 10.6
Francisco Icaza, *La peste [The Plague],* 1963, mixed media (two versions). Courtesy Francisco Icaza, Mexico City.

tion for his art. Like some of the other Nueva Presencia artists, particularly Artemio Sepúlveda, he used small, hatched strokes in his drawings and prints. In 1963, he participated in the group's *War and Peace* exhibition at the Galería Misrachi, which comprised a portfolio of drawings and works in diverse media by the Nueva Presencia artists. The purpose of the exhibition was to make these drawings and prints available at reasonable prices to a broad public. Góngora continued to work on the themes he had developed during his affiliation with Nueva Presencia long after the group disbanded. His subjects find their strongest parallel in the contemporary works of Francisco Corzas and Rafael Coronel (b. 1932). These artists' repertoire included couples, performers, anonymous city dwellers, and men wearing large hats derived from medieval conventions and Rembrandt's self-portraits. The hats functioned as symbols of masculine power and domination.[21]

Góngora and Corzas, both of whom had lived in Italy, developed a close friendship in Mexico during the 1960s,

and for a brief time their subjects were similar, including Titianesque couples represented as a naked female and a dressed male wearing a Rembrandt-style hat. In 1967, Corzas arrogantly titled one of his paintings on this theme *Derecho de propiedad [Right of Ownership]*. Two years later, Góngora painted a slightly less blatant version, *La recámara amorosa [The Love Chamber]* (1969; FIG. 10.7), in which a clothed male and a naked female appear more in the spirit of the artist-and-his-model theme. The overt sexual references in Góngora's work, however, were not typical of Mexican painting at the time and are discussed further in the Colombian context.

During the late 1950s and early 1960s, Corzas and Coronel chose performers as a theme. One cannot deny some kinship with Picasso's pink-period performers in the work of Corzas, who had studied in Mexico City, then in Italy in the late 1950s. But he had been especially drawn to Michelangelo Merisi da Caravaggio's characters and sharp chiaroscuro as well as to contemporary Italian cinema.[22] An early example of Corzas's performers is *Los tres Antonios [The Three Antonios],* also known as *Presencias carnavalescas [Carnival Presences]* (1963), in which three disturbing figures are huddled together against a light background. The characters in his work became increasingly ominous. *Transhumantes [Nomads]* (1967; FIG. 10.8) shows three figures with shadowy faces silhouetted against a loosely painted, abstract, yellow and reddish background tinged with green and with the barest suggestion of land and sky. These are the poor, ambulant performers that are the subjects of Spanish literature and rococo and late-nineteenth-century painting. One dark figure with an unexplained skull-like cranial distortion carries on his shoulders a boy clad in diamond-patterned leggings like those worn by some of Picasso's harlequins. In Corzas's paintings, Caravaggio's tenebrism (intense dark and light contrast) is reversed. The figures are darkly and ominously silhouetted against the lighter back-

FIGURE 10.7
Leonel Góngora, *La recámara amorosa [The Love Chamber]*, 1969, mixed media on paper. Courtesy Leonel Góngora, Amherst, Massachusetts.

FIGURE 10.8

Francisco Corzas, *Transhumantes [Nomads]*, 1967, oil on canvas, 165 × 182 cm. / 65 × 71⅝ in. Collection Angélica León de la Vega, Mexico City. Courtesy Bianca Dall'Occa de Corzas, Mexico City. Photo: Crispin Vázquez C.

FIGURE 10.9

Rafael Coronel (Mexican, b. 1932), *Los que viven en el No. 31 [Those Who Live in No. 31]*, 1964, oil on masonite, 50.3 × 59.7 cm. / 19¾ × 23½ in. Jack S. Blanton Museum of Art (formerly Archer M. Huntington Art Gallery), The University of Texas at Austin. Gift of John and Barbara Duncan, 1971. Photo: George Holmes, G1971.3.14.

ground. As a result, Corzas's figures appear to dissolve in a penumbral haze against a sometimes garishly colored background that conveys desolation rather than distance. One has a sense of some impending disaster, comparable to the feeling of suspense in a Bergman or Fellini movie that results in an unalleviated tension.

Like Corzas's repertoire of types, Coronel's derives from Spanish and Italian baroque painting. Although they are less sinister than Corzas's, they are nonetheless disturbing in their existential isolation. In *Los que viven en el No. 31 [Those Who Live in No. 31]* (1964; FIG. 10.9), an oil painting on masonite, an anonymous group of people in a penumbral world, distinguishable only by subtly modeled heads, share something of the sense of alienation of Cuevas's *Retratos de Kafka y su padre* and the muted tonalities of Corzas's *Transhumantes*. As Coronel's title indicates, his subjects' only identifying mark is the number of their common dwelling.

Alberto Gironella (1929–1999), a painter, draftsman, and assemblage artist, had not been affiliated with the Nueva Presencia but found his subjects in similar seventeenth-century sources. He tapped a Spanish baroque legacy in painting as well as literature. He was especially taken with Velázquez's paintings of the Spanish royal family and made Velázquez's *Portrait of Queen Mariana of Austria* (1652–1653) the center of a series of drawings, paintings, and assemblages titled *Muerte y transfiguración de la Reina Mariana [The Death and Transfiguration of Queen*

FIGURE 10.10
Alberto Gironella, *La reina Mariana [Portrait of Queen Mariana]*, 1961, oil and collage, 97.5 × 121 cm. / 77⅞ × 49¼ in. Courtesy Alberto Gironella, Valle de Bravo, Mexico. Photo: Ron Jameson, from Edouard Jaguer, *Gironella*.

Mariana], begun in 1959.[23] In some of the paintings, Gironella replaced the queen's image with distorted silhouettes suggesting positive or negative photographic images; in others, he subjected her to unlikely substitutions, mutilations, lacerations, and ultimate humiliation. In an early mixed-media work, *La reina Mariana [Portrait of Queen Mariana]* (1961; FIG. 10.10), all the features of the Velázquez original are recognizable except for Gironella's substitution of a painted fluted pilaster for the queen's bodice and balusters for her sleeves.

Gironella also appropriated features from two other Velázquez paintings, *Las meninas [The Maids of Honor]* (1652) and *El niño de Vallecas [The Boy from Vallecas,* otherwise known as *The Dwarf Francisco Lezcano]*. Playing with various combinations of these and *La reina Mariana*, Gironella inverted characters from these paintings in his Queen Mariana series by placing Francisco Lezcano in the role of Velázquez at his easel, giving Queen Mariana the face of the dog, or substituting the female dwarf from *Las meninas* for the Infanta Marguerita. These transpositions result in a satire of the seventeenth-century Spanish royal family, whose bloodline had been weakened by intermarriage.

As a collector of antiques and bric-a-brac, Gironella had accumulated stuffed animals, casts of anatomical fragments, furniture legs, and wainscoting that he used in his assemblages. In a wood and mixed-media assemblage version of *Reina Mariana [Queen Mariana]* (1964; PL. 10.1), the image of the queen is fragmented into isolated sections. The queen's anatomy is replaced by odd objects glued onto the wooden base. Strips of decorative wall covering and aluminum food cans with colorful lids placed around the figure evoke the opulent brocades of the royal palace's decor. The back of a boy's severed head, set upside down in a box above a meat-red cross section in the shape of the *Victory of Samothrace*, substitutes for the queen's abdomen. An isolated severed hand in Gironella's work

replaces the painted hand in the Velázquez portrait. The colorful food cans, which Gironella used in several other assemblages as well, add visual appeal.[24]

Gironella's collages and assemblages incorporating painted sections with objects and photos invite comparisons with Robert Rauschenberg's "combine paintings." But Gironella's work is not about surface and shifting points of view, nor did he seek to neutralize the subject, as Rauschenberg did. Quite the reverse. Gironella's work results in parody and narrative associations through unlikely substitutions. As an admirer and friend of the Mexico-based Spanish filmmaker Luis Buñuel, Gironella charged the objects he used with meanings drawn from a Spanish literary legacy, with and without Buñuel's sacred/profane references. Gironella's use of objects is more neosurreal than it is pop, since the objects play an associative role in his work.[25] The cans in the 1964 *Reina Mariana* assemblage are from imported Norwegian sardines, which stand as a metaphor for foreign imports in general and, by extension, for imported Spanish culture. The *Victory of Samothrace* implies the Greek legacy inherent in Western art in general. But Gironella also added a Mexican ele-

PLATE 10.1
Alberto Gironella, *Reina Mariana [Queen Mariana]*, 1964, assemblage, 197.5 × 125 cm. / 77⅞ × 49¼ in. Collection Vicente Rojo, Mexico City. Photo: Courtesy Archivos del CENIDIAP, Mexico City.

FIGURE 10.11
Ignacio (Nacho) López, *El pollero [Poultry Man]*, 1961, black-and-white photograph, 12.7 × 22.9 cm. / 5 × 9 in. Courtesy Instituto Nacional de Antropología e Historia (INAH), Pachuca, Mexico.

ment. He replaced the queen's monu-
mental headdress and face with a blowup
of Nacho López's well-known photo-
graph *El pollero [Poultry Man]* (1961; FIG.
10.11), in which the necks of plucked
dead chickens dangle limply, partially
covering the poultry man's grinning face.
Images of flayed chickens had also been a
source of interest to Belkin and other
Nueva Presencia artists as metaphors for
violated human bodies.[26] In Gironella's
case, Queen Mariana is the object of
violation by the artist.

In another group from the same series,
the queen becomes the object of ecstasies
as well as Chinese torture through lacera-
tion. In the painting *Extasis de la reina
Mariana [The Ecstasy of Queen Mariana]*
(1970), Francisco Lezcano as Velázquez
plunges his brush into the queen's reclin-
ing clothed body in a take on Gianlorenzo
Bernini's *Ecstasy of St. Theresa.* In the tor-
ture scenes, the queen stands impassively
with only the marks of the lacerations
visible as Chinese characters on her rigid
body—an allusion to the final destruction
of the Spanish royal lineage. These works
also address questions of time, perishabil-
ity, and ultimate destruction of the flesh,
as do some of Buñuel's films. They are
also blatantly cruel.

ARGENTINA'S
OTRA FIGURACIÓN GROUP

In contrast to the Mexicans' preference
for the graphic media and appropriations
from the past, Argentines and Venezu-
elans chose high-keyed, festive colors as
integral components of their form of
expressionism, and their neofiguration
had contemporary abstraction among its
various sources. Among Argentine artists
to take up neofiguration and assemblage
were Raquel Forner, Antonio Berni,
Alberto Heredia, Antonio Seguí, Ernesto
Deira, Rómulo Macció, Jorge de la Vega,
and Luis Felipe Noé. But Berni and
Forner retained a narrative thread in
their brand of neofiguration that dis-

tanced them from the younger gener-
ation's anarchistic expression, even
though by the 1980s Noé claimed Berni
as a source.[27] Likewise, Heredia's assem-
blages and objects were assigned very
specific meanings, either as surrealist
references or as political metaphors;
therefore they, too, fall outside the nar-
rower definitions of neofiguration. The
major exponents of neofiguration were
Deira (1928–1986), Macció (b. 1931), de
la Vega (1930–1971), and Noé (b. 1933).
From 1961 to 1963 the four artists
worked together in a loftlike space under
the name Otra Figuración and exhibited
once under that name in 1962 and several
times as a group.[28] Although not a mem-
ber of the group, Seguí at first partici-
pated in their exhibitions, but his art
soon took a different direction.

Otra Figuración and Nueva Presencia
were exact contemporaries, even though
there was no direct contact between the
two groups. In 1959, Cuevas (as well as
Francis Bacon) had been included in the
Fifth São Paulo Biennial. Cuevas had also
exhibited in Buenos Aires that year and
claimed to have played a role in promot-
ing the Argentine neofigurative move-
ment. But according to Noé, Otra
Figuración's most direct links were not
with Cuevas but with the Boa group, an
Argentine offshoot of the international
neosurrealist Phases. In 1958, the Boa
artists, most of whom were abstract,
published the first of three issues of their
journal *Boa,* which served as a bridge
between European and Argentine cur-
rents.[29] It was through *Boa* that the Otra
Figuración artists first learned about the
Cobra artists,[30] as well as Jean Dubuffet
and contemporary Spanish painters such
as Antonio Saura. In addition, the Argen-
tine painters adopted free brushwork and
drip techniques that combined the de-
vices of late surrealism and the expres-
sionism of de Kooning (whose woman
paintings of the early 1950s were exhib-
ited in the *Second São Paulo Biennial* in
1953).

One thing the Argentines and Mexi-
cans shared was their anti-aesthetic plat-

form and their rejection of what Noé described as the "sacred mission of art that led to all mystifications."[31] Like Cuevas, the Argentines perceived the world as a spectacle, but they saw themselves as participants in a chaotic world instead of as mere observers, as Cuevas did. The fact that their subjects, whether human or animal, were generally undifferentiated by gender distanced them from de Kooning as well as from Cuevas and the other Mexicans, for whom gender did play a part. As a group, the Otra Figuración artists believed that they lived in a collective society, and they shared the conviction that "the only way to adventure into art was by the adventure into man himself."[32] For de la Vega, the rejection of all rules meant being "natural, without limitations or formulas, improvised as life is."[33] For Noé, who lived in New York between 1963 and 1966, the task, above all, was

to understand [the] chaos that we are living, because what we call chaos is nothing but that for which we lack a pattern of understanding. . . .

Here in the United States, as is manifest in Pop Art, the need for affirmation of the gregarious symbols is very urgent. It is a society which affirms itself. But in our country, as in the whole of South America, we are still at a stage previous to that of formulating our own way of life, as compared to the "American way of life," and thus we are left with that which precedes all order: chaos. Therefore we must invest ourselves with it. . . .

Long live chaos, because it is the only thing which is alive![34]

Underlying these statements was the sense that each had to function as an individual in a world where the unexpected was the rule and planning ahead was an exercise in futility. They celebrated this condition in the form of existential and aesthetic freedom in their oil and acrylic paintings and collages. De la Vega's work of 1961 to 1963 has been referred to as his "bestiary" period because his subjects took on animal charac-

teristics as metaphors for humans. In 1964, he did a series of six collages, *Los conflictos anamórficos [Anamorphic Conflicts]*, in which distorted phantom creatures— some painted, others composed of rags, rumpled bedsheets, coins, buttons, and broken pieces of tile—expressed de la Vega's existential ideas. The title "Anamorphic Conflict" refers to an image reflected in distorting mirrors and to the conflict between the real and the reflected, or inner, self. *El espejo al final de la escalera [The Mirror at the End of the Stairs]* (1963; PL. 10.2) exemplifies this conflict as a feline confronts its image in a mirror. According to de la Vega's biographer, Mercedes Casanegra, the conflict also results from the human confrontation with the void as a way of measuring oneself and testing the use made of one's freedom.[35] Although *Caída de conciencia [Fall from Consciousness]* (1965) does not belong to the *Anamorphic Conflict* series, it is similar in its meaning and configuration. It consists of two jumping, nightmarish creatures—one painted, the other a collage—in an uneasy confrontation between the tangible (the collage) and the intangible (the painted) being, which also represents the unconscious mind or "memories."[36] Some of de la Vega's later works are paintings of figures based on photographs as they might appear in distorting mirrors.

In contrast to de la Vega's timeless and individual psychological references, Noé's paintings of the same years refer to a collective experience in an urban world without structure or order. More specifically, he was thinking of the Argentine world in the aftermath of Juan Domingo Perón's regime (1946–1955) that had, according to him, created a "cultural fracture" between the Europeanized bourgeois world in which he grew up and a new, as yet unformed cultural system.[37] This idea lay at the core of his statement celebrating chaos. Noé's large painting *Cerrado por brujería [Closed for Sorcery]* (1963; FIG. 10.12) is divided into two main zones. In the lower half, furtive,

PLATE 10.2

Jorge de la Vega, *El espejo al final de la escalera* [*The Mirror at the End of the Stairs*], 1963, mixed media on canvas, 129.5 × 161 cm. / 51 × 63⅜ in. Courtesy of Eduardo Grüneisen, Buenos Aires. Photo: H. O. Casenave.

haunted faces peering out of a gridlike structure convey a sense of helpless urban entrapment. The upper section contains an unidentifiable animal, a human, and a large X, and the whole is divided by a painted crucifix set at an angle. A small, barely detectable photograph of a face (insecurely identified by some as Perón but resembling Mussolini) is glued to the crucifix. The crucifix implies some sort of martyrdom in the midst of chaos. But neither Noé nor his colleagues defended or denounced a particular political system. Noé saw such systems merely as agents of change resulting in unsettled conditions. His paintings and those of his colleagues went "beyond all folkloric nationalism."[38]

In 1966, Noé exhibited what Lawrence Alloway described as "a shambling collection of objects, paintings and linking struts and planes" at the Galería Bonino in New York.[39] These complex constructions included hinged doors and canvases turned backward. From a commercial standpoint, Noé's work had become "unsalable." He broke his association with

his New York dealer, stopped painting for almost ten years, and returned to Buenos Aires to manage a bar where he and his artist friends continued to meet.[40] In a curious and perhaps symptomatic parallel, de la Vega stopped painting the following year (1967), also returned to Buenos Aires, and became a performer and popular singer. These artists' gregarious instincts were played out in real life where they could be free from the pressures of the art market.[41]

NEOFIGURATION AND MULTIMEDIA IN VENEZUELA

An analogous experience was that of the Venezuelan painter Jacobo Borges (b. 1931), who likewise abandoned painting in 1966 for a period of five years to devote his energies to directing a multimedia production titled *Imagen de Caracas* [*Image of Caracas*]. This collaborative endeavor combined light, props, and sound effects with projections of fractured and shifting film images of Caracas life.[42] Prior to that, Borges had been a

neofigurative painter whose style in the early 1960s blended characteristics of both the Mexican and Argentine artists, along with their sources in de Kooning, Bacon, Goya, Rembrandt, Posada, Orozco, the Cobra artists as well as Emil Nolde and James Ensor. Borges's contact with the Mexicans was direct: he had exhibited with a group of younger artists at the Palacio Nacional de Bellas Artes in Mexico City in 1959. But closer to home, he also greatly admired his compatriot Armando Reverón—whom he had visited in Macuto before the latter's death—for his original treatment of the local landscape and figures in his work.

Borges was more overtly political than either his Mexican or Argentine neofigurative colleagues. In the early 1960s, he sought to create an art that had cultural relevance and, at least initially, denounced the ruling classes. In 1958,

Venezuela's ten-year military regime had come to an end and was replaced by a democratic one. Although the new government had socialist leanings, which angered the right, it also opposed the Castroites, which angered the left. Borges, who sided with the left, had developed a form of neofiguration characterized by bright, sometimes raw colors that hardly disguised his indictment of Venezuelan bourgeois society.

When Borges returned to Caracas in 1956 from a four-year stay in Europe, he perceived it as "a city without myths, separated from all historical continuity."[43] But he eventually found his main subjects in Caracas: the city, its outskirts, and its society. In the early 1960s, he used Caracas society as the means through which to express his social concerns. After 1971, he invented a history for Caracas based on the average family's

FIGURE 10.12
Luis Felipe Noé
(Argentinean, b. 1933),
Cerrado por brujería
[Closed for Sorcery], 1963,
oil and collage on canvas,
199.6 × 249.7 cm. / 78½ ×
98¼ in. Jack S. Blanton
Museum of Art (formerly
Archer M. Huntington
Art Gallery), The
University of Texas at
Austin. Archer M.
Huntington Museum
Fund, 1973. Photo:
George Holmes,
P1973.11.3.

collective rituals, such as First Communions and betrothals. Many works of his early phase parody the pomposity of the current ruling classes. In *Ha comenzado el espectáculo [The Show Has Begun]* (1964; PL. 10.3), he borrowed from traditional personifications of evil and human folly. The characters are prelates, military figures, a prostitute, and a skeleton in a garishly colored composition evoking James Ensor's *Christ's Entry into Brussels* of 1889.[44] The prostitute here is not a specific individual, but a symbol of political corruption.

Borges's work on *Imagen de Caracas* was the result of his affiliation with intellectuals, writers, and filmmakers who shared his leftist tendencies. This production, like other contemporary environments and theater productions, was intended to reach a broad public by incorporating the spectators into the work. For this purpose, ordinary citizens, approached in the street, were invited to participate. It was hoped that as active spectators they would also become aware of the social inequities and hypocrisy in the system that victimized them, as these issues were addressed in *Imagen*'s filmed shots.[45] But Borges's didactic objectives failed to elicit an active response from the audience/participants. Moreover, the government closed the production within a short time, perhaps because they perceived it as a threat to their authority.

Nonetheless, *Imagen*'s experience was not a total loss. When Borges returned to painting in the early 1970s, he took from his experience filmmaking and photographic devices such as shifting frames to create a sense of shifting time without the obvious political content. Instead, he sought to depict the myths and traditions he had found missing in Venezuelan history. Taking as his source photographs from old albums collected over the years, he translated them into painted images with varying degrees of sharpness, as though seen alternately in and out of focus through veiled layers of memory. He replaced the heavy impastos he had used in his earlier work with glazes through which one glimpses other rooms in a fading background, some rococo

PLATE 10.3
Jacobo Borges, *Ha comenzado el espectáculo [The Show Has Begun]*, 1964, oil on canvas, 180.25 × 270.5 cm. / 71 × 106½ in. Courtesy Fundación Galería de Arte Nacional, Caracas. Photo: Petre Maxim, Archivo CINAP.

decor, half-blurred figures that evoke past times, or fragmented images like in movie flashbacks. Besides First Communions and betrothals, his subjects included family pictures commemorating other special moments, or Caracas landscapes with Mount Avila—a major landmark and popular subject of earlier landscape painters—visible in the background. The mountain appears in the large painting *Paisaje en tres tiempos [Landscape in Three Times]* of 1977 (FIG. 10.13) and was also the subject of a book written and illustrated by Borges titled *La montaña y su tiempo* (The mountain and its time), published the same year. In the paintings of this period, he invented a history for his city based on the idea of a collective memory by linking past and present in the same work.

POP, COLLAGE, AND ENVIRONMENTS

In Latin America, pop, collage, environments, and performance art were not always separate. Pop frequently overlapped with environmental and performance art. Lawrence Alloway, the originator of the term *pop,* identified three phases of pop: the first, characterized by an art that included "all of man's artifacts"; the second, by the shrinking from a more general definition of pop culture to "an iconography of signs and objects known from outside the field of art"

characterized by "the presence of objects" like Campbell's soup cans for instance; and the third, in the mid-1960s, by the application of the term to "fashion, films, interior decoration, toys, parties, and town planning." Above all, it was an "art of industrialism," which is why it arose in "the most fully industrialized country [the United States]."[46] In Latin America, some aspects of pop did exist as local variants because of pop art's accessibility to a much broader public and because of pop's function as "a polemic against elite views of art."[47] There was an art of objects that paralleled the second category cited by Alloway. The Argentine kineticists such as the GRAV and Borges in *Imagen de Caracas* would seem to fit Alloway's definition of the third pop category, since they incorporated aspects of popular culture by inviting the public to participate in media-related work. But pop was not a manifestation of industrialism nor of consumerism in Latin America. In some cases, it took the form of local kitsch or parody.

Collage, pop, and environmental art occurred briefly in some Andean countries as well as in Mexico, but these modes were too short-lived to have any significance. For short periods of time, artists throughout Latin America (Argentina, Brazil, Chile, Colombia, Ecuador, Mexico, Venezuela) painted or collaged human-made objects onto a surface or

FIGURE 10.13

Jacobo Borges, *Paisaje en tres tiempos [Landscape in Three Times]*, 1977, acrylic on canvas, 80 × 200 cm. / 31½ × 78¾ in. Courtesy Banco Central de Venezuela, Caracas.

made the objects themselves: in Brazil, Rubens Gerchman, Antonio Dias, and Nelson Leirner; in Chile, Francisco Brugnoli; in Colombia, Santiago Cárdenas, Omar Rayo, Carlos Rojas, and Bernardo Salcedo; in Ecuador, Osvaldo Viteri; in Mexico, Gironella. All included or referred to banal objects in their work. But when these artists made collages with food cans, grocery bags, or wearing apparel, although they were incorporating popular referents into mainstream art in accordance with Alloway's first two definitions of pop, they generally used these objects metaphorically.[48] Furthermore, collage was not a major component of pop art in the United States because of this medium's previous affiliations with elitist mainstream art there, whereas this mode was used extensively in Latin America, including in local versions of pop.

The most active centers of object and mass-media art were in Brazil and Argentina. In Brazil, environmental and object art were more often absorbed into the prevailing neoconcrete tendencies rather than into pop. Pop there was more often present in painting as well as in collages and sometimes in installation art. It took the form of parody (of the exotic), such as in Gerchman's *O rei do mau gosto* (1966; see PL. 9.5); the celebration of some popular performer, as in Nelson Leirner's installation *Altar de Roberto Carlos [Altar to Roberto Carlos]* (1967), in which the central image of the pop singer on the altar replaces that of Christ; or a reference to violence in a comic-strip style, such as in Antonio Dias's *Nota sob a morte imprevista [Note on an Unexpected Death]* (1965), in which separate frames of a comic-strip sequence show the bloody results of a murder blended with phallic evocations.

Argentine Pop and Multimedia

Argentine artists were the most visible and active practitioners of object and mass-media art owing to the promotion both in Argentina and abroad of international avant-garde styles in the 1960s.

Jorge Glusberg attributes the origins of pop in Buenos Aires to an exhibition at the Galería Florida in 1962 titled *El hombre antes del hombre [Man Confronts Man]*, sponsored by the Museo de Arte Moderno in Buenos Aires. Two of Argentina's pop representatives, Marta Minujín and Delia Puzzovio, were included.[49] Under the auspices of the Department of Visual Art of the Torcuato di Tella Foundation in Buenos Aires, directed in the 1960s by Jorge Romero Brest, pop—or, more concisely, object art—received a boost throughout the decade.

If Argentine pop shared a single aspect with U.S. pop, it was the appropriation of mass media and advertising as common denominators into art. A great number of artists, some better known at home than abroad, were labeled pop and called themselves the Popes of Pop. These included Edgardo Giménez, Susana Salgado, Delia Puzzovio, Carlos Squirru, Delia Cancela, and Pablo Mesejian.[50] But there were many others outside the group. All of these artists made farcical objects, some with notable exaggerations, others with scale shifts or paradoxical twists. Salgado created giant vinyl sunflowers, Giménez, a large, brightly colored papier-maché winged insect. Juan Stoppani (who was not one of the Popes of Pop) made an automobile whose allover bright yellow windows, tires, and trim gave it an eerie appearance that suggested parody (or a take on the Beatles song "The Yellow Submarine") rather than a celebration of modern industry and its materials. The automobile was converted into an icon or a toy, not a consumer commodity. Puzzovio spray-painted large billboards, including one of an exotic reclining female with her own face, which she displayed in a public space in downtown Buenos Aires. In some cases, Argentine artists made objects out of discarded materials. Puzzovio, for instance, created art out of old plaster casts collected from hospitals.

More prevalent among Argentines was pop's third phase that crossed over into

the domain of fashion and interior design. Artists and critics decorated their homes with pop furnishings. The late critic Jorge Romero Brest had upholstery in his home that was a cross between Andy Warhol pillows and oversized Claes Oldenburg objects. By the early 1970s, the married couple Carlos Squirru and Delia Puzzovio had renounced making objects and instead made their home into a work of art. They decorated their Buenos Aires apartment with leopard-skin wall coverings, ornate mirrors, satin- and brocade-covered upholstery, large pillows negligently tossed around the floor, and animal-skin area rugs to create an environment that exuded a blend of fashion and decadent luxury.[51]

Marta Minujín (b. 1943) was better known abroad than were the others, largely due to Romero Brest's enthusiastic promotion of her work and to a Guggenheim Fellowship that took her to New York. Between 1963 and 1968 she worked in Paris and New York as well as Buenos Aires. During her stay in Paris in the early 1960s, she took an existential and iconoclastic position denouncing the so-called mystification of the art object. Before returning to Argentina in 1963, she declared the end of painting and staged a happening in a vacant lot in which she and some friends destroyed all her previous work in a public ritual rather than leave it to the commercialism of the galleries. This event drew crowds of bystanders into the act, a feature Minujín continued to exploit in later works. At the time, she made giant spiderlike monsters and other unidentifiable objects out of mattress ticking because beds are "where people are born, make love and die."[52] When she returned to making objects in 1964, it was for a different purpose, as she now used them as components of her environments.

Minujín was not a Pope of Pop. She worked independently or in collaboration with other environmental artists. Believing that many of her compatriots completely misunderstood what pop was about, she offered her own definition,

explaining that it was "popular art, an art which the whole world can understand, happy art, fun art, comic art."[53] In spite of her populist pronouncements, the work she produced under the pop label was addressed to an urban middle-class audience. Besides happenings, her production included environments, performances, and communications media, such as filling a room with television sets all tuned to the same station. In 1965, she collaborated with Rubén Santantonín, Leopoldo Maler, Pablo Suárez, David Lamelas, and Rodolfo Prayón to create a half-block-long structure, *La menesunda [The Challenge],* in Buenos Aires that assaulted the senses. The event initially drew a crowd of thirty thousand, who waited in line for eight hours to get in. *La menesunda* presented a conglomerate of urban frenzy: neon lights, narrow passages smelling of fried foods, televisions, fans, soft vinyl stairs, and rooms with soft vinyl walls separating womblike spaces where a battery of sense-bombarding experiences awaited participants. Inside the structure they encountered a variety of unexpected situations: a couple in bed in one room; two people applying cosmetics to each other in another; in a third, they found themselves in an oppressive space with gutlike walls, relieved by slide projections of cool mountain lakes visible through a small window.[54] This multisensorial experience was very different from the meditative one that occurred in Oiticica's *Tropicalia,* in which a television was presented as an alienating intrusion into an otherwise contemplative experience, not as an urban means of mass and simultaneous communication.

In 1966, Minujín presented a smaller environment, *El batacazo [The Long Shot]* (FIGS. 10.14 and 10.15), at the Bianchini Gallery in New York. Flashing multicolored neon tubes outlining figures of astronauts on the exterior plastic casing and vinyl stuffed figures accompanied by sound effects inside greeted participants. After removing their shoes, participants

had to proceed through a narrow passage past live flies trapped inside double plastic partitions; climb up soft vinyl stairs past a cage of live rabbits,[55] two palsied, stuffed vinyl astronauts, and dangling rugby players with the appropriate sounds of cheering crowds; they then tobogganed down a chute to land on a seventeen-foot, pink vinyl recumbent figure supposedly of the actress Virna Lisi, causing her to moan erotically and whisper endearments.[56]

During the mid-1960s, Minujín looked increasingly to the world of media and technology for her models as a means to address an urban middle-class audience (this phase of her work corresponded to the New York–based Experiments in Art and Technology [E.A.T.] in which artists and technicians collaborated on art projects). Minujín was an admirer, not of Merleau-Ponty, but of the Canadian philosopher Marshall McLuhan, whose books *Understanding Media* (1965) and *The Medium Is the Massage* (1967) were widely

read at the time.[57] In 1967, Minujín exhibited the *Minuphone* (FIG. 10.16) at the Howard Wise Gallery. It was a telephone booth with a working number, built with the collaboration of a Bell Laboratories engineer. By dialing a number, the caller set off a sequence of media events: a fan, sirens, the caller's self-conscious image appearing on a TV screen at his/her feet, green water rising in the booth's double glass partitions, a window shade slamming down suddenly to be used as a screen for shadow pictures. Finally, a Polaroid photo mechanically shot inside the booth was handed to the participant as he/she left the booth.

Minujín tapped the vocabulary and resources of a developed urban world to play out some of the chaos Noé sought to express in his paintings. Her use of technology to assault the senses, to stimulate participants' awareness of their daily experiences, and to break ingrained behavioral habits had far more in common with the GRAV artists' use of tech-

FIGURE 10.14
Marta Minujín, *El batacazo [The Long Shot]*, 1964–1966, Bianchini Gallery installation of 1966, New York (destroyed), neon tubes and plastic enclosure, 156 × 120 × 120 ft. Courtesy Marta Minujín, Buenos Aires. Photo: Author.

nology and industrial materials to create situations for public participation than with Oiticica's notion of the environment as a meditative sensorial experience for a Third World audience. Minujin aggressively directed her work to an urban, international middle class, not to a Third World audience. Her work was sensorial in the sense that it addressed (or rather, bombarded) the senses, but it was not sensuous.

By 1970, the Visual Arts Department of the Instituto Torcuato di Tella closed its doors for lack of funds. The artistic frenzy of the 1960s came to an end in Buenos Aires, and a more sober and somber atmosphere became increasingly noticeable under the military government that took over in 1966. In the late 1970s, when the latter was at its most oppressive, Minujin began a new series of ephemeral monuments generically titled *Los mitos y la ley de la gravedad [Myths and the Law of Gravity],* also intended for public participation. These large-scale works, made of wire, cotton, and, sometimes, edibles, were site-specific. In 1980, she created the *Obelisco de pan dulce [Obelisk of Sweet Rolls]* (FIG. 10.17), a same-size replica of the obelisk on the Avenida de Mayo in downtown Buenos Aires.[58] Minujin scheduled its installation, not far from the original, to coincide with a street fair in order to ensure the presence of a large crowd. Minujin's obelisk, like the original, measured 32 meters in height. Its entire wire-frame surface was covered with 10,000 packages of sweet rolls from a local bakery. Following a ritualistic raising and lowering with cranes, attended by throngs of people, the obelisk's packaged rolls were distributed among the crowd to symbolize the consumption of a work of art. The act of erecting the obelisk to a vertical position as a hierarchical symbol of power, then lowering it to a horizontal one as a reference to a classless society—emphasized by the distribution of the bread—offers a Marxist reading that could easily be understood as an indictment of local power as well.[59]

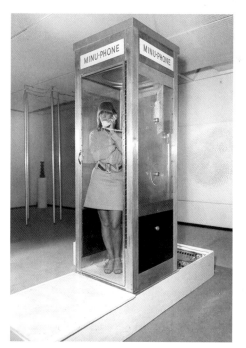

FIGURE 10.15
Marta Minujin, *El batacazo [The Long Shot],* Bianchini Gallery installation of 1966, New York, toboggan, stuffed vinyl astronauts, rugby players, figure of Virna Lisi, cage with live rabbits, and live flies within plastic enclosure. Courtesy Marta Minujin, Buenos Aires. Photo: Author.

FIGURE 10.16
Marta Minujin, *Minuphone,* 1967, electronic phone booth; in collaboration with Pier Bjorn, as technical assistant. Shown in Howard Wise Gallery, New York, in 1967. Courtesy Marta Minujin, Buenos Aires. Photo: Geoffrey Clements.

FIGURE 10.17
Marta Minujin, *Obelisco de pan dulce [Obelisk of Sweet Rolls]*, from *Los mitos y la ley de la gravedad [Myths and the Law of Gravity]* series, 1980, wire frame covered with 10,000 packages of sweet rolls, Buenos Aires, 32 m. high/c. 105 ft. high. Courtesy Marta Minujin, Buenos Aires. Photo: Ron Jameson, from Jorge Glusberg, *Los mitos y la ley de la gravedad* (brochure).

FIGURE 10.18
Marta Minujin, *Carlos Gardel*, 1981, from *Los mitos y la ley de la gravedad* series, wire frame and cotton before setting on fire, 12 m. high/c. 40 ft. high, shown at the 1981 Coltejer Medellín Biennial, Medellín, Colombia. Courtesy Marta Minujin, Buenos Aires. Photo: Ron Jameson, from Jorge Glusberg, *Los mitos y la ley de la gravedad* (brochure).

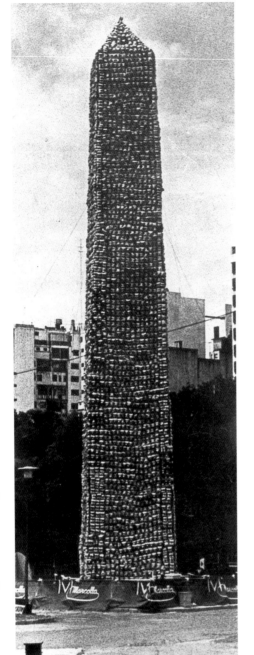

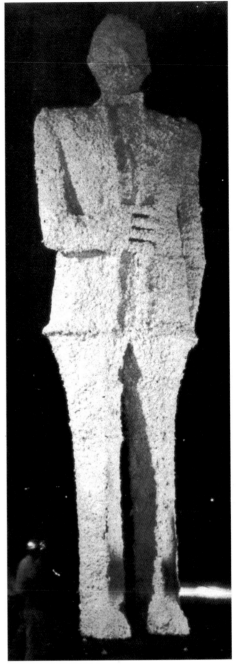

Besides erecting and dismantling symbols of dominance and masculine power, the series *Los mitos y la ley de la gravedad* also addressed the power of popular myths in controlling the minds of the masses. Minujin's contribution to the 1981 biennial in Medellín, Colombia, was a 12-meter-high wire and cotton replica of Carlos Gardel, the late Argentine singer and tango idol who had died in 1936 in a plane crash during a landing in Medellín, where he was to have given a performance. The raising of Gardel's wire and cotton effigy outside the biennial's pavilion was accompanied by couples dancing tangos to recordings of Gardel's music (*Carlos Gardel;* FIG. 10.18).[60] The figure was then set on fire as a reenactment of the fiery plane accident that had killed him forty-five years earlier. One may ponder what such an act might have provoked in the United States had the subject been Elvis Presley. Although Gardel continues to be revered in Argentina, there was no adverse reaction to this event, either in Colombia or in the Argentine press.

COLOMBIAN FIGURATIVE, REPRESENTATIONAL, AND POP ART

In Colombia, there was no equivalent for Argentine and Brazilian neofiguration and environments. Instead, a representational and figurative art and an art of objects took distinctive forms there.[61] Two tendencies can be identified in Colombian figuration: the first began in the mid-1950s and was characterized by some form of distortion, as in the work of Fernando Botero and Enrique Grau; the second, occurring after 1968, was based on academic models and photo-realism and included Juan Antonio Roda, Luis Caballero, Darío Morales, and Alfredo Guerrero among some of its many representatives.

Fernando Botero (b. 1932) and Enrique Grau (b. 1920) were among the first Colombians to take up the new figuration. Their particular form of distortion, which was contemporary with that of Cuevas and other Mexican and Argentine artists, had its roots in late cubism rather than in expressionism or abstraction. The cubist legacy is evident in Botero's paintings of the 1950s in the manner in which he spread out his volumes within the picture space, as though opening them up to show all their facets. The work of Botero and Grau represented the first major rupture with the Mexican-derived social-realist legacy that had prevailed in Colombia during the 1940s. But like their colleagues in Mexico and Argentina, Botero and Grau also sidestepped other twentieth-century models, seeking theirs in the European masters of the past, from the Italian Renaissance through nineteenth-century history painting. This was especially true of Botero. Grau confined himself to Goya and Velázquez, with only an occasional reference to the classics.

Botero and Grau began appropriating from earlier models in the 1960s, several years before this practice was adopted in parts of the Western world outside Latin America and placed under the aegis of postmodern discourse. Instead of using the loose brush strokes, drips, and accidents favored by their neofigurative contemporaries, these two artists looked to academic painting as a model for style as well as subject matter. Grau adopted the brushwork of baroque painting, especially that of Velázquez. For a while in the 1950s, Botero allowed brush strokes to show in his work. But after 1960, he eliminated them in favor of a smooth surface and in spite of the fact that this type of painting was unfashionable then. The figures painted by these two artists were endowed with a Dionysiac sensuality that conveyed enjoyment and pleasure regardless of the subject, instead of the Baconesque, tortured appearance of living in some existential hell. This could be as true of a decapitation scene or a pile of corpses as it was of a happy couple. Grau's figures exude a zestful joy, and Botero's wallow happily in their own plump sensuality.

Gabriel García Márquez's magic realism is invariably invoked to explain exaggerations and scale discrepancies, especially in Botero's work. But in spite of an occasional narrative parallel, the comparison does not explain the visual sources.[62] Botero and Grau had both traveled to Italy at separate times and studied the artists of the quattrocento. Botero had admired Piero della Francesca for his volumetric figures and focus on total formal expressiveness instead of just individual features. Both artists had also lived in Paris, Grau in the 1950s, Botero on several occasions, returning to live there in the 1970s. They had also spent a significant amount of time in New York. Grau had studied at the Art Students League there in the early 1940s; Botero, who lived in New York from the late 1950s to 1973, made his initial reputation there with the sale to the Museum of Modern Art of his *Mona Lisa Age Twelve* (1959).

Beyond some of the above similarities, the two artists utilized their sources very differently. Grau remained the most

faithful to academic standards, especially those of Spanish baroque painting. Instead of the scale shifts adopted by Botero, Grau extended his amplifications evenly to the whole figure by simply widening all its parts without sacrifice to other proportions. Botero, on the other hand, took liberties with scale, either by showing figures of vastly differing sizes in the same painting as an indication of their relative status or through proportional discrepancies between heads and bodies or heads and faces. These discrepancies make some of his figures appear compressed or stacked like mounds of whipped cream.

The two artists also used different methods to obtain volume. Grau did so tonally by using traditional chiaroscuro. Botero did so coloristically by adjusting color intensities in the manner of Cézanne to obtain volume. The sophistication in his understanding of the function of line and color is disguised beneath a layer of studied naïveté and by the sources he used from popular and colonial art. He owned a collection of Colombian colonial art but had also admired an anonymous nineteenth-century watercolor, *Policarpa Salavarrieta al patíbulo [La Pola Goes to the Gallows]* (1823), in the National Museum in Bogotá (see FIG. 0.2). In the latter, the figures seem voluminous even though they were not treated with conventional shading. Another way in which Grau and Botero differ is in their rendering of different textures. Grau differentiated between soft or hard substances, such as flesh, clothing, or metal, in the manner of the seventeenth-century masters. Botero deliberately ignored these distinctions. A face or a kettle on a stove were similar in their rubbery consistency.

Grau's and Botero's neofigurative work was concurrent with pop art in the United States, but the artists resisted the language of advertising and the comic strip, opting instead for imagery that was immediately understandable to a Colombian audience familiar with the sources, both from art of the past as well as from contemporary referents. Grau, who is from the Caribbean coastal town of Cartagena, found his models in local types presented in the trappings of Raphael, Velázquez, Delacroix, or Goya. *La Cayetana* (1962) makes reference to Goya's favorite subject, the Duchess of Alba, whose full name was María Cayetana del Pilar. Most of Grau's other subjects are zesty, commonplace youths from the lower classes. Men are often performers; women are frequently represented as prostitutes, dressing, undressing, or receiving phone calls. Healthy and arrogant, they look out at the viewer playfully and seductively. Even a decapitation becomes the justification for the promise of a pleasurable banquet as its perpetrator, a young woman in a bra and lacy hat, smiles at the viewer while holding aloft a platter with a decanter of wine (or blood) and the severed head of a seemingly ecstatic St. John the Baptist resting comfortably on the tray. An element of paradox or the illogical often characterizes Grau's work. In the half-length painting *Niño con paraguas [Boy with Umbrella]* (1964; FIG. 10.19), a young man with a bare torso stands against the railing of a balcony inexplicably holding an umbrella over his head like a hat; a coffee

FIGURE 10.19
Enrique Grau, *Niño con paraguas [Boy with Umbrella]*, 1964, oil on canvas, 101.5 × 111.75 cm. / 40 × 44 in. Courtesy Art Museum of the Americas, OAS, Washington, D.C.

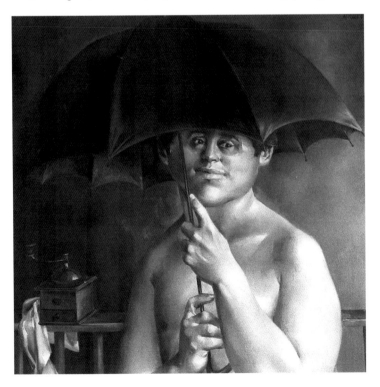

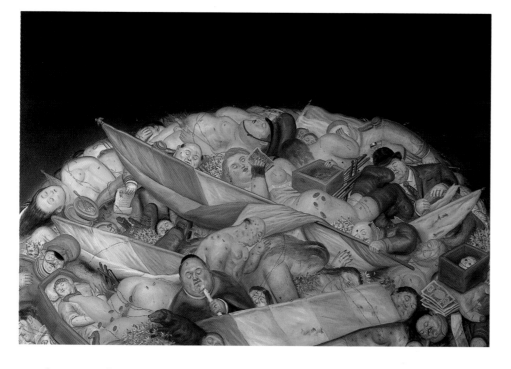

PLATE 10.4

Fernando Botero, *Guerra [War]*, 1973, oil on canvas, 190.5 × 279.5 cm. / 75 × 110 in. Collection Mr. and Mrs. Carlos Haime. Courtesy Nohra Haime, New York. Photo: Robert Lorenzson.

grinder sits on the railing at his side. One senses the presence of a very private mythology bordering on the surreal.

Botero's figures are as blank and expressionless as Grau's are expressive and personalized. The apparent humor of Botero's social stereotypes obscures the seriousness of the formal aspects in his art. He treats his paintings as abstract compositions, even though they cannot be divorced from their subjects. This is one of the reasons why differentiation between textures in his paintings is irrelevant. For instance, the mound of corpses in *Guerra [War]* (1973; PL. 10.4) and a mass of fruit in *Canasta de frutas [Fruit Basket]* (1972; PL. 10.5) are interchangeable. In *Guerra,* a compact mass of dead, obscene humans parodying medieval allegories of greed, piety, and hypocrisy seem to have been caught unexpectedly at the instant of some disaster. Nonetheless, they convey no greater degree of emotion or tragedy than does the fruit in *Canasta de frutas.* Both are equally and palpably sensuous.[63]

Besides still lifes, Botero's subjects include modern prelates, military leaders, heads of state, poets, lovers, middle-class couples in their homes, scenes in houses of prostitution, landscapes, and lone trees. He used appropriations from

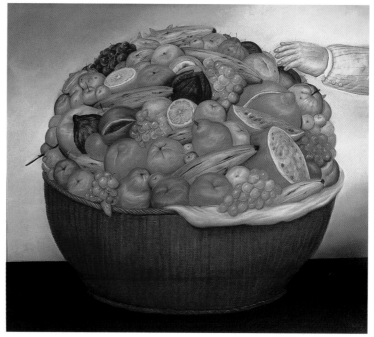

Western art-historical sources to parody modern situations. *Junta militar [Military Junta]* (1973)—painted the year of the coup that brought the Chilean military junta to power—is based on Jacques Louis David's *Oath of the Horatii* (1785) and provides a humorous twist on the stoicism and Roman virtue celebrated in David's very serious painting. Botero further ridicules the pompousness of the military by varying the figures' propor-

PLATE 10.5

Fernando Botero, *Canasta de frutas [Fruit Basket]*, 1973, oil on canvas, 123.2 × 141 cm. / 48½ × 55½ in. Collection Mr. and Mrs. Carlos Haime. Courtesy Nohra Haime, New York. Photo: Robert Lorenzson.

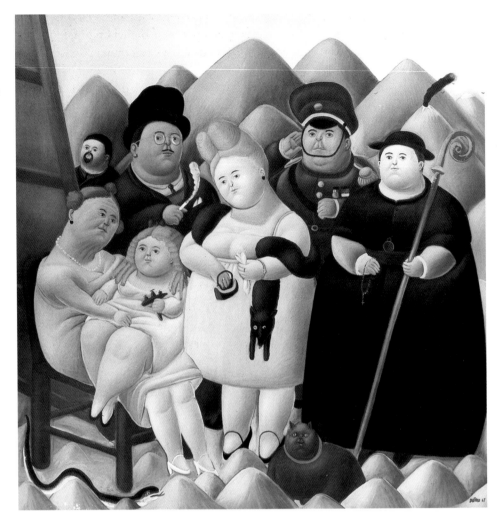

tions to correspond to their status and by ostentatious displays of uniform decorations.

La familia presidencial [The Presidential Family] of 1967 (FIG. 10.20) is based on Goya's *Family of Charles IV* (1800), itself presumed to be a mockery of the Spanish royal family. Botero's modern Colombian family is as commonplace as Goya's royal subjects. *La familia presidencial* appears against a landscape with a smoking volcano and a lurking snake on the ground nearby. The First Lady carries a fox stole on her arm as a mark of bourgeois opulence, a little girl sitting on her grandmother's lap clutches a toy airplane, while a much-decorated president in military uniform stands in a rigid salute next to the family priest and a monstrous cat. Botero's self-portrait appears at his easel in the background, just as Goya's self-portrait does in *Family of Charles IV*, as

though Botero's painting were an official commission too.[64] His representations of Latin American stereotypes provide what his foreign public expects, but in turn, he also inverts this idea by parodying such stereotyping.

After 1968, there emerged a new generation of figurative and representational artists whose work derived not from cubism but from academic models filtered through photorealism. Artists from Europe, the United States, and Latin America, known in Colombia through the Medellín Biennial (1968–1972, 1981), may have contributed to the rise of both photorealism and pop in Colombia. In addition, the Colombian representational painter Santiago Cárdenas (b. 1937) and his brother Juan Cárdenas, also a painter, had lived and studied in the United States for eight years while their father served as a Colombian diplomat there. Santiago subse-

quently taught in Bogotá universities in the early 1970s and thus helped to establish a new paradigm for Colombian art.[65]

Instead of looking to the past, Cárdenas found his subjects in contemporary household commodities. He had studied art with Alex Katz at Yale University. After receiving his M.F.A. there in 1965, he returned to Bogotá and began depicting nonexpressive manufactured objects such as articles of clothing, umbrellas, ironing boards, metal clothes hangers, electric cords and outlets in shallow empty rooms in a factual, naturalistic manner. Lawrence Alloway remarked that Cárdenas's correlation of the canvas with identically sized objects reflected his "familiarity with the double-takes of pop art."[66] His work of the 1970s was neither photographic nor academic. Cárdenas explained that "those who look for *trompe l'oeil* effects in my paintings are usually off the track, because my intentions are not to trick nor to play with the viewer. I use illusionism in order to create a 'presence,' just as nature does."[67]

In *Enchufe [Plug]* (1970; FIG. 10.21), a shallow room, whose back wall is parallel to the picture plane, has as its sole contents a plug and an electric cord that turns a corner into an unseen space.[68] Cárdenas's naturalistic charcoal drawings of articles of clothing, umbrellas, or

clothes hangers show these objects as whole images on the white paper. Whether Cárdenas's drawings represent a man's waistcoat, a pair of pants, or an illusionistically shaded hanger, his manner of isolating these objects on the white paper emphasizes their quality as icons rather than their banality as objects. This aspect links his work indirectly to Omar Rayo's geometric intaglios of similar objects. But Cárdenas's insistence on matching the painting to the scale of the original is what separates him from Rayo's reference to these objects as his point of departure.

By the mid-1970s, Cárdenas (like Jasper Johns) had restricted his subjects to things that were in themselves two-dimensional, such as blackboards, window shades, the side of a corrugated packing box, empty picture frames, and the backs of canvases. But unlike the textured surfaces of Jasper Johns's flags and targets, Cárdenas's paintings of equally nonexpressive subjects have no detectable brushwork. In *Pizarrón grande con reprisa [Large Blackboard with Shelf]* (1975; FIG. 10.22), the only visible marks are the ones realistically rendered to mimic the wiped chalk left on the blackboard, which is not the same as the artist's hand. In the end, the stark compositions and pristine surfaces of

FIGURE 10.21
Santiago Cárdenas, *Enchufe [Plug]*, 1970, oil on canvas, 206 × 400 cm. / 81 × 157½ in. Courtesy Santiago Cárdenas, Bogotá. Photo: J. C. Flores, Galería Freitas, Caracas.

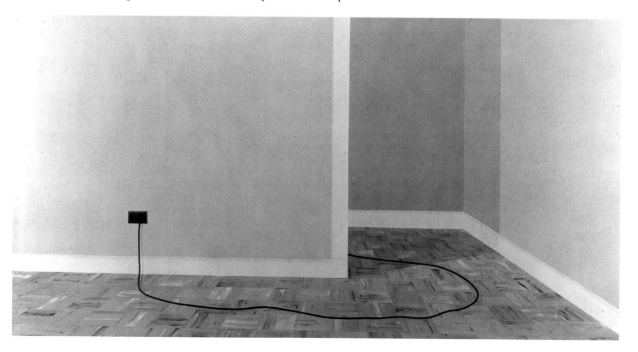

FIGURE 10.22
Santiago Cárdenas,
*Pizarrón grande con
reprisa [Large Black-
board with Shelf]*, 1975,
oil on canvas, 128.4 ×
240.1 cm. / 50½ × 94½ in.
The Museum of
Modern Art, New York,
Mrs. John C. Duncan
Fund. Photograph © 1997
The Museum of Modern
Art, New York.

Cárdenas's paintings convey a cool sense of order that have more affinity with Rayo and Carlos Rojas than with U.S. artists. The distinction between Rayo's objects and Cárdenas's is that Rayo's parody the world of consumerism and Cárdenas's were never intended as parodies.

Colombian Erotic Figuration

Although the figurative tendencies in Colombian painting in the 1970s can be traced to Cárdenas's impact as a teacher, he did not paint figures in the 1970s and did not reintroduce figures into his work until the 1980s. The emerging figurative artists based their work on both photorealism and academic models. The prevalence of realistic figure painting in Colombian art of the 1970s can be seen in the context of a tendency toward figural representation in the Western world in general.[69] But one of the aspects that made this phase of Colombian figuration distinctive from earlier modes was the existence of sexual allusions and overt eroticism. Some artists and critics have claimed that this eroticism was a response to years of sexual and political repression in Colombia. When sexuality

was present in art before 1968, it lacked the frankness of the 1970s. Neither Botero's scenes of lovers in bed or on a couch nor Grau's hedonistic youths could be considered erotic. Nor was Rayo's white intaglio *Bed Duties* (1964), of a foreshortened copulating couple, in any way erotic. But several other artists chose to represent the human body as an object of erotic pleasure, sometimes with an overlay of violence.[70]

Between 1950 and 1953, when *la violencia* was in full force in Colombia, the very conservative President Laureano Gómez had established a repressive, authoritarian system of censorship of press and religion enforcing strict adherence to the puritanical restrictions of the Roman Catholic Index. Góngora, who grew up in Cartago (Colombia) during those years, equated sexual repression with social oppression and violence. He once stated that "sex is a manifestation of intelligence. Violence and sexual repression go together."[71]

The depiction of sexuality in art was at times suffused with expressions of guilt, even revulsion; at others, it was overtly erotic. Although Góngora lived outside Colombia for most of his adult life (first in Mexico, then in the United States), his paintings and drawings of the 1960s sati-

rize clerical hypocrisy and celebrate sexual encounters, although without manifesting the strong erotic element visible in the work of others. Some of the individuals in his paintings of couples (usually the male had his own features) or single figures with furtive expressions convey some degree of guilt or exist in an atmosphere of sinfulness. They may appear in bedroom settings with small religious images on the walls as a reminder that they were engaging in a forbidden activity. Sex and violence can also be noted in the drawings and prints of the Cali-based artist Pedro Alcántara. But the political content of his work belongs more properly to the next chapter.

In an equally negative context, artists such as María de la Paz (Maripaz) Jaramillo (b. 1948) and Oscar Muñoz (b. 1951) made sexuality the subject of disturbing works. In the 1970s, some of Jaramillo's garishly colored paintings of women or couples recall the sordid characterizations of the earlier German expressionists, but in a contemporary framework. In a series of drawings he made in 1973 and 1974, Muñoz used distortion as a means to render sexual encounters repulsive. In one drawing, a couple appears divided at the waist, with the top half showing a man and a woman fully clothed and the bottom half—the hidden side—depicting obscenely bloated seminaked abdomens with ambiguous genitals. His later drawings of unidentifiable presences in shadowy rooms are far more subtle and voyeuristic.

Other artists depicted the whole or a fragment of the male or female figure as a source of erotic pleasure, in some cases with religious overtones. In 1973, the Spanish-born painter and graphic artist Juan Antonio Roda (b. 1921), who settled in Colombia in 1959, produced a series of etchings on the subject of dead nuns. The portrayal of nuns as the eternal brides of Christ after their death was a colonial tradition in Latin American countries.

Roda addressed themes of sensuality as much as sexuality in this series. In *El delirio de las monjas muertas no. 9 [The Delirium of the Dead Nuns No. 9]* (1974; FIG. 10.23), a dead nun's head is shown, her eyes smiling but closed as if asleep, enjoying the pleasures she was denied during her life. Although Bernini's *Ecstasy of St. Theresa* comes to mind, Roda's nuns have none of the orgasmic aspect of Bernini's baroque sublimation of sexuality through religious experience. Rather, the eroticism here is gentle and suggests an ongoing pleasurable state expressed by the nun's smile. Throughout the series, nuns are represented as young and beautiful women teased by phallic symbols. Their faces are touched by floating hands or fingers, flowers, wings, lines, or arabesques. Roda addresses the issue of sexual repression through compensation while also equating sex with death. In Marta Traba's words, "the denial of the flesh in life seems to have earned them a paradise of sensuality in death."[72]

FIGURE 10.23
Juan Antonio Roda (Colombian, b. 1921), *El delirio de las monjas muertas no. 9 [The Delirium of the Dead Nuns No. 9]*, 1974, etching, 100.5 × 72.1 cm. / 39⅝ × 28⅜ in. Courtesy Jack S. Blanton Museum of Art (formerly Archer M. Huntington Art Gallery), The University of Texas at Austin. Archer M. Huntington Museum Fund, 1987. Photo: George Holmes, P1976.13.4.

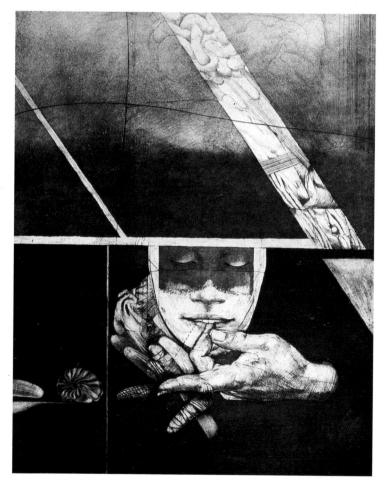

Luis Caballero (1943–1993), a former student of Roda's, not only paired sexuality with death, ecstasy, or martyrdom in his paintings and drawings of male figures, he also equated sex with implied violence. In his drawings and paintings, he represented nude or partially clothed males in the tortured poses of Michelangelo's or Géricault's figures. The product of a strict Catholic upbringing, Caballero left Colombia for Paris, where he studied and finally settled from 1969 to his death in 1993. The independence he experienced far from Colombian social constrictions and market pressures allowed him the option to follow his preference for the traditional masters of figure painting (Grünewald and Caravaggio besides Michelangelo and Géricault) rather than the modern schools, as well as the freedom to acknowledge his own homosexuality.

Caballero's figural compositions of the 1960s evolved out of a semiabstract vocabulary. At the *First Medellín Biennial* in 1968, he had exhibited a thirteen-panel polyptych set up to look like a room with floating, androgynous figures in amorous encounters painted across the side panels and ceiling. These figures were not particularly erotic, but by the mid-1970s, his drawings and paintings were clearly identifiable as males in suggestive poses,

with and without distinguishable faces. Figures appeared tied with, or restrained by, ropes, bandages, or other partial clothing, designed to draw attention to some anatomical part. Several paintings of the early 1970s represent figures in a penumbral space illuminated by sudden flashes of light or heightened by Goyesque splashes of red paint. The male figures appear to have just succumbed to erotic satiation or to a martyr's sudden violent death. Such ambiguities are evident in the large triptych *Sin título [Untitled]* (1977; FIG. 10.24), in which a group of figures appear to have fallen one over the other in contorted poses illuminated by eerie flashes of light. The mass of figures in this life-sized composition evokes Géricault's *Raft of the Medusa* (1818). Caballero had seen and admired the nineteenth-century painting at the Louvre.

Caballero's choice of the older masters as models was also determined by his own reading of erotic content in many Renaissance and baroque interpretations of religious subjects. The depiction of Christ as an attractive man in much Italian art was especially stirring to Caballero. For him, death, suffering, or erotic experience had equal intensity, and he perceived the presence of all these elements in traditional Italian figural paint-

FIGURE 10.24
Luis Caballero, *Sin título [Untitled]*, triptych, 1977, oil on canvas, 195 × 390 cm. total (195 × 130 cm. each) / 76¾ × 153½ in. total (76¾ × 51¼ in. each). Courtesy Galería Garcés Velázquez and Beatriz Caballero, Bogotá.

ing. The act of painting heightened this experience: "One must paint erotically . . . more with semen than with turpentine," he once said. He compared his painted figures to the "sacred images I adored" when he had seen them as a child.[73]

Caballero was not alone among Colombians in choosing the male as an object of desire. But many other artists continued the more conventional practice of painting the female nude in such a way that the model has no religious or mythological references but is presented as the object of male pleasure. In this category are Darío Morales (1947–1988) and Alfredo Guerrero (b. 1936). Morales, who, like Caballero, moved to Paris in 1969, looked to classical models such as those of French nineteenth-century academic painting, but he used his wife as a model. He combined the academic style with the precise detail and lighting of contemporary photography, which he used as a source for his paintings. His work attracted considerable attention because of his "frankly erotic . . . nude women, seated in, or leaning back in rocking chairs" and for their apparent photographic exactness.[74] Although he usually set his figures in very sparse interiors, in *Desnuda sobre mecedora con fogón* [Nude in a Rocking Chair with Stove] (1977–1978; FIG. 10.25), he included the trappings of an artist's studio. The nude leans back uncomfortably in a chair set in a room with a stove, an easel, and the artist's tools. A reproduction of Courbet's *The Artist's Studio* on the wall behind the nude is a metaphor for the artist and his model theme. But in Morales's painting, the figure is shown in a foreshortened position that draws attention to the sexual core of her body as a central focus. He invariably selected poses in which the sitter's face was hidden in order to preserve the nude's anonymity. In *Desnuda sobre mecedora con fogón,* the face is concealed behind the open shirt she wears as a provocative agent, something like Caballero's use of clothing or ropes for a similar purpose.

Alfredo Guerrero also depicted female nudes in a precise academic manner. Like Morales's models, Guerrero's were young, slender, and sleekly painted. But Guerrero often selected a back view, with the buttocks as the focal point and the head sometimes turned toward the viewer just enough to reveal the face. He also added a temporal note, as for instance in *Desnudo de espaldas* [Nude from the Back] (1977), by faithfully recording the marks left by a bikini, thus giving the figure the appearance of having just returned from a morning at the beach. This aspect alone distinguishes his work from Morales's less temporal settings.

The coexistence in Colombia of erotic figuration with constructivism from the late 1960s through the 1970s may seem

FIGURE 10.25

Darío Morales, *Desnuda sobre mecedora con fogón [Nude in a Rocking Chair with Stove],* 1977–1978, oil on canvas, 195 × 130 cm. / 76 × 47¼ in. Courtesy Aberbach Fine Art, New York. Photo: Willo Font for the Americas Society (formerly the Center for Inter-American Relations), New York.

contradictory. Seen in the context of Colombian history, however, it becomes less so. The monastic purity of Colombian constructivist art and the religious overtones of some erotic art might represent a response to similar external experience expressed in different ways. The constructivist and the erotic were fused in Edgar Negret's *Acoplamiento* series, in which a double meaning seems evident. One may conclude that the constructivists chose to control and harness the forces of nature, and the erotic figurative artists, to liberate them from a restrictive legacy of repression. Beyond that, there was the artists' choice and the models each chose to focus on.

Pop Art Colombian Style

Figuration of a different order was also present in a Colombian version of pop art that arose in Bogotá and Cali. But it differed considerably from the factual style of Santiago Cárdenas.[75] The artists referred to here as pop borrowed from local imagery rather than from a U.S. vocabulary of objects. Two artists to be considered in this category are Beatriz González (b. 1939) of Bogotá and Hernando Tejada (1928–1999) of Cali. Both made art out of furniture. González painted store-bought furniture and Tejada

carved or fashioned his own. González's painted furniture had a local source in the chairs with landscapes painted on their backs that were prevalent in middle-class households earlier in the century. Taking her images from well-known Italian Renaissance and history paintings or from the contemporary news media, González transferred these images to cheap, store-bought beds, nightstands, coffee tables, and dressers as flattened designs with the mechanically reproduced appearance of a Warhol piece. In her use of reproductions of past European masterpieces, particularly of religious figures, she exploited a ready-made language, familiar to the average Colombian. Her special brand of popular imagery drew from the religious postcards people bought for devotional purposes.[76]

González carefully coordinated her images with the furniture's function. For instance, she replaced dresser mirrors with simplified copies of Raphael's *Madonna of the Chair* or Fra Filippo Lippi's *Madonna and Child and Two Angels,* as in her *Santa Copia [Holy Copy],* which combined the notion of a dresser with an altar; Vermeer's *Seamstress* appears inside the lid of an open sewing basket; a replica of Leonardo's *Last Supper* adorns the top of a coffee table. *Saluti da San Pietro [Greetings from Saint Peter]* (1971; PL. 10.6) records the images of three popes on the tops of

three nightstands. The images are based on photographs, which she transferred to sheets of metal glued to the tops of the nightstands and then painted with enamel. The popes' faces conjure up devotional images commonly found over beds or on nightstands in Colombian households. The title of this work also evokes the idea of a postcard sent home by a tourist visiting the Vatican.

Hernando Tejada, who had designed wooden puppets and run a puppet show in 1963, brought this experience to his furniture/women hybrids.[77] In the 1960s, he began fashioning out of wood, straw, and other assorted materials life-sized, female figures to which he added appropriate accessories. The titles of these works were an integral part of them, as were some of Rayo's titles. Tejada's titles rhymed with the name of the object they represented. In *Paula la mujer jaula [Paula*

the Cage Woman] (1976; FIG. 10.26), the head and limbs of a woman sitting cross-legged are made of carefully carved and polished wood like the legs of a chair, and the face is painted on. The woman's torso is the straw cage whose entrance is—predictably—in her pubic region. In *Berta la mujer puerta [Bertha the Door Woman]* (1976), a fantastic image of a woman emerges from the door. These elaborately carved or constructed figures, decorated with flowers or butterflies or sometimes adorned with complex hairdos or hats, recall the painted carved decorations in colonial churches in which female figures with heads, sometimes surmounted by decorative panaches, grow out of scrolls and vegetation. Aside from the fact that Tejada's works could ostensibly be open to feminist protests and accusations of sexism for presenting women as furniture, he created a contemporary and

FIGURE 10.26
Hernando Tejada, *Paula la mujer jaula [Paula the Cage Woman]*, 1976, wood and straw, 128 × 122 cm. / 50⅜ × 48 in. Private collection, Bogotá. Courtesy Hernando Tejada, Cali.

personal folklore with these figures that must be understood outside the context of feminist debates. According to the Cali critic Miguel González, Tejada "made his own the tradition of colonial statuary and appropriated all the best customs of artisanry of America."[78] Both Tejada and González found their subjects and materials in Colombian popular culture.

SUMMARY

In spite of their international sources, neofiguration, representational, environmental, and pop art in the 1960s and 1970s took distinctive forms in different countries and regions. Artists transformed these modes into locally understandable variants by appropriating from the popular media and customs around them. Between 1962 and 1972, a greater number of artists than ever before traveled outside their countries, some of them on Guggenheim fellowships. During those years, biennial and international exhibitions brought foreign currents to Latin America, and artists received exposure abroad to an unparalleled extent. But by the mid-1970s, communication and exchange diminished or took place on a more individual basis as governments changed and institutional or corporate funding dwindled. As a result, artists tended to remain in their countries. If they left, it was more often for political, than for artistic, reasons. A new breed of politically engaged artists whose modes of expression transcended the world of objects surfaced in the 1970s and 1980s. Many chose printmaking and conceptual art as means to communicate their ideas.

In the late 1960s, a rise in politically committed art was evident in many countries. This new militancy was not fueled by social or labor problems, as it had been in the 1930s and 1940s, but rather by a range of more recent concerns. Artists objected to the dominance of official art institutions and the commercialization of art that had escalated in the 1960s. They also took a militant position toward local politics, the Vietnam War, and U.S. interventionist and exploitative policies in Latin America and elsewhere.[1] Political art was made in most countries, but major groups with specific agendas can be identified especially in Colombia, Brazil, Uruguay, Argentina, and Chile. In Colombia, the lingering effects of *la violencia,* still felt in the early 1960s, and a pervasive dislike of the clergy, oppressive leaders, and the United States provided major catalysts for activist art. In the 1970s and part of the 1980s, political art was especially prevalent in countries under military governments.[2]

The militant art that arose after the late 1960s did not take the form of a single identifiable style like *indigenismo* or social realism in earlier decades, but took off in a variety of directions in different media. Therefore, this art lent itself to more ambiguous readings. Many artists continued to express their ideas through the traditional mediums of painting, collage, and graphic art; others did so through installations and body, performance, and conceptual art, as well as street actions. Conceptual art proved especially useful as a cryptic form of communication when a direct statement in a painting would have been imprudent. A conceptual work could consist of anything from a single printed image or photograph to a whole installation.[3] The manner of expression—whether overt or veiled in metaphoric references—depended in large part on the degree of censorship and repression artists were subjected to in their country.

Printmaking proved to be very effective as a means of ideological diffusion

POLITICAL ART

GRAPHIC ART,

PAINTING, AND

CONCEPTUALISM AS

IDEOLOGICAL TOOLS

ELEVEN

for several reasons. Historically it was already associated with denunciatory art, and prints could be made in multiple editions and readily circulated. The graphic biennials and workshops that came to replace the international exhibitions of the 1960s were major catalysts for the widespread use of this particular mode. As early as 1955, the Chilean painter Nemesio Antúnez had founded the Taller 99 graphics workshop in Santiago, Chile,[4] and the *First American Graphics Biennial* took place there in 1963. By the early 1970s, other graphics biennials were established in San Juan, Puerto Rico, and Cali, Colombia, in 1970 and 1972 respectively.[5] During the 1970s, some graphics and poster workshops became centers for political debate as well as for experimentation in the graphics media. By the 1970s, politically active workshops existed in Colombia, Cuba, Nicaragua, and Chile.

PLATE 11.1
Nirma Zárate and Diego Arango (Taller 4 Rojo), *Agresión del imperialismo [Imperialist Aggression],* **1972, three photo-serigraph posters. Courtesy Nirma Zárate, Bogotá. Photo: Ron Jameson, from** *Historia del arte colombiano,* **ed. Ricardo Martín (7:1570–1571).**

GRAPHIC ART IN COLOMBIA

In Colombia, graphic art was the main vehicle for activist art in the 1970s. Large-scale drawings, prints, and posters acquired a new status that equaled that of other media. Some of the most militant centers of print and poster-making

emerged in Bogotá and Cali. The Taller 4 Rojo (4-Red Workshop) was founded in Bogotá in 1972 by a husband and wife team, Nirma Zárate (1936–1999), a painter and printmaker trained in Colombia and at London's Royal Academy, and Diego Arango (b. 1942), an anthropologist, philosopher, and photographer. They were joined by the Colombian artists Carlos Granada and Fabio Rodríguez and the Italian-born Umberto Giangrandi. Their work, which included etchings, lithographs, serigraphs, photo-serigraphs, and photo-engravings, was specifically directed toward the diffusion of their ideological views. In statements made in 1972, they had voiced their objections to "all manifestations of cultural oppression by the imperialists" and had exhorted "every Latin American artist with a revolutionary conscience" to "contribute to the rescue and formation of our own values, in order to configure an art that is the patrimony of the people, and a genuine expression of our America."[6]

For its part in the war in Vietnam, the United States was a major target of the Taller 4 Rojo. In *Agresión del imperialismo [Imperialist Aggression]* (1972; PL. 11.1), a series of three photo-serigraph posters by Zárate and Arango, a photomontage of a dollar bill, in which the portrait of

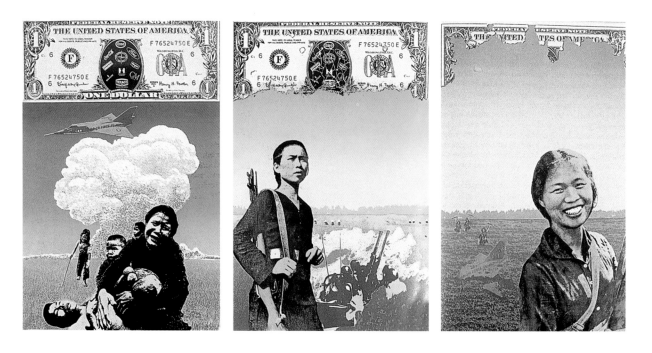

George Washington is replaced by the names of multinational U.S. companies (Esso, Coca-Cola, Ford, Texaco, etc.), appears in progressive stages of disintegration above a barren Vietnamese landscape. In the first poster, the dollar bill is whole above a crying woman who carries her dead children across a field as a United States army jet sprays Agent Orange over the field. In the second of the sequence, the bottom of the dollar bill has been eaten away, the sky has paled from orange to yellow, and a Vietnamese girl brandishing a rifle stands defiantly against a background with soldiers. In the third, the triumphant girl smiles broadly at her victory as the dollar bill has almost disappeared and the sky is a pale green. These posters and others like them were distributed directly by the workshop.

The militancy of the Taller 4 Rojo artists was evident in the work of numerous other Colombian graphic artists. But their subjects also included references to personal alienation, insanity, and Colombia's recent history. Among these Colombians is Pedro Alcántara (b. 1942), an artist and illustrator from Cali who in 1955 had played a key role in first introducing avant-garde art in his hometown. Alcántara also denounced all forces of domination and imperialism, but some of his major works were on themes of *la violencia* and local politics. In a type of inverted eroticism, he represented the human body mutilated, turned inside out, or emasculated in unsettling correlations between sexuality and violence. In his work of the early 1960s, his figural distortions were the Baconesque ones typical of neofigurative artists elsewhere. But by 1966, he had developed a personal repertoire for expressing violence in his drawings and prints by eviscerating the figure, disassembling, then reassembling it into an aggregate of internal parts. These vulnerable, flayed, martyred bodies clearly convey pain, not pleasure, although a perverse erotic component is present.

Many of his titles were taken from literary sources, fragments of poems by

Pablo Neruda and other writers, and from accounts and photographs of *la violencia* in *La violencia en Colombia* (The years of violence in Colombia), a book by Germán Guzmán Campos, Orlando Fals Borda, and Eduardo Umaña published in two volumes in 1963 and 1964 respectively.[7] Alcántara's subjects include anonymous revolutionary heroes, particularly those of the popular Colombian struggle Movimiento Revolucionario Liberal (Liberal Revolutionary Movement, or MRL) of the 1950s,[8] as well as homages to Ché Guevara, warriors, and faces and bodies in varying states of putrefaction.[9] In a life-sized ink drawing, *El martirio agiganta a los hombres-raíz [Martyrdom Aggrandizes the Root-Men]* (1966), two men tied by ropes and hung upside down

FIGURE 11.1
Pedro Alcántara, *Qué muerte duermes, levántate [Oh What Death Do You Sleep, Arise]*, from the *Los Cuerpos [The Bodies]* series, 1967–1968, ink drawing, 70 × 50 cm. / 27½ × 19¾ in. Courtesy Pedro Alcántara, Cali. Photo: Ron Jameson, from *Historia del arte colombiano*, ed. Ricardo Martín (p. 1576).

by their feet, their genitals exposed, are brutally compressed within the picture's boundaries. The focus on exposed genitals to further humiliate the victims evokes Goya's *Disasters of War* prints, some of which also showed victims with mutilated genitals. But Alcántara's are rendered more gruesome by their monumental scale.

A year later, Alcántara began *Los Cuerpos [The Bodies],* a series of pen-and-ink drawings. In *Qué muerte duermes, levántate [Oh What Death Do You Sleep, Arise]* (1967–1968; FIG. 11.1) from this group, the face and body of a male have been replaced by viscera and tendons, as though the figure had been turned inside out to reveal all its vulnerabilities, then reassembled in vaguely human form. In *Guerreros [Warriors]* (1972), a related work from a series of lithographs, snakeskin patterns interweave through the exposed tendons and entrails. Fueled by Colombia's own history of violence, Alcántara's blatant representation of violence to the human body in these works is considerably more disturbing than anything by the Nueva Presencia artists and can be understood in the context of photographs of dead bodies published in newspapers and books during *la violencia.*

POLITICAL METAPHOR
IN PAINTING

In Brazil and Chile, a number of artists continued to use the traditional medium of paint on canvas as a mode of expression. By means of a strategy of self-censorship, they invented new symbols or invested previously used ones with new meaning. The São Paulo printmaker and painter Antonio Henrique Amaral (b. 1935) made bananas the subject of a series of paintings between 1967 and the mid-1970s. Prior to moving to New York for two years in 1973,[10] Amaral painted hyperrealist close-ups of bananas, either singly or in clusters, compressed within the picture's space. The yellow and green

of his earliest versions evoke the colors of the Brazilian flag, just as Segall's colors had in his 1927 painting *Bananal [Banana Plantation]* (see PL. 2.13). But by the early 1970s, these colors in Amaral's paintings yielded to overripe yellow-browns. His choice of bananas as subject matter was a by-product of the *tropicalismo* of the 1960s. But he turned this theme into a symbol of vulnerability and colonization. According to the Brazilian critic Frederico Morais, Amaral's bananas parodied Brazil as a banana republic because "Brazil had been an exporter of bananas since the colony."[11]

In New York, Amaral reduced the bananas to atomized fragments in various stages of decay, seemingly torn apart in sadomasochistic confrontations with sharp instruments, strangulated by ropes, punctured by forks, or cut into by knives. Although critics have offered various interpretations of these paintings, including a claim that bananas were metaphors for "an amorphous mass of slowly decaying tropical [Brazilian] people" in a "heavy atmosphere of terror and oppression,"[12] Amaral himself evaded explicit interpretations but did not deny being a political painter. The sexual connotations go without saying. But it is difficult to avoid making associations with oppression or incarceration and torture when looking at *Só em verde [Alone in Green]* (1973; PL. 11.2) and *Campo de batalha 31 [Battlefield 31]* (1973). In the first, ropes above a suspended banana suggest jail bars. In the second, the bananas have been reduced to a few morsels scattered in a maze of forks whose tines also evoke prison bars, "the [human] body against the metals of oppression," to use the title of an essay by Frederico Morais.[13] The scattered morsels of gutlike banana flesh in *Campo de batalha 31* evoke torture as well as a jail cell. In *A morte no sábado—Tributo a Wladimir Herzog [Death on Saturday—Tribute to Wladimir Herzog]* (1975; PL. 11.3), Amaral admittedly alluded to the well-publicized death on a Saturday in 1975 of a Brazilian socialist journalist, Wladimir Herzog, while in the custody

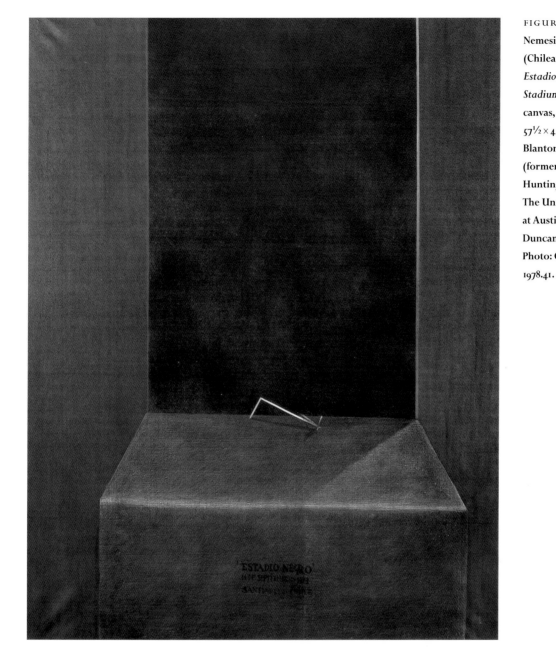

FIGURE 11.2
Nemesio Antúnez
(Chilean, 1918–1993),
*Estadio negro [Black
Stadium]*, 1977, oil on
canvas, 146.0 × 114.0 cm. /
57½ × 44⅞ in. Jack S.
Blanton Museum of Art
(formerly Archer M.
Huntington Art Gallery),
The University of Texas
at Austin. Barbara
Duncan Fund, 1978.
Photo: George Holmes,
1978.41.

of the Information Service of the Brazilian army. The banana flesh in this painting is not yellow but a visceral red.

Amaral's compatriot João Câmara (b. 1944), from the northeastern city of Recife, used Brazil's past history as a metaphor for contemporary conditions. Between 1973 and 1975, Câmara, who remained in Brazil during the military government, chose as his subject the years of the Vargas administration (1930–1954). In 1937, Vargas dissolved the constitution and went from being president to dictator, and his dictatorship ended with his suicide in 1954. Câmara, who was only ten years old in 1954, based his scenes on historical accounts in fragmented images, sometimes with neosurrealist overtones. Naked figures appear inexplicably contorted, with body parts turned back to front or missing altogether to address issues of power, corruption, and dishonesty.[14]

In Chile, painting was carefully monitored by the military government. Painters who dared to make identifiable references to repression generally did so while living in exile. Nemesio Antúnez (1918–1992), one of Chile's major painters and director of Santiago's government-sponsored Museo Nacional de Bellas Artes at the time of the military coup,

PLATE 11.2
Antonio Henrique
Amaral (Brazilian, b.
1935), *Só em verde [Alone
in Green]*, 1973, oil on
canvas, 151 × 150 cm. /
59⅜ × 59 in. Courtesy Jack
S. Blanton Art Museum
(formerly Archer M.
Huntington Art Gallery),
The University of Texas at
Austin. Gift of Barbara
Duncan, 1975. Photo:
George Holmes,
GI975.22.1.

PLATE 11.2
Antonio Henrique
Amaral (Brazilian, b.
1935), *Só em verde [Alone
in Green]*, 1973, oil on
canvas, 151 × 150 cm. /
59⅜ × 59 in. Courtesy Jack
S. Blanton Art Museum
(formerly Archer M.
Huntington Art Gallery),
The University of Texas at
Austin. Gift of Barbara
Duncan, 1975. Photo:
George Holmes,
GI975.22.1.

PLATE 11.3
Antonio Henrique
Amaral, *A morte no
sábado—Tributo a
Wladimir Herzog [Death
on Saturday—Tribute to
Wladimir Herzog]*, 1975,
oil on canvas, 123 × 165 cm.
/ 48½ × 65 in. Courtesy
Antonio Henrique
Amaral, São Paulo. Photo:
Romulo Fialdini.

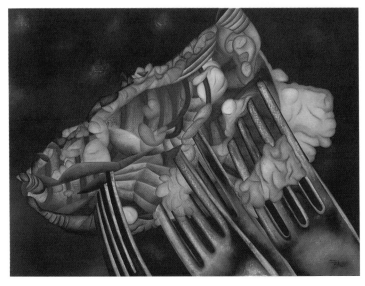

left for Spain in 1974 and later lived in London and Rome before returning to Chile in 1984. Between 1966 and 1968, when he lived in New York as cultural attaché to the Chilean embassy, he had done a series of predominantly black paintings of football stadia with clearly defined goal lines, sometimes populated by specklike crowds. This subject was inspired by the night ball games Antúnez had attended at Yankee Stadium. In *Estadio negro [Black Stadium]* (1977; FIG. 11.2), he converted the earlier apolitical theme into a political metaphor with what seem like minimal changes. The crowds are absent, the title is spelled out in the painting, and the goal line is bent to resemble an instrument of torture used to apply electricity to a body's delicate parts.[15] *Estadio negro* refers to Santiago's National Stadium, where suspected political dissidents were held, tortured, and killed the day after the 1973 coup.

CONCEPTUALISM

In many cases, especially those in which artists remained in their countries during the repressive years, conceptualism (which is the preferred term for Latin America) proved to be the most effective way to address political issues.[16] In its early stages, conceptualism functioned to challenge the commercialization of the art object and official art institutions, as was the case elsewhere. Aside from its desirable affinities with literature, conceptual art in Latin America owes its popularity as an art form to the fact that it was not a style imported from abroad but was an intellectual process that could develop out of individual frames of reference. The Brazilian artist Regina Vater once observed that, as someone from a Third World country, "the only luxury I can afford is my brain."[17]

In its initial stages, conceptual art eliminated the need for expensive materials, fulfilled the anti-commercial objectives that preoccupied artists from many countries after the mid-1960s, and, after 1968, furnished an alternate means for ideological expression when traditional modes were too closely monitored. Conceptual art could exist as a print or collage as well as a whole installation, performance piece, or in the form of a street action.[18] The different aspects conceptual art took in each country were determined by the materials available there as well as by the idea to be communicated.

Conceptual art was taken up in most Latin American countries, including Mexico, Peru, and Colombia. It played a major function in the 1970s and 1980s in Argentina, Uruguay, Brazil, and Chile. In the latter four countries, it took two major directions: it questioned Cartesian logic and notions of reason (Argentina, Uruguay, and Brazil) or it had an ideological purpose as political metaphor (Uruguay, Chile, Argentina, and Brazil).[19] In Brazil, the two categories melded, since artists considered the questioning process itself to be potentially subversive.

The military governments were at their most repressive from 1968 to the early 1980s, with the mid-1970s as the peak years. Death squads in Brazil and *desaparecidos* (those who were incommunicado and subsequently disappeared) in Argentina, Uruguay, and Chile as well as Brazil were the focuses of leaked news reports in spite of efforts by the respective governments to suppress information.

In Argentina, political activism began in the mid-1960s and was initially motivated by anti-commercial and anti-capitalist concerns. A number of artists who objected to the dominance of art critics like Jorge Romero Brest and visiting U.S. art dealers like Leo Castelli, who traveled there in search of Argentine art, began exhibiting dissident art that had no commercial or promotional appeal. Some artists also carried out acts of outright rebellion. In 1968, a group of them interrupted a lecture Romero Brest was giving at the Circle of the Friends of the Arts in Rosario. Juan Pablo Renzi, as the group's representative, took over the podium and, at the end of an anti-establishment statement, declared that "we believe that art should constantly question the structures of official culture."[20]

That same year several artists affiliated with the Instituto Torcuato di Tella, still under Romero Brest's direction, deliberately included subversive works in the di Tella's 1968 exhibition *Experiencias 68 [Experiences 68]* to express dissatisfaction with neocolonialism in art institutions that acquiesced to capitalist wishes. One of the works that drew particular attention consisted of a bathroom booth for spectators to enter and scribble their thoughts on the walls. The resulting graffiti was overwhelmingly opposed to General Juan Carlos Onganía's military government, which was in power at the time, so the police ordered the work removed. Interpreting this as an act of aesthetic censorship, other participating artists withdrew their works and tossed them out of windows.[21]

Dissident artists also formed art collectives in Buenos Aires and Rosario in a

campaign to find strategies with the power to transform existing social structures because they felt "it was immoral to make their art in the society that existed there."[22] To this end, the Rosario group carried out a series of political actions in Buenos Aires as well as in Rosario and Santa Fe, with the collaboration of local artists from each of those cities.

One of these actions, *Tucumán arde [Tucumán Burns],* had as its objective to call attention to the miserable conditions of the thousands of workers who had recently been laid off from sugar refineries in the northwestern city of Tucumán. These refineries had been a staple industry in Tucumán Province and had provided minimal wages for the workers there, known as the poorest in Argentina. Onganía had closed these refineries, presumably for economic reasons, and replaced them with other industries financed by North American capital under a false appearance of prosperity. As a result, artists who viewed the labor injustices, the military government, and its U.S. backing as neocolonialism sought to create an "art in the form of an action that would modify the milieu that produced this art."[23] The *Tucumán arde* project was initiated by a posting—with official authorization—of flyers reading "Tucumán" printed in large letters on walls in Rosario and Santa Fe. This action was followed by a second round of posting—this time clandestine—of flyers reading "Tucumán Burns" as attention getters. The participating artists then traveled to Tucumán to collect documentation on the conditions of unemployed workers. They made photographs, slides, and films and conducted interviews with local officials and workers. With the collaboration of syndical employees, journalists, students, workers, and artists attracted by the "Tucumán Burns" posters, the project's participants produced a montage of sound, film, and slide projections that was shown daily for a week in Rosario and for two days in Buenos Aires

at the General Federation of Labor (CGT).[24] The police closed not only the exhibitions in both cities but also the syndical buildings in which they took place. The participants considered this official interference as a positive sign that the project was a success.[25] By using existing communications circuits such as advertising spaces and local channels of communication, they succeeded in reaching a broad public.

In Latin America as in the United States, from the late 1960s on, many artists looked to Marcel Duchamp as a major source for conceptual art. It was not so much Duchamp of the ready-mades that appealed to artists in Latin America as Duchamp the intellectual provocateur. The Brazilian conceptualist Cildo Meireles observed that Duchamp's contribution "has the merit of forcing the perception of art, not as a perception of artistic objects but as a phenomenon of thought."[26] Brazil's conceptual artists found original—sometimes paradoxical—ways to apply Duchamp's linguistic and intellectual games, especially his ways of challenging logic. Besides Meireles, artists to take up conceptual art included Antonio Dias, Waltercio Caldas, Tunga (Antônio José de Mello Mourão), and Anna Bella Geiger.[27]

Originally from the northeast of Brazil, Dias (b. 1944) settled first in Rio, then in Milan, Italy, in 1968; he made frequent trips home to Brazil and had one brief stay in New York in 1970. In the late 1960s, he began a series of schematic, rectangular paintings in synthetic polymer on canvas that combined image and text, and for which he often used English titles. One of these, *Free Continent* (1968), consists of a grid of twenty-three squares with the bottom right one left blank. In referring to another similar series of paintings from the early 1970s, Dias claimed that the rectangle with a missing corner evoked for him "the floor plan of an art gallery" as a reflection of the way in which the "relationship between art and society is defined through cultural institutions."[28] In *Free Continent,* Dias also

tricks the viewer by spelling out the word *hungry* in each square. As a result, one is tempted to think in broader terms of social conditions in Brazil and to identify the rectangle and missing corner as the map of Brazil. In another example from this series, the background is solid black except for the missing square. The word *imagination,* spelled out across its center, leaves the viewer to ponder over the missing part or over the censorship enforced on the news media and the arts in Brazil. The stark black functions as a field on which the imagination can act. It also implies the need for self-censorship, and the single word *imagination* (implying creative thought) spelled out suggests a potentially dangerous or subversive activity.

Dias also used English for word games. In *The Tripper* (1971; FIG. 11.3), irregularly sized white dots and a thin white line linking some of the dots cover an all-black field. Dias explained that "in these works I tried to exploit a type of wrong reaction the public had towards my paintings. Namely, every time I proposed paintings in which the basic image was a black surface with white dots, there was always someone who came up with the story of the sky with stars. To me, that was any old image thought up by chance." He associated these, he said, with games found in the dailies and children's papers in which, by linking one dot to another to mark the itinerary for "tripping" through them, an image would appear.[29] However the title printed at the top along with the image seemed planned to trick or "trip" up the viewer into making associations between a cosmological map and the Big Dipper.

Some of Dias's colleagues followed a parallel exploration of visual deception. In 1975, several artists (Carlos Vergara, Carlos Zilio, Cildo Meireles, José Rezende, Luis Baravelli, Rubens Gerchman, Waltercio Caldas) and the critic Ronaldo Brito, who shared a desire to overthrow what they perceived as middle-class apathy, coedited three issues of an ephemeral journal, *Malasartes* (literally "Badarts"; 1975–1976). The journal was grounded in a global conceptualism

FIGURE 11.3

Antonio Dias, *The Tripper,* 1971, acrylic on canvas, 130 × 195 cm. / 51¼ × 76¾ in. Courtesy Antonio Dias, Rio de Janeiro. Photo courtesy Brito Cimino, São Paulo.

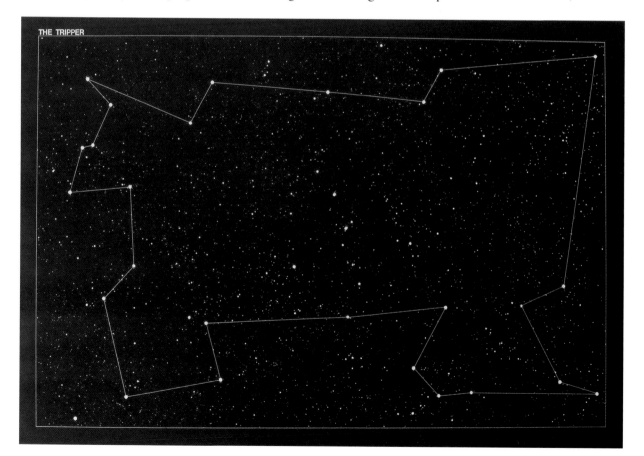

THE TRIPPER

based on the ideas of Duchamp. Besides statements by the participating artists, the editors reprinted essays by foreign and other Brazilian conceptual artists and writers who addressed a range of issues from provincialism and their geographic location in the periphery to how to subvert the existing media in Brazil.

One of the essays, a translation of Joseph Kosuth's "Art after Philosophy," led a Brazilian reviewer to denounce Kosuth as "irresponsible" because of his apparent distancing "from the world around him."[30] While Kosuth was of interest to the Brazilians, none of them could identify with his tautological position. In a manifesto published in *Malas-artes*'s last issue (June 1976), its authors, who included Caldas, Meireles, and Tunga, like some of their Argentine colleagues, voiced their opposition to the current cultural ideology's "links with the art market" as well as to "cultural colonialism." As an alternative they proposed to intervene in the process of "manipulation and reading of their works within the art circuit."[31]

Caldas, Tunga, and Meireles set out to address questions of perception by attempting to destroy ingrained associations with given images and by challenging logic, as Dias had done in *Free Continent* and *The Tripper*. Caldas (b. 1946) created objects as "thought devices" to stimulate perceptual associations. He sought to reverse the concept of logic and reason rooted in nineteenth-century positivism and, by extension, the colonialism implicit in the Brazilian flag's logo "Order and Progress." He made reference to reason and aboriginal or indigenous resourcefulness in two works, *Centro de razão primitiva [Center for Primitive Reasoning]* (1970), consisting of a box lined with black velvet containing four vertical spikes, and *Convite ao raciocínio [Invitation to Reasoning]* (1978), comprising a tortoise shell with an iron pipe running through it. Both works juxtapose the notion of native ingenuity with that of industry (the metal), implying encroachment by an alien culture. Brazilian lore also abounds with myths about tortoises winning races against enemies of superior strength through perseverance, wit, and ingenuity. Although Caldas rejected conventional associations, he was nonetheless working within the framework of a preexisting language.

Much of Caldas's work also addresses the intimate relationship between object and viewer and the act of looking. He invites the viewer to approach his work through visual seduction. A single object, waiting to be discovered, is displayed with Zen reverence. On initial viewing it may look familiar. But on closer inspection, recognition gives way to questioning. In some cases, the materials themselves present some paradoxical twist. For instance, a saucer-shaped granite slab titled *Escultura de granito [Granite Sculpture]* (1986) defies the natural roughness of stone by mimicking the high polish expected of chrome or brass. But this polish also makes the sculpture seem to disappear as an object and become a meeting point between light and shadow, a fleeting illusory image, the infinite edge that is nonetheless perceived in finite time. Another work comprises eighty equally sized shallow sections of highly polished wood, each cut in the shape of a zero from a different species of tree from the Amazon forest and lined up horizontally at eye level. This installation is an allusion to the three hundred known Amazonian tree species—and, therefore, to the forest's ecological vulnerability—as well as to an evanescent horizon line. In *Tubo de Ferro/Copo de Leite [Metal Tube/Glass of Milk]* (1978; PL. 11.4), the unlikely combination of a glass of milk inside an impeccably fashioned iron tube is a play on two similarly shaped but totally disparate objects, the one permanent, the other perishable, but stripped in their current relationship of their individual functions as industrial part and food. Here, they are equalized by their common shape and their momentary existence as the object of a visual experience or deception.

Caldas also uses photography to record ephemeral objects or situations. His photographic works include a series in which dice appear in situations alien to their nature as agents in games of chance. They serve as the building blocks of small objects (a small table for instance) or they appear trapped in some other way. In *Dado no gelo* [*Dice in Ice*] (1976)—a play on the English words—a single die, embedded and trapped inside a block of ice, challenges the notion of dice as free-flowing objects of chance by being immobilized and denied its freedom.[32] Caldas was not by definition a political artist, nor did he directly address governmental oppression. Nonetheless, by inverting accepted systems of thought and perception or the laws of chance and physics, he breaks down conventional expectations.

Tunga (b. 1952) goes a step further by weaving his objects into an unlikely narrative sequence that parodies the methods of psychology, paleontology, anthropology, zoology, and physics as well as the medical disciplines. Several of his individual works are incorporated into a video titled *O nervo de prata* [*The Silver Nerve*] (c. 1986).[33] Tunga creates works whose main subjects, generally large, braided, lead wire tresses, can be seen snaking down a wall and across the floor of galleries or museums. With great versatility, he follows through on a theme in a variety of media, including wood, magnets, and copper or lead wire. These themes also find their way into paintings on silk, metal reliefs, printed pages, and altered photographs.

Tunga makes far-fetched associations between hair, snakes, molars, and femurs in a narrative sequence. The oblong pattern found on the top of a molar (supposedly belonging to one of two brothers discovered under a tunnel) becomes the subject of a painting on silk in which a

PLATE 11.4

Waltercio Caldas, *Tubo de Ferro/Copo de Leite [Metal Tube/Glass of Milk]*, 1978, iron tube and milk, 28 × 60 cm. / 11 × 23⅝ in. Klabin Collection, São Paulo. Courtesy Waltercio Caldas, Rio de Janeiro. Photo: Miguel Rio Branco.

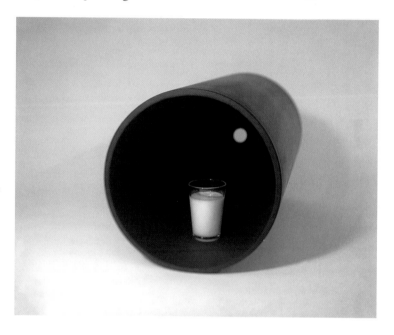

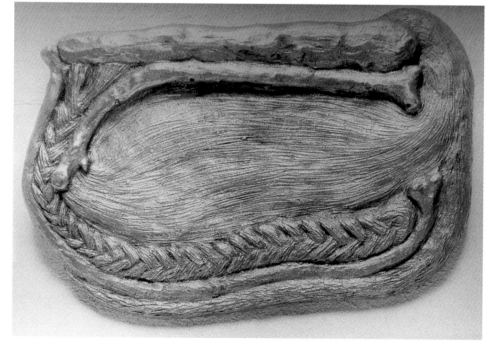

FIGURE 11.4

Tunga (Antônio José de Mello Mourão), *Rêve la antinomia [I Dreamed of Antinomy, or Prosthesis]*, 1985, antimony relief, 25 × 40 cm. / 9⅞ × 15¼ in. Courtesy Affonso Costa, Rio de Janeiro. Photo: Wilton Montenegro.

braid and a curved femur mimic the molar's pattern. The same design also appears as an enlarged relief made of antimony, a metal alloy. In *Rêve la antinomia [I Dreamed of Antinomy,* also known as *Prosthesis]* (1985; FIG. 11.4), cast in antimony (the word is similar in Portuguese), the whole surface is textured to look like an impression of loose hair. The title and the materials also provide an occasion for a play on the words *antimony,* referring to the metal used, and *antinomy,* which means a paradox or a contradiction in a law and is also the subject of the dream in the work's title. The idea of contradiction or paradox underlies all of Tunga's work. He also manipulates printmaking processes and photography to produce images of mutated lizards with a tail or a head at both ends, three snakes interwoven into a mating ritual that mimics braided hair, or Siamese twins joined by the hair. Thus the photograph in Tunga's hands is no more reliable as a source of objective truth than other media.

In the *Nervo de prata* video, these themes are linked into a narrative about the discoveries made in an archaeological exploration in the tunnel that passes under Rio's twin mountains, known as Dois Irmãos (Two brothers), linking two beaches. In the film-editing process, the interior of the tunnel as seen from a moving vehicle is converted into an endless circle (infinity). The hypothetical discoveries include the bones (as well as a molar) of one of the two brothers, whose femurs Tunga turned into large, circular, cast-bronze objects mimicking the circular tunnel, titled *The Jewels of Madame de Sade.* These discoveries were also recorded in paintings, reliefs, and photographs, or as printed data explaining a prenatal condition linking two sisters by the hair because of a xiphopagous (the term Tunga used) condition of their capillary cells. The latter was documented in a series of photographs (*Xifopagas capilares [Capillary Siamese Twins];* FIG. 11.5). Other "discoveries"

include the likes of a shrunken human brain and individual printed pages from a Lithico-Viperine Library about a paleontological account by a Danish scientist of the mating habits of snakes. The printed information on a loose page ends midsentence at the bottom, just as the author appeared to have begun formulating a conclusion about his findings.[34]

Within their broader framework, these explorations beneath a twentieth-century tunnel—the product of modern engineering—to discover objects from some remote archaeological past have the makings of invented history as well as of allusions to the primacy of the illogical. The latter aspect in particular recalls Oswald de Andrade's "Anthropophagite Manifesto" of 1928 defending the somnambulist condition of Brazilians (the unconscious) as superior to imported Cartesian logic (the conscious mind). Tunga's work focuses to a great extent on psychological as well as archaeological layers of meaning. Like Caldas's work, Tunga's is the product of a subtle, educated mind. Tunga challenges scientific methods by mimicking, or rather parodying, them. His objects can function individually as mental provocations as well as collectively within a narrative framework.

The 1970s and 1980s work of Cildo Meireles (b. 1948) also addresses the laws of physics and perceptions of Euclidean space. In a series of fake corners of rooms made of wood painted to mimic walls and baseboards, as well as an entire room filled with real red household furnishings, he explored the psychological potential and impact of anomalies in ordinary interiors. In the corners, these anomalies took the form of illusory perspective and its deviations from the norm, or in the room, of an oppressive overabundance of a single color. In *Desvio para o vermelho [Red Shift]* (1980–1984), Meireles explored the viewer's tolerance for red with a room filled with red furnishings because red produces "longer wavelengths of greater duration than those of other colors."[35] The room's entire con-

FIGURE 11.5
Tunga, *Xifopagas capilares [Capillary Siamese Twins]*, 1989, photograph of two girls joined by the hair. Courtesy Affonso Costa, Rio de Janeiro. Photo: Wilton Montenegro.

tents—chairs, sofa, lamps, bookshelves, pictures, carpet, typewriter—are red. A red refrigerator is open to reveal red peppers and a pitcher full of red liquid, and a closet is filled with red uniforms. In an adjoining space is a sink tilted (or "shifted," in a further play on the work's title) at a thirty-degree angle from its normal position. Red water pours out of its open faucet seemingly at an angle because of the sink's tilt. A third element

of this work is a disproportionately large red stain inexplicably caused by a tiny bottle of ink spilled on the floor. The stain threatens to take up an entire room.

The color saturation of the first red room initially evokes Oiticica's dense yellow penetrable *Grande núcleo,* but where the latter provided a purely senso-rial color experience independent of other associations, Meireles's red room transformed an ordinary middle-class

interior into a disturbingly oppressive experience. When it was first completed, it could potentially have been understood as a political statement. However, after the mid-1980s, when Brazil had returned to civilian rule, Meireles, like many other previously politicized artists, sought alternate interpretations for some of the work he had done during the military government, in this case, on the effects of color on the psyche.[36]

In the early 1970s, however, Meireles's work was admittedly political: "By 1969 and 1970 . . . the regime was strictly monitoring all the standard means of communication—television, radio, newspapers, book publishing, galleries," he explained. Consequently, "In my earliest work I set myself the task of inventing alternative methods of communication—or rather, taking advantage of some of the alternate systems of circulation that already existed." In 1969, he began incorporating Coca-Cola bottles and currency into projects destined for circulation in the public domain.[37]

In *Inserções em circuitos ideológicos: Projeto Coca-Cola [Insertions into Ideological Circuits: Coca-Cola Project]* (1970; FIG. 11.6), Meireles silk-screened subversive messages with a vitrified white ink similar to

that of the Coca-Cola logo onto empty bottles, then returned them to the store for deposit. In turn, these went back to the factory, were disinfected, refilled, and put back into circulation. The messages, visible only when the bottles were full, carried the slogan "Yankees go home," in reference to U.S. support of the military government, and imperatives for action, such as "to print critical opinions on bottles and put them back into circulation."[38] Thus, he proposed a means of communication that could easily escape detection by those who did not know this project. The use of bottles also carried connotations of the message in a bottle sent out to sea in a desperate plea for help, not to mention the "cocacolonization" of Latin America.

Between 1970 and 1975, Meireles also used banknotes for analogous purposes. In 1969, he first exhibited *Arvore do dinheiro [Money Tree]*, a package of one hundred one-cruzeiro bills (relatively worthless in a high inflationary system) bound with rubber bands, as was the custom in banks. The work was marked for sale at two thousand cruzeiros, twenty times its actual monetary value. Thus it also alluded to the commercial character of the art market.[39] In *Inserções em circuitos ideológicos: Projeto cédula (Quem matou Herzog?) [Insertions into Ideological Circuits: Banknote Project (Who Killed Herzog?)]* (1975; FIG. 11.7), Meireles stamped the words "Quem matou Herzog?" on one-cruzeiro bills, then immediately proceeded to spend them. The reference to the death of the journalist Wladimir Herzog—also the subject of Antonio Amaral's painting *A morte no sábado* (see PL. 11.3) of the same year—came at a time of increasing disbelief and suspicion on the part of the public regarding the credibility of official reports.

Currency was a component of two later installations with broader implications, *Missão / Missões [How to Build Cathedrals]* and *Olvido [Oblivion]*, both originally of 1989 but re-created in 1992 and 1990 exhibitions. In both these works, questions of territorial encroachment and

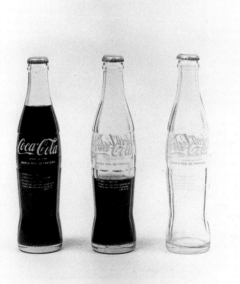

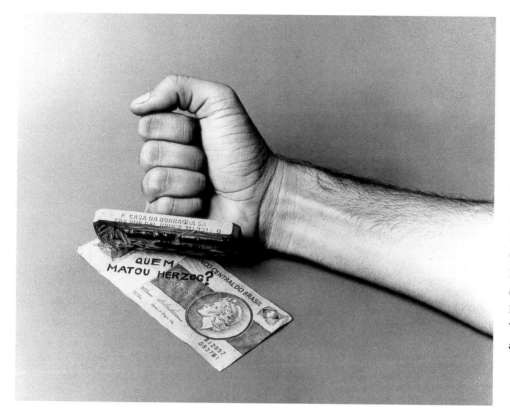

FIGURE 11.7

Cildo Meireles, *Inserções em circuitos ideológicos: Projeto cédula (Quem matou Herzog?)* [*Insertions into Ideological Circuits: Banknote Project (Who Killed Herzog?)*], 1975, rubber stamp on one-cruzeiro bills. Courtesy Cildo Meireles, Rio de Janeiro. Photo: Pedro Oswaldo Cruz, courtesy Jack S. Blanton Art Museum (formerly Archer M. Huntington Art Gallery), The University of Texas at Austin.

colonization of Indian populations by other cultures are reinforced by the currency, a system of exchange imported by the colonizers. *Missão/Missões* (PL. 11.5) originated as a commission, ironically, to commemorate the three-hundredth anniversary of the founding of the Jesuit missions in southern Brazil. The work consists of a six-foot-square space blocked off by paving stones and filled with 600,000 newly minted coins, usually those of the country where the work is being exhibited. A thin column of communion wafers in the center extends the shape of the coins up to a ceiling comprising two hundred suspended cattle bones eerily lit from above. The displacement of these symbols, with the wealth of the church underfoot and the boneyard overhead where one would expect to find symbols of salvation, functions as a reminder of "the continuous extermination of the producers by the predator" by reversing the order of church iconography.[40]

Likewise, *Olvido* (FIG. 11.8) dramatized the contrast between the poverty of Indians and the wealth of the Catholic Church. The piece is dominated by a central teepee covered with leaflike paper currency from all the countries in North, Central, and South America where large Indian populations had existed and been exploited or exterminated. Burnt charcoal on the ground of the teepee's interior is visible from outside. Cow bones cover the ground in the surrounding space within a circular retaining wall made of 60,000 white votive candles that encloses the whole. This work alludes to the "greed and rapaciousness that have doomed successive generations of native Americans."[41]

Besides territorial encroachment by foreign cultures, Meireles and several of his compatriots, including Rubens Gerchman and Anna Bella Geiger (b. 1933), addressed Brazil's relative geographic position in their work.[42] Geiger took up the subject in two etching and serigraph prints, *Centro-Periferia* [*Center-Periphery*] and *Certo-Errado* [*Right-Wrong*], both of 1973. Both works incorporate a photo-engraving of the moon's surface with color silk-screened onto the first and spray-painted onto the second around a large *X*. In both works, the

embossed titles are integral components. In the first, the word *centro* appears in the center of a blue-green rectangular area containing the lunar surface, and *periferia* is visible at the juncture where the color turns dark (the dark side of the moon). In both works, the lunar surface functions as a metaphor for Brazil's satellite status (periphery) in relation to the United States and Europe (center). In *Certo-Errado* (FIG. 11.9), the *X* drawn across the whole image implies a canceling of the printing plate, as is customary, to mark the end of a printed edition. The idea of negating something is reinforced by the title *Certo-Errado* as part of the work, which also brings in the notion of judgment. Geiger's combination of elements in this image invites speculation, not only about Brazil's secondary status as an art center, but also about absolute determinations of right and wrong and the absence of judgmental freedom. It was more often in this oblique way that Bra-

zilian artists addressed the absence of freedom during the most repressive years of the military government.

Among Uruguayans, the political component of conceptual art was far more unequivocal. Following the 1973 military takeover, one fifth of the country's young males became political prisoners. By the mid-1970s, most of the country's young intellectuals and professionals had gone into exile.[43] Artists who remained in Uruguay for the twelve-year period of the military government sought ways to express their ideological position within the confines of censorship. The environmental and conceptual artist Nelbía Romero (b. 1938) resorted to a metaphoric use of past historical events. For instance, in *Sal-si-puedes [Get-Out-If-You-Can]*, a multimedia work (involving dancers, photographers, writers, musicians, and visual artists), she used as her theme a nineteenth-century incident, the brutal massacre of Charrúa Indians in

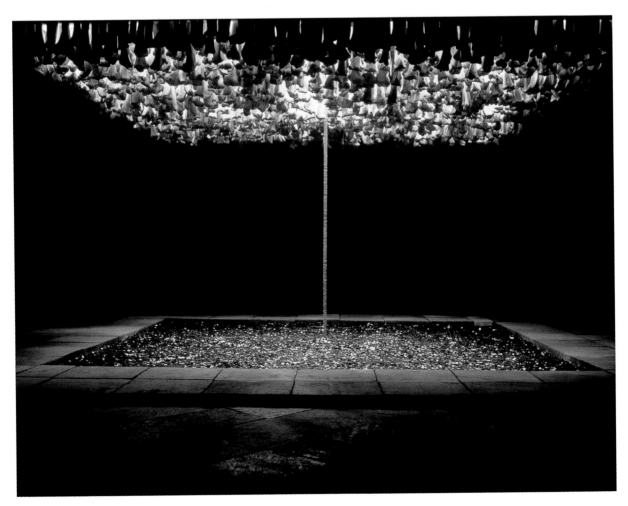

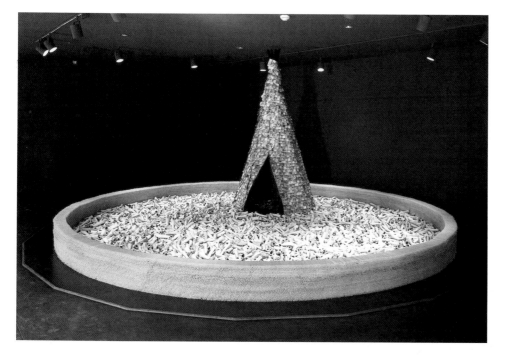

FIGURE 11.8

Cildo Meireles, *Olvido [Oblivion]*, 1989, re-created in 1990 at the Museum of Modern Art, New York, 60,000 votive candles, 6,000 banknotes, 3 tons of cow bones, 800 cm. diam. × 400 cm. high / 26 ft. diam. × 13 ft. high. Courtesy Cildo Meireles, Rio de Janeiro, and Museum of Modern Art, New York. Photograph © 1997 The Museum of Modern Art, New York.

Uruguay, to make a powerful point about contemporary parallels.

Both Romero and Luis Camnitzer addressed the subject of torture, Romero in a series of photographic collages with crayon titled *A propósito de aquellos oscuros años [Regarding Those Dark Years]* (1973–1985),[44] and Camnitzer, in a series of color photo-etchings, *Uruguayan Torture* (1983). Unlike Romero, however, Camnitzer made this series while living in New York, where he had moved in 1964 and where he had founded and codirected a printmaking workshop.[45] Born in Germany in 1937 and raised in Uruguay from the age of four, Camnitzer remained closely committed to events in Uruguay during the years of the military government and based the *Uruguayan Torture* series on accounts of specific events. He explored the psychological aspects of torture from both the victim's and the torturer's point of view, with a full awareness of the role of artist and spectator as witnesses.

The impact of these prints derives from the combination of the image and the written captions. Ordinary household items, like a glass of water, a thimble, or an electrical wire, are transformed into objects of fear when seen in combination

with the accompanying text. The image of a finger (Camnitzer's) wrapped with a half-bare electrical wire supplemented by the caption *Her Fragrance Lingered On* (FIG. 11.10) alludes to a well-known female torturer. The anomaly of a woman (the only one in Latin America) in an occupation usually carried out by men leads to the added notion of castration (the finger). The wire also refers to torture by electroshock. In another print from this series, the caption *He Feared Thirst* implies that something as commonplace as a half-filled glass of water can become an object of dread, as water can

FIGURE 11.9

Anna Bella Geiger (Brazilian, b. 1933), *Certo-Errado [Right-Wrong]*, 1973, color etching, serigraph, and spray paint, 55.6 × 76.1 cm. / 21⅞ × 29¹⁵⁄₁₆ in. Courtesy Jack S. Blanton Art Museum (formerly Archer M. Huntington Art Gallery), The University of Texas at Austin. Archer M. Huntington Museum Fund, 1974. Photo: George Holmes, P1974.11.1.

either be withheld or rendered foul be-
fore the victim is forced to drink.[46]
Camnitzer introduced a contradictory
note in these works by using appealing
shades of pale green, soft yellow, or
lavender tints that initially attract the
viewer and delay awareness of the sub-
jects' nature.

Many of Camnitzer's works, which
include installations as well as prints,
address the unequal relationship between
the First and Third World. An example is
his 1970 installation *Sobras [Leftovers]* (FIG.
11.11), comprising eighty cardboard
disposable boxes wrapped in gauze, with
red stains each numbered and stenciled
with the word *leftovers.* One hardly needs

to compare Camnitzer's work to Andy
Warhol's Brillo, Kellogg's, and other
boxes, shown individually or stacked in
groups as works of pop art on gallery
floors, to understand the differences.
Warhol's boxes, which he made of wood
or silk-screened with ink, represent
containers as substitutes for the con-
sumer goods themselves. Camnitzer's
have more gruesome associations. Do
they contain remnants of dismembered
bodies or toxic waste shipped from the
First to the Third World for disposal?[47]

Alfredo Jaar (b. 1956), a Chilean con-
ceptual artist trained in architecture and
filmmaking and living in New York since
1982, shared Camnitzer's concern for
First-to-Third-World dynamics. Some of
his work consists of blown-up photo-
graphs shown in projection boxes with
mirrors strategically placed in the gallery
to reflect and incorporate the viewer into
the installation. But Jaar's major produc-
tion has been outside the gallery circuit
in public places such as advertising spaces
on subway platform walls or other exte-
rior locations. One of these, titled *This
Is Not America (A Logo for America)* (1987;
FIG. 11.12), was shown in Times Square.
Consisting of a sequence of computer-
ized, animated projections on spectacolor
light board, it was shown above the lit
advertising strip on the old Times Square

Her fragrance lingered on.

building, one of the most visible locations in New York City, situated ironically near the U.S. Army recruitment office. In this municipally funded project, Jaar appropriated a commercial medium (the advertising space) for political art. Playing on the title of Magritte's well-known work *Ceci n'est pas une pipe* (This is not a pipe), Jaar adapted the idea in several frames; besides "This is not America," which appeared over the map of the United States, "This is not America's Flag" appeared over the U.S. flag. The sequence dissolved into the corrected map of "America" showing all of North, Central, and South America.[48]

Before his departure from Chile, Jaar had carried out an art action in the form of a questionnaire administered in a Santiago street as part of a two-year project. The work, titled *Studies about Happiness* (1980–1981), consisted of stopping passersby in the street and asking them whether they were happy. The same question was then asked of visitors to a museum during an exhibition. Statistical graphs and photographs documenting the collected data showed comparisons in percentages between those who said they were happy and those who said they were not. The resulting graphs, subsequently exhibited as part of an installation, also measured the degree of happiness in the world compared with Chile.[49] Jaar's use of what appeared to be an empirical system of inquiry to obtain his answers made government interference virtually impossible, since there would have been no logical grounds on which to object.

In Chile, artists and intellectuals had already been politicized prior to the 1973 military coup. The rising socialist movement, culminating in the Popular Unity Coalition in the 1960s and the four-year administration of the democratically elected President Salvador Allende in 1969, had created a sense of renewed hope and won the full support of the poet and diplomat Pablo Neruda. Mural brigades that had worked clandestinely before Allende's election were allowed to work openly during his presidency. One

of these groups was the Brigada Ramona Parra (BRP)—named after a twenty-year-old communist, Ramona Parra, who had been shot to death by the police in 1946 when she demonstrated in support of a group of striking nitrate workers in Santiago.

Most of the Brigada Ramona Parra muralists were not trained professional artists like the earlier Mexicans. They were high-school or university students, factory workers, and sometimes slum residents, who worked as a team, usually under the direction of a trained artist, and signed their murals with the brigade's acronym, BRP. They did not use permanent materials, as the Mexican mural painters had, but ordinary house paints on unprepared exterior walls. As a result, their murals deteriorated rapidly, but the wall paintings' impermanence was also a part of the strategy. The brigade's purpose was to provide an affordable and alternate means of communication to the standard channels—radio, television, and the press—for the purpose of political diffusion and the possibility of updating information as necessary by altering or simply painting over earlier murals. The brigade's first

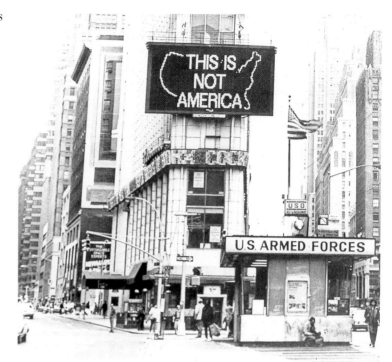

FIGURE 11.12

Alfredo Jaar, *This Is Not America (A Logo for America)*, 1987. Photograph documenting a computerized animated projection on Spectacolor lightboard in Times Square, New York. Courtesy of the artist and Galerie Lelong, New York.

murals consisted of little more than slogans and graffiti. But the repertoire soon increased to include popularly accessible symbols like the star (of the Chilean flag), the dove of peace, a hammer and sickle, faces with flowing hair, and hands open or clenched as fists, painted in a comic-strip style.[50]

The Brigada Ramona Parra's largest mural, *El río Mapocho [The Mapocho River Mural]* (FIG. 11.13), was painted in 1972 to commemorate the fiftieth anniversary of the founding of the Chilean Communist Party. It extended for a quarter of a mile between two bridges along the embankments of the River Mapocho (the river's name means "water that gets lost in the earth") that runs through Santiago. Reading from left to right, the mural began with a quotation from Neruda: "You have given me the fatherland as a new birth," followed by images of marchers, flags, people reborn under the new system, heroic workers, a mining village, martyrs, a large "No" (to fascism), and ended with scenes celebrating Chile's copper industry.[51]

These murals were whitewashed in 1973 by the incoming military junta. Some political dissidents went underground; others went into exile. Many were rounded up, detained, tortured, or killed.[52] During the following four years, much of the work seen in galleries and government-run institutions like the Museo Nacional de Bellas Artes was traditional painting. However, many

artists who remained in Chile found alternate modes of expression as vehicles of protest. Their means ranged from paint and collage to performance art and street actions. In some cases, supportive art dealers took the risk of showing provocative work in their galleries. Among the artists to address political issues in their work, both inside and outside galleries, were José Balmes, Graciela Barrios, Guillermo Núñez, Francisco Brugnoli, Virginia Errazuriz, Gonzalo Díaz, Catalina Parra, Eugenio Dittborn, Carlos Leppe, Raúl Zurita, Diamela Eltit, and Lotty Rosenfeld, to name a few.

Images of objects or figures shown tied, bandaged, torn, severed, or mutilated were common and to be found in the work of many artists. Carlos Gallardo's poster *A la carne de Chile [To the Meat of Chile]* (late 1970s) alludes to violation of the human body under the appearance of a butcher shop ad of a carcass; Alvaro Donoso's line drawing of a chair with back, seat, and legs tied with a rope illustrates the cover of the catalog for his 1977 exhibition. Others disguised violent themes beneath expressionist paintings or collages, as did José Balmes and Guillermo Núñez. Balmes (b. 1927), an exile in Chile from Franco's Spain since 1939, used both paint and collage as expressive means to denounce U.S. intervention in the Dominican Republic and in Vietnam, and for a series on the death of Ché Guevara. Implicit in these subjects was an indictment of Chile's human rights violations.

A year after the military coup, Guillermo Núñez (b. 1930), a painter and printmaker, was arrested, tortured, released, then kept under surveillance in Santiago. During those months, he recorded his "cruel experience . . . in drawings, paintings, engravings, sculpture and poetry," in which he sought to "speak of man alienated, destroyed, annihilated, humiliated, blindfolded, forced to see a distorted reality; separated from nature and his fellow man."[53] In Paris, where he had gone into exile in 1975, he worked on a series of paintings and mixed-media

FIGURE 11.13
Brigada Ramona Parra (mural brigade), *El río Mapocho [The Mapocho River Mural]*, section showing a copper mining town, banks of the Mapocho River, Santiago, Chile (destroyed), 1972, commercial paints, ¼ mile long. Photo: Author.

objects. On first viewing, the paintings look like abstractions until it becomes apparent that they represent various body parts turned inside out, suspended, dismembered, or pierced with sharp objects in colors ranging from raw pinks to red. In 1975, prior to his exile, he exhibited at the French Chilean Cultural Institute in Santiago a series of objects consisting of bread, paper hands, birds, flowers, mirrors that reflected the image of the spectators seen through cages, and a necktie the colors of the Chilean flag "knotted and hanging like a noose," to quote Shifra Goldman's description. The authorities quickly closed the exhibit. Núñez was imprisoned a second time, tortured, then released and ordered out of the country, as he was considered "a threat to national security."[54]

Although not all artists who made political art suffered Núñez's fate, the mere fact of exhibiting their work in Chile placed them at some risk. On the other hand, after the mid-1970s, many found common ground not only as colleagues and sometimes as collaborators, but through the support of art critics. Numerous intellectuals had been fired from university posts by the Pinochet government. Those who continued to teach art there were forbidden to mention politics. However, a small number of individuals developed a theoretical language that masked its ideological content. In the mid-1970s, the German-born aesthetician Ronald Kay, who taught at the University of Chile, formed Visual, a group that included Catalina Parra and Eugenio Dittborn. The group published exhibition catalogs and a theoretical magazine, *Manuscritos,* edited by Kay and designed by Catalina Parra. With Kay's collaboration, an exhibition of work by the German artist Wolf Vostell combining mixed-media works, film, happenings, and conceptual art was brought to the Galería Epoca in Santiago in 1977.[55]

Although artists had already used alternate imagery and materials as political metaphors prior to Vostell's exhibition, according to the French-born theoretician Nelly Richard, the widespread use of such imagery and materials dated from then. Many artists used photographic blowups, serigraphy, collage, and video as alternates to painting. They extracted photographic images from official records, photo albums, magazines, and newspapers, and these were sometimes used in conjunction with words and letters. Catalina Parra and Eugenio Dittborn were among the first in Chile to combine newsprint, photographs, and printmaking techniques with other materials.

Catalina Parra (b. 1940), daughter of the poet Nicanor Parra and niece of the folksinger Violeta Parra, had spent four years (from 1968 to 1972) in Germany, where she first saw these composite techniques used in art. She had especially admired the political work of John Heartfield (Wieland Herzfelde). In 1972, she returned to Chile, where she remained until her move to New York in 1980. Besides photographic images and pages from newspapers and magazines, she also incorporated in her work maps and—in some cases—X-rays (of her own body), which she cut, tore, aligned, stitched, and pasted into new configurations. Her practice of tearing apart and reassembling materials metaphorically evoked acts of mutilation.

In 1977, Parra exhibited a series of *Imbunches* at the Galería Epoca in Santiago. *Imbunche* refers to the Araucanian Indian practice of sewing a baby's orifices shut, either to prevent the escape of evil from the body or to ward it off. The idea for this series was in part stimulated by a reading of José Donoso's novel *The Obscene Bird of Night,* in which he used the *imbunche* as a metaphor for silencing. Parra's *Imbunche* series consisted of collages of newspaper fragments, gauze, animal hides, barbed wire, burlap, potato sacking, and thread (materials associated with wounds, killing, confined spaces, and corpses).[56] One of these works consisted of a row of plastic sacks stuffed with burlap to resemble corpses,

FIGURE 11.14
Catalina Parra, *Diario de
vida [Diary of Life,* or
Newspaper], 1977,
newspaper, acrylic
sheets, and bolts, 71 × 89
cm. / 28 × 35 in. Courtesy
Catalina Parra, New York.

skewered, and lined up in horizontal
formation. In two other works from the
series, *Diariamente [Daily]* (1978) and
Diario de vida [Diary of Life, or *Newspaper]*
(1977), she used pages from the newspa-
per *El Mercurio* (the only newspaper in
circulation at the time). In *Diario de vida*
(FIG. 11.14), she compressed pages from
El Mercurio between two acrylic sheets
screwed down at the four corners with
bolts that convey the dual notion of
crucifixion and censorship. The pages
appear torn at the edges and crudely
sewn together with rope. Visible through
the acrylic and on the sides are headlines
such as "Inminente crisis política
francesa" (Imminent French political
crisis) as substitutes for crises nearer to
home, which *El Mercurio* typically with-
held from readers. Parra relied to a great
extent on the communicative power of
the materials themselves: "How can you
censor a cut or a knot or a tear? And I
don't say anything myself. I don't have
to."[57]

The graphic and performance artist
Eugenio Dittborn (b. 1943), who had
studied art in Madrid, West Berlin, and
Paris as well as Santiago, produced im-
ages of great psychological impact from
the late 1970s on. He recycled photos of
anonymous faces retrieved from official
police records or taken from newspapers,
magazines, and photo albums, converting
these into photo serigraphs through a
complex mechanical process and adding
provocative captions.

In the composite photo serigraph *Nada
Nada* (c. 1980), with its double meaning
as "nothing" and "swim," he transformed
an ordinary photo of a lap swimmer into
that of a drowning victim by superimpos-
ing a close-up of the swimmer's face over
an Olympic-sized swimming pool. A
caption appears three times in varying
stages of completion, beginning with the
hypothetical statement "This sign has a
particular value" and ending with "This
sign has a particular value because it
allows for a precise determination of the
time the corpse remained in the water,"
implying an unquestionable conclusion:
that of a drowning victim. The swimmer
metaphor was an especially sensitive one
in light of the reports about bodies being
washed ashore or down major rivers like
the Mapocho in Chile and the Río de la
Plata in Argentina.

Notions of time and distance play a
major role in Dittborn's *Airmail Paintings*
(1983–1988). These consist of photo-silk-
screened faces and paint marks on large
sheets of brown wrapping paper and,

after 1988, nonwoven fabric. The possibility of sending works through the mail bridges the distance between the peripheral world where they originate and the major centers where they are shown. Their inexpensive, flexible, and light-weight material (paper) makes it possible to fold them flat, place them in an envelope, and send them through the mail to any destination. On arrival, they are in turn unfolded, exhibited, refolded, and mailed back to the sender. The accompanying postmarks become integral parts of the work as records of these transactions. By eliminating the expense of crating and shipping works in the traditional way, Dittborn's *Airmail Paintings* also propose a solution to the problem of diffusion of art from a Third World country.[58] By co-opting the postal system, they become a Chilean counterpart of Meireles's Coca-Cola bottles and banknotes.

In *Para vestir [To Clothe]* (1986–1987), done on brown wrapping paper, anonymous faces, recycled from original images and lined up frontally, are juxtaposed with painted drawings in a child's hand (that of his small daughter) and accompanied by captions and other images. In *Sin rastros [No Tracks]* (1983; FIG. 11.15), Dittborn enlarged the printed image of José Guadalupe Posada's hanged man dating from the Mexican Revolution, juxtaposing it to a printed image of a more recent victim (a disappeared person) in an equation between two fates in different historical moments. The Posada image was itself originally based on a photograph of a revolutionary victim and incorporated in his own work. Dittborn exploited the image's inherent history dating to the 1910s in Mexico to end up in a work of the 1980s in Chile. Dittborn's juxtapositions have been interpreted as a desire to "'salvage memory' within a political climate that attempted to erase virtually every trace of it" (no tracks).[59] The title also implies the notion of disappearance without a trace. But according to Guy Brett, rather than a reference to "Chile's traumatic recent history," Dittborn's work gives "the sensa-

tion of frailty," which the artist qualified as "the body's eternal helplessness."[60] It is, nonetheless, difficult to avoid political readings for some of Dittborn's works.

Pietà (No Cor) (1985; FIG. 11.16), an *Airmail Painting* combining wool, cotton, and photo silk screen on wrapping paper, exemplifies Dittborn's interest in notions of time and space. The image, showing the agonized body of the boxer Benny Kid Paret stretched out in the ring mercilessly facing the viewer, was based on a 1962 photo Dittborn had first found by chance some fifteen years later in an issue of the Chilean magazine *Gol y Gol*. At the time of the event, the image had been relayed via UPI from Madison Square Garden (New York City) to Santiago, where it was shown on television. Dittborn recycled this image numerous times in different configurations by putting it through a complex transfer process. Here the image appears divided into twelve sections, then reassembled as though seen

FIGURE 11.15
Eugenio Dittborn (Chilean, b. 1943), *Sin rastros (Pintura aeropostal, num. 13) [No Tracks (Airmail Painting No. 13)]*, 1983, photo screenprint on Kraft wrapping paper, 175.0 × 145.5 cm. / 68¾ × 57⅛ in. Courtesy Jack S. Blanton Art Museum (formerly Archer M. Huntington Art Gallery), The University of Texas at Austin. Archer M. Huntington Museum Fund, 1991. Photo: George Holmes, 1991.85.

through a grid or window. Irregular small hatches painted at intervals across the bands forming the grid resemble rough stitching. The grid lines correspond to the creases in the paper formed by folding and unfolding. A painted plaque on the same sheet below the image enumerates the states of this image in time from its inception as a real event captured on television to its final form reproduced on wrapping paper and converted into an *Airmail Painting.* The work's title refers to the absence of pity for this dead but unburied figure in an image with powerful associations to contemporary Chilean events.

Other strategies taken up by artists included installations, body art, and street actions as major forms of conceptualist expression in Chilean art of the late 1970s and early 1980s.[61] The installation artist Gonzalo Díaz (b. 1947), unlike some of his colleagues who were forced to work outside official institutions under the military government, continued to teach art at the University of Chile. This post placed him in the precarious position of seeming to acquiesce to the system, but it also gave him the advantage of a position from which he could maneuver within mainstream circuits instead of on a cultural periphery within the Santiago art community, as did many other conceptual artists. Díaz took advantage of this situation by alluding to "the occupation of the Chilean territory and its conceptualization as a 'cultural landscape'" in his work.[62] An example is *Banco/Marco de Prueba [Testing Bank/Frame]* (1986–1989; PL. 11.6). In its current form, this work is reduced from a much larger installation to a space of approximately nine feet square. The title implies both the process of making something and the idea of a traditional picture (the frame). A bench for modeling balusters shielded by a canopy, two boxes for modeling and inspecting balusters on the floor, and a neon light like those over pictures in a gallery occupy the center of the installation. In the background are the full-length images of two women, Zulema Morandé, a victim of domestic violence who became a martyr after a fraudulent judgment acquitted the guilty husband, and St. Theresa, a nun, as a symbol of self-abnegation and sacrifice. The figures appear against the Chilean landscape (the coast and the Andean mountain range) like two suspended vertical banners. The balusters allude to the nineteenth-century neoclassical architectural style of Santiago's official government buildings, like La Moneda (the main government building) and the Museo Nacional de Bellas Artes, as symbols of the state. According to Mari Carmen Ramírez, the balusters encased in casting, drying, and inspection boxes, and the pictorial background elements, function as a reference to "limits, boundaries, confinement," or in Díaz's words, "the Chilean cartography of pain."[63]

FIGURE 11.16
Eugenio Dittborn, *Pietà (No Cor), Airmail Painting No. 33,* 1985, paint, wool, cotton, and photo silk screen on Kraft wrapping paper, 210 × 154 cm. / 82¾ × 60⅝ in. Courtesy Eugenio Dittborn, Santiago, Chile. Photo: Ron Jameson, from Eugenio *Remota: Airmail Paintings* (pp. 54–55).

PLATE 11.6

Gonzalo Díaz, *Banco/Marco de prueba [Testing Bank/Frame]*, 1986–1989, mixed-media installation, balusters, neon light, varying sizes; includes two paintings in background. Courtesy Jack S. Blanton Art Museum (formerly Archer M. Huntington Art Gallery), The University of Texas at Austin, Archer M. Huntington Museum Fund, 1989. Photo: George Holmes.

Artists involved with body, performance, and video art worked largely outside the mainstream circuits. A group known as the Avanzada (avant-garde), championed by the French-born theorist Nelly Richard, included Carlos Leppe, Lotty Rosenfeld, and the writers Raúl Zurita and Diamela Eltit. These artists' work was often daringly provocative, but they succeeded in evading censorship by veiling their work in metaphor or, as Richard proposed, through strategies the government considered "marginal to other creative forms, like theater or folklore," which were seen as far more influential, and therefore subversive. Because of its peripheral nature, the Avanzada appeared to pose less of a threat to authorities.[64]

FIGURE 11.17

Carlos Leppe, *Acción de la estrella [Action of the Star]*, 1979, videotape of performance at Galería Cal, Santiago. Courtesy Carlos Leppe, Santiago. Photo: Ron Jameson, from Milan Ivelic and Gaspar Galaz, *La pintura en Chile desde la colonia hasta 1981* (foldout 4 after p. 344).

Carlos Leppe's performances from the late 1970s on functioned on both a national and personal level. In one performance piece, he drew on Marcel Duchamp's 1919 *Tonsure*, a photographic record of the back of Duchamp's head with the hair shaved away in the shape of a star. Leppe videotaped the step-by-step process of having the back of his own head shaved off in the shape of a star in *Acción de la estrella [Action of the Star]* (1979; FIG. 11.17). Despite the appearance of literal appropriation, Leppe actually turned Duchamp's idea into one protesting the current government's abuse of the Chilean flag.

Leppe, the poet Zurita, and the novelist Eltit all used their own bodies as bases for action. But unlike earlier Brazilian body art, which was centered on a pleasurable experience for participants, these Chilean artists used their own bodies as fields for acting out collective guilt, suffering, or painful experiences through impersonations and self-mutilation. This type of body art had no precedent in Chile before 1978. By applying the aesthetics of guilt and pain, Leppe enacted sexual roles of mixed identity or violence as metaphors for alienation and marginalization.

In *Sala de espera [Waiting Room]* (1980; FIG. 11.18), from a sequence involving impersonation, Leppe's body appeared on a television screen imprisoned in a plaster cast. In another frame, he appears with his face made up to resemble a female singer as he mouthed the words of a song sung by a recorded voice. The acts of lip-synching and impersonation and the plaster cast incorporated the double-identity inference of transvestism and imprisonment (the plaster cast) as "an imaginary woman in a body that is also trapped in plaster."[65]

Diamela Eltit's performances also addressed marginalization, in her case because she carried out her actions in houses of prostitution, psychiatric hospitals, or jails in poor sections of Santiago. The purpose of these actions was to draw attention to Pinochet's rejection of the social programs Allende had planned for his administration. *Maipú* (1980; FIG. 11.19), from a series titled *Zona del Dolor [Zone of Pain]*, consisted of a sequence of acts in which Eltit, after inflicting cuts and burns to her arms, read portions of her novel *La lumpérica* in a brothel. She then washed down (or cleansed) the pavement in front of the run-down building while her face (photographed and videotaped by Lotty Rosenfeld) appeared as a projection on a wall on the opposite side of the street, where it was visible from the brothel.[66] Eltit's self-inflicted cuts and bruises were designed to dramatize the contradiction between the maltreated body and "submission to the model of appearances," as symbolized by clothes and makeup. In another related performance piece, *Trabajo de amor [Work of Love]* (1983), Eltit was videotaped kissing a derelict from a flop house in Santiago. By offering herself up for nothing, Eltit subverted "the network of sexual transactions, including prostitu-

FIGURE 11.18

Carlos Leppe, *Sala de espera [Waiting Room]*, 1980, video installation and performance, Galería Sur, Santiago. Courtesy Carlos Leppe, Santiago. Photo: Ron Jameson, from Milan Ivelic and Gaspar Galaz, *La pintura en Chile desde la colonia hasta 1981* (p. 359).

tion," as Richard put it. Eltit's two works were also meant to draw attention to the primitive tradition of communal sacrifice or "the ritual exorcism of violence."[67] Their allusions to penitence also carried the aura of Christian martyrdom.

In 1979, Zurita, Eltit, Rosenfeld, Juan Castillo, and the sociologist Fernando Balcells organized street actions as members of the Colectivo de Acciones de Arte (CADA; Actions of Art Collective). The effectiveness of this group resided in their potentially disruptive use of public places and metaphoric actions. In 1979, these CADA artists organized a series of interrelated actions titled *Para no morir de hambre en el arte [Not to Die of Hunger in Art]*. The work consisted of the distribution of one hundred liters of powdered milk, a staple in short supply among poor children, to the inhabitants of a slum community just outside of Santiago. Each package of milk was stenciled with the words "Half a liter of milk," in a reference to Allende's campaign slogan "Half a liter of milk for every Chilean child."[68] A page in the popular magazine *Hoy* was left

blank except for a short message reading "Imagine this page completely blank . . . like the daily consumption of milk. . . . Imagine every corner of Chile deprived of the daily consumption of milk." This action was followed by a gallery display of unused milk, along with the empty packages discarded from the used milk, all sealed in an acrylic box and left to decompose. At the same time, a text denouncing the marginalization of the Third World was read in five languages (Spanish, English, Russian, French, Chinese) over loudspeakers outside the United Nations Building in Santiago.[69]

As a follow-up six months later, CADA managed to requisition ten milk trucks from SOPROLE, a major milk distribution company. The trucks were driven through the city in a procession that ended in front of the Museo Nacional de Bellas Artes, whose entrance was then covered by a blank banner (FIG. 11.20). Although the latter act was not immediately understood as a negative one, it in

FIGURE 11.19

Diamela Eltit, *Maipú*, from *Zona del Dolor [Zone of Pain]* series, 1980, videotape of a performance of Eltit washing down the pavement outside a brothel. Courtesy Diamela Eltit. Photo: Lotty Rosenfeld.

FIGURE 11.20

Colectivo de Acciones de Arte (CADA), *Para no morir de hambre en el arte [Not to Die of Hunger in Art]*, 1979, videotape showing SOPROLE milk trucks parked in front of the Museo Nacional de Bellas Artes, with entrance covered with canvas. Courtesy Lotty Rosenfeld archives, Santiago. Photo: Lotty Rosenfeld.

fact barred entrance into the museum as the representative of official art by closing it down for the duration of the action. The CADA actions summarized the equation between the social problems of continuing hunger and the artistic problem of survival. To colleagues, the group's actions had the potential of a "concealed bomb."[70]

The possibilities of active communication were daringly taken up by Lotty Rosenfeld in a series of highway and urban street actions. In *Una milla de cruces sobre el pavimento [A Mile of Crosses on the Pavement]*, she converted the white lines dividing traffic lanes into crosses by tap-

ing white intersecting lines of the same width across them at given intervals. Between 1979 and 1984, she had taped over lane demarcations in several locations in Santiago, Valparaíso, the northern desert highways, the Easter Island airport runway, and (in the United States) the mall in front of the White House in Washington, D.C. She carried out these acts furtively as they were being videotaped. In 1984, she chose as her location the Alameda (FIG. 11.21), the wide avenue in Santiago that passes in front of La Moneda, Santiago's government palace. The process of turning a minus into a plus sign constituted a conscious act of disobedience by subverting the implicit meaning of official road signs. It not only defied the authorities' expectation of feminine submission, it was also intended to draw attention to the rigidity of the system that denied free acts of decision.

SUMMARY

The events that occurred in Latin America in the 1970s and 1980s tested the ingenuity of artists, who were forced to find alternate means of communication under governments that monitored traditional circuits. On the other hand, the inventiveness of the art produced

FIGURE 11.21

Lotty Rosenfeld, *Una milla de cruces sobre el pavimento (en frente de La Moneda) [A Mile of Crosses on the Pavement (in front of La Moneda)]*, 1984, videotape of art action with white tape. Courtesy Lotty Rosenfeld archives, Santiago. Photo: Gloria Camizuaga.

under these circumstances leads to the conclusion that many artists had the will to make art out of adversity without compromising their ideological principles. During the years of the military governments, art had lost its meaning as object, and artists sought other means of expression, particularly through conceptual art and street actions. While the audience for this type of art was limited, those directly involved became part of the ideological discourse. The main objective for artists was to communicate a political message within the limitations of censorship.

After the mid-1980s, as countries returned to civilian rule, memories of repression lingered for some artists, while others found new directions. Many artists returned to more traditional ways of making art. For younger artists, who had grown up and studied art during the repressive years when teachers in schools and universities were forbidden to talk about politics, art took more mundane directions with little or no historical reference. As a result, the art of these younger people focused on the materials themselves or on their own daily personal experience. But some older artists, for whom memory still played a part, tapped their Indo-American and historical legacy as a way of reclaiming a past free from colonialism.

TWELVE

SOME TRENDS
OF THE 1980S

In the 1980s, art took multiple directions in Latin America, as it did elsewhere. In contrast to earlier decades, it was not so much dominated by specific styles as by common themes. In addition to political ones, these themes included allusions to urban violence and alienation, the ordinary things of daily life, new takes on earlier art—especially of the 1960s—and Latin America's Indian legacy.[1] Assemblage, installations, and conceptual art have continued to be major forms of expression and will be addressed in a future study. But many artists also returned to traditional painting and sculpture as well as to making objects as ends in themselves rather than as agents for activating spectators. Art took a more subjective and personal direction as artists responded to their own internal feelings rather than to external conditions, as had been the case earlier.

Even though during the 1980s the tendency was toward themes that crossed the boundaries of medium and style, figuration, neosurrealism, and neoexpressionism continued to be visible currents in painting of this decade. Of these modes, neoexpressionism was especially prevalent, finding adherents among Chileans, Peruvians, Argentines, Brazilians, Cubans, and Mexicans. As is the case with the German, Italian, and North American practitioners of this mode, Latin American neoexpressionists conveyed a sense of personal anxiety in their work. Expressions of anguish were especially evident in the work of a new generation of artists, active after the late 1970s, who were living abroad for practical or political reasons. Although the condition of being an exile was not new to Latin Americans, many of whom lived abroad for many years, the generation of the 1980s responded to this condition in ways that differed from those of earlier expatriates. Instead of allusions to their culture of origin, as was the case for Pacheco, de Szyszlo, and, sometimes, Fernández-Muro (taking Argentina, not Spain, as his source), the younger exiles expressed a personal sense of rootlessness as an internalized condition.

PLATE 12.1
Luis Cruz Azaceta
(Cuban, b. 1942), *Homo-
Fragile*, 1983, acrylic on
canvas, 183.5 × 305.4 cm. /
72¼ × 120¼ in. Jack S.
Blanton Museum of Art
(formerly Archer M.
Huntington Art Gallery),
The University of Texas
at Austin. Archer M.
Huntington Museum
Fund, 1987. Photo:
George Holmes, 1987.1.

ALIENATION AND SEXUAL IDENTITY IN THE 1980S

Cuban-born Luis Cruz Azaceta (b. 1942), a U.S. resident since the 1960s, settled in New York City, where he lived for many years and made the city his main subject. He depicted a world of urban alienation and violence in bright, raw colors. As Lucy Lippard noted in referring to Azaceta's generation, this sense of alienation did not derive from feelings of futility in the aftermath of H-bombs and holocausts, but from a lived personal sense of displacement.[2] For Azaceta, this displacement meant transferring his sense of uprootedness to a new relationship with the violent urban environment in which he lived.[3] Many of his paintings of the 1980s include self-portraits in which he appears as the victim of his urban environment—a cockroach-like presence whose head sometimes fuses with the cityscape. In *Homo-Fragile* (1983; PL. 12.1), an acrylic on canvas, a raw meat–pink, dismembered body with Azaceta's head appears propped up by sticks, studded with nails, and surrounded by barbed wire. This work is related to Azaceta's series *Tough Ride around the City* of 1986,[4] which depicts the sordid, crass subterranean world of New York City, where homelessness

becomes a metaphor for his own experience as an exile.

In Mexico, as in the Andean countries, artists upheld a tradition of pictorial symbolism through neoexpressionism, neosurrealism, and figurative art. Among the neoexpressionists are Gabriel Macotela and Estela Hussong. Macotela (b. 1954) focused on the urban industrial landscape in semiabstract iron sculptures as well as in paintings in muted colors. Estela Hussong (b. 1950) used clear, bright colors in land- and seascapes with hints of Matisse-like still lifes in them.

Other Mexican artists adopted figuration as a means to address the subject of sexual identity, cloaking these subjects in religious and Mexican popular

PLATE 12.2
Nahum Zenil, *Con todo
respeto [With All
Respect]*, 1983, mixed
media on paper, 30.5 × 41
cm. / 12 × 16⅛ in.
Courtesy Galería de Arte
Mexicano, Mexico City,
and Nahum B. Zenil.

imagery. Prior to the 1980s, blatant allusions to sexuality were virtually absent from Mexican art, but they came to dominate the art of several painters during the 1980s. The Mexican phenomenon came a decade after the Colombian one. But rather than creating the large-scale, sometimes monumental, figuration of the Colombians, Mexicans who took up this subject leaned toward a more intimate—if not always smaller—scale, with a tendency to reduce the illusion of three-dimensional space to an abstract one.

Three painters in this category are Julio Galán, Nahum Zenil, and Rocío Maldonado. Of the three, Galán (b. 1958), who comes from a privileged background, displays a greater degree of worldliness in his combination of Mexican and international imagery. As Dan Cameron has noted, Galán draws from "folklore, surrealism, kitschy melodrama, old cinema, religious art, [and] high camp" to create paintings in which everyday life is eroticized.[5] Following the tradition of Frida Kahlo, many of his paintings include self-portraits. In some of the paintings, he is seminaked; in others, he is dressed as someone else—a witch doctor with an Aztec headdress for instance. In a number of paintings, the figure—his own or someone else's—appears in an erotic context, usually accompanied by fetishistic objects. Galán blends the real and the dream by defining some areas clearly and blurring others. His symbolism is filled with personal, sometimes cryptic, psychological references that reveal a picture of pampered sexuality.

Nahum Zenil (b. 1947), a mestizo from a modest background, began exhibiting in the 1970s. Unlike Galán's imagery, most of which derives from the contemporary world, Zenil's is based on traditional religious symbols (saints, Christ, and the Virgin of Guadalupe), *retablos,* colonial devotional images, and *casta* paintings as well as appropriations from Kahlo, Rivera, and Posada. Through these models, Zenil establishes his own identity within the Mexican context. Kahlo's ability to scrutinize herself and to objectify her passions and misfortunes made her an especially desirable model for artists seeking a cultural or sexual identity of their own.[6] In *Con todo respeto [With All Respect]* (1983; PL. 12.2), a homage to Kahlo and a quotation of her painting *The Bus* of 1929, Zenil appears as a passenger on a bus wearing worker's clothing and seated next to Kahlo (dressed as the Tehuana in *Las dos Fridas;* see FIG. 4.6). Although the worker makes a reference to Rivera's politicized versions of workers, in Zenil's painting, the worker does not represent the artist's ideological position but alludes to his own working-class background and Mexican identity. Zenil's techniques and materials—drawing, collage, oil on wood, and mixed media on paper—give his work an appearance of fragility and age that mimic old manuscripts.

Zenil's work, unlike Galán's, is exclusively centered on Mexican imagery. He focuses on his homosexuality and Mexicanness at the same time, a combination that would have been unthinkable in Mexico a decade earlier. Many of his works are explicitly erotic. At the same time, Zenil, like the Colombian Luis Caballero—though perhaps less ambiguously than he—attempts to reconcile sexuality with the sacred, sometimes recasting himself as Christ wearing thorns (in one of Kahlo's self-portraits, she too wears a crown of thorns as a necklace) or imploring the Virgin of Guadalupe. Far from the self-indulgent, pampered dandy of Galán's self-portraits, Zenil's always convey something of the martyr or suffering servant seeking redemption, as though his paintings functioned as a form of exorcism (like Kahlo's), in the manner of *retablos.*[7]

Rocío Maldonado (b. 1950) also works within the Mexican tradition by borrowing isolated elements from Kahlo and Rivera, as well as from folk images of saints and Mexican and European religious and mythological imagery. Her large oil and synthetic polymer paintings

and collages center on the experience of being a woman. In many of her paintings she casts the female in different roles, that of an angel or a doll, for instance, based on Mexican popular art, or of a classical Greek figure. In *Sin título [Untitled]* (1987; FIG. 12.1), an acrylic and mixed-media painting, an armless, headless torso resembling a fleshy statue of Venus de Milo is surrounded by religious and secular symbols: a barely perceptible face of Saint Theresa based on Bernini's *Ecstasy of St. Theresa* (the latter was also the subject of another of her paintings), the sacred heart, the Virgin of Guadalupe, a second lactating female torso, an isolated male torso, an infant with the umbilical cord still attached. Maldonado's equation of physical with religious ecstasy implies that her subject, presumably a pregnant woman, might be the Virgin in the Immaculate Conception (the subject and title of yet another of her paintings). A star at the top suggests the idea of the Magi. In this work, the artist acknowledges her debt to both European and Mexican art. The extension of the painting onto the wooden frame and the presence of the newborn indicate the artist's familiarity with Edvard Munch's lithograph of a very seductive *Madonna* (1893) in which spermatozoa are shown running along a border around the figure to end with the image of an infant. But Maldonado also borrows consciously from Mexican popular art in the directness of her style. Her paintings' symbolism, derived from baroque representations of ecstasies as sexual sublimation, convey unconsummated desire rather than frank eroticism. Her combination of sacred and profane allusions also refers to contemporary female identity.[8]

MATERIALS AND EVERYDAY LIFE

A generation of artists born in Brazil in the 1950s and 1960s were unafflicted by a sense of alienation, problems of sexual identity, or metaphysical questions. Many

of them had studied art at a time when information was censored. They appropriated from earlier Brazilian art or made art whose significance resided in the materials themselves and that reflected their daily experiences. Two examples of this tendency are Hilton Berredo (b. 1954) from Rio and Leda Catunda (b. 1961) from São Paulo. Berredo's work of the 1980s consists of large accretions of brightly painted rubber, such as *Desdobrada flamejante [Flaming Accretions]* of 1985 (PL. 12.3). Berredo declared himself a Tropicalist in a reference to Oiticica's and Gerchman's art of the 1960s, with the additional ability to anthropophagize the whole world from many locations, including the United States.[9] Berredo stated that "whoever works in art today in Brazil has to confront the neoconcrete legacy," indicating that his sources came mainly from Lygia Clark, Ligia Pape, and Helio Oiticica. But he sought to go

FIGURE 12.1
Rocío Maldonado (Mexican, b. 1951), *Sin título [Untitled]*, 1987, mixed media on canvas with painted wood frame, 200 × 165 cm. / 78½ × 64⅜ in. Jack S. Blanton Museum of Art (formerly Archer M. Huntington Art Gallery), The University of Texas at Austin. The 1990 Friends of the Archer M. Huntington Art Gallery Purchase. Photo: Georges Holmes, 1990.165.

PLATE 12.3
Hilton Berredo,
*Desdobrada flamejante
[Flaming Accretions]*,
1985, acrylic on rubber,
varying sizes. Private
collection, São Paulo.
Courtesy Hilton
Berredo, Rio de Janeiro.
Photo: João Bosco.

PLATE 12.4
Leda Catunda, *Vestidos
[Dresses]*, 1989, acrylic
on collaged dresses, 240 ×
180 cm. / 94½ × 70⅞ in.
Courtesy Leda Catunda,
São Paulo. Photo:
Eduardo Brandão.

beyond questions of the body proposed by the neoconcrete artists, "without abandoning the production of objects."[10]

Leda Catunda was the product of conventional art training in the Art School of the University of São Paulo, where, according to her, she was taught to avoid politics and to include "an awareness of the life" around her. Her years of training in drawing drove her to reject all conventional media, including drawing, and to create art out of leather, clothing, wigs, wood, nylon, cotton, plastic, or anything else that came her way. Her sewing machine is her medium. She uses fabrics with designs already printed on them, which she sews into playful scenes with landscapes. For instance, she turns store-bought household fabrics—printed crib coverlets, towels, or curtains—into unexpected images with comic-strip elements, sometimes with a few added touches of acrylic paint. A piece of gray cloth becomes a bird's-eye view of a road, a flowery fabric becomes a garden, and a print of jumping Donald Ducks and sea horses becomes a window open to the sea. Her rejection and parody of traditional painting and the solemnity of art is further emphasized in her work by the absence of frames. She also subverts meaning through the materials themselves. In one work, she transformed a fabric into a panther-skin rug that hangs loose without frames or stretchers, thus also shifting the role of an animal skin as a floor rug to that of a painting or wall hanging.

In *Vestidos [Dresses]* (1989; PL. 12.4), two rows of rumpled dresses are lined up next to one another, as though to dry on a line. The dresses have been stripped of their function as clothing and have become part of a pictorial composition. The whimsical, childlike quality of her work also reverses the social, scientific, and

PLATE 12.5
César Paternosto, *T'oqapu*, 1982, synthetic polymer and marble powder on canvas, 4 panels bolted together, 167.75 × 167.75 cm. / 66 × 66 in. total. Courtesy César Paternosto, New York.

metaphysical content of Meireles's, Caldas's, and Tunga's work. At the same time, her imaginative use of materials shares with Berredo an awareness of the Brazilian legacy of *arte povera* and nontraditional materials, like those used by Oiticica in *Tropicalia*.[11] But these artists have not replaced artists such as Meireles, Caldas, and Tunga. Rather, they represent one of the more recent currents in Brazil in which materials similar to those used by the older artists are used, but as ends in themselves.

THE PRECONQUEST PAST RECONSIDERED

A number of artists from Hispano-American countries (Argentina, Chile, Colombia, and Venezuela), many of whom were born before 1950, sought to reclaim a past legacy on a level that transcended personal identity. Some found this legacy in the Indo-American civilizations; others, in the age of discovery of the New World. César Paternosto, Miguel Angel Ríos, Eduardo Ramírez Villamizar, and Edgar Negret looked to the Andean past as a way to retain some sense of historical continuity and identity with preconquest America. Their reexamination of Indo-American roots, however, differed from that of Villacís or from Estuardo Maldonado's *Precolombinos* for instance. In the 1960s, Villacís, Tábara, and, to a lesser degree, Maldonado had interpreted this legacy as an integration of the mythical and material qualities of ancient art with informalist abstraction. In the 1980s, however, it was the metaphysical and architectonic qualities that artists like Paternosto tapped, not the mythological ones. They sought the key to the meaning of pre-Hispanic geometry in order to incorporate it into their art with the objective of creating a sense of continuity with this past, not merely a readaptation of it into contemporary modes.

Paternosto and Miguel Angel Ríos had come out of a minimalist tradition in

painting; Ramírez Villamizar and Negret, out of a constructivist one in sculpture. Both of these currents were European in origin. But by the 1980s these artists wanted to justify their geometric tendencies in terms of something closer to home, preferably models found in Inca and earlier Andean art and architecture. For Paternosto (b. 1931), an Argentine from La Plata, this choice was by adoption rather than by inheritance, as it had been for Torres-García. For Miguel Angel Ríos, from the western Argentine town of Catamarca, once a part of the Inca Empire, the legacy was legitimately his own. But regardless of which category they belonged to, both Paternosto and Ríos shared a common desire for a continental identity. In his search for alternatives to European geometry, Paternosto studied Indo-American architecture and textiles for their semiotic as well as their visual components. By claiming Indo-American sources, he could also bypass the technological and materialistic implications of Western capitalist society.

Another catalyst was Paternosto's rediscovery in the 1970s of the writings of Torres-García. But by the late 1970s and 1980s, Paternosto sought a modification of Torres-García's theories by rejecting, rather than incorporating, European constructivism, as Torres-García had done. The latter had also sought in the Indo-American model the "tradition of the collective history and society as the reason and justification for artistic production" as much as its visual aspects.[12] But Paternosto perceived in this model geometric configurations that differed from the modern European ones.

When in 1977 Paternosto had visited Cuzco and other Inca sites, he noted the isochronous rhythm, or repeated spacing, and the asymmetrical knobs found on the fortifications at Ollantaytambo in the Peruvian highlands, which confirmed that "space [is] as important as form."[13] He based his paintings of the 1980s on these proportional systems as they occurred in textiles, in pottery, and in Inca stone fortifications, and he published a book on

his observations.[14] His paintings have the luminous earth tones of ancient pottery. They consist of patterns of interlocked flat triangles, rhomboids, and squares based on the shapes of pre-Columbian religious architecture and textiles. Many of his titles are in Quechua. The title of one of his works, *T'oqapu* (1982; PL. 12.5), means "garments of the kings" in Quechua. Paternosto proposed interpretations for the word *t'oqapu* based on the possible semiotic function of its designs in Inca art.[15]

Paternosto felt that the intrinsic meaning of Indo-American art had not been given sufficient recognition for its impact on twentieth-century artists. His combination of architectonic and linguistic factors made possible the reappropriation of an Indo-American legacy in the way that Torres-García had intended it to be understood: as a functional part of one's daily life. For this reason, it was important for Paternosto to have an understanding of the semiotic meaning of this art so as not merely to appropriate it for its visual attributes, as Picasso had done with African art.

Although in the early 1980s Miguel Angel Ríos (b. 1943) also took up Indo-American themes, his work retained a minimalist sense of scale. He focused less on the architectonic qualities of religious

structures than on the rhythms of textile patterns and Indo-American, or more specifically Andean, culture as an ongoing and living force. In a series of paintings on a llama motif, he reduced the animal symbol to a system of pictographs repeated rhythmically to obey an invisible grid. In his large, monochromatic diptych *Pensamientos negros [Black Thoughts]* (1981), the llama theme appears in horizontal rows with slight irregularities that mimic those found in handwoven textiles. In this all-black painting, the llama pattern is detectable because of its raised texture.[16]

Ríos, too, reclaimed the Andean legacy as a substitute for modern European models. But unlike Paternosto, who came to his subject originally through a systematic study of it, Ríos had grown up in a family that was close to its Indian roots. His mother was of Quechua descent and had taught him the ancient arts (it should be noted that both Torres-García and Paternosto considered the crafts to be equivalent to mainstream art). Initially Ríos emphasized his attachment to his native soil by mixing his own pigments with local earth, clay, and sand. Since the late 1980s, he has also made clay and terra-cotta reliefs composed of rows of ovoids in square or rectangular formations. In *Sueño de las alturas [Dream of the*

FIGURE 12.2
Miguel Angel Ríos
(Argentinean, b. 1943),
*Sueño de las alturas
[Dream of the Heavens]*
(diptych), 1988–1989,
mixed-media panels
with terra-cotta, each
127 × 123.6 × 12.7 cm. /
50 × 48⅝ × 5 in. Jack S.
Blanton Museum of Art
(formerly Archer M.
Huntington Art
Gallery), The University
of Texas at Austin. Gift
of Barbara Duncan,
1994. Photo: George
Holmes, 1994.123.

Heavens] (1988–1989; FIG. 12.2), small painted or incised markings on the surfaces of terra-cotta ovoids assembled in rows covering the background suggest a hypothetical system of communication like that proposed by the markings found on beans used in the northern Peruvian Mochica culture. Even though neither the Inca nor earlier Andean cultures were known to have had a written language like the Maya or Mixtec for instance, some believe that the bean markings had such a function.[17]

Ramírez Villamizar's and Negret's interest in the Indo-American past also began in the late 1970s. Both artists substituted sculpture of more evocative complexity and color for their earlier reductive constructions. Although this rebirth of Indo-Americanism was widespread at the time, according to Paternosto, its emergence in Colombia coincided with his visit to Bogotá—in transit from Peru to New York—where he met Ramírez Villamizar.[18] Ramírez Villamizar, in a reversal of the formal purity of his earlier sculpture, chose the tactile appeal of oxidized finishes and weathered earth tones similar to those Paternosto used in his paintings. Negret, on the other hand, continued to paint his sculpture rather than use chemical processes as finishes. But instead of the pristine white, black, or red he had used earlier, he introduced yellow, orange, and gold as a reference to the ancient Andean sun cult. The Inca were said to have faced the tops of temple entrances with gold to reflect and catch the rays of the rising or setting sun at specific times of the year, such as the summer solstice.

In the 1980s, an Indianist[19] revival was also evident in other forms in the work of several artists, some of them conceptual. The Argentine sculptor Raquel Rabinovich makes tangential references to an ancient Indo-American culture in her tempered-glass enclosures designed to

PLATE 12.6
Cecilia Vicuña, *Precario/ Precarious*, 1987, installation consisting of 19 objects in stone, feathers, and twigs painted with nontoxic colors displayed on a table and hung, 114.25 × 228.5 × 335.25 cm. / 45 × 90 × 132 in. Courtesy Cecilia Vicuña, New York.

evoke sacred spaces, at least as fictitious spaces of the mind. One may also cite Catalina Parra's *imbunches* as another manifestation of this revival, although Parra used the subject metaphorically to refer to present conditions, whereas the revival applies specifically to artists who incorporated Indian references for the purpose of establishing a continuum with a native culture of ancient origin. This tendency is most visible in the work of the Chilean poet and artist Cecilia Vicuña (b. 1948) and the Argentine filmmaker and multimedia artist Leandro Katz, among others.

Vicuña's move to New York in 1980 led her to reinforce her spiritual connection with her Indian roots as a foil against the noise of her adopted city. As an advocate of feminist and ecological issues and the first Chilean to revive Indianism in poetry and art, Vicuña addressed questions of ritual, frailty, and the perishability of life. In her art, references to native culture and the sacred have informed her performances and installations. By staking out territorial spaces in riverbeds or on beaches with string, and using twigs, stones, and marks on rocks drawn with nontoxic color crayons, she wished to draw attention to the gradual destruction of the environment and the precariousness of the current Indian condition. The concept of fragility and vulnerability found expression in her book of poetry *Precario/Precarious* (1983) and in an installation by the same title (1987; PL. 12.6) consisting of similar small, perishable objects—twigs, feathers, stones, shells—which she painted in fresh, luminous colors. Some were set on a table; others were hung from the ceiling to emphasize their weightlessness and frailty. In her book she wrote: "Listening with the fingers, a sensory memory, came first: / the scattered bones, the sticks and feathers, were sacred objects I had to put in order." She also thought of this work as "a prayer, . . . something that disappears, or tends to disappear," referring to the precariousness of our condition as human beings.[20]

Leandro Katz (b. 1938) is also a specialist in pre-Columbian art and has taught courses in it. Prior to his move to New York in 1965, he traveled to Peru, Ecuador, and Mexico and studied and photographed many sites, focusing especially on Maya ones, and he has since incorporated his photographs of these sites into multimedia projects. In his works, he brings together the pre-Hispanic world of the Maya and the European nineteenth-century vision of these sites through the eyes of explorers and traveling artists. In *The Judas Window,* an installation shown at the Whitney Museum in New York in 1982, he fused art and literature by combining slide projections with loose pages from Daniel Defoe's novel *Robinson Crusoe* collaged onto a large parasol (a reference to tourism and tropical beaches), theater lights, neons, fragments of mirrors with words written backward on them and set on the floor, so that the spotlight on them reflected the words written in the right direction onto the wall. Katz creates spatial and temporal shifts by means of a play between the real and illusory elements in a maze of cross-references. A detail of *The Judas Window* titled *Friday's Footprint* (PL. 12.7) consists of a slide projection of the base of a Maya stela from Copán showing the feet of a ruler. Lying on the floor at its base is an actual box filled with sand in which a real footprint was made. The projected image appears to be standing on the sand. The

PLATE 12.7
Leandro Katz, *Parasol* and *Friday's Footprint,* details from *The Judas Window,* 1982, mixed-media installation with slide projections, theater lights, sandbox, umbrella covered with pages from Daniel Defoe's novel *Robinson Crusoe.* Sandbox, 10 × 139.75 × 63.5 cm. / 4 × 55 × 25 in. Umbrella diameter, 256.4 cm. / 100 in.; umbrella stem, 256.4 cm. / 100 in. long. Courtesy Leandro Katz, New York.

footprint, the image of the Maya stela, and the printed pages on the parasol—as a reference to Crusoe's faithful servant, Friday, in Defoe's novel—are about a world of colonial intrusion. The reflections of words projected from the floor mirrors onto the walls are those of the modern world, where the fictitious and the real become indistinguishable one from the other.[21]

Between 1984 and 1988, Katz worked on a series of silverprint photographs that he used in *The Catherwood Project,* a work involving various media begun in 1985. These photographs represent the actual Maya sites as they appear today juxtaposed with the artist's thumb holding Frederick Catherwood's nineteenth-century drawing of the same monument. The artist's thumb visible in the foreground of the photograph can also be read as the viewer's.[22] Katz used some of these photographs in several other related works. One of them is a book titled *The Milk of Amnesia* (1985), in which he begins with the ironic lines:

Vanishing moments. Vanishing monuments. The archaeological ruins have been restored. Like surgeons in a labyrinth, the archaeologists have disinterred the temples and given us the ancient past, manicured lawns, sight and sound shows, nightclubs performing sacrificial acts.[23]

One of the photographs from *The Catherwood Project,* showing the pyramid at Tulum (*Tulum after Catherwood;* FIG. 12.3) held up by Katz's, or the viewer's, hand against the contemporary restored site, is an image designed to bridge past and present.[24]

For other artists, the past meant the time around the Spanish Conquest. Themes relating to this period can be found in the work of Chileans, Argentines, and Venezuelans. In the mid-1980s, the young Chilean painter Ismael Frigerio (b. 1955) did a series of tempera and acrylic paintings in which the conquest is implicit in his somber, expressionist images of ships and lurking snakes. Like his compatriots Vicuña and Parra, whose works often allude to ecological issues,

FIGURE 12.3
Leandro Katz, *Tulum after Catherwood,* from the *Catherwood Project,* 1985, gelatin silver print, 16 × 20 in. Courtesy Leandro Katz, New York.

Frigerio equated contemporary ecological perils with contamination by invading forces. In *The Loss of Our Origin* (1985–1986), a barely identifiable gray figure lies in the grip of a serpent against the dark prow of a ship, and in *The Lust of Conquest* of the same date, a mass of shadowy figures tied together roast over a fire as a serpent lurks nearby and a black ship is visible in the distance. Metaphorically, the fire is destroying the past (like the fire of the Spanish Inquisition), and the serpent is both Christian and pre-Hispanic: in the first case, a symbol of temptation; in the second, of eternity, among other meanings.[25] Frigerio presents the theme of conquest as a potential threat to the environment.

Several Venezuelan artists addressed historical themes in terms of spatial and temporal shifts, as Jacobo Borges had done in the 1970s, but in new forms. The preoccupation with time seems especially relevant in a country whose historical development does not go back much before the eighteenth century.[26] Carlos Zerpa and Miguel von Dangel chose as their referent the period of the discovery of the New World and just prior, through a mythology of its human and animal inhabitants primarily located in the Caribbean and the area now occupied by Venezuela. There Columbus encountered "new tribes, strange animals and lush forests," which he imagined as belonging to some "earthly paradise."[27] Carlos Zerpa (b. 1950) capitalized on these myths as well as on his grasp of Western art history, from which he appropriated liberally. Trained in Italy, Germany, and the United States, he blended kitsch with references to Giotto, Van Gogh, Picasso, Mondrian, and Duchamp. In 1987, Zerpa exhibited in Caracas a series of acrylic paintings titled *Carlos Zerpa India Nova* based on the fanciful chronicles and records of European explorers and visually on prints by the Belgian artist Theodore de Bry. Without ever traveling to the New World, de Bry had relied for his subjects on the drawings of John White and other sixteenth-century art-

ists. He thus created a secondhand visual account of an already distorted Eurocentric one. By borrowing from de Bry, Zerpa deliberately perpetuated the farce by creating a modern-day mythology for the New World. In *El Dorado [The Golden One]* (1987; PL. 12.8), from the *India Nova* series, Zerpa used de Bry's 1594 print of an Indian ruler being dusted with gold before a ritual ceremony. In Zerpa's garishly colored painting, the Indian ruler stands in a classical *contrapposto* while two attendants sponge him with paint and blow the gold powder onto his naked body. A dark eagle hovers menacingly above. Zerpa reversed the figures to account for the fact that the source was a printed image. The eagle in his painting substitutes for a mountain in de Bry's print. In *Acéfalo [Acephalous,* or *The Headless One]* (1987), Zerpa parodies accounts of a headless tribe with an arrow-bearing figure whose face is on his chest. In one of his typical anachronisms, Zerpa includes a barely detectable chair in the sky above the figure, appropriated from Van Gogh's painting of his bedroom in Arles. *Estaballenadeoroestaballena [This Golden Whale]* (1987), whose title shown here as a single word also forms a wordplay in Spanish meaning "This golden whale was full," mocks reports of a hybrid sea creature with scaly skin and a vicious, rhinoceros-like snout. Faintly drawn mermaids (also reported by chroniclers) in graceful dance poses cavort in the background.[28]

Miguel von Dangel (b. 1946) took an archaeological approach to his complex collages and assemblages of the 1980s. The materials he uses are integral to a work's meaning. He combines bird feathers, animal skins, beads, mirrors, bones, ropes, and organic remains, all of which he enhances and binds together with polyester paint. Born in Germany and brought to Venezuela as a three-year-old, von Dangel first worked as a taxidermist, then studied sculpture in Caracas. In the 1980s, he made large-scale assemblages that included crucified dogs and dwarfs. When he exhibited a crucified dog (in

FIGURE 12.4

Miguel von Dangel, *Tityus discrepans [Scorpion]*, 1980, 14K gold, 5.6 cm. long / 2³⁄₁₆ in. long, cast by Lazar Rudich Lohner. Courtesy Miguel von Dangel, Caracas. Photo: Ron Jameson, from *Miguel von Dangel: Tres aproximaciones hacia el paisaje venezolano* (fig. 1).

PLATE 12.8

Carlos Zerpa, *El Dorado [The Golden One]*, from the *Carlos Zerpa India Nova* series, 1987, acrylic on canvas, 192 × 132 cm. / 75⁵⁄₈ × 52 in. Banco Mercantil Collection, Caracas. Courtesy Carlos Zerpa. Photo: Carlos Germán Rojas.

this case, found dead on the road, then cleaned and stuffed) in Caracas in the mid-1980s, he offended church authorities.[29] In his work he sought to destroy Christian symbols in order to reclaim what was sacred in an idealized preconquest world because of what he perceived as the fall in ethical values and the lack of spirituality in our present society. He felt that only the preconquest past held the key to genuine spirituality. The feathers he used in many of his assemblages symbolize the aboriginal vertical axis through which the native people communicated with the supernatural. For this reason, the use of feathers had been censored by the Spaniards after the conquest.[30]

In both his sprawling assemblages and small, cast, fourteen-karat-gold animals, von Dangel alludes to the period of the discovery and the one immediately preceding it. The gold insects, amphibians, and reptiles, cast from dead models by a goldsmith, include scorpions (*Tityus discrepans [Scorpion];* FIG. 12.4), frogs, lizards, crustaceans, and serpents, "the dramatic symbols of Genesis, and its imminent destruction," according to

Francisco Márquez.[31] These pieces also recall the small gold animals made by pre-Hispanic people in Central America and Colombia. By extension, von Dangel's pieces also allude to the greed of the conquerors, who melted down much of what they found for their own purposes.

In 1987, a room-sized environment titled *La Batalla de San Romano [The Battle of San Romano]* was in the making. It occupied most of the space in von Dangel's rooftop studio in Caracas. The title of this sprawling relief, composed of accretions of debris painted in deep rich colors, refers to the battle that culminated in the Florentine victory over the Sienese in 1432, celebrated in Uccello's three panels of 1455. Between 1984 and 1990, von Dangel made separate detachable panels of this work, such as *La Batalla de San Romano,* Panel 3, Section 1, "The Battle" (PL. 12.9). The allusion to a European historic period before Columbus's discovery also draws attention to that time in the aboriginal Ameri-

PLATE 12.9

Miguel von Dangel, *La Batalla de San Romano [The Battle of San Romano],* Panel 3, Section 1, 1984–1990, mixed media glued with polyester and fiberglass, 371 × 30 cm. / 145 × 11¾ in. Courtesy Archivos CINAP, Fundación Galería de Arte Nacional. Photo: Nelson Garrido.

FIGURE 12.5
Miguel von Dangel, *El regreso de la cuarta nave [The Return of the Fourth Ship]* (destroyed), 1981–1983, mixed media, 5 × 10 m. / 16½ × 32¾ ft. Courtesy Archive CINAP, Fundación Galería de Arte Nacional. Photo: Carlos Germán Rojas.

can world before it was tainted by European intrusions. Von Dangel's obsession with the discovery was reenacted in a macabre work, *El regreso de la cuarta nave [The Return of the Fourth Ship]* (1981–1983, since destroyed; FIG. 12.5). Resembling the skeleton of a ship's hull hung with skulls and assorted detritus, this large assemblage represents an unknown fourth ship that presumably accompanied Columbus's three other ships on their voyage to the New World, returned centuries later like a ghost out of the past.[32]

In the absence of a legacy like the Maya and Inca civilizations, which provided a concrete history for artists in Mexico and the Andean countries to draw on, Zerpa and von Dangel reclaimed a mythical legacy from written chronicles that had questionable bases in fact. Consequently, they re-created their own version of genesis: Zerpa in a humorous vein and with a dose of contemporary kitsch, von Dangel in an anthropological, mystical, and apocalyptic one. Zerpa represented the aboriginal man as the New Adam in one of his paintings, *Triton, un Adán en el trópico [Triton, an Adam in the Tropics]* (1986), in which Michelangelo's Adam from the Sistine Chapel's *Creation* scene is recognizable in the darker face of Zerpa's tropical Adam,

who is accompanied by a toucan. For Zerpa, the legacy was one of parody of the myths based on European accounts. For von Dangel, it was a spiritual problem. Redemption for von Dangel did not lie in the imported European religions but in an impossible return to a primordial state and native traditions. Many artists—Argentines, Chileans, and Colombians as well as other Venezuelans—claimed a legacy from virtues the conquerors had usurped and obliterated as a way of identifying with the preconquest past and rejecting four centuries of colonialism.

SUMMARY

These are just a few of the currents that existed in the 1980s. Some of them are ongoing. It has become increasingly more difficult to identify national or regional characteristics in the art of Latin Americans today than it was in earlier decades. First, we are still too close to recent art to label it. Second, cross-fertilization has diluted much of what defined specific national identities. Although questions of national or cultural identity continue to exist, they are no longer defined in terms

of specific iconographies, nor do these issues have the same immediacy as they did in the past. Whether artists travel, or receive input through easily accessible televised and printed information, most of them are entirely familiar with past and present art in Europe and the rest of the Western Hemisphere, a fact that has led to a new discourse for Latin American art regarding its imminent globalization. On the other hand, artists are free to choose to use or not to use these sources.

In the absence of a current centralized bank of art information in Latin America, as had existed to some extent through biennials and international exhibitions in the 1960s—and looking at this absence from the positive side—artists are now freer to work in modes that are not dictated by foreign art markets, although some of them have chosen to do so. The direction the art took in the 1980s and 1990s in individual countries also depended on available outlets and the state of art criticism in those countries. In countries such as Ecuador and Bolivia, the art-critical community with few exceptions has not kept pace with the art currently being produced there. This disjunction has made it necessary for artists to develop their own critical debates. On the other hand, most other South American countries and Mexico have maintained a level of critical inquiry that is providing a platform for these debates.

What is certain is that there is no single style unifying today's art. The referents differ from country to country. Artists who remain in their own country are working within the community that nourishes them, while others have chosen to extend their horizons by living abroad. Rather than a definable entity known as Latin American art, what exists is the art of individuals from many countries and regions, a notion that gained acceptance among some Argentine and Venezuelan artists and critics as early as the 1960s but that was slower to be accepted elsewhere.

Although the purpose of this book has been to propose a structure for studying in some intelligible order the art of these different countries, it is evident that such an attempt remains problematic and open to other possibilities. Nevertheless, the structure provided here is one way of giving coherence to a very large and diverse subject, one that unequivocally belongs to the history of Western art.

1. The books include Gilbert Chase's *Contemporary Art in Latin America* (1970); Damián Bayón's *Aventura plástica de Hispanoamérica* (1974) and *Arte moderno de América Latina* (1985); Edward Lucie-Smith's *Latin American Art of the Twentieth Century* (1993); and Leopoldo Castedo's *A History of Latin American Art and Architecture* (1969) and *Historia del arte iberoamericano* (1988), in which the modern period is part of a broader survey along with pre-Columbian and colonial art. Edward J. Sullivan's more recent (1996) multiauthored book *Latin American Art in the Twentieth Century* contributes a country-by-country survey of this art.

Jean Franco's *The Modern Culture of Latin America* (1970) does not include art that does not correspond to the social and political issues she addresses through literature as a cultural historian, but she provides a valuable basis for organizing the material. Other less comprehensive books on this subject are Oriana Baddeley and Valery Fraser's *Drawing the Line* (1989) and *Being América: Essays on Art, Literature, and Identity from Latin America* (1991), edited by Rachel Weiss and Alan West. Exhibition catalogs include Dawn Ades, *Art in Latin America* (1989); Holliday Day and Hollister Sturges, *Art of the Fantastic: Latin American Art, 1920–1987* (1987); *Latin American Artists of the Twentieth Century* (1993), edited by Waldo Rasmussen, Fatima Bercht, and Elizabeth Ferrer; and Luis R. Cancel, *The Latin American Spirit* (1988). In Latin America since the late 1960s there has also been considerable activity among young scholars, many of whom have provided studies of the art of their particular country with a focus on theory.

2. For instance, Stanton Loomis Catlin and Terence Grieder, as well as Gilbert Chase and Damián Bayón.

3. For a list of exhibition catalogs, see note 1. *Postmodern* as a term has been in use since the late 1960s. It refers to an art whose meaning lies in its extrapictorial connotations more than in its formal components. It was a reaction against modernist practices—sometimes a rejection of these, especially in conceptual art. It came into use as a way of identifying art that differs from modernism because of its multivalent meanings. *Modernism* usually refers to some form of abstraction or semiabstraction. Postmodernism is not a single style but applies to most art produced since the 1960s.

4. The Spanish term *indigenista* or *indigenismo* is used to define the specific movement centered around the depiction of Indians. The English term *indigenist* or *indigenism* is used when a more general reference to nativist culture is intended.

5. Jean Franco (*The Modern Culture of Latin America,* 25) reverses this system by using *modernism* to refer to the Spanish literary and art movement of the 1880s to the early twentieth century, and the Portuguese word (*modernista*) for the Brazilian avant-garde.

INTRODUCTION

1. Two good general sources in English for more information on the nineteenth century are Stanton Loomis Catlin and Terence Grieder's *Art of Latin America since Independence* and Dawn Ades's *Art in Latin America.* Among the studies for the individual countries is Justino Fernández's *El arte del siglo XIX en México.*

2. The issues of civilization and barbarism represented by the two parties were taken up by the educator and later president of Argentina Domingo Faustino Sarmiento in his book *Life in the Argentine Republic in the Days of the Tyrants; or Civilization and Barbarism,* originally published in 1868.

3. In Mexico, as in Brazil, the positivist theories of the French philosopher Auguste Comte were influential during those years. Velasco was profoundly religious, but he had the ability to reconcile the pragmatism of positivism, through his scientific studies of nature, with a mystical sense of the landscape's grandeur, through his use of harmonic proportions and an underlying structural system as equations for cosmic order.

4. Posada died in 1913. Zapata was assassinated in 1919. Posada's prints were often reused after his death, in this case, to illustrate a revolutionary ballad about Zapata's burial.

1. *Modernismo* AND THE BREAK WITH ACADEMIC ART

1. As a literary movement, *modernismo* is given a shorter span. Naomi Lindstrom in her *Twentieth-Century Spanish-American Fiction* (1994) gives 1900 to 1920 as the inclusive dates. In art it is more difficult to pinpoint. I have chosen *El ahorcado* (1890) by the Mexican artist Julio Ruelas as the starting point

NOTES

and *Bodegón con figura* (1934) by the Colombian artist Andrés de Santa María as the ending one. Santa María's work of the early 1930s was stylistically eclectic, but its contents had many symbolist elements. The Uruguayan painter Pedro Figari continued to work in a postimpressionist manner, sometimes tinged with symbolism, into the 1930s.

2. It was not completed until 1934. Long the site of performances, including those of the Ballet Folklórico, today it is best known for its art exhibitions and murals by Diego Rivera, José Clemente Orozco, David Alfaro Siqueiros, and Rufino Tamayo.

3. See Franco, *Modern Culture of Latin America,* 27.

4. Politically, *modernismo* in Hispano-America corresponded to a time when U.S. influence in Latin America was increasing and the United States was replacing Spain as the common enemy. Cuba did not defeat Spain until 1898, but it did so with the assistance of the United States, which led Cuba into an unwanted political dependence on the latter. This dependence spread to the rest of Latin America as U.S. political influence was increasingly felt. As a result, there was a concern throughout Latin America for cultural autonomy. After almost a century during which Latin Americans denied their mother country Spain, the need for an identity in Latin America that was distinct from that of the Anglo-Saxon world led artists to look again to Spanish culture as a role model, as well as to France and Italy.

5. Gerardo Murillo (Dr. Atl) organized this exhibition at the San Carlos Academy a month after the inauguration of the official Spanish exhibition and at one tenth the cost. The official exhibition cost 30,000 pesos, the one at San Carlos, 3,500. José Clemente Orozco was among the Mexican participants. See Jean Charlot, *Mexican Art and the Academy of San Carlos, 1785–1915,* 153–154.

6. By the second decade of the twentieth century, some Latin Americans also collected contemporary (of their period) Spanish painting. The Museo Nacional de Bellas Artes in Buenos Aires acquired three paintings by the fashionable Andalusian artist Julio Romero de Torres when he had traveled to Argentina in the 1920s. His painting was also known in Bolivia through Cecilio Guzmán de Rojas, who had studied with him at the San Fernando Academy in Madrid in the 1920s. Romero de Torres was so revered in Bolivia that the Bolivian government invited him to come and direct the Escuela de Bellas Artes

in La Paz in 1930, but the artist died that year. See Miguel Salcedo Hierro, *El Museo Julio Romero de Torres,* 13; and Rigoberto Villarroel Claure, *Arte contemporáneo,* 23.

7. A good example of this type of anachronism can be seen in the sequence of styles found in the work of the Brazilian Eliceu Visconti (1867–1944). At the turn of the century, he was a symbolist and art nouveau designer. He did not take up impressionism until the 1930s. Exhibitions of the work of the Nabis—Maurice Denis, Edouard Vuillard, and Pierre Bonnard—more often than that of Claude Monet and Auguste Renoir, were held at the Witcomb Gallery in Buenos Aires early in the twentieth century, and the Uruguayan impressionist painter Milo Beretta returned to Montevideo from France early in the century with a collection of paintings by Van Gogh, Bonnard, and Vuillard. For the latter, see José Pedro Argul, *Pintura y escultura del Uruguay,* 99.

8. In literature there are numerous examples of moon imagery. The most obvious example is *Lunario sentimental* by the Argentine poet Leopoldo Lugones. In addition, Oliverio Girondo and Jorge Luis Borges both wrote poems and short stories on this subject.

9. Since the 1970s, many Colombian artists have made the nude figure—male and female alike—the subject of erotic imagery, sometimes shrouded with allusions to religion and death, liberation and guilt. Administrations prior to Alberto Lleras Camargo's presidency (1958–1962) had been under the domination of the clergy, who sought to ban all religions outside of Catholicism in Colombia (see Hubert Herring, *A History of Latin America,* 558). Although the Catholic Church's power had not diminished significantly by the 1960s, the church was becoming somewhat more liberal as Colombia opened itself to more internationally directed programs. According to Herring, "The Colombian Church has developed a new fervor for social improvement which is refreshing and hopeful" and also showed increased concern for literacy in rural areas (571). The impact of the church is especially evident in the art of Colombians from the 1960s on.

10. Teresa del Conde, *Julio Ruelas,* 23.

11. Ibid., 26.

12. José Clemente Orozco, *An Autobiography,* 15.

13. The authorship of this painting has since been questioned by a relative of Julio's, Severino Ruelas Crespo, because the artist's

father also painted. But Teresa del Conde, who generously offered this information, states that Severino did not see it being painted and, furthermore, that several members of the Ruelas family painted but only Julio Ruelas has been included in the history of art; thus it was most probably done by him (pers. com., 2 June 1998).

14. This journal featured translations of writings by European symbolist writers, Poe, Huysmans, Maeterlinck, and Verhaeren as well as of Mexicans and other Latin Americans.

15. Conde, *Julio Ruelas*, 43–44.

16. Orozco, *Autobiography*, 20–21.

17. Diego Rivera and Roberto Montenegro had been among Herrán's fellow students there.

18. For a biography of Saturnino Herrán, see Fausto Ramírez, *Saturnino Herrán*.

19. I owe some of the information on the Jijón y Caamaño commission to María Trinidad Pérez (see Pérez, "The Indian in the 1920s Painting of the Ecuadorian Painter Camilo Egas," 45). Camilo Egas participated in the 1924 *Exposition d'Art Américain-Latin* at the Musée Galliéra in Paris, in which objects from his collection of Ecuadorian pre-Columbian pottery and folk art were included along with his own paintings. See La Maison de l'Amérique Latine and l'Académie Internationale des Beaux Arts, *Exposition d'Art Américain-Latin*.

20. Carlos Salazar Mostajo, *La pintura contemporánea de Bolivia*, 66.

21. My interpretation of this work is based not only on a recurring tendency in Bolivian art to equate the human figure, especially the female, with nature and the land, but also on its obvious content. For further information, see Villarroel Claure, *Arte contemporáneo*, 24–25, and Salazar Mostajo, *La pintura contemporánea*, 66.

22. The series was widely exhibited after 1929 in Buenos Aires, London, Paris, and New York. In 1932 it was shown at the Hispanic Society in New York City. See Christian Brinton, *Cesáreo Bernaldo de Quirós*.

23. The Chilean impressionist group also included Pedro Lira and Alfredo Helsby. See Milan Ivelic and Gaspar Galaz, *La pintura en Chile desde la colonia hasta 1981*, 125–175.

24. Examples of this type of painting can be found in the work of Darío de Regoyos, Santiago Rusiñol, Joaquín Sorolla, Ramón Casas, and Joaquín Mir. See *Spanish Painters (1850–1950) in Search of Light*, ed. Santiago Saavedra.

25. The striking students were locked out of the academy, which was then under the direction of Antonio Rivas Mercado, and as an alternative, began working out-of-doors. Diego Rivera was in Europe at the time, but David Alfaro Siqueiros, who began as an impressionist painter, and José Clemente Orozco were among the strikers. Orozco soon abandoned the group because of his distaste for impressionism. For information about the strike, see Charlot, *The Mexican Mural Renaissance, 1920–1925*, 44–45.

26. See Laura González Matute, *Escuelas de pintura al aire libre y centros populares de pintura*, 123.

27. Adolfo Best-Maugard, *Método de dibujo*.

28. According to his own testimony, Atl added the title "Dr." to his Mexicanized name at the suggestion of the Argentine symbolist poet Leopoldo Lugones, whom Atl met on one of his trips to Europe. Instituto Jalisciense de Bellas Artes, *Homenaje del pueblo*, 7–8.

29. Justino Fernández speculated that Clausell left Mexico for political reasons. Clausell was known to have gone to jail on several occasions for vociferously defending his populist views. See Fernández, *El arte del siglo XIX en México*, 158.

30. Orozco, *Autobiography*, 15.

31. Prior to 1922 he was known for his monumental allegorical figure compositions based on his memory of Michelangelo's frescoes in the Sistine Chapel. In 1921, he collaborated with Roberto Montenegro on a mural in the ex-Colegio Máximo de San Pedro y San Pablo, where he painted such figures. Commissioned by the Minister of Education José Vasconcelos, this mural was the first painted under the new administration of José Obregón. See Orlando S. Suárez, *Inventario del muralismo mexicano*, 212.

32. In a review of a Paris exhibition of Swiss mountain scenes by Dr. Atl in 1914, Guillaume Apollinaire described the artist's use of Atl colors in these works. See Le Roy C. Breunig, *Apollinaire on Art*, 371–372.

33. Curvilinear perspective was not new, but it was revived in Mexico when, in 1934, Luis G. Serrano published *Una nueva perspectiva, la perspectiva curvilínea*, for which Dr. Atl wrote the introduction. Albert Flocon and André Barre, authors of *Curvilinear Perspective*, trace this system back to the Renaissance. They make no mention of Atl or Serrano, an omission that can in all probability be attributed to the tendency in the north

to exclude Latin America from Western art discourse. Both Atl and Siqueiros were known to have used curvilinear perspective.

34. Besides the numerous drawings and paintings recording Paricutín's activity, Atl also published a treatise on the subject titled *¿Cómo nace y crece un volcán? El Paricutín.*

35. In the absence of a notable pre-Hispanic legacy, these regions developed relatively late and their culture was centered around cattle. Consequently, artists and writers continued to seek regional identities in pampa imagery.

36. "Modernismo e impresionismo, a esta altura, se alían en la necesidad de crear un arte que transfigure la realidad a través de sus legítimos valores" (Romualdo Brughetti, *Historia del arte en la Argentina,* 51).

37. Ibid., 55.

38. The Witcomb Gallery in Buenos Aires regularly featured exhibitions of these artists. Picasso's blue period was known in Buenos Aires as early as 1904, when five of his pastels were exhibited at the Witcomb, although his cubist art was not known there until well into the 1920s in the form of reproductions.

39. Lugones's book of poems *Lunario sentimental* (1910) was entirely devoted to the moon. Besides Borges in *Luna de enfrente* (1925), other Argentine poets to take up this subject included Oliverio Girondo in *Interlunio* of the 1930s. The subject was also embraced by the Uruguayan poet Julio Herrera y Reissig in "Moon Gathering" from his book *La torre de las esfinges* (1909). In European painting, moon imagery can be found in works by Kupka, Hodler, Munch, and Van Gogh, but usually with disturbing or threatening, rather than playful or romantic, connotations. In Argentina and Uruguay, in both literature and painting, this imagery took on a more surreal character by the 1930s.

40. A further connection between Fader and Germany was through the Müller Gallery in Buenos Aires, where the work of German artists, including von Zügel's, was shown.

41. Malharro's life was plagued by misunderstandings and a lack of appreciation for his innovative work. He had been dispossessed by a father who disapproved of his artistic aspirations. As a practicing artist, he encountered the rivalry of many of his less daring colleagues and received adverse criticism from other artists when he exhibited in 1902 and 1908.

42. Besides Collivadino, the other members included Justo Lynch, Carlos Ripamonte, Alberto Rossi, Cesáreo Bernaldo de Quirós, and the sculptor Arturo Dresco. The common features linking these artists were their interest in landscape and their bold brushwork that departed from earlier illusionistic painting.

43. Shawls from Manila were popular in many countries at the time, including Mexico. They are featured in a painting by Alfredo Ramos Martínez, but were infrequent in the work of other Mexicans.

44. See Graciela Taquini, *Guillermo Butler,* 2, 7.

45. One of the reasons for the strike at the academy in Caracas was the enactment of a new policy to eliminate some of its annual awards.

46. Mount Avila was a favorite subject for many Venezuelan artists because it contained and protected an otherwise impossible city (Caracas; see Dore Ashton, *Jacobo Borges*). It also represented a counterpart of Cézanne's Mont Sainte Victoire.

47. After his death, this unusual complex of thatch shelters, interspersed with caged parrots and inhabited by life-sized stuffed dolls he had made himself, was converted into a museum.

48. Marta Traba, *Historia abierta del arte colombiano,* 85.

49. Reverón's case epitomizes the type of inversion and anachronism that have made it problematic for art historians to classify his, as well as other Latin Americans', art when this art does not correspond to a European chronology. The same has been true for art in the United States. But in the latter country, an art-historical and art-critical system has developed within the culture to explain its art. This has not always been the case for Latin American countries, which continue to be evaluated by outsiders according to foreign criteria.

50. For this information, see Alfredo Boulton, *La obra de Armando Reverón,* 62.

51. For biographical information, see Carmen Ortega Ricaurte, *Diccionario de artistas en Colombia,* 369.

52. Santa María's years spent in Belgium afforded him an opportunity to familiarize himself with that country's legacy as an important center of symbolist painting and literature. *Annunciation* was originally painted with an archlike background, but the corners were later filled in to form a rectangular composition.

53. Traba, *Historia abierta,* 81–100. Here I use the term *modernist* in its broader sense to mean most of twentieth-century art up to the 1960s that began with the early century's rejection of academic art.

54. In this instance, *creole* refers to a native of Latin America of European ancestry.

55. In the 1890s, Figari served as the defense lawyer in the criminal case of Lieutenant Enrique Almeida, who was tried for an offense Figari did not believe he had committed. This case has been compared by Uruguayan scholars to the Dreyfus affair in nineteenth-century France. After considerable frustration, Figari was able to get his client acquitted. But Almeida's life was profoundly marked by this accusation, and the case left Figari embittered. See Luis Víctor Anastasía, Angel Kalenberg, and Julio María Sanguinetti, *Figari, crónica y dibujos del Caso Almeida,* 55–63.

56. Bergson's theories about time were opposed to the futurist notion of simultaneity. He favored a notion of time as an ongoing condition, a succession of moments known as *la durée.* This aspect is evident in the timeless character of Figari's paintings.

57. Luis V. Anastasía, *Pedro Figari, americano integral,* 223.

58. Anastasía, *Pedro Figari,* 23.

59. Ibid., 223.

60. This volume dedicated to Figari is in the archives of the late Dr. Jorge Faget Figari. Interview with the author in Montevideo, December 1980.

61. Noting the differences between Figari's brush strokes and those of the intimists, Marianne Manley remarked that Figari's use of the arabesque brush stroke had more in common with Anglada-Camarasa's. See Marianne M. Manley's essay "Intimate Recollections of the Rio de la Plata," 17.

62. Victoria Ocampo, "Pedro Figari," 30–35.

63. Güiraldes wrote ecstatically about Figari's ability to make of the pampa something memorable. See Ricardo Güiraldes, "Don Pedro Figari," 5–6. During a visit to Figari's studio in Buenos Aires in 1924, the Hindu poet Rabindranath Tagore had commented on Figari's splendid skies. See "Tagore ante los negros de Figari," a transcript of an anonymous article in the archives of the late architect Dr. Jorge Faget Figari in Montevideo.

64. Figari had written from Paris about this encounter in a letter dated 9 November 1932 to his nephew Jorge Faget Figari. Quoted in Anastasía, *Pedro Figari,* 239.

65. He was criticized for showing these subjects along with other popular themes in an exhibition in Montevideo in 1921. See Fernando Laroche, "El arte de Figari," 9.

66. See Alicia Haber, "Vernacular Culture in Uruguayan Art," 3–9.

67. For detailed information about *candombe,* see Haber, "Vernacular Culture," 4–6.

68. Anastasía, *Pedro Figari,* 67.

2. THE AVANT-GARDE OF THE 1920S

1. The term *avant-garde* here refers specifically to groups whose art was based on cubism, futurism, or expressionism. In Brazil the avant-garde was known as *modernism,* not to be confused with the Hispano-American term *modernismo.* Because of its specific designation in Brazil, *modernism* is used here interchangeably with *avant-garde* for that country's art and literature of the 1920s.

2. These terms were used by writers in Argentina, among other places, and appeared in the Buenos Aires avant-garde journal *Martín Fierro.* Except for the Mexicans Siqueiros and Dr. Atl, futurism was infrequent in Latin American art. But the term was often used by writers as a battle cry against symbolism and romanticism, both of which were components of *modernismo* in literature. Although futurist art was not generally known in the 1920s in Latin America except through journal illustrations, its literary counterpart was known early through the manifestos and writings by the Italian futurist poet and founder of the movement Filippo Tommaso Marinetti, as well as through translations of the "First Futurist Manifesto" into Spanish by Ramón Gómez de la Serna in 1910. Poets from many Latin American countries had also traveled to Europe before, and right after, World War I.

3. Modernity has been the focus of considerable debate in Latin America because it implies industrial progress, and many regions are not part of urban settings where this industrialization occurs. Consequently, vast populations of underprivileged people are left out of this process. But since urban development occurred in many countries, it became part of avant-garde discourse. It enabled artists to shed what they perceived as a regressive rural image. In the 1920s, the city symbolized progress for many intellectu-

als, and avant-garde movements tended to occur in countries where urban development was the strongest, as compared to those dominated by a rural economy.

4. See Chapter 3 on social and ideological art of the 1930s and 1940s.

5. Enrique Anderson-Imbert, *Spanish-American Literature*, 2: 583.

6. *Revista de Avance*, 1927, quoted in Juan A. Martínez, *Cuban Art and National Identity*, 5–11.

7. Abela designed the logo for the 1927 *Exposición de Arte Nuevo (Exhibition of New Art)*. The exhibition included U.S. artists Alice Neel and Adja Yunkers besides Cuban artists. Juan A. Martínez offers further good information on the Cuban avant-garde in general (Martínez, *Cuban Art*, 5–11). See also José Gómez-Sicre, *Pintura cubana de hoy*, 27.

8. The origin of this term was disputed between Guillaume Apollinaire and Huidobro (Anderson-Imbert, *Spanish-American Literature*, 490).

9. They first exhibited as a group at the Casa de Remates (Auction House) "Rivas y Calvo" in 1923, then at the *Salón de Junio* two years later in 1925. The latter exhibition also included paintings by Léger, Marcoussis, and Picasso, sculpture by Lipchitz, and calligrammes (a form of visual poetry initiated by Apollinaire) by Huidobro.

10. The statement with this passage was published in the *Revista de Educación* in 1928. Quoted in Antonio R. Romera, *Historia de la pintura chilena*, 185.

11. The idea for a modern mural movement began in 1910 when Dr. Atl, impressed by the monumentality of Italian Renaissance murals in Europe, attempted to launch such a movement in Mexico. But the outbreak of the revolution delayed this plan for a decade.

12. For Rivera's cubist years, see Ramón Favela, *Diego Rivera: The Cubist Years*.

13. Mari Carmen Ramírez-García, "The Ideology and Politics of the Mexican Mural Movement: 1920–1925," 132–135.

14. The Spanish titles are "Tres llamamientos de orientación actual a los pintores y escultores de la nueva generación americana" and "Cinematografía mexicana." His interest in film also derived from futurism. For the Spanish texts and a discussion thereof, see Raquel Tibol, *Un mexicano y su obra: David Alfaro Siqueiros*, 28–29. For the English version, see "Three Appeals," in Dawn Ades, *Art in Latin America*, 322.

15. Raquel Tibol, *Siqueiros: Vida y obra*, 49. English translation in Ades, *Art in Latin America*, 322–323. Siqueiros, like Dr. Atl, defended the use of European avant-garde modes as appropriate models for the new Mexican art. In *Vida Americana*, he included statements by Georges Braque and Gino Severini and illustrations of work by the Uruguayan modernists Rafael Barradas and Joaquín Torres-García.

16. These included copies of the *Nike of Samothrace*, Michelangelo's *Moses*, and figures from the Medici tomb in Florence.

17. Stanton Loomis Catlin, "Mural Census," 237, 245.

18. Rivera's first wife, Lupe Marín, who was from the state of Jalisco, can be recognized in the figures of Woman, Song, and Strength. Rivera's model for Erotic Poetry was Dr. Atl's companion, Carmen Mondragón, known by her Nahuatl name Nahui Olin (Four Movement). For a detailed analysis of this mural, see Ramírez, "Ideology and Politics," 177–190.

19. Although Vasconcelos's *La raza cósmica* (The Fifth Race) was not published until 1925, his mystical theories, particularly his belief in a source of primal energy that unified the male and female principles, were previously expressed in his *El monismo estético* (Aesthetic monism, 1918) and *Pitágoras* (Pythagoras, 1916), both of which furnished some of the ideas expressed in Rivera's mural. Aesthetic function played an important part in Vasconcelos's theories. His writings can be found in *Obras completas*, 1958. Quoted in Ramírez, "Ideology and Politics," 182–185.

20. Jean Charlot, *The Mexican Mural Renaissance, 1920–1925*, 202, fig. 30. Also see pages 232–233 for Charlot's reconstructions of Orozco's destroyed murals.

21. *El Machete* 7 (1923). This tabloid-sized journal functioned as the Communist organ of the mural avant-garde community. For an English translation, see Ades, *Art in Latin America*, 323–324.

22. Tibol, *Siqueiros: Vida y obra*, 58–59.

23. This pessimism had its counterpart in Mariano Azuela's novel *Los de abajo* (1916; translated in 1929 as *The Underdogs*), which Orozco had illustrated.

24. When in 1926 the Calles government closed schools and convents and deported foreign priests in an attempt to control the church, the resulting conflicts between the church and the government in Mexico culminated in a general strike by the clergy. As a result, outraged believers formed terrorist groups known as Cristeros. For a discussion

of these occurrences, see Herring, *History of Latin America,* 354.

25. At the time, Rivera was involved with the Mexican Communist Party, but he was later expelled. See Catlin, "Mural Census," 252–259.

26. Catlin, "Mural Census," 270.

27. Monteiro Lobato, "Paranoia ou mistificação." Mary Lombardi has suggested that Malfatti's particular experience may have been due to her being a Brazilian national as well as a woman, but that Segall was spared a similar fate because he was a man and a foreigner, therefore not subject to local criteria. Lombardi, "Women in the Modern Art Movement in Brazil," 80. Marta Rossetti Batista's *Anita Malfatti no tempo e no espaço* offers the most complete biography of the artist. Aracy Amaral, in *Arte y arquitectura del modernismo brasileño,* also discusses the Brazilian avant-garde more generally.

28. According to Malfatti's account, Homer Boss tested her courage by taking her out to sea in a small boat and rowing perilously close to some rocks. After they returned to shore, seeing that she had met his challenge without apparent fear, Boss instructed her to stretch a canvas and to "go ahead and paint" (Rossetti Batista, *Anita Malfatti,* 34). Malfatti described this incident in a statement first published in *Revista Anual do Salão de Maio (RASM),* Section 1: unp.

29. Brecheret also designed a heroic monument to the *bandeirantes* (the heroes of the independence of São Paulo) for the occasion, but it remained in maquette form and was not erected until the mid-1950s in São Paulo's Parque Ibirapuera, where the Biennial Pavilion, the Museu de Arte Contemporâneo, and the Museu de Arte Moderno are located.

30. In 1972, a *Cinquentennial Commemorative Exhibition* took place at the Museu de Arte de São Paulo to celebrate the fiftieth anniversary of the Semana. Besides the works that had been included in the original exhibition, other later works by artists who had not participated in it originally were added. Hence, the purpose of the later exhibition seems to have been to convey the notion of modernism in Brazil rather than to be an accurate re-creation of the original exhibition.

31. Together they came to be known as the Grupo dos Cinco (Group of the Five).

32. Tarsila and Oswald each had a child from a previous marriage: Tarsila, a daughter, and Oswald, a son.

33. Aracy Amaral, *Tarsila, sua obra e seu tempo,* 1:114.

34. Aracy Amaral, *Tarsila,* 1:77. In 1923, Tarsila wrote in a letter from Paris to her family in São Paulo, "I feel more and more Brazilian all the time: I want to be the painter of my land" (1:84).

35. Cendrars wrote two books of poems about São Paulo and the Brazilian landscape: *Feuilles de Route—Le Formose* (1924) and *Poemas de Blaise Cendrars—Feitos no Brasil sôbre o Brasil* (1926). These poems were reprinted in France in *Poésies complètes de Cendrars* (Paris: Denoël, 1944). See Aracy Amaral, *Blaise Cendrars no Brasil e os modernistas,* 123–131.

36. Tarsila do Amaral, "Pintura Pau-Brasil e Antropofagia," a statement published in *Revista Anual do Salão de Maio (RASM),* Section 1: unp.

37. See the English translation of this manifesto in Ades, *Art in Latin America,* 310.

38. Ades, *Art in Latin America,* 310–311.

39. This work by Delaunay is now in the collection of the Solomon R. Guggenheim Museum in New York. Blaise Cendrars also painted, and the Eiffel Tower was the subject of one of his works too.

40. Péret was then married to the singer Elsie Houston (Amaral, *Tarsila,* 1:268). The famous surrealist meeting place in Paris, Le Boeuf sur le Toit, was named for a Brazilian folk dance, *O boi no teilhado.*

41. Amaral, *Tarsila,* 1:249. See also Tarsila do Amaral, "Pintura Pau-Brasil e Antropofagia." Tarsila had painted *A negra [The Black Woman]* (1923) in Paris. This painting, representing a *mulata* with a single pendant breast, anticipated *Abaporú* and *Anthropophagy.* But *A negra*'s distortions and proportions are those of cubism, not surrealism. The original impetus for *A negra* was cubist and corresponded with the Ballet Suedois's 1923 production of the *La Création du Monde: Ballet Nègre,* for which Léger painted the sets, Blaise Cendrars wrote the lyrics, and Darius Milhaud (who had also traveled to Brazil) composed the music. All three paintings, including *A negra,* reflect the widespread interest in primitivism that existed then in Paris. During the early 1920s, primitivism was centered on black culture, but toward the end of the decade and into the 1930s, it incorporated Indian and pre-Columbian themes as well. Both *Abaporú* and *Anthropophagy* represent Indians, not blacks. Besides her focus on Indian culture as a metaphor for Brazil in these paintings, Tarsila also practiced the unlikely scale shifts typical of surrealism.

42. When Raúl Bopp first saw *Abaporú,* he exclaimed, "We are going to create a movement around this painting" (Amaral, *Tarsila,* 1:247).

43. "Manifesto Antropófago," 3, 7. *Anthropophagy* (cannibalism) as a catchall word has remained in the language of Brazilians ever since. In the 1970s, it was used to mean appropriation of foreign influences in music as well as art.

44. The English translation of this manifesto is from Ades, "Anthropophagite Manifesto," *Art in Latin America,* 312. Aracy Amaral also discusses the manifesto and Tarsila's corresponding work in *Tarsila—sua obra e seu tempo,* 1:257.

45. Tarsila was more cautious than Malfatti and did not exhibit in Brazil until 1929, at which time she held her first exhibition in Rio. She had already exhibited twice successfully at the Galerie Percier in Paris in 1926 and 1928.

46. I use this term here to indicate that his brand of expressionism had a strong cubist base.

47. Its members, who included Plinio Salgado, Menotti del Picchia, and Ricardo Cassiano, favored a "Brazilian solution to Brazilian problems" as well as the unification of primitivism with modernism. In a dig at other São Paulo modernists, they rejected what they called the "parrots of imported 'isms.'" See Ricardo Cassiano, "Verdeamarelismo," Section 1: unp.

48. The 1926 lecture was not published at the time. A modified form of it titled *Manifesto regionalista* (Regionalist manifesto) first came out in Recife in 1951 and was reprinted in later editions. See Gilberto Freyre, *Manifesto regionalista.*

49. The contents and design of the book were the product of a performance comprising poetry readings, native dances, and costumes organized in Rio de Janeiro by do Rêgo Monteiro in 1923. The book was translated into French and published in Paris the same year.

50. Vargas's election closed the era known as Brazil's First Republic, established in 1889 when the Brazilian monarchy was overthrown. The Second Republic was declared in 1945. A year later, Eurico Gaspar Dutra was elected president and served until 1950, when Vargas was reelected and remained in office until his death by suicide in 1954.

51. The capitalized letters were in the original text. Oliverio Girondo, "Manifiesto de *Martín Fierro,*" 1, 2.

52. Pettoruti describes this experience in detail in his autobiography. See Emilio Pettoruti, *Un pintor ante el espejo,* 45.

53. The Milan- and Florence-based futurists had exhibited in Paris in 1912 and were thoroughly familiar with cubism, which served as a source for their change of style from pointillism to faceted compositions. Carrá and Soffici had both traveled to Paris again in 1913, and Soffici wrote about cubism in *Cubismo e Oltre* (first published in Florence in *La Voce* in 1913).

54. He did this by setting geometric solids of different colors in bright sunlight in order to determine at what point the color was most intense: in full sun, in shadow, or at points in between. Pettoruti, *Un pintor,* 92–93.

55. For instance, Borges wrote "Ascendencias del tango," published in *Martín Fierro* (20 January 1927): 9.

56. Alberto Prebisch, "Pablo Curatella-Manes," *Martín Fierro* (October/November 1924): 6–7.

57. Xul Solar, whose full name was Alejandro Oscar Agustín Schulz Solari, changed his name while in Europe. He began signing his name with an *X* while in Italy and by the early 1920s, with just Xul. His full last names, Schulz and Solari, were the names of his immigrant German father and Italian mother respectively. According to some sources, the name Xul comes from the Latin *lux* (light) spelled backward, and Solar refers to something ancestral as well as to the sun. See Xul Solar, "Palabras Xul," 10–11. It should also be noted that the *X* occurs in the spelling of numerous Mexican names of pre-Hispanic origin, like Xolotl, *xochil,* etc., and Xul utilized this coincidence to blend his name, or its first letter, with his paintings' subjects.

58. Xul Solar's mother and aunt had taken up residence in Zoagli, a suburb of Genoa, and he often stayed with them between trips. For information about Xul Solar's travels, see Mario H. Gradowczyk, *Alejandro Xul Solar,* 8, 19.

59. In the mid-1920s he began keeping a written record of his visions. He wrote a total of fifty, which Jorge Luis Borges later baptized "San Signos."

60. Jorge O. García Romero has discussed the surrealist interpretation of Xul Solar's visions in "Alejandro Xul Solar," 86. Mario Gradowczyk has proposed a Jungian interpretation for these visions; see his *Alejandro Xul Solar.*

61. The second language he invented was Panlengua, based on words from languages of the Western world. Xul Solar is believed to have spoken eight languages. His initial interest in creating a universal language may also have been sparked by Esperanto, popularized during and after World War I.

62. Xul Solar, "Pettoruti," 7.

63. Alfredo Chiabra Acosta (Atalaya), *La Protesta* (October 1924), quoted in Atalaya, *Críticas del arte argentino, 1920–1932,* 83–84.

64. He referred to his synthesis as a "panbeldokie." See Naomi Lindstrom, "Xul Solar's Synthesis," 21–24. In 1929, he exhibited in a two-person show with Antonio Berni, who was a surrealist at the time. For a while, the surrealist label allowed critics to explain unreal and seemingly fantastic elements in Xul Solar's work in those terms.

65. The Boedo affiliates were committed to a nationalist as well as a social cause. They opposed *Martín Fierro*'s apolitical stand and Francophilism, accusing the Florida writers of paying too much attention to French poets at the expense of their own. See Roberto Mariani, "'Martín Fierro' y yo," 2. See also Cayetano Córdova Iturburu, *La Revolución Martínfierrista,* 20.

66. In the early 1930s, Pettoruti founded the Asociación Signo, a club more or less on the same order as São Paulo's SPAM and CAM, where artists could meet, have banquets, and organize lectures.

67. Translation is mine from Pettoruti, *Un pintor,* 218, 221.

68. The tendency in Argentina to overlook native subjects in favor of imported ones has its roots in the nineteenth-century conflicts between "barbarism" (the country) and civilization (the city). See Sarmiento's *Life in the Argentine Republic.*

69. Brazilians referred to this event as *legumes en liberdade* (vegetables at liberty) in a satire on Marinetti's poetic form, *parole in libertá* (words at liberty). See Aracy Amaral, *Arte y arquitectura,* 161.

70. "Ay Marinetti / si yo fuera como tú / daría conferencias / montado en un bambú" (my translation). Ibid., 160.

71. Marinetti's visit to Buenos Aires was celebrated with banquets and exhibitions of the most advanced art Buenos Aires had to offer (Pettoruti, Xul Solar, Curatella-Manes, and Norah Borges), and a double issue of *Martín Fierro* (June–July 1926) was entirely devoted to him and futurism.

3. SOCIAL, IDEOLOGICAL, AND NATIVIST ART

1. Here I use the Spanish term *indigenismo* as a noun and the English terms *indigenous* or *indigenist* in all other cases. The term *indigenismo* was borrowed from literature. The Peruvian writer José María Arguedas distinguished between the terms *indigenista* and *indianista*. According to him, an *indigenista* is a follower of a pro-Indian literary movement, and an *indianista* is someone who cultivates the languages and literatures of the Indians. See Arguedas, *Yawar Fiesta,* 196. Although Arguedas's definitions of *indigenismo* and *indianismo* have parallel meanings for artists—the first referring to an art that addresses the contemporary social problems of Indians, the second, to an art that records Indians and their customs without social implications—these terms are still being debated among art historians in Peru and Bolivia, as will be seen further. It should be noted that Indians have been represented in painting since the mid-nineteenth century in some countries, especially Mexico, but usually as a romantic, idealized figure and symbol of a past legacy, not as a contemporary figure.

2. Among them were the Conferencia Comunista Latinoamericana in Buenos Aires and the Confederación Sindical Latinoamericana in Montevideo, both in 1929. David Alfaro Siqueiros attended the meetings in Montevideo. See Tibol, *Un mexicano y su obra,* 42.

3. The Bolivian revolution occurred under the Movimiento Nacional Revolucionario and ended in 1964 with a return to a reactionary government. See Herring, *History of Latin America,* 627.

4. In Mexico, a racial hierarchy has existed since the colonial era. Church parishes kept detailed records of all interracial marriages or unions, maintained in part by *castas,* small, artist-commissioned paintings of couples of different ethnic mixtures with their offspring, set in a domestic setting. In the second half of the nineteenth century, Indians were also depicted in academic history painting in which they were idealized and Europeanized. For a discussion of the representation of Indians in Mexican art, see Stacie G. Widdifield, "Dispossession, Assimilation, and the Image of the Indian in Late-Nineteenth-Century Mexican Painting," 125–132, and her book *The Embodiment of the National.* The mural painters and

their contemporaries were the first to portray Indians with non-European features, even though their original models had come from European modernism.

5. Orozco, *Autobiography,* 123–130.

6. Except for Rivera's movable fresco *Frozen Assets,* showing masses of homeless and unemployed people as victims of the depression sleeping in crowded conditions on a wharf while the rich visit a safe-deposit vault on a lower level, his representations of workers and machines were generally optimistic. He equated the machine with Marxist ideology as the means to a workers' utopia.

7. Bertram Wolfe, *The Fabulous Life of Diego Rivera,* 277.

8. In these murals, Rivera also paid homage to Mexico's ancient legacy. The stamping press shown to the right of the south wall masks an image of the Mexican goddess Coatlicue, and the two rows of giant spindles framing the center blast furnace on the north wall evoke images of Toltec warrior figures. See Max Kozloff, "The Rivera Frescoes of Modern Industry at the Detroit Institute of Arts: Proletarian Art under Capitalist Patronage," 62. Rivera had spent three months going through the Ford River Rouge plant to study his subject. Above and to the sides of the north and south wall panels, twenty-five other panels represent the biological, geological, pharmaceutical, and transportation industries. For a fine discussion of this mural, see Dorothy McMeekin's *Diego Rivera: Science and Creativity in the Detroit Murals.*

9. Rivera used the money he had been paid for the destroyed mural to paint twenty-one panels depicting the history of the United States, as he interpreted it, in the New Workers' School in New York. These portable murals have since been dispersed. Their subjects are discussed in *Portrait of America,* coauthored by Rivera and Bertram Wolfe, who also later collaborated on *Portrait of Mexico* (1937), which covers Rivera's Palace of Cortés (Cuernavaca) and National Palace (Mexico City) murals.

10. The title originally proposed by Rockefeller for this mural was *Man at the Crossroads Looking with Hope and High Vision to the Choosing of a New and Better Future.* The ample literature on this event includes Bertram Wolfe's *The Fabulous Life of Diego Rivera,* 317–340, and more recently *Diego Rivera: Paradise Lost at Rockefeller Center* (1986), edited by Irene Herner de Larrea and with essays by several authors. Lucienne Bloch,

who had been one of Rivera's assistants, systematically documented the events that led to the mural's destruction in "On Location with Diego Rivera," 102–123. In the second version of *Man at the Crossroads* at the Instituto Nacional de Bellas Artes in Mexico City, Rivera inserted a portrait of Nelson Rockefeller in the night-club scene beneath the wing containing bacteria for venereal disease.

11. Both murals were whitewashed shortly after Siqueiros had finished them. See Shifra M. Goldman, "Siqueiros and Three Early Murals in Los Angeles," 321–327.

12. In the 1936 Siqueiros Experimental Workshop in New York City, a collective workshop in which Jackson Pollock and the Bolivian painter Roberto Guardia Berdecio participated, he experimented with automatist techniques and what he referred to as the "accident" by dripping paint or mixing colloidal substances, enamels, and glue. See Orlando Suárez, *Inventario del muralismo mexicano,* 51. See also Tibol, *Un mexicano y su obra,* for a discussion of Siqueiros's life; Laurance Hurlburt, "The Siqueiros Experimental Workshop: New York, 1936," 237–246; and Laurance P. Hurlburt, *The Mexican Muralists in the United States.* It should be noted that in 1936 the Museum of Modern Art in New York featured a major exhibition, *Fantastic Art, Dada, Surrealism,* which Siqueiros must have seen. In Siqueiros's case, automatist methods yielded patterns that invariably suggested political subjects to the workshop artists as they developed the resulting marks into finished images. An example is *Suicidio colectivo [Collective Suicide]* (1936), in which these accidental marks suggested a group of Incas hurling themselves into the sea rather than succumbing to the Spanish invaders.

13. Siqueiros had been implicated in Trotsky's assassination in 1940. During his two years of exile in Chile, Siqueiros painted *Muerte al invasor [Death to the Invader]* (1942) in the library of the Escuela México in Chillán, which covered two end walls and the oblong ceiling that linked them. In the late 1970s, these murals were ordered tarred by Augusto Pinochet, who thought them subversive even thirty-five years after they were painted.

14. See Romualdo Brughetti, *Historia del arte en la Argentina,* 137.

15. Throughout the nineteenth century, but especially under Domingo Faustino Sarmiento in the 1860s, the Argentine gov-

ernment had made a concerted effort to Europeanize Argentina by encouraging immigration from Europe, which explains the large number of European immigrants among the Argentine working classes in the early twentieth century.

16. In the 1970s, Berni's success was sealed in Argentina when Juanito Laguna became the subject of tangos that were recorded for popular distribution.

17. Tulio Halperin Donghi, *The Contemporary History of Latin America,* 232–234.

18. The Ministry of Education, finished in 1943, was designed by Lucio Costa and the young architect Oscar Niemeyer under the supervision of Le Corbusier, who first visited Rio in 1929.

19. In 1940, Rivera depicted the products and resources of Mexico and the United States in a five-panel portable mural, *Unidad panamericana [Pan-American Unity],* for the Golden Gate International Exposition in San Francisco. However, an earlier example can be found in his representation of Mexico's resources in the Ministry of Public Education murals.

20. The good relations between Brazil and the United States also resulted in art exhibitions. In 1941, the Museu Nacional de Belas Artes in Rio hosted a traveling exhibition of Latin and North American art, *Arte Contemporânea do Hemisferio Occidental (Contemporary Art of the Western Hemisphere),* organized by International Business Machines.

21. In 1940 Portinari also had major exhibitions at the Museum of Modern Art in New York and the Detroit Museum of Art, and Rockwell Kent wrote the first monograph on his work in the United States, *Portinari: His Life and Art.*

22. Annateresa Fabris, *Portinari, pintor social,* 34.

23. The *sertão* is known for endemic drought conditions, which often force its inhabitants to migrate to other regions in search of subsistence.

24. Among those to debate the terminology applied to the depiction of Indians is the Bolivian writer and artist Carlos Salazar Mostajo. He identifies *indianismo* with nineteenth-century folkloric representations of Indians without social content as opposed to *indigenismo.* He classified many Bolivian artists working in the 1930s and 1940s as *indianistas* rather than *indigenistas.* See Salazar Mostajo, *La pintura contemporánea,* 39, 57, 79. The Peruvian writer Mirko Lauer sees

costumbrismo as a component of *indianismo.* He, too, considers the idealization, ethnologization, Incaization, and folklorization of the Indian practiced in Peru in the 1930s and 1940s as *indianismo* instead of *indigenismo.* The painter José Sabogal, known in Peru as the "founder of *indigenismo,*" took issue with this term because he considered it "racist" as well as a reflection of the country's social discomfort. Lauer classified Sabogal as an *indianista.* See Mirko Lauer, *Introducción a la pintura peruana del siglo XX,* 103, 113. More recently, the Peruvian scholar Natalia Majluf has questioned the accepted definitions of *indianismo* and *indigenismo,* and reverses their meanings. See Majluf, "The Creation of the Image of the Indian in Nineteenth-Century Peru: The Paintings of Francisco Laso (1823–1869)."

25. The Syndicate of Ecuadorian Writers and Artists was patterned after the Mexican Liga de Escritores y Artistas Revolucionarios (LEAR; League of Revolutionary Writers and Artists) of 1934. Ecuador was not the only country with a May Salon. A Salão de Maio was founded in São Paulo in 1937, but the exhibiting artists were those of the earlier avant-garde, not Portinari. The opening exhibition of the May Salon in Quito included the work of Eduardo Kingman Riofrio, Leonardo Tejada, Diógenes Paredes, Oswaldo Guayasamín (barely twenty years old at the time), and several others. Initially, the May Salon group rebelled against the staid art of the School of Fine Arts in Quito and issued a manifesto proclaiming the need for artistic freedom and for new forms of creativity. By the mid-1940s, the art this group produced came to be officially sanctioned and accepted by the government with the founding by Benjamín Carrión of the Casa de la Cultura in Quito. The new institution's purpose was to promote an art that would represent Ecuador as a nation. See Diane Hajicek, "The Nation as Canvas." The Casa de la Cultura's impact on Ecuadorian art was far-reaching. It was criticized by a later generation of abstract artists, who sought to reverse its influence in the 1960s, but with limited success. Jacqueline Barnitz, *Abstract Currents in Ecuadorian Art,* 5–9.

26. The interpretation was offered by Egas's widow, Claire Richard Egas, in an interview with the author on 17 February 1981.

27. The Cuban painter Mario Carreño was also teaching at the New School for Social Research in the 1940s. The connections

between European war exiles and artists from the United States and Latin America who taught there during the 1940s have yet to receive scholarly attention.

28. Chronologically, the mural corresponds to Rivera's and Portinari's murals on the subject of national wealth and productivity.

29. The source of this information is Silvana Fierro, an Ecuadorian student and scholar who was in the Communications Department at the University of Texas in 1995.

30. José Camón Aznar, *Guayasamín*, 169.

31. Later he also traveled to Europe and Asia, visiting China, the Soviet Union, and other Soviet bloc countries, as well as the United States, and met the heads of state in both the Communist and capitalist worlds. See Camón Aznar, *Guayasamín*, 169–170.

32. This series has been on display in the Guayasamín Museum in Quito since the 1970s and, as of 1999, was still on display.

33. Catavi had special significance for Alandía Pantoja. He was born there, but in 1942 the town had also been the site of a massacre of striking miners who had demonstrated to denounce their long working hours, wretched conditions in the mines, and low pay. For a discussion of the mural, see Salazar Mostajo, *La pintura contemporánea*, 144.

34. Natalia Majluf, in her dissertation, offers a lucid and extensive discussion on the issue of Peruvian identity as a duality of the Indian and European legacies without consideration for hybridization. See Majluf, "Creation of the Image."

The labor force in Peru and Bolivia, composed primarily of miners, was relatively small compared to the vast Indian population at large. Ugarte-Elespuru has noted that before the 1920s, "Peru was totally agrarian with feudal remnants" and that is was to those conditions that "*costumbrista* literature, political programs of vindication of the peasant, pictorial indigenism along with incipient movements for social justice" had to address themselves. See Juan Manuel Ugarte-Elespuru, *Pintura y escultura en el Peru contemporáneo*, 34. He further remarked that "in reality [in Peru], one should emphasize that indigenism never produced themes of social and politically belligerent content," citing *El gamonal [Political Boss]*, by José Sabogal, as the only picture of this type. Ugarte-Elespuru, 32 n. 3 (my translation of quoted passages).

There were artists in Peru and Bolivia who were actively involved in labor or political causes but whose art did not reflect their involvement. Cecilio Guzmán de Rojas and fellow Bolivian Arturo Borda had each founded labor syndicates, the first, the Partido Socialista Obrero de Bolivia (The Socialist Workers' Party of Bolivia), and the second, the Gran Confederación Obrera del Trabajo (The Great Labor Confederation of Workers), both in 1921. Both artists came away frustrated and disappointed at the failure of their efforts to change the conditions of workers. Except for Majluf, whose dissertation specifically addresses attitudes and representations of Indians, Ugarte-Elespuru and some earlier activists—including artists—fail in their statements and politics to make a distinction between the worker and peasant as labor issues, and indigenism as an Indian issue. The question of the Indian is what José Carlos Mariátegui attempted to rectify, although at times he, too, confused the problem of the Indian with that of Peruvian identity.

35. Herring, *History of Latin America*, 599.

36. Ibid., 600.

37. These debates were reprinted as a series of essays in Mariátegui's *Peruanicemos el Perú*.

38. This statement was first published in "La polémica del indigenismo," *Mundial* 347 (4 February 1927), and later reprinted in *La polémica del indigenismo*, 38, with essays by other authors as well as Mariátegui.

39. José Carlos Mariátegui, "Literature on Trial," 188–189. See also Majluf, "Creation of the Image."

40. See José Sabogal Diéguez, *Obras literarias completas*, 440.

41. There is no mention of the ideological issues in the art Sabogal saw in Mexico. See María Wiesse, *José Sabogal, el artista y el hombre*, 31–33. In early 1923, Rivera had just finished *La Creación* at the Colegio de San Idelfonso and had barely begun his murals in the Ministry of Education. Orozco was working on his early allegorical panels in the Colegio, and Siqueiros was painting *Los elementos*. The latter painted his first political work, *Entierro de un obrero*, after Sabogal's departure.

42. Sabogal went to Italy, France, Algeria, Morocco, and Spain, where he saw postimpressionist painting. There is no indication that he was involved with cubism and futurism. In Argentina, Spilimbergo was still

painting in his early academic style during Sabogal's stay there.

43. Andrés Zeballos, *Tres pintores cajamarqueños: Mario Urteaga, José Sabogal, Camilo Blas,* 51.

44. See, for instance, José Sabogal Diéguez, *Mates burilados: Arte vernacular peruano.*

45. Codesido, along with Siqueiros, Orozco, Tamayo, and several other Latin American and U.S. artists, attended the meetings of the American Artists Congress against Fascism held at New York's New School for Social Research in 1936. But neither a leftist leaning nor a social concern for the condition of Indians was apparent in her art.

46. In this war, Bolivia was stripped of its access to the sea and became landlocked. For information on Urteaga, see Gustavo Buntinx and Luis Eduardo Wuffarden, *Mario Urteaga, 1875–1947,* 91. Also see Herring, *History of Latin America,* 621.

47. Elizardo Pérez, *Warisata, la escuela-ayllu,* 101.

48. Not until the administrations of Víctor Paz Estenssoro (1952–1956; 1960–1964) were Indians granted voting rights for the first time. Herring, *History of Latin America,* 624–628.

49. There are numerous books on the subject of indigenous rural schools in Bolivia. For general information as well as information on the rural school of Warisata, see Salazar Mostajo, *La pintura contemporánea* and *Warisata: Historia en imágenes,* and Pérez, *Warisata, la escuela-ayllu.*

50. The date of Yllanes's death is insecure. There is very little information on him. Some of his oil paintings were discovered in a New York collection when they were exhibited for the first time in the United States at the Ben Shahn Art Gallery of William Patterson College in Wayne, New Jersey and 1992. Aside from references to Yllanes's Warisata murals in Elizardo Pérez's book and Salazar Mostajo's *La pintura contemporánea,* and a brief mention in Villarroel Claure's *Arte contemporáneo,* the most recent information is contained in a flyer compiled by Betsy R. Ruderfer, planning coordinator of the Quipus Cultural Foundation and a member of the editorial staff of the *Bolivian Times.* Although Ruderfer gives the date of Yllanes's death as 1960, she suggests the possibility that it might have occurred as late as 1972, since his name continued to appear in *Who's Who in American*

Art until then. See Betsy R. Ruderfer, "Let's Bring the Yllanes Collection Home."

51. A First Inter-American Indigenist Congress was scheduled to take place in La Paz in 1940, but the new right-wing government objected, so the meeting place was transferred to (Pátzcuaro) Mexico, then under the administration of Lázaro Cárdenas. The participating countries included Peru, Bolivia, Ecuador, Colombia, and Mexico. See Salazar Mostajo, *Warisata,* 333, 416.

52. Yllanes's paintings were exhibited in Bolivia with some success, but for political reasons, he was forced to leave Bolivia in the 1940s. He settled in New York and remained there until his death. See Salazar Mostajo, *La pintura contemporánea* and *Warisata;* see also Pérez, *Warisata, la escuela-ayllu.*

53. Marta Traba theorized that eastern-seaboard countries like Argentina, Uruguay, Brazil, and Venezuela were "open" countries because of their ongoing contact with the outside world, particularly the European avant-garde, and that the Andean countries like Ecuador, Peru, and Bolivia were "closed" and thus developed their art more independently. See Traba, *Dos décadas vulnerables en las artes plásticas latinoamericanas,* 36–37.

54. For further discussion of these contacts, see Salazar Mostajo, *La pintura contemporánea,* 41, 59, 75.

55. Armando Pacheco Pereyra's painting *Incertidumbre [Uncertainty]* (1948), representing a powerful kneeling figure of an Indian tied with ropes, is remarkably similar in pose to Siqueiros's duco painting *Víctima proletaria [Proletarian Victim]* of 1933, in which the victim is similarly bound with ropes. But unlike Siqueiros's very compressed figure, Pacheco Pereyra's is set against an open *altiplano* landscape. See Villarroel Claure, *Arte contemporáneo,* 73–75.

56. Salazar Mostajo has argued that Guzmán de Rojas, his followers, and Crespo Gastelú were *indianistas,* not *indigenistas.* *Indianistas,* he states, are precursors to the *indigenistas.* He considered Yllanes an *indigenista.* See Salazar Mostajo, *La pintura contemporánea,* 70, 94.

57. Ibid., 72.

58. "Hay una complementación natural entre la figura humana y el paisaje andino" (Salazar Mostajo, *La pintura contemporánea,* 141, 142).

59. This association has since become controversial in current feminist usage but should be understood in its context of time and place.

60. Borda's early forays into journalism, syndical work, and social causes ended in disappointment, for which he attempted to compensate with a life of bohemian living. In a Bolivian parallel to Van Gogh's relationship with his brother Theo as his protector, when Borda sank into alcoholism and poverty, his brother Héctor helped and protected him. In the 1930s, Borda seems to have devoted himself to journalism and writing. He produced the major part of his art in the last ten years of his life. Much of it remained in his brother's estate until the latter's death in the 1970s. See José de Mesa and Teresa Gisbert's essay "Arturo Borda, el hombre y su obra," 8–20.

61. Although Salazar Mostajo situates Borda's work within a nationalist discourse and refers to the artist as the "father of Bolivian painting," there are parallels between Borda and the U.S. artists Peter Blume and O. Louis Guglielmi in their particular blend of the real with the incongruous. Blume and Guglielmi were known alternately as surrealists or magic realists, but neither of them shared Borda's apparent liking for Hieronymous Bosch. Bosch has remained a frequent source of reference for Andean artists, who continue to appropriate details from Bosch's paintings. The symbolist connection in Borda's work may have come from his earlier affiliation with Bolivian *modernista* poets such as Ricardo Jaimes Freyre, Franz Tamayo, and Gregorio Reynolds.

62. One of Borda's landscapes of the 1940s, *Selva yungueña [Valley Jungle],* is uncannily similar to an 1850 print titled *Landscape in Peru* by the German artist Eduard Poeppig. Borda was known to copy photographs of monuments and famous figures such as Mohandas Gandhi, Rabindranath Tagore, Alfonse Dodet, Edgar Allan Poe, and Walt Whitman. Borda especially admired Michelangelo's *Pietá,* among major Renaissance pieces, as well as classical Greek culture, which he knew through literature and illustrations. See de Mesa and Gisbert, *Arturo Borda.* It should be noted that Bernardo Bitti, an Italian mannerist follower of Leonardo da Vinci's, worked in Bolivia in the sixteenth century and is regarded as one of the founders of Bolivian viceregal painting.

63. Arturo Borda, *El loco.*

64. Salazar Mostajo, *La pintura contemporánea,* 45–46. Salazar Mostajo's nationalist interpretation of Borda's work is not unique to Bolivia. In other Andean countries, especially Ecuador, critics have tended to follow a similar interpretative discourse for the art of their countries.

65. A group of Bolivian artists from Potosí, who worked under the collective name of Pintores Libres de la Sierra (Free Painters of the Highlands), used the term *andinismo* for their art because landscape was such an integral component of their nativism. See Salazar Mostajo, *La pintura contemporánea,* 141.

4. SURREALISM, WARTIME, AND NEW WORLD IMAGERY

1. In the following years, Breton labeled as surrealists several artists who had not considered themselves so. Among these were Frida Kahlo and, after 1946, Rufino Tamayo and Hector Hyppolite. Tamayo appears for the first time in the 1965 edition of Breton's *Surréalisme et la peinture* (first published in 1928, reprinted by Brentano in 1948) and was not included in earlier editions; see *Surrealism and Painting.*

2. "La fantasía del mexicano es infantil, la del surrealista [the European] sofisticada. El surrealista crea un mundo fantástico, no lo refleja, el mexicano quizá porque lo vive lo oculta" (Ida Rodríguez-Prampolini, *El surrealismo y el arte fantástico de México,* 96). The term *fantastic* had actually been used in the title of the Museum of Modern Art's 1936 surrealist exhibition, *Fantastic Art, Dada, Surrealism.*

3. The distinction made here between surrealism and neosurrealism is problematic, since surrealism underwent mutations that gradually gave way to neosurrealism. What differentiates the two here, however, is that the surrealists such as Remedios Varo and Leonora Carrington were directly affiliated with, or contemporaries of, the original surrealist group, whereas the neosurrealists (some of whom studied with surrealists) were not part of the original generation. The neosurrealists were also less autobiographical and often focused on the paradoxical (Magritte was a favorite model) rather than the psychological and the overtly personal. The neosurrealists included the Argentines Roberto Aisenberg, Noé Nojechowiz (both of whom had studied with the surrealist Batlle-Planas), Héctor Borla, Miguel Caride, Guillermo Roux, and Juan Carlo Liberti; the Chileans Rodolfo Opazo and Carmen Aldunate (the latter studied with the Cuban-born

Mario Carreño); the Peruvian Tilsa Tsuchiya; and the Mexicans Pedro Friedeberg and—with some reservations—Alberto Gironella and Julio Galán.

The neosurrealist Phases group organized in Paris by Edouard Jaguer in the 1950s was at first identified with surrealism. As a movement, Phases consisted of publications and, between 1954 and 1964, annual exhibitions in different Western cities, including Mexico City, Buenos Aires, Santa Fe (Argentina), São Paulo, and Rio. These exhibitions, which included surrealists from the original group as well as neosurrealists and artists who belonged to neither category, indicated that by the 1950s surrealism had acquired a very broad definition. Both Gironella and Antoni Tàpies exhibited with the group.

4. Guillermo de Torre, "Neodadaísmo y superrealismo," 54–60. This essay was first published in Spain in 1924. Guillermo de Torre, a former contributor to *Martín Fierro,* married Norah Borges in 1928.

5. There were two isolated cases, the painter Ismael Nery, whose work was more like Marc Chagall's than the more orthodox surrealists after 1928, and the sculptor María Martins, known in the 1940s for her evocative organic forms.

6. See Stefan Baciü, *Antología de la poesía surrealista latinoamericana,* 87–88.

7. *Pro. Revista de Arte* 2 (1934).

8. Moro apparently had serious conflicts with the Chilean poet Vicente Huidobro. See César Moro, *Anteojos de azufre,* 10–11.

9. See César Moro, *Anteojos de azufre,* for illustrations.

10. They included Orlando Pierri, Luis Barragán, Vicente Forte, Bruno Venier, Ideal Sánchez, Leopoldo Presas, Juan Fuentes, Alberto Altaleff, Antonio Miceli, and José Manuel Moraña. See Romualdo Brughetti, *Historia del arte en la Argentina,* 145–149. The group exhibited together twice, in 1939 and 1940. Neither the poet Aldo Pellegrini nor the artists Juan Batlle-Planas, Xul Solar, or Raquel Forner were involved with this group. Some of them have since been forgotten, while others have gone on to make reputations in areas other than surrealism.

11. Guillermo Whitelow alludes to comments made by Dalí about a "photographic developer," although it is difficult to document this as a source for Batlle-Planas. Whitelow does not refer to the images by Dalí that would seem like logical sources. See Whitelow, *Obras de Juan Batlle-Planas,* 32.

12. This was a two-person exhibition with Norah Borges. Batlle-Planas later referred to this exhibition as an important experience for him. See his comments in "Cuatro devociones," *La Opinión Cultural,* Suplemento (Sunday, 15 June 1975), 3.

13. Whitelow, *Obras de Juan Batlle-Planas,* 16. Batlle-Planas's statement corresponds to Xul Solar's mystical visions, not to surrealist images conjured up through self-hypnosis.

14. See Susana Sulic, *Batlle-Planas,* 4, and Whitelow, *Obras de Juan Batlle-Planas,* 40.

15. Reich was just developing these theories in 1941 and 1942 in New York and Maine. At the time, his work was controversial because of its claims as a cure for cancer and other problems. See Wilhelm Reich, *Selected Writings: An Introduction to Orgonomy.* See also Sulic, *Batlle-Planas,* 2.

16. In 1932, after her return from her second trip to France and Spain, Forner and three colleagues opened an independent studio, Cursos Libres de Artes Plásticas, as an alternative to the academy. She returned to expressionism in the 1960s and 1970s. For a discussion of this artist, see Guillermo Whitelow, *Raquel Forner.*

17. Whitelow writes about Forner's subjects as "mankind," with no mention of the exclusive presence of victimized women and children. Forner herself never commented on her choice of women as subject nor disputed Whitelow's interpretations.

18. Classical torsos with severed parts appeared in several of her works and were also a feature in the work of other Argentines, including Orlando Pierri, a member of the Grupo Orión. But Forner had more immediate models in the carved nude torsos by her sculptor husband, Alfredo Bigatti.

19. *Exposición Internacional del Surrealismo.*

20. Hayden Herrera, *Frida: A Biography of Frida Kahlo,* xi, 230.

21. Ibid., 47.

22. Ibid., 278.

23. Some of Kahlo's resistance to this classification may have reflected both a general reluctance in Mexico to acknowledge an art form that had not originated there and her own specific irritation with Breton's arrogance. But she never turned down an invitation to exhibit with other surrealists. See Nancy Deffebach, "Pre-Columbian Symbolism in the Art of Frida Kahlo."

24. Relatively little scholarship on this artist existed until very recently. Elizabeth Ferrer's essay "María Izquierdo," in *Latin American Artists of the Twentieth Century,* 116–

121, is a good recent source. A dissertation by María de Jesús González, "María Izquierdo: The Formative Years," offers a biography of the artist's early life. At press time, a study by Nancy Deffebach was underway on botanical imagery in the work of Kahlo, Carrington, and Izquierdo.

25. Carrington's mural was titled *El mundo mágico de los maya [The Magic World of the Maya]*. She was acquainted with Mexican popular customs, including the uses of medicinal herbs and hallucinogens, but did not make any of these the subjects of her paintings, although references to the latter come out in her writings.

26. Péret had lived in Brazil from 1929 to 1931 with his first wife, the singer Elsie Houston. He married Remedios Varo in 1937 and lived with her first in France, then in Mexico until 1947, when their marriage ended. He returned to Paris alone and died there in 1959. His book of Mexican legends, myths, and folk tales, *Air Mexicain,* was published posthumously.

27. After her divorce from Péret, Remedios Varo went to Venezuela to visit a brother who lived there, remaining until 1949. While there she began illustrating for a group of epidemiologists who were studying disease-bearing insects. This experience led her to work on a minute scale through a magnifying glass. See Janet A. Kaplan, *Unexpected Journeys: The Art and Life of Remedios Varo,* 114.

28. Carrington's short stories were compiled in a book and first published in 1939 as *La dame ovale* in Paris. The book has since been translated into English. See Leonora Carrington, *The Oval Lady.*

29. *Leonora Carrington: A Retrospective Exhibition,* 23.

30. Breton's *Fata Morgana,* or Morgan le Fay, was based on a medieval legend of a sorceress in the time of King Arthur and also alluded to a mirage.

31. For a discussion of the role of ethnography in surrealism, see Martica Sawin's essay "Ethnographic Surrealism and Indigenous America" in *El surrealismo entre Viejo y Nuevo Mundo,* 325–327.

32. Wolfgang Paalen, "Farewell au Surréalisme," 26.

33. This aspect of Paalen's career was the subject of an unpublished paper, "Between Surrealism and Abstract Expressionism: Wolfgang Paalen and 'The New Image,'" presented by Robert Mattison in 1992 at the annual meeting of the College Art Association in Chicago.

34. Breton, *Surrealism and Painting,* 234. Tamayo made such comments in informal conversations as well as in a published interview with Annick Sanjurjo Casciero, "The Poet of Mexican Realism," 47.

35. Sanjurjo Casciero, "The Poet of Mexican Realism," 44–47.

36. Ibid., 47.

37. Breton, *Surrealism and Painting,* 234.

38. Matta's training in architecture as a route to painting was not unusual for male artists in Latin America, as men were customarily trained to take up lucrative professions. Other such cases include the Uruguayan Gonzalo Fonseca, the Argentines Marcelo Bonevardi and César Paternosto, the Ecuadorian Luis Molinari, and scores of others.

39. Dore Ashton, "Surrealism and Latin America," 109.

40. Romy Golan, "Matta, Duchamp et le mythe: Un nouveau paradigme pour la dernière phase du surréalisme," 48.

41. William Rubin, *Matta,* 6.

42. Ibid., 4.

43. Ibid., 9.

44. Tariana Navas, "Erotic Violence in Matta's Works of the Years in New York: 1939–1948."

45. Matta left New York at a time of personal crisis. His friend Arshile Gorky had committed suicide in 1948 after a series of misfortunes. Gorky had been seriously injured in an automobile accident and had cancer. Matta became involved with Gorky's wife, Mougouche, but the affair ended abruptly after Gorky's death. See Lionel Abel, *The Intellectual Follies,* 113–114.

46. As a university student in Paris in the 1930s, Césaire cofounded in 1934 the journal *L'Etudiant noir* (The black student), in which he first coined the term *negritude.* As a result, a whole generation of writers from Africa and the Caribbean made *negritude* the central theme of their poetry. See Janis L. Pallister, *Aimé Césaire,* xi. The Martiniquais philosopher and psychoanalyst Franz Fanon perceived contradictions in the notion of *negritude* and wrote about them in *Black Skin, White Masks* (first published in French as *Peau noire, masques blancs*).

47. Carlos Franqui, "Entrevista con Wifredo Lam," 15.

48. Max Pol Fouchet, *Wifredo Lam,* 199.

49. Although Cuban Santería and Haitian voodoo have similar origins in the African

Yoruba religions, their rituals are different. One of the differences is that voodoo religion personifies its deities, who appear in Christian disguise. Santería includes figures and their attributes directly related to their African origins.

50. Fouchet, *Wifredo Lam,* 200.

51. Quoted in Fouchet, *Wifredo Lam,* 199.

52. Ibid., 198.

53. For a discussion of Lam's use of Santería symbols, see Gerardo Mosquera, "Modernidad y africanía: Wifredo Lam en su isla," 21–41.

54. Some of the stalks and ripe fruit in this painting are remarkably similar to those found in the grove by the house in Marianao, a suburb of Havana, where Lam painted this picture.

55. Fouchet, *Wifredo Lam,* 199.

56. Ibid., 204.

57. Breton, *Surrealism and Painting,* 171.

58. Fouchet, *Wifredo Lam,* 45.

59. After changing his style several times from organic to geometric forms, Carreño turned to a more classicizing form of neosurrealism in the 1970s. Although stylistically different from his earlier work, he retained a surrealist vocabulary of metaphors for the female body.

60. José Gómez-Sicre, *Mario Carreño,* 5.

61. Hyppolite liked to relate stories about his travels to New York and Africa, but the only documented trip he took out of his country was to Cuba. Gerald Alexis, "A propos d'Hector Hyppolite," 122–126.

62. During the colonial period, art was imported from Europe. But a popular tradition in art existed long before 1944. Artists painted Catholic saints from European prints as disguises for their Afro-Cuban deities. Not all Haitian artists were naïve painters. Since the 1940s, artists have worked in a diversity of styles, as they do elsewhere. But work done by trained artists was not in demand abroad, since it did not correspond to foreigners' thirst for exotic imagery from Haiti. For a detailed discussion of Haitian painting, see Michel Philippe Lerebours, *Haïti et ses peintres.*

63. Hyppolite would hold the cardboard flat on the palm of his left hand, as a priest holds the plate with the cornmeal and palm oil mixture used to draw the *vevers,* and he would apply the paint with his right. See Gérald Alexis's "A propos d'Hector Hyppolite," 122–126.

64. Breton and Rodman both wrote about Peters's discovery of Hyppolite. See Breton, *Surrealism and Painting,* 309, and Selden Rodman, *The Miracle of Haitian Art,* 24.

65. Robert Farris Thompson, quoted in Selden Rodman, *Artists in Tune with Their World,* 11.

66. This work was reproduced in the 1964 edition of Breton's *Surrealism and Painting,* with an essay on the artist written by Breton in 1947 (311).

5. CONSTRUCTIVE UNIVERSALISM AND THE ABSTRACT LEGACY

1. This was not the case for Mexico, where pre-Hispanic art was largely anthropomorphic.

2. The late Argentine art historian Damián Bayón claimed geometric art as an Argentine phenomenon in his essay "A geometria sensível: Uma vocação argentina" (Sensitive geometry: An Argentine vocation), in *América Latina: Geometria sensível,* 115–125.

3. Torres-García's work received wide diffusion when it was exhibited at the *Fifth São Paulo Biennial* in 1959.

4. He is especially known for his monumental book *Universalismo constructivo,* a collection of lectures first published in Buenos Aires in 1944.

5. The murals were commissioned under the administration of Prat de la Riba. After the latter's death in 1916, the commission was canceled by officials of the following administration, presumably because they objected to the murals' secular themes and nude figures.

6. For a detailed biography of Torres-García's life, see Barbara Duncan, *Joaquín Torres-García, 1874–1949.*

7. The golden section is a harmonic proportion with a ratio of 1 to 1,686 believed to have been in use at various times since antiquity. In pictorial terms, the ratio results in the shorter side of a rectangle being to the longer side what the longer side is to both.

8. Theo Van Doesburg, "Elementarism," 238.

9. Joaquín Torres-García, *Universalismo constructivo,* 749.

10. Pre-Columbian art was on display at the Trocadero, now the Musée de l'Homme, where Torres-García's eldest son, Augusto, had worked in the ethnographic section drawing Nasca pots. A large exhibition of pre-Columbian art, *Ancient Art of the Americas,* also took place at the Musée des Arts

Décoratifs in Paris in 1928. See Margit Rowell, *Torres-García: Grid-Pattern-Sign,* 13.

11. The artists included Jean Arp, Wassily Kandinsky, Le Corbusier, Fernand Léger, Piet Mondrian, Amédée Ozenfant, Antoine Pevsner, Kurt Schwitters, Frank Stella, Sophie Taeuber-Arp, Georges Vantongerloo, Friedrich Vordemberge-Gildewart, and numerous others.

12. Zaniah, *Diccionario esotérico,* 298. See also Jacqueline Barnitz, "An Arts and Crafts Movement in Uruguay: El Taller Torres-García," 139–157.

13. The Quechua word *Inti,* meaning "sun," appears spelled out in some of his works of the 1940s.

14. Similar statements are repeated in different forms throughout his writings. See, for instance, Torres-García, *Universalismo constructivo,* 126, 270, 292, 822.

15. This statement was reprinted in Torres-García, *Universalismo constructivo,* 213. The reversed map was the subject of two drawings, one of which was reproduced in the May 1936 issue of *Círculo y Cuadrado;* the other, dated 1943, was used after Torres-García's death to illustrate the cover of the publication *Escuela del Sur* of 1958. See Ramírez, *El Taller Torres-García,* 53, for an English translation of this text.

16. For the most complete discussion of the AAC and TTG, see *El Taller Torres-García,* ed. Mari Carmen Ramírez. The AAC and TTG together were contemporary with Black Mountain College in North Carolina, which Torres-García knew about. He was also familiar with the former Bauhaus in Germany and with the work of Josef Albers, who taught at Black Mountain after he arrived in the United States in 1933.

17. Torres-García, *Universalismo constructivo,* 203, 212, 605.

18. It seems significant that the publication of this work was contemporary with Claude Lévi-Strauss's studies of Amazonian Indians in Brazil.

19. Torres-García, *The Abstract Rule,* 1946, originally published as part of an article, "Nueva Escuela de Arte del Uruguay," posthumously published under the above title in 1967. Reprinted in *El Taller Torres-García,* ed. Ramírez, 168–170. The outbreak of World War II changed the focus of Latin American art to a great extent. Artists who had traditionally looked to Europe for models could no longer do so in the early 1940s. This was one of the factors that drew attention to Indo-American culture.

20. Torres-García's rejection of industrialization was opposed to the concerns of Figari, who had attempted to establish courses in industrial design earlier.

21. Barnitz, "An Arts and Crafts Movement," 148. Torres-García had learned to be frugal during his travels in Europe, when he had had to support his family on skimpy resources. Initially he made toys for his children and his own furniture with wood wrested from the packing crates he used in his many moves.

22. For the complete Spanish text of this manifesto, see Tibol, *Siqueiros: Vida y obra,* 47.

23. For the Mexicans, the mural served a didactic purpose outside of and beyond its architectural setting. Barnitz, "An Arts and Crafts Movement," 152.

24. Torres-García's panels were removed from their location at Saint-Bois and transferred to canvas stretched on metal frames. While they were on exhibit in the *Geometria Sensível* show at the Museu de Arte Moderna in Rio de Janeiro in 1978, they were among the many works that were destroyed in a fire.

25. The focus on specific Indo-American references in the early 1940s is borne out by the coincidental presence of Pacha Mama (Mother Earth) in a painting by Arturo Borda of the same year. The two artists did not know of each other.

26. A proportional system of subdivisions based on the square and devised by the Canadian geometer Jay Hambidge (d. 1928) before and during the early 1920s.

27. In 1951, *Removedor* was revived by Torres-García's followers under the name *Escuela del Sur* (School of the South) and did not cease publication for good until 1961. See Duncan, *Torres-García,* 42.

28. Artists and writers in Chile, Argentina, and Brazil honored Torres-García with letters and statements published in *Marcha* (Montevideo, 6 October 1944). During the same period he received the visit of Lincoln Kirstein from the Museum of Modern Art in New York.

29. The source and meaning of "Madí" are uncertain. Some believed it to be a contraction of Materialismo Dialéctico (Dialectic Materialism); others thought it was derived from "movimiento de arte de invención." Kosice later claimed that it was an invented word with no meaning, although that would seem at odds with these artists' well-planned program of events and type of art. See Osiris Chierico, *Reportaje a una anticipación,* 35.

30. For Max Bill's definition of *concrete,* see Lawrence Alloway's essay "Lawrence Alloway on Max Bill," 14.

31. Nelly Perazzo, *El arte concreto en la Argentina,* 19.

32. Alloway, "Lawrence Alloway on Max Bill," 14.

33. Perazzo, *El arte concreto,* 84. It should be noted that Argentina had not been directly involved in the war. Argentine concrete art evolved during the early years of the Perón administration. It is difficult to determine what connection, if any, there might have been between the artists' beliefs and those of the Argentine government's. Concrete art as a phenomenon of the 1940s in Argentina has been equated with optimism and a new order reflecting none of the postwar angst evident in the contemporary art of Western Europe and the United States.

34. Rhod Rothfuss, "The Frame: A Problem of Contemporary Art," quoted in English translation from Dawn Ades, *Art in Latin America,* 329–330.

35. Tomás Maldonado had first visited Max Bill in Europe in 1948. In the 1950s, at Bill's invitation, Maldonado went to teach at the Hochschule für Gestaltung in Ulm, Germany, then under Bill's direction, and Maldonado later codirected it with him. The Ulm Hochschule für Gestaltung was an updated postwar version of the Bauhaus, where Bill had studied before 1933. Maldonado, who taught theory of design there rather than painting, was one of several artists from foreign countries to go to Ulm. The Brazilian concrete painter Alvir Mavignier also studied there. See *Ulm Design,* edited by Herbert Lindinger. Raúl Lozza was the founder of *perceptismo* (perceptism), a term he devised to define the elimination of form and content as separate elements, since the flat color field of the painting was also the content. It also established a visual experience that dynamized the surrounding space. See Perazzo, *El arte concreto,* 177–179.

36. Mari Carmen Ramírez, "Re-positioning the South: The Legacy of El Taller Torres-García in Contemporary Latin American Art," 282. Ramírez's essay offers a thorough analysis of Torres-García's direct and indirect followers; see 252–287.

37. Ramírez, "Re-positioning the South," 265.

38. Torres-García, *La recuperación del objeto: Lecciones sobre plástica.*

6. NEW MUSEUMS,
THE SÃO PAULO BIENNIAL,
AND ABSTRACT ART

1. By taking up abstraction, artists had to find ways to explore their role either as nationals by tapping their cultural symbols or as members of an international community by choosing to shed the limitations of their nationalities. For a discussion of this question, see Lawrence Alloway, "Latin America and International Art," 65–76.

The degree of concern many artists and critics felt for the dilemma of identity versus internationalism was expressed in numerous symposia and panel discussions that took place from 1960 through the 1980s on the subject of Latin American identity. In her book *Dos décadas vulnerables en las artes plásticas latinoamericanas,* Marta Traba addressed some of these issues. Many Latin American critics writing from the mid-1950s through the mid-1970s also had to find a new critical language to accommodate abstraction, and many of them, including Marta Traba, patterned some of their ideas on foreign models, sometimes including formalists like Clement Greenberg.

2. Although some authors have applied the term *abstract expressionism* to Latin American abstraction, this term does not correspond to what most artists were doing. *Informalism* is the Spanish, French, and Latin American equivalent of abstract expressionism and is not necessarily always the result of a gestural brush stroke or chance effects. More often, it was related to the thick impenetrable surfaces of Spanish "matter painting" practiced by such painters as Antoni Tàpies. Therefore, throughout this chapter, the English terms *informalist abstraction, abstraction,* and *informalism* are used, and where applicable, *gestural abstraction* or *tachisme,* from the French "to stain" or "to mark."

3. The Museo de Arte Moderno in Mexico City was founded within the Instituto Nacional de Bellas Artes (INBA) and was housed in that building until it moved into its own quarters in 1964. The Museo de Arte Moderno in Buenos Aires was founded in 1956, in name only, by the poet and art critic Rafael Squirru, who had assembled a collection of contemporary Argentine art and made it the initial basis of the museum's collection. It opened officially in 1960 on two floors of the Teatro San Martín in downtown Buenos Aires.

4. Frederico Morais, *Artes plásticas: A crise da hora atual,* 74.

5. Marta Traba was one of the critics to object to the perpetration of this image in some art. She denounced Mexican social painting and the indigenism of Guayasamín in particular as "cultural degradation." On the other hand, she praised the Grupo de los Once (with Raúl Martínez, Hugo Consuegra, and Sergio Milian, among others), a group of Cuban abstractionists working under Castro's government, for bringing Cuban art up-to-date. Traba, *Dos décadas vulnerables,* 31–32, 127.

6. Diament Sujo vehemently opposed the classification of Latin American artists by nationality. See Clara Diament Sujo, "Open Letter to a University Man in Texas Concerning Some Venezuelan Artists," 80–82.

7. For instance, although the Nicaraguan painter Armando Morales maintained close ties with his country, both as artist and diplomat, he lived and worked abroad for several decades. Many artists from Bolivia, Cuba, Ecuador, Guatemala, Peru, and El Salvador also lived abroad for several years. Some forms of abstraction were practiced in Cuba from the early 1950s on, particularly by a group of artists known as the Grupo de los Once (there were usually more than eleven of them in the group) who exhibited under that name for the first time in 1953 (see note 5 above). The group was founded by Guido Llinás and included Hugo Consuegra, who brought these artists to my attention in a letter dated 10 December 1977. It should be noted that after the 1959 Cuban revolution, far from imposing aesthetic restrictions, Fidel Castro defended the creative rights of artists to work in any mode they wished as long as it did not oppose the government. He stated this in a speech made on 30 June 1961. See Fidel Castro, "Words to the Intellectuals," reprinted in *Radical Perspectives in the Arts,* ed. Lee Baxandall, 267–298.

8. In a lecture given in 1954 at the Palacio Nacional de Bellas Artes in Mexico City, Siqueiros denounced the United States for its covert attempt to ban ideological art in favor of the apolitical School of Paris. He cited a traveling exhibition of Mexican art that included pre-Columbian, colonial, and popular art as well as work by the mural painters that had been well received in Europe and that the Metropolitan Museum of Art in New York had requested. But the conditions set forth by the museum were that they did not want the "political" art. The exhibition was then canceled. According to him, after 1943, the Mexican mural painters were denied entry permits to the United States (actually Orozco did return to New York in 1945). See David Alfaro Siqueiros, "The Salutary Presence of Mexican Art in Paris," 145–175. See also Eva Cockcroft, "Abstract Expressionism: Weapon of the Cold War," 39–41.

9. Salas Anzures was active at the INBA for four years, during which he faced constant criticism. See Miguel Salas Anzures, *Textos y testimonios,* 122.

10. For a detailed discussion of the debates and confrontations that occurred at that time, see Shifra Goldman, *Contemporary Mexican Painting in a Time of Change,* 27–40.

11. The younger generation in Mexico included neofigurative as well as abstract artists. Besides Cuevas, they included Alberto Gironella, Francisco Corzas, Francisco Toledo, and Rafael Coronel. These artists, discussed in Chapter 10, all made use of the free style introduced by abstract art, but preserved the human figure as the basis for their art.

12. Subtle references to Mexican culture exist in Rojo's tightly packed patterns of squares that evoke glazed tile designs on exterior walls in his *Recuerdo [Remembrance]* series, and the colors of popular and folk art are—by his own admission—present in the *México bajo la lluvia [Mexico under the Rain]* series of the 1980s. Although Felguérez can be considered a constructivist, and it would seem more appropriate to include him in the chapter on geometric, optical, and kinetic art, he is discussed here because he began as an informalist and his work subsequently fluctuated between informalist abstraction and geometric art. His geometric period lasted for about ten years. In the late 1970s, he returned to informalist abstraction.

13. See Jacqueline Barnitz, "Three Mexican Artists at the C.I.R.," 42–44.

14. Octavio Paz, "Multiple Space," unp.

15. Felguérez began a series of geometric works in the late 1960s that led to his computerized drawings. He worked on this project, which consisted of devising model drawings for processing, in collaboration with the Colombian electrical engineer and computer scientist Mayer Sasson. See Felguérez and Sasson, *Paintings and Sculpture: Manuel Felguérez.*

16. In 1953, Rojo also cofounded the magazine *Artes de México* with Miguel Angel Anzures.

17. See Vicente Rojo, *Vicente Rojo,* a book published on the occasion of his exhibition at the Dirección General de Bellas Artes y Archivos in Madrid comprising published interviews and short essays by several authors, 46.

18. See Raquel Tibol, "Herméticos recuerdos de Vicente Rojo," 110–111.

19. For a discussion of the work of Mabe, see Manabu Mabe, *Manabu Mabe: Vida e obra,* 72.

20. Mabe, *Manabu Mabe,* 64.

21. Manabu Mabe, *Mabe,* interview with Olivio Tavares de Araujo.

22. See Georges Mathieu, *De la révolte à la renaissance: Au-delà du Tachisme,* 233–242.

23. Mabe, *Mabe,* unp.

24. Argentine painters to practice gestural abstraction in the 1960s included Kasuya Sakai, Clorindo Testa, Marta Peluffo, Mario Pucciarelli, Sarah Grilo, and Miguel Ocampo, while José Antonio Fernández-Muro chose the textured surface. For a while, Rogelio Polesello painted informalist abstractions, but he turned to optical and kinetic art and three-dimensional work in the late 1960s.

25. See Jacqueline Barnitz, *Latin American Artists in the U.S. 1950–1970,* 26.

26. Thomas M. Messer, introduction to *Fernández-Muro,* unp.

27. Lawrence Alloway, "The Search for a Legible Iconography," 74–77.

28. Barnitz, *Latin American Artists in the U.S. 1950–1970,* 26.

29. Quoted from a statement made to the author during a studio visit in New York in 1966.

30. As an outcome of the new government policies, the *First Hispano-American Biennial* was founded in Madrid in 1951, the same year as the *First São Paulo Biennial.*

31. Another artist who moved to Ecuador was the Nebraska-born U.S. painter Lloyd Wulf, who lived there from 1941 to 1959 and was influential on the work of Tábara.

32. In Mexico, the break with the art establishment represented by the muralists was known as *ruptura* (break), a name first given to the younger artists' break with tradition by Octavio Paz in 1951 and seconded by Luis Cardoza y Aragón in 1961. José Luis Cuevas and Alberto Gironella were among the representatives of this break.

33. The term *se van* in Ecuador has literary precedents in a short-story collection of 1930, *Los que se van* (Those who go away), with texts by Aguilera Malta, Gallegos Lara, and Gil Gibert. The writers, however,

worked in an indigenist context. See Naomi Lindstrom, *Twentieth-Century Spanish-American Fiction,* 116. For the younger artists, these words were used to define the new abstract avant-garde. The Grupo VAN was followed in 1968 by the *First Quito Biennial,* a separate—and competing—event that did not survive beyond the first exhibition. Subsequently, the Grupo VAN artists disbanded and continued to work independently. See Barnitz, *Abstract Currents,* 7.

34. Barnitz, *Abstract Currents,* 26.

35. Ibid., 28.

36. Quoted from a conversation with the artist in Quito, December 1976. See also Barnitz, *Abstract Currents,* 28.

37. *Estofado,* from the root word *stuff* or *étoffe* in French meaning "quilted silk" or "to paint on burnished gold," was widely practiced during the colonial period along with *encarnadura,* a term derived from *carne* (flesh) to define the technique used to imitate flesh for the face and hands.

38. Villacís used the term *precolombino* as the title of a series. Marta Traba seems to have coined the term to describe a type of Ecuadorian abstraction based on the formal characteristics of pre-Columbian pottery and textiles. Traba, *Dos décadas vulnerables,* 41. In other countries, terms like *ancestralismo* (ancestralism) were used to denote references to an ancient past but with different connotations. The latter term applied to references to a historical and mythical legacy that was more prevalent in Peru and Bolivia than elsewhere. See Isabel Rith-Magni, "El ancestralismo—un 'indigenismo abstracto'?"

39. His designs are very similar to those on roller stamps from the sites of Esmeraldas and La Tolita. See Emilio Estrada, *Arte aborigen del Ecuador, sellos o pintaderas.*

40. Damián Bayón, *Aventura plástica de Hispanoamérica,* 305.

41. Maldonado joined the research team of the Sillem Company in Verolanuova, Brescia, in 1973 and, as a result of experiments, managed to produce six different colors on metal by soaking sheets of stainless steel in a chromosulphuric solution. By stopping out sections of the metal with an enamel substance and leaving others exposed to the solution in a process similar to etching, he obtained a wide range of colors. The specific color depended on the length of time the exposed surface was immersed in the solution: fifteen minutes for bronze, seventeen for blue, longer for yellow, red, or green. See Barnitz, *Abstract Currents,* 42.

42. See Marco Antonio Rodríguez, "Del libro *Viteri*," 4.

43. Two years earlier, in 1949, Enrique Kleiser, a little-known artist, had also shown abstractions at the Galería Lima, but his exhibition went unnoticed. Therefore, critics have credited de Szyszlo as the first to exhibit abstract work in Peru. Gilbert Chase, *Contemporary Art in Latin America,* 105.

44. Beginning in 1957, de Szyszlo also sporadically taught classes in painting at the Universidad Católica.

45. Mirko Lauer offers an analysis of how de Szyszlo adapted the quoted phrases in this elegy to his paintings. These passages are quoted from *Szyszlo: Indagación y collage,* ed. Mirko Lauer, Javier Sologuren, and Emilio A. Westphalen, 38–46.

46. Ibid., 46.

47. This state of civil war followed the 1948 assassination of Jorge Eliécer Gaitán, who represented the liberal faction in Colombian politics in opposition to Laureano Gómez of the extreme right. See Herring, *History of Latin America,* 555.

48. Marta Traba, who disliked indigenism and Mexican muralism, had praised Picasso's work because it dramatized violence and conflict without sacrifice to a painting's formal qualities. See Marta Traba, "El artista comprometido," quoted in Gary Alan Seloff, "Alejandro Obregón and the Development of Modern Art in Colombia," 35 n. 68.

49. An account of *la violencia,* by Germán Guzmán Campos and other authors, titled *La violencia en Colombia* was first published in Bogotá in 1963. The volume was amply illustrated with photographic documentation. Obregón began this series before the publication of this book, but his known affiliation with poets and writers made it probable that he knew the authors. In addition, acts of violence had been regularly illustrated in the dailies.

50. Isabel Rith-Magni discusses Pacheco with other Andean painters in her paper "El ancestralismo—¿un 'indigenismo abstracto'?"

51. Barnitz, *Latin American Artists in the U.S. 1950–1970,* 20.

52. For Pacheco's recollections, see Leopoldo Castedo, "Primera retrospectiva de María Luisa Pacheco," unp.

53. Mentioned in a conversation with the author in New York in 1975.

54. Her type of abstraction has a sculptural counterpart in the contemporary work of her compatriot, the sculptor Marina Núñez del Prado.

55. In the following years, the São Paulo Biennial was sometimes politically controversial and the subject of artists' boycotts during the military regime in Brazil. Since the inauguration of the Havana Biennial (Cuba) in 1984, artists from Third World countries and marginalized groups from the First World have found a new venue for exchange outside the sphere of the First World market system.

56. Besides the *Primera Bienal Americana de Grabado* in Santiago, Chile (1963), these graphics biennials included the *Exposición Latinoamericana de Dibujo y Grabado* at the Central University of Venezuela in Caracas (1967); the *Primera Bienal del Grabado Latinoamericano de San Juan de Puerto Rico* (1970), organized by the Instituto de Cultura Puertorriqueña in San Juan; and the *Primera Bienal Americana de Artes Gráficas,* organized by the Museo La Tertulia in Cali, Colombia (1971).

7. FUNCTIONALISM, INTEGRATION OF THE ARTS, AND THE POSTWAR ARCHITECTURAL BOOM

1. He later contributed urban-planning designs for Buenos Aires (1938) and Bogotá (1950), as he had for other locations throughout the world. For a concise biography, see Françoise Choay, *Le Corbusier,* 118.

2. El Pedregal, meaning "the rocky place," is a residential development built on a lava desert created by the extinct Xitle volcano in the southern section of Mexico City. See Max Underwood, "Luis Barragán: Modern Mexican Architecture," 44–49.

3. The Palacio de Bellas Artes was originally planned as a national theater but became an art museum, the Instituto Nacional de Bellas Artes (INBA), in the 1930s. Rivera, Orozco, Siqueiros, and Tamayo all painted murals there in the following three decades.

4. This manifesto was first published in June 1925 as "Futurism" in the Italian-Brazilian newspaper *Piccolo* and again in November 1925 as "Apropos of Modern Architecture" in the Rio daily *Correio da Manhã.* Geraldo Ferraz, *Warchavchik,* 259.

5. In order to have his designs for this house approved by the building code authorities, Warchavchik was asked to include exterior ornamentations, which he managed through subterfuge to avoid using. Ferraz, *Warchavchik,* 23.

6. Today, this house is in a lamentable state of deterioration, and the garden is completely overgrown for lack of maintenance while litigation is in progress to decide the property's fate. This information was obtained from the Museu Lasar Segall in 1992.

7. The bedroom had orange curtains, and the living room was in tones of light green and violet. See Ferraz, *Warchavchik,* 96, 263.

8. Both Tarsila do Amaral and Dona Olivia Guedes de Penteado owned work by these artists.

9. Ferraz, *Warchavchik,* 96.

10. Frank Lloyd Wright had gone to Rio de Janeiro in 1931 and met the architects Lucio Costa and Gregori Warchavchik. See Ferraz, *Warchavchik,* photo facing title page.

11. In Quito, the painters Araceli Guilbert and Oswaldo Viteri and the architect Alberto Solís built very original homes with brick, and in Bogotá the painter Ana Mercedes Hoyos and the architect Jacques Mosseri live in an all-brick house designed by him.

12. Building plans often failed to include sufficient funding for maintenance. This was the case in Pampulha in the 1950s, when, for lack of such funding, the buildings fell into disrepair, the damming system failed, and the lake dried up. See Leopoldo Castedo, *A History of Latin American Art and Architecture,* 267. Repairs have since been made, the lake has been refilled, and Pampulha now functions as a tourist landmark.

13. See Stamo Papadaki, *Oscar Niemeyer,* 22.

14. This information was given to the author informally in a conversation with a church attendant during a visit to Pampulha in June 1976. Now postcards are sold at the entrance. For further information on Pampulha, see Henry-Russell Hitchcock, *Latin American Architecture since 1945,* 28, and Papadaki, *Oscar Niemeyer,* 22.

15. For a discussion of Villanueva's architecture, see Sibyl Moholy-Nagy, *Carlos Raúl Villanueva;* the library is discussed on p. 125. See also Castedo, *A History of Latin American Art and Architecture,* 278–279.

16. For a discussion of Ciudad Universitaria in Caracas, see Paul Damaz, *Art in Latin American Architecture,* 140–154.

17. This industrialization and internationalization had begun in Mexico under the previous administration of Manuel Avila Camacho (1940–1946).

18. Max Cetto, *Modern Architecture in Mexico,* 30. O'Gorman contradicted himself regarding his views on architecture. By the 1950s, his main preoccupation was with the integration of architecture and painting (mosaics), which the functionalist architecture he practiced in the 1930s could not accommodate. See also Ida Rodríguez-Prampolini, *Juan O'Gorman, arquitecto y pintor,* 121–123.

19. Under Lazo's direction, 150 architects, engineers, sculptors, and painters and about 6,000 workmen collaborated on the project. Cetto, *Modern Architecture in Mexico,* 66.

20. Ibid., 68.

21. Ibid., 72.

22. Ibid., 70.

23. Antonio Luna Arroyo, *Juan O'Gorman,* 138. O'Gorman had originally gone to Pennsylvania to do a mural commission that was subsequently canceled. Some years later when Frank Lloyd Wright visited Mexico and saw O'Gorman's house, he in turn admired its "organic" architecture. See Luna Arroyo, *Juan O'Gorman,* 186.

24. Damaz, *Art in Latin American Architecture,* 227.

25. The School of Altamira was the first abstract art school in Spain, and Goeritz promoted a surrealist-derived type of free-form abstraction there.

26. See Selden Rodman, *Mexican Journal,* 94–95. See also Damaz, *Art in Latin American Architecture,* 222.

27. In his own sculpture, Henry Moore had been inspired by Maya art, particularly the Chac Mool at Chichén Itzá.

28. See, for instance, Paul Goldberger, "Architecture Approaches a New Internationalism," E-9.

29. Olivia Zúñiga, *Mathias Goeritz,* 38.

30. Damaz, *Art in Latin American Architecture,* 222.

31. For a discussion of Goeritz's work vis-à-vis minimal art, see Gregory Battcock, *Minimal Art: A Critical Anthology,* 20.

32. Rodman, *Mexican Journal,* 95.

33. Raquel Tibol, *Fernando González Gortázar,* 18.

34. Ibid., 25.

35. Ibid., 31.

36. Castedo, *A History of Latin American Art and Architecture,* 275.

37. Underwood, "Luis Barragán," 44–49. The reference to emotion in architecture originated with the French intellectual Ferdinand Bac, whom Barragán had met.

38. Jesús Reyes also claimed to have inspired the colors of Goeritz's and Barragán's *Cinco Torres* at Ciudad Satélite,

according to González Gortázar in a conversation with the author.

39. Underwood, "Luis Barragán," 49.

40. Castedo, *A History of Latin American Art and Architecture,* 274.

41. Cetto, *Modern Architecture in Mexico,* 81.

42. The idea for this chapel may have derived from the sixteenth-century Mexican *capilla abierta* (open chapel), usually adjacent to churches to accommodate large congregations and attract neophytes. But the chapel's absence of liturgical decor in favor of the natural landscape visible outside the altar window was viewed at first with some degree of skepticism.

43. Cetto, *Modern Architecture in Mexico,* 96.

44. Although this structure also bears a superficial resemblance to Gaudí's so-called Hipostyle Hall (designed as a market) at Parque Güell (Barcelona), Candela's umbrellas were not organic but rather the result of a calculated structural system.

45. For a detailed and technical discussion of Candela's buildings and mathematical solutions, see Colin Faber, *Candela, the Shell Builder.*

46. Cetto, *Modern Architecture in Mexico,* 120.

47. Castedo, *A History of Latin American Art and Architecture,* 273.

48. Faber, *Candela,* 15.

49. The practice of designing museums with natural lighting was especially popular in the 1960s, although conservators do not consider it to be an optimum solution, since ultraviolet rays can prove detrimental to paintings.

50. In São Paulo, architecture tended toward a more international style than in Rio. An emphatic horizontality characterizes Eduardo Kneese de Mello's museum buildings in São Paulo's Ibirapuera Park, including the Biennial Pavilion.

51. Pietro María Bardi, *Profile of the New Brazilian Art,* 52.

52. In an effort to make Brasília into a great cultural center, artistic activity was encouraged there during its first years. An international Congress of Art Critics was held there in 1959, an annual National Salon was initiated in the early 1960s, and musical and experimental theater groups were established there. Several artists and other intellectuals already lived in Brasília by 1959. The conceptual artist Cildo Meireles and the late Bahia-born painter Rubem Valentim both lived there for several years and, according to

a statement made informally by Meireles to the author during a visit to Austin in November 1992, had found the experience invigorating.

53. Salvador (Bahia) was the first capital until the seat of government was moved to Rio de Janeiro by the Portuguese Crown in 1763. Rio, which was initially founded as a small colonial settlement in the late sixteenth century, remained the capital until 1960.

54. Norma Evenson, *Two Brazilian Capitals,* 163.

55. In the 1960s, Brasília was satirized by the Rio-based Tropicalia musical group, who identified it with the military regime and perceived it as a mix of "images of sophistication and progress with anachronism and poverty." See Christopher Dunn, "It's Forbidden to Forbid," 14–21.

56. Evenson, *Two Brazilian Capitals,* 165, 210.

57. Initially created to accommodate the workers, a temporary settlement known as Cidade Livre (Free City) was established. But plans to eliminate this community after completion of Brasília were ineffective, and Cidade Livre—later renamed Núcleo Bandeirante (Pioneer Nucleus)—grew into a thriving self-sustaining community that acquired the status of a satellite city. Gradually, other neighboring towns were incorporated into a network of satellite cities as a means to solve the problem of low-cost housing, which was never resolved, as originally planned, within the city itself. The spacious apartments and houses designed for this purpose in Brasília proved to be too profitable economically to fulfill these social ideals.

58. These sculptural columns' distinctive design was subsequently appropriated by the advertising media as a new national emblem. See Bardi, *Profile of the New Brazilian Art,* 53.

59. Evenson, *Two Brazilian Capitals,* 193.

60. Damaz, *Art in Latin American Architecture,* 68.

61. This information is based on a visit to Brasília in 1976. *Candomblé* and other Afro-Brazilian customs such as the practice of *umbanda,* a form of magic used to cast spells, can be found in most of the major cities in Brazil, including São Paulo.

62. Evenson, *Two Brazilian Capitals,* 192.

63. Ronaldo Brito discusses these issues in *Neoconcretismo, vertice e ruptura do projeto construtivo brasileiro,* 104.

8. GEOMETRIC, OPTICAL, AND KINETIC ART

1. The significance of geometric art in Latin America was confirmed in 1978 with an exhibition titled *América Latina: Geometria Sensível* (*Latin America: Sensitive Geometry*) at the Museu de Arte Moderna in Rio de Janeiro that included artists from Mexico to Argentina. The exhibition's selections were made not so much to distinguish between the different forms of geometric art or their underlying philosophies as to prove the widespread existence of geometry in Latin America. See Roberto Pontual, *América Latina: Geometria Sensível*.

2. In 1948, he was included with Ramírez Villamizar and the painter Enrique Grau in an exhibition of Colombian art, *Sculpture and Painting in Colombia,* held at the New School for Social Research. See Galaor Carbonell, *Negret: Las etapas creativas,* unp.

3. He had mentioned seeing work by contemporary Spanish artists—without specifying which ones—in a conversation with the author during a studio visit in Bogotá. His statement about African fetishes is cited in Carbonell, *Negret,* unp.

4. A number of writers have alluded to curves and roundness in connection with Colombian art, usually with Fernando Botero's inflated figures in mind. But Galaor Carbonell, for instance, even saw a connection between Negret's use of curves and the roundness of Botero's and Enrique Grau's figures. The Brazilian critic Frederico Morais referred to Colombia as "un país redondo" (a round country). It is, nonetheless, a tenuous, if intriguing, assertion dating to the publication of Gabriel García Márquez's magic-realist novel *One Hundred Years of Solitude.* In referring to the aluminum bands Negret bent into curves, Carbonell also noted that the U.S. painter Barnet Newman had remarked that Negret could make a work of art out of a single colored band. Newman's own paintings usually involved a single color stripe on a monochrome surface. See Carbonell, *Negret,* unp.

5. Carbonell commented on Negret's "machines" as having lost their productive function (*Negret,* unp.).

6. Douglas Hall, *The Sculpture of Edgar Negret,* unp.

7. Eroticism in art was a widespread tendency in Colombian figurative art of the 1970s. Its presence in Negret's dockings corresponds to this trend.

8. During his eleven-year stay in New York, he taught in the Artistic Education Department at New York University.

9. The tendency of Colombian artists to limit color to a minimum or to just black or white was noticed by foreign critics. Ramírez Villamizar's work was included in the *Black and White Show* in Boston in 1965. See *Black and White Show,* exhibition catalog. He was also included in the *White on White* exhibition in Lincoln, Massachusetts, the same year. See *White on White,* exhibition catalog.

10. Between 1970 and 1972, *Construcción suspendida [Suspended Construction]* served as the model for a later large-scale, white, welded-steel construction for the patio of Westbeth, an artists' residence in New York City.

11. Galaor Carbonell, "Eduardo Ramírez Villamizar: Ultimas esculturas," unp. In this respect, Marta Traba also noted that the Colombian defines him/herself as "an orderly spirit, in contrast to the disorder peculiar to his/her milieu." See Traba, quoted in Frederico Morais, "Ramírez Villamizar." unp.

12. Dynamic symmetry was a system of classic Greek origin based on natural forms and on the premise that one can build upon a geometric structure and extend it indefinitely according to the proportional system. Dynamic symmetry was popularized in the United States by the Canadian geometer Jay Hambidge, who died in 1928. Hambidge's theories were well known in the 1920s and had influenced Orozco, who applied them to his New School for Social Research (New York) murals in 1930.

13. See Carlos Rojas and Santiago Cárdenas, *Carlos Rojas, Santiago Cárdenas,* unp.

14. Galaor Carbonell, "Carlos Rojas en São Paulo," unp.

15. Mario Rivero, *Rayo,* unp.

16. In 1956 he also lived for a while among indigenous tribes in Brazil. Rivero, *Rayo,* unp.

17. Ibid.

18. Ibid.

19. Ibid.

20. Ibid. Although Rayo continues to live in New York a good part of the time, he commutes to Roldanillo, where in 1981 he founded the Rayo Museum. The museum houses a collection of graphics by different Latin American artists and provides temporary exhibitions and cultural activities for the local people, such as workshops for children. For a discussion of the museum, see Agueda Pizarro, "Beyond the Gallery Walls," 8–13.

21. After the mid-1970s, Hoyos painted a series of *Atmospheres,* inspired by Monet's *Waterlilies,* which consisted of nothing but a carefully worked surface of subtle tonal variations of pale blue-grays. In the 1980s, she turned to a type of figuration in which she represented fragments of figures, fruits, and flowers in flat patterns.

22. The power of the Catholic Church in Colombia has sometimes created oppressive conditions. The government was in the hands of the Conservative Party for many years, including during *la violencia.* The conflation of these two forces (government and church/ violence and oppression, or repression) did affect how Colombian artists responded to their environment and was at the core of the art of Leonel Góngora and, less blatantly, Luis Caballero, not to mention of representations of the human body in painting of the late 1960s to the 1970s. For a discussion of the Catholic Church's role in Colombia, see Herring, *History of Latin America,* 539.

23. This exhibition did not establish distinctions between the different ways to produce retinal responses. Neither the exhibition nor the catalog essay addressed any of the questions this art raises. The term *optical* in relation to art was coined for this exhibition. See *The Responsive Eye,* ed. William C. Seitz. The term *kinetic* was of ancient origin and was used in the nineteenth century in connection with movement in physics and chemistry. It was applied to art by Naum Gabo and Antoine Pevsner. As an art term, *kinetic art* came to be used in the 1950s by the Israeli painter Yacov Agam, and it also appears in the exhibition catalog essay for *Le Mouvement* (1955) at the Galerie Denise René in Paris. See Frank Popper, *Origins and Development of Kinetic Art,* 94–95.

24. For instance, Mateo Manaure, who did abstract geometric murals at Ciudad Universitaria, later practiced a romantic and gestural type of landscape painting when not executing public commissions; and Osvaldo Vigas replaced geometric art with a totemic form of gestural figuration.

25. The work of Monasterios, Monsanto, and especially Reverón represented a transitional phase between academic art and optical and kinetic art in Venezuela. All of these artists studied effects of light via different media. The dazzling tropical light of Venezuela had preoccupied artists from the mid-nineteenth century on, including Camille Pissarro and Fritz Melbye, and continued to be a factor in optical and kinetic art.

26. Following a stay in the United States, Otero settled in Paris again in the early 1950s. Far ahead of the academic currents still prevalent in his country, he and several compatriots collaborated in founding a dissident group and the journal *Los Disidentes* (The Dissidents) for the purpose of defending artistic freedom. The journal published five issues. José Balza, *Alejandro Otero,* 6.

27. Otero and Soto were both admirers of the work of Mondrian. They also shared a common interest in light and space as early as 1951, and both were included in the *Espace-Lumière* exhibition at the Galerie Suzanne Michel in Paris (1951–1952). The main focus of the exhibition was "time/space/light." Other participants in this exhibition included the Venezuelan Mercedes Pardo, the Uruguayan Arden Quin, and the U.S. artist Jack Youngerman. Alfredo Boulton, *Historia de la pintura en Venezuela,* 3:192.

28. Otero and Soto both temporarily interrupted their kinetic work to take up other materials. In Paris during the early 1960s, Otero did Schwitters-like collages and also incorporated ordinary objects, such as saws, keys, a paintbrush, or a broom dangling from a nail hammered onto a fragment of a door, into his work by gluing them onto white painted surfaces. Although these works presented a parallel to pop art, they had more in common with the aesthetic qualities of the French *art des objets.* Soto's case was more circumstantial. In the course of a return trip to Venezuela, because of the expense or unavailability of the materials he had used abroad, he found an alternative in the use of locally available rubber and wire, out of which he created kinetic works. In the process, he discovered the possibilities for activating a surface optically by suspending thin wire bent into irregular curves in front of a rough surface, in this case rubber.

29. Margarita D'Amico, "Alejandro Otero en la vanguardia espacial," 34.

30. Balza, *Alejandro Otero,* 126.

31. Ibid.

32. During the 1971–1972 year, Otero received a Guggenheim fellowship to work at the Massachusetts Institute of Technology (MIT) in Cambridge. There he explored "solar mirrors," which were wheels—designed along the same lines as the cubes—with an internal system of shiny propellers that spun in the wind and reflected light. These works were not purely about modern technology. It seems relevant to consider that the Inca faced the top of their temple en-

trances with gold to reflect the sun at specific times of the day (sunrise) or year (equinox).

33. In 1955, Soto participated in the Galerie Denise René's landmark exhibition *Le Mouvement* together with Vasarely, Tinguely, Agam, Bury, Duchamp, Calder, and others.

34. Soto understood the mathematical components of classical music. He also liked popular music. During his first years in Paris, he supported himself by playing the guitar and singing in clubs.

35. In *Plexiglas Spiral* (1954), Soto obtained the illusion of spirals by superimposing two sheets of Plexiglas, one with concentric ellipses, the other with broad curves. It was probably inspired by Duchamp's motorized *Rotative,* known as an "optical machine," which was included in the *Mouvement* exhibition at Denise René. Neither Soto's nor Otero's kinetic work was motorized, but depended instead on natural phenomena to activate it. See Jean Clay, "J. R. Soto: Creating Imaginary Space," 2–5.

36. The generic term *penetrable* was used by the Brazilian artist Hélio Oiticica in 1967 to denote a space to be entered by the spectator. It is difficult to verify who was the originator of the term, but it was probably Oiticica. Many of Soto's works were renamed some time after they were made. Not until 1969 was the term *penetrable* in common usage.

37. In 1974, a similar one was set up in the open ground-floor space of the Guggenheim Museum in New York City as part of a Soto retrospective exhibition.

38. A diagram of this project was reproduced in *Robho* 5–6 (2d term, 1971), 40. The idea of labyrinths or penetrables was especially prevalent among Argentine, Brazilian, and Venezuelan artists in 1968 and 1969. In 1967, Carlos Cruz-Diez conceived of labyrinths that would engage all the senses, including sound, smell, and touch, for a total "sensorial release." The same year, the Brazilian artist Hélio Oiticica—discussed in the next chapter—produced a tentlike environment for a similar purpose.

39. The *Penetrable sonoro [Sonorous Penetrable]* is in the Museo de Arte Moderno Jesús Soto, inaugurated in 1973 in Ciudad Bolívar. Plans to include this work in Soto's 1974 retrospective at the Guggenheim Museum were vetoed, apparently for fear of assaulting the participants' decibel tolerance and out of respect for visitors to other galleries in the museum.

40. Carlos Cruz-Diez, *Cruz-Diez: Physichromies, Couleur Additive, Induction Chromatique, Chromointerferences,* 3.

41. The contemporary Israeli artist Yaacov Agam, living in Paris at about the same time as Cruz-Diez, had developed a similar system of vertical triangular ridges cut into a wooden panel and painted on their sides to produce floating, changing geometric patterns whose appearance depended on the spectator's position vis-à-vis the work.

42. Merleau-Ponty died in 1962. His best-known books were *The Structure of Behavior* (1961) and *Phenomenology of Perception* (1962). In the latter, he addressed issues of perception that were of particular interest to the kineticists. Frank Popper noted that Merleau-Ponty affirmed "the primacy of vision over the construction of the mind in so far as painterly representation of movement is concerned. 'My movement is not a decision of the mind, an absolute doing, which decrees, from the depths of the subjective retreat, some change in position that is miraculously carried out in extension. It is the natural consequence and the maturing of a vision.' Relying principally on the views of Rodin and Michaux, and bringing out the well-known paradox inherent in the distinction between an arrested movement and a photographic snapshot, Merleau-Ponty then launches into a discussion on the aesthetics of movement which results in a phenomenological explanation very much in the tradition of Husserl: 'Painting does not see the externals of movement—but its secret codes'" (Popper, *Kinetic Art,* 226–227).

43. Aided by his experience in the photographic processes of industrial design, photomechanics, and printing, and his knowledge of color theory, Cruz-Diez developed a series of works whose colors, according to him, act "with violence equal to that of cold, heat, sound, libido . . . upon the human being" (Cruz-Diez, *Cruz-Diez,* 3).

44. Ibid.

45. See Saul Yurkievich, "La réflexion chromatique de Luis Tomasello," unp. The fugitive qualities of color in Tomasello's work are analogous to Paternosto's paintings of the 1970s, which appear to exist by virtue of the reflection of their painted sides on the walls. Tomasello also worked with architects using the side walls of buildings to create geometric designs and "chromoplastic" effects similar to his easel paintings. But here he sought to complement the architecture with the texture and color reflections of his work.

An example can be found in the Edificio San Pedro in Guadalajara, Mexico, designed by Fernando González Gortázar.

46. See Gyula Kosice, *Arte hidrocinético: Movimiento, luz, agua.* He attributed his fascination with water to a near-drowning experience in his youth. Popper, *Kinetic Art,* 138.

47. Other artists to use lenses at the time included the Germans A. Luther, Karl Gerstner, and Willy Bauemeister.

48. Luciano Caramel, *Groupe de Recherche d'Art Visuel, 1960–1968 (GRAV),* 41.

49. The statements titled "Assez de mystifications" and "Transformer l'actuelle situation de l'art plastique" are published in Caramel, *Groupe de Recherche,* 23–25. The GRAV was one of several kinetic groups with similar ideological objectives in Europe. Others included Grupo T based in Milan and the Grupo N in Padua, Italy, as well as groups in Yugoslavia, Holland, Belgium, Spain, Germany, and Israel. Members of these groups exhibited with the Nouvelles Tendances, a loosely knit collective founded by Matko Mestrovic in Zagreb, Yugoslavia, where the Nouvelles Tendances held its first exhibition in 1961. Other exhibitions followed in other cities. The Nouvelles Tendances was not limited to kinetic art but included many tendencies of the 1960s. According to its founder, the group's main objective was to "operate upon the psychophysical mechanisms of perception, and not on the psychological or cultural background of the spectator." See Popper, *Kinetic Art,* 102.

50. Caramel, *Groupe de Recherche,* 23.

51. Donald Drew Egbert defines the New Left as a position whose "main strands are anarchism, socialism, especially utopian socialism, and nihilism, while also including elements of bohemianism, existentialism, humanism, transcendentalism, and even populism and black nationalism." Many radical intellectuals were drawn to the French New Left. See Egbert, *Social Radicalism and the Arts,* 359.

52. Popper, *Kinetic Art,* 183, and Caramel, *Groupe de Recherche,* 25.

53. It should be noted that during the 1960s, because of the general appeal of pop art, gallery audiences were not confined to an elite group of art lovers but included a much broader segment of society. Therefore, the GRAV artists' work reached a wide-ranging public of all ages, including children.

54. Caramel, *Groupe de Recherche,* 36.

55. Ibid., 48.

56. This period corresponded to experiments in Brazilian and Venezuelan theater in which playwrights and producers attempted to eliminate the separation between stage/actor and audience by engaging the audience in the action either by bringing the action to the audience in a theater or by initiating an event without a script at a public location such as a bus stop or on a train. See Augusto Boal, *Teatro do oprimido e outras poéticas políticas,* translated as *Theater of the Oppressed.*

57. This journal, edited by Jean Clay, includes articles on Goeritz, Kosice, and Madí; the Brazilians Hélio Oiticica and Lygia Clark; the Venezuelans Soto and Cruz-Diez; several articles on the political conceptual art that occurred in Buenos Aires, Tucumán, and Rosario (Argentina) after the military takeover of 1966; and statements and letters by, or to, Le Parc. Statements by Marx and Trotsky regarding "bourgeois institutions" that "must die" were also quoted. See *Robho* 5–6 (2d term, 1971), 19. The GRAV members, and Le Parc in particular, had high visibility in the mid-1960s, including in the Soviet Union. *Robho* published a letter addressed to Le Parc from Lev Nusberg, a Soviet artist who wrote to him from Moscow in 1967 to inform him about Dvijenie, a group in Moscow similar to the GRAV, comprising thirty members. See *Robho* 2 (spring 1968), 3.

58. Elena Bértola, *Le Parc,* 4. Ten years later, Le Parc referred to himself as "an experimental artist aware of his contradictions in a capitalist system" ("un artista experimentador consciente de sus contradicciones en una sociedad capitalista"; translation mine) in a statement he made in 1978 at the Primer Encuentro Ibero-Americano de Críticos de Arte y Artistas Plásticos in Caracas.

59. Many of these artists belonged to a generation that grew up during a time of uncertainty and postwar existentialism and shared an interest in phenomenological issues, regardless of their style and media.

60. Rafael Squirru, *Eduardo Mac Entyre,* 27.

61. Ibid., 25.

62. The idea of color and geometry as the means to a cosmic dimension in Argentine art was codified by Jorge Romero Brest in the exhibition *Beyond Geometry* in 1968 at the Instituto Torcuato di Tella (shown also at the Center for Inter-American Relations in New York). Polesello and the Generative painters were included among the exhibition's fourteen participants. The purpose of the show

was not metaphysical; rather, it aimed to demonstrate the transition these artists had made from a three- to a four-dimensional notion of time and space. See Jorge Romero Brest, *Más allá de la geometría: Extensión del lenguaje artístico-visual en nuestros días.*

63. Renzo Zorzi described the works of Otero as "scenic machines conceived for cities and contemporary architecture, entirely functional yet more than utilitarian, which seem to evoke a kind of free poetic presence in the polished panorama of the city's glass and concrete forms" (Zorzi, "Introduction," vii). Soto considered that Venezuela was "backward and had yet to build its own world" (Claude-Louis Renard, "Excerpts from an Interview with Soto," 21). One of the reasons Soto founded the Museo de Arte Moderno Jesús Soto in his hometown of Ciudad Bolívar in 1973 was to make the art of an industrialized world accessible to his fellow Bolivarians.

9. CONCRETE AND NEOCONCRETE ART AND THEIR OFFSHOOTS

1. By the 1960s, Bossa Nova, Cinema Novo, and experimental theater groups flourished until the military government imposed an oppressive new censorship system in 1968 that cracked down on the arts in general but especially on experimental theater and cinema.

2. The Argentine concrete artists exhibited as a group at the Museu de Arte Moderna in Rio in 1953, and the Argentine critic and curator Jorge Romero Brest gave a lecture there on that occasion. See *Projeto constructivo brasileiro na arte (1950–1962),* ed. Aracy A. Amaral, 21, 107, 317. Furthermore, in the late 1940s, the Brazilian poet and critic Murilo Mendes had contributed to Argentine concrete journals.

3. Brito, *Neoconcretismo,* 100, 106.

4. Mario Pedrosa, *Mundo, homen, arte em crise,* 26–27.

5. Ibid., 38.

6. Ferreira Gullar, "Arte concreta," 107.

7. The name Noigandres was inspired by an Ezra Pound Canto based on a French Provençal poem. The Brazilian poets chose it in part for its appealing sound.

8. In 1956, poets and artists exhibited together in the *First National Exhibition of Concrete Art* at the Museu de Arte Moderna in Rio de Janeiro. *Projeto construtivo,* ed. Amaral, 23.

9. Ibid., 25.

10. Ibid., 220.

11. The notion of a "sensitive" geometry to denote irregularities in its use as opposed to the mechanical appearance of its concrete manifestations in much art in Brazil and other Latin American countries led the critic Roberto Pontual to organize an exhibition titled *Geometria Sensível* at the Museum of Modern Art in Rio in 1978.

12. *Projeto construtivo,* ed. Amaral, 134.

13. The other cosigners were Franz Weissmann, Reynaldo Jardim, and Theon Spanudis. It was published in the Sunday supplement of the *Jornal do Brasil* (Rio, March 1959). For an English translation, see Dawn Ades, *Art in Latin America,* 335–337.

14. *Projeto construtivo,* ed. Amaral, 85–94. Gullar's ideas were based on the phenomenological theories of Maurice Merleau-Ponty. The latter's *The Structure of Behavior* was widely read by the neoconcrete artists, particularly Lygia Clark and Hélio Oiticica.

15. Brito, *Neoconcretismo,* 106.

16. Ibid., 110–113. See also Ferreira Gullar, "Teoria do não-objeto," 85–94.

17. Pedrosa, *Mundo,* 291.

18. José Guilherme Merquior, "A Criação do Livro da Criação," 277.

19. This notion is related to concrete poetry in the sense that reading is facilitated by recognition of the visual components in a work.

20. She actually practiced psychology and held therapeutic sessions with patients.

21. This interest was apparent in the early 1950s when she already had contact with the Institut Endoplastique in Paris and exhibited at the institute's gallery in 1952. In 1971, Clark published an essay, "Le corps est la maison: Sexualité: envahissement du 'territoire' individuel" (The body is the house: Sexuality: invasion of the individual "territory"), subtitled "L'Homme, structure vivante d'une architecture biologique et cellulaire" (Man, living structure of a biological and cellular architecture), in the Paris-based tabloid journal *Robho.*

22. Lygia Clark, *Signals Newsbulletin,* 61.

23. Ades, *Art in Latin America,* 336.

24. See Merleau-Ponty's *Phenomenology of Perception.* This aspect was also referred to in Lygia Clark, "Unité du champ perceptif," 8, and "Le corps est la maison," 12–13. Several essays on Clark's work were also published in *Robho* 4 (last term, 1968).

25. Brett, *Kinetic Art,* 62, 65.

26. Jacqueline Barnitz, "Brazil," 49.

27. She always referred to humankind in male-gendered terms. Clark, "Le corps est la maison," 12.

28. Ibid.

29. Works along these lines by Rubens Gerchman and Hélio Oiticica were reproduced in the same issue of *Robho*. The U.S. artist James Lee Byers was featured in this issue with his *Pinksilk Airplane* (1969) showing a group of people wearing a large collective expanse of fabric that gave the ensemble the appearance of a procession. *Robho* 5–6 (2d term 1971): 8–13.

30. The social and political character of Bertold Brecht's theater and the elimination of the space between actors and audience initiated by the Polish playwright Jerzy Grotowski were models for contemporary Brazilian theater. See Grotowski's *Towards a Poor Theater* (1968). Augusto Boal patterned his socially oriented theater on the latter and published his experiences in his *Teatro do oprimido e outras poéticas políticas* (1975). Not only did Boal eliminate the distance between actor and spectator, he involved the common people by approaching them in the street, at bus stops, and in trains to create impromptu performances in which they became the actors. The Brazilian educator Paulo Freire offers another parallel, as he explained in his book *Pedagogy of the Oppressed,* in which he discusses his method for educating the illiterate according to a system designed to teach them to read while simultaneously raising their sense of having control over their own lives.

31. See English translation in Ades, *Art in Latin America,* 336.

32. His father had worked for two years at the National Museum in Washington, D.C., as a Guggenheim fellow, and Oiticica lived there as a boy. He returned to the United States briefly in 1969 (with Lygia Clark to participate in the First International Tactile Sculpture Symposium in California), then moved to New York in 1970 as an exile until his return to Rio in 1978. For the most complete information on this artist, see *Hélio Oiticica,* cur. Guy Brett, Catherine David, Christ Dercon, Luciano Figueiredo, and Ligia Pape. This exhibition traveled to Rotterdam, Barcelona, Lisbon, and Minneapolis between 1992 and 1994. The catalog reproduces many of Oiticica's notes, some of which were reprinted from his posthumously published collection of writings in *Aspiro ao grande labirinto.* The catalog also contains essays by Guy Brett and Catherine David as well as a chronology.

33. See Guy Brett, "Hélio Oiticica: Reverie and Revolt," 111–121, 163–165.

34. Brett, "Reverie and Revolt," 112, 116, 163.

35. When the *Parangolés* were first presented publicly at the Museu de Arte Moderna in Rio in 1965, Oiticica's Mangueira friends were present to show them off after considerable conflicts with museum administrators over this unprecedented event.

36. Brett, "Reverie and Revolt," 116. According to Waly Salomão, Oiticica had invented a Third World art form that exalted its subjects by making something out of minimal and inexpensive materials without embellishment of misery (he avoided folkloric effects). He had liberated the "peripheral world of its inferiority complex." Quoted from *Hélio Oiticica,* cur. Brett et al., 242–243.

37. The plants used by Oiticica had specific symbolism for *candomblé* practitioners and initiates who incorporated them in their ceremonies.

38. Noted by Morais, *Artes plásticas: A crise da hora atual,* 87.

39. See Dunn, "It's Forbidden to Forbid," 14–21, 18, and Morais, *Artes plásticas,* 100.

40. The title of Veloso's song had been inspired by a slogan of the May student uprisings in Paris in 1968. See Dunn, "It's Forbidden to Forbid," 18. But it also conveys an anarchistic bent in a parallel to Oiticica's philosophy.

41. This observation was made by Regina Vater, who noted in November 1994 that in *candomblé,* the body is considered a sacred space. In countries with strong African roots, artists' attitudes toward the body are ritualistic and respectful without the guilt and penitential overtones found in body art in countries with entrenched Judeo-Christian attitudes, as was the case in Chile in the 1980s and in the United States.

42. Brett, "Reverie and Revolt," 118.

43. Dunn, "It's Forbidden to Forbid," 14, 21.

44. This information was given to the author by Oiticica during a visit to his New York studio in 1970.

45. In conversation with the artist in New York in 1970 and 1972, and with Luciano Figueiredo of the Projeto Oiticica archives (Rio de Janeiro) in Austin, 9 July 1996.

46. Morais, *Artes plásticas,* 105–106.

47. Such populism was in fact co-opted by the official media such as television. A Rio station that catered to a broad-based public and featured a host who went by the name of Chacrinha directed a free-for-all program in which everything from food to commodities was tossed into the eager audience. Chacrinha was known to regularly appear in costume, such as in a Roman toga.

48. One of the small boxes from a series Oiticica baptized "*Pocket Stuff*" was made of sky-blue translucent plastic and contained white cotton and the word "sky" imprinted inside. See *Rubens Gerchman,* ed. Silvia Roesler, unp.

49. Pedrosa, *Mundo,* 162.

50. This play was produced in São Paulo in 1967 by one of the experimental theater companies but was immediately closed by the police because it was considered subversive.

51. The Portuguese sixteenth-century sailor who discovered a route to the Indies via the Cape of Good Hope.

52. Oiticica and Meireles contributed statements about Brazil's relative geographic location to the catalog of the 1970 *Information* show at the Museum of Modern Art in New York. See Kynaston L. McShine, *Information,* unp.

53. Aracy A. Amaral, ed., *Alfredo Volpi: Pintura (1914–1972),* 10.

54. For further information on this artist, see also Alfredo Volpi, *Retrospectiva Alfredo Volpi.*

55. See Jayme Maurício, "Arte, idéias e encanto de Ione Saldanha," quoted in Marguerite Itamar Harrison, "Ione Saldanha's Sculptural Forms in the Context of Brazilian Art."

56. For a discussion and reproductions of John McCraken's work, see Robert Pincus-Witten, *Postminimalism,* 16, 38.

57. Fuad Atala, "Interview with Ione Saldanha"; quoted in Harrison, "Ione Saldanha's Sculptural Forms," 33.

58. Reproduced in Max Bill and James N. Wood, eds., *Max Bill,* 89.

59. Jacqueline Barnitz, "Five Latin American Women Artists," 38–41.

60. Rubem Valentim, *Rubem Valentim: Panorama da sua obra plástica,* unp. Salvador, Bahia, is a major center of African culture and *candomblé* practice in Brazil.

61. Brito, *Neoconcretismo,* 292.

62. See Frederico Morais, "Rubem Valentim," 145.

10. NEOFIGURATION, REPRESENTATIONAL ART, POP, AND ENVIRONMENTS

1. Neofiguration developed in the early 1960s as an expressive form that differed from earlier types of figuration. It borrowed its free play of color and brushwork from abstraction rather than figuration. In Mexico, some artists preferred the graphic media and practiced what is now referred to as neofiguration without the bright color used by artists elsewhere. José Luis Cuevas, for example, preferred ink and wash and avoided color. The term *new figuration* was used by the French writer and critic Michel Ragon in Paris in 1962. The Argentine painter Luis Felipe Noé had proposed the term *new figuration* in 1960 to define the work of the group to which he belonged. For further discussion of terminology, see note 28.

2. Although Cuevas showed stronger affinities with Orozco's figures, Shifra Goldman pointed out some resemblance between Tamayo's "grotesque and fanciful" human forms of the 1950s and Cuevas's figures. Goldman, *Contemporary Mexican Painting,* 18. Cuevas recorded his birth as 1934, whereas Shifra Goldman gives the date as 1933. The latter is the more reliable (see Goldman, *Contemporary Mexican Painting,* 105).

3. He attributed his liking for paper to having been born over a paper mill. See José Gómez-Sicre, "Introduction," in *José Luis Cuevas: Self-Portrait with Model,* 10.

4. The others were José Bartolí, Vlady, and Héctor Xavier.

5. Gómez-Sicre held that post from 1948 until his retirement in the 1980s. By the 1970s, the Museum of Modern Art of Latin America, now known as the Art Museum of the Americas, was established as an adjunct of the Pan American Union. There Gómez-Sicre was responsible for launching numerous Latin American artists for the first time in the United States.

6. Traba included Cuevas in her 1965 book, *Los cuatro monstruos cardinales,* in which he was one of the cited "monsters." The other three were Willem de Kooning, Jean Dubuffet, and Francis Bacon.

7. José Luis Cuevas, "La cortina de nopal," cultural supplement "México en la Cultura," *Novedades* (1956), reprinted as "The Cactus Curtain: An Open Letter on Conformity in Mexican Art." See Goldman, *Contemporary Mexican Painting,* 111 n. 61, 205. See also José Luis Cuevas, *Cuevas por Cuevas,* 204.

8. Cuevas described the impact Orozco's mural *Katharsis* had on him when he saw it for the first time at the Instituto Nacional de Bellas Artes. See Cuevas, *Cuevas por Cuevas,* 191.

9. His study of the insane had precedents in the French nineteenth-century painter Theodore Géricault's psychological portraits of the insane. Cuevas's, however, were not meant as psychological portraits so much as expressions of the contemporary human condition.

10. Francisco Icaza, "José Luis Cuevas pinta actualmente en el manicomio," 48–50.

11. José Luis Cuevas, *The Worlds of Kafka and Cuevas.*

12. See note 16 for the source of the name Nueva Presencia. Icaza and Belkin had visited Siqueiros in jail, where the latter was incarcerated since 1960 by the Mexican government on accusations of leftist activities in opposition to the policies of then-President Adolfo López Mateos. Siqueiros was released in 1964 after serving four years of an eight-year sentence. But although Siqueiros was an original catalyst for the new group, the younger artists soon became aware of a generation gap. Belkin, a former disciple of Siqueiros's, was the only one of the Nueva Presencia artists to continue doing murals. The others preferred to work on a small scale, as Cuevas did, producing graphics and some easel paintings. See Goldman, *Contemporary Mexican Painting,* 37–38.

13. The others included Antonio Rodríguez Luna, José Muñoz Medina, Emilio Ortiz, Artemio Sepúlveda, José Hernández Delgadillo, Benito Messeguer, and, briefly, Rafael Coronel. Other artists exhibited with the group but did not join. See Goldman, *Contemporary Mexican Painting,* 42.

14. All of these statements were published in *Nueva Presencia* (Mexico City) 1 (August 1961). See English translation by Shifra Goldman in *Contemporary Mexican Painting,* 48.

15. Besides Leonard Baskin and Rico Lebrun, artists featured in *New Images of Man* included Karel Appel, Francis Bacon, Jean Dubuffet, Willem de Kooning (who painted women in the early 1950s between two abstract phases), and Jackson Pollock (whose paintings of the early 1950s contained a residual human presence). See Peter Selz, *New Images of Man.*

16. Selden Rodman, *The Insiders: Rejection and Rediscovery of Man in the Arts of Our Time,* 4. The name Nueva Presencia (literally, "new presence") evolved from Rodman's title. The original name for this group was Interioristas (Insiders). They first exhibited under that name at the Cober Gallery in New York in 1961. Other names they proposed for their art, before they opted for Nueva Presencia, included "New Humanism" and "Neohumanism." Rodman chose the title for his book as a response to the English critic Colin Wilson's earlier book *The Outsiders,* published in 1956 about Britain's angry young men. Both writers were the products of postwar existentialism and defended the same artists, but Rodman had objected to Wilson's apparent nihilism, feeling that the artist had a responsibility to society. Of the Nueva Presencia artists, Belkin was the one to embody this idea most fully.

17. See Goldman, *Contemporary Mexican Painting,* 99.

18. This series was exhibited at the Galería Misrachi in Mexico City in 1963 as part of a portfolio of drawings, prints, and works in diverse media in subdued colors titled *War and Peace* in which other Nueva Presencia artists also participated.

19. Goldman, *Contemporary Mexican Painting,* 152.

20. Góngora left Colombia in 1952, first studying in the United States at Washington University in St. Louis, then traveling to Italy in 1959. In 1961, he went to live in Mexico for several years before moving to New York City. He later taught in Amherst, Massachusetts.

21. Goldman, *Contemporary Mexican Painting,* 151.

22. Corzas had grown up poor and had been jailed and committed to an asylum in his youth. See Goldman, *Contemporary Mexican Painting,* 121–125.

23. Gironella was half Spanish on his father's side. His interest in Spanish literature led him to write a picaresque novel, *Tiburcio Esquirla,* at the age of nineteen.

24. See Jacqueline Barnitz, *Young Mexicans,* 4.

25. Gironella was affiliated with the neosurrealist group Phases, in whose international exhibitions he participated. The group's organizer, Edouard Jaguer, wrote the first monograph on Gironella (see Jaguer, *Gironella*). Gironella's affiliation with this group gave him a wide exposure to contemporary trends, though his use of these was selective.

26. Goldman, *Contemporary Mexican Painting,* 82–83, illus. 178.

27. See Luis Felipe Noé, untitled MS of a lecture on the Otra Figuración given at the University of Texas at Austin on 4 October 1989. Author's personal archives, 13.

28. In 1960, Noé had proposed *new figuration, neoexpressionism, postinformalism,* and *new image of man* to define the expressionist figuration in Argentina (see note 1). The artists' choice of Otra Figuración as a name derived from *l'art autre,* coined in 1952 by the French critic Michel Tapié to denote an alternative to the prevailing modes, a truly "other art" that was neither abstract nor literally figurative.

29. See Noé, untitled MS, 2. *Phases* was also the name of the journal first published in Paris in January 1954. See also Agnès de Maistre, "Le Groupe Argentin Deira, Macció, Noé, De la Vega 1961–1966, ou la Figuration Eclectique," 1:51. The first issue of *Boa* corresponded to the 1958 exhibition of the Phases group in Buenos Aires. For this information, see Aldo Pellegrini, *New Tendencies in Art,* 290.

30. So named for the three European capitals—Copenhagen, Brussels, and Amsterdam—where the group's members lived. The artists included Karel Appel, Asger Jorn, Carel Henning Pederson, Jean Atlan, Corneille (Cornelis van Beverloo), Pierre Alechinsky, and several others.

31. Noé, untitled MS, 5. See also Luis Felipe Noé, *Antiestética.*

32. Guillermo E. Magrassi, *De la Vega,* 4; for an English translation of this statement, see also Alloway, "Latin America and International Art," 64–77, and Jacqueline Barnitz, "New Figuration, Pop, and Assemblage in the 1960's and 1970's," 125.

33. Magrassi, *De la Vega,* 8.

34. Luis Felipe Noé, "Solemn Letter to Myself," a statement published in the catalog of his 1966 exhibition *Luis Felipe Noé: Paintings,* at the Galería Bonino in New York, unp.

35. Mercedes Casanegra, *Jorge de la Vega,* 105–108. According to the definition given in the *New Shorter Oxford English Dictionary, anamorphosis* relates to transformation and refers to "a distorted projection or drawing of anything which appears normal when viewed from a particular point or by means of a suitable mirror." See *New Shorter Oxford English Dictionary,* ed. Lesley Brown (Oxford: Clarendon Press, 1993).

36. Casanegra, *De la Vega,* 105–108.

37. Agnès de Maistre, "Le Groupe Argentin," 2:102.

38. Casanegra, *De la Vega,* 36.

39. Alloway, "Latin America and International Art," 75.

40. The bar was named Bárbaro after a popular Argentine exclamation. In Argentina, the notion of barbarian or barbarism had roots in nineteenth-century history and literature. Civilization, symbolized by Buenos Aires and the Unitarian Party, was pitted against the barbarism symbolized by the uneducated gauchos in the interior of the country and the Federalist Party. This nineteenth-century Argentine dichotomy was immortalized in Domingo Faustino Sarmiento's *Civilización y barbarie: Vida de Juan Facundo Quiroga* of 1845. See D. F. Sarmiento, *Life in the Argentina Republic in the Days of the Tyrants; or Civilization and Barbarism.* In more recent times, the term *bárbaro* has been used as an exclamation to mean something like "okay" or "fantastic." Here Noé used the word as a pun.

41. Barnitz, "New Figuration," 126. 1966 was also the year of the military take-over in Argentina, although no specific connection has been established between these artists' shift from painting to popular media and the military government.

42. Ibid.

43. See Dore Ashton, "Jacobo Borges—Life and Work," 26.

44. Ensor's painting had made an impact on others as well, including the Nueva Presencia artist Francisco Icaza. Other Venezuelan artists to take up neofiguration include Alirio Rodríguez, who applied a type of Baconesque distortion to his figures, and Humberto Jaime Sánchez, who used elements of pop art in some of his collages—though he later changed to abstraction.

45. Barnitz, "New Figuration," 128.

46. Lawrence Alloway, *Topics in American Art since 1945,* 119–121.

47. Alloway, *Topics,* 120.

48. See Alloway, *Topics,* 121.

49. Other Argentine artists included in this exhibition were Rubén Santantonín and Zulema Ciorda. See Jorge Glusberg, *Del pop-art a la nueva imagen,* 77.

50. The poet and critic Rafael Squirru noted that Argentine artists such as Emilio Renart, Marta Minujin, Carlos Squirru, and Delia Puzzovio practiced an art of objects rather than pop art. See his "Pop Art and the Art of Things," 15–21. The Buenos Aires journal *Primera Plana* 4, no. 19 (August 1966), 23–29, featured pop-related essays and a psychological analysis of pop as well as interviews with artists Alfredo Rodríguez Arias,

Juan Stoppani, Pino Milas, Mesejian, Cancela, Giménez, Puzzovio, Squirru, and Salgado. Minujin was featured in a separate essay (see *Primera Plana, 70*).

51. Within this mutable setting, the artists lounged, dressed up in outrageous clothes and accessories such as paper-flower necklaces and a gold button for Puzzovio's exposed navel. Press coverage of their home life in the pages of fashion journals was an integral part of their work. Among the media coverage was a full spread of pictures in the interior design supplement *Claudia Decoración* (Buenos Aires; early 1970s). In a curious inversion, a number of Argentines who proclaimed themselves pop artists later abandoned art for industrial or interior design, in contrast with U.S. pop artists like Rosenquist who came from backgrounds in advertising and industrial design and later took up art. Both Giménez and Puzzovio went from art to careers in industrial or interior design.

52. "Latin Labyrinth," 90.

53. Quoted in an interview with John King. See John King, *El di Tella*, 244.

54. This information was given to the author by Minujin in an interview in New York in 1966. See also Jacqueline Barnitz, *Latin American Artists in the U.S. 1950–1970*, 30.

55. It should be noted that Richard Serra also exhibited live caged animals in a Rome gallery in 1966. See *Time* (10 June 1966), 70.

56. "Latin Labyrinth," 90. See also Barnitz, "A Latin Answer to Pop," 35–39.

57. Marshall McLuhan, *Understanding Media: The Extensions of Man* and *The Medium Is the Massage*. The latter title has often been misquoted as *The Medium Is the Message*, which was, in fact, the title of another piece by McLuhan.

58. The original was erected in 1936 to commemorate the fourth centennial of the first founding of Buenos Aires in 1536. The city was founded a second time in the 1580s after raids of Indians destroyed the first settlement.

59. Jorge Glusberg, *Los mitos y la ley de la gravedad*, unp.

60. Ibid.

61. The term *figuration*, rather than *neofiguration*, is used here to define a form of figure painting without expressionist or abstract components. For paintings without figures, the term *representational* is used.

62. This is not to say that there was not a conscious connection. Both Grau and Botero were admirers of García Márquez, and Botero acknowledged him as an inspiration. Cynthia Jaffee McCabe, among others, makes the comparison between Botero's 1973 painting *War* and García Márquez's 1975 novel *Autumn of the Patriarch*, since both are references to violence (the novel refers to *la violencia*) and the devastation it wrought from the mid-1940s through the 1950s. See Cynthia Jaffee McCabe, *Fernando Botero*, 97. But such comparisons apply only to content, which is the stuff of literature more than of the visual arts.

63. In *Guerra*, some figures lie in coffins, others are piled on top of one another amid flags, insects, skulls, and paper currency. According to McCabe, this painting was inspired by the Yom Kippur War between Israel and its Arab neighbors in 1973, but some reference is inevitably made to Colombia's past and *la violencia*. See McCabe, *Fernando Botero*, 97. See also Barnitz, "New Figuration," 130.

64. Barnitz, "New Figuration," 130.

65. In 1965, Santiago Cárdenas began teaching art at the Universidad Jorge Tadeo Lozano in Bogotá, and in 1972, he took over the direction of the School of Fine Arts of the Universidad Nacional de Bogotá.

66. Lawrence Alloway, *Realism and Latin American Painting: The 70's*, 15.

67. Quoted from artist's statement in Sheldon M. Lurie, ed., *The Art of Santiago Cárdenas*, unp.

68. Cárdenas was awarded the prize as Best Colombian Painter for this work in 1970. Lawrence Alloway was a member of the Medellín Biennial selection committee that awarded the prize. See Alloway, *Realism and Latin American Painting*, 15. See also Barnitz, "New Figuration," 131.

69. In 1980, Lawrence Alloway, noting a sizable number of artists working in some form of academic or photorealist modes in several Latin American countries, organized the exhibition *Realism and Latin American Painting: The 70's* in New York (see note 68). Of the twelve artists included in the exhibition, six were Colombian (Darío Morales, Oscar Muñoz, Ever Astudillo, Santiago Cárdenas, Gregorio Cuartas, and Saturnino Ramírez). These artists shared a form of realism that, according to Alloway's definition, preserved a "sense of fact" in contrast to other more expressive modes. See Alloway, *Realism and Latin American Painting*, 9. Eduardo Serrano attributes the rise of hyperrealism and photorealism in Colombia

to U.S. models and to a first hyperrealist exhibition in Bogotá in 1971 in which Darío Morales exhibited drawings. See Eduardo Serrano, *Cien años de arte colombiano,* 207–208.

70. Violence as an ingredient in art was acknowledged by several Colombian critics. For instance, Eduardo Serrano titled a section of his book *Cien años de arte colombiano, 1886–1986* "Sociedad, sexo y violencia." See Eduardo Serrano, *Cien años,* 149.

71. Quoted in Goldman, *Contemporary Mexican Painting,* 144, from Raquel Tibol, "Góngora: Virtuoso y disciplinado," *Excelsior* (13 August 1972), 3. The work Góngora did during his affiliation with the Nueva Presencia in Mexico contained numerous allusions to violence and hypocrisy more than to eroticism.

72. Marta Traba, *Los grabados de Roda,* 31.

73. José Hernández, *Luis Caballero: Me tocó ser así,* 33, 52.

74. This was the case when he exhibited in the hyperrealist show in Bogotá in 1971. See Serrano, *Cien años,* 9.

75. A number of artists used objects or made installations that bordered on pop. For instance, Bernardo Salcedo used fragments of dolls in unlikely combinations, sometimes placed inside boxes, or he assembled commonplace objects, as he did in his installation *Hectárea [Hectare]* for the 1972 *Second Coltejer Biennial* in Medellín that consisted of numbered bags, presumably of manure. However, Salcedo's work is as much a product of neosurrealist tendencies as of pop art and, more recently, shares affinities with conceptual art.

76. In years past, González's work was ill received and misunderstood abroad. Several catalogs of her exhibitions have recorded adverse reviews outside of Colombia, with Marta Traba as a staunch supporter coming to her defense. Traba's introduction in the catalog of her exhibition at the 1971 *Eleventh São Paulo Biennial* addresses these issues. See also Jaime Ardila, coord., *Beatriz González: Apuntes para la historia extensa,* Vol. 1, for a reprint of reviews of her work. An indication of changing sensibilities rather than of the art objects affecting the success of a work is exemplified in the positive review by Holland Cotter of her recent exhibition at the Museo del Barrio in New York City. See Holland Cotter, "A Wry Defiance behind Garish Colors and Tabloid Dramas," B28.

77. The puppet show was known as the Teatro de Cocoliche in Cali.

78. "Haciendo suya la tradición de estatuaria colonial y recogiendo todas las mejores costumbres de la artesanía en América" (statement by Miguel González in *Cali a la vanguardia*). These works were seen by the author during a studio visit in July 1974. There are numerous examples of polychrome carvings in colonial churches in which women appear decorated with fruits and flowers emerging from the wall carvings. An example is in the church of Santa Bárbara in the colonial town of Tunja near Bogotá. See illustration in Ricardo Martín, ed., *Historia del arte colombiano,* 6:1207.

11. POLITICAL ART

1. See Eva Cockcroft, "Abstract Expressionism, Weapon of the Cold War," 39–41; and Max Kozloff, "American Painting during the Cold War," 43–54. Marta Traba denounced the importation to Latin America not of U.S. art styles but of a whole way of life. See Traba, *Dos décadas vulnerables,* 15, 35, 38, and 157.

2. Brazil had been under a military government since 1964; Argentina since 1966; Uruguay and Chile since 1973. All returned to civilian rule between the mid- and late 1980s. In Chile, the presidency of the first freely elected socialist president, Salvador Allende, began in 1969 and ended in his death in the coup that brought Augusto Pinochet and his military junta to power in 1973. Pinochet remained in power until a plebiscite in 1988 led to a vote against his government.

3. The term *conceptual art* has recently been reformulated as *conceptualism* by the Uruguayan artist Luis Camnitzer to distinguish the phenomenon as it developed in the United States from that of Third World countries. He writes, "It is important to delineate a clear distinction between *conceptual art* as a term used to denote an essentially formalist practice developed in the wake of minimalism, and *conceptualism,* which broke decisively from the historical dependence of art on physical form and its visual apperception" (Camnitzer, Foreword to Luis Camnitzer, Jane Farver, and Rachel Weiss, orgs., *Global Conceptualism,* viii). Conceptual art in general refers to an art of ideas and concepts combining image with text so as to modify meaning, or it can refer to a whole installation whose components combine to convey an idea. The term *conceptual* has been variously attributed to Joseph Kosuth, the Fluxus, and

the English Art Language group led by Terry Atkinson. The origin of conceptual art as a mode was attributed to Marcel Duchamp, a pioneer in challenging the value, status, and nature of the art object. See Benjamin N. D. Buchloh, "Conceptual Art 1962–1969: From the Aesthetic of Administration to the Critique of Institutions," 105–145. Conceptual art is discussed further in the text. See note 61 for a definition of *installation*.

4. Antúnez had studied with and assisted the English printmaker Stanley William Hayter in New York and Paris in the 1940s.

5. In Puerto Rico, the Bienal de Grabado Latinoamericano de Puerto Rico (Latin American Graphics Biennial of Puerto Rico) was inaugurated in San Juan in 1970. In Colombia there were two biennials: the *Primera Bienal Americana de Artes Gráficas* (*First American Graphic Arts Biennial*) took place in 1971, and the *Exposición Panamericana de Artes Gráficas* (*Pan American Exhibition of Graphic Art*), in 1972, both in Cali. In 1984, the Cuban critic Gerardo Mosquera was instrumental in initiating the *Primera Bienal de La Habana* (*First Havana Biennial*), which featured not just prints but a broad spectrum of art modes in all media from Third World countries. As early as 1972, meetings and debates in Havana brought together critics and artists from all over Latin America. See Martín, *Historia del arte colombiano*, 7:1572.

6. These statements were made by Carlos Granada and Nirma Zárate in a signed document titled "Llamamiento a los artistas plásticos latinoamericanos" and presented at the Encuentro de la Plástica Latinoamericana held at the Casa de las Américas in Havana, Cuba, in 1972. See Germán Rubiano Caballero, "La figuración política," in *Historia del arte colombiano*, 7:1571–1572. (Translations are mine unless otherwise stated.)

It should be noted that in the 1960s and early 1970s, many artists and intellectuals had felt a sense of solidarity with Fidel Castro. They perceived in his revolution a potential solution to the problems of poverty and autonomy plaguing Latin America. Castro was particularly appealing to members of the New Left, for whom he represented a welcome substitute for the old hard-line Marxist position. Furthermore, Castro had more liberal views on art than the Soviet Union, and he imposed no formal restrictions. See Fidel Castro, "Words to the Intellectuals," 267–298; see also Luis Camnitzer, *New Art of Cuba*, 125.

7. The original edition of this two-volume book contained graphically detailed photographs of victims of violence. See Germán Guzmán Campos, Orlando Fals Borda, and Eduardo Umaña Luna, eds., *La violencia en Colombia*. For a reference to this source, see also Miguel González, *Alcántara, 1960–1980*, 4, 8.

8. This was an extremist faction that opposed the more moderate one led by President Alberto Lleras Camargo in 1958.

9. The Argentine guerrilla fighter Ernesto "Ché" Guevara was executed in Bolivia in 1967. For further information on Alcántara, see Miguel González, *Pedro Alcántara: Obras recientes*.

10. He had been awarded a travel prize by the *National Salon of Modern Art* in Rio in 1971 for this purpose.

11. See Frederico Morais, *Antonio Henrique Amaral: Caminhos de Ontem, 1957–1982*, unp.

12. Vilém Flusser, "'Battlefields' by Antonio Amaral," 8.

13. Frederico Morais, "O Corpo contra os Metais da Opressão," 35.

14. For information on this artist, see Aracy A. Amaral, "El múltiple itinerario de João Câmara," 43–46; and Frederico Morais, "João Câmara Filho: Cenas da Vida Brasileira 1930/54," unp.

15. Luis Camnitzer produced an image of a pencil bent into a similar shape in *The Instrument and Its Work* (1975).

16. See note 3 for a definition of *conceptualism*. For earlier anthologies and essays on conceptual art in general, in addition to Buchloh's essay cited above, see Ursula Meyer, ed., *Conceptual Art*; Gregory Battcock, ed., *Idea Art*; Lucy Lippard, *Six Years: The Dematerialization of the Art Object from 1966 to 1972*; and Robert C. Morgan, *Art into Ideas: Essays on Conceptual Art*. The best analysis of conceptual art that includes a discussion of Spanish and Latin American art's special issues is Simón Marchán Fiz, *Del arte objetual al arte de concepto*; see especially his chapter "Más allá de la tautología," 268–271.

17. See Janis Bergman-Carton, "The Politics of Selfhood: Latin American Women Artists in New York, 1970–Present," 35.

18. It also took the form of artists' books in which text and image function together. Two artists to direct presses for such books were the Mexican conceptualist Felipe Ehrenberg, who was associated with Fluxus—an international art movement founded in 1962 by a group of artists in western Europe and the United States—and

ran the Beau Geste Press in Devon, England, during the 1970s; and the Argentine artist and filmmaker Leandro Katz, who ran The Vanishing Rotating Triangle (TVRT) Press in New York during the same years.

19. Marchán Fiz identified three phases of conceptual art—the "tautological," "empirical medial," and "ideological"—and considered the latter phase to be the most prevalent in Latin America. However, several Brazilian artists, whose work questions logic and the laws of physics, also fall into the empirical medial category. Marchán Fiz, *Del arte objetual,* 268–271. Camnitzer's use of the term *conceptualism* would refer to ideological art.

20. Pablo Suárez, "Trois actes," 20.

21. Ibid., 19–21.

22. Lippard, *Six Years,* 8, 49. Among the numerous artists to take up an activist form of conceptual art were Margarita Paksa, José Carballa, Oscar Bony, Pablo Suárez, Roberto Jacoby, Antonio Trotta, David Lamelas, and Eduardo Ruano. See "Les Fils de Marx et Mondrian," 16.

23. "Tucumán brûle," 17.

24. The press secretary; see "Tucumán brûle," 18.

25. "Bilan, perspectives . . . ," Buenos Aires, 21 juillet 1969, *Robho,* 22.

26. Cildo Meireles, "Inserçoes em circuitos ideologicos," 15.

27. Other prominent Brazilians to take up conceptualism include Regina Vater and Roberto Evangelista.

28. Quoted in Paulo Herkenhoff, "The Theme of Crisis in Contemporary Latin American Art," 136.

29. Ernesto L. Francalanci, "A Work on Antonio Dias," unp.

30. Kosuth's "Art after Philosophy" was reprinted in the first issue of *Malasartes* from Ursula Meyer's 1970 book, *Conceptual Art.* At the time, Kosuth's stand on conceptual art was tautological. Art was self-reflexive, that is, about itself. For the critique, see Suzana Geyerhahn, "A arte dos mestres," 20–21. Translations of Allan Kaprow's "The Education of the Artist," from the February 1971 issue of *Art News,* and of the Australian critic Terry Smith's essay "The Provincialism Problem," from the September 1974 issue of *Artforum,* were also published, the first in *Malasartes's* first issue, the second in the last issue. Smith's article treated the problem of provincialism in Australia, but the Brazilians saw a parallel in their own problem.

31. The manifesto was signed by Waltercio Caldas, Carlos Vergara, Tunga, Antonio Manuel, Anna Bella Geiger, Rubens Gerchman, Ligia Pape, and Cildo Meireles, among its forty-seven contributors (see "Manifesto," 28–29). The idea of intervening in the art system was also discussed in an essay by Ronaldo Brito, who stated: "A questão não é um sintoma mas conhecer uma realidade para poder intervir nela" ("The question is not a symptom but a matter of understanding a reality in order to intervene"; Brito, "Análise do circuito," 28–29).

32. For information on this artist, see Ronaldo Brito, *Waltercio Caldas Junior "Aparelhos"* and *A natureza dos jogos: Waltercio Caldas Junior;* and Guy Brett, *Transcontinental: Nine Latin American Artists.*

33. The videotape (c. 1986) was produced by Tunga in collaboration with the filmmaker Arthur Omar and was viewed by this author at the home of Afonso Costa in Rio de Janeiro, 21 July 1992.

34. For a discussion of this artist, see Catherine de Zegher, Guy Brett, Catherine David, and Paulo Venâncio Filho, eds., *Tunga "Lezarts"/Meireles "Through,"* unp. See also Brett, *Transcontinental,* 54–55. Some of this information was also obtained from interviews with the artist on 11 July 1987 and with Afonso Costa in Rio, 21 July 1992. Since this writing, Tunga has exhibited extensively outside Brazil, and there are more recent catalogs documenting his later work.

35. Cildo Meireles, *Desvio para o vermelho: Cildo Meireles,* unp. According to the *Oxford English Dictionary, red shift* is an astronomical term describing the displacement of spectral lines, resonance peaks, etc., toward longer wavelengths or the red end of the spectrum, implying that a celestial object exhibiting this is receding. See *The New Shorter Oxford English Dictionary on Historical Principles,* ed. Leslie Brown, Vol. 2, N–Z (Oxford: Clarendon Press, 1993 ed., 2515).

36. In an interview with this author in Rio in July 1987, Meireles explained this work in more political terms than he did in later conversations in Austin and Rio in 1992.

37. In Latin America, Coca-Cola had a very different meaning than it did in the United States. As a staple of U.S. advertising and pop art, the Coca-Cola bottle and its logo was often turned into a symbol of commercial and cultural colonialism by Latin American artists. In the words of the Brazilian critic Paulo Herkenhoff, "Coca-Cola represented, like no other company, the

negative, imperialist expansion of capitalism through the spread of multinational companies in Latin American countries" (Herkenhoff, "Deconstructing the Opacities of History," 49).

38. Lawrence Weschler, "Cildo Meireles: Cries from the Wilderness," 95. See also Ronaldo Brito and Eudoro Augusto Macieira, *Cildo Meireles,* 95. The Coca-Cola Project was first described by Cildo Meireles in 1970 and published in *Malasartes* (September–November 1975), 15.

39. Currency was used by several artists in the United States, namely Rauschenberg and Warhol. For the latter, money referred to the commercial value of art as a commodity and also to its worth as subject matter artistically equivalent to soup cans or faces.

40. The work was commissioned by a Brazilian firm, LOCHPE, for an exhibition to commemorate this event. See Lu Menezes, "How to Build Troubled Skies," 40.

41. Members of Meireles's family had been active supporters of territorial rights for Indians and had worked in the Amazon. Meireles had accompanied one such expedition. See Weschler, "Cildo Meireles," 95–98.

42. Map and journey themes appeared in the work of artists from several countries— for instance, Richard Long, Agnes Denes, Jasper Johns, and Rafael Ferrer, to mention a few—in one form or another from the 1950s into the 1980s. However, among Latin Americans, map art and references to location generally referred to Latin America's subordinate cultural status in relation to the dominant northern art centers. The question of geographic location of South America originated with Joaquín Torres-García's map of the Western Hemisphere drawn upside down. Anna Bella Geiger's geographer husband also provided her with recent cartographic information.

43. Tulio Halperin Donghi, *The Contemporary History of Latin America,* 658–659.

44. See Beverly Adams, "The Subject of Torture: The Art of Camnitzer, Núñez, Parra, and Romero," 64.

45. He cofounded the New York Graphic Workshop with Liliana Porter and Guillermo Castillo.

46. See Mari Carmen Ramírez, "Moral Imperatives: Politics as Art in Luis Camnitzer," 5–6, and Madeleine Burnside, "Luis Camnitzer: Uruguayan Torture"; see also Adams, "The Subject of Torture," 67–68.

47. See Ramírez, "Moral Imperatives," 8. Camnitzer's themes find parallels in the work of the German-born artist Hans Haacke and the Chilean Alfredo Jaar.

48. Jaar was one of eight artists, including Luis Camnitzer and Jenny Holzer, to be invited in a city-funded Artists Opportunity program to do a project in Times Square. For information on Jaar, see Madeleine Grynsztejn, "Illuminating Exposures: The Art of Alfredo Jaar," 18–19, 54–55. Besides the United States, three other countries are "united states" in the Western Hemisphere: Mexico, Colombia, and Bolivia.

49. See Shifra M. Goldman, *Dimensions of the Americas,* 254. Illustrations of these events can be found in Milan Ivelic and Gaspar Galaz, *La pintura en Chile desde la colonia hasta 1981,* 365.

50. Although Siqueiros had painted a mural, *Death to the Invader* (tarred by government authorities in the 1980s), in the Escuela México in Chillán, Chile, during his political exile in 1941–1942, the BRP artists did not follow his example. They considered the Mexican muralists to be part of an establishment to which they were opposed. The Brigada Ramona Parra was one of many mural groups in the Western Hemisphere to be active between 1968 and the mid-1970s. Most major cities in the United States and Mexico had community mural workshops. The early Chicano murals were also a part of this phenomenon. For a discussion of these mural groups, see Eva Cockcroft, John Weber, and James Cockcroft, *Toward a People's Art.*

51. See Eva S. Cockcroft and James D. Cockcroft, "Murals for the People of Chile."

52. The national stadium incident, in which hundreds of dissidents were detained and tortured following the military takeover, is well known. Information on the whereabouts of brigade members during the military regime remains vague. It was believed that some of them moved to Rome, Italy, where they continued to paint political murals. The then-politicized Chilean musical group Inti-Illimani was active in Italy during those years.

53. Núñez had been kept blindfolded for five months while in custody. See *Artists in Exile,* unp.

54. Ibid. For a description of Núñez's 1975 exhibition and an account of his imprisonments, see also Soledad Bianchi, "El movimiento artístico en el conflicto político actual," quoted in Goldman, *Dimensions of the Americas,* 252.

55. Goldman gives the date of Vostell's exhibition as 1975, and Nelly Richard gives it as 1977. I have used the latter date. See Nelly Richard, *Margins and Institutions: Art in Chile since 1973,* 54. See also Goldman, *Dimensions of the Americas,* 257.

56. Ronald Christ, "Catalina Parra and the Meaning of Materials," 5.

57. Christ, "Catalina Parra," 5.

58. Mari Carmen Ramírez, "Blueprint Circuits: Conceptual Art and Politics in Latin America," 157.

59. Ibid., 158.

60. Brett, *Transcontinental,* 78–79.

61. In contrast to environments, installations by a single artist mimic the museum curator's role of hanging pictures or placing sculpture within a space. Usually an environment is set up for the viewer to walk through. An installation may or may not allow for this participation, but it invariably consists of objects the artist has arranged in a given sequence to be interpreted as a single work. This mode was adopted by many conceptualists because it allowed for the use of diverse materials within the same work and offered the possibility of multiple readings. For a discussion of installations, see Beverly Adams, "Installations," 25–33.

62. Gonzalo Díaz, unpublished statement (Austin: Archer M. Huntington Gallery archives, University of Texas), quoted in Ramírez, "Blueprint Circuits," 163.

63. Quoted in Ramírez, "Blueprint Circuits," 162.

64. Ironically, these artists were also ostracized by clandestine left-wing groups because they did not follow the conventional methods for making ideological art. They were seen by the left as using tools imported from the First World. Richard, *Margins and Institutions,* 20, 23.

65. Ibid., 72.

66. Ibid., 68.

67. Ibid., 68–69, 71, 73.

68. Goldman, *Dimensions of the Americas,* 258.

69. Ibid.

70. Richard, *Margins and Institutions,* 62 n. 7. For illustrations of these actions, see also Ivelic and Galaz, *La pintura en Chile,* foldouts 2 and 3 between pages 344 and 345.

12. SOME TRENDS OF THE 1980S

1. From the late 1970s through the 1980s, interest in a remote past was widespread among artists both within and outside Latin America. This phenomenon was addressed by Lucy Lippard in her book *Overlay* and, in a broader sense, in Miranda McClintic's essay "Content: Making Meaning and Referentiality," 25–38.

2. Lucy Lippard, *Mixed Blessings,* 86. Azaceta currently lives in New Orleans, where he moved from New York in the early 1990s. His entire formation as an artist took place outside of Cuba.

3. It should be noted that Luis Camnitzer expresses an analogous sense of displacement in his writings as well as through his conceptual works, but on a more political level by addressing questions of living as an individual from a Third World country in a capitalist and mainstream world. The problem for him is not only one of displacement but one of conflict over his ambiguous position between the mainstream, from which he borrows and within which he functions, and his desire to preserve a sense of personal and cultural independence. See Luis Camnitzer's two essays, "Access to the Mainstream" and "Wonderbread and Spanglish Art," in Jane Farver's *Luis Camnitzer: Retrospective Exhibition, 1966–1990,* 41–47.

4. This series was shown at the Museum of Contemporary Hispanic Art in New York in 1986. See Linda McGreevy, "Down in the Streets with Luis," unp.

5. Dan Cameron, "Seeing as (Dis)believing," 3. See also Brooks Adams, "Julio Galán's Hothouse Icons," 64–69.

6. As is known, Kahlo was a favorite model for Chicano artists in the United States. But she was also quoted by numerous artists in other countries such as Chile, where Juan Dávila and Roser Bru used her image or appropriated from her paintings. Dávila represented himself with some of her attributes, and Bru painted homages to Kahlo.

7. I am grateful to Eduardo Douglas for his insights and for sharing some of this information based on his interviews with Zenil in Mexico in 1994. See Eduardo de Jesús Douglas, "The Colonial Self: Homosexuality and *Mestizaje* in the Art of Nahum B. Zenil," 14–21.

8. For a discussion of this artist, see Charles Merewether, "Displacement and the Reinvention of Identity," 149. Many artists

from other countries also made their work an arena for autobiographical content but not in specifically sexual ways. The Argentine printmaker Liliana Porter plays with linguistics, metaphor, paradox, and a personal vocabulary of symbols based on Lewis Carroll's *Alice in Wonderland* and Jorge Luis Borges's short stories, with which she could personally relate. In her large canvases, she combines three-dimensional objects such as toy boats, paint brushes, and small glued-on figurines with two-dimensional painted ones and trompe-l'oeil shadows, along with photo-etchings of her own hand or of some other image. Although these references can be read in broader terms, they are also records of the artist's personal world.

9. Interview with the artist in his Rio studio on 23 July 1992. Berredo worked for four months as Keith Sonnier's assistant in New York in 1986, but this experience seems not to have affected his art very much. He was already working with rubber and latex on free-form objects before his stay in the United States. It seems more likely that Berredo chose to work with Sonnier because of their common interests. Robert Pincus-Witten discusses Sonnier and Serra in *Postminimalism*, 32–41. A work by Serra is reproduced in fig. 1, facing page 64 of that book.

10. See "Interview with Marcio Doctors," unp.

11. This information is based on an interview with the artist in São Paulo on 15 July 1992. See also Aracy A. Amaral, "Leda Catunda," 144.

12. The *Geometria Sensível* exhibition at the Museu de Arte Moderna in Rio in 1978 contributed considerably to reviving Torres-García as a pioneer and source of geometric art. For a discussion of the Torres-García legacy in the work of these artists, see also Mari Carmen Ramírez, "Re-positioning the South," 276–278.

13. See Lippard, *Overlay*, 140. The exact function of the knobs visible on fortress walls at Ollantaytambo are still a matter of debate.

14. César Paternosto, *The Stone and the Thread: Andean Roots of Abstract Art*.

15. Paternosto explains the definition of *t'oqapu* according to the chronicler Pedro de Cieza de León's description of these garments as "shirts without sleeves or collars, of the finest wool, with paintings in different manners that they called *tocapu*, which in our language means garments of the kings" (Paternosto, *The Stone and the Thread*, 166).

16. Barnitz, "Latin American Artists in New York since 1970," 13. See also Ted Castle, "Painting with the Earth," in *Miguel Angel Ríos*, unp.; and "Miguel Angel Ríos at Allen/Wincor" by the same author, 174. In addition, see *Miguel Angel Ríos: Obra reciente*.

17. Castle, "Painting with the Earth," unp. Rafael Larco Hoyle believed that the Mochica people had a form of communication based on markings on beans. For a discussion of this system, see R. Larco Hoyle, "La escritura peruana preincana," 219–238. The Inca used *quipu*, a system of colored strings with knots tied at given intervals, for keeping agricultural and population records. Throughout his book *The Stone and the Thread*, Paternosto hypothesizes—convincingly—that textile patterns and stone configurations on fortifications functioned as a means of communication.

18. In conversation with Paternosto in Austin in November 1992.

19. Here the term *Indianism* does not refer to the representation of Indians, as it did in the 1930s, but to a general interest in reviving Indian culture. I also use it to differentiate between "Indian," referring to a native of the continent, and "Indo-Americanism," which refers specifically to pre-Hispanic culture, art, and architecture.

20. The lines are from her poem "Entering," in Cecilia Vicuña, *Precario/Precarious*, unp. The comments that followed were made in New York during an interview in June 1986. See also Barnitz, "Latin American Artists," 18.

21. Barnitz, "Latin American Artists," 19. See also Ted Castle, *Leandro Katz*; and Leandro Katz, *The Judas Window*.

22. Catherwood's visits to the Yucatán and Central America in the 1840s with the North American archaeologist John L. Stephens, discussed in the Introduction, resulted in a published account of their travels. See John L. Stephens, *Incidents of Travel in the Yucatan*.

23. Leandro Katz, *The Milk of Amnesia*, unp.

24. See also Lippard, *Mixed Blessings*, 131. In a humorous vein, the Colombian painter Enrique Grau published *El pequeño viaje del Baron von Humboldt* as a travel journal in which he presents—through drawings, accompanying text, and advice to travelers—a fanciful compendium of the perils and findings of naturalist Alexander von Humboldt in the early nineteenth century. The book includes descriptions of mythical human and animal creatures, botanical draw-

ings, and warnings about the overuse of certain herbs.

25. For illustrations of these works by Frigerio, see John Beardsley and Jane Livingston, *Hispanic Art in the United States,* 48–49, 122–123. Frigerio explained the multiple meanings of the serpent in Christian and pre-Hispanic terms to Laura Hoptman in an interview published in the catalog *Presencia y Esencia: Essential Presences,* unp.

26. Venezuela (Little Venice) became a republic in 1830. Its major claim to historical fame was the birth of the liberator Simón Bolívar in that country. Prior to independence, Venezuela was a part of Gran Colombia and the Viceroyalty of New Granada. Before the mid-eighteenth century, it was largely neglected, since it held little interest for Spain. It had neither a notable colonial tradition nor a sedentary pre-Hispanic one. Some of its Indian tribes were related to those of the Caribbean and Colombia and, in the south, to those of the Amazon basin. Venezuela shared a plantation economy with Caribbean nations and Brazil and, until the twentieth century, had a high rate of illiteracy. With the economic boom resulting from its petroleum exports in the twentieth century, it rapidly developed a layer of high industrialization with next to no transition between its rural past and its highly urbanized present. See Herring, *History of Latin America,* 161, 511–514.

27. Columbus found the coast of Venezuela and the Orinoco River on his third voyage in 1498. See Herring, *History of Latin America,* 126.

28. *Carlos Zerpa India Nova,* unp.

29. In conversation with the artist in his studio in Caracas on 24 June 1987.

30. I am grateful to Cristina Rocca for sharing this information with me. She presented this material as an unpublished paper titled "Cosmovisiones y palimpsestos: Lo indígena en el arte venezolano contemporáneo" at the meeting of the 47th Congress of Americanists in July 1991 in New Orleans, 3–5.

31. Francisco Márquez, Introduction to *Miguel von Dangel: Tres aproximaciones hacia el paisaje venezolano,* unp.

32. In conversation with the artist in Caracas on 24 June 1987. It is difficult to document which of Columbus's four voyages this work relates to. Venezuela was discovered during the third voyage, and there were more than three ships on all of the expeditions. See Herring, *History of Latin America,* 126–128.

1890 Modernismo
1890–1935
J. Ruelas, *El ahorcado,* 1890

1900

1910

S. Herrán, *Nuestros Dioses,* 1918

1920 Avant-Garde
1920–1930
D. Rivera, *La Creación,* 1922–1923

Social and Indigenous Art
1925–1950

A. Reverón, *El Playón,* 1929

Week of Modern Art, São Paulo, 1922; E. Pettoruti's exhibition at Witcomb, Buenos Aires, 1924

J. Sabogal, *El alcalde indio de Chincheros: Varayoc,* 1925 *Amauta,* 1926

Surrealism
1928–1964

1930

A. de Santa María, *Bodegón con figura,* 1934

A. Pellegrini founds *Qué,* Buenos Aires, 1928
Exiles W. Paalen, L. Carrington, R. Varo to Mexico 1939–1942; Intl. Surrealist Exhib. Mexico City, 1940; R. Matta to New York 1939–1948; W. Lam to Cuba 1942–1948, paints *La jungla* 1943

Constructivism
1934–1949
(1st phase)
J. Torres-García returns to Uruguay 1934; Arg. concrete art 1944–1950

1940

1950

Displacement of Social Realism
1950

São Paulo Biennial 1951; Braz. concrete art 1951–1959 Rio Neoconcrete Manifesto 1959

Abstractionism
1950

1960

Neosurrealism
1955

Death of R. Varo 1964

Informalism
1959–c. 1974

Oiticica, *Tropicalia,* 1967

1970

Oiticica, *Newyorkaises,* 1971–1972

1980

Constructivism
1959–1980s
(2nd phase)

1990

1890

The following chronology is based on the closest approximation of when current events occurred in Latin America. Some of the later currents were ongoing in the 1990s. *Modernismo* is given a narrower span in literature (from about 1900 to 1920) than it is in art. In art, it incorporates symbolism, art nouveau, impressionism, postimpressionism, and, after the late 1920s, some elements of expressionism. It overlaps with the avant-garde of the 1920s.

1900

1910

1920

1930

Architecture
1928–1988
Le Corbusier to Rio 1929; Modernist houses in Braz. and Mex. 1929–1931

1940

O. Niemeyer, Pampulha Buildings (Belo Horiz.) 1944

1950

Ciudad Universitaria in Mex., 1951–1954; in Caracas, 1953–1957; in Brasília, 1956–1960s

Geometric, Optical, Kinetic 1955–1980
Gal.D. René, *Le Mouvement*, 1955, Paris GRAV 1960; *Une journée dans la rue*, GRAV, Paris, 1966
Generative painting, 1960s–1980

NeoFiguration 1953–1980
Cuevas's exhib. at Prisse Gal., Mexico City, 1953
Nueva Presencia, Mexico & Otra Figuración, Buenos Aires, 1961–1963; M. Minujin and others, *La menesunda,* 1964

1960

Conceptualism & Political Art 1968–c. 1980s
Buenos Aires Rosario, *Tucuman arde,* 1968
Brigada Ramona Parra, 1969–1973; W. Vostell exhib. at Gal. Epoca, Santiago, 1977; CADA, Santiago, 1979 L. Rosenfeld, *Una milla de cruces,* 1979–1984

1970

Gender, Identity, Everyday-Life Indian Themes 1977
C. Paternosto visits Inca sites, 1977; J. Galán, N. Zenil, Mex., & L. Catunda, Braz., 1980s

L. Barragán dies 1980

Erotic Figuration in Colombia, 1972–1980

Neoexpressionism 1979–1980s
Cruz Azaceta 1979–1980s

1980

1990

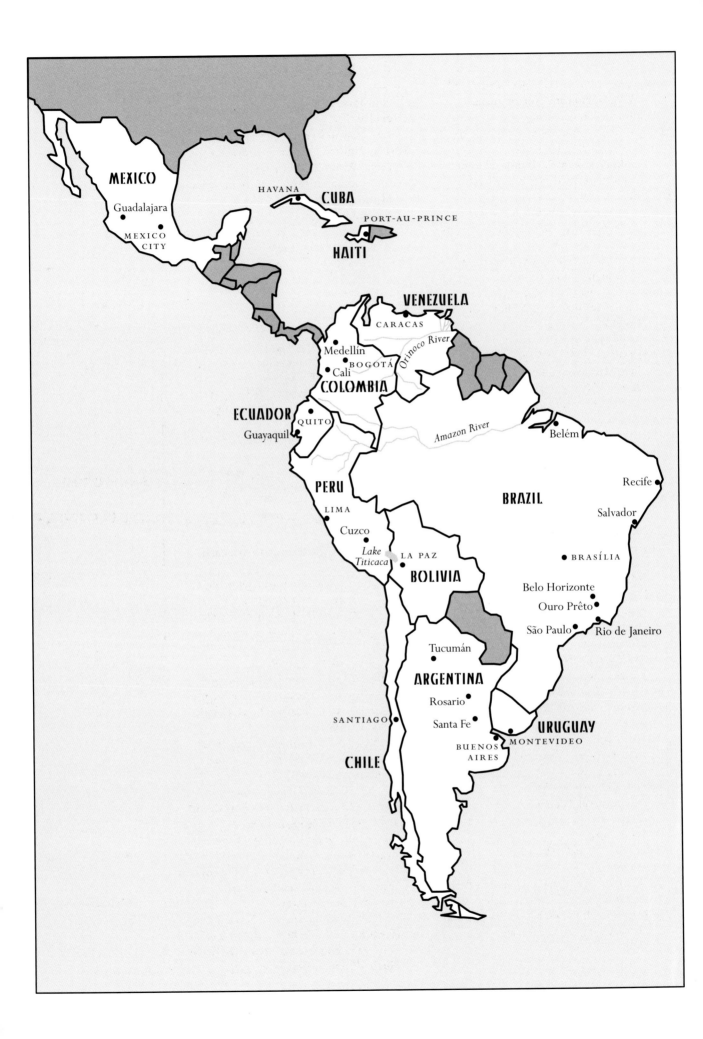

BOOKS

Abel, Lionel. *The Intellectual Follies*. New York: W. W. Norton and Norton, 1984.

Alloway, Lawrence. *Topics in American Art since 1945*. New York: W. W. Norton, 1975.

Amaral, Aracy A. *Arte y arquitectura del modernismo brasileño*. Translated from the Portuguese by Marta Traba. Caracas: Biblioteca Ayacucho, 1978.

———. *Blaise Cendrars no Brasil e os modernistas*. São Paulo: Livraria Martins Editora, 1970.

———. *Tarsila, sua obra e seu tempo*. 2 vols. São Paulo: Editora Perspectiva, 1975.

Anastasía, Luis Víctor. *Pedro Figari, americano integral*. Montevideo: Publicaciones de la Comisión Nacional del Sesquicentenario de los Hechos Históricos de 1825, 1975.

Anastasía, Luis Víctor, Angel Kalenberg, and Julio María Sanguinetti. *Figari, crónica y dibujos del Caso Almeida*. Montevideo: ACALI Editorial, 1976.

Anderson-Imbert, Enrique. *Spanish-American Literature*. Vol. 2. Detroit: Wayne State University, 1969.

Arguedas, Alcides. *Raza de bronce*. Valencia: Prometeo, 1923.

Arguedas, José María. *Yawar Fiesta*. Trans. Frances Horning Barraclough. Austin: University of Texas Press, 1985.

Argul, José Pedro. *Pintura y escultura del Uruguay*. Montevideo: Instituto Histórico y Geográfico del Uruguay, 1958.

Ashton, Dore. *Jacobo Borges*. Translated into Spanish by Esdras Parra. Caracas: Ernesto Armitano, 1982.

Atl, Dr. (Gerardo Murillo). *Las artes populares en México*. 2 vols. Mexico City: Editorial Cultura, 1922.

———. *¿Cómo nace y crece un volcán? El Paricutín*. Mexico City: Editorial Stylo, 1950.

Baciü, Stefan. *Antología de la poesía surrealista latinoamericana*. Mexico City: Joaquín Mortiz, 1974.

Baddeley, Oriana, and Valerie Fraser. *Drawing the Line: Art and Cultural Identity in Contemporary Latin America*. London; New York: Verso, 1989.

Balza, José. *Alejandro Otero*. Milan: Olivetti, 1977.

Bardi, Pietro Maria. *Profile of the New Brazilian Art*. Translated from the Italian by John Drummond. Rio de Janeiro/São Paulo/Porto Alegre: Livraria Kosmos Editora, 1970.

Battcock, Gregory, ed. *Idea Art*. New York: E. P. Dutton, 1973.

———, ed. *Minimal Art: A Critical Anthology*. New York: E. P. Dutton, 1968.

Baxandall, Lee, ed. *Radical Perspectives in the Arts*. New York: E. P. Dutton, 1968.

Bayón, Damián. *Arte moderno de América Latina*. Madrid: Taurus, 1985.

———. *Aventura plástica de Hispanoamérica*. Mexico City: Fondo de Cultura Económica, 1974.

Bértola, Elena. *Le Parc*. Buenos Aires: Centro Editor de América Latina, 1981.

Best-Maugard, Adolfo. *Método de dibujo*. Mexico City: Secretaría de Educación Pública, 1923.

Boal, Augusto. *Teatro do oprimido e outras poéticas políticas*. Rio de Janeiro: Editora Civilização Brasileira, 1975.

Borda, Arturo. *El loco*. 3 vols. La Paz: Municipalidad de La Paz, 1966.

Borges, Jorge Luis. *El idioma de los argentinos (Vinetas de A. Xul-Solar)*. Buenos Aires: M. Gleizer, 1928.

———. *Luna de enfrente*. Buenos Aires: Proa, 1925.

Boulton, Alfredo. *Historia de la pintura en Venezuela*. Vol. 3. Caracas: Ernesto Armitano, 1972.

———. *La obra de Armando Reverón*. Caracas: Editorial Arte, 1966.

———. *Soto*. Caracas: Ernesto Armitano, 1973.

Breton, André. *Surrealism and Painting*. New York: Harper and Row, 1972.

Brett, Guy. *Kinetic Art*. London: Studio Vista; New York: Reinhold Book Corporation, 1968.

Brett, Guy, Sean Cubitt, and Eugenio Dittborn, eds. *Camino Way: Las pinturas aeropostales—The Airmail Paintings de/of Eugenio Dittborn*. Santiago: Brett, Cubitt, Dittborn, 1991.

Breunig, Le Roy C. *Apollinaire on Art*. Trans. Susan Suleiman. New York: The Viking Press, 1972.

Brito, María Eugenia, Gonzalo Muñoz, Diamela Eltit, Nelly Richard, Raul Zurita, and Francisco Zegers, eds. *Desacato sobre la obra de Lotti Rosenfeld*. Santiago: Francisco Zegers Editor, 1986.

Brito, Ronaldo. *Neoconcretismo, vertice e ruptura do projeto construtivo brasileiro*. Rio de Janeiro: Edição Funarte, 1985.

———. *Waltercio Caldas Junior "Aparelhos"* (Portuguese and English). English translation by Florence Eleanor Irvin. São Paulo: Museu de Arte de São Paulo, 1975.

Brughetti, Romualdo. *Historia del arte en la Argentina*. Mexico City: Editorial Pormaca, 1965.

Buntinx, Gustavo, and Luis Eduardo Wuffarden, eds. *Mario Urteaga, 1875–1947: Catálogo razonado*. Trujillo: Comité Organizador de la 3ra Bienal, 1987.

Calles, Sylvia, ed. and trans. *Art and Revolution*. London: Lawrence and Wishart, 1975.

Camnitzer, Luis. *New Art of Cuba*. Austin, University of Texas Press, 1994.

Camón Aznar, José. *Guayasamín*. Barcelona: Ediciones Polígrafa, 1974.

Carrington, Leonora. *The Oval Lady*. Trans. Rochelle Holt, foreword by Gloria Orenstein. Santa Barbara: Capra Press, 1975.

Casanegra, Mercedes. *Jorge de la Vega*. Buenos Aires: S. A. Alba, 1990.

Castedo, Leopoldo. *Historia del arte iberoamericano*. 2 vols. Madrid: Alianza Editorial, c. 1988.

———. *A History of Latin American Art and Architecture*. New York: Frederick A. Praeger, 1969.

Cetto, Max. *Modern Architecture in Mexico*. New York: Frederick A. Praeger, 1961.

Charlot, Jean. *Mexican Art and the Academy of San Carlos, 1785–1915*. Austin: University of Texas Press, 1962.

———. *The Mexican Mural Renaissance, 1920–1925*. New Haven: Yale University Press, 1967.

Chase, Gilbert. *Contemporary Art in Latin America*. New York: Free Press, 1970.

Chiabra Acosta, Alfredo (Atalaya). *Críticas del arte argentino, 1920–1932*. Buenos Aires: M. Gleizer, 1934.

Chierico, Osiris. *Reportaje a una anticipación*. Buenos Aires: Ediciones Taller Libre, 1979.

Choay, Françoise. *Le Corbusier*. New York: George Braziller, 1960.

Cockcroft, Eva, John Weber, and James Cockcroft. *Toward a People's Art: The Contemporary Mural Movement*. New York: E. P. Dutton, 1977.

Conde, Teresa del. *Julio Ruelas*. Mexico City: Universidad Nacional Autónoma de México, 1976.

Córdova Iturburu, Cayetano. *La Revolución Martínfierrista*. Buenos Aires: Ediciones Culturales Argentinas, 1962.

Cuevas, José Luis. *Cuevas por Cuevas*. Intro. Juan García Ponce, translated into English by Ralph Dimmick, Lysander Kemp, and Asa Zats. Mexico City: Ediciones Era, 1965.

Cuevas, José Luis. *The World of Kafka and Cuevas*. Philadelphia: Falcon Press, 1959.

Damaz, Paul. *Art in Latin American Architecture*. Preface by Oscar Niemeyer. New York: Reinhold Publishing Corp., 1963.

Egbert, Donald Drew. *Social Radicalism and the Arts*. New York: Alfred A. Knopf, 1970.

Estrada, Emilio. *Arte aborigen del Ecuador, sellos o pintaderas*. 2d ed. Guayaquil: Separata de la *Revista Humanitas* de la Universidad Central, 1959.

Evenson, Norma. *Two Brazilian Capitals*. New Haven: Yale University Press, 1973.

Faber, Colin. *Candela, the Shell Builder*. New York: Reinhold Publishing Corp., 1963.

Fabris, Annateresa. *Portinari, pintor social*. São Paulo: Editora da Universidade de São Paulo, 1990.

Fanon, Franz. *Black Skin, White Masks*. Translated from the French by Charles Lam Markmann. New York: Grove Press, 1967.

Fernández, Justino. *El arte del siglo XIX en México*. Mexico City: Imprenta Universitaria, 1967.

Ferraz, Geraldo. *Warchavchik*. São Paulo: Museu de Arte de São Paulo, 1965.

Figari, Pedro. *Arte, estética, ideal: Ensayo filosófico encarado de un nuevo punto de vista*. Montevideo: Juan J. Dornaleche, 1912.

Flocon, Albert, and André Barre. *Curvilinear Perspective: From Visual Space to the Constructed Image*. Trans. Robert Hansen. Berkeley: University of California Press, 1987. Originally published in French as *La Perspective curviligne* (Paris: Flammarion, 1967).

Fouchet, Max Pol. *Wifredo Lam*. New York: Rizzoli, 1976.

Franco, Jean. *The Modern Culture of Latin America*. Rev. ed. Middlesex, England: Penguin Books, 1970.

Freire, Paulo. *Pedagogy of the Oppressed*. Trans. Mira Bergman Ramos. New York: Herder and Herder, 1970. Originally published in 1968.

Freyre, Gilberto. *Manifesto regionalista*. 4th ed. Recife: Instituto Joaquim Nabuco de Pesquisas Sociais, 1967.

Gerchman, Rubens. *Gerchman*. Edited by Marcos da Veiga Pereira, text by Wilson Coutinho, English translation by Teresa da Costa. Rio de Janeiro: Salamandra Consultoria Editorial, 1989.

Girondo, Oliverio. *Interlunio*. Buenos Aires: Sur, 1937.

Glusberg, Jorge. *Del pop-art a la nueva imagen*. Buenos Aires: Ediciones de Arte Gaglianone, 1985.

Goldman, Shifra. *Contemporary Mexican Painting in a Time of Change.* Austin: University of Texas Press, 1981.

————. *Dimensions of the Americas.* Chicago: University of Chicago Press, 1994.

Gómez-Sicre, José. *José Luis Cuevas: Self-Portrait with Model.* New York: Rizzoli, 1983.

————. *Mario Carreño.* Contemporary Artists of Latin America Series. Washington, D.C.: Pan American Union, 1947.

————. *Pintura cubana de hoy.* Havana: María Luisa Gómez Mena, 1944.

González, Miguel. *Pedro Alcántara: Obras recientes.* Cali, Col.: Corporación Poligráfica, 1983.

González Matute, Laura. *Escuelas de pintura al aire libre y centros populares de pintura.* Mexico City: Instituto Nacional de Bellas Artes, 1987.

Gradowczyk, Mario H. *Alejandro Xul Solar.* Buenos Aires: Ediciones ALBA, Fundación Bunge y Born, 1994.

Grau, Enrique. *El pequeño viaje del Baron von Humboldt.* Caracas: Litografía Arco, 1977.

Grotowski, Jerzy. *Towards a Poor Theater.* Preface by Peter Brook. New York: Simon and Schuster, 1968.

Guzmán Campos, Germán, Orlando Fals Borda, and Eduardo Umaña Luna, eds. *La violencia en Colombia.* Bogotá: Ediciones Tercer Mundo; Vol. 1, 1963; Vol. 2, 1964.

Halperin Donghi, Tulio. *The Contemporary History of Latin America.* Ed. and trans. John Charles Chasteen. Durham: Duke University Press, 1993. Originally published as *Historia contemporánea de América Latina* (Madrid: Alianza Editorial, 1972).

Herner de Larrea, Irene, ed. *Diego Rivera: Paradise Lost at Rockefeller Center.* Mexico City: Ediciupes, 1986.

Herrera, Hayden. *Frida: A Biography of Frida Kahlo.* New York: Harper and Row, 1983.

Herrera y Reissig. *La torre de las esfinges.* Montevideo [?]: N.p., 1909.

Herring, Hubert. *A History of Latin America.* 3rd ed. New York: Alfred A. Knopf, 1968.

Hoptman, Laura. *Presencia y esencia: Essential Presences.* Caracas: Galería Bass, 1991.

Hurlburt, Laurance P. *The Mexican Muralists in the United States.* Albuquerque: University of New Mexico Press, 1989.

Instituto Jalisciense de Bellas Artes. *Homenaje del pueblo y del gobierno de Jalisco al pintor Gerardo Murillo, "Dr. Atl", en el primer aniversario de su fallecimiento.* Guadalajara: Gobierno del Estado de Jalisco, 1965.

Ivelic, Milan, and Galaz, Gaspar. *La pintura en Chile desde la colonia hasta 1981.* Valparaíso: Universidad Católica de Valparaíso, 1981.

Jaffe, Hans L. C. *De Stijl, 1917–1931.* Cambridge: Harvard University Press, 1986.

Jaguer, Edouard. *Gironella.* English translation by Asa Zats. Mexico City: Ediciones Era, 1964.

Kaplan, Janet A. *Unexpected Journeys: The Art and Life of Remedios Varo.* New York: Abbeville Press, 1988.

Katz, Leandro. *The Milk of Amnesia.* Buffalo, N.Y.: CEPA, 1985.

Kent, Rockwell. *Portinari: His Life and Art.* Chicago: University of Chicago Press, 1940.

King, John. *El di Tella.* Buenos Aires: Ediciones de Arte Gaglianone, 1985.

Kosice, Gyula. *Arte hidrocinético: Movimiento, luz, agua.* Buenos Aires: Paidós, 1968.

Lauer, Mirko. *Introducción a la pintura peruana del siglo XX.* Lima: Mosca Azul Editores, 1976.

Lauer, Mirko, Javier Sologuren, and Emilio A. Westphalen, eds. and contribs. *Szyszlo: Indagación y collage.* Lima: Mosca Azul Editores, 1975.

Lerebours, Michel Philippe. *Haïti et ses peintres.* 2 vols. Port-au-Prince: L'Imprimeur II, 1989.

Lévi-Strauss, Claude. *Tristes Tropiques.* Trans. John Russell. New York: Atheneum, 1968.

Lindinger, Herbert, ed. *Ulm Design.* Trans. David Brit. Cambridge: MIT Press, 1991.

Lindstrom, Naomi. *Twentieth-Century Spanish-American Fiction.* Austin: University of Texas Press, 1994.

Lippard, Lucy. *Mixed Blessings.* New York: Pantheon Books, 1990.

————. *Overlay.* New York: Pantheon Books, 1983.

————. *Six Years: The Dematerialization of the Art Object from 1966 to 1972.* New York: Praeger Publishers, 1973.

Lucie-Smith, Edward. *Latin American Art of the Twentieth Century.* London; New York: Thames and Hudson, 1993.

Lugones, Leopoldo. *Lunario sentimental.* 2d ed. Buenos Aires: M. Gleizer, 1926.

Luna Arroyo, Antonio. *Juan O'Gorman: Autobiografía, comentarios, juicios críticos, documentación exhaustiva.* Mexico City: Cuadernos Populares de Pintura Mexicana Moderna, 1973.

Magrassi, Guillermo E. *De la Vega.* Buenos Aires: Centro Editor de América Latina, 1981.

Marchán Fiz, Simón. *Del arte objetual al arte de concepto.* 3rd ed. Madrid: Ediciones Akal, 1988.

Mariátegui, José Carlos. *Peruanicemos el Perú.* Lima: Siglo XXI, Ediciones S.A., 1984.

———. *La polémica del indigenismo.* Ed. Manuel Quézolo Castro, intro. Luis Alberto Sánchez. Lima: Mosca Azul Editores, 1976.

Martín, Ricardo, ed. *Historia del arte colombiano.* Vols. 5–7. Bogotá: Salvat Editores Colombiana, 1977.

Martínez, Juan A. *Cuban Art and National Identity: The Vanguardia Painters, 1927–1950.* Gainesville: University Press of Florida, 1994.

Mathieu, Georges. *De la révolte a la renaissance: Au-delá du Tachisme.* Paris: Gallimard, 1972.

McCabe, Cynthia Jaffee. *Fernando Botero.* Washington, D.C.: Smithsonian Institution Press, 1979.

McLuhan, Marshall. *The Medium Is the Massage.* New York, London, Toronto: Bantam Books, 1967.

———. *Understanding Media: The Extensions of Man.* New York, London, Sydney, Toronto: McGraw-Hill, 1965.

McMeekin, Dorothy. *Diego Rivera: Science and Creativity in the Detroit Murals.* East Lansing: The Michigan State University Press, 1985.

Meireles, Cildo. *Desvio para o vermelho: Cildo Meireles.* Intro. Aracy Amaral. São Paulo: Museu de Arte Contemporânea da Universidade de São Paulo, 1986.

Merleau-Ponty, Maurice. *The Structure of Behavior.* Trans. Alden I. Fisher. Boston: Beacon Press, 1963.

———. *Phenomenology of Perception.* Trans. Colin Smith. London and New York: Humanities Press, 1962.

Meyer, Ursula, ed. *Conceptual Art.* New York: E. P. Dutton, 1972.

Moholy-Nagy, Sibyl. *Carlos Raúl Villanueva.* Stuttgart: Verlag Gerd Hatje, 1964.

Morais, Frederico. *Artes plásticas: A crise da hora atual.* Rio de Janeiro: Editora Paz e Terra, 1975.

Morgan, Robert C. *Art into Ideas: Essays on Conceptual Art.* New York: Cambridge University Press, 1996.

Moro, César. *Anteojos de azufre.* Lima: Ediciones Torre Aguirre, 1956.

Mosquera, Gerardo, ed. *Beyond the Fantastic: Contemporary Art Criticism from Latin America.* Cambridge: MIT Press, 1996.

Murillo, Gerardo. *See Atl, Dr.*

Noé, Luis Felipe. *Antiestética.* 2d ed. Buenos Aires: Ediciones La Flor, 1988.

Oiticica, Hélio. *Aspiro ao grande labirinto.* Rio de Janeiro: Editora Rocco, 1986.

Oliver, Samuel. *Figari.* Buenos Aires: Ediciones de Arte Gaglianone, 1984.

Orozco, José Clemente. *An Autobiography.* Trans. Robert C. Stephenson. Austin: University of Texas Press, 1962.

Ortega Ricaurte, Carmen. *Diccionario de artistas en Colombia.* Bogotá: Ediciones Tercer Mundo, 1965.

Pallister, Janis L. *Aimé Césaire.* New York: Twayne Publishers, 1991.

Papadaki, Stamo. *Oscar Niemeyer.* New York: George Braziller, 1960.

Paternosto, César. *Piedra abstracta: La escultura inca, una visión contemporánea.* Mexico City: Fondo de Cultura Económica, 1989.

———. *The Stone and the Thread: Andean Roots of Abstract Art.* Trans. Esther Allen. Austin: University of Texas Press, 1996.

Pedrosa, Mario. *Mundo, homen, arte em crise.* São Paulo: Editora Perspectiva, 1975.

Pellegrini, Aldo. *New Tendencies in Art.* Trans. from the Spanish by Robin Carson. New York: Crown Publishers, 1966.

Perazzo, Nelly. *El arte concreto en la Argentina.* Trans. María Herminia Alonso. Buenos Aires: Ediciones de Arte Gaglianone, 1983.

Péret, Benjamin. *Air Mexicain.* Paris: Librairie Arcanes, 1952.

Pérez, Elizardo. *Warisata, la escuela-ayllu.* La Paz: Impresa Industrial Gráfica E. Burillo, 1963.

Pettoruti, Emilio. *Un pintor ante el espejo.* Buenos Aires: Solar/Hachette, 1968.

Pincus-Witten, Robert. *Postminimalism.* New York: Out of London Press, 1977.

Popper, Frank. *Origins and Development of Kinetic Art.* Greenwich: New York Graphic Society, 1968.

Querejazú, Pedro, and Fernando Romero. *Pintura boliviana del siglo XX.* La Paz: Ediciones "INBO," 1989.

Ramírez, Fausto. *Saturnino Herrán.* Mexico City: Universidad Nacional Autónoma de México, 1976.

Regler, Gustav. *Wolfgang Paalen.* New York: Nierendorf Editions, 1946.

Reich, Wilhelm. *Selected Writings: An Introduction to Orgonomy.* New York: Farrar, Straus and Giroux, 1973.

Richard, Nelly, ed. *Margins and Institutions: Art in Chile since 1973.* Preface by Juan Dávila and Paul Foss. Victoria, Australia: *Art and Text* 21 (May/July 1986). Special issue.

Rivera, Diego, and Bertram Wolfe, eds. *Portrait of America*. New York: Covici-Friede, 1934.

—————. *Portrait of Mexico*. New York: Covici-Friede, 1937.

Rivero, Mario. *Rayo*. Bogotá: Italgraf, 1975.

Rodman, Selden. *The Miracle of Haitian Art*. New York: Doubleday, 1965.

—————. *Mexican Journal: The Conquerors Conquered*. Carbondale: Southern Illinois University Press, 1965.

—————. *The Insiders: Rejection and Rediscovery of Man in the Arts of Our Time*. Baton Rouge: Louisiana State University Press, 1960.

Rodríguez-Prampolini, Ida. *El surrealismo y el arte fantástico de México*. Mexico City: IIE / Universidad Nacional Autónoma de México, 1969.

—————. *Juan O'Gorman, arquitecto y pintor*. Mexico City: Universidad Nacional Autónoma de México, 1982.

Romera, Antonio R. *Historia de la pintura chilena*. Santiago: Editorial del Pacífico, 1951.

Rossetti Batista, Marta. *Anita Malfatti no tempo e no espaço*. São Paulo: IBM, 1985.

Sabogal Diéguez, José. *Obras literarias completas*. Lima: Ignacio Prada P., 1989.

—————. *Mates burilados: Arte vernacular peruano*. Buenos Aires: Editorial Nova, 1945.

Salas Anzures, Miguel. *Textos y testimonios*. Collected by Myra Landau de Salas Anzures and Jorge Olvera. Mexico City: Imprenta Madero, 1968.

Salazar Mostajo, Carlos. *La pintura contemporánea de Bolivia*. La Paz: Librería Editorial "Juventud," 1989.

—————. *Warisata, historia en imágenes*. La Paz: Ediciones Gráficas, 1991.

Salcedo Hierro, Miguel. *El Museo Julio Romero de Torres*. León, Spain: Editorial Everest, 1973.

Sarmiento, Domingo Faustino. *Life in the Argentine Republic in the Days of the Tyrants; or Civilization and Barbarism*. New York: Hafner Publishing Co., 1971. Originally published in 1868.

Serrano, Eduardo. *Cien años de arte colombiano, 1886–1986*. Bogotá: Museo de Arte Moderno, 1985.

Serrano, Luis G. *Una nueva perspectiva, la perspectiva curvilínea*. Mexico City: Editorial Cultura, 1934.

Soffici, Ardengo. *Cubismo e Oltre*. Florence: *La Voce*, 1913. Republished in enlarged edition as *Cubismo e Futurismo* (Florence: *La Voce*, 1914).

Squirru, Rafael. *Eduardo Mac Entyre*. Buenos Aires: Ediciones de Arte Gaglianone, 1981.

Stephens, John L. *Incidents of Travel in the Yucatan*. 2 vols. Illustrated by Frederick Catherwood. Reprint. New York: Dover Publications, 1963. Originally published by Harper and Brothers, New York, 1843.

Suárez, Orlando S. *Inventario del muralismo mexicano*. Mexico City: Universidad Nacional Autónoma de México, 1972.

Sulic, Susana. *Batlle-Planas*. Buenos Aires: Centro Editor de América Latina, 1980.

Sullivan, Edward J., et al., eds. *Latin American Art in the Twentieth Century*. London: Phaidon, 1996.

Taquini, Graciela. *Guillermo Butler*. Buenos Aires: Centro Editor de América Latina, 1980.

Tibol, Raquel. *Fernando González Gortázar*. Mexico City: Universidad Nacional Autónoma de México, 1977.

—————. *Un mexicano y su obra: David Alfaro Siqueiros*. Mexico City: Empresas Editoriales, 1969.

—————. *Siqueiros: Vida y obra*. Mexico City: Colección Metropolitana, 1973.

Torres-García, Joaquín. *Universalismo constructivo*. Reprint. Madrid: Alianza Editorial, 1984. Originally published in Buenos Aires: Editorial Poseidon, 1944.

—————. *La recuperación del objeto: Lecciones sobre plástica*. Montevideo: Asociación de Arte Constructivo Taller Torres-García, 1948.

Traba, Marta. *Art of Latin America, 1900–1980*. Baltimore: Johns Hopkins University Press, 1994.

—————. *Los cuatro monstruos cardinales*. Mexico City: Ediciones Era, 1965.

—————. *Dos décadas vulnerables en las artes plásticas latinoamericanas, 1950–1970*. Mexico City: Siglo XXI, 1973.

—————. *Los grabados de Roda*. Bogotá: Museo de Arte Moderno, 1977.

—————. *Historia abierta del arte colombiano*. Cali, Col.: Museo de Arte Moderno La Tertulia, 1974.

Ugarte-Elespuru, Juan Manuel. *Pintura y escultura en el Perú contemporáneo*. Lima: Ediciones de Difusión del Arte Peruano, 1970.

Valladares, Clarival do Prado. *Di Cavalcanti*. Buenos Aires: Editorial Codex, 1966.

Vasconcelos, José. *Obras completas*. 4 vols. Mexico City: Libreros Mexicanos Unidos, 1958.

Vicuña, Cecilia. *Precario / Precarious*. New York: Tanam Press, 1983.

Villarroel Claure, Rigoberto. *Arte contemporáneo: Pintores, escultores y grabadores bolivianos.* La Paz: Privately printed, 1958.

Weiss, Rachel, and Alan West, eds. *Being América: Essays on Art, Literature, and Identity from Latin America.* Fredonia, N.Y.: White Pine Press, 1991.

Whitelow, Guillermo. *Obras de Juan Batlle-Planas.* Buenos Aires: Ediciones Ruth Benzacar, 1981.

―――. *Raquel Forner.* Buenos Aires: Ediciones de Arte Gaglianone, 1980.

Widdifield, Stacie G. *The Embodiment of the National.* Tucson: University of Arizona Press, 1996.

Wiesse, María. *José Sabogal, el artista y el hombre.* Lima: Cia. de Impresiones y Publicidad, 1957.

Wolfe, Bertram. *The Fabulous Life of Diego Rivera.* New York: Stein and Day, 1969.

Zaniah. *Diccionario esotérico.* Buenos Aires: Editorial Kier, 1979.

Zeballos, Andrés. *Tres pintores cajamarqueños: Mario Urteaga, José Sabogal, Camilo Blas.* Cajamarca: Asociación Editora Cajamarca, 1991.

Zúñiga, Olivia. *Mathias Goeritz.* Mexico City: Editorial Intercontinental, 1963.

EXHIBITION CATALOGS

Ades, Dawn. *Art in Latin America.* London: Hayward Gallery, 1989.

Alejandro Obregón. New York: Center for Inter-American Relations, 1970.

Alloway, Lawrence. *Realism and Latin American Painting: The 70's.* New York: Center for Inter-American Relations, 1980.

Amaral, Aracy A. *Modernidade: Arte brasileira do século XX.* Paris: Musée d'Art Moderne de la Ville de Paris, 1987; São Paulo: Museu de Arte Moderna de São Paulo, 1988.

―――, ed. *Alfredo Volpi: Pintura (1914–1972).* Rio de Janeiro: Museu de Arte Moderna, 1972.

―――, ed. *Projeto construtivo brasileiro na arte, 1950–1962.* Rio de Janeiro: Museu de Arte Moderna, and São Paulo: Pinacoteca de São Paulo, 1977.

Arcangeli, Francesco. *Matta, mostra antologica.* Bologna: Museo Civico, 1963.

Ardila, Jaime, coord. *Beatriz González: Apuntes para la historia extensa.* Vol. 1. Bogotá: Ediciones Tercer Mundo, 1974.

Artists in Exile. Boston: The Boston Visual Arts Union, 1977.

Barnitz, Jacqueline. *Abstract Currents in Ecuadorian Art.* Ed. Phyllis Freeman. New York: Center for Inter-American Relations, 1977.

―――. *Latin American Artists in New York since 1970.* With essays by Janis Bergman-Carton and Florencia Bazzano Nelson. Austin: Archer M. Huntington Art Gallery, The University of Texas, 1987.

―――. *Latin American Artists in the U.S. before 1950.* Flushing, N.Y.: The Godwin-Ternbach Museum at Queens College, 1981.

―――. *Latin American Artists in the U.S. 1950–1970.* Flushing, N.Y.: The Godwin-Ternbach Museum at Queens College, 1983.

―――. *Young Mexicans.* New York: Center for Inter-American Relations, 1971.

Batista, Alicia, Orlando Britto, Orlando Franco, Gilma Miguel, and Luis Sosa, coords. *El surrealismo entre Viejo y Nuevo Mundo.* Las Palmas, Grand Canary: Centro Atlántico de Arte Moderno, 1980–1990.

Beardsley, John, and Jane Livingston, eds. *Hispanic Art in the United States: Thirty Contemporary Painters and Sculptors.* Houston: Museum of Fine Arts, 1986.

Bill, Max, and James N. Wood. *Max Bill.* With essays by Lawrence Alloway and James N. Wood. Buffalo, N.Y.: The Buffalo Fine Arts Academy and the Albright-Knox Art Gallery, 1974.

Black and White Show. Boston: Eleanor Riguelhaup Gallery, 1965.

Breton, André, Wolfgang Paalen, and César Moro. *Exposición Internacional del Surrealismo.* Mexico City: Galería de Arte Mexicano, 1940.

Brett, Guy. *Transcontinental: Nine Latin American Artists.* London: Verso, in association with Ikon Gallery, 1990.

Brett, Guy, Catherine David, Christ Dercon, Luciano Figueiredo, and Ligia Pape, curators. *Hélio Oiticica.* Paris: Galerie National du Jeu de Paume, 1992.

Brinton, Christian. *Cesáreo Bernaldo de Quirós.* New York: The Hispanic Society of America, 1932.

Brito, Ronaldo. *A natureza dos jogos: Waltercio Caldas Junior.* São Paulo: Museu de Arte de São Paulo, 1975.

Brito, Ronaldo, and Eudoro Augusto Macieira de Sousa, eds. *Cildo Meireles.* Rio de Janeiro: Edição Funarte, 1981.

Cali a la vanguardia. Cali: Museo de Arte Moderno La Tertulia, 1974.

Camnitzer, Luis. *Uruguayan Torture.* New York: Alternative Museum, 1984.

Camnitzer, Luis, Jane Farver, and Rachel Weiss, organizers. *Global Conceptualism: Points of Origin, 1950s–1980s.* New York: Queens Museum of Art, 1999.

Cancel, Luis R. *The Latin American Spirit: Art and Artists in the United States, 1920–1970.* With essays by Jacinto Quirarte, Marimar Benítez, Nelly Perazzo, Lowery S. Sims, Eva Cockcroft, Félix Angel, and Carla Stellweg. New York: The Bronx Museum of the Arts, 1988.

Caramel, Luciano. *Groupe de Recherche d'Art Visuel, 1960–1968 (GRAV).* Mostra retrospettiva. Lago de Como. Milan: Electa Editrice, 1975.

Carbonell, Galaor. *Negret: Las etapas creativas.* Medellín, Col.: Fondo Cultural Cafetero, 1976.

Carbonell, Galaor, Dicken Castro Duque, Bernardo Caíz de Castro, and Inés Torres de Quintero, organizers. *Omar Rayo: Exposición Retrospectiva, pintura, grabado, 1960–1970.* Bogotá: Museo de Arte Moderno, 1971.

Carvalho, Flavio de, ed. *Revista Anual do Salão de Maio, RASM.* São Paulo: N.p., 1939.

Catlin, Stanton Loomis, and Terence Grieder. *Art of Latin America since Independence.* New Haven: Yale University, 1966.

Coldewey, Elke, Dieter Ruckhaberle, Peter B. Schumann, and Carmen Vogt, eds. and coords. *Jacobo Borges.* Berlin: Staatliche Kunsthalle, 1987.

Cruz-Diez, Carlos. *Cruz-Diez: Physichromies, Couleur Additive, Induction Chromatique, Chromointerferences.* New York: Galerie Denise René, 1971.

Day, Holliday T., and Hollister Sturges. *Art of the Fantastic: Latin American Art, 1920–1987.* With contributions by Edward Lucie-Smith, Damián Bayón, and others. Indianapolis: Indianapolis Museum of Art, 1987.

Dittborn, Eugenio. *Remota: Airmail Paintings.* Ed. Roberto Merino and Neil Davidson. New York: The New Museum of Contemporary Art, and Santiago: Museo Nacional de Bellas Artes: Pública Editores, 1997.

Drot, Jean-Marie, and Gérald Alexis. *Haïti: Art naïf art voudou.* Paris: Galerie Nationale du Grand Palais, 1988.

Duncan, Barbara, guest curator. *Joaquín Torres-García, 1874–1949.* Austin: Archer M. Huntington Art Gallery, The University of Texas, 1974.

Eduardo Ramírez Villamizar. Bogotá: Galería Tempora, 1980.

Eduardo Ramírez Villamizar. Bogotá: Museo de Arte Moderno, 1975.

Farver, Jane. *Luis Camnitzer: Retrospective Exhibition, 1966–1990.* Bronx, N.Y.: Lehman College Art Gallery, 1991.

Favela, Ramón. *Diego Rivera: The Cubist Years.* Phoenix: Phoenix Art Museum, 1984.

Felguérez, Manuel, and Mayer Sasson. *Paintings and Sculptures: Manuel Felguérez.* Cambridge: Carpenter Center for the Visual Arts, Harvard University, 1976.

Fernández-Muro, José Antonio. *Fernández-Muro.* Intro. Thomas M. Messer. Rome: Galeria Poliani, 1964.

Fox, Howard N., Miranda McClintic, and Phyllis Rosenzweig. *Content: A Contemporary Focus, 1974–1984.* Washington, D.C.: Hirshhorn Museum and Sculpture Garden, 1984.

Galán, Julio. *Julio Galán.* New York: Annina Nosei Gallery, 1992.

González, Miguel. *Alcántara, 1960–1980.* Bogotá: Museo de Arte Moderno, 1980.

Gradowczyk, Mario H. *Alejandro Xul Solar.* Buenos Aires: Galería Kramer, 1988.

Grynsztejn, Madeleine. *Alfredo Jaar.* La Jolla: La Jolla Museum of Contemporary Art, 1990.

Helms, Cynthia Newman, ed. *Diego Rivera: A Retrospective.* Linda Downs and Ellen Sharp, curators. Detroit: Founders Society of the Detroit Institute of Arts, and Mexico City: Instituto Nacional de Bellas Artes, 1986.

Hernández, José. *Luis Caballero: Me tocó ser así.* Bogotá: Galería Garcés Velásquez, 1986.

Hitchcock, Henry-Russell. *Latin American Architecture since 1945.* New York: Museum of Modern Art, 1955.

Katz, Leandro. *Leandro Katz.* Spanish translation by Cecilia Vicuña. Providence: Museum of Art, Rhode Island School of Design, and New York: Center for Inter-American Relations, 1984.

Lam, Wifredo. *Wifredo Lam.* Ed. Lou Laurin Lam and Marta González Orgebozo. Madrid: Museo Nacional Centro de Arte Reina Sofía, 1992.

Lurie, Sheldon M., ed. *The Art of Santiago Cárdenas.* Miami: Frances Wolfson Art Gallery, Miami Dade Community College, Wolfson Campus, 1983.

Mabe, Manabu. *Mabe.* Interview with the artist by Olivio Tavares de Araujo. Rio de Janeiro: Galería de Arte Ipanema, 1973.

Mabe, Manabu. *Manabu Mabe: Vida e obra.* Intro. Pietro Maria Bardi. São Paulo: Raízes Artes Gráficas, 1986.

La Maison de l'Amérique Latine and l'Académie Internationale des Beaux Arts. *Exposition D'Art Américain-Latin.* Paris: Musée Galliéra, 1924.

Manley, Marianne. *Intimate Recollections of the Rio de la Plata: Pedro Figari* (English and Spanish). Spanish translation by Lori Carlson, Cynthia Ventura, and Cecilia Vicuña. New York: Center for Inter-American Relations, 1986.

Matta Echaurren, Roberto Sebastian. *Matta.* Org. and ed. Alain Sayag and Claude Schweisguth. Paris: Centre Georges Pompidou Musée National d'Art Moderne, 1985.

McShine, Kynaston L. *Information.* New York: Museum of Modern Art, 1970.

Mesa, José de, and Teresa Gisbert, eds. and curators. *Arturo Borda.* La Paz: Museo Nacional de Arte del Ministerio de Educación y Cultura, Salón Municipal de Arte, 1966.

Morais, Frederico. *Antonio Henrique Amaral: Caminhos de Ontem, 1957–1982.* São Paulo: Alberto Bonfiglioli Galeria de Arte, 1983.

Negret, Edgar. *Edgar Negret: A Retrospective.* With essays by Galaor Carbonell and Paul Foster. English translation by Andree Conrad. New York: Center for Inter-American Relations, 1976.

Pacheco, María Luisa. *María Luisa Pacheco: Retrospectiva.* Text by Leopoldo Castedo. La Paz: Museo de Bellas Artes, 1976.

Peraza, Nilda, Marcia Tucker, and Kinshasha Holman Conwill. *Decade Show: Frameworks of Identity in the 1980s.* New York: Museum of Contemporary Hispanic Art, The New Museum of Contemporary Art, and The Studio Museum in Harlem, 1990.

Pontual, Roberto, ed. *América Latina: Geometria sensível.* Rio de Janeiro: Edições *Jornal do Brasil* for the Museu de Arte Moderna, 1978.

———. *Visão da Terra.* Rio de Janeiro: Edições *Jornal do Brasil* for the Museu de Arte Moderna, 1977.

Portinari, Cândido. *Portinari.* Intro. Manuel Bandeira and essay by Mario de Andrade. Rio de Janeiro: Ministerio da Educação, 1939.

Ramírez, Mari Carmen, ed. *Encounters/Displacements: Luis Camnitzer, Alfredo Jaar, Cildo Meireles.* Austin: Archer M. Huntington Art Gallery, The University of Texas, 1992.

———, ed. *El Taller Torres-García: The School of the South and Its Legacy.* Cecilia Buzio de Torres and Mari Carmen Ramírez, curators. Austin: University of Texas Press for the Archer M. Huntington Art Gallery, 1992.

Ramírez Villamizar, Eduardo. *Eduardo Ramírez Villamizar: Exposición Retrospectiva, 1958–1972.* Cali, Col.: Museo La Tertulia, 1972.

Rasmussen, Waldo, Fatima Bercht, and Elizabeth Ferrer, eds. *Latin American Artists of the Twentieth Century.* New York: Museum of Modern Art, 1993.

Renfrew, Nita M., ed. *Leonora Carrington: A Retrospective Exhibition.* New York: Center for Inter-American Relations, 1976.

Ríos, Miguel Angel. *Miguel Angel Ríos. Earth Paintings: An Exhibition.* Texts by Yusuke Nakahara, César Paternosto, and Ted Castle. Tokyo: Gallery Ueda, 1980.

———. *Miguel Angel Ríos: Obra reciente.* Mexico City: Galería de Arte Mexicano, 1988.

Rodman, Selden. *Artists in Tune with Their World.* New Haven: Yale University Art Gallery, 1985.

Roesler, Silvia, ed. *Rubens Gerchman.* Rio de Janeiro: Museu de Arte Moderna, and São Paulo: Museu de Arte de São Paulo, 1973.

Rojas, Carlos. *América: Carlos Rojas.* Intro. Galaor Carbonell. Catalog for the 13th Bienal de São Paulo. Bogotá: Instituto Colombiano de Cultura, 1975.

———. *Carlos Rojas.* Essay by Eduardo Serrano. Bogotá: Museo de Arte Moderno, 1974.

Rojas, Carlos, and Santiago Cárdenas. *Carlos Rojas, Santiago Cárdenas.* Intro. Bernice Rose. New York: Center for Inter-American Relations, 1973.

Rojo, Vicente. *Vicente Rojo.* Madrid: Dirección General de Bellas Artes y Archivos, Ministerio de Cultura, 1985.

Romero Brest, Jorge. *Más allá de la geometría: Extensión del lenguaje artístico-visual en nuestros días.* Buenos Aires: Instituto Torcuato di Tella, 1968.

Rubin, William. *Matta.* New York: Museum of Modern Art, 1953.

Saavedra, Santiago, ed. *Spanish Painters (1850–1950) in Search of Light.* New York: National Academy of Design, 1985.

Saldanha, Ione. *Ione Saldanha.* Interview by Fuad Atala. Rio de Janeiro: Galería do Instituto de Arquitetos do Brasil, 1981.

Seitz, William C., ed. *The Responsive Eye.* New York: Museum of Modern Art, 1966.

Selz, Peter. *New Images of Man.* New York: Museum of Modern Art, 1959.

Solar, Xul. *Xul Solar, 1887–1963.* Preface by Jacques Lassaigne and essays by Jorge-Luis Borges and Aldo Pellegrini. Paris: Musée d'Art Moderne de la Ville de Paris, 1977.

Tomasello, Luis. *Tomasello, oeuvres récentes.* Paris: Galerie Denise René, 1972.

Torres-García, Joaquín. *Torres-García: Grid-Pattern-Sign.* Organized by Susan Ferleger Brades, essay by Margit Rowell. London: Hayward Gallery (Arts Council of Britain), 1986.

Torruella Leval, Susana, curator. *Luis Cruz-Azaceta: Tough Ride around the City.* New York: Museum of Contemporary Hispanic Art, 1986.

Valladares, Clarival do Prado. *Análise iconográfica da pintura monumental de Portinari nos Estados Unidos.* Coord. María Elisa Carrozzini with Margarida Maria Barbosa da Silva Guimarães. Rio de Janeiro: Museu Nacional de Belas Artes, 1975.

Valentim, Rubem. *Rubem Valentim: Panorama da sua obra plástica.* Brasília: Fundação Cultural do Distrito Federal, 1975.

Viteri, Oswaldo. *Algunos hitos en la trayectoria de O. Viteri.* Quito: Museo Camilo Egas / Banco Central del Ecuador, 1987.

———. *Obra reciente de O. Viteri.* Quito: Museo de la Casa de la Cultura Ecuatoriana "Benjamín Carrión," 1987.

Volpi, Alfredo. *Retrospectiva Alfredo Volpi.* Essay by Diná Lopes Coelho. São Paulo: Museu de Arte Moderna de São Paulo, 1975.

White on White. Lincoln, Mass.: De Cordova Museum, 1965.

Zegher, Catherine de, Guy Brett, Catherine David, and Paulo Venâncio Filho, eds. *Tunga "Lezarts" / Meireles "Through."* Kortrijk: Kunststichting-Kaanal-Art Foundation, 1989.

Zerpa, Carlos. *Carlos Zerpa India Nova.* Intro. Axel Stein. Caracas: Sala Mendoza, 1987. Exhibition flyer.

ARTICLES, PERIODICALS,
AND PAMPHLETS

Adams, Beverly. "Installations." In *Encounters / Displacements,* ed. Mari Carmen Ramírez, 25–33. Austin: Archer M. Huntington Art Gallery, The University of Texas, 1992.

Adams, Brooks. "Julio Galán's Hothouse Icons." *Art in America* (July 1994): 64–69.

Alexis, Gérald. "A propos d'Hector Hyppolite." In Jean-Marie Drot and Gérald Alexis, *Haïti: Art naïf art voudou,* 122–126. Paris: Galerie Nationale du Grand Palais, 1988.

Alloway, Lawrence. "Latin America and International Art." *Art in America* (June 1965): 64–77.

———. "Lawrence Alloway on Max Bill." In Max Bill and James N. Wood, *Max Bill,* 11–18. Buffalo: The Buffalo Fine Arts Academy and Albright-Knox Art Gallery, 1974.

———. "The Search for a Legible Iconography." *Artforum* (October 1972): 74–77.

Amaral, Aracy A. "Duas linhas de contribuição: Concretos em São Paulo / neoconcretos no Rio." In *Projeto construtivo brasileiro na arte, 1950–1962.* Rio de Janeiro: Museu de Arte Moderna, and São Paulo: Pinacoteca de São Paulo.

———. "Leda Catunda." In *Modernidade: Arte brasileira do século XX,* ed. Aracy A. Amaral. Paris: Musée d'Art Moderne de la Ville de Paris, 1987; São Paulo: Museu de Arte Moderna de São Paulo, 1988.

———. "El múltiple itinerario de João Câmara." *Plural* (Mexico City) 5, no. 4 (January 1976): 43–46.

Amaral, Tarsila do. "Pintura Pau-Brasil e Antropofagia." *Revista Anual do Salão de Maio, RASM* (São Paulo) Section 1 (1939): Unpaginated.

Ashton, Dore. "Jacobo Borges—Life and Work." In *Jacobo Borges,* ed. and coord. Elke Coldewey, Dieter Ruckhaberle, Peter B. Schumann, and Carmen Vogt. Berlin: Staatliche Kunsthalle, 1987.

———. "Surrealism and Latin America." In *Latin American Artists of the Twentieth Century,* ed. Waldo Rasmussen, Fatima Bercht, and Elizabeth Ferrer, 106–115. New York: Museum of Modern Art, 1993.

Araujo, Olivio Tavares de. "De uma conversa con Mabe." In Manabu Mabe, *Mabe.* Rio de Janciro: Galería de Arte Ipanema, 1973.

Atala, Fuad. "Interview with Ione Saldanha." In *Ione Saldanha,* 17–18. Rio de Janeiro: Galería do Instituto de Arquitectos do Brasil, 1981.

Barnitz, Jacqueline. "An Arts and Crafts Movement in Uruguay: El Taller Torres-García." In *El Taller Torres-García,* ed. Mari Carmen Ramírez, 139–157. Austin: University of Texas Press for the Archer M. Huntington Art Gallery, 1992.

———. "Brazil." *Arts Magazine* (February 1971): 49.

———. "Five Latin American Women Artists." *Review* (New York, Center for Inter-American Relations) (spring 1975): 38–41.

———. "Latin American Artists in New York since 1970." In *Latin American Artists in New York since 1970,* ed. Jacqueline Barnitz, 1–22. Austin: Archer M. Huntington Art Gallery, University of Texas, 1987.

———. "A Latin Answer to Pop." *Arts Magazine* 40, no. 8 (June 1966): 35–39.

———. "New Figuration, Pop, and Assemblage in the 1960s and 1970s." In *Latin American Artists in the Twentieth Century,* ed. Waldo Rasmussen, Fatima Bercht, and Elizabeth Ferrer. New York: Museum of Modern Art, 1993.

———. "Three Mexican Artists at the C.I.R." *Arts Magazine* 43, no. 6 (April 1969): 42–44.

Batlle-Planas, Juan. "Cuatro devociones." *La Opinión Cultural,* Supplement, Sunday, 15 June 1975, 3.

Bayón, Damión. "A geometria sensível: Uma vocação argentina" (Sensitive geometry: An Argentine vocation). In *América Latina: Geometria sensível,* ed. Roberto Pontual, 115–125. Rio de Janeiro: Edições Jornal do Brasil for the Museu de Arte Moderna, 1978.

Benedetti, Jean-Marc. "A Propos d'Air Mexicain." In *Benjamin Péret,* ed. Jean-Michel Goutier, 130–146. Paris: Editions Henri Veyrier, 1982.

Bergman-Carton, Janis. "The Politics of Selfhood: Latin American Women Artists in New York, 1970–Present." In *Latin American Artists in New York since 1970,* ed. Jacqueline Barnitz, 31–36. Austin: Archer M. Huntington Art Gallery, University of Texas, 1987.

Berredo. Rio de Janeiro: Thomas Cohn Gallery, 1985. Exhibition brochure.

Bianchi, Soledad. "El movimiento artístico en el conflicto político actual." *Casa de las Américas* (Havana) 130 (February 1987): 26.

"Bilan, perspectives . . . " (Buenos Aires, 21 juillet 1969). *Robho* (Paris) 5–6 (2d term 1971): 22.

Bloch, Lucienne. "On Location with Diego Rivera." *Art in America* (February 1986): 102–123.

Borges, Jorge Luis. "Ascendencias del tango." *Martín Fierro* (20 January 1927): 9.

Brett, Guy. "Hélio Oiticica: Reverie and Revolt." *Art in America* (August 1989): 111–121, 163–165.

———. "Lygia Clark: In Search of the Body." *Art in America* (July 1994): 57–63, 108.

Brito, Ronaldo. "Análise do circuito." *Malasartes* (Rio de Janeiro) 3 (April–June 1976): 28–29.

———. "O espelho crítico." In *A natureza dos jogos: Waltercio Caldas Junior,* 1–14. São Paulo: Museu de Arte de São Paulo, 1975.

Buchloh, Benjamin N. D. "Conceptual Art 1962–1969: From the Aesthetic of Administration to the Critique of Institutions." *October* 55 (winter 1990): 105–145.

Burnside, Madeleine. "Luis Camnitzer: Uruguayan Torture." In Luis Camnitzer, *Uruguayan Torture,* 3–4. New York: Alternative Museum, 1984.

Caballero, Germán Rubiano. "La figuración política." In *Historia del arte colombiano,* ed. Ricardo Martín, 7:1563–1584. Bogotá: Salvat Editores Colombiana, 1977.

Cameron, Dan. "Seeing as (Dis)believing." Intro. to *Julio Galán.* New York: Annina Nosei Gallery, 1992.

Camnitzer, Luis. "Access to the Mainstream." In Jane Farver, *Luis Camnitzer: Retrospective Exhibition 1966–1990,* 41–43. Bronx, N.Y.: Lehman College Art Gallery, 1991.

———. "Wonderbread and Spanglish Art." In Jane Farver, *Luis Camnitzer: Retrospective Exhibition 1966–1990,* 44–47. Bronx, N.Y.: Lehman College Art Gallery, 1991.

Carbonell, Galaor. "Carlos Rojas en São Paulo." In *América: Carlos Rojas.* Bogotá: Instituto Colombiano de Cultura, 1975.

———. "Eduardo Ramírez Villamizar: Ultimas esculturas." In *Eduardo Ramírez Villamizar.* Bogotá: Museo de Arte Moderno, 1975.

Cassiano, Ricardo. "Verdeamarelismo." In *Revista Anual do Salão de Maio (RASM)* Section 1 (1939): Unpaginated.

Castedo, Leopoldo. "Primera retrospectiva de María Luisa Pacheco." In *María Luisa Pacheco: Retrospectiva,* unp. La Paz: Museo de Bellas Artes, 1976.

Castle, Ted. "Leandro Katz." In *Leandro Katz.* Providence: Museum of Art, The Rhode Island School of Design, 1984. Pamphlet.

———. "Miguel Angel Ríos at Allen/Wincor." *Art in America* (May 1985): 174.

———. "Miguel Angel Ríos: Epics from the Earth." *Artforum* (November 1988): 123–125.

———. "Painting with the Earth." In *Miguel Angel Ríos,* unp. Tokyo: Gallery Ueda, 1980.

Castro, Fidel. "Words to the Intellectuals." Reprinted in *Radical Perspectives in the Arts,* ed. Lee Baxandall, 267–298. New York: E. P. Dutton, 1968.

Catlin, Stanton Loomis. "Mural Census." In *Diego Rivera: A Retrospective,* ed. Cynthia Newman Helms. Detroit: Founders Society of the Detroit Institute of Arts, and Mexico City: Instituto Nacional de Bellas Artes, 1986.

Christ, Ronald. "Catalina Parra and the Meaning of Materials." *ArtsCanada* (March/April 1981): 3–7.

Clark, Lygia. "Le corps est la maison: Sexualité: envahissement du 'territoire' individuel." *Robho* 5–6, (2d term 1971): 12–13.

—————. "Nostalgia of the Body." Intro. Yve-Alain Bois. *October* 69 (summer 1994): 85–109.

—————. *Signals Newsbulletin* (London) 1, no. 7 (May–July 1965): Unpaginated.

—————. "Unité du champ perceptif." *Robho* 5–6 (2d term 1971): 8.

Clay, Jean. "J. R. Soto: Creating Imaginary Space." *Studio International* (January 1966): 2–5.

Cockcroft, Eva. "Abstract Expressionism, Weapon of the Cold War." *Artforum* 12, no. 10 (June 1974): 39–41.

—————, and James D. Cockcroft. "Murals for the People of Chile." Brochure with text reprinted from *Toward Revolutionary Art,* No. 4. New York: Public Art Workshop, 1973.

Cordeiro, Waldemar. "Teoria e prática do concretismo carioca." In *Projeto construtivo brasileiro na arte, 1950–1962,* ed. Aracy A. Amaral, 134–135. Rio de Janeiro: Museu de Arte Moderna, and São Paulo: Pinacoteca de São Paulo, 1977.

Cotter, Holland. "A Wry Defiance behind Garish Colors and Tabloid Dramas." *The New York Times,* Friday, 4 September 1998, B28.

Cuevas, José Luis. "The Cactus Curtain: An Open Letter on Conformity in Mexican Art." *Evergreen Review* 2 (winter 1959): 111–120.

D'Amico, Margarita. "Alejandro Otero en la vanguardia espacial." *Vea y Lea* (Caracas) 92 (21 September 1971): 30–34.

Diament Sujo, Clara. "Open Letter to a University Man in Texas Concerning Some Venezuelan Artists." Trans. Sheila M. Ohlendorf. *Texas Quarterly* (autumn 1965): 80–82.

Doctors, Marcio. "Interview with Marcio Doctors." In *Berredo.* Rio de Janeiro: Thomas Cohn Gallery, 1985.

Douglas, Eduardo de Jesús. "The Colonial Self: Homosexuality and *Mestizaje* in the Art of Nahum B. Zenil." *Art Journal* 57, no. 3 (fall 1998): 14–21.

Dunn, Christopher. "It's Forbidden to Forbid." *Americas* (September/October 1993): 14–21.

Ferrer, Elizabeth. "María Izquierdo." In *Latin American Artists of the Twentieth Century,* ed. Waldo Rasmussen, Fatima Bercht, and Elizabeth Ferrer, 116–121. New York: Museum of Modern Art, 1993.

"Les Fils de Marx et Mondrian." Trans. from Spanish to French by Genevieve Sobrino. *Robho* (Paris) 5–6 (2d term 1971): 16–17.

Flusser, Vilém. "'Battlefields' by Antonio Amaral." *Artes* (São Paulo) 9, no. 43 (July 1975): 8.

Francalanci, Ernesto L. "A Work of Antonio Dias." Trans. Alessandro Leipold. In *Antonio Dias, The Tripper.* Milan: Galeria Breton, 1971.

Franqui, Carlos. "Entrevista con Wifredo Lam." *Plástica* (Bogotá) 11 (April/June 1958): 15.

Geyerhahn, Suzana. "A arte dos mestres." *Malasartes* (Rio de Janeiro) 2 (January–February 1976): 20–21.

Girondo, Oliverio. "Manifiesto de *Martín Fierro.*" *Martín Fierro* (15 May 1924): 1–2.

Goldberger, Paul. "Architecture Approaches a New Internationalism." *The New York Times,* Sunday, 1 June 1980, E-9.

Goldman, Shifra. "Siqueiros and Three Early Murals in Los Angeles." *Art Journal* 32, no. 4 (summer 1974): 321–327.

Golan, Romy. "Matta, Duchamp et le mythe: Un nouveau paradigme pour la dernière phase du surréalisme." In *Roberto Sebastian Matta Echaurren, Matta.* Paris: Centre Georges Pompidou Musée National d'Art Moderne, 1985.

Grynsztejn, Madeleine. "Illuminating Exposures: The Art of Alfredo Jaar." In Madeleine Grynsztejn, *Alfredo Jaar.* La Jolla: La Jolla Museum of Contemporary Art, 1990.

Güiraldes, Ricardo. "Don Pedro Figari." *Martín Fierro* (August/September 1924): 5–6.

Gullar, Ferreira. "Arte concreta." In *Projeto construtivo brasileiro na arte, 1950–1962,* ed. Aracy A. Amaral, 105–107. Rio de Janeiro: Museu de Arte Moderna, and São Paulo: Pinacoteca de São Paulo, 1977.

—————. "Arte neoconcreta, uma contribuição brasileira." In *Projeto construtivo brasileiro na arte, 1950–1962,* ed. Aracy A. Amaral, 114–129. Rio de Janeiro: Museu de Arte Moderna, and São Paulo: Pinacoteca de São Paulo, 1977.

—————. "Da arte concreta à arte neoconcreta." In *Projeto construtivo brasileiro na arte, 1950–1962,* ed. Aracy A. Amaral, 108–113. Rio de Janeiro: Museu de Arte Moderna, and São Paulo: Pinacoteca de São Paulo, 1977.

————. "Manifesto neoconcreto." Reprinted in *Projeto construtivo brasileiro na arte, 1950–1962,* ed. Aracy A. Amaral, 80–84. Rio de Janeiro: Museu de Arte Moderna, and São Paulo: Pinacoteca de São Paulo, 1977.

————. "Teoria do não-objeto." In *Projeto construtivo brasileiro na arte, 1950–1962,* ed. Aracy A. Amaral, 85–94. Rio de Janeiro: Museu de Arte Moderna, and São Paulo: Pinacoteca de São Paulo, 1977.

Haber, Alicia. "Vernacular Culture in Uruguayan Art: An Analysis of the Documentary Function of the Works of Pedro Figari, Carlos González, and Luis Solari." In Latin American and Caribbean Center Occasional Papers Series, no. 2: 3–9. Miami: Florida International University, 1982.

Hall, Douglas. *The Sculpture of Edgar Negret.* Edinburgh: Richard Demarco Gallery, 1967. Pamphlet reprinted from *Studio International* (September 1967).

Herkenhoff, Paulo. "Deconstructing the Opacities of History." In *Encounters/ Displacements,* ed. Mari Carmen Ramírez, 49–57. Austin: Archer M. Huntington Art Gallery, University of Texas, 1992.

————. "The Theme of Crisis in Contemporary Latin American Art." In *Latin American Artists of the Twentieth Century,* ed. Waldo Rasmussen, Fatima Bercht, and Elizabeth Ferrer, 134–143. New York: Museum of Modern Art, 1993.

Herrera, Hayden. "Frida Kahlo: Her Life, Her Art." *Artforum* (May 1976): 38–44.

Hurlburt, Laurance P. "The Siqueiros Experimental Workshop: New York, 1936." *Art Journal* 35, no. 3 (spring 1976): 237–246.

Icaza, Francisco. "José Luis Cuevas pinta actualmente en el manicomio." *Mañana* (Mexico City), 5 May 1995, 48–50.

Katz, Leandro. *The Judas Window.* Exhibition flyer. New York: Whitney Museum of American Art, 1982.

Kosuth, Joseph. "Art after Philosophy." Reprinted in *Malasartes* (Rio de Janeiro) 1 (September–November 1975): 10–13.

Kozloff, Max. "American Painting during the Cold War." *Artforum* 11, no. 9 (May 1973): 43–54.

————. "The Rivera Frescoes of Modern Industry at the Detroit Institute of Arts: Proletarian Art under Capitalist Patronage." *Artforum* (November 1973): 58–63.

Larco Hoyle, Rafael. "La escritura peruana preincana." *México Antiguo* 6 (1944): 219–238.

Laroche, Fernando. *El arte de Figari.* Lecture published as a pamphlet. Montevideo: Imprenta y Editorial Renacimiento, 25 May 1923: 9.

"Latin Labyrinth." *Newsweek,* 21 February 1966, 90.

Lindstrom, Naomi. "Xul Solar's Synthesis." *Americas* (June/July 1979): 21–24.

————. "Xul Solar, Star-Spangler of Languages." *Review* (New York: Center for Inter-American Relations) 25–26 (1980): 117–121.

Lobato, Monteiro. "Paranoia ou mistificação." *O Estado de São Paulo,* 20 December 1917.

"Manifesto." *Malasartes* (Rio de Janeiro) 3 (April–June 1976): 28–29.

"Manifesto Antropófago." *Revista de Antropofagia* 1, no. 1 (May 1928): 3, 7.

Manley, Marianne. "Intimate Recollections of the Rio de la Plata." In *Intimate Recollections of the Rio de la Plata: Pedro Figari* (English and Spanish). Spanish translation by Lori Carlson, Cynthia Ventura, and Cecilia Vicuña. New York: Center for Inter-American Relations, 1986.

Mariani, Roberto. "'Martín Fierro' y yo." *Martín Fierro* (July 1924): 2.

Mariátegui, José Carlos. "Literature on Trial." In *Seven Interpretive Essays on Peruvian Reality,* ed. and trans. Marjory Urquidi, intro. Jorge Basadre. Austin: University of Texas Press, 1971.

Márquez, Francisco. *Miguel von Dangel: Tres aproximaciones hacia el paisaje venezolano.* Caracas: Privately published by the artist, 1982. Brochure.

Maurício, Jayme. "Arte, idéias e encanto de Ione Saldanha." *Correio da Manhã* 3 (July 1956).

McClintic, Miranda. "Content: Making Meaning and Referentiality." In Howard N. Fox, Miranda McClintic, and Phyllis Rosenzweig, *Content: A Contemporary Focus, 1974–1984.* Washington, D.C.: Hirshhorn Museum and Sculpture Garden, 1984.

McGreevy, Linda. "Down in the Streets with Luis." In *Luis Cruz-Azaceta: Tough Ride around the City,* Susana Torruella Leval, curator. New York: Museum of Contemporary Hispanic Art, 1986.

————. "Painting His Heart Out: The Work of Luis Cruz Azaceta." *Arts Magazine* (summer 1985): 126–128.

Meireles, Cildo. "Inserções em circuitos ideológicos Abril/Maio 1970." *Malasartes* (Rio de Janeiro) 1 (September–November 1975): 15.

Menezes, Lu. "How to Build Troubled Skies." In Guy Brett, *Transcontinental: Nine Latin American Artists,* 40. London: Verso, in association with Ikon Gallery, 1990.

Merewether, Charles. "Displacement and the Reinvention of Identity." In *Latin American Artists of the Twentieth Century,* ed. Waldo Rasmussen, Fatima Bercht, and Elizabeth Ferrer, 144–155. New York: Museum of Modern Art, 1993.

Mesa, José de, and Teresa Gisbert. "Arturo Borda, el hombre y su obra." In *Arturo Borda,* 8–20. La Paz: Museo Nacional de Arte del Ministerio de Educación y Cultura, Salón Municipal de Arte, 1966.

Minujin, Marta. *Los mitos y la ley de la gravedad.* Essay by Jorge Glusberg. Buenos Aires: Centro de Arte y de Comunicación (CAYC), 1981.

———. *The Venus of Cheese.* Buenos Aires: CAYC, 1981.

Morais, Frederico. "O Corpo contra os Metais da Opressão." In *Antonio Henrique Amaral,* ed. Alexandre Dórea Ribeiro, 35–79. São Paulo: DBA Dórea Books and Art, 1977.

———. "João Câmara Filho: Cenas da Vida Brasileira 1930–1954." Rio de Janeiro: N.p., 1976. One-page text to accompany an audiovisual presentation.

———. "Ramírez Villamizar." In *Eduardo Ramírez Villamizar.* Bogotá: Galería Tempora, 1980.

———. "Rubem Valentim." In *Visão da Terra,* ed. Roberto Pontual, 145. Rio de Janeiro: Edições *Jornal do Brasil* for the Museu de Arte Moderna, 1977.

Mosquera, Gerardo. "Modernidad y africanía: Wifredo Lam en su isla." In *Wifredo Lam,* 21–41. Madrid: Museo Nacional Centro de Arte Reina Sofía, 1992.

Merquior, José Guilherme. "A Criação do Livro da Criação." In *Projeto construtivo brasileiro na arte, 1950–1962,* ed. Aracy A. Amaral, 277–278. Rio de Janeiro: Museu de Arte Moderna, and São Paulo: Pinacoteca de São Paulo, 1977.

Noé, Luis Felipe. "Solemn Letter to Myself." In *Luis Felipe Noé: Paintings,* unp. New York: Galería Bonino, 1966.

Ocampo, Victoria. "Pedro Figari." *Revista Sur* 14, no. 131 (September 1945): 30–35.

Paalen, Wolfgang. "Farewell au Surréalisme." *Dyn* 1, no. 1 (April/May 1942): 26.

Paz, Octavio. "Multiple Space." In *Paintings and Sculptures: Manuel Felguérez,* ed. Manuel Felguérez and Mayer Sasson, unp. Cambridge: Carpenter Center for the Visual Arts, Harvard University, 1976.

Pizarro, Agueda. "Beyond the Gallery Walls." *Americas* (January/February 1984): 8–13.

Prebisch, Alberto. "Pablo Curatella-Manes." *Martín Fierro* (October/November 1924): 6–7.

Querejazú, Pedro. "Ensayo crítico en torno a Arturo Borda y su obra." *Revista Municipal de Cultura,* (nueva época) 21 (1989).

Ramírez, Mari Carmen. "Blueprint Circuits: Conceptual Art and Politics in Latin America." In *Latin American Artists of the Twentieth Century,* ed. Waldo Rasmussen, Fatima Bercht, and Elizabeth Ferrer, 156–167. New York: Museum of Modern Art, 1993.

———. "Moral Imperatives: Politics as Art in Luis Camnitzer." In Jane Farver, *Luis Camnitzer: Retrospective Exhibition, 1966–1990,* 4–13. Bronx, N.Y.: Lehman College Art Gallery, 1991.

———. "Re-positioning the South: The Legacy of El Taller Torres-García in Contemporary Latin American Art." In *El Taller Torres-García: The School of the South and Its Legacy,* ed. Mari Carmen Ramírez, 253–289. Austin: University of Texas Press for the Archer M. Huntington Art Gallery.

Renard, Claude-Louis. "Excerpts from an Interview with Soto." In Thomas M. Messer, *Soto: A Retrospective,* 21. New York: The Solomon R. Guggenheim Museum, 1974.

Rodríguez, Marco Antonio. "Del libro *Viteri.*" In *Algunos hitos en la trayectoria de O. Viteri,* 4–5. Quito: Museo Camilo Egas/Banco Central del Ecuador, 1987.

Ruderfer, Betsy R. "Let's Bring the Yllanes Collection Home." Poster/flyer, 1995.

Sanjurjo Casciero, Annick. "The Poet of Mexican Realism." Interview with Rufino Tamayo. *Americas* 42, no. 4 (1990): 42–47.

Sawin, Martica. "Ethnographic Surrealism and Indigenous America." In *El surrealismo entre Viejo y Nuevo Mundo,* coord. Alicia Batista, Orlando Britto, Orlando Franco, Gilma Miguel, and Luis Sosa, 325–327. Las Palmas, Grand Canary: Centro Atlántico de Arte Moderno, 1989–1990.

Siqueiros, David Alfaro. "The Salutary Presence of Mexican Art in Paris." In *Art and Revolution,* ed. and trans. Sylvia Calles, 145–175. London: Lawrence and Wishart, 1975.

Squirru, Rafael. "Pop Art and the Art of Things." *Americas* (July 1963): 15–21.

Suárez, Pablo. "Trois actes." *Robho* (Paris) 5–6 (fall 1971): 19–21.

Tibol, Raquel. "Góngora virtuoso y disciplinado." *Excelsior,* 13 August 1972.

———. "Herméticos recuerdos de Vicente Rojo." In *Vicente Rojo,* 110–111. Madrid: Dirección General de Bellas Artes y Archivos, Ministerio de Cultura, 1985.

Torre, Guillermo de. "Neodadaísmo y superrealismo." *Proa* (January 1925): 54–69.

Traba, Marta. "El artista comprometido." *Prisma* (Bogotá) 5 (May/June 1957).

"Tucumán brûle." *Robho* (Paris) 5–6 (fall 1971): 17–19.

Underwood, Max. "Luis Barragán: Modern Mexican Architecture." *Latin American Art* (fall 1990): 44–49.

Van Doesburg, Theo. "Elementarism." *De Stijl,* final number (Paris, 13 July 1930). In Hans L. C. Jaffé, *De Stijl, 1917–1931.* Cambridge: Harvard University Press, 1986.

Weschler, Lawrence. "Cildo Meireles: Cries from the Wilderness." *Art News* (summer 1990): 95–98.

Widdifield, Stacie G. "Dispossession, Assimilation, and the Image of the Indian in Late-Nineteenth-Century Mexican Painting." *Art Journal* (summer 1990): 125–131.

Yurkievich, Saul. "La réflexion chromatique de Luis Tomasello." In *Luis Tomasello, Tomasello, oeuvres récentes.* Paris: Galerie Denise René, 1972.

Xul Solar. "Palabras Xul." *The Bulletin Board* (Buenos Aires: The American Women's Club) 34, no. 5 (August 1969): 10–11.

———. "Pettoruti." *Martín Fierro* (September/October 1924): 7.

Zorzi, Renzo. "Introduction." In José Balza, *Alejandro Otero,* vi–viii. Milan: Olivetti, 1977.

UNPUBLISHED SOURCES

Adams, Beverly. "The Subject of Torture: The Art of Camnitzer, Núñez, Parra, and Romero." Master's thesis, University of Texas at Austin, 1992.

Deffebach, Nancy. "Pre-Colombian Symbolism in the Art of Frida Kahlo." Master's thesis, University of Texas at Austin, 1991.

de Maistre, Agnès. "Le Groupe Argentin Deira, Macció, Noé, De la Vega 1961–1966, ou la Figuration Eclectique." 2 vols. Master's thesis, Université de Paris IV, La Sorbonne, 1987.

García Romero, Jorge O. "Alejandro Xul Solar." Master's thesis, Art Department, Universidad Nacional de La Plata, 1972.

González, María de Jesús. "María Izquierdo: The Formative Years." Ph.D. diss., University of Texas at Austin, 1998.

Hajicek, Diane. "The Nation as Canvas." Master's thesis, University of Texas at Austin, 1995.

Harrison, Marguerite Itamar. "Ione Saldanha's Sculptural Forms in the Context of Brazilian Art." Master's thesis, University of Texas at Austin, 1984.

Lombardi, Mary. "Women in the Modern Art Movement in Brazil: Salon Leaders, Artists, and Musicians, 1917–1930." Ph.D. diss., University of California at Los Angeles, 1977.

Majluf, Natalia. "The Creation of the Image of the Indian in Nineteenth-Century Peru: The Paintings of Francisco Laso (1823–1869)." Ph.D. diss., University of Texas at Austin, 1995.

Navas, Tariana. "Erotic Violence in Matta's Works of the Years in New York 1939–1948." Paper presented at The University of Texas at Austin, 1990.

Noé, Luis Felipe. Untitled MS of a lecture on the Otra Figuración given at the University of Texas at Austin on 4 October 1989. Author's personal archives.

Pérez, María Trinidad. "The Indian in the 1920s Painting of the Ecuadorian Painter Camilo Egas." Master's thesis, University of Texas at Austin, 1987.

Ramírez-García, Mari Carmen. "The Ideology and Politics of the Mexican Mural Movement: 1920–1925." Ph.D. diss., University of Chicago, 1989.

Rith-Magni, Isabel. "El ancestralismo—¿un 'indigenismo abstracto'?" Paper presented at the 47th International Congress of Americanists, Tulane University, New Orleans, La., July 1991.

Rocca, Cristina. "Cosmovisiones y palimpsestos: Lo indígena en el arte venezolano contemporáneo." Paper presented at the 47th Congress of Americanists, Tulane University, New Orleans, La., July 1991.

Seloff, Gary Alan. "Alejandro Obregón and the Development of Modern Art in Colombia." Master's thesis, University of Texas at Austin, 1983.

INDEX